THE PHILOSOPHY OF
RODERICK M. CHISHOLM

him. All contributed essays will finally be submitted to the philosopher with whose work and thought they are concerned, for his careful perusal and reply. And, although it would be expecting too much to imagine that the philosopher's reply will be able to stop all differences of interpretation and of critique, this should at least serve the purpose of stopping certain of the grosser and more general kinds of misinterpretations. If no further gain than this were to come from the present and projected volumes of this Library, it would seem to be fully justified.

In carrying out this principal purpose of the Library, the editor announces that (as far as is humanly possible) each volume will contain the following elements:

First, an intellectual autobiography of the thinker whenever this can be secured; in any case an authoritative and authorized biography;
Second, a series of expository and critical articles written by the leading exponents and opponents of the philosopher's thought;
Third, the reply to the critics and commentators by the philosopher himself; and
Fourth, a bibliography of writings of the philosopher to provide a ready instrument to give access to his writings and thought.

<div align="right">

PAUL ARTHUR SCHILPP
FOUNDER AND EDITOR, 1939–1981

</div>

DEPARTMENT OF PHILOSOPHY
SOUTHERN ILLINOIS UNIVERSITY AT CARBONDALE

ADVISORY BOARD

ACKNOWLEDGMENTS

The editor hereby gratefully acknowledges his obligation and sincere gratitude to all the publishers of Roderick M. Chisholm's books and publications for their kind and uniform courtesy in permitting us to quote—sometimes at some length—from Professor Chisholm.

LEWIS E. HAHN

#Added to Board after the subject of this volume was chosen.
*Deceased.

TABLE OF CONTENTS

PREFACE

In recent years Roderick M. Chisholm, now emeritus, has taught at both Brown University and the University of Graz, and in earlier years at a host of other distinguished universities. Starting with Aristotle, "the Philosopher," and his views on substance, he continues in outstanding fashion, with his own variations, the intentionalistic tradition of Brentano and Meinong. Broad, systematic, and historically erudite, his works in metaphysics, particularly ontology, theory of knowledge, philosophy of mind, and value theory have been translated into sixteen or more foreign languages. Three or more Festschrifts (two in English and one in German) have been done on Chisholm, who has been called the Immanuel Kant of American Philosophy.

His intellectual autobiography and his critics tell us more about his key concepts, and the former sketches some of his activities and a few of the many honors he has earned.

I am grateful to Professor Chisholm and his thirty critics for making this volume possible.

I sadly report reading in the May 1997 issue of the *Proceedings and Addresses of the American Philosophical Association* of the death on 6 April 1996 of Sterling Moss McMurrin, long-term member of the Library of Living Philosophers Advisory Board. His wise counsel and unfailing cooperation will long be remembered.

It is a pleasure to note once more the support, encouragement, and cooperation of our publisher, Open Court Publishing Company, especially M. Blouke Carus, David R. Steele, Kerri Mommer, and associates. And I am also grateful for continued support, understanding, and encouragement from the administration of Southern Illinois University. Although there have been some personnel changes, the pattern of support remains constant.

As always, moreover, I am grateful for the friendly and unfailing help of the staff of Morris Library. It is invaluable for my work. Loretta Koch, David Koch, and their associates are ever resourceful. My thanks go also to Claudia Roseberry, Vernis Shownes, and the Philosophy Department secretariat for help on numerous projects, and I give special thanks to Sharon R. Langrand for help with manuscripts and proofs and keeping our lines of communication open.

Finally, I am deeply grateful to my pluralistic colleagues for warm support, stimulation, and counsel. Their resourcefulness and diversity in a common cause never cease to amaze me and to warm my heart.

LEWIS EDWIN HAHN
EDITOR

DEPARTMENT OF PHILOSOPHY
SOUTHERN ILLINOIS UNIVERSITY AT CARBONDALE
JUNE 1997

PART ONE

INTELLECTUAL AUTOBIOGRAPHY OF RODERICK M. CHISHOLM

Roderick M. Chisholm

MY PHILOSOPHICAL DEVELOPMENT

General Introduction

Following my autobiographical reminiscences, I will set forth my philosophical views in the order in which I have developed them. My Harvard Ph.D. dissertation (1942) was entitled "The Basic Propositions of the Theory of Knowledge." My first book (1957) was *Perceiving: A Philosophical Study.* And the first edition of my second book, *Theory of Knowledge,* appeared in 1960.

After discussing knowledge, I shall consider intentionality and the concept of the *subject* of thinking, sensing, and feeling—in short, the *bearer* of intentional properties. Quite naturally, I turned to ontology and then to the general theory of categories. My third book, *Person and Object* (1976), was so titled to distinguish its intentional point of view from the linguistic point of view of W. V. Quine's *Word and Object,* a book which I greatly admire and which has had a profound influence upon my thinking.

My most recent book, *A Realistic Theory of Categories,* appeared in 1996. I conclude this account of my philosophical development with a discussion of ontology.

<p style="text-align:center">REMINISCENCES</p>

Student Days

I entered Brown University in 1934 and graduated in 1938. There I received my introduction to serious philosophy. The philosophy department was an excellent one and very small. The tenured faculty were C. J. Ducasse, R. M. Blake, Charles A. Baylis, and Arthur Murphy. Frederick C. Dommeyer and Donald Whittemore were instructors. The tenured faculty members all lived on a small street in East Providence leading

down to the Seekonk River. The general area, therefore, came to be known as "Athens on the Seekonk."

The member of this group who influenced me the most was probably Blake. He had written a number of analytic papers which are first-rate contributions to philosophy. He also taught an annual two-semester course on the history of Western philosophy—beginning with the pre-Socratics and usually concluding with Kant. He was a counterinstance to Schopenhauer's generalization, according to which historians of philosophy are not themselves philosophers. What he taught me, in addition to his way of doing philosophy, was a respect for the history of the subject.

There was a good group of graduate students and they welcomed me to take part in their philosophical discussions. One of these graduate students was Vincent Tomas who is my oldest friend among philosophers. Indeed, there are now very few people whom I have known as long as I have known him.

Ducasse advised me to become a graduate student of philosophy at Harvard and I enrolled there the day before the great hurricane of 1938. I received my Ph.D. in June 1942, just in time to enter the United States Army—or, as it was known then, "the Army of the United States." At Harvard there were many more teachers and many more graduate students than there were at Brown. And in addition to the regular faculty, there were always visiting philosophers, including many refugees from the Nazi regime.

The members of the regular faculty who influenced me the most were C. I. Lewis and Donald C. Williams, who were the readers of my Ph.D. thesis ("The Basic Propositions of Empirical Knowledge"). I felt that Lewis was not only a great logician, but also, I believe, the most profound philosopher on the staff. (On one occasion, Henry Aiken, then a student from at least the previous year, was helping to orient some of us who were first-year graduate students. He pointed to Lewis's *Mind and the World Order,* and said: *"That* book is our Bible.") Donald Williams was what a teacher should be; he was extraordinarily generous, not only with his time, but also with his detailed comments.

I took one course with Ralph Barton Perry—a seminar on the general theory of value. I had hoped to take more, because (thanks to the influence of Baylis at Brown) I had become interested in the issues that divided the two schools of American realism: the "New Realism," of which Perry was more or less the leader; and "Critical Realism." But this was a time during which most Americans were concerned with "interventionism"—the question whether the nation should take a more active role in defeating Hitler. Perry was one of the intellectual leaders of

the interventionists and most of his time was devoted to that cause. The three-column letters-to-the-editor which he published regularly in the Sunday edition of *The New York Times* were good examples of a philosopher dealing with the problems of humanity. But they prevented me from studying the New Realism in the way in which I had hoped to study it.

W. V. Quine was a young instructor who had just returned from a long stay in Vienna. (There were some old ladies who regularly helped themselves to the philosophy offering at Harvard. One day, just after the first edition of Quine's *Mathematical Logic* appeared in 1940, I overheard one of them saying to another: "Have you seen Professor Quine's new book? Nothing but symbols!!!") I did not have much contact with him when I was a graduate student, unfortunately. But I want to mention that subsequently he was to have a profound influence on my work—despite some fundamental philosophical disagreements.

Another teacher who influenced me was D. W. Prall. This was the result of a course on Leibniz that he offered. He had us read Leibniz—in particular, the Open Court edition of the *Monadology* and other essays, as well as the editions edited by Latta and by Duncan. Like Blake, he had a great respect for the history of philosophy and he was able to teach Leibniz the way that Leibniz should be taught. And this was remarkable, since Prall, who was then one of the few philosophers who liked to call himself "a materialist," disagreed with Leibniz on almost every point. His toleration had its limits, though. I told him one day that I had read Leibniz's *New Essays* (in the Langley Open Court translation), with great admiration and profit. "You can't mean that you've read *all* of it?" Prall replied in astonishment. (Langley, incidentally, was another Rhode Island philosopher. I bought his edition one cold day in the middle of winter.)

There was also William Ernest Hocking, an older and imposing but gentle man who was an "absolute idealist" in the sense of Bradley, Bosanquet, and Royce. (Quotations attributed to him appeared regularly on the signboards to be found in front of Protestant churches throughout New England.) What affected me was his desire that we reflect upon the question, "What *is* the self?" He assumed we would agree that there *is* in fact a self—one for each of us. The standard answer at the time was that the self can be reduced to "a bundle of sensations," just as many would say that numbers can be reduced to classes or sets. In the case of the thesis about numbers, many gave their all, so to speak, to prove that the thesis is true. But in the case of the thesis about the self, so far as I knew then and so far as I know now, no one has made a serious effort even to *try* to show that the thesis is true.

Another regular member of the faculty who influenced me was Julius Seelye Bixler who, among other things, brought to my attention the existence of Albert Schweitzer. I also attended an evening discussion group that was held by John Wild in his home. There we read, among other things, a translation of St. Thomas Aquinas's *De Ente et Essentia.* This was certainly interesting, but I realize now how much more helpful it would have been to me had we read parts of the *Summa Theologica,* or some other work in which Thomas followed his usual method of setting forth explicit objections and then replying to them in his characteristic way.

I mention, finally, Raphael Demos. Knowing of my interest in skepticism, he advised me to read Sextus Empiricus. This was excellent advice. If one were to understand all the implications of Sextus's distinction between "commemorative signs" and "indicative signs," one would be well on the way to understanding the essentials of the theory of knowledge. I wrote a paper for Demos called "Sextus Empiricus and Modern Empiricism." He advised me to revise it and submit it to *Philosophy of Science.* They accepted it and this paper is, in a way, my first philosophical publication. (I say "in a way" because, after the bibliography of the present book was prepared, I came across a book review I had published in the *Boston Transcript* on August 31, 1939. This was a review of *The New Immortality* by J. W. Dunne, a book about the "serial theory of time.")

Discussing philosophy with others is, of course, essential to one's education in philosophy. I was fortunate in being at Harvard at a time when many good students were there.

Among those whose graduate studies at Harvard overlapped with mine were the following: Henry Aiken, George Berry, Donald Davidson, Douglas Dryer, Lyne Few, Roderick Firth, John Ladd, David Savan, Arthur Smullyan, Samuel Stratton, Arthur Szathmary, Robert Tucker, Rulon Wells, and Howard Wiedemann.

I had many good conversations with these people and with others. I have found, however, that it takes a long time before one is *able* to have a serious philosophical discussion with any other person. One must know that person's philosophical vocabulary and one must know what, if anything, he or she is taking as provisional preanalytic data. (There are two corollaries to this principle. The first is that, if the one you are talking with professes to have *no* preanalytic data, then the discussion is likely to be fruitless. And the second is that others should realize that "three's a crowd.")

Firth and I, for at least two years, had rooms in the same house and

sometimes we talked philosophy from breakfast until the time we retired. My discussions with him were really successful. I recommend to the reader the symposium on Firth that appeared in *Philosophy and Phenomenological Research,* vol. 51 (1991). Our discussions continued, at less frequent intervals, until shortly before his death. Fortunately we did have one further occasion to do philosophy at some length together. This was on the occasion of a "Summer Seminar on the Theory of Knowledge" that was sponsored by the Council for Philosophical Studies and held at the University of Amherst in 1972. Norman Malcolm, who had left the Harvard Graduate School the year before I arrived, was also on the staff and his presence there provided just the philosophical balance that was needed. The students, chosen from among younger teachers of philosophy, soon came to be divided over the question of the relevance of ordinary language to the supposed problems of the theory of knowledge. The sessions were impassioned and really good. Arguments usually continued until late in the evening.

Returning to my account of life at the Harvard Graduate School, I should note that, in addition to the regular Harvard faculty, there were many distinguished visiting professors. These included Rudolf Carnap, Morris Cohen, Herbert Feigl, Alfred Tarski, Bertrand Russell, and Philip Frank. Frank was an extraordinarily kind man whom I met by chance and with whom I regularly had coffee. He was Einstein's successor at Prague. I have often thought that I missed a unique opportunity in not seeking out a topic of common philosophical interest and discussing it with him.

I was elected president of the Harvard Philosophy Club for the academic year 1941–1942, my final year at Harvard. There were many distinguished speakers whom I met while serving in that capacity. Of these the most impressive, to me at least, was G. E. Moore, who presented the lecture "Four Forms of Skepticism," later to be published in his *Philosophical Papers.* This event and attending Russell's seminar (on the topic of his later *Inquiry into Meaning and Truth*) were, in many respects, the high points of my graduate career.

That career had another side which I have not yet mentioned. One of the issues that had divided the American schools of New Realism and Critical Realism turned, of course, upon the concepts of *appearance* and of *sensation,* as well as upon what was intended by such terms as "sense-data," "sensa," and "sense-impressions." In *Mind and the World Order,* Lewis had used the singular term *"quale"* and the plural *"qualia."* Lewis advised me to take a course in psychology with Edwin G. Boring who happened to be offering a seminar on the psychology of sensation.

Fortunately for me, I followed Lewis's advice. Boring's sense of the importance of the history of the subject more than made up for his tendency to offer simple behavioristic answers to difficult philosophical questions. In this course I first learned something about Franz Brentano. (But I was not led to read Brentano until a few years later when I had seen Russell's discussion of Brentano and Meinong in *The Analysis of Mind*.) The seminar with Boring prepared me to serve with Reinhard Fabian, some years later, as co-editor of the second edition of Brentano's *Untersuchungen zur Sinnespsychologie,* a work which is important primarily as a contribution to what Brentano called "descriptive psychology," or *"beschreibende Phänomenologie."*

The thought of having psychology as a secondary subject also appealed to me for other reasons. At that time, philosophy and psychology departments were still combined in many institutions. And the study of psychology provided the opportunity to acquire some practical skills—of which I had practically none at all. I studied clinical psychology with F. L. Wells. He had developed the "concrete directions" test that was used as a screening test in the military induction centers where draftees were examined ("put the hammer to the right of the screw-driver . . ."). Under Wells's supervision I acquired some skills in psychological testing and I then had the opportunity to do some apprentice work at the Armed Services Induction Station in Boston.

I received the Ph.D. in philosophy, as I have said, in June 1942. Because of the impending military service, the department waived certain requirements about deadlines. These requirements would have put off the degree for another year.

I was drafted into the Army in July 1942.

A Touch of Military Service

I was sent to Fort McClellan in Alabama where I was to receive my basic training. The experience was hardly a pleasant one, but it was certainly good for me. The basic training was in the infantry, and I cannot say that it was entirely successful. It was next to impossible for me to plunge my bayonet into the cloth dummy that was provided for that purpose. And on one occasion I had to receive medical treatment for a leg that was almost scalded. This happened on KP duty one evening when, after the evening meal, I was trying to clean a container half-filled with hot spinach. It would be only a slight exaggeration to say that this incident marked the end of my period of training in the infantry.

More and more men were being called up for the draft and the Boston Induction Station had to move to much larger quarters at 1065 Commonwealth Avenue. They needed more personnel and I was sent there to become a member of the section on psychological testing.

In 1943 I married Eleanor Parker of North Attleboro, Massachusetts, whom I had known since my undergraduate days at Brown. She has been everything that a wife should be. Without her support I would not now be in the position of writing an autobiography for the *Library of Living Philosophers.*

My work involved going for brief periods to the induction station in New Haven which, unlike the one in Boston, was open only intermittently. Someone at Harvard (I think it may have been Henry Aiken) told Charles Stevenson of Yale that I was working in New Haven and Stevenson got in touch with me. We got to know each other well. At that time he was working on his contribution to the Moore volume of *The Library of Living Philosophers* and recommended to Professor Schilpp that I be invited to contribute to the volume on Russell. Schilpp invited me to submit something. I was able to adapt some material from my thesis that I thought would be suitable. To my great joy, he accepted it. And this made considerable difference to my subsequent career.

After about two years at the induction station, I received orders to go to Officers' Training School at Fort Sam Houston in San Antonio so that I might study clinical psychology. Master Sergeant John Stanley, in charge of the enlisted men in the induction station, uttered an oath and said: "That's the army for you. They want to educate somebody, so who do they take? The only guy here who's been to school for twenty years already!"

I was glad to find that Eleanor wanted to come with me.

After the training at Fort Sam, I was sent to do clinical work at the army hospitals associated with Camp Van Dorn, Mississippi and with Camp Polk, Louisiana. We acquired considerable knowledge of the Deep South, and I added to my clinical experience. Finally we were sent back to New England.

The date is easy to fix. The train made a brief stop in St. Louis. We got out to walk around and, after an enlisted MP had the nerve to send the young new officer back to the train to get his cap, we went into the station. There we learned that Franklin Delano Roosevelt had died the night before [on 12 April 1945].

Dr. Barnes of Merion

Toward the end of my military career (I was discharged in 1946), I became acquainted with Dr. Albert C. Barnes of Merion, Pennsylvania. He had invented the patent medicine, Argyrol, which for many years had been used in hospitals throughout the United States and elsewhere to rinse out the eyes of newborn babies. He became very wealthy and was able to acquire one of the best private collections of paintings in the world. These were housed in Merion, in the museum of what was called "The Barnes Foundation." The museum contained works of art of many types, but it was best known for its collection of French impressionistic paintings. I say "best known," but the museum did not have its doors open to many people and so only a few knew at first hand what was there.

In 1940 Bertrand Russell had been invited to serve as visiting professor at the College of the City of New York, where he intended to lecture on what was to appear in the *Inquiry into Meaning and Truth,* already referred to. But because of his popular writings, particularly those on religion and on love and marriage, the city of New York broke the contract. (Russell writes in the preface: "This book would have formed the substance of my lectures at the College of the City of New York, if my appointment there had not been annulled.") So Russell found himself without a teaching position.

John Dewey, who was very close to Barnes and had written *Art as Experience* at the Barnes Foundation, suggested to Barnes that it would be a fine thing to come to the rescue and invite Russell to lecture at his foundation. Barnes accepted the advice and Russell went to the foundation where he began the lectures that were to become the *History of Western Philosophy.* But Barnes was a difficult person. (There had been a comic-strip character at the time known as "The terrible tempered Mr. Bang"; and the *Saturday Evening Post* had published a series of articles on Barnes and entitled them "The Terrible-Tempered Dr. Barnes.") Barnes fired Russell; and Russell sued the foundation for breach of contract. In consequence Barnes published a pamphlet called "Bertrand Russell versus Democracy and Education." I saw a notice of the pamphlet in the *Journal of Philosophy.*

Being interested in things Russell, I wrote Barnes for a copy of the pamphlet and I included a check for two dollars to cover the cost of mailing. Barnes sent the pamphlet and returned the check, advising me to use the two dollars to buy a drink of good Scotch whiskey. A brief correspondence ensued and after a short time, I received, much to my surprise, a letter from John Dewey, inviting me to come to lunch with him in New York City. Naturally I accepted. I was very much impressed

by Dewey as a person. He was in his late eighties, but very much alert and a pleasure to be with. It was instructive to talk with a great philosopher whose conception of the subject was so different from my own.

Dewey must have sent a good report to Barnes who then invited me to visit him and to spend the night at his home in Merion. I had dinner with Dr. and Mrs. Barnes and Charles Collingwood who was a prominent radio journalist of that time. The next day, after a long talk, Barnes invited me to become a lecturer at the foundation after my discharge from the army. He said that I would be "Russell's successor."

By this time, I have to confess, I was completely confused by the world around me. I accepted the invitation—at the advice of C. J. Ducasse, but against the advice of C. I. Lewis.

As it happens, the University of Pennsylvania had a joint arrangement with Barnes which involved the arboretum in Merion which was directed by Mrs. Barnes. It was apparently in the interest, not only of the university but also of Dr. Barnes, to bring the two institutions even more closely together. Dr. Barnes endowed a chair to be called "The Barnes Foundation Professorship of Philosophy." I was then made "The Barnes Foundation Professor" at the university; my lectures were to be given at the foundation. All this took place before I had given any lectures at the foundation—and, indeed, before I had ever done any formal teaching at all. I began to feel a little uncomfortable. And with good reason, for my lectures turned out to be not at all what Barnes had wanted. And so Dr. Barnes fired me in the late fall of 1946. Moreover, for reasons that were not entirely clear to me, he also fired the university.[1]

The university, however, honored its contract with me. I resigned the full professorship and taught epistemology during the second semester. Professor Glenn Morrow of the philosophy department, who had shared my interest in Greek skepticism, was exceptionally kind, and no one, in fact, was difficult. But by that time, I wanted to put all reminders of the foundation behind me. I began by applying to join the Brown philosophy department.

To my great joy, once again, things turned out as I had hoped.

Return to More Orthodox Academic Philosophy

When I returned to Brown, Baylis, Blake, and Ducasse were still members of the philosophy department. The new members included my old friend Vincent Tomas, as well as Ian McGreal. And there was an

excellent group of students. These included Richard Cartwright, George Chatalian, Gerald Myers, and Richard Taylor, all of whom were to make significant contributions to the subject.

I was able to teach the way I wanted to teach. I soon found myself using a method that goes back to Aristotle. One begins by formulating philosophical puzzles, or *aporiae,* and then trying to find the most plausible ways of solving them. Here I was in the best possible company. In his paper "On Denoting" (1905), Russell had said: "A logical theory may be tested by its capacity for dealing with puzzles, and it is a wholesome plan, in thinking about logic, to stock the mind with as many puzzles as possible, since these serve much the same purpose as is served by experiments in physical science." Russell then began that paper by stating the three puzzles that it was designed to solve.

It is sometimes said that people who work in philosophy may be divided into those who are "drones" and those who are not drones. I would put myself in the first group. What are we to call the others? Perhaps "commentators" is the best word. In the first instance, one might suppose, what the commentators comment on is the work of the drones, but many commentators prefer to comment on the work of other commentators.

And so the way I found myself teaching was this. I would present a puzzle and then ask for possible solutions. The next thing would be to comment on the proposed solutions and, in so doing, to resist the easy temptation to refrain from offering any positive solutions or suggestions. If one wants to *find* a solution, then one should present what one *thinks* is the most plausible solution and then challenge the others to refute it. So the students came to see that their role was that of refuting me. (One of the students—Richard Taylor—had an infant son upon whom he hung the sign, "Please don't feed me." Another of the students suggested that I be given a similar sign: "Please refute me." The students were very accommodating in that respect.

I was later to consider two questions when invited to lecture elsewhere. Would the people at the host institution be good refuters? And would the trip involve a beautiful train ride?

One place satisfied the first criterion to such a high degree that it was not necessary even to consider the second. This was the University of Massachusetts at Amherst. After giving a few lectures there, I was invited to becomes an adjunct professor. For many years I presented a seminar there once a week, bringing my puzzles and solutions with me and sometimes even bringing the solutions back—but in improved form. I'm sure I could not have found a more eager and adept group anywhere.

Staff members who attended almost regularly included Herbert Heidel-berger, Edmund L. Gettier, Gareth Mathews, as well as two former Brown students, Fred Feldman and Robert Sleigh. Others who attended from time to time included Bruce Aune and V. C. Chappell. The sessions were as strenuous as they were rewarding. Finally budgetary considera-tions forced the department to give up its adjunct professorship. I was thankful for the experience and regretted only that it was over.

But it wasn't quite over. A group of University of Massachusetts graduate students petitioned the philosophy department there, saying in effect: "Well, if *he* can't come here, how would it be if *we* went to Brown for one term and took his seminar there? Could we get credit for it at the University of Massachusetts?" The department at the University of Massachusetts was very cooperative, as was the department at Brown. So the students drove to Brown one day a week (one hundred miles each way) in two cars, I think, and the result was a seminar for University of Massachusetts students and Brown students. Which for me, at least, gives the story a happy ending.

Graz and Austrian Philosophy

Russell's *Analysis of Mind* led me to Brentano and Meinong. I then found the insights of both philosophers especially helpful in the work that I was trying to do on the philosophy of perception. In the early 1950s I published articles, notes, and reviews pertaining either to Brentano or to Meinong. I also defended Meinong against some of Russell's more extreme criticisms.

In 1956, A. J. Ayer invited me to lecture at the University of London. This invitation led in turn to another—to speak before the Aristotelian Society. My topic was "Sentences about Believing" (item 68 in the bibliography). I defended Brentano's thesis about the irreducibility of intentionality. I may be permitted to say, after almost forty years, that the paper was a good one.

One other memory of the visit to England stands out clearly. My friend Morris Lazerowitz from Smith College was there at the time and he took me to Cambridge to pay a call on G. E. Moore. This was the last time that I was to see Moore.

The announcement that I would be in London and would speak on Brentano and intentionality led to an invitation to visit Graz at the same time. My writings on Meinong had led to a correspondence with Hofrat Dr. Rudolf Kindinger, an engineer in Graz who had attended Meinong's

seminar and who ordered Meinong's *Nachlass* at the university. ("The Hofrat," as he was known, was subsequently to become one of Meinong's *Gesamt Ausgabe*.) On learning that I was going to present a series of lectures at the University of London in 1956, Kindinger arranged that I be invited to give a lecture on Meinong at the University of Graz. I accepted with enthusiasm. The lecture wasn't very good; I had never tried to lecture in German before; and I didn't know quite what to say, believing that lecturing on Meinong in Graz would be like carrying coals to Newcastle—or, as the Austrians would put it, "bringing owls to Athens." But the lecture was warmly received and Professor Ferdinand Weinhandl, the chairman, said at the end of the lecture: *"Glänzend!"* They appreciated the fact that a philosopher from what then seemed to be far-away America was impressed by the significance of Meinong.

A related development occurred shortly after this visit. John C. M. Brentano, the son of Franz Brentano, invited me to visit him at Northwestern where he was then teaching. He was a physicist who had studied with Röntgen and was devoting the final years of his life to his father's philosophy. He felt, with justification, that others were getting undue credit for the philosophical achievements of his father. He had several projects in mind that he was able to support financially. These were to include the ordering and preservation of his father's *Nachlass,* which included manuscripts, notes from dictations, and a vast amount of philosophical correspondence, as well as Franz Brentano's philosophical library. Then it was his hope that the philosophical writings be translated from the German into other languages and, first of all, into English. John Brentano invited me to join Dr. George Katkov in carrying out these projects. It turned out to be a great privilege to work with Katkov who was an extraordinary man and a real philosopher. William Kneale consented to succeed Katkov in this project. And Stephan Körner also consented to take an active part, including that of being the principal editor of Franz Brentano's *Space, Time, and the Continuum.* I was the other editor.

John Brentano lent his father's philosophical library to Brown University in the 1960s, where it was used by many philosophers, most of them from Europe. The fact that the library was of more interest to European philosophers than to American philosophers led me to decide in the late 1980s that the library should be moved to the *Dokumentationszentrum für Öesterreichische Philosophie* in Graz, which is directed by Rudolf Haller, with Reinhard Fabian serving as chief archivist.

To complete this narration, I return to other things that had taken place earlier in Graz.

At the time of my first visit to Graz I had become acquainted with

Haller who was then a graduate student in philosophy. This resulted in a friendship that has increased through the years and that has deeply affected my life and my philosophical career. When I received a Fulbright grant to study in Graz during the academic year 1959–1960, housing was very difficult to come by and Haller provided an apartment in his own home for the Chisholm family which now included three small children.

A few years later, when Haller had become an active member of the Philosophical Institute, I was invited to become a guest professor at the University of Graz and to present a "Block Seminar" for four or five weeks each year, beginning in May. The Brown philosophy department was most cooperative in permitting me to do this. The graduate students who attended the seminar were excellent, and I was happy to find that many of them came back year after year. They, too, turned out to be good refuters, and many of them are now distinguished teachers of philosophy.

The Austrian visits coincided with the beginning of vacation time. In the pension in Schladming that Eleanor and I would visit each year after the seminar, and sometimes weekends during the seminar, my status in the world was not entirely clear and I was identified as "Der amerikanische Professor aus Graz."

Haller arranged that the University of Graz award me an honorary degree in 1972. The citation said in part: "As a result of his investigations, he has served to rescue some of our philosophers of a former time from oblivion and to make their merits known both here and across the seas."

Still another thing that Haller arranged was that, for several years, Eleanor and I would be guests of the city of Graz during the times of my classes and allowed to live in the "Dichter Stüberl," an apartment that the city kept in the Stadt Museum for visiting poets. And the Stadt Museum is a very special place. On entering the building, one sees a plaque that reads:

HIER WURDE DER AN 28. JUNI 1914 IN
SARAJEVO ERMORDETE THRONFOLGER
FRANZ FERDINAND GEBOREN.

Two Further Courses of Lectures in England

During the summer seminar on the philosophy of mind that was held in Boulder, Colorado in 1965, I received a letter from Gilbert Ryle inviting me to present the Nellie Wallace Lectures at Oxford. I mentioned this to

Elizabeth Anscombe who was a visiting member of the staff. "Oh," she said, "he must be pulling your leg!" I was somewhat taken aback and she added: "I wasn't thinking of *you* when I said that; I was thinking of *her*." This helped a little. Nellie Wallace, it seems, had been a well-known music-hall singer. But Nellie Wallace—*another* Nellie Wallace—had also been a benefactress of Oxford.

I presented the following lectures in January 1967: (1) Some metaphysical questions about the self; (2) Are there characteristics that some things necessarily have? (3) What sorts of things come into being and pass away? (4) The loose and popular and the strict and philosophical senses of *Identity;* (5) Is *self* same with *substance?* (6) To be able to do otherwise; and (7) Some puzzles about agency and their solution.

The discussions, I thought, were excellent and I found many of the objections extraordinarily useful. And the lectures were apparently successful, for, as Ryle observed, the attendance was high from beginning to end.

In the spring of 1979 I presented The Benefactors' Lectures before the Royal Institute of Philosophy in London. Here my direct contact was with H. D. Lewis, the director of the council, and Godfrey Vesey, the executive secretary.

I introduced the lectures this way:

> I attempt to deal philosophically with the ancient question: How is objective reference possible? How is it possible for one thing to direct its thoughts upon another thing? Wittgenstein summarized the question by asking: What makes my idea of him an idea of *him?*

The book that resulted was: *The First Person: An Essay on Reference and Intentionaliity* (1981). But *The First Person* is not at all as clear as it might be. I shall provide a much better statement and defense of its principal theses below.

Europe Beyond Graz

There is also a Europe beyond Graz.

The first course that I taught in Europe was a seminar presented jointly with Paul Weingartner at the University of Salzburg in 1972. This possibility arose from the fact that Sir Karl Popper, who was to teach the seminar, was forced by illness to cancel at a rather late date. I think that the seminar was successful, but that was due in large part to Weingartner's collaboration and to the presence of Edgar Morscher and an active

group of younger philosophers. It was in Salzburg that I first acquired practical experience with the teaching methods in German-speaking universities. And living there was a great joy, especially in the weeks just before Christmas.

I served as guest professor at the University of Heidelberg on two occasions in the 1970s. These invitations were initiated by Professor Dieter Henrich with whom I presented joint seminars. His philosophical orientation was Kantian and Hegelian. He and I had many long discussions, as a result of which I came to appreciate a side of German philosophy that I had previously neglected. (I took part in a symposium which he was to publish under the title, *"Kant oder Hegel?"* I chose the first alternative.) The arrangement with Heidelberg meant that one year, for two weeks, I commuted (the Germans would say *"pendelte"*) between Heidelberg and Graz.

I was also to have a connection with the University of Würzburg where Brentano had completed his *Psychologie* before moving to Vienna. Professor Franz Wiedmann arranged that the university appoint me as permanent guest professor which means, I believe, that I may present a seminar there at any time that I choose. Wilhelm Baumgartner was then teaching philosophy there, and his wife Elisabeth was teaching psychology. Wilhelm Baumgartner is now professor and one of the editors of the Brentano *Gesamtausgabe.*

I taught courses on several different occasions at the *Internationale Akademie für Philosophie* in Liechtenstein. The rector, Professor Josef Seifert, as well as most of the students and members of the faculty, are devout Roman Catholics, and many of them came to philosophy *via* the study of phenomenology. They know, as St. Augustine did, that a sense of humor has its place in serious philosophy. And the students are eager to learn whatever it is that so-called "analytic philosophy" has to offer. I found my visits there highly rewarding.

Still another institution should be mentioned, one that has played a significant role in contemporary philosophy. This is the Society for Austro-German Philosophy which came into existence in England in the latter half of the 1970s. The society consisted of three young English students of philosophy, each of them very competent in philosophy and filled with boundless energy and enthusiasm. Later known to many as "the Triumvirate," they are Kevin Mulligan, Peter Simons, and Barry Smith. They were concerned, as I had been, with the fact that a large part of the philosophical world was unaware of the great philosophical riches to be found in the Austro-German philosophy of the previous one hundred years. I was invited to become a member of the society and

accepted at once. I first met the trio when, in 1979, I presented "The Benefactors' Lectures" (later to be published as *The First Person*) before the Royal Institute of Philosophy in London.

The Austro-German Society had great success, organizing countless meetings throughout Europe, both east and west. I have attended many of these meetings. One that I especially recall, naturally, was a meeting on my philosophy at the University of Salzburg. One memorable meeting, in which both the society and the University of Graz were involved, was devoted to "The Philosophy of Christian von Ehrenfels," and took place at the Ehrenfels Schloss in Upper Austria.

One more Austrian institution should be mentioned. This is the International Wittgenstein Symposium which was founded by Dr. Adolf Hübner in Kirchberg am Wechsel and meets there every summer. I first took part in these meetings in 1977 and continued to do so for a number of years thereafter. I presented the formal opening address in 1985 and served as co-editor of the *Proceedings* for that year (see entry 256 of the bibliography). The general topic was: Philosophy of Mind and Philosophy of Psychology. The other co-editors were Hübner, Johann C. Marek, and John Blackmore.

I had profited greatly by the study of Wittgenstein's writings, particularly *Philosophical Investigations, On Certainty,* and *Remarks on Colour.* While I was at the Boston Induction Station I had read with great excitement a pirated copy of the so-called "Blue Books." At Kirchberg I occasionally found myself at an impasse with some of Wittgenstein's more intense followers. Having ventured an objection to something Wittgenstein had said, I would be told, "What Wittgenstein is really talking about there is *grammar.*" I would say: "And exactly *what* does the passage tell us about grammar?" The reply would then be something like: "You have to *see* it!" And then the discussion of *that* point would be over.

Return to Brown University

I conclude these reminiscences as I had started them, by referring to Brown University. There are many things that I have to be thankful for. I will note, all too briefly, a few of those that might interest the reader.

I have already said that as a result of the active cooperation of Brown's Department of Philosophy, I was able to make the teaching arrangements that I have described here. From the very outset, the Brown students of philosophy were all that I could hope for. They went

far beyond the call of duty in supplying the refutations that I had asked for. In retrospect, I see that this is not surprising, for they include some of our best philosophers.

In 1986, on the occasion of my seventieth birthday, the university supported a three-day symposium in my honor. The topic was the theory of knowledge; the speakers were distinguished epistemologists; and the one who conceived and organized the project was Ernest Sosa.

In 1988, on the fiftieth anniversary of my graduation from Brown, I was given an honorary degree by the university.

And in the academic year 1994–1995 Ernest Sosa and Jaegwon Kim presented a graduate seminar at Brown on "The Philosophy of Roderick Chisholm."

So what more could one ask for?

TRADITIONAL EPISTEMOLOGY DEFENDED

Introduction

The theory of knowledge consists of Socratic inquiry involving the following questions: (1) What can I know? (2) How can I distinguish beliefs that are reasonable for me from beliefs that are not? (3) How can I tell whether I have a good reason for a belief? and (4) What can I do to replace *un*reasonable beliefs by reasonable beliefs about the same subject matter, and to replace beliefs that are less reasonable by beliefs that are more reasonable? In the first of his *Meditations,* which is entitled "Of the Things which May Be Brought into the Sphere of the Doubtful," Descartes begins by saying:

> It is now some years since I detected how many were the false beliefs that I had from my earliest youth admitted to be true, and how doubtful was everything I had since constructed on this basis; and from that time I was convinced that I must once for all seriously undertake to rid myself of all the opinions which I had formerly accepted, and commence to build anew from the foundation, if I wanted to establish any firm and permanent structure in the sciences.

Our approach to the questions is a version of commonsensism that may be called, to use C. S. Peirce's phrase, a "critical commonsensism." Although we start out with a mass of uncriticized beliefs, we will refine upon that mass and improve it. One way of improving it is to sift it down, so to speak, and try to cast away the things that shouldn't be there.

Epistemic Concepts

The theory of knowledge that will be set forth here makes use of the following undefined locution:

───── is more reasonable for S than ─────.

An instance would be:

Believing that there are stones is more reasonable for S than not believing that there are stones.

The following is a convenient formula for abbreviation:

Bp R −Bp

To understand the positive steps that are involved in the final and constructive stage of the theory of knowledge, namely "the road back," it is essential to distinguish several different *levels* of reasonability. I shall distinguish five levels in what follows.

D1 It is *probable* for S that p =Df. Believing-that-p is more reasonable for S than believing-that-not-p.
 Bp R B−p

Formulae of the following type will exhibit some of the logical relations obtaining among the five epistemic concepts here distinguished.

D2 Believing-that-p is (epistemically) *acceptable* for S =Df. *Not*-believing that p is *not* more reasonable for S than believing-that-p.
 −[−Bp R Bp]

D3 It is *beyond reasonable doubt* for S that p =Df. Believing-that-p is more reasonable for S than not-believing-that-p. Bp R −Bp

D4 It is *evident* for S that p =Df. (1) It is beyond reasonable doubt for S that p; and (2) there is no belief such that *not* having that belief is more reasonable for S than believing p.

Without the first clause, the second clause would be satisfied by every nonthinking thing.

D5 It is *certain* for S that p =Df. (1) It is evident for S that p; and (2) there is no q such that believing q is more reasonable for S than believing p.

As in the case of the previous definition, the second clause, which is negative, would be satisfied by every nonthinking thing.

It is essential to the theory of knowledge that *being evident* does not imply *being true*. But it is reasonable to believe that *being certain,* in the epistemic sense just defined, does imply *being true.*

The list of concepts just distinguished forms a hierarchy in that each one that appears later on the list implies the one that appears just before it on the list.

In order to have examples of the five epistemic concepts just considered, let us consider someone who works in the same office five days a week. If he is there today, it may be *probable* for him that all the offices that were occupied at this time yesterday are also occupied now. It may be *epistemically acceptable* for him that some of the other offices are occupied today. The sound of activity seems to come from the office just above. This makes it *beyond reasonable doubt* for our observer that that office is occupied. The sound of activity seems to come from the office just below. Under the circumstances, it will be *beyond reasonable doubt,* for our observer, that that office is occupied. It will be *evident to him* that his office is occupied today and it will be *certain* for him that *his* office is open today.

These distinctions could be of practical significance if there were later to be an inquiry into exactly what the person knew about the occupancy of the building at this time today.

Methodological Doubt

There are three different stages in this Socratic enterprise. We may call the first stage that of "methodological doubt," the second that of "finding a foundation," and the third that of "the road back."

It is not entirely accurate, therefore, to say that, in carrying out our Socratic inquiry, we should "bracket" our system of beliefs or "hold it in *epochē.*" What we shall "bracket," or "hold in epochē," are our epistemological beliefs—our beliefs about the reasonability or justification of the beliefs that we find ourselves having. Descartes had said that he undertook to rid himself of all the beliefs that he had formerly accepted. But what we shall do, in attempting to solve Descartes's problem, is to rid ourselves of all the *epistemic* beliefs that we have with respect to the reasonability of such opinions.

Finding a Foundation

Traditionally, one has distinguished two types of epistemic certainty. The first is that a posteriori certainty we can have with respect to some of our conscious states—namely, those states that are either sensory or intentional. And the second is the a priori certainty exemplified by

beliefs that are necessarily true. An examination of these two types of certainty will make clear some of the respects in which our treatment of traditional theory of knowledge may be said to be *realistic.*

The objects of sensing are traditionally called *"appearances"* and we shall use that term here. Other terms that have been used in the same sense are "sensations," "sense-impressions," "sense-data," "sensa," and "qualia."

We formulate the following epistemic principle about such entities.

A1 Every appearance x has internal properties which are necessarily such that it is evident to anyone who senses that appearance that he or she is sensing something that has those properties.

A property P may be said to be *internal* to an individual thing y, provided only that: x has P; and there is no contingent property Q which is necessarily such that, if x has P, then something having no parts in common with x has Q.

A2 For every x, if being-F is an intentional property and if x has that property, then it is evident to x that he or she has that property.

Intentional properties include (a) what Russell had called "propositional attitudes," for example, believing, thinking, and considering; (b) such emotional states as liking and disliking, loving and hating; and (c) such combinations of intellectual and emotive properties as hoping and fearing.

We turn now to those foundations of knowledge that are a priori and not a posteriori.

A priori certainty pertains to what have traditionally been called *axioms.* Our definition is this:

D7 The proposition-that-p is *axiomatic* =Df. The *proposition-that-p* is necessarily such that (1) it is true and (2) if a person understands it and considers it, then it is evident to that person that it is true.

We add as a further epistemic principle about a priori knowledge this:

A2 If p is axiomatic and if a person understands and considers p, that person *knows a priori* that "there is something p" is true.

Frege observes that "an axiom has been taken, since the time of antiquity, to be a thought whose truth is known without being susceptible to demonstration by a logical chain of reasoning."[2] Aristotle had said that an axiom, or a "basic truth," as he called it, is such that no other belief is "prior to" it; nothing is "better known" than it is.[3]

Some Twentieth-Century Philosophers and the Road Back

I will now set forth one way of dealing with the problems of what I have called "the road back." That is the road upon which one sets out after finding "a foundation of certainty." I begin with some remarks about certain twentieth-century philosophers whose contributions to the subject are, unfortunately, ignored by most writers on the theory of knowledge.

Having some faith in ourselves, then, we start out with our native common sense—with what we find ourselves believing. And we assume that the mere fact that we find ourselves inclined to believe one thing rather than another is itself a provisional—or prima facie—justification for believing the one thing rather than the other. "So far, so good," we say.

The key to this approach is suggested by the following quotation from C. I. Lewis:

> First, whatever is remembered, whether as explicit recollection or merely in the form of our sense of the past, is *prima facie* credible because so remembered. And second; when the whole range of empirical beliefs is taken into account, all of them more or less dependent upon memorial knowledge, we find that those which are most credible can be assured by their mutual support, or as we shall put it, by their *congruence.*[4]

Lewis is telling us that the principal ground for any particular memory is the *act* of *thinking-that-one-remembers.*

This type of epistemic ground suggests that there is an analogy between remembering and *perceiving*—or, more accurately, between *thinking* that one remembers and *thinking* that one perceives.

Indeed, previous philosophers had asserted the *perceptual* analogue of what Lewis here asserts about *remembering.* Meinong had formulated a similar view of remembering in 1886 and worked out its perceptual analogy in 1906.[5] And H. H. Price was to set forth a similar account of perceiving in 1933. One thing especially noteworthy in Price's account is the analogy that he draws between "*perceptual* consciousness" and "*moral* consciousness."[6]

Following Meinong and Price, we could say that, if one has a belief to the effect that one is perceiving a certain thing, then that belief is prima facie justified just because one *does* think that one is thus perceiving that thing. And we could say, of perceptual beliefs that *are* thus prima facie justified, that those that mutually support each other have an even higher degree of justification.

At this point we will take "p confirms q" as an undefined concept.

(We will use "p disconfirms q" as an abbreviation for "p confirms the negation of q.") Subsequently we will define "p confirms q" in terms of the epistemic vocabulary we have been using. At that point we will discuss in detail the analogy between *confirmation* and the ethical concept of *requirement.*

Otto Neurath has compared the predicament of the epistemologist with that of a sailor who needs to repair his ship at sea.[7] If the sailor were to throw all the doubtful parts of the ship overboard, hoping thereby to build the ship anew, he might be sunk. What the sailor should do, obviously, is to make the most of what is at his disposal, however flimsy and inadequate that material may seem. We should begin, similarly, with the set of beliefs that we have (where else *could* we begin?) and then try to refine upon them and make the set more respectable, epistemically.

Additional Epistemic Principles

Having some faith in ourselves, we start out with our native common sense—with what we find ourselves naturally inclined to believe. And we assume that the mere fact that we find ourselves inclined to believe one thing rather than another is itself a provisional—or prima facie— justification *for* believing the one thing rather than the other. "So far, so good," we say.

This provisional justification may be expressed as a principle about *probability:*

A3 If you are trying to reconstruct and improve your set of beliefs, then those of your beliefs which are such that you have not yet examined them (you have not yet considered their logical relations to your other beliefs) are *probable* for you.

Our commonsensism, as we have said, is *critical* commonsensism. Although we start out with a mass of uncritical beliefs, we will refine upon it and improve it. One way of improving it is to sift it down, so to speak, and try to cast away the things that shouldn't be there.

To take these further steps, we make use of the a priori knowledge that has already been referred to. As rational beings, we can know, by contemplating various beliefs, that some of them logically imply others, that some contradict others, that some are such that they would confirm others, and that some are such that they would disconfirm others.

If, now, we find ourselves with beliefs that *contradict* each other, we will reject at least one of them. Suppose we find ourselves believing that all red-haired people are quick-tempered, as well as believing that Michael is red-headed and that Michael is not quick-tempered. Then we

should cast off *at least one* of these beliefs—either the belief that Michael is red-haired, or the belief that he is not quick-tempered, or the belief that all red-haired people are quick-tempered.

If, after removing the contradictions that we find among our system of beliefs, we conclude the whole set that remains tends to *disconfirm* some of its members, then we will reject the ones that we believe to be disconfirmed.

This sifting procedure enables us to improve upon the set of probable beliefs which we have attained and to single out a set of beliefs that are epistemically *acceptable:*

A4 If you remove the contradictions you find in the set of beliefs that are probable for you, and if further you remove those you conclude to be disconfirmed by the set of your other beliefs, then the beliefs that remain will be *acceptable* for you.

To move up a further step and assure ourselves that some of our beliefs about other substances are beyond reasonable doubt, we appeal to the experiences of *perceiving* and *remembering.*

We characterize *appearances* in terms of sensing and causation; and we characterize *perception,* both *veridical perception* and *unveridical perception,* in terms of sensing an appearance.

D8 S senses an appearance of x =Df. S is sensing in a way that is a function of a process in x; i.e., systematic variations of a process within x will produce systematic variations in the way that S is sensing.

D9 S veridically perceives x to be an F =Df. (1) S senses an appearance of x; (2) x believes that he is sensing an appearance of something that is an F; and (3) x is an F.

The expression "an F" could be replaced by such expressions as "a sheep."

D10 S unveridically perceives x to be F =Df. S is appeared to, but not veridically appeared to, by an F.

The definition of *unveridical perception* is similar except that the final clause ("x is an F") should be replaced by "x is not an F."

We may now put our perceptual principle in the following way.

A5 If you veridically perceive there to be an F that is appearing to you, and if that belief is epistemically acceptable for you, then (a) the belief that you are *perceiving there to be an F* and (b) the belief that there *is* an F is also beyond reasonable doubt for you.

The principle just formulated is not one telling us how the nature of the *appearance* may signify the nature of what it is that appears; it tells us how the nature of the act of *sensing* may signify something about what it is that appears.

One may object: "But what if it is evident to you that most of the things that look like sheep at the particular place where you happen to be are *not* sheep? In such a case, the general principle would be false." The objection does not apply when we are setting out on the road back. We have not yet reached the stage where we can appeal to such evident beliefs. (The airplane pilot who is taking off does not have all the options that are available to him when he is airborne and in flight.) And in conducting our Socratic inquiry, we are attempting to withhold our beliefs about what may or may not be evident to us.

What has been said about the relation between *perceiving* there to be an F and *taking* there to be an F may also be said, *mutatis mutandis,* about *remembering* and about the experience of *seeming-to-recall.* We may, therefore, formulate still another principle about that which is beyond reasonable doubt:

A6 If you *seem to recall* that you were such-and-such and if the belief that you were such-and-such is epistemically acceptable for you, then (a) the belief that you remember having been such-and-such is beyond reasonable doubt for you; and (b) the belief that you *were* a such-and-such is beyond reasonable doubt for you.

Given the concept of *confirmation,* we may define the important epistemic concept of *mutual support. We shall make use of the concept now and will* discuss it in detail below.

By appeal to this concept of *mutual support,* or *concurrence, we may ascend to evident* beliefs about contingent substances other than ourselves. The proper procedure is one that was proposed, in a similar context, by Carneades[8]: This important epistemic concept of *concurrence* or *mutual support* was central to the positive views of Carneades and had been emphasized by Meinong in the present century.

Conclusion

If we can ever know that we know, and surely we can, then we can have knowledge about what we are *justified* in believing. Such knowledge is, to use D. J. Mercier's term, *objective;* it is not merely subjective and arbitrary.[9] And since epistemic propositions are to be construed as

normative propositions, then, contrary to one widespread philosophical view, normative propositions may be either true or false. Under what conditions, then, can we be said to *know,* with respect to a given normative proposition, that *that* proposition is true?

It is safe to say at least this much: if a belief is justified for you in the sense of being one that is *certain* for you, then, if you reflect upon just what it is that you are believing and if you ask yourself whether it is true, *then* you will know that it is true.

PRIVILEGED ACCESS

Introduction

The epistemology that I have defended is based upon a long and respected philosophical tradition. We have *privileged access* to certain of our own states of mind. I shall consider a number of familiar objections to the view.

Among those who have opposed the theory are, of course, those who contend that we do not have any access *at all* to our own states of mind. In more recent times, the rejection of the theory of privileged access has been given a new lift, so to speak, by Wittgenstein's *Philosophical Investigations*—or, to be more accurate, by what many *believe* that Wittgenstein has demonstrated in that work.

There is, in the *Philosophical Investigations,* a penetrating discussion of the nature of language, a discussion that has come to be known as "the private language argument."[10] Wittgenstein sets forth what is a very technical sense of the expression "private language." He then shows that, in his technical sense of that expression, there cannot be said to *be* any "private language." My present concern is not with the soundness of this contention, for it seems to be true enough. Our concern is with certain of the epistemological observations that have been made *in connection with* Wittgenstein's discussion, either by Wittgenstein himself or by other philosophers who have written about what he has said.[11]

These epistemological observations imply, incorrectly, that there is no significant respect in which any of us can be said to have *privileged access* to our own experiences and states of mind. My concern here, as I have said, is to make it clear that we do have such access.

Examples of Privileged Access

In formulating the doctrine of privileged access, we should characterize the type of subject matter to which the doctrine is intended to apply; and we should do so, of course, without describing it merely as that area to which we have such access. Some philosophers—Richard Rorty, for example—have suggested that the challenge to provide such an independent description cannot be met.[12]

The doctrine of privileged access has two sides. One has to do with *access,* the other with *privilege.*

The *access* is directed upon what we have been calling the *content* of thinking—content that may be *intellectual* (as in the case of believing), or *emotive* (as in the cases of loving and hating), or *sensory* (as in the case of sensing or being appeared to).

Such attitudes constitute their own evidence—for those who have them. In Meinong's terms, they may be called "self-presenting." They present *themselves.* They present *themselves* to a self—to the self or person who has them. Hence they are "self-presenting" in a twofold sense: they present *them*selves *to* a self.

And such attitudes may be said to be *"privileged"* in that the acts in question present themselves *directly* to the selves whose acts they are.

Consider a simple example. Suppose you are thinking about taking a walk. *If* you are thinking about taking a walk, then, *ipso facto,* you know directly and immediately that you are thinking about taking a walk. You don't need to look around for further evidence in order to assure yourself that that is what you are thinking about. You do not need to ask yourself: "Could I be thinking about something else instead?" If we use "thinking about" in its ordinary sense, then we may say that *thinking about taking a walk* constitutes adequate evidence for *believing* that one is thinking about taking a walk. (Of course, if English is not your native language, you may ask yourself "Is 'taking a walk' the right expression? Or should I say something like 'making a promenade'?" But these doubts are not doubts about the *content* of your thought; they are doubts about how to use the English *language.)*

I have said that we have privileged access, not only to some of our intentional attitudes, but *also* to certain facts involving our *sensations* and *feelings.* I may not know directly and immediately that a leaf that I see appears green, but I do know directly and immediately that something *appears green* to me. (It would be more accurate to say that I know directly and immediately that I am *"appeared green to,"* or *"appeared greenly to."*) Analogously for feeling warm, feeling cold, for enjoying and disenjoying, and for feeling happy and feeling sad.

In these cases, too, one's access is privileged. In order for *you* to know that *I* am appeared greenly to, or that *I* feel depressed, you have to know much *more* about me than *I* need to know about me in order to know that I am appeared to greenly or feel depressed.

There are three familiar objections to all of this. The first may be called "the case of the learned scientist." The second may be called "the problem of the noncomparative description." And the third may be called "the Freudian objection."

(1) The Case of the Learned Scientist

The case of the learned scientist, or as it may also be called, "the case of the perfect technician," would constitute an objection to *all* forms of the doctrine of privileged access. It has been described in the following way by David Armstrong:

> Consider . . . the case of a brain technician who has a perfect understanding of the correlation between states of my brain and inner experiences. Suppose . . . that I report, 'I seem to be seeing something green', using the sentence as a phenomenological report on my visual experience. The brain technician is able to say from his knowledge of brain patterns that (i) I am not lying; (ii) my brain is in the appropriate state for some *other* experience; (iii) there are disturbances in the brain processes which would account for my mistake. On the evidence offered by the brain technician it ought to be concluded that I have made a mistake.[13]

The argument is very much like Hume's argument for "the bundle theory of sensations." It seems to presuppose the very fact that it is intended to deny.

Everything turns upon what is said in the first statement of the citation from Armstrong—the statement according to which the brain technician has that *perfect understanding* of the correlation between the brain state and the "inner experience." How did *he* come to know that *seeming to see something green* is so correlated with a certain brain state that *it,* the seeming, takes place just at those times that the brain is in the state in question? If the technician knows of this correlation between the "inner experience" and the relevant brain state, then either the technician or some other person has been so situated as to be able to correlate *his* or *her* "inner experiences" with *his* or *her* brain states. And if a technician thus has a "perfect understanding" of such a correlation, the technician had direct—and therefore privileged—*access* to the sensation.[14]

(2) The Problem of the Noncomparative Description

The epistemological objection calls attention to a supposed difficulty in supposing that one can have the kind of knowledge that privileged access is thought to involve. And the reply to the objection calls attention to a certain general fact about our knowledge that is insufficiently appreciated.

The general fact could be put by saying that not every attribution is a matter of *comparing* one thing with *another* thing.

The objection that we shall consider, then, may be put in the form of a logical argument—an argument presupposing that all predication is comparative.

"You have suggested that, among the simplest types of privileged access is the direct and immediate knowledge that we have of the ways that we are appeared to. Yet (a) if the statement 'I am appeared white to' does not express a comparison between a present way of appearing and anything else, then the statement is completely empty and says nothing at all about a present way of appearing. But (b) if 'I am appeared white to' expresses what is directly and immediately known, then it cannot assert a comparison between a present way of appearing and anything else. Therefore, (c) either 'I am appeared white to' is empty or it does not express what is directly and immediately known."

Here the difficulty lies in the first premise. It may well be true that, if an appear-statement is to *communicate* anything to *another* person, then it must assert some comparison of things. Thus if I wish *you* to know the way in which I am appeared to now, I must relate this way of being appeared to with something that is familiar to you. ("Describe the taste? It's something like the taste of a mango.") Two different questions have been confused here. One is this:

> (A) "If you are to understand me when I say something about the way in which I am appeared to, must I be comparing that way of appearing with the way in which some object, familiar to you, happens to appear?"

And the second question is, more simply:

> (B) "Can I apprehend the way in which I am now appeared to without thereby supposing, with respect to some object, that the way I am being appeared to is the way in which that object sometimes appears or has appeared?"

The question that we have been concerned with is (B), not (A). And from the fact that question (A) must be answered affirmatively, it does not follow that question (B) must also be answered affirmatively.

The argument, moreover, presupposes an absurd thesis about the nature of thought or predication. This thesis might be expressed by saying that "all judgments are comparative." To see that this is absurd, we have only to consider more carefully what it says. It tells us that whenever we believe, with respect to any particular thing x, that x has a certain property F, then we *compare* x with a second thing and believe of x that it *resembles* that second thing. But clearly, we cannot derive "x is F" from "x resembles y" unless, among other things, we can believe *noncomparatively* that y is F.

(3) The Relevance of Psychoanalysis

According to the theory of psychoanalysis, we have nonconscious beliefs and desires that conflict with our conscious beliefs and desires. Our account of privileged access should allow for the possibility that some such theory is true. We should, therefore, confront an objection to which such theories give rise. The objection is that emphasis upon privileged access exaggerates the significance of our conscious states. These states—so the objection goes—have only a subordinate role to play in the mental life of conscious beings. What the objection overlooks is the fact that nonconscious states are essential to the understanding and interpretation of psychoanalysis.

Psychoanalytic theory, when it is not put metaphorically, cannot be formulated except by reference to conscious states—those states to which we do have privileged access. A patient may be said, for example, (i) *consciously* to love one of his or her parents and also (ii) *subconsciously* to hate that same parent. What about the subject matter of the second type of statement?. Obviously it must be spelled out in much more detail—in a *complex* statement about the patient. The complex statement, according to the theory, will tell us about a manifold of different things. It will tell us, for example, about *other* things that the patient consciously loves and other things that the patient consciously hates. It will also tell us about other conscious beliefs and desires that the patient has. And it will tell us about the conscious states that the patient *would have* under various possible contingencies.

The philosopher, as such, is not in a position to criticize the data upon which the theory of psychoanalysis is based. But the philosopher, as such, *is* in a position to criticize any dubious philosophical assumptions that are imported into any nonphilosophical theory. It may be useful, and it is certainly very tempting, to formulate the theory in

metaphors.[15] But to the extent that our interest is theoretical, we must look for the literal truth that underlies such metaphors. If an entity can think and feel, then that entity cannot be anything other than a substance. The entity cannot be a *state* or a *boundary* or a *property* or a *number*. For such entities cannot be said in any sense to think or to feel. What, then, *is* that thing that has subconscious desires—if it is not identical with the subject of *conscious* desires? We will consider just two possible answers.

(1) According to the first possibility, there is, for each of us, a *second substance* which is not a conscious substance; and this second substance may hate some of the things that the first substance loves. But what *is* this second substance if it is neither the conscious substance, nor the body, nor any part of the body, of the conscious substance? This first possibility leaves us with a problem.

(2) According to the second possibility, there is, for each of us, a "quasi-substance" which is "substance-like" in that it can love and hate and think and desire, but which, nevertheless, cannot be subsumed under any of the familiar metaphysical categories. This second possibility leaves us with bad metaphysics.

Important as psychoanalysis is for the understanding and treatment of mental illness and for the understanding of the psychology of our everyday life, it does not have either the *epistemological* nor the *ontological* significance that it is sometimes thought to have.

Substance and the Theory of Categories

Consider any conscious property—say, sensing, judging, wondering, wishing, or hoping. We can know what it is to judge, wonder, wish, and hope. As rational beings we can grasp the nature of such properties. We can know what it is to *have* such a property. We can see that they are properties that can be exemplified only by *individual things*. Judging, wondering, wishing, hoping cannot possibly be properties of *states* of things, or of *processes*. And they cannot be properties of *abstract objects*—of such things as properties, numbers, and relations. *You* can hope for rain, but no state or process or number or property or relation can hope for rain.

I have defended the following thesis at length. From the fact that a psychological property is exemplified—the fact, say, that the property of

hoping for rain is exemplified—we may infer that there is an *individual substance* that has that property.

We may single out three different phases of this situation:

(1) I can know that I hope for rain; (2) as a rational being, I can conceive what it is to hope for rain; and (3) in so doing, I can see that the only type of entity that can have the property of hoping for rain is an individual thing or substance.

Kant, for example, was right in saying: "Our awareness of judging is not accompanied by any *sensory intuition* of judging." And so, too, for the other intentional phenomena. Our awareness of intentional phenomena need not be sensory—even if such awareness is always *accompanied by* some sensory experience or other.

Are Substances Bundles of Properties?

There are many who say that the concept of substance may be replaced by that of a bundle of properties. The concept of a "bundle of properties" is thought to remove the need for supposing that there are things that are "bearers" of properties. According to this version of "the bundle theory," *no* properties have bearers. And this is dangerously close to saying that nothing *has* any properties. This, of course, is not very clear. And it turns out to be rather difficult to formulate the proposal.

But there are many sets of properties. How are we to decide *which* bundle is the one that does duty for the self? There is the set of my bodily properties and there is the set of your mental properties. And there is the set of some third person's bodily properties and that of some fourth person's mental properties and so on *ad infinitum*.

No one has ever suggested a way of *reducing* statements that are ostensibly about individual things to statements that refer to bundles of properties. Nor has anyone even suggested a way of deciding just *what* bundle of properties is to do duty for any particular individual thing. Indeed, it would seem to be impossible to do this without making clandestine use of the concept of an individual thing. One could not just say, "The bundle of properties that constitutes *that* thing is just that set of properties that the thing happens to have." For this would be to explicate the concept of a bundle in terms of that of an individual thing. But the point of the bundle theory was to do things the other way around.

A Theory of Categories

What Is the Theory of Categories?

What a theory of categories is may be shown by depicting the diagram of categories that is presented here.

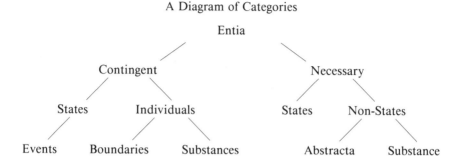

A Diagram of Categories

I define the concept of an *attribute,* or *property,* intentionally, by reference to those states that are acts of believing. And I will defend in detail the view that there *are* attributes. Following Russell and Carnap, I defend the view that *classes,* or *sets,* may be reduced to attributes. And following Wiener and Kuratowski, I show that *relations* may be reduced to classes or sets. And the function of *"propositions"* may be performed by attributes.

What philosophers call *"times"* are dispensable. The useful functions that the concept of "a time" does perform may be performed by tensed statements about temporal relations. What the latter statements express does not involve the philosophical problems that the concept of "a time" involves.

Events may be construed as being a subspecies of *states.*

Contingent *individuals* are contingent things that are not states. *Places* and other spatial entities may be reduced to contingent individuals and their states. *Spatial boundaries* are contingent individuals which are necessarily such that they are constituents of other contingent individuals. Contingent *substances* are contingent individuals that are not boundaries. *Persons* are substances; and you and I are persons.

Our theory of categories makes use of the following undefined locutions.

(1) x is necessarily such that it is F
(2) x is a state of y

(3) x is a constituent of y
(4) x believes there to be something that is F
(5) x senses y
(6) x wholly precedes y
(7) It is a law of nature that p.

In addition to making use of these seven undefined locutions, we also make use of a language enabling us to express distinctions of *tense*. There is thus a distinction between "x is F," "x was F," and "x will be F."

APPEARANCES AND REALITY

Introduction

In writing about the theory of knowledge, I for many years defended the view that what philosophers call "appearances" are not individual things but are ways of sensing. I had said that, under certain circumstances, ways of appearing could be called "ways of being appeared to." But in later years, after I turned to ontology and to the theory of categories, I came to see that appearances can *only* be individual things. (There have been two "Copernican revolutions" in the development of my philosophy. One is this change of views about appearances. The other, which was earlier, had to do with the nature of *events*. I had viewed them as abstract states of affairs. But I no longer believe that there *are* any abstract states of affairs. And I view events as being a type of contingent *state*.)

How are we to identify appearances? The traditional approach is this. Merely by varying the conditions under which an external physical thing is perceived, one may vary the appearances that that thing will present. I say that one may do this *merely* by varying the conditions under which the thing is perceived. One does not need to introduce any changes in the thing itself. The time-honored—or notorious—examples of the epistemologist are designed to bear this out. These include the stick that is made to look bent merely by immersing it in water and the white cloth that is made to appear pink merely by looking at it through rose-colored glasses.

Are *appearances* included among the individual things that have been provided for in our scheme of categories? Or are they another type of thing? We here defend the view that appearances are individual things.[16] Our present concern is ontological, not epistemological.

Dispositional Properties and Nondispositional Properties

We begin by taking seriously the following observation by Aristotle.

> The earlier students of nature were mistaken in their view that without sight there would be no white or black, without taste no savour. This statement of theirs is partly true, partly false. 'Sense' and 'the sensible object' are ambiguous terms; i.e., they may denote either potentialities or actualities. The statement is true of the latter, false of the former. *De Anima,* book 3, chap. 2

Aristotle is here making a distinction between (a) what we may call a *dispositional property* of a material thing and *the appearance* to which the thing's possession of the dispositional property may give rise. In Aristotle's example, the distinction may be applied to being white or black, or to a taste. In another traditional example it is applied to making a sound ("Does the falling tree make any noise when there's no one in the forest to hear it?").

What Aristotle says does *not* imply that the experiencing subject's property of sensing a noise is itself a dispositional property. Otherwise what he is saying runs the risk of a vicious infinite regress. Hence we shall say that the property of sensing is a *nondispositional property* of the subject.

The Spatial Properties of Appearances

One of the preanalytic data of our problem is the fact there are truths of the following sort:

> "I sense an appearance which consists of a triangular red thing being to the left of a circular blue thing."

It is easy to imagine a situation in which one would sense such a spatial appearance.

Consider the hypothesis that the objects of visual sensing are *surfaces* within *the subject's own body.* This hypothesis does not require us to say that the subject is identical with his or her body. Nor does it require us to say that he or she is *not* identical with his or her body. But the hypothesis is one implying that the subject needs a body in order to sense.

The hypothesis enables us to deal easily with our example, above, of the spatial nature of sensing. We may say, of the example, that what the subject is sensing contains a red triangle being at the left of a blue circle. What is being sensed is a constituent of one of the body's surfaces. (I have taken "x is a constituent of y" as undefined and have, in effect,

defined "x is a part of y" as "x is a constituent of y, and x is not a boundary."

The objects of visual sensing are certainly spatial. Either (1) *all* objects of sensing are individual things or (2) *some* objects of sensing are individual things and *others* are of a quite different sort. *What* would the others be? How should we characterize those objects of sensing that are *not* individual things?

The most reasonable hypothesis would seem to be that *all* objects of sensing are individual things. And this hypothesis becomes more plausible if we consider what we know about the relation between sensing and perceiving.

External Perception Defined

In the nineteenth century, Thomas Case defended a theory according to which the object of supposed external perception is always a part of one's own nervous system.[17] The view was easily ridiculed: "You're telling us that, whenever we sense an appearance, we are appeared to by our own brains. So what we perceive is always our own insides!" But, as we shall see, the present hypothesis does not have this consequence.

We may now define the concept of external perception. We first say what it is to sense an appearance of a physical thing.

D1 S senses an appearance of x =Df. S senses an individual thing and does so in such a way that his sensing is a function of a process external to S's body; i.e., systematic variations of such a process will produce systematic variations in a way in which S is sensing.

D2 S veridically perceives x to be F =Df. S senses an appearance that is F; and the appearance that S senses is an appearance of something that is F.

The expression replacing the first occurrence of the schematic letter "F" should refer to a *dispositional property* of the external thing x; the expression replacing the "F" in "appears F to" should refer to a *nondispositional* property of the subject S.

How does it happen that sensing a nondispositional property of ourselves enables us to know something about a nondispositional property of an external thing? This is a question about *epistemology* and not a question about *ontology*. The answer is one involving the concept of an epistemic rule.[18]

D3 S unveridically perceives x to be F =Df. S senses an appearance that is F; the appearance is an appearance of x; and S does not veridically perceive x to be F.

What of the more general "S perceives x"? Given the distinction between "veridical" and "unveridical" perception, the more general sense of "perceives" turns out to be equivalent to the "is appeared to by" that is defined in D1.

D4 S perceives x =Df. S senses an appearance of x.

The Existence of Qualities

In our concern to do justice to the spatial nature of sensing, we do not lose sight of the fact that sensing is preeminently qualitative.

I do not hesitate to say that the qualitative nature of sensing is of cosmological significance. One could use Gustav Fechner's metaphor and say that the facts in question provide us with "a daylight view" of the world. The suggestion may be particularly tempting in connection with those acts that are qualitatively rich and pleasing. But *other* acts of sensing could be said, with equal justification, to provide us with "a dark and pain-ridden view of the world"—where the predicates "dark" and "pain-ridden" are taken in what we have called a *"positive"* and not merely in a *"negative"* sense.[19]

Our qualitative experience—what we have called *"sensing"* (or *"appearing"*)—is "subjective" in being dependent for its existence upon the existence of the sensing subject of experience. And perhaps it is well to add what should be obvious: the fact that there are sentient beings having such qualitative experiences *is* a fact—an "objective" fact— about the nature of this world.

The Epistemological Status of Appearances

Since I have been discussing the *ontological* status of appearances, I conclude by making some remarks about their *epistemological* status.

Most of what I have written about epistemology has presupposed a version of "the adverbial theory of appearing," but it is an easy matter to adapt what I have said to the theory that appearances are individual things.

I had defended two general epistemic principles. The following are *instances* of those two principles.

(1) For every x, if x is appeared to in a way that is red, then it is evident to x that he or she is appeared to in a way that is red.

(2) Being appeared to in a way that is red tends to make it probable (confirms) that one is appeared to by an external physical thing that is red.

Being appeared red(ly) to is a nondispositional property of the subject of experience; being red is a dispositional property of the external physical thing.

I would now put the principles as follows:

(1') For every x, if x senses an appearance that is red, then it is evident to x that he or she senses an appearance that is red.

(2') Being appeared to in a way that is red tends to make probable (confirms) that one is sensing an appearance of an external physical thing that is red.

The redness of the external physical thing is dispositional, that of the appearance is nondispositional.

<div style="text-align: right">October 23, 1995</div>

NOTES

1. An account of this episode may be found in William Schack, *Art and Argyrol* (New York and London: Thomas Yoselloff, 1960), pp. 390ff.

2. Gottlob Frege, "Über die Grundlagen der Geometrie" (1903), in Ignacio Angelelli, ed., *Kleine Schriften* (Hildesheim: Georg Olms Verlagsbuchhandlung, 1967), pp. 262–66. The citation is from page 262.

3. *Posterior Analytics,* book I, chap. 2.

4. C. I. Lewis, *An Analysis of Knowledge and Valuation* (La Salle, Ill.: Open Court Publishing Company, 1946), p. 334.

5. Meinong's conception of remembering is defended in his "Toward an Epistemological Assessment of Memory" (1886), translated in Roderick M. Chisholm and Robert Swartz, eds., *Empirical Knowledge: Readings from Contemporary Sources* (Englewood Cliffs, N.J.: Prentice-Hall, Inc., 1973), pp. 253–70. The corresponding view of perceiving may be found in Meinong's *Über die Erfahrungsgrundlagen unseres Wissens* (1905); see section 18, entitled "External Perceptions and Evident Presuppositions," pp. 89–91; reprinted in Rudolf Kindinger and Rudolf Haller, eds., *Alexius Meinong: Gesamt Ausgabe,* vol. 5 (Akademische Druck- und Verlagsanstalt, 1975).

6. H. H. Price, *Perception* (New York: Robert M. McBride and Company, 1933), pp. 139–51.

7. See Otto Neurath, "Protokollsätze," *Erkenntnis,* vol. 3 (1938), pp. 204–14. For a general discussion of Neurath's views, see Rudolf Haller, *Neopositivismus: Eine Historische Einführung in die Philosophie des Wiener Kreises* (Darmstadt: Wissenschaftliche Buch Gesellschaft, 1993), pp. 150–78.

8. See *Sextus Empiricus,* vol. 2 (London: William Heinemann, Ltd., 1930), p. 95.

9. See D. J. Mercier, *Criteriologie Générale,* 8th ed. (Louvain: Institut Supérieur de Philosophie, 1934), p. 234.

10. Ludwig Wittgenstein, *Philosophical Investigations* (Oxford: Basil Blackwell, 1953), secs. 243–315.

11. See, for example, the article by F. M. S. Hacker, entitled "Private

Language Argument," in Jonathan Dancy and Ernest Sosa, eds., *A Companion to Epistemology* (Oxford: Basil Blackwell, 1992), pp. 368–74.

12. See Richard Rorty, "Mind-Body Identity, Privacy, and Categories," in David M. Rosenthal, ed., *Review of Metaphysics* 19 (1965): 41–48. Strictly speaking, however, Rorty is primarily concerned with a *linguistic* question and not with the epistemological problem to which the doctrine of privileged access is intended to provide a solution. His concern is with "the privacy of first person *reports*" (my italics). But much that is relevant to *that* question is not relevant to the present epistemological question. Compare Rorty's *Philosophy and the Mirror of Nature* (Princeton: Princeton University Press, 1980).

13. David Armstrong, "Is Introspective Knowledge Incorrigible?" in David M. Rosenthal, ed., *The Nature of Mind* (New York and Oxford, 1991), pp. 126–36; the quotation is from page 129. This article first appeared in *Philosophical Review* 72 (1962): 413–22.

14. One variant of this reasoning may plausibly be interpreted in this way: (a) the belief that we have such access to our own states is a tenet of folk psychology; but (b) such tenets are false; and therefore (c) we do not have such access. If the premises are taken in the most plausible way, then, of course, the argument is an equivocation; for it would be question-begging to assume that "folk psychology" in the second premise has the same sense that it has in the first. See Steven Stich: *From Folk Psychology to Cognitive Science* (Cambridge: MIT Press, 1983), p. 5ff.

15. The temptation may be illustrated by citing one author's discussion of the following situation. A patient, in talking with his psychoanalyst, has just made a significant Freudian slip. The psychoanalyst asks himself: "And just *who* is it who is talking with me *now?*" One theorist puts the answer this way: "If we think we know who is speaking a well-formulated utterance, if we think that the ego we know maintains control over such a statement, then who is responsible for the slip? Lacan has answered that this other speaker, this other subject, is the subject of the unconscious, precisely the subject whose being we are never conscious of." The quotation is from page 12 of Stuart Schneiderman's introduction to his *Returning to Freud: Clinical Psychoanalysis in the School of Lacan* (Yale and New London: Yale University Press, 1988). The author is here expressing the views of Jacques Lacan.

16. I thus reject the "adverbial theory of appearances." The classic discussion of the adverbial theory may be found in the articles by C. J. Ducasse and G. E. Moore in P. A. Schilpp, ed., *The Philosophy of G. E. Moore*, vol. 4 of *The Library of Living Philosophers* (Evanston, Ill.: Northwestern University Press, 1942). Ducasse's discussion ("Moore's Refutation of Idealism") appears on pages 223–52; Moore's Reply ("Subjectivity of Sense-Data") on pages 653–60. See the article, "Adverbial Theory," by Bruno Schuwey, in Hans Burkhardt and Barry Smith, eds., *Handbook of Metaphysics and Ontology*, pp. 18–20. In earlier writings. I have defended the adverbial theory.

17. Thomas Case, *Physical Realism* (London: Longmans Green and Co., Ltd., 1888), pp. 24–33.

18. I have written at length about such epistemic rules in the third edition of my book, *Theory of Knowledge* (Englewood Cliffs, N.J.: Prentice-Hall, 1989). This discussion presupposes the adverbial theory of appearances, but it may be readily adapted to the view that appearances are individual things.

19. It has been questioned whether Fechner himself would accept the present version of "the daylight view." See Leopold Stubenberg, "Chisholm, Fechner, und das Leib-Seele Problem," in *Grazer Philosophische Studien* 28 (1986): 187–210. But, as we have noted, the differences in philosophical terminologies make it very difficult to compare the views of different philosophers who are concerned with this complex set of problems.

DESCRIPTIVE AND CRITICAL ESSAYS WITH REPLIES

1

Richard Taylor

CHISHOLM'S IDEA OF A PERSON

I earned my philosophical degree under Roderick Chisholm's direction. I believe I was the first such. The years since have confirmed that this was one of the blessings of my life. I got from him what few teachers, even among philosophers, are able to give, and that was an appreciation of the idea that in philosophy it is the argument that counts, not the conclusion. He had no patience with teachers of philosophy who are chiefly concerned with promoting fond notions, who choose their premises in the light of conclusions already arrived at. Chisholm never minded if the conclusion he arrived at seemed bizarre. He wanted us to appreciate the beauty of the argument that yielded it, and to see whether we could find anything wrong with it.

This great lesson, this great blessing of my life, which was a gift from Chisholm, nourishes a kind of skepticism, but mercifully so. It taught me, in philosophy, to appreciate philosophical subtleties for their own sake, unencumbered by doctrine, and this, as all students of Chisholm discover, is an exquisite intellectual joy. But beyond this it enabled me to see beyond philosophy, and beyond what is ordinarily thought of as belief, to some of those things, dimly discerned, that can seldom be fathomed or even clearly expressed but which have, along with all of my folly, given my life part of its meaning.

In what follows I want, however inadequately, to express my gratitude by considering what is surely one of the strangest ideas ever to emerge from this philosopher's extraordinary mind, and that is the idea of a person which he expressed in the late seventies in a paper called "Is There a Mind-Body Problem?" *(Philosophic Exchange,* vol. 2 [Brockport, N.Y.: SUNY, 1978]). There he argued—correctly, I think—against the traditional concept of the mind or soul, and then astonished his audience by suggesting that a person is, i.e., is identical with, a minute particle of matter located, presumably, in the brain.

This is, of course, not a conception of a person to which anyone would naturally be drawn. Indeed, Chisholm is probably the first person

in the history of the world to suggest it, and he conceded that it invites ridicule. But this illustrates perfectly what I said at the outset, that for Chisholm, what is important is the philosophical argument, not its conclusion. And it seemed to him that the argument for this view is stronger than those for any other view. At the end of his talk he invited anyone in his audience to come up, if they could, with a better view, that is to say, one that rested on premises better than those he had cited in support of this one.

I accepted this challenge. I suggest that a person—me, for example— is precisely what a person is taken by unreflective common sense to be, namely, a visible, palpable living physical body which has—that is, consists of—torso, limbs, head, brain, nerves, heart, and so on. Such statements as the following are, on this view that I am suggesting, literally and not figuratively true, to wit: Most basketball players are large persons, while infant children are small persons; we see persons walking hither and thither in the street, sometimes bump into them, and when we look into mirrors we literally see ourselves. Persons, whom we see and sometimes bump into, have many interesting and sometimes puzzling characteristics, some of them not found in other living and nonliving bodies. For instance, they believe various things, fall in love, rejoice, dream, perceive, draw inferences, speculate about the future, and so on.

This is, of course, a version of materialism, just as Chisholm's particle view of a person is a version of materialism. I am not at all interested in persuading anyone that this view is correct. I only want to suggest that Chisholm's reasons for rejecting it are open to doubt, and that he has not, therefore, shown it to be incorrect.

Basic to Chisholm's argument is the fact that a living human body— that is, the thing that ordinary people unreflectively take to be a person—is an *ens successivum,* that is, something that is made up of different things at different times. The components of my body at this moment—cells, and the bits of matter of which cells are composed—are not the same cells and bits of matter as constituted what I yesterday referred to as my body.

A good illustration of what Chisholm means by an *ens successivum* is provided by a symphony orchestra of long standing—one that, for example, may have been founded a hundred years ago. Let us imagine such, and give it a name—say, the Boston Symphony. One might write a history of this orchestra, beginning with its birth one hundred years ago, chronicling its many tours and triumphs and the fame of some of its musical directors, and so on. But are we talking about one orchestra?

In one sense we are, but in another sense we are not. The orchestra

persists through time, is incorporated, receives gifts and funding, holds property, has a bank account, returns always to the same city, and rehearses, year in and year out, in the same hall. Yet its membership constantly changes, so that no member of fifty years ago is still a member today. So in that sense it is an entirely different orchestra. We are in this sense not talking about one orchestra, but many. There is a succession of orchestras going under the same name. Each, in Chisholm's apt phrase, *does duty* for what we are calling the Boston Symphony.

The Boston Symphony is thus an *ens successivum.* So is my body. Thus "the thing that does duty for my body today is other than the thing that did duty for it yesterday and other than the thing that will do duty for it tomorrow. But what," Chisholm asks, "of me? Am *I* an entity such that different things do duty for *me* at different days?"

Chisholm thinks not, and his argument is that it cannot be one thing that, for example, does my feeling depressed for me today and *another* thing that did it yesterday and still another thing that will do it tomorrow. "If I happen to be feeling sad," he says, "then, surely, there is no *other* thing that is doing my feeling sad for me." And from this he concludes that "we must reject the view that persons are *entia successiva.*"

But it seems to me that the same argument could be given to show, falsely, that the Boston Symphony Orchestra is not an *ens successivum.*

Suppose, for example, that this orchestra, on a given day, makes a recording of Beethoven's Fifth Symphony. The next day the sound engineer discovers a flaw in the second movement, so the orchestra is summoned to re-record that portion. The percussionist is out of town, however, so another does duty for him in the brief passage that calls for the kettle drum, and the work, now flawlessly recorded, is marketed, glowingly reviewed, and praised by the countless listeners.

A metaphysician now raises the question: Is it one thing that records that portion of the piece today and *another* thing that recorded it yesterday? What about the orchestra? If the Boston Symphony records Beethoven's Fifth, then, surely, there is no *other* thing that is recording Beethoven's Fifth *for* it. And, he fallaciously concludes: We must reject the view that orchestras are *entia successiva.*

Chisholm summarizes his argument in these four statements:

> (1) Suppose I am now sad. Now (2) if there is an *ens successivum* that bears my name and is now sad, then it is sad in virtue of the fact that one of its stand-ins is now sad. But (3) I am not sad in virtue of the fact that some *other* thing is doing my feeling for me. Therefore (4) I am not an *ens successivum.*

Now let us formulate precisely this argument with respect to the orchestra. It will go:

(1) Suppose the Boston Symphony Orchestra is now playing Beethoven's Fifth. Now (2) if there is an *ens successivum* that is called the Boston Symphony Orchestra and is now playing Beethoven's Fifth, then it is playing Beethoven's Fifth in virtue of the fact that one of its stand-ins is playing Beethoven's Fifth. But (3) the Boston Symphony Orchestra is not playing Beethoven's Fifth in virtue of the fact that some *other* thing is playing Beethoven's Fifth for it. Therefore (4) the Boston Symphony Orchestra is not an *ens successivum.*

And that conclusion is, of course, contrary to fact. The Boston Symphony Orchestra is a paradigm of an *ens successivum.* And so, indeed, we can suppose that I, too, am an *ens successivum,* at least so far as this argument is concerned. And thus, for anything that has been shown to the contrary, we may suppose that I am, that is, am one and the same thing as, the body that people turn towards when they address me and to which they customarily apply my name.

Chisholm finds it hard to see how a person can persist through time as one and the same person if that person is identical with his gross physical body which does not persist through time as one and the same physical body. It is, at one time, a quite different body than it was at another time. And he is not, of course, the first to find the supposition of such an identity puzzling. Anyone who thinks about it will find it such, and to some, I suppose, it seems simply impossible.

But I think we can suppose that the living human body that I call my body is an *ens successivum* in the most extreme sense and still say that I am identical with that body.

By supposing this body to be an *ens successivum* "in the most extreme sense" I mean to suppose that at a given time, such as this moment, it has not one single component part, however minute, that it had fifty years ago. The succession of parts, let us suppose, has been complete, and this body, which I refer to as my body, is in this sense a totally different body than the one which, fifty years ago, I referred to as my body, the one that appears in snapshots taken of me back then when I was a young man.

And now I am asking whether both of these bodies, sharing not a single component part, however minute, can be identical with me, that is, can be one and the same thing as the person I refer to as myself; whether, for example, the person who sometimes felt sad back then can be identical with the person who sometimes feels sad now if, as we are

supposing, this person is identical with each of these two bodies which share not a single component part.

There are, of course, many arguments to the contrary, but I am not now concerned with them, or with refuting them. I only want to show that this supposition is not, as Chisholm supposed, inherently flawed.

It will be useful here, I think, to compare persistence through time with persistence through space. These are different, to be sure, but I think the similarities will shed light on what we are looking for.

Consider, then, a rope, fifty feet long, composed entirely of fibers of varying lengths, none of which is more than three feet long. The rope, then, has a succession of parts over the fifty-foot interval of space that at any moment it fills, and is in that sense a spatial *ens successivum*. And from the description it follows that none of its components at one end is the same as any component at the other end.

And let us suppose, in order to give the rope a unique identity, that it is the rope used to hang some notorious criminal long ago, and is now called "the hanging rope."

Now if you are holding one end of this rope, and I the other, we are both holding the hanging rope. And one would entirely miss the point by asking: But how can you both be holding one and the same rope, if the rope one of you is holding consists of one set of fibers, and the rope the other is holding is composed of an entirely different set of fibers?

Next let us suppose we mark off segments of this rope at, say, five-foot intervals. We can now say that these are all segments of one and the same rope, notwithstanding that no two of them, separated by a third, shares a single component part.

Now let us suppose that three different museums would like to have this rope, to display for its historical significance. So it is decided to cut the rope into two pieces, one museum getting one of them, another museum the other, and the third museum gets an exact replica, that is, a rope from the same period made to look exactly like the original.

All three museums label the display as "The Hanging Rope," and give the same description of its historical significance. They have in common that they are all exactly alike, except that the first two are shorter. The third exactly resembles the other two before they were cut in half.

The descriptions given by the first two museums are correct. They are both displaying the hanging rope, or, strictly speaking, parts of one and the same rope, and it really is the hanging rope. But the description given by the third is really a lie. That is not really the hanging rope, even though it exactly resembles it. It is a different rope altogether.

Now if someone said that these are three entirely different ropes, sharing not a single component part, and therefore only one of the

museums can be giving a true description of what is being displayed, then that would be mistaken. In one clear sense we are talking about three entirely different ropes, but in another sense we can say that two of them together constitute one and the same rope, and are identical with the hanging rope.

It is, of course, in this second sense that we can say that the physical body to which people attached my name fifty years ago, the one appearing in the snapshot that people now describe as a picture of me back then, together with the body to which people now attach my name, and towards which they usually turn when addressing me, constitute one and the same physical body, and are identical with me. It is no valid criticism of this suggestion to say: "But how can they be the same, when they do not share a single component part? Surely we are here talking about two entirely different bodies, one of them doing duty as your body now, and the other doing duty for it fifty years ago." It is only in the first of the two senses I have elicited that we are here talking about two different bodies, and this is consistent with saying that both of them, together, are parts of one and the same body, and that I am that body.

By virtue of what, then, can we say of two living human bodies, sharing no component part, that both of them are my body, and yet, that I have but one body? Suppose we consider three different human bodies—these two, which at different times I correctly refer to as my body, and the third, the body of my twin brother. How do we say which two of these three constitute my body, and thus constitute me, and distinguish them from the body of my twin?

The answer is suggested by my example of the rope. There we were dealing with three distinct ropes, having no component parts in common. What made two of these parts of one rope was their spatial and temporal continuity, not shared by the third. And similarly, what makes my two different bodies, at widely separated parts of my life, both to constitute my body at those different times, is the spatial and temporal continuity they have with all the other bodies that are, at different times, mine.

How, then, are we going to understand the word "have," in the statement, "I have a body?" I think we should, in this context, take it to mean simply, "I *am* a body," that is, I am one and the same thing as this living body, having all its component parts arranged in the manner that they are. This word can be understood, then, in the same way as used in the statement, "this bicycle *has* two wheels, a seat, frame, and handle bars." The bicycle is not one thing, and these something else which the bicycle *has*.

And how, finally, shall we resolve the difficulty Chisholm found in the

idea that, if he is feeling sad, then it cannot be something *else* that is feeling sad *for* him.

We can say, I think, that my feeling sad, fifty years ago, was a condition of my body then, or of some part of it—my nervous system, perhaps—and my feeling sad today is also a state or condition of my body, or some part of it, and, while these two bodies share no component part, they are nevertheless both *my* body, in the sense just explained, and there is no *other* thing that is doing my feeling sad for me, because I am one and the same thing as that body.

There may be difficulties in this version of materialism, which identifies persons with their bodies, but I do not think Chisholm has elicited any that is fatal to it, and the presuppositions from which it is drawn—that we see persons moving around in the street, bump into them sometimes, and so on—are at least in accordance with commonplace notions.

RICHARD TAYLOR

DEPARTMENT OF PHILOSOPHY
UNION COLLEGE
JUNE 1995

REPLY TO RICHARD TAYLOR

Of the Ph.D. theses that I have supervised during the course of my teaching career, Richard Taylor's was the first. Therefore I deeply appreciate the kind remarks with which he begins his challenging paper, "Chisholm on the Nature of the Person." I hope that what I say will be worthy of his tribute.

I have held that there is something to be said for the view (1) that you and I are minute proper parts of our gross material bodies. Let us call this "the bodily-part view of the self." The alternatives are to say either (2) that each of us is nonbodily or (3) that each of us is identical with his or her gross body. Taylor defends the latter view, which I will call "the orthodox materialistic view of the self."

I had suggested that the orthodox view should be rejected on the ground that it implies that the self is an *ens successivum*. Taylor has persuaded me that *that* difficulty can be met. Reflection on Taylor's paper, however, has persuaded me that there is a more serious difficulty.

My gross material body is a component of many collections of bodily particles. There is that collection of bodily particles which did duty for my living body a year ago; there is that collection which does duty for it now; and, if I live long enough, then there will be that collection which will do duty for my living body a year from now. Unless these particles have ceased to be without remainder (ceased to be *in nihilum*), and there is no reason at all to suppose that that is true, then there will be *scattered objects* which now exist in a great variety of places.

The relevant concepts may be defined this way.

D1 x is spatially discrete from y =Df. x and y are spatial objects that have no parts in common.

D2 x is a continuous spatial object =Df. x is a spatial object which is such that, for every y, if y is a proper part of x, then y touches a proper part of x that is spatially discrete from y.

A spatial object that has holes in it may yet be continuous. There could be a continuous object that is shaped like a doughnut or like a piece of Swiss cheese.

D3 x is a scattered spatial object =Df. x is a spatial object that is not continuous.

Any lower-case "i" that appears on this page is a scattered spatial object. We may be tempted to say that the two parts that we can distinguish in any such object are themselves nonscattered. Presumably observation through a microscope would show that we are mistaken.

Orthodox materialism, then, does not enable us to say *which*, if any, of the many surviving collections can be identified with me. Could it be just one or two of them? Or am I to be identified with the entire collection of collections?

The bodily-part view does not have this difficulty. According to it there is exactly *one* collection of bodily particles which can do duty for me.

If one wants a materialistic view of the self, then, it would seem, one should accept the bodily-part theory.

And the view that we are simple substances (and therefore non-bodily substances) is still another possibility.

R.M.C.

2

Philip L. Quinn

TINY SELVES: CHISHOLM ON THE SIMPLICITY OF THE SOUL

Problems of the self have loomed large in Roderick M. Chisholm's philosophical thought. He has written extensively about self-knowledge. He has also addressed such metaphysical issues as the self's agency and its persistence through time. In a couple of recent papers he has turned his attention to the doctrine of the simplicity of the soul. One of them is devoted to a critical examination of Bernard Bolzano's views on the simplicity of the soul; the other sets forth Chisholm's own argument for its simplicity.[1] My aim in this essay is to extend the discussion begun in these two papers.

The essay has two parts. In the first, I summarize what Chisholm has to say about the simplicity of the soul. I discuss briefly the philosophical methods he advocates and introduce the concepts he employs in his argument for the simplicity of the soul. Then I lay out the argument. In the second part, I try to show that what Chisholm says about simple souls is consistent with several accounts of the nature of the soul. Simple souls might lack spatial location, or they might be spatially located. If they are spatially located, they might lack additional physical properties, or they might possess such properties. And if they do possess such physical properties, their psychological properties might supervene on their physical properties, or they might not. I give reasons for preferring an account of simple souls according to which some of them at least are spatially located.

PART I: THE ARGUMENT FOR SIMPLICITY UNFOLDED

Chisholm begins his Carus Lectures with some reflections on philosophical method. When we think about ourselves, we are entitled to treat as philosophical data propositions we all presuppose in our ordinary

activity. We have a right to believe these propositions in the sense that "whether or not they are true, they are all such that they should be regarded as innocent, epistemically, until we have positive reason for thinking them guilty."[2] According to Chisholm, our data may have different degrees of epistemic justification. Each of them has some presumption in its favor, and most of them are epistemically acceptable. Some are beyond reasonable doubt; some are evident; and some are absolutely certain. Any philosophical theory that is inconsistent with our data is prima facie suspect. The burden of proof is on one who accepts such a theory. To show that one is justified in accepting such a theory, one must show that it is based on things that are at least as respectable as our data. Data can be reformulated in response to the pressure of philosophical argument. Suppose I begin by including among my data the proposition that I weigh 220 pounds. If it is proved to me that I am not identical with my body, I can resort to paraphrase and take my original claim to abbreviate the claim that I have a body that weighs 220 pounds. Each of us could formulate his or her list of data as a single sentence with a common subject. Chisholm's schematic example is this: "I am an x such that x thinks so-and-so, x has such-and-such a body, x is doing such-and-such things, x formerly thought such-and-such, x formerly had a body of such-and-such a different sort, and x formerly brought about such-and-such other things."[3] Later on I shall be looking into the question of whether the doctrine of the simplicity of the soul is inconsistent with any of the items on my list of philosophical data.

Chisholm's treatment of the simplicity of the soul begins with some striking promises. He says:

> I will defend the thesis according to which there is something that is metaphysically unique about persons: we have a nature wholly unlike anything that is known to be true of things that are known to be compound physical things. I will attempt to show how this thesis coheres with the traditional doctrine of "the simplicity of the soul." And I will argue that the doctrine of the simplicity of the soul is, in William James' terms, very much of a live option. (p. 167)

But before we can understand how he proposes to deliver on these promises, we must grasp his concepts of soul and simplicity.

Following Augustine, Descartes, Bolzano, and others, Chisholm uses the word "soul" to mean the same thing as the word "person." On this usage, you and I do not have souls; we are souls. It contrasts with the Aristotelian usage according to which the word "soul" designates a principle in individual things in virtue of which they perform activities such as perceiving or thinking. On that usage, you and I are not souls, but we do have souls.

According to the thesis of the simplicity of the soul, we are substances but not compounds of substances. As Chisholm sees it, every extended physical substance is compound because it has proper parts which are themselves extended physical substances. Hence simple souls are not extended physical substances. Following Augustine, Chisholm adopts a definition of body according to which a body is whatever consists of parts, whether greater or less, which occupy greater or smaller local spaces. On this definition, every bodily substance is an extended physical substance. Hence simple souls are not bodily substances. For Chisholm, an incorporeal substance "is a substance that is *not* a bodily substance" (p. 168). Thus simple souls are incorporeal substances. According to the thesis of the simplicity of the soul, then, we are unextended and incorporeal substances.

When Chisholm speaks of extended substances, he means to refer to substances that are extended in three spatial dimensions. Although he thinks there is good reason to suppose that extended physical bodies contain boundaries, he classifies boundaries among their unextended constituents. This contrasts with the usage in which the boundaries of things that are extended in three dimensions are also extended because they are extended in two dimensions. In this usage, only the points that bound one-dimensional line segments are unextended boundaries.

It is worth mentioning that the doctrine of the simplicity of the soul, thus construed, is not the same as and is much weaker than the traditional theological doctrine of divine simplicity. Those who endorse the latter doctrine often presuppose a constituent ontology according to which anything in which there is diversity of constituents is not simple.[4] A being which has as constituents both act and potency is not simple. Hence a simple God must be pure act without admixture of potency. A being in which essence and existence are distinct is not simple. Thus a simple God's essence must be identical with its existence. A being that has distinct faculties or powers among its constituents is not simple. So a simple God's intellect must be identical with its will. A being that has diverse attributes among its constituents is not simple. Therefore a simple God's omniscience must be identical with its omnipotence. And so forth. But simple souls need not be simple in all these ways. As Chisholm conceives them, it is possible for them to exemplify diverse mental or psychological properties such as judging, wondering, wishing, hoping, enjoying oneself, being sad, being depressed, having a sensation, and dreaming.

With these preliminaries out of the way, we are now in a position to turn to Chisholm's argument. There are three possibilities to consider. Using the first person, they may be formulated as follows:

The first is that I am identical with my body. The second is that I am
identical with a proper part of my body. And the third is that I am not
identical with *any* body. (Surely, whatever else I may be, I am not identical
with any bodily thing having parts that are not shared by *this* body). (p. 168)

For reasons that will become apparent in the second part of this essay,
Chisholm's formulation of the second possibility needs to be spelled out
a bit in the interests of clarity. I take it to be the claim that I am identical
with a proper part of my body that is itself a body and so is an extended
thing. Chisholm's opening move is to dismiss the first of these three
possibilities rather quickly. My hand, he observes, is not an essential
part of me, for I could have lost it without thereby ceasing to be.
Philosophers who do not share Chisholm's commitment to mereological
essentialism may object to this quick dismissal, and philosophers who,
like Peter van Inwagen, reject the doctrine of arbitrary undetached parts
could challenge it.[5] But if for the sake of argument we go along with it,
the possibilities worth considering reduce to two. Either I am identical
with some body that is a proper part of my gross body, or I am not
identical with any body and so am an incorporeal thing. How are we to
argue for preferring one of these hypotheses to the other?

Chisholm recommends that we approach this question by consider-
ing the nature of our mental properties because they "provide us with the
most assured information that we have about *any* individual thing or
substance" (p. 169). When we do reflect on our mental properties, he
thinks we will be able to ascertain that they are necessarily such that only
substances exemplify them and possibly such that simple substances
exemplify them. What is more, he thinks we will also discover that they
have five additional formal or structural marks. First, mental properties
are open in the sense that a property is open just in case it is possibly
such that, for any number n, there are n substances that have it and n
substances that do not have it. Second, mental properties are repeatable
in the sense that a property is repeatable just in case it is possibly such
that there is something that does not have it but did have it and will have
it. Third, mental properties are not compositive, where a property is
compositive just in case it is necessarily such that whatever is composed
of things that have it is itself a thing that has it. Fourth, mental properties
are not divisive, where a property is divisive just in case it is necessarily
such that any compound thing that has it has a proper part that has it.
And, fifth, mental properties are internal properties of substances in the
sense that a property is an internal property of substances just in case it
is necessarily such that whatever has it is a substance, and either it is
necessary to whatever has it or it is necessarily such that whatever has it
has every open and repeatable property that it implies.

These five additional marks provide the ingredients for Chisholm's definition of a qualitative property. Certain disjunctive properties that have all five of them have to be ruled out by the definition if qualitative properties are to be restricted to things that are capable of thinking. Certain conjunctive properties also have to be excluded by the definition for similar reasons. As a result the actual definition he proposes contains a couple of clauses whose technical details are meant to do these jobs. Since nothing I am going to say depends on such details, I shall not take the trouble to reproduce the definition. For my purposes it suffices to say that qualitative properties are characterized as being both open and repeatable, being neither compositive nor divisive and being internal properties of substances. And if Chisholm has got the technical details right, anything that has a qualitative property is a substance that is capable of thinking.

We are now prepared to understand Chisholm's argument. I quote his formulation in its entirety:

(1) We have qualitative properties.
(2) Every qualitative property that we are acquainted with is known to be possibly such that it is exemplified by simple substances.
(3) No qualitative property is known to be such that it may be exemplified by compound substances.

Hence

(4) Some of our properties are known to be such that simple substances can have them and are not known to be such that compound substances can have them.

Therefore

(5) We have a nature which is wholly unlike the nature that anything known to be a compound physical thing is known to have (p. 177).

This, then, is the argument that is supposed to deliver on Chisholm's striking promises.

It might be objected that the argument's third premise begs the question against those philosophers who, like John Searle, hold that *"consciousness, in short, is a biological feature of human and certain animal brains."*[6] Of course brains are known to be compound substances. However I do not think such philosophers know that brains exemplify the property of being conscious, though they may think that they do. So I do not think the property of being conscious is known by anyone to be such that it is, or even may be, exemplified by compound substances. More important, neither the argument's third premise nor its

conclusion begs the question against biological naturalism of the sort espoused by Searle. Chisholm points out that:

> the conclusion of this argument leaves us with two possibilities: either (a) the soul is an unextended substance or (b) souls have a type of property that extended physical substances are not known to have. The latter option is defended by those who have argued that the fact of thinking indicates the presence of a peculiar type of "emergent property" in nature. (p. 177)

To be sure, Chisholm leaves little if any room for doubt that he prefers the former option. He immediately goes on to write that "I have said that we *are* souls and that souls are simple substances" (p. 178). But even if we grant that his argument shows this to be a live option, it does not follow that emergentist alternatives to it are not also live options. It is consistent with souls having a type of property that extended physical substances are not known to have that extended physical substances have properties of that type. Hence it is consistent with the second possibility Chisholm acknowledges that souls are, unknown to us, extended physical substances such as brains. In other words, Chisholm's argument does not preclude the possibility that we are souls and souls are extended physical substances such as brains. Even if I accept its conclusion, I do not get a decisive answer to the question of whether I am a bodily substance or an incorporeal substance.

Must we simply acknowledge that there is no way to answer this question decisively? Perhaps in the end we will be forced to this conclusion. Can we make further progress toward answering it? I think so. As I see it, both the hypothesis that I am a bodily substance that is a proper part of my gross body and the hypothesis that I am an incorporeal substance can be fleshed out in different ways, some of them more plausible than others. If I am some extended part of my gross body, I am on empirical grounds more likely to be my brain than to be my left toe. I am convinced something similar holds in the case of the doctrine of the simplicity of the soul. Different ways of developing it will yield versions of the doctrine that differ in plausibility. So those who are sympathetic to the doctrine, as I am, would be well advised to try to identify the more plausible versions of it. I next turn my attention to that task.

PART II. VARIETIES OF SIMPLE SOULS

I begin with a naive question. If I am a simple soul, where am I? Some philosophers seem to think that the answer is that I am nowhere. Joshua Hoffman and Gary Rosenkrantz have recently proposed the following definition of a soul:

(6) x is a soul = df. (i) x is a substance, and (ii) x is unlocated, and (iii) x is capable of consciousness.[7]

For reasons I need not go into here, they leave open the possibility of an alternative definition:

(7) x is a soul = df. (i) x is a substance, and (ii) x is unlocated, and (iii) x is conscious.

On either of these formulations, it is a matter of definition that souls have no spatial location. So if I am a soul, I have no spatial location. But some of the items on my list of philosophical data can be put together in a single sentence as follows: I am an x such that x is on the surface of Planet Earth, x is in Indiana, x is on the campus of Notre Dame, and x is in room 331 of Decio Hall. These data are beyond reasonable doubt for me. It is therefore beyond reasonable doubt for me that I have a spatial location. Hence if souls are by definition unlocated, it is beyond reasonable doubt for me that I am not a soul.

But need we accept the claim by Hoffman and Rosenkrantz that unlocatedness is a logically necessary condition of being a soul? What they say in support of it is this:

> It is arguable that there could be a substance that is conscious and unextended, but occupies a point of space. It can be further argued that such an entity is a soul or spirit. However, it is not obvious that either of these are genuine possibilities. But, even if there could be an unextended spiritual substance occupying a point of space, it would not be a *purely* spiritual being. That is, it would not be *wholly* outside of the physical world, inasmuch as it would occupy a point of space. When traditional Western theism affirms the existence of God, angels, etc., it is affirming the existence of purely spiritual beings, and this is what we mean by the term 'soul' or 'spirit'.[8]

So it turns out the concept Hoffman and Rosenkrantz mean to define is the concept of a being which, like the transcendent God of traditional theism, is entirely outside the physical world. One or the other of their definitions may serve this purpose quite well. The thought that God is unlocated comports well with the Cartesian dictum that God in virtue of his essence has no relation to place at all, though he is omnipresent in

virtue of his power.[9] But it does not follow that either of their definitions captures the concept of a human soul. The thought that human souls are unlocated does not comport well with the fact that their perceptual perspectives on the physical world are spatially located or the fact that their powers to act on the physical world directly are spatially localized. Something that coheres better with such facts is the hypothesis that human souls are conscious and unextended substances that occupy spatial points. Hoffman and Rosenkrantz dismiss that hypothesis too quickly.

Nor is it inconsistent with the simplicity of the human soul. Presumably the argument from simplicity to unlocatedness would go as follows:

(8) Necessarily, whatever is simple is unextended.
(9) Necessarily, whatever is unextended is unlocated.

Hence

(10) Necessarily, whatever is simple is unlocated.

But this argument is unsound because its second premise is false. As Hoffman and Rosenkrantz note, the point particles postulated by Boscovich's physics are unextended but located.[10] Surely it is possible that such particles exist even if none actually exist.

There are, then, two ways to develop the doctrine of the simplicity of the human soul. According to the first, simple souls are unlocated. On this view, if I am a simple soul, then I am nowhere at all. According to the second, simple souls are located at spatial points. On this view, if I am a simple soul, then I occupy a spatial point, presumably one somewhere inside my gross body. The first view about where we are if we are simple souls is inconsistent with data that are beyond reasonable doubt for us; the second is not. Therefore the second way of developing the doctrine of the simplicity of the soul is to be preferred to the first. So I shall pursue it further. I ask and try to answer a series of questions about spatially located simple souls.

Could such souls be proper parts of human bodies in which they reside? I think this is possible. They would satisfy a standard definition of the relation of being a proper part of. It goes as follows:

(11) x is a proper part of y just in case y completely overlaps x, and there is some z such that z completely overlaps x and does not completely overlap y.[11]

To fix ideas, consider a simple soul located inside the pineal gland of a human body. The body completely overlaps the soul, and there is something, namely, the pineal gland, such that it completely overlaps the

soul and does not completely overlap the body. Hence the soul is a proper part of the body. Moreover, I know of no true mereological principle that precludes this possibility. Chisholm remarks that "any body that is extended also has a proper part that is extended" (p. 172). It is true that:

(12) Necessarily, whatever is extended has extended things as proper parts.

But this principle is consistent with extended things having unextended proper parts in addition to their extended proper parts. Such unextended proper parts would be ruled out by the principle that:

(13) Necessarily, whatever is extended has only extended things as proper parts.

But I think this principle can be shown to be false. Consider a geometrical sphere. It has extended proper parts, for instance, its left hemisphere and its right hemisphere. Now consider a point inside its right hemisphere. The sphere completely overlaps the point, and there is something, namely, the right hemisphere, such that it completely overlaps the point and does not completely overlap the sphere. Hence the point is a proper part of the sphere. The sphere thus has both extended proper parts and unextended proper parts. It is extended but does not have only extended things as proper parts.

 Could simple souls that are located in and are proper parts of human bodies be physical substances? I think they could. Perhaps such location and parthood alone suffice for physicality. If they do not, the answer to this question depends on whether other physical properties are possibly such that they are exemplified by located but unextended things. Numerous physical properties do satisfy this condition. Some of the basic properties of classical physics such as having charge and having mass are among them. When physicists talk about point charges and point masses, they may be speaking of idealizations, but they are not talking about impossibilities. What is more, the property of being a source of so-and-so long-range attractive forces and of such-and-such short-range repulsive forces, which is the fundamental property of Boscovich's physics, is such that it can be exemplified by unextended things. So a fairly rich array of physical properties could be exemplified by unextended things. The exemplification of mental properties by simple souls does not preclude them from also exemplifying such physical properties. Nor does Chisholm's argument rule out this possibility. Its key assumption is that our qualitative properties are not known to be such that compound physical substances can have them. This is

consistent with our qualitative properties being such that simple physical substances can have them. And it seems clear to me that our qualitative properties are not known to be such that simple physical substances cannot have them.

It might be objected that simple souls cannot be parts of human bodies and cannot be physical substances because they are incorporeal. I admit that it sounds odd to say that a bodily substance has incorporeal proper parts or that a single thing is both physical and incorporeal. But I submit that the oddity is an artifact of Chisholm's Augustinian way of talking about bodies. Within this framework, bodily substances are by definition compound. Since being bodily entails being compound, being simple entails being incorporeal. So Boscovich's point particles will be incorporeal in this sense, no matter what physical properties they exemplify. As the example of such particles shows, being incorporeal in this sense does not entail being nonphysical. Similarly, the simple parts of anything whatsoever will be incorporeal in this sense. The nondenumerable infinity of points that constitutes a geometrical sphere is a collection of simples, and so each such point will be an incorporeal proper part of the sphere. As this example shows, being incorporeal in this sense does not entail not being a proper part of an extended thing. Hence the objection fails. And once it is apparent that the oddity arises from a particular definitional convention, we see that we could get rid of it, if we wished, by adopting a somewhat different way of talking about bodily substances.

Could the mental properties of a simple soul that also has physical properties be emergent or supervenient? In a recent paper to which Chisholm refers, James Van Cleve offers the following account of emergent properties:

(14) If P is a property of w, then P is emergent if and only if P supervenes with nomological necessity, but *not* with logical necessity, on the properties of the parts of w.[12]

Properties of parts are to be understood as including relations among parts, and parts are to be understood as proper parts. Emergence, on this view, is a kind of multiple-domain supervenience in which the supervening properties are possessed by wholes and the subvening properties by their parts. This account of emergence fits nicely with the possibility that I am a proper part of my gross body, such as my brain, that is itself an extended body. It allows mental properties to be emergent properties of the brain that supervene with nomological necessity on physical properties of such things as neurons that are its parts. But the mental properties of a simple soul cannot supervene on the physical properties of its parts

because a simple soul has no proper parts. Hence the mental properties of a simple soul cannot be emergent properties in this sense.

Nevertheless the mental properties of a simple soul that has physical properties could be supervenient in another sense. According to Jaegwon Kim, one important kind of supervenience can be defined as follows:

(15) A-properties supervene on B-properties = df. Necessarily, for any object x and A-property a, if x has a, then there is a B-property b such that (i) x has b, and (ii) necessarily, if anything has b, it also has a.[13]

This formulation defines supervenience for a single domain of objects; the A-properties of a thing supervene on the B-properties of that very thing. Single-domain supervenience is required if the mental properties of a simple soul are to supervene on its physical properties alone.[14] It seems to me that simple souls endowed with physical properties could satisfy this definition because it places no restrictions on the kinds of objects that can have supervenient properties. So I think the mental properties of a simple soul that has physical properties could be supervenient on those physical properties.

In this essay I have been trying to advance the discussion of the doctrine of the simplicity of the soul begun by Chisholm. When we get down to the specifics of developing the doctrine, I have argued we confront at least four choices. Either we conceive of simple souls as spatially located, or we conceive of them as unlocated. I have also argued that our philosophical data dictate a preference for the first option in this choice. If we do conceive of simple souls as spatially located, either we conceive of them as being proper parts of human bodies in which they reside or we conceive of them as not being such proper parts. If we conceive of them as being such proper parts, either we conceive of them as possessing further physical properties, or we conceive of them as not possessing such properties. And if we conceive of them as possessing further physical properties, either we conceive of them as being such that their mental properties supervene on those physical properties, or we conceive of them as being such that their mental properties do not supervene on those physical properties. I have argued that the first option in each of these three choices represents a genuine logical possibility. But I have not argued that the first option is to be preferred to the second in any of them, for I can think of no compelling arguments for such conclusions.

This suggests a research program for the friends of simple souls. Let them seek arguments that will dictate a preference in these three choices and perhaps others as well. What may emerge from such deliberations is

the strongest version of the doctrine of the simplicity of soul. They will then be armed with the best version of the thesis that we are simple substances. Presumably friends of the view that we are extended proper parts of our gross bodies and so are compound substances will endeavor to work out the strongest version of that doctrine. If they succeed, they will then be armed with the best version of their thesis. The two strongest contenders can be pitted against each other, and a comparative assessment of their merits conducted to determine the winner.

Let me conclude with a question. Many contemporary philosophers who place their faith in naturalism express disdain or even contempt for a Cartesian ontology in which there are unextended thinking things. But what if such unextended thinking substances were, in addition, spatially located in human bodies, proper parts of those bodies, endowed with further physical properties, and such that their mental properties supervened on those physical properties? Would anything more be needed to render them respectable in the eyes of philosophical naturalism?[15]

PHILIP L. QUINN

DEPARTMENT OF PHILOSOPHY
UNIVERSITY OF NOTRE DAME
JULY 1993

NOTES

1. Roderick M. Chisholm, "Bolzano on the Simplicity of the Soul," *Traditionen und Perspektiven der Analytischen Philosophie*, ed. W. L. Gombocz, H. Rutte, and W. Sauer (Vienna: Holder-Pichler-Tempsky, 1989) and Roderick M. Chisholm, "On the Simplicity of the Soul," *Philosophical Perspectives 5: Philosophy of Religion 1991*, ed. J. E. Tomberlin (Atascadero, Calif.: Ridgeview, 1991). Hereafter I make page references to the second of these papers parenthetically.

2. Roderick M. Chisholm, *Person and Object* (La Salle, Ill.: Open Court, 1976), p. 16.

3. Ibid., p. 17.

4. See Nicholas Wolterstorff, "Divine Simplicity," *Philosophical Perspectives 5: Philosophy of Religion 1991*, ed. J. E. Tomberlin (Atascadero, Calif.: Ridgeview, 1991).

5. Peter van Inwagen, "The Doctrine of Arbitrary Undetached Parts," *Pacific Philosophical Quarterly* 62 (1981): 123–37. See also Peter van Inwagen, *Material Beings* (Ithaca, N.Y.: Cornell University Press, 1990).

6. John R. Searle, *The Rediscovery of the Mind* (Cambridge: MIT Press, 1992), p. 90.

7. Joshua Hoffman and Gary Rosenkrantz, "Are Souls Unintelligible?"

Philosophical Perspectives 5: Philosophy of Religion 1991, ed. J. E. Tomberlin (Atascadero, Calif.: Ridgeview, 1991), p. 183.

8. Ibid., pp. 184–85.

9. For discussion of Descartes on this point, see Stephen Voss, "Simplicity and the Seat of the Soul," in *Essays on the Philosophy and Science of René Descartes,* ed. S. Voss (New York and Oxford: Oxford University Press, 1993), p. 133.

10. For information about Boscovich, see Lancelot Law Whyte, "Roger Joseph Boscovich," *The Encyclopedia of Philosophy,* vol. 1, ed. Paul Edwards (New York: Macmillan, 1967).

11. See Nelson Goodman, *The Structure of Appearance,* 3d ed. (Dordrecht: D. Reidel, 1977), p. 35.

12. James Van Cleve, "Mind-Dust or Magic? Panpsychism versus Emergence," *Philosophical Perspectives 4: Action Theory and Philosophy of Mind 1990,* ed. J. E. Tomberlin (Atascadero, Calif.: Ridgeview, 1990), p. 222.

13. Jaegwon Kim, "Concepts of Supervenience," *Philosophy and Phenomenological Research* 45 (1984), p. 165. As Van Cleve notes, the modal operators in Kim's definition are very often taken to express nomological rather than logical necessity in discussions of the supervenience of the mental on the physical.

14. Another possibility worth mentioning is the kind of multiple-domain supervenience according to which the mental properties of a simple soul supervene with nomological rather than logical necessity, not on its physical properties alone, but at least in part on the physical properties of parts of the brain in which it is lodged. Such a view seems to cohere nicely with some things Chisholm says: "Presumably nothing can think unless it has a brain. The property of thinking, therefore may causally require the existence of a brain" (p. 170). One might wonder whether brains are causally necessary for all the mental properties of simple souls or only for some of them.

15. My thanks to James Cushing, Trenton Merricks, Stephen Voss, and Dean Zimmerman for helpful conversations on the topic of this essay.

REPLY TO PHILIP L. QUINN

I have defended three controversial theses about the self or the soul. Using the first person, I would put them this way: (1) I am not identical with this gross physical body; (2) I could be a small proper part of body; and (3) I could be a simple substance. Most of what Quinn has to say pertains to thesis (3) and I shall restrict myself here to those parts of his paper.

Like Quinn, I am, to use his phrase, one of "the friends of simple souls."

I should point out, what Gary Rosenkrantz has brought to my attention, that the "could" in "I could be a simple substance" should not be taken as the "could" of logical or metaphysical possibility, for taken in that sense, "I could be a simple substance" implies that I *am* a simple substance. It should be taken as the "could" of *epistemic possibility*—and, more particularly, that sense of "epistemic possibility" in which "it is epistemically possible that p" may be read as "the proposition that p is consistent with everything that is known."

I have said that the parts of an extended substance are themselves extended substances, from which it would follow that, if the soul is a simple substance, then it is not a part of the body. But I have used "part" in this way only in order to conform to the usage of most formulations of the principles of mereology. And I agree completely with Quinn's suggestion that the question *whether* to use "part" in this way is pretty much a verbal question. And so, too, for the question whether to use "physical substance" in such a way as to imply "extended substance."

I would also agree with Quinn that the soul, even if it is a simple substance, has a location. Indeed I applaud his insistence that this fact should be one of the preanalytic data of our inquiry. Like Quinn, then, I will make some remarks about the *location* of souls.

There is a possible ambiguity in Quinn's use of "x *in* y." Sometimes he interprets it in such a way that "y" refers to a *substance* or *individual*

thing (as in "The soul may be in the pineal gland"). And sometimes he uses it to refer to "locations in *space.*" But the two senses of "in" may be quite different. If two roads cross each other, without one going under or over the other, then there is a piece of matter that is common to the two roads. But a road may cross an area of space without going over it or under it and without there being any piece of matter that is shared by both; for no piece of matter is a part of space. I am here speaking, of course, of so-called "absolute space"—that infinitely extended entity that would remain if God were to annihilate all contingent individuals. (I have written at length about the theory of categories but must confess that I cannot make up my mind about the existence of such an entity.)

The only point concerning which I am inclined to disagree with Quinn concerns what he says about the theory according to which mental properties "supervene on" physical properties. In recommending that theory, Quinn makes use of Jaegwon Kim's definition of what it is for one property to "supervene on" another:

> A-properties supervene on B-properties =Df. Necessarily, for every object x and A-property *a,* if x has A, then there is a B-property *b* such that (i) x has *b,* and (ii) necessarily, if anything has *b,* it also has *a.*

If we take the theory seriously, then we should consider how we might go about applying it to some property that is quite obviously mental and not merely sensory. Let it be the property of concluding that it is about to rain. We should have at least *one* plausible version of how the explication might go. We would like to know, for example, how to complete the following thesis:

(T) The mental property of concluding that it is about to rain super-venes upon the physical property of ———.

How are we to fill the blank? At present, the only examples we have are make-believe, such as "The mental event supervenes upon the Z excitation of the C-fibers," where one offers no real terms with which "Z excitation" and "C-fibers" might be replaced. Have there been any real attempts to answer the question? Or have there been any conflicting theories about what the answer might be? When we try to consider *all* the things that can influence one's mental life, doesn't it seem clear that *the* physical property upon which *any* mental event depends would need to be put as an extraordinarily complex disjunctive property? One cannot help but wonder whether the finding of such a property would have to await the completion of the natural sciences.

I am inclined to think, therefore, that Quinn is more friendly toward

the supervenience theory of mental events than one ought to be at the present time.

Quinn has provided an accurate and sympathetic discussion of my attempt to show that the attribute of thinking is "qualitative," but I have now revised that project in two respects. One is to look for a peculiar property of *persons* rather than for a peculiar property of *thinking.* (It is much easier to show that computers can calculate than it is to show that they can feel.) And the second is to look, not for "qualitative" properties, but for "structural" properties. Where the requisite sense of "qualitative" is usually left undefined, we may define "structural" in the following way:

D1 P is a structural attribute =Df. P is an attribute that may be defined by reference just to the following: attribute; individual; constitutent of; exemplification; and necessity.

What I would now affirm is this:

D2 P is a structural attribute that only persons can have =Df. P is the attribute of having an attribute that is: restricted to substances; internal to substances; nonexpansive, and proper-part implying.

I call attention to the fact that the definiens contains the phrase, "the *attribute of having an attribute.*"

At this point the following definitions are necessary in order to explicate some of the technical expressions that appear in the definiens.

w is composed of x and y =Df. (1) x is part of w; (2) y is part of w; (3) x and y have no parts in common; and (4) every part of w has a part in common either with x or with y.
P is nonexpansive =Df. P is necessarily such that, for every x and y, if x and y each have P, then nothing that has P is composed of x and y.
P is an internal attribute of substances =Df. P is restricted to substances; and, for every attribute Q, if Q can be exemplified by contingent substances, and if P is necessarily such that it is exemplified only if Q is exemplified, then whatever has P has Q.
x is a proper part of y =Df. (1) x is part of y; and (2) x is not identical with y.
P is proper-part implying =Df. There is a Q which is necessarily such that whatever has P has a proper part that has Q.

The present sense of "expansive" is an adaptation of one first used by Nelson Goodman and Henry S. Leonard; and the definition of "composed of" is adapted from one formulated by A. N. Whitehead.

Definition D2, according to our present thesis, provides us with the essence of our analysis. Possibly a conjunction formed by some subset of these four attributes is also a structural attribute that only persons can have. But such a situation would be consistent with the thesis that is defended here. That thesis may be falsified by showing, with respect to the attribute P described in the definiens, *either* (a) that P may not be exemplified by persons *or* (b) that P may be exemplified by things that are not persons.

R.M.C.

3

Dean W. Zimmerman

CHISHOLM AND THE
ESSENCES OF EVENTS

I. INTRODUCTION

Like Bertrand Russell, Roderick Chisholm has never been afraid to change his mind. Indeed, with respect to the metaphysics of events, facts, and truth, the views of both Russell and Chisholm underwent the same transformation. According to Chisholm's earliest and best-known theory of events, both events and facts are a subspecies of "states of affairs."[1] States of affairs are abstract, necessarily existing things, some of which obtain or occur and some of which do not; some of those that obtain are facts and others are events. Consequently, events continue to exist even when they have ceased to occur. States of affairs also constitute the objects of belief and of all the other propositional attitudes. Thus, with Meinong and the early Russell and Moore, we find Chisholm advocating the "identity theory of truth": my believing (truly) that snow is white is to be analyzed *not* in terms of my being related to something distinct from the fact that snow is white which is true in virtue of its corresponding to this fact; instead, my believing that snow is white is a matter of my standing in a special believing-relation to *the fact* that snow is white itself.[2]

Both Russell and Moore became disillusioned with such a metaphysics. It makes truth a primitive property of the objects of belief, whereas truth, they felt, should never be primitive: if something is true, this must always be in virtue of its corresponding to something beyond it. Furthermore, the nonobtaining states of affairs posited by their view were a bit too much like "false facts" for someone with Russell's "vivid sense of reality."[3] Chisholm, too, has come to reject his original, very similar metaphysics of states of affairs. Chisholm's new theory of events and facts, like that of Russell-the-logical-atomist, no longer places them in a category that admits nonoccurring or nonobtaining members. Also

like the atomist Russell, Chisholm now takes acts of judging to be the most basic category of true things. And both agree that a judgment is true just in case there is a fact or event to which it corresponds.

The present paper is concerned entirely with Chisholm's most recent views about "states"—the broad ontological category which includes both facts and events. I shall argue (1) that Chisholm's claims about the essential properties of states have considerable appeal, but (2) that if he is right about state essences, then his theory of events faces a serious "ontological problem of individuation." The solution I offer to the problem tears a page from Chisholm's older theory of events as states of affairs. Before taking up issues of event essences, however, I sketch the outline of Chisholm's new metaphysics of states and events in section II, and briefly discuss its utility for theories of causation and truth-making in section III.

II. Chisholm's "Events without Times"

Chisholm's new theory of events finds its most complete expression in "Events Without Times: An Essay On Ontology"[4] (parenthetical page references pertain to this article). Events are there exhibited as a species of *states*. Gerundive expressions conforming to the schema *"x-being-F"* are the canonical names of states: if some x exemplifies *being-F,* then there exists the state of x-being-F (p. 417); and, for every state $y,$ there is some x and property *being-F* (the state's "substrate" and "content," respectively) such that x exemplifies *being-F,* and y is identical with x-being-F.[5] Events are said to be just those states whose substrates are contingent things and whose contents are properties which are only contingently exemplified by their substrates (p. 419).

One might quibble about both these restrictions. Perhaps God is a necessary being, whose actions should qualify as events with a noncontingent substrate. And if even static "standing conditions" can serve as part of a cause, and if every causal relatum should qualify as an event (many philosophers appear to use the term "event" to mean no more than "any condition or occurrence that could figure in a causal explanation or prediction"), then maybe we need events with "natural kind" properties for contents—properties like *being H_2O* or *being a quark.* But such kind-properties would appear to be *essential* to the things that have them.

Some might also find Chisholm's strictures on events to be, in other ways, too loose. Perhaps mere "Cambridge" states should be ruled out— states such as my being thought about by someone, or Xantippe's

becoming a widow. According to this suggestion, a state is an event only if its content is in some sense *intrinsic* to its substrate. Or one might think of events as an even narrower category: they are the states that really "do all the work," the ones upon which every fact about the world supervenes as a matter of causal necessity. In that case, an even stricter criterion would be called for, perhaps along these lines: a state is an event just in case its content is a property that figures in a fundamental law of nature.[6]

It seems to me, however, that neither of these narrower notions can make a stronger claim on the word "event" than the other, or than Chisholm's original characterization itself; and since Chisholm's ontology includes more than enough states to satisfy anyone's need for events (in fact, on some accounts, *too many*),[7] there is little point in arguing about precisely where to draw the line.

If *x*-being-*F* is the canonical schema for event names, what then becomes of ostensibly relational events (for example, a particular passage of the moon between the earth and the sun) which do not appear to conform to the substrate-content pattern? In his first defense of the new theory of events, Chisholm admits that a theory of states which recognized only states with one substrate would be radically incomplete. There are also states with irreducibly dyadic contents, which must have two substrates; states with triadic contents having three substrates; etc.[8]

In "Events Without Times," however, Chisholm identifies relations with monadic "ordered properties" of a certain sort, and seems to imply that such ordered properties are the real contents of all ostensibly relational events (p. 420). But, as Chisholm himself points out, his ordered properties can only be exemplified *by other properties* (p. 420). And properties are, by his lights, abstract objects—that is, necessarily existing nonindividuals. Since he restricts the category of *event* to just those states which are contingently possessed *by contingent things,* a state could not both be an event (by Chisholm's criterion) and also have one of Chisholm's relations for its content.

The proposed reduction of relations to properties presents further difficulties, a full discussion of which would take us far from the theory of events.[9] Although it will not make any difference to the arguments that follow, I believe that Chisholm's first thoughts were best: not all events with seemingly relational contents can be identified with states having monadic contents.

Chisholm's states and events may appropriately be called "structured complexes."[10] They are *complex,* for each must be composed of at least two constituents: namely, a thing and one of its properties. They are *structured* inasmuch as a state is never identifiable with the simple sum

of its constituents; it depends not just upon the existence of its constituents, but also upon their being related or "structured" in a certain way. Chisholm's states, Russell's facts,[11] Arthur W. Burks's ontological compounds,[12] and D. M. Armstrong's states of affairs[13] all seem to satisfy the following characterization of "structured complex": a structured complex is a whole made up of things-exemplifying-properties, or properties-being-exemplified-by-things. Every constituent of a structured complex is related by exemplification or its converse to another constituent, and the holding of these exemplification relations comprises the essential structure of the complex; if they were to cease to obtain, the whole would cease to be. These features are captured in (D1):

(D1) x is a structured complex =Df. There is a set S which is necessarily such that: (i) S contains every constituent of x that is essential to x; and (ii) for every y in S, either (a) there is some property (relation) u in S which is such that, if x exists, then y exemplifies u (stands in relation u to some member of S); or (b) there is some v in S such that, if x exists, then v exemplifies y (stands in relation y to some member of S).[14]

III. STATES AS BOTH CAUSAL RELATA AND TRUTH-MAKERS

Chisholm's views about events have, he says, been "especially influenced by the work of Jaegwon Kim" (p. 426, n. 3). In the paper of Kim's to which Chisholm refers, Kim describes his theory of events as broad enough to take in changes, "unchanges," conditions, and processes—in general, every possible subject of causal explanation or prediction. Chisholm's net is cast just as widely, with an eye to including every sort of causal relatum (cf. pp. 417 and 421–22). And there is good reason to think that each of their theories of events can be incorporated with equal fecundity within a theory of causation and causal explanation that makes use of constant conjunction or the "subsumption" of events under laws of nature.[15]

The fact that Chisholm's events look perfectly tailored to fit into at least one very plausible program for the philosophical treatment of causation should be enough to make his theory of considerable interest. It would appear, however, that counterfactual analyses of causation cannot tolerate either Kim's or Chisholm's theory of events.[16] But who knows *what* events would have to be like to satisfy a counterfactual analysis? Although interesting work has begun on the question, it still awaits a truly satisfactory answer.[17] More generally, defenders of counterfactual analyses face mounting opposition; each time a counterexample is eliminated by the introduction of some new epicycle, a similar

counterexample steps up to take its place.[18] So, even if Chisholm's events are ill-suited to a counterfactual analysis, this may not constitute much of an objection to his view.

In addition to serving as causal relata, Chisholm's states also "play the role of 'truth makers'—those things *in virtue of which* beliefs, sentences and assertions may be said to be true."[19] If, for example, I now believe that a certain dog is barking, and my belief is true, the truth of my belief is to be explained in terms of the presence in the actual world of a state which makes it true—presumably, a state with the dog as substrate and barking as content: i.e., the *event* of this-dog-barking. But do we really need events to serve as truth-makers? Let me suggest some reasons to think that we do.

The critics of deflationist theories of truth appear to be gaining ground.[20] As the deflationists' fortunes wane, the appeal of a correspondence theory grows. But, as Russell points out, simply enumerating all the individuals, properties, and relations that there are does not suffice to "make-true" every true belief.[21] A correspondence theory cannot identify the set or sum of Casio, *loving,* and Desdemona with the truth-maker corresponding to someone's belief that Casio loves Desdemona. This set would exist even if Casio did not love Desdemona. So what else could correspond to this belief, if not a structured complex consisting of these three components which exists if and only if the first is related by the second to the third?

It has recently been proposed that the role of truth-maker be played by entities that are not structured complexes. Sometimes called "particularized qualities," "particular characters," "abstract particulars," or "tropes,"[22] the proposed truth-makers are the contemporary representatives of Aristotelian "individual accidents" and the "modes" of the early moderns.[23] Even the most sophisticated of such approaches has trouble finding truth-makers for the beliefs typically expressed by certain negative and general statements, such as "This liquid is odorless," "Ba'al does not exist," and "All ravens are black."[24] By contrast, Chisholm's view offers many well-qualified candidates for the job of making-true beliefs of these sorts.

Since Chisholm recognizes negative properties like *being-nonodoriferous,* his theory implies that there are states like this-liquid-being-nonodoriferous which can serve as truth-makers for the first sort of problematic negative belief. Chisholm could account for the truth of my belief that Ba'al does not exist by appealing to states with properties as substrates. If "Ba'al" is a disguised definite description, then my belief may be made true by the state with the conjunction of the properties

concealed in "Ba'al" for its substrate and the attribute *being-unexemplified* as content. If, on the other hand, a token of "Ba'al" refers to something just in case it stands in that peculiar, unanalyzable "causal relation *R*" to some appropriate baptismal ceremony, then a state with my utterance of "Ba'al" for substrate and the property failing-to-be-*R*-related-to-anything as content would be sufficient to make my belief true.

It also seems to me that, for roughly Russellian reasons, the existence of all the "particularized blacknesses" of actual ravens could not be the truth-maker for my belief that all ravens are black.[25] If the aggregate of these blacknesses really made the belief true, then its existence would be sufficient by itself for its truth—which of course it is not, since the aggregate could coexist with a white raven and the belief be false. (Cf. the discussion of the "sufficiency principle" [SP] in the next section.) A Chisholmian state with the conjunction of the properties *nonblackness* and *ravenhood* for its substrate, and *being-unexemplified* for its content would, however, suffice to make the statement true. If the friends of particularized qualities cannot find any truth-makers for these sorts of negative and general statements, then the correspondence theorist has considerable motivation to recognize something like Chisholm's states as truth-makers.

Whatever one thinks of these considerations, there seems to be growing recognition that we cannot do without structured complexes.[26] Facts, situations, states of affairs, and their ilk are everywhere once again, just like in the good old days of logical atomism and the *Tractatus*. Chisholm's states can, I believe, perform all of the functions for which such entities are typically introduced. And, since states also make splendid causes and effects, it is reasonable for Chisholm to reject the notion that, "in addition to the property of falling, there is also a kind of 'particularized property' or 'universal as particular'" (p. 417). If states must be recognized anyway, and states can do everything "particularized properties" can do, then why multiply ontological categories beyond necessity?

IV. EVENT ESSENCES

We are now in a position to examine the plausibility of Chisholm's doctrines about the essences of states and events. Given Chisholm's new theory of states and events and the assumption that states and events must serve as both causal relata *and* truth-makers, should they be thought to have just the essential properties he ascribes to them?

"The most we can say about the essential properties of events" is, Chisholm says, the following: (1) "Events have necessarily those properties that *everything* has necessarily"; (2) "Events, like everything else, have their *categorial* properties necessarily," i.e., each event is necessarily an event, and not, for instance, a number; (3) "Events are necessarily such that they have the *substrates* that they do"; and (4) "Events are necessarily such that they have the *contents* that they do" (pp. 422–23). Thus each event—and, presumably, each state of whatever sort—has only one interesting essential characteristic: it necessarily has the substrate and content that it does.

A number of philosophers have objected to the thesis that an event is a state whose content and substrate are essential to it.[27] But, given a certain conception of the truth-making relation, and Chisholm's assumption that events are truth-makers, the reasons typically given for thinking that an event could have differed in substrate or content lose their force.

Let us assume that the most basic category of things made true are something like "token beliefs," "thoughts," or "acts of judgment." A belief or judgment B is true in virtue of the fact that it corresponds to some state, some part of the world which makes it true. A particular state S_1 that makes B true may not be the *only* truth-maker for B. Perhaps B *is* the belief that either p or q; S_1 makes the belief that p true, but not the belief that q; and there is some state S_2 that makes the latter true but not the former. In that case, each of S_1 and S_2 is *a* truth-maker of B, and B can be made true by both of them without our having to suppose that there is a third thing—a conjunctive or disjunctive state of which S_1 and S_2 are both parts—that *also* makes-true B. Again, a "disjunctive" or a "general" belief may in fact be made true by some state, even though it could have been made true in the absence of that state by some very different state. But even if I were convinced that we should allow for such possibilities, I would still want to maintain that the truth-making relation should respect the following sort of rough-and-ready "sufficiency principle": if my present belief is true because it corresponds to some state, then the existence of that state would have been enough to make-true any thought that anyone could have had now which made the same "claim" about the world, or which had the same "content."[28]

(SP) If x now makes-true the belief B, then x is necessarily such that, if a belief B^* has the content B actually has, then x makes-true B^*.

According to (SP), if some state S is really responsible for the truth of my belief B, then S's existence alone would have been enough to make-

true the belief of anyone who had been "thinking the same thing." So even if we were to suppose that S could have differed somehow in substrate and content, we could not suppose that it differed in such a way as to fail to make-true a belief with the content B actually had.

Suppose I now believe that a is F, and this belief is made-true by a certain state S with just a as substrate and being-F as content. (Any state that has a as substrate and being-F as content may be called "a state of a-being-F.") By (SP), S could not have failed to make-true any belief to the effect that a is F. Now suppose that being-F is not a "determinable," but is rather a fully determinate property—a property that is never exemplified by a thing in virtue of its having some other set of properties. (Never mind that few, if any, of our beliefs are ascriptions of fully determinate properties to things. We *could* have such beliefs, and God surely does.) Since being-F is not a property a could have in virtue of anything other than a's exemplifying being-F, the only available state that could serve as truth-maker for a belief that a is F is a state of a-being-F—or a state having a state of a-being-F as some kind of part. Thus, under any counterfactual circumstances in which S exists, it must make true a belief to the effect that a is F; and this requires furthermore that it somehow include an a-being-F state within it. So, at least every truth-making state that has a fully determinate property for content necessarily includes a state with the substrate and content it in fact has as a component.

This argument does not show that all states have their substrates and contents essentially. It does, however, show that every state belonging to one very important category—that of the most fundamental events, the ones that determine all the facts about the way things are—has the substrate and content it actually does among its essential components if states are to play the role of truth-makers. We might put this point by saying that, whether or not such states could have been "thicker" (involving more substrates or contents than their actual ones), they could not at any rate have been any "thinner."

Furthermore, in the literature about event-essences the view that an event could differ in substrate or content is never supported by arguments for the conclusion that some event could have been *merely* "thicker." In fact, the reasons typically given for supposing that an event could have differed in *any* way in its substrate or content are ones that cannot be taken seriously if the event in question is assumed to be a truth-maker satisfying (SP).

Here is how arguments for the conclusion that events could have had different contents or substrates typically go: We are supposed to share

certain intuitions about the essences of events, or to be willing to assent to counterfactuals with implications about event essences. Reflection on which counterfactuals we accept and which we reject is expected to bring the essential and contingent properties of events into focus. Would we not agree, for example, that the following statement could be true: "If Sebastian's leisurely stroll had been a bit more brisk, his heart rate would have been higher?" But then the state Sebastian-strolling-leisurely could have been Sebastian-strolling-briskly, where strolling-leisurely and strolling-briskly are two incompatible content-properties. On the other hand, "it is highly dubious that Sebastian's leisurely stroll could have been a run or a crawl, and it certainly could not have been a coughing or dozing, although Sebastian could have stayed at home that night with a cold, coughing and dozing."[29] Thus there are some properties which an event like Sebastian-strolling-leisurely could have had for its content instead of strolling-leisurely, and others that it could not have had. Or, if "each night someone, chosen by drawing a card, takes a stroll at 2 A.M. . . . [t]hen we might say that had the cards fallen out differently, another person might have taken that stroll."[30] So there are some individuals that Sebastian's stroll could have had for its substrate in place of Sebastian.

These "intuitions" in support of the view that states could have different substrates or contents fit the following patterns: (1) a particular event of a-being-F *actually* had being-F for its content (for example, strolling-leisurely), but it could have had the incompatible property being-G (for example, strolling-briskly) as its content, and then it would have been the state a-being-G; and (2) a-being-F *actually* had a for its substrate (for example, Sebastian), but it could have had a different thing b for its substrate (for example, some other fellow who was chosen by lot instead of Sebastian to take "that night's stroll"), and then it would have been b-being-F. But now suppose that the state of a-being-F in question is also a truth-maker for my belief that a is F. A judgment conforming to either pattern would support the view that this state, which actually makes-true a belief to the effect that a is F, could have *failed* to make-true a belief affirming that a is F. And this is precisely the sort of possibility which, according to (SP), is ruled out by the selection of states as truth-makers: if a-being-F really makes-true the belief that a is F, then the existence of this state must be sufficient for the truth of any belief with the same content. Should one desire a theory of events which can respect intuitions fitting the above patterns, it had better not *also* be one that takes events to be a species of states, and states to be truth-makers.

I can see very little reason to resist this argument or to search for non-

truth-making events with greater modal ductility. I agree with Jonathan Bennett that the linguistic evidence for such "intuitions" about event essences is, at best, inconclusive. Careful attention to our "counterfactualizing" about events does not reveal solid convictions about the essential and contingent properties of events, for the reasons he indicates.[31] But even if Bennett were wrong about this, intuitions fitting schemata (1) and (2) would still provide no basis for denying the essentiality of substrate and content *if events are states and states are truth-makers.* On these assumptions, all such intuitions have to go.

If the relation between a belief and the part of the world that makes it true is as strong as I have supposed, Chisholm's claim that his states necessarily have the substrate and content that they do appears to be vindicated. At least with respect to the most fundamental states, a certain sort of essentiality of substrate and content follows from their service as truth-makers. And the familiar reasons for supposing that a state could differ at all in substrate or content are ones that cannot be taken seriously by someone who takes the state to be a truth-maker.

V. CHISHOLM ON TIME AND TENSE

Chisholm wants to develop "a theory of events that does not presuppose that there are such things as 'times' " (p. 413). His consequent denial that happening at a particular time could be among the essential characteristics of an event leaves many events without individual essences and leads to the difficulties about "individuation" to be discussed in the next section. Before going into these matters, however, we need a brief resume of Chisholm's views about time and tense.

Chisholm has been admonishing us to "take tense seriously" for many years.[32] Like Augustine, Brentano, and Prior,[33] he insists that the tensed nature of ordinary languages points to the truth of what I will call "presentism": everything that exists, exists now; the "no more" *did* exist, and the "not yet" *will* exist, but neither exists at present (p. 414). Indeed, in a tensed language these claims are tautological; and those with a sufficiently " 'robust sense' . . . of what is temporal"[34] will not ascribe any sort of reality to presently nonexistent things.

Perhaps one could consistently regard tensed-language statements as eliminable, or as admitting tenseless truth-conditions, while maintaining a kind of purely *metaphysical* presentism.[35] But Chisholm's presentism will not allow for this. On his view, even if *(per impossibile?)* all truths expressed in a tensed idiom could somehow be translated into a tenseless

language, that would not show that tensed talk is eliminable—or that temporally oriented properties, such as *having walked* or *being such as to be going to walk,* are reducible to properties or relations that are not temporally oriented. Tensed language is more fundamental than tense-less language, and temporally oriented properties are real and inelimin-able (pp. 413–15).[36] As one might expect, the definitions and axioms of his theory of events are all tensed, and make use of temporally oriented properties.

VI. TIME AND THE INDIVIDUATION OF EVENTS

According to Chisholm, the only deep difference between his theory of events and that of Jaegwon Kim is due to Kim's "commitment to times" (p. 426, n. 3). Kim identifies events with complexes that are very much like Chisholm's states, except that they are constituted not simply by a substance and a property, but by a substance, a property, and a time.[37] Kim's theory thus presupposes, says Chisholm, "that there are such things as 'times'," a presupposition Chisholm rejects (p. 413). He thinks that a metaphysics which withholds commitment to times benefits in two ways: it has a relatively simpler ontology, and also "avoids the difficult questions that the assumption of such entities involves" (p. 413).

The precise nature of the disagreement between Kim and Chisholm about "times" and events is hard to pin down, since neither of them says much about what they take "times" to be. Chisholm does not say exactly which "difficult questions" he has in mind, and Kim does not say anything about what "times" would have to be like to serve as constitu-ents in his events. I shall not attempt to adjudicate this dispute. What is important for my purposes is that there is a sense in which both Kim and Chisholm "individuate" events on the basis of times, inasmuch as they both accept the following "different time–different event" thesis: where $n_2 > n_1 > n$, if x was F n_2 time-units (days, minutes, etc.) ago, subsequently ceased to be F n_1 time-units ago, and then was F again n time-units ago, then the state of x-being-F that existed n_2 time-units ago is not identical with the one that existed n time-units ago—and *mutatis mutandis* for future states of x-being-F.[38] I expect that Chisholm regards this statement as a necessary truth, in which case he should have added the following to his catalogue of the essential properties of events: every event is necessarily such that it does not display "intermittent exis-tence." If an event passes away, it cannot possibly come into being again.

Consider some thing a and property being-F that a has exemplified a

number of times, including once n time-units ago. By the different time–different event thesis, there was a different state of a-being-F that existed during each episode of x's exemplifying being-F. One might try to raise an "ontological problem of individuation"[39] for these various states by asking the question: What is it in virtue of which the particular state of a-being-F that existed n time-units ago was the one that it was, and not some one of the earlier or later states that had a as substrate and being-F as content?

The question presupposes that each particular state has some individuating feature which "makes" it the state that it is and not another, and that such features are essential to their respective states. Merely pointing to some *contingent* feature C of event a that distinguishes it from event b would not suffice as an answer. Since a and b would have been distinct even if a had lacked C, C cannot be what makes it the case that a *had* to be a and not b. Even more obviously, if an individuating feature really makes a to be a and *not any other thing,* it must be impossible for anything else besides a to have had it. Therefore, the question presupposes that, for each state e, there is an *individual essence* of e—an essential property or conjunction of properties that is necessarily such that, if anything exemplifies it, that thing is identical with e.[40]

I am satisfied with R. M. Adams's argument that bare identity differences are possible for at least some kinds of individual,[41] and so I agree with Chisholm that we should not presuppose that *everything* that exists has an individual essence.[42] In particular, then, the mere fact that we can ask, "What makes this state to be this state, and not that state?" should not be taken to imply that the question must have an answer, and that every state has an individual essence. Perhaps the right answer to this question may, on occasion, be: "*Nothing* makes this state to be this state, and not that one."

Indeed, Chisholm does seem to think that the right answer to this question, with respect to states having the same substrate and content, is: Nothing. In section IV, we saw that Chisholm puts very little into the essences of his events. The only interesting way in which events can differ *essentially* is in their substrates and contents. So, as long as being-F is a repeatable property, there may have been many states involving a particular individual a's having the property being-F, all of them with the same essential properties. Chisholm believes, then, that as far as we can tell, the many different states of me-being-bent that have occurred differ from one another *only contingently*.[43] In particular, then, yesterday's first episode of me-being-bent only contingently preceded the second one.[44] In fact, it was perfectly possible that their order have

been reversed. Thus we arrive at a kind of "existentialism" with respect to pairs of events having the same substrate and content: worlds that are indiscernible with respect to facts about which substances exemplify which properties in what order may still differ with respect to which events happen when.[45]

Many philosophers would be unhappy with this result.[46] My discomfort with it is born of the feeling that what is possible for a *composite* entity is at least somewhat restricted by facts about the parts that actually make it up. In the case of composite physical objects, for instance, it is hard to believe that two such objects could have "switched roles" without there having been *some* changes in the histories of their (actual) parts. Suppose my neighbor and I both purchase brand-new cars, and she remarks that her car could easily have been mine, and vice versa. I might agree, saying, "Yes, I looked at yours, and you no doubt looked at mine, and either of us could easily have chosen the other's car." But suppose this is not what she means. What she means, she says, is this: her car could have come from the same Michigan factory that produced my car, made out of the very parts that actually make up my car; while my car could have been manufactured in Japan in the same plant that actually produced hers, out of the very heap of parts now in her garage. In other words, the world could have been exactly the same with respect to the histories of the parts of our cars, yet have differed in which car was which. Surely this sort of *bare* difference in the identities of complex objects—a difference entirely independent of differences in the identity of any proper part—should not be countenanced.

It is tempting (to me, anyway) to think that Chisholm's states are sufficiently like composite objects that something similar should hold for them. The story about the cars supports an "antiexistentialist" principle about cars: if all the facts about the proper parts of my car and my neighbor's car were the same as they actually are, then everything would have to be the same with respect to which car is where, and when. An analogous antiexistentialist principle may be formulated with respect to states: if everything were the same with respect to which substrates possess which properties when, then everything would have to be the same with respect to which events occur, and the order in which they occur.[47] Although a number of philosophers working on events have been attracted to antiexistentialist principles like this one, I know of no knock-down argument for such a view.[48] I can only record my conviction that Chisholm's theory of events would be more attractive if it were less existentialist. As we saw above, Chisholm's slender event essences allow for a kind of existentialism with respect to events with the same

substrates and contents—an existentialism which obviously violates this principle. In what follows, I attempt to modify Chisholm's metaphysics in such a way that the antiexistentialist principle is respected; what results is a theory of events which will, I hope, prove of some interest in its own right.

One way to block existentialism with respect to states with the same substrate and the same repeatable content would be to add something to Chisholm's list of essential properties for states. L. B. Lombard has suggested that the *time of occurrence* is essential to every event; and, on the plausible assumption that there could only be one event that is the exemplifying of a certain property by a given substance at a time, Lombard's proposed amendment to Chisholm's list results in a conjunction of essential properties that can serve to block existentialism. If, for every event *e,* having the particular substrate, content, and time of occurrence it does constitutes the individual essence of *e;* then any change in which events occur, or the order in which they occur, would require a change in which substances exemplify which contents when.[49]

Chisholm would have a difficult time following Lombard here, however, given his views about "times." Lombard's "times" might be taken to be either (1) individual things of a peculiar sort (a slice of substantival space-time, say), (2) sets or sums of simultaneously existing states, or (3) some kind of abstract object that can serve to represent a moment of time. So far as I can tell, this exhausts the possibilities. When Chisholm sets himself the goal of doing without "times," I believe it is primarily times considered as a funny kind of individual that he has in mind—his aversion to such times presumably coming from an allegiance to temporal (or spatiotemporal) relationism. So appeal to times of the first sort will be unacceptable to him. It seems, therefore, that the only way for Chisholm to follow Lombard in making the time of a state part of its essence would be for him to identify "times" either with giant states compounded somehow out of maximal sets of concurrently existing states, or with some kind of abstract object—for example, A. N. Prior's propositionlike "instantaneous world-states,"[50] or perhaps a property which in some sense constitutes or comprehends the entire way the world is at a particular moment. But, as I shall show, the possibility of everything's being "just like this" all over again makes times of both sorts insufficient to fix the individual essences of Chisholmian events.[51]

A. N. Prior is perhaps the most famous exponent of times as "instantaneous world-states"—proposition-like entities which are such that, if they obtain, then they imply every other true state of affairs.[52] Prior's times and states of affairs are quite unlike structured complexes;

interpreted realistically, his calculi of world-states is about giant, momentarily true propositions which exist *whether or not* they are the case.[53] Chisholm himself, when he accepted an ontology of such states of affairs, agreed that instantaneous world-states can serve as "times."[54] So perhaps one might try to smuggle times into the essences of events by insisting that, if an event occurs while a certain world-state obtains, then it could not possibly have occurred while any *other* world-state obtained. Similarly, one could treat all the (Chisholmian) states existing simultaneously with a given event as together comprising a moment of time; with times so construed, the time of an event could be made essential to it by claiming that each state necessarily coexists with all of its contemporaries. On this view, states come in maximal "batches" (which are being called "times"); and no member of a batch could have existed outside of the precise batch in which it finds itself.

Now it must be granted that, in all likelihood, no Priorian instantaneous world-state that obtains in the actual world could be exemplified more than once—for, on the assumption that such world-states include states of affairs that "reflect" the past and future, "if we have had it all once before there is no limit to the number of times we have had it all before,"[55] or shall have it all again. But we should be slow to banish from the realm of logical possibility an oscillating universe in which the same individuals go through (and have gone through) the very same states over and over, *ad infinitum.* In such a world, the same instantaneous world-states would obtain again and again; consequently, such a world would contain distinct events with the same substrate, content, and (Priorian) time of occurrence—and existentialism for events will have returned. Similarly, in such a universe existentialism could not be avoided by identifying times with maximal batches of Chisholmian states; for these giant states themselves will be beset with a kind of existentialism. Each only *contingently* differs from infinitely many past and future giant states of the world; so once again, the antiexistentialism principle for states is violated.

One might argue that, since neither Prior's world-states nor giant Chisholmian states face problems of recurrence in the *actual* world, there is no problem with using them to block existentialism for actual-world events. But events are events, and their essences should be similar whether or not the world is in fact repetitive. If more than the substrate, content, and time of occurrence would have to figure in the individual essences of states in some situations (for example, in oscillating universes), then we should not expect the individual essences of similar actually existing states to be exhausted by these three components.

There is no other likely candidate for the role of "times" if they are neither (1) slices of a substantival space-time, (2) giant sums or maximal sets of concurrent states, nor (3) abstract objects reflecting the way things are at a moment, such as Prior's world-states. Chisholm rejects times of the first sort, and standing in the relation of "necessarily occurring at" to times falling under categories (2) and (3) could not fill the gap in the essences of events. We must look elsewhere, then, for materials from which to build essences thick enough to block existentialism.

Let us consider just one other proposal. Perhaps the "number" of an event is essential to it—for example, perhaps the first state of a-being-F is necessarily the first, the second necessarily the second, etc. This strategy could only serve as a perfectly general way to block existentialism for states if, necessarily, for every state, there is a first time the substrate of the state exemplifies the content of the state—a dubious assumption, I should think. Furthermore, one could just as easily "number" events in the other direction: there is the last time I am bent, the second to the last, etc. An event's location in this ordering would serve equally well as the missing component in its individual essence. Counting from the earliest occurrence seems more natural in many cases, I suppose; but if you were describing Jesse James's last shoot-out, for example, it might seem more natural to count the shots he fired in the other way. If the sheriff had arrived one minute sooner, the last shot Jesse James ever fired would have been the one that hit so-and-so. . . .

The uncertainty we would feel if forced to choose between these alternative ways of putting "number" into event essences is symptomatic of a general murkiness surrounding the essential properties of events. There are no widely shared a priori intuitions about event essences; and even a philosopher as sensitive to the subtleties of ordinary language as Jonathan Bennett can find no significant evidence for a theory of event essences buried in the ways we commonly talk about events.[56] We saw that, if events are truth-makers, they must have their substrates and contents necessarily; but beyond that there seems to be precious little solid ground. Any further property or relation we could add to complete an individual essence for an event would inevitably be controversial. We are simply casting about for likely candidates, any of which will do just so long as it is not possible for there to be more than one event having the proposed feature and also having the same substrate and content.

So here is a dilemma for Chisholm's theory of events: the only essential properties of events which we can feel at all confident about are those he mentions; but they are not sufficient to rule out the strange kind of event-existentialism we have described. It would be nice to be able to

go no further than Chisholm does in ascribing essential properties to events, while respecting the above antiexistentialist principle. Is there a way to do both these things at once?

VII. Intermittently Existing Events

Yes. All one need do is reject the "different time–different event" thesis, insisting instead that each state of *a*-being-*F* that has ever existed or will ever exist is *the very same state.* If *a* exemplifies being-*F,* then stops, and then exemplifies being-*F* again, there is one state of *a*-being-*F* that exists intermittently. Artifacts that can be disassembled and reassembled, such as watches or military rifles, are sometimes thought of as exhibiting a similar kind of intermittent existence. When the watch is taken apart, we are tempted to say that it ceases to be; and when the parts are put back together in the proper way, it seems to come into being again. Whether or not artifacts can plausibly be regarded as passing in and out of existence when disassembled and reassembled, states *really are* like this. A state is a structured complex consisting of a substrate and property "put together" in a certain way. When the "parts" of the state are properly related, the structured complex exists; when they "come apart" it does not. And so long as the constituents of the state exist, it remains possible to put them back together, thereby bringing the original state "back to life."

On this view of states, the following is a necessary truth: for any past or future state *e* with the same substrate and content as some presently existing state *e**, *e* = *e**. Now we can posit no more than the most obvious essential properties for states—i.e., that they have the substrates and contents they do—and be antiexistentialists at the same time. All we need do is insist that having a particular substrate and content constitutes the individual essence of an event—for any state *e,* having the substrate and content it does is not only necessary but *sufficient* for being *e.* Now there can be no changes in which states occur, or in their order of occurrence, without a change in the facts concerning substances and their properties. But how costly is this vindication of the antiexistentialist principle?

The chief problem for a theory of intermittently existing events (or at any rate the only problem I will take up here) is this: in some cases, Jesse James's trigger-pulling causes the gun's firing, in others his trigger-pulling fails to cause the gun's firing, and in still others the gun's firing is caused by someone else's trigger-pulling. If each trigger-pulling by Jesse

James is a distinct state, and likewise for each shot fired by the gun, then causation can be a simple two-term relation between particular trigger-pullings and firings—a relation which would not have linked them had it not been for the existence of certain other standing conditions, etc., but still *not* a relation which has to be relativized to any third thing, be it another state, a time, a period of time, or what-have-you. On the other hand, if each of James's trigger-pullings is the very same event, and similarly for each shot fired by the gun, then the causal relation holding between these events cannot be so simple.

Suppose, for example, that Jesse James is pulling the trigger now, causing the gun to fire almost instantaneously. And suppose, too, that the *next* time the gun is fired it will be Charlie Ford's trigger-pulling that is the cause. So the trigger-pulling that exists now is such that it causes the very next firing of the gun, but not the firing that will follow. If causing were a simple two-term relation holding between James's trigger-pulling and the intermittently existing state of the gun's firing, it would be both true and false that the former is now such that it causes the latter. Is there a sensible way of complicating the causal relation between intermittently existing states so that James's trigger-pulling clearly qualifies *at present* as the cause of the next shot but not of the following one?

In his older theory of events-as-states-of-affairs, Chisholm attempted to overcome a similar difficulty for his intermittently *"obtaining"* states by construing causal contribution as a three-term relationship holding among cause, effect, and the time at which the cause is operative.[57] A theory of events in which an event may exist intermittently must adopt similar tactics: the causal relation (being causally sufficient for, being a necessary part of a state that is causally sufficient for, or whatever causal locution you like best) should be complicated so as to relativize the causing in which a state is involved at present to the time of its effect, and its being caused to the time of its cause. (From now on I restrict my attention to the problem of relativizing causing to time of effect; but the application to the second problem will be obvious.) An event e does not cause an event e^* *simpliciter;* rather, e is *at the present time t causing e^* at t or at some later time t^*.*[58]

Chisholm's insistence that all talk of "times" be cashed out using just the resources of a tensed language makes it impossible to leave matters here; causing cannot be a four-term relation holding among two states and two "times." But the sort of relativization effected in terms of the times t and t^* in the previous paragraph can be carried out in Chisholm's tensed and "time"-less idiom as well, since at the time t when e is causing e^*, the following statement is true: *e now* has the property of causing—

either right now or after a certain interval—e^*'s existence. Since we should allow for the possibility of causation over temporal gaps, we cannot say that a cause e must always be responsible for e^* *the next time* e^* exists. Where $t < t_1 < t_2 < t_3$, e might at t be causing e^2 at t_2, and then at t_1 a different event e^1 could be causing e^2 not at t_2 but at t_3. If an event could only cause a certain state upon that state's next appearance, then it would have to be the case at t_1 that e^1 is causing e_2 *at* t_2 as well as at t_3; so always relativizing causation to the *next* time the effect appears would be to unwisely foreclose questions about the possibility of causation over temporal intervals. We need to be able, at least in some cases, to specify the *length* of the interval after which e's present causal contribution comes into play.

To make allowance for this possibility, we must construe *causing* as a relation which is relativized to a certain period of time, a relation best represented by an expression like *"causing-in-n-time-units"* (where $n = 0$ in the limiting case of simultaneous causation). The fact that Jesse James's present trigger-pulling causes the gun shot occurring 1/100th-of-a-second later should therefore be given the following tensed analysis: the state James-pulling-the-trigger stands (now) in the relation of *causing-in-1/100th-of-a-second* to the state of the-gun-firing. A relativized causing-relation always "goes from" an existing causing state to an effect state, which may or may not exist when the cause exemplifies the causing-relation. A state *was* the cause of a certain state just in case it formerly stood in a relation of *causing-in-n-time-units* to the state; and it *will be* the cause of a state just in case it will bear this relation to the state.

If events are intermittently existing, they must be capable of standing in different causal relations at different times; a-being-F may now be causing the immediate appearance of a-being-G, even though yesterday a-being-F existed without causing the state a-being-G. For example, perhaps yesterday the gun's chamber was empty, so that *then* the state James-pulling-the-trigger existed but did *not* bear the relation *causing-in-1/100th-of-a-second* to the state of the-gun-firing.

On the view I am advocating, causation is typically a relation holding between an existing thing and a not-yet-existing thing.[59] But how can a relation hold between two things if only one of them exists? *When* are they related if they never coexist? It would be in keeping with Chisholm's solutions to similar puzzles to say that what James-pulling-the-trigger really causes is the state whose substrate is everything that will last for at least 1/100th-of-a-second and whose content is the property *being such as to be, in 1/100th-of-a-second, such that there will be a state of this-gun-firing.* That is, the movement of James's finger now makes "the rest of

the universe" such that it will, a moment later, include the state of this gun firing.[60] If we adopt this approach, it turns out that, in a strange way, *all* causation is simultaneous.

The only sure test of the above account of *causing* as a temporally relativized relation that can hold between intermittently existing events would be its incorporation within a satisfactory, comprehensive, independently plausible theory of causation—one in which the concepts of law of nature, necessary and sufficient causal condition, preemptive cause, etc., can be explicated. I see no reason, however, to think that my theoretical framework should prove any less conducive to such a project than, for example, that provided by the more familiar, Kim-style structured-complex theory of events.

One might wonder, though, whether Chisholm's presentism gives him the right to make free use of "units of time." We may recall St. Augustine's question: "Where then is the time which we call long?"[61] In particular, where then is the time which is so many units in length? If presentism is true, "temporal extension is not a dimension of anything."[62] If "three minutes from now" does not measure distance along a dimension of something, what is the significance of this phrase? Here Chisholm could sensibly argue that his tensed language provides the resources to define metrical concepts for temporal distances without reference to any problematic temporally extended entities.

What we need is a tensed interpretation of such metrical claims as "*x* was (will be) F *n* time-units from now." The fact that Chisholm is able to provide tensed-language, "time"-less translations for "*x* is (was, will be) F for the *n*th time" (p. 424) suggests the following approach, which makes use of the notion of a clock's having completed *n* cycles. Since "interval measurement involves the synchronizing of events with the phases of some cyclical process,"[63] statements about what will happen after so-and-so many time-units (days, hours, minutes, seconds) are really claims about what will happen after a certain number of "cycles" of some clocklike system. We choose as clocks those physical systems which are such that, when the time between any two consecutive cycles is assumed to be the same, the laws of nature take their simplest form. For simplicity let us assume that we have an indefinite supply of "clocks" satisfying these conditions: each clock has only gone through its characteristic phases a finite number of times; and for any past or future state of *x*-being-*F*, there is a clock which is completing its *n*th cycle now which was or will be completing its *n**th cycle then. *n* and *n** may be replaced with any positive real number, for we may take "*x* is completing its 3.78th cycle" to mean that *x* has completed exactly three cycles and is in

its ".78-state," that state it is in every time it has passed through 78% of one of its characteristic cycles. (Having cycles with distinct phases corresponding to every real number between zero and one is another feature we must ascribe to our idealized clocks.)

On these assumptions, x was F m time-units ago just in case, for some n and n^* such that $n^* - n = m$, there is a clock completing its n^*th cycle which was such that it is completing its nth cycle and x is F. x will be F in m time-units just in case, for some n and n^* such that $n^* - n = m$, there is a clock completing its nth cycle which will be such that it is completing its n^*th cycle and x is F. This represents just one way to define metrical concepts within a tensed language in such a way that quantification over temporal intervals may be avoided. There are other proposals which, unlike this one, are compatible with the assumption that every "clock" has "cycled" an infinite number of times already.[64] But however the details be worked out, as long as the length of time between two moments is really a measure of how many times *some* kind of clock passed through its successive states after the earlier one and before the later one, it will always be possible to give a tensed-language interpretation of expressions like "being F three seconds from now" which is compatible with Chisholm's presentism.

The presentist can, therefore, avail herself of the temporally oriented metric properties required by my theory of causation for states having intermittent existence—properties like *being such as to be F in n time-units.* Modifying Chisholm's theory of events in the way I suggest does not, then, render events unsuitable for service as causal relata. And if "event existentialism" is as unappealing as it seems to me to be, there is good reason to make the change.[65]

DEAN W. ZIMMERMAN

DEPARTMENT OF PHILOSOPHY
UNIVERSITY OF NOTRE DAME
SEPTEMBER 1994

NOTES

1. Chisholm defended his states-of-affairs theory of events in a half-dozen places over the course of more than fifteen years. Cf. "Language, Logic, and States of Affairs," in *Language and Philosophy,* ed. Sidney Hook (New York: New York University Press, 1969), pp. 241–48; "Events and Propositions," *Noûs* 4 (1970): 15–24; "States of Affairs Again," *Noûs* 5 (1971): 179–89; *Person and*

Object: A Metaphysical Study (La Salle, Ill.: Open Court, 1976), chap. 4; "Events, Propositions, and States of Affairs," *Ontologie und Logik,* ed. P. Weingartner and E. Morscher (Berlin: Duncker and Humblot, 1979), pp. 27–47; "Objects and Persons: Revision and Replies," *Essays on the Philosophy of Roderick M. Chisholm,* ed. Ernest Sosa (Amsterdam: Rodopi, 1979), pp. 317–88, esp. pp. 342–61; "The Structure of States of Affairs," in *Essays on Davidson: Actions and Events* (Oxford: Clarendon Press, 1985), pp. 107–14.

2. Cf. Chisholm, *Theory of Knowledge,* 2d ed. (Englewood Cliffs, N.J.: Prentice-Hall, 1977), chap. 5; Alexius Meinong, *On Assumptions,* ed. and trans. James Heanue (Berkeley: University of California Press, 1983), chap. 3; Russell, "Meinong's Theory of Complexes and Assumptions," reprinted in his *Essays in Analysis,* ed. Douglas Lackey (London: George Allen and Unwin, 1973), pp. 21–76; and G. E. Moore, "The Nature of Judgment," reprinted in *G. E. Moore: The Early Essays,* ed. Tom Regan (Philadelphia: Temple University Press, 1986), pp. 59–80. Stewart Candlish introduced the term "identity theory of truth" in "The Truth about F. H. Bradley," *Mind* 98 (1989): 331–48; see also Thomas Baldwin, "The Identity Theory of Truth," *Mind* 100 (1991): 35–52.

3. Russell, *Logic and Knowledge,* ed. Robert C. Marsh (New York: Capricorn Books, 1971), p. 223 (from "The Philosophy of Logical Atomism").

4. *Noûs* 24 (1990): 413–28. The same theory of events is set forth in less detail in "The Basic Ontological Categories" *(Language, Truth and Ontology,* ed. Kevin Mulligan [Dordrecht: Kluwer Academic Publishers, 1992], pp. 1–13) and "Substances, States, Processes, and Events" (forthcoming in a Festschrift for Guido Küng). A preliminary formulation of the view may be found in "On the Positive and Negative States of Things," *Grazer Philosophische Studien* 25/26 (1985/1986): 97–106 (reprinted, with some changes, as chap. 16 of Chisholm's *On Metaphysics* [Minneapolis: University of Minnesota Press, 1989]).

5. The thesis that every state is the exemplification of a property by something (and that there are, consequently, no "subject-less" events) is left implicit in "Events without Times." It is clearly presupposed, however, by principles A4 and A5 in "Substances, States, Processes, and Events."

6. Both these suggestions are mentioned by Jaegwon Kim, "Events as Property Exemplifications," in *Action Theory,* ed. M. Brand and D. Walton (Dordrecht: D. Reidel, 1976), pp. 159–77, esp. pp. 162–63.

7. Jonathan Bennett, in *Events and Their Names* (Indianapolis: Hackett Publishing Co., 1988), marshalls unimpeachable evidence for the claim that the events of Kim and Chisholm are, by and large, too finely individuated to serve as the things referred to by means of perfect nominals (for example, "Quisling's betrayal of Norway") (chap. 1). Kim- and Chisholm-style events are better suited to be the kinds of things referred to by imperfect nominals ("Quisling's betraying Norway") and "that"-clauses (". . . that Quisling betrayed Norway . . .")—what Bennett appropriately calls "facts" (chap. 2). However, he also develops a quite satisfactory means of finding, for any (coarse-grained) perfect nominal event name, a corresponding fact; so that it can *almost* be said that "events are facts of a special kind, named in a special way" (p. 130). Bennett's reservations about this conclusion do not seem to be strong enough, in his own estimation, to force recognition of events as a special ontological category over-and-above that of facts (see pp. 12–20). And the most serious problem he raises for identifying events with facts may, I believe, be easily overcome (see pp. 136–37). In essence, Bennett's work shows that, although there are grounds for the familiar complaint

that Kim- and Chisholm-style criteria for event identity are too fine-grained, the complaint cuts no metaphysical ice.

8. Chisholm, "On the Positive and Negative States of Things," p. 99, n. 6.

9. For one thing, Chisholm's informal presentation of his reduction (in "The Basic Ontological Categories," pp. 11–12) is inconsistent with the actual definitions he gives (which are essentially the same in "The Basic Ontological Categories" and "Events without Times," p. 420). The relation *taller-than,* for example, that holds between John and Mary is said to be a property exemplified by each of the many "ordered properties" which order John-to-Mary ("The Basic Ontological Categories," p. 11). But, according to his official definitions, relations *are* ordered properties. And it is easy to show that *taller-than,* being a property of many ordered properties, cannot itself be an ordered property— since ordered properties are supposed to be exemplified by only two things. Although it should not prove too difficult to bring the definitions into line with the intuitive motivation for his reduction, there will, I believe, remain serious questions about the adequacy of the theory. Here is one worry: Chisholm's reduction, like that of ordered pairs to sets on which it is modeled, may be carried out in ever-so-many equally convenient—but incompatible—ways. If Paul Benacerraf's multiple-reducibility objection has any force against reductions of arithmetic to set-theory, then a similar objection would raise problems for Chisholm's reduction of relations. See Benacerraf, "What Numbers Could Not Be," *Philosophical Review* 74 (1965): 47–73.

10. Kim accepts this appellation for his events ("Events as Property Exemplifications," p. 160). However, my definition of "structured complexes," (D1), is not satisfied by his events. See note 14, below.

11. See Russell, "The Philosophy of Logical Atomism," in *Logic and Knowledge.* Russell sometimes calls his facts "complexes" or "complex unities"; see, for example, Russell, *The Problems of Philosophy* (Oxford: Oxford University Press, 1912), pp. 127–30.

12. See Burks, "Ontological Categories and Language," *Visva-Bharati Journal of Philosophy* 3 (1967): 25–46; see esp. pp. 38–39.

13. See Armstrong, *Universals: An Opinionated Introduction* (Boulder, Colorado: Westview Press, 1989), pp. 88–93.

14. In "Causation, Nomic Subsumption, and the Concept of Event" (*Journal of Philosophy* 70 [1973]: 217–36), Jaegwon Kim says that, if an event is constituted by substrate x, content P, and constitutive time t, then the event "exists only if x has P at t" (p. 223). Reading the "only if" as more than simply material implication would put Kim's events into the category of structured complexes defined in (D1). In "Events as Property Exemplifications," however, Kim expresses reservations about whether an event necessarily has the content it does (p. 172); and he seems fairly sure that events do not have their constitutive times essentially (pp. 172–73). These qualifications would take his events out of the category of structured complexes as here defined—although they would, of course, still be a kind of structured complex. Kim also suggests an alternative way of developing a theory of events which construes them not as structured complexes of any sort, but as ordered sets (see "Events as Property Exemplifications," pp. 160–61).

15. See Kim, "Causation, Nomic Subsumption, and the Concept of Event," pp. 217–36. Chisholmian conditions for the subsumption of two events under a law would be somewhat complicated by his insistence upon the use of tensed

language, and his rejection of variables or names for times; but the model conditions for nomic subsumption formulated by Kim (pp. 226–36) admit of translation into fairly straightforward tensed versions.

16. See David Lewis, "Events," in his *Philosophical Papers,* vol. 2 (Oxford: Oxford University Press, 1986), pp. 241–69. See also Bennett, *Events and Their Names,* pp. 64–65; Jaegwon Kim, "Causes and Counterfactuals," *Journal of Philosophy* 70 (1973): pp. 570–72; and Kim, "Noncausal Connections," *Noûs* 8 (1974): 41–52.

17. David Lewis tries to give us some idea in "Events." Jonathan Bennett remains unsatisfied by the picture that emerges (see Bennett, *Events and Their Names,* pp. 58–72).

18. For criticisms of a series of versions of the counterfactual analysis, see Jaegwon Kim, "Causes and Counterfactuals"; Bernard Berofsky, "The Counterfactual Analysis of Causation" (abstract), *Journal of Philosophy* 70 (1973): 568–69; Alexander Rosenberg, "Causation and Counterfactuals: Lewis' Treatment Reconsidered," *Dialogue* 18 (1979): 209–19; Martin Bunzl, "Causal Preemption and Counterfactuals," *Philosophical Studies* 37 (1980): 115–24; Wayne A. Davis, "Swain's Counterfactual Analysis of Causation," *Philosophical Studies* 38 (1980): 169–76; Cindy D. Stern, "Lewis' Counterfactual Analysis of Causation," *Synthese* 48 (1981): 333–45; Marjorie S. Price, "Causal Preemption and Counterfactually Necessary Chains," *Southern Journal of Philosophy* 20 (1982): 225–32; Jig-Chuen Lee, "Causal Condition, Causal Asymmetry, and the Counterfactual Analysis of Causation," *Synthese* 67 (1986): 213–23; and Douglas Ehring, "Preemption and Probabilistic Counterfactual Theory," *Philosophical Studies* 56 (1989): 307–13. See also the discussion in Charles B. Cross, "Counterfactuals and Event Causation," *Australasian Journal of Philosophy* 70 (1992): 307–23.

19. Chisholm, "On the Positive and Negative States of Things," p. 98.

20. See Anil Gupta, "Minimalism," in *Philosophical Perspectives Vol. 7: Philosophy of Language,* ed. James Tomberlin (Atascadero, Calif.: Ridgeview, 1993); Gupta, "A Critique of Deflationism," forthcoming; and Marian David, *Correspondence and Disquotation: An Essay on the Nature of Truth* (Oxford: Oxford University Press, 1994).

21. Bertrand Russell, "The Philosophy of Logical Atomism," *Logic and Knowledge,* pp. 191–92.

22. The first two expressions are introduced by John Cook Wilson and G. F. Stout, respectively. Donald C. Williams is responsible for the last two. See Cook Wilson, *Statement and Inference,* vol. 2, ed. A. S. L. Farquharson (Oxford: Clarendon Press, 1926), p. 713; Stout, "The Nature of Universals and Propositions," *Proceedings of the British Academy* 10 (1921–22): 157–72; and Williams, "On the Elements of Being: I and II," *Review of Metaphysics* 7 (1953): 3–18 and 171–92.

23. See Kevin Mulligan, Peter Simons, and Barry Smith, "Truth-Makers," *Philosophy and Phenomenological Research* 44 (1984): 287–321; see esp. pp. 290–93.

24. The first two examples are from Mulligan, et al., "Truth-Makers," pp. 314–15. The authors do not seem entirely satisfied with their own proposed truth-makers for these negative statements (see the conclusion of the paper, p. 318, which seems merely to express the confidence that problems about negative

statements will be overcome somehow). At any rate the tentative suggestions they make (pp. 314–15) can, I believe, be shown to be inadequate. The more complex truth-maker program set forth recently by Peter Simons introduces more structure in the realm of truth-makers (in the form of relations of dependence). But his truth-makers are still not structured complexes in the sense of (D1), and there is still no obvious way in which the recalcitrant negative statements could be made true by his candidate truth-makers. See Simons, "Putting the World Back into Semantics," *Grazer Philosophische Studien* 44 (1993) (this volume was also published as *Relativism and Contextualism: Essays in Honor of Henri Lauener,* ed. Alex Burri and Jürg Freudiger [Amsterdam: Rodopi, 1993]), pp. 91–109.

25. See Russell, "The Philosophy of Logical Atomism," pp. 235–36. I disagree, then, with Michael Pendlebury and Mulligan et al., who see no need for general facts as long as, for every "*a*" that names a raven, "*a* is black" is made true by something. See Pendlebury, "Facts as Truthmakers," *Monist* 69 (1986): 177–88, esp. 181; and Mulligan et al., "Truth-Makers," p. 316.

26. See, for example, Keith Devlin, *Logic and Information* (Cambridge: Cambridge University Press, 1991); Michael Pendlebury, "Facts as Truth-makers"; Barry Taylor, *Modes of Occurrence* (Oxford: Basil Blackwell, 1985); Jon Barwise and John Perry, *Situations and Attitudes* (Cambridge, Mass.: MIT Press, 1983); N. L. Wilson, "Notes on the Form of Certain Elementary Facts," *Fact, Value, and Perception: Essays in Honor of Charles A. Baylis,* ed. Paul Welsh (Durham, N.C.: Duke University Press, 1975), pp. 43–51; Romane L. Clark, "Facts, Fact-Correlates, and Fact-Surrogates," in *Fact, Value, and Perception,* pp. 3–17; and Bas C. van Fraassen, "Facts and Tautological Entailments," *Journal of Philosophy* 66 (1969): 477–87.

27. See Donald Davidson, "Eternal vs. Ephemeral Events," reprinted in his *Essays on Actions and Events* (Oxford: Clarendon Press, 1980), p. 197; and Kim, "Events as Property Exemplifications," pp. 172–73.

28. A rough idea of what I mean by "content" may be suggested by this condition: two beliefs have the same content if they could be expressed by utterances of the same sentence, with each word being used in the same sense and with all indexicals and proper names referring to the same things.

29. Kim, "Events as Property Exemplifications," p. 172.

30. Donald Davidson, "Eternal vs. Ephemeral Events," p. 197.

31. Bennett, *Events and Their Names,* pp. 56–58.

32. The theme becomes prominent only after the publication of *Person and Object.* In a response to criticisms of that book, Chisholm writes: "I have come to realize the importance of distinctions of tense and to reject the philosophical dogma according to which such distinctions are illusory. I had seen this point when I wrote *Person and Object,* but was not then fully aware of its ramifications" ("Objects and Persons: Revision and Replies," p. 318). Since this publication, Chisholm has frequently emphasized the philosophical importance of utilizing a tensed language.

33. See Saint Augustine, *Confessions,* trans. Henry Chadwick (Oxford: Oxford University Press, 1991), bk. 11, sec. 14, esp. p. 231; Franz Brentano, *Psychology from an Empirical Standpoint,* ed. Oskar Kraus, English edition ed. Linda L. McAlister, trans. Antos C. Rancurello, D. B. Terrell, and Linda L. McAlister (New York: Humanities Press, 1973), p. 364; and A. N. Prior,

"Changes in Events and Changes in Things," in his *Papers on Time and Tense* (Oxford: Clarendon Press, 1968), pp. 1–14, and "The Notion of the Present," *Studium Generale* 23 (1970): 245–48.

34. Chisholm, "Referring to Things that No Longer Exist," *Philosophical Perspectives* 4 (Action Theory and Philosophy of Mind) (1990), 545–56; the quoted phrase is on p. 550.

35. James L. Plecha suggests this possibility in "Tenselessness and the Absolute Present," *Philosophy* 54 (1984): 529–34.

36. See also Prior, *Papers on Time and Tense*, p. 123.

37. See "Events as Property Exemplifications," p. 160.

38. See Kim, "Events as Property Exemplifications," p. 161; and Chisholm, "Events without Times," pp. 417 and 423–24. Kim might very well allow that there could be some more comprehensive state, involving both of the times when *x* was or is *F*, that would serve as a sort of fusion of the two events. But still, on his view, the event that exists now is distinct from the one that existed yesterday, whether or not they may both be in some fashion "parts" of a single larger event.

39. Chisholm distinguishes between epistemological and ontological problems of individuation in "Individuation: Some Thomistic Questions and Answers," *Grazer Philosophische Studien* 1 (1975): 25–41. For another discussion of the individuation of Chisholmian states, see Johannes Brandl's contribution to this volume.

40. The essential properties in an individual essence could include "impure properties" like *having a as a substrate,* "properties" that are really relations to other things. For the purposes of solving a problem of ontological individuation, however, relations to other particular *states* could not be allowed into the individual essence of *every* state. Someone who linked the individuation of different events together in this way would be forever putting off her answer to the question, "What makes each state the state that it is, and not some other?"

41. Robert Merrihew Adams, "Primitive Thisness and Primitive Identity," *Journal of Philosophy* 76 (1979): 5–26.

42. See Chisholm, "Possibility without Haecceity" in *Midwest Studies in Philosophy,* vol. 11, *Studies in Essentialism,* ed. Peter A. French, Theodore E. Uehling, Jr., and Howard K. Wettstein (Minneapolis: University of Minnesota Press, 1986), pp. 157–63.

43. Johannes Brandl, in his contribution to this volume, cites an unpublished manuscript in which Chisholm says that states may differ with respect to their substrate, their content, and their contemporaries (i.e., the types of states with which a state coexists). Brandl goes on to suggest that, since the content and substrate of an event cannot solve the ontological problem of individuation for events, Chisholm must be relying on the contemporaries to do this job. Such a solution would amount to the introduction of an abstract "time-property" into an event essence, which I discuss below. Perhaps Chisholm is now attracted to this proposal. However, his position on event individuation in "Events without Times" and the forthcoming "Substance, States, Processes, and Events" is clearly that there need be no answer to some questions of event individuation. Events do not have individual essences; and distinct events with the same substrate and content have all the same essential properties.

44. Chisholm does say that, if we ask, of some event that is going on now, whether it "is possibly such that it does not exist but will or did exist?" we should

answer, "No" (p. 423). But this negative answer does not mean that the event could not have stood in different temporal relations with other events (his example in the previous paragraph implies that such switching around is possible). The negative answer follows from Chisholm's understanding of the phrase "is necessarily F," which he takes to be equivalent to "is necessarily such that it exists if and only if it is F" (see *On Metaphysics*, p. 163). On this reading, everything "exists necessarily," since "everything is necessarily such that it exists if and only if it exists"—although, in another sense, there are plenty of non-necessary things, things that need not have come into being and which could also pass away.

45. For a closely related use of the term "existentialism," see Chisholm, "Identity through Possible Worlds: Some Questions," reprinted in *The Possible and the Actual,* ed. Michael J. Loux (Ithaca, N.Y.: Cornell University Press, 1979), pp. 80–87. Chisholm seems to favor a version of existentialism with respect to people, too (see his "Possibility without Haecceity").

46. The possibility of a difference in facts about which events are which, without any other differences, violates restrictions some philosophers have imposed upon the "intrinsic grounding of transworld identities." See, for example, Graeme Forbes, *The Metaphysics of Modality* (Oxford: Clarendon Press, 1985), chaps. 5 and 6.

47. This antiexistentialist principle asserts a kind of dependence between different realms: which events occur is fixed or determined by which substrates exist and what properties they exemplify. For this reason, Lombard calls his antiexistentialism about events, "event supervenience" (see Lawrence Brian Lombard, *Events: A Metaphysical Study* [London: Routledge and Kegan Paul, 1986], chap. 8, "The Supervenience of Events"). Jonathan Bennett also maintains that "events are supervenient entities," by which he means that "all the truths about them are logically entailed by and *explained* or *made true* by truths that do not involve the event concept" (Bennett, *Events and their Names,* p. 12).

48. Lombard says that, "if one has in mind a certain picture of how events fit into the ontological scheme of things," then the sort of antiexistentialist view I am suggesting will seem "very natural" (chap. 1, p. 217). Lombard's admittedly "impressionistic, suggestive, and speculative" case for "the supervenience of events" is, I expect, the best one can do by way of an argument for the antiexistentialist principle above (see *Events,* chap. 8).

49. Lombard, *Events,* pp. 220–22. (Lombard's views about what properties can serve as the content of an event are more restrictive than Kim's; but their views are similar in every respect that matters for present purposes.)

50. See A. N. Prior, *Past, Present, and Future* chap. 5.

51. Brandl makes a related point when he says that, if the history of the universe were to repeat itself, there would be events with the same substrates, contents, *and contemporaries.* See Brandl, this volume.

52. See A. N. Prior, *Past, Present, and Future,* chap. 5.

53. Prior himself resists a realist construal of his quantification over world-states; see "Changes in Events and Changes in Things."

54. See "Objects and Persons," pp. 357–59.

55. Prior, *Past, Present, and Future,* p. 84.

56. For a good discussion of the darkness surrounding event essences, see Bennett, *Events and Their Names,* chap. 4.

57. Chisholm, *Person and Object,* p. 133.

58. I neglect the possibility of backward causation, although the strategy sketched below could easily be made to countenance it.

59. The exceptions are these: (1) simultaneous causation; and (2) a case in which the effect state e which *will be* caused in one second, say, by a presently existing event c happens to also exist now, even though it is not *now* being caused by c relative to a time interval of zero (of course it could *have been* caused by c relative to an interval of one second, but that is quite compatible with c's not *now* being the "simultaneous cause" of e).

60. See Chisholm, "Referring to Things that No Longer Exist," pp. 553–55.

61. Augustine, *Confessions,* p. 232.

62. Chisholm, "On the Positive and Negative States of Things," p. 100.

63. Prior, *Past, Present, and Future,* p. 106.

64. See Prior, *Past, Present, and Future,* pp. 106–12; and *Papers on Time and Tense,* p. 164.

65. I thank Johannes Brandl, Andrew Cortens, Marian David, Anthony Everett, Al Howsepian, Larry Lombard, Trenton Merricks, Alvin Plantinga, Phil Quinn, Mike Rea, Leopold Stubenberg, and Paul Weithman for reading a draft of this paper. Their criticisms and suggestions led to significant improvements, although I am sure they could still find problems with the final version. Special thanks are due to David, Plantinga, and Cortens for some long discussions about the nature of "truth-making." I have also benefited from unpublished material furnished by Roderick Chisholm and Johannes Brandl. Research for this paper was supported by a grant from the Pew Evangelical Scholars Program.

REPLY TO DEAN W. ZIMMERMAN

My reply to Zimmerman's challenging criticisms will be restricted to the following topics: (A) essences; (B) a supposed dilemma for my theory of events; (C) the difficulties involved in the concept of *a "time"*; (D) the question whether events have their temporal positions necessarily; (E) existence as nonintermittent; and (F) the question whether "we could have had it all before."

(A) Zimmerman's paper is entitled "Chisholm and the Essences of Events." In order to do justice to his critique, I would note that the technical term "essence" may lead to misunderstandings. I understand the technical philosophical term *"essence"* in the following way and I assume that Zimmerman has been taking it pretty much in the same way:

D1 P is an essence =Df. P is necessarily such that: (1) it can be exemplified; (2) whatever exemplifies it exemplifies it necessarily; and (3) if it is ever such that it can be exemplified by a given thing x, then it is never such that it can be exemplified by anything other than x.

I shall avoid the technical term "haecceity," even though it is now often used in the present sense of the word "essence."

So far as I have been able to see, the two types of things that we can know to be such that each thing of that type has its own essence known to be such that each of its members has its own essence are (1) *abstracta* and (2) *states* (and hence also *events*). Numbers provide us with one type of example, properties with another. Thus the property of *being green* has the following property necessarily: being such that it is exemplified by all and only those things that are green; and this property is repugnant to everything else. It is the essence of the property of being green.

And why do I say that, on my theory, *states* have essences? The state "x-being-F" has its *content* (the property of being-F) necessarily and it

also has its *substrate* (the individual x) necessarily. I have noted that everything has its *categorial* properties necessarily (states are necessarily such that they *are* states, individuals are necessarily such that they *are* individuals; and so forth).

Zimmerman, if I understand him correctly, suggests that *some* individuals have essences. But he doesn't tell us *which* individuals may have essences and, more important, he doesn't say *why* he thinks that some individuals may have essences. The difficulties with this assumption may be put as follows.

I have said, in effect, that your essence, if you have one, is a property that is (i) essential to you and (ii) "repugnant to all other things"; nothing but you could possibly have it. Hence *being rational,* although it is one of your essential properties, is not your essence. *Other* people can be rational, too.

Suppose that Socrates had one essence and that Plato had another. What can we say about the difference between the two essences—*other than* that one is essential to Socrates and repugnant to Plato, and the other the other way around? Either the essence of Socrates ("Socrateity," let us say) is a simple property or it is a compound (conjunction) of many properties. If it is a simple property, then how are you and I able to say what distinguishes it from Platonicity, or the essence of Plato? And if the essences are complex, then one would think that we could find at least one property that only Socrates has necessarily. But what could it be?

Or could the essence of Socrates be a conjunction of properties that are not unique to Socrates? Properties that are not unique to one thing, we can, of course, use to form a conjunction of properties such that the conjunction *is* unique to one thing. But can we form a conjunction which will satisfy condition (3) of the above definition—the condition saying that if there is one thing that has the essence in question, then no other thing can possibly have it? No one has yet suggested a way of doing this.

(B) Zimmerman proposes the following as a dilemma for my theory:

> Here is a dilemma for Chisholm's theory of events. The only essential properties of events which we can feel at all comfortable about are those he mentions; but they are not sufficient to rule out the strange kind of event existentialism we have described. It would be nice to go no further than Chisholm does while respecting the above antiexistentialistic principle. Is there a way to do both at once?

But what is so bad about "event existentialism"? If I interpret Zimmerman's technical term correctly, then, I would say, that the doctrine follows from principles that are entirely reasonable.

And this is just as well, since Lombard's theory, which Zimmerman offers me as an alternative, has yet to be worked out. Zimmerman writes:

> Chisholm would have a hard time following Lombard here, however, given his views about "times." Lombard's "times" might be taken to be either (1) individual things of a peculiar sort (a slice of substantial space-time, say), (2) sets or groups of simultaneously existing states, or (3) some kind of abstract object that can serve to represent a moment of time.

I agree with Zimmerman's statement: "Chisholm would have a hard time following Lombard here."

(C) Zimmerman suggests that, since I believe that the concept of *a time* involves certain difficulties, I should say what the difficulties are. Here are some of them.

For those who think that there are such entities as *times,* one puzzling question is whether *times* have essential properties and, *if* they do, whether you and I have any way of finding out what they are. A closely related question is whether times come into being or pass away. Does that time which is 25 April 1872, 10:30 A.M., Atlantic Coast Time still exist? If it does still exist, then why can't we be said to exist *at* that time? Or is there something *more* to existing *at* a time than *coexisting with* that time? It would hardly do to say: "There are only certain times *at* which a thing is *at* any given time." But if the time we have been discussing (April 25, etc.) *did exist* but *no longer* exists, what are we to say of that event which is the *ceasing to be* of the time in question? If we are trying to construct a theory of events, we would need a *very* good reason before we commit ourselves to the existence of events of *that* kind. But I cannot imagine what such a reason would be.

I trust that these remarks will suggest some of the difficulties that the concept of *"a time"* involves.

(D) Do events have their temporal positions necessarily? Is the place of each event in the temporal order of things *necessary* to that event? For example, are the things that happened last Sunday necessarily such that they are separated by two days from the things that happened last Wednesday? I cannot think of a good reason for answering this question affirmatively. And so I would also say that I cannot think of any good reason for supposing that events have their times necessarily.

(E)* Zimmerman affirms that there are problems with "intermittent existence," and on this point I agree but over and beyond this, I want to

*The transcript of the original first few lines of this section was not clear and has been modified to fit what we know about Zimmerman's and Chisholm's views, but it seems clear that they agree that there are problems with the notion of "intermittent existence." Chisholm, however, goes beyond this in his own position. L.E.H.

say that *nothing whatever* can have intermittent existence. In holding this position I follow Locke's principle according to which "nothing can have two beginnings of existence." The principle can be understood by reference to the property of *ceasing to be,* as I have conceived that property. To say that a thing is ceasing to be is to say that there is no property which is internal to that thing and which is such that the thing *is going to have* that property. The needed definitions are these:

D2 P is internal to events =Df. P is necessarily such that (i) only events have it and (ii) if it implies a property Q that events can have, then whatever has P has Q.

(Here we use "P implies Q" to abbreviate "If P is exemplified then Q is exemplified.")

D3 x is an event that is ceasing to be =Df. (1) x is an event; and (2) there is no internal property of events which is going to be exemplified by x.

The reason for restricting our account to properties that are *internal* to events is to provide ourselves the possibility of saying, with respect to things that have ceased to be, that those things still have such converse intentional properties as being remembered and being admired.

It will follow that nothing enjoys any intermittent periods of nonexistence.

(F) "Could we have had it all before?" The question may be taken in two ways. First, it may be taken literally to refer to *us*—to you and Zimmerman and me. Could *we* have had it all before? The literal question is answered by the doctrine according to which nothing can have two beginnings of existence.

The second sense of "We could have had it all before" is suggested by what Zimmerman calls the doctrine that "history is cyclical," when this doctrine is so understood that it does not imply the literal doctrine about *us.* The following may suggest how the weaker doctrine should be taken. A book on the history of the world which covered all the details but which was otherwise as brief as possible would consist of three parts: (i) a very long chapter describing all the details of one of the cycles; (ii) then a statement to the effect that the previous chapter should be preceded; followed by (iii) an infinite number of chapters just like it. And so we should ask: What *reason* is there for thinking that history is of *that* sort?

How could we reply to a philosopher who said: "*Prove* to me that history isn't thus cyclical?" Pretty much the same thing that we would say to a philosopher who challenged us by saying: "*Prove* to me that there will be exactly twenty-seven more cycles, no more and no less."

I have profited greatly by Zimmerman's criticisms. As a result of what he has pointed out, what I say henceforth about events will be a considerable improvement over what I have said about them before.

I trust that these remarks will suggest some of the difficulties that the concept of *"a time"* involves.

R.M.C.

4

William P. Alston

CHISHOLM ON THE EPISTEMOLOGY OF PERCEPTION

I

Perception and the epistemology of perception have been prominent themes in Chisholm's thought since the beginning of his career. "The Problem of Empiricism" (1948) is the classic critique of a phenomenalist interpretation of statements about physical objects, and it also contains the first statement of Chisholm's view that perceptual beliefs are prima facie credible without further support. "The Theory of Appearing" (1950) has been thought by many (mistakenly, I believe) to give the coup de grace to that account of sensory experience. His first book was entitled *Perceiving: A Philosophical Study* (1957). He has addressed himself repeatedly to the task of developing an epistemology of perceptual belief—in the three successive editions of *Theory of Knowledge* (1966, 1977, 1989), and in numerous essays, some of which will be tapped for this discussion.

As with other topics, Chisholm has been given to frequently modifying his formulations, often in minor ways. This creates problems for an enterprise like this; short of an exhaustive intellectual biography, for which the editor would certainly not allot the space, one is forced to pick one's target from a variety of options. I shall concentrate on recent formulations: "A Version of Foundationalism" (1980), reprinted with revisions in 1982 (I will be using the later version), and *Theory of Knowledge,* 3d ed. (1989). Earlier formulations will come in only incidentally.

The general aim of Chisholm's epistemology of perception is to bring out how it is that perception (or perceptual experience) is a source of justified belief and of knowledge. Since he is firmly wedded to some form of a true justified belief conception of knowledge, the focus is on principles of justification of perceptual beliefs, principles that spell out

the conditions under which such beliefs are justified. One of Chisholm's major contributions to philosophy is the provision of a scheme for distinguishing different grades of the justification, or positive epistemic status, of beliefs. I will not have time to go into that, but I will give brief explanations of his terms for different degrees of justification as we go along.

I have already pointed out Chisholm's determined opposition to phenomenalism. This implies that he rejects any attempt to cut the epistemological Gordian knot (of how to get from sense experience to knowledge about the physical environment) by reducing beliefs about the latter to complex, largely conditional, beliefs about the former. He is uncompromisingly realistic in his construal of perceptual beliefs and, more generally, of talk about the physical world.

II

Just how perception provides justification for beliefs about the environment depends, of course, on what perception is. Thus Chisholm generally prefaces his account of the justification of perceptual beliefs with some indication of the nature of perception. There is a fairly detailed treatment in *Perceiving* (1957), but the topic receives much more summary treatment in subsequent writings; and it is not always clear how these are related to the views set forth in 1957. Chisholm's characteristically terse style creates problems for the exegete. The serious Chisholmian must often wish that the master had concentrated on a single full-dress development of a topic, rather than a long series of slightly different brief presentations of his epistemological position.

The fullest formulation Chisholm has given of his epistemology of perception in the last fifteen years is found in "A Version of Foundationalism" (1982). The later versions in 1988 and 1989 differ from this somewhat, but mostly only in minor ways. I will concentrate my attention on the 1982 formulation.

We encounter one difference right at the outset. There would seem to be a direct contradiction between the versions of 1982 and 1989 concerning the construal of "object perception," what it is to perceive a certain object—a tree, a house, a cow. In 1982 we find the following definition.

> (II) x perceives y = Df. There is a property such that x perceptually takes y to have it. (20)

We will get an explicit definition of "perceptually taking" later, but for now it is sufficient to realize that it is a kind of belief or judgment. To take y to be F is to believe or judge that y is F. Indeed, on the previous page Chisholm had written "If I perceive a thing, then I judge that just one thing is appearing to me in a certain way" (19). But in 1989 Chisholm writes,

> Sometimes perceptual verbs take a very simple object, as in, "He sees a cat," and "She hears a dog." This first use has no implications about what the perceiver believes. (39–40)

Here we have the echoes of a prominent contemporary controversy concerning the perception of objects—whether it essentially involves believing, judging, or "taking" the object to be so-and-so, whether it involves the application of concepts to the object.[1] Those who take the negative position on this need not deny that normal adult perception of objects is heavily laced with conceptualization and judgment. The only issue is as to whether the perceptual presentation of an object *consists in* or *essentially involves* conceptualization and/or judgment. And Chisholm would appear to stand squarely on both sides of this issue.

Interestingly enough, however, this makes little or no difference to his epistemology of perceptual belief. For whatever the role of conceptualization and judgment in perception, Chisholm is always insistent that they are not the whole story and that perception also essentially involves what he calls "appearing" or "being appeared to." The roots of this concept are to be found in ordinary ways of talking about how things look, sound, smell, etc. to us. How things "sensorily appear" is just a more general way of pointing to the same phenomenon. Chisholm's favored account of this aspect of perception is an "adverbial" one. Since he wants to be able to talk about sensory appearances without implying that there is something external that is appearing in that way (in order to handle hallucinations and the like), and since he has objections to the sense datum way of accomplishing this, he proposes that we think of sensory appearances in terms of *ways* of being conscious. When we want to restrict our commitments to the sensory experience itself, we will say not "The house looks brown," but "I am being visually appeared to brown-housely."

On numerous occasions Chisholm argues that an adequate account of sensory experience will have to deal with appearances in what he calls a "noncomparative" sense. When I say "I am being appeared to *redly*" in this sense, I am not comparing my experience with other experiences ("I am being appeared to in the way in which I typically am when looking at a ripe tomato"), nor am I characterizing the experience in terms of its

typical causes ("I am being appeared to in a way that results when I am looking at a red object in normal circumstances"). Rather I am reporting the *intrinsic character* of the experience, the qualitative distinctiveness of it, a distinctiveness that, on Chisholm's "adverbial" view, resides in the *way* I am sensing, rather than in any (internal) *object* I am aware of, as the sense-datum theory would have it.

Though I wholeheartedly agree with Chisholm on the existence and importance of the "noncomparative" sense of appearing terms, I am not at all disposed to go along with his adverbial way of construing such appearances. Nor do I accept the sense-datum view. I prefer the "theory of appearing," according to which sensory experience always involves something (usually but not invariably something external) appearing to one in a certain way. However, this is not the time to fight that battle. To avoid getting distracted from the epistemology of perceptual belief, I will go along with Chisholm's adverbial construal of the intrinsic character of sensory appearances.

I now return to my point that it doesn't really matter for the epistemology of perceptual belief whether or not the perception of objects essentially involves judgment. Whatever our decision on that point, the epistemological problem involves perceptual *beliefs*—that is, something in the territory of judgment and the application of concepts. And, as Chisholm repeatedly says, what makes a belief a *perceptual* belief is the way it is related to appearing. Thus, when we are discussing epistemological issues in this area, we are confronted both with beliefs and with appearing, and it doesn't matter whether perceiving an object essentially involves the former or not.

Chisholm's first venture into the delineation of conditions under which a perceptual belief will have a certain epistemic status is a very modest one. The belief in question is not that there is something external that has a certain property, much less that a particular external object has a certain property (we will come to these later), but only that there is something (external) that is appearing to one in a certain way. The principle in question runs as follows.

> P4 For every x, if there is a way of appearing such that (i) it is self-presenting and (ii) x is appeared to in that way, then the following is evident for x provided it is epistemically in the clear for him and something that he considers: there is something that is appearing that way to him. (1982, p. 18)

This calls for some explanations of terms. The intuitive idea of a "self-presenting" state is that of a state of a person that "presents itself" to the person, cognitively. This is cashed out by Chisholm in different ways in different publications. In 1982 it is explained as follows.

> The mark of a self-presenting property is this: every property it entails is necessarily such that, if a person has it and also considers whether he has it, then *ipso facto* he will attribute it to himself. (10)

(Remember that every property entails itself.) This definition is rather modest. It does not make it true by definition that a self-presenting property is such that its possessors will *know* that he has it if he does and if he considers whether he does. But Chisholm does commit himself to that in one of his epistemic principles (P1, p. 12). Any state of being appeared to, in the "noncomparative," intrinsic character sense, is taken by Chisholm to be self-presenting.

Chisholm defines the various degrees of positive epistemic status in terms of a single undefined comparative property, sometimes "more reasonable than" (as in 1982), sometimes "at least as justified as" (1988), and sometimes "more justified than" (1989). These properties apply to doxastic attitudes. Thinking in terms of these as attitudes to propositions, they are (1) *accepting* a proposition, (2) *rejecting* a proposition, and (3) *withholding* a proposition. The last amounts to neither accepting nor rejecting the proposition. The epistemic statuses we will be concerned with here can be defined as follows (in application to propositions).

> p has some presumption in its favor for S (subject) =Df. Accepting p is more reasonable than rejecting p.
> p is beyond reasonable doubt for S =Df. Accepting p is more reasonable for S than withholding p.
> p is evident for S =Df. p is beyond reasonable doubt for S and is one of those propositions on which it is reasonable for S to base S's decisions.
> p is certain for S =Df. p is beyond reasonable doubt for S and accepting p is at least as reasonable for S as is the acceptance of any other proposition. (1982, pp. 8–9)

Being evident is the epistemic status Chisholm takes to be required for knowledge.

Note that what we have here are degrees of what is often called "propositional justification" rather than "doxastic justification." That is, in saying that it is beyond reasonable doubt (evident, certain . . .) for S that p, we are not implying that S believes (accepts) that p and ascribing a certain status to that belief. Rather we are saying that S is so related to the proposition that p that if he were to believe it, his belief would have an appropriate positive epistemic status.

Finally a proposition, p, is epistemically in the clear for S provided S believes it and it is not disconfirmed by the set of propositions other than p that have some presumption in their favor for S. In other words a proposition is epistemically in the clear if the subject lacks sufficient reason for supposing it to be false.[2]

So what P4 amounts to is the claim that whenever I am appeared to in a certain way (I sense redly) it is evident to me that there is something (external) that is looking red to me, provided I don't have sufficient reason for believing this is false. Sensory appearances provide a prima facie presumption that something external is currently appearing that way. We don't need further positive reasons for supposing this is the case. The burden of proof is on the negative. I am fully justified in believing it unless I have strong enough reasons against it.

How do we get beyond this modest claim to a positive epistemic status of more full-blooded perceptual beliefs, for example, that this is a tree? Chisholm's route goes through the concept of "perceptual taking."

> (III) The property of being F is such that x perceptually takes there to be something that has it =Df. The property of being F is a sensible property such that x is appeared to in such a way that he directly attributes to himself the property of being appeared to in that way by something that is F. (1982, p. 20)

Chisholm adds, "The definiendum may also be read as "x perceptually takes there to be something that is F."

Note that this concept is restricted to "sensible properties." Chisholm explains the term in this way.

> What is intended by the expression "sensible property" may be suggested by the following list: such visual properties as blue, green, yellow . . . such auditory properties as sounding or making a noise; such somesthetic properties as rough, smooth, hard, soft . . . such gustatory properties as sweet, sour. . . . Sensible properties would also include such "common sensibles" as movement, rest, number, figure, and magnitude. And we may understand "sensible property" sufficiently broadly so that relations of resemblance and difference among sensible properties may also be counted as sensible properties. (1982, p. 19)

This is a familiar category, though it is not at all clear how a general definition should be constructed. It has often been held that it is only sensible properties that one can get direct, noninferential knowledge of by perception.

The definition (III) reflects Chisholm's later view that all judgment is egocentric. One "directly" attributes properties to oneself, and "indirectly" attributes properties to other things by way of some relation to them that one attributes to oneself. In the case of perception the relation in question is that of something's *appearing* to one in a certain way. In order to streamline my discussion I will ignore this feature of Chisholm's exposition whenever possible, translating his talk into terms of subjects'

attitudes to propositions. Thus where Chisholm speaks of indirectly attributing a property to a perceived object I will speak of accepting the proposition that that object has that property.[3] Indeed, we have to look no further than 1989 to find a definition of perceptual taking in terms of propositions.

> *S takes* there to be an F =Df. (1) S is appeared ———— to; (2) it is evident to S that he is appeared ———— to; and (3) S believes that there is only one thing that appears ———— to him and that that thing is F. (1989, p. 41)[4]

As with P4, Chisholm proceeds by supposing the belief involved in perceptual taking to be prima facie credible just by "being there," needing only the absence of sufficient overriding considerations to be "beyond reasonable doubt."

> P5 For every x, if (i) x perceptually takes there to be something that is F, and if (ii) his perceiving an F is epistemically in the clear for x, then it is beyond reasonable doubt for x that he perceives something that is F. If, moreover, his perceiving something that is F is a member of a set of properties, which mutually support each other and each of which is beyond reasonable doubt for x, then it is evident for x that he perceives something that is F. (1982, p. 21)

Note that this principle provides for two different degrees of positive epistemic status. The higher (being evident) presupposes the former and is attained by way of "mutual support." The concept of mutual support is explained as follows. (Here I take the simpler definition of what is called "concurrence" in 1989.)

> D4 A is a set of propositions are *concurrent* for S =Df. A is a set of three or more propositions each of which is made probable for S by the conjunction of the others. (1989, p. 71)

Mutual support introduces a coherence element into the epistemology.

I said that Chisholm takes the belief involved in perceptual taking to be prima facie credible just as such, but this principle does not seem to say exactly that. The proposition that is accorded one or another epistemic status in P5 is specified not as the belief that *S is being appeared to by something that is F*, but rather as the belief that *S perceives something that is F*. These propositions are identical only if the concept of *perceiving an F* is identical with the concept of *being appeared to by something that is F*. Is that the case for Chisholm? In the sources from which we are working he gives no definition, or informal characterization, of either of these notions. My impression is that where, contrary to principle II quoted earlier from 1982, he takes perceiving an F not to require attributing some property to an F, he would take them to be

identical. Both amount to having a certain appearance caused in a certain way by something external.[5] In any event I shall adopt this assumption.

Thus far Chisholm has provided conditions for a positive epistemic status only for beliefs to the effect that one perceives *something* that is F. The belief "reaches out to the external world" only by way of being a claim to the effect that one is perceiving something external that has a certain property. There is no claim to identify any *individual* that is perceived and that has a certain property. Or, as Chisholm puts it, P5 "does not enable us to say, *de re,* of that person and any external object y, that it is beyond reasonable doubt for that person that he perceives that *that* particular thing is F" (1982, p. 22). To remedy this deficiency, he defines a concept of de re perceptual taking.

> (I) The property of being F is such that x perceptually takes y to have it =Df.
> There is a way appearing such that y and only y appears in that way to x;
> and the property of being G is a sensible property that x indirectly
> attributes to y, as the thing that appears to him in that way. (1982, p. 19)

The last clause could be translated into propositional terms as follows: "x accepts the proposition that y (as the thing that appears to him in that way) is G." The force of the parenthetical phrase is that the proposition will contain, as part of its conceptual content, that way of identifying y— as the thing that appears to him in that way.

As in the definition of perceptual taking quoted above from 1989, we get the uniqueness of the object from the uniqueness of the way it is (currently) appearing to the subject. One might protest, "But what if several things are appearing in the same way to S at that time?" Chisholm answers this objection as follows.

> If many things are such that each one is appearing red to me, then for each of
> them there will be a further way of appearing such that that thing is the sole
> thing that is appearing to me in *that* way. One thing might appear red and
> round, another thing red and square, and so on. (1982, p. 19)

But what if several things are appearing to me at the same time as having the same intrinsic qualities? At least, Chisholm would say, they appear as occupying different parts of the sensory field in question.

The de re perceptual principle of justification is set out as follows.

> P6 For every x and y, if (i) x perceptually takes y and only y to be F, and if
> (ii) it is epistemically in the clear for x that he perceives something that is
> F, then y is such that it is beyond reasonable doubt for x that it is F; and
> if it is evident for x that he perceives something that is F, then y is such
> that it is evident for x that it is F. (1982, p. 22)

I note in passing that P6 differs from P5 in that what is accorded positive epistemic status is not the proposition that x *perceives* something or

other, but a purely objective proposition about *what is perceived.*[6] Another point is that whereas in the definition of de re perceptual taking, we have "x perceptually takes y to be F," P6 is in terms of taking "y *and only y* to be F." I am inclined to doubt that these differences reflect any important features of Chisholm's thought, but I am by no means sure of this. Be that as it may, I pass them over here.

This concludes Chisholm's development of the epistemology of perceptual belief in 1982. It will be noted that he has not progressed beyond beliefs ascribing *sensible properties* to perceived objects. He has not dealt with beliefs that a perceived object is of a certain kind—a house, a maple tree, a dog—or that it has more complex properties— being angry, thrashing about, or being asleep. Earlier versions were bolder. In 1977, for example, Chisholm held that for any property, F, if S believes that he is perceiving something to be F,[7] and this is in the clear, then it is *beyond reasonable doubt* for S that he perceives something that is F.[8] The higher status of *evident* was then reserved for the attribution of sensible properties. Chisholm has obviously become more cautious with the passing of the years. One would be interested to discover his current thought on how to develop the epistemology beyond sensible properties.

III

In the remainder of this essay I will first raise some questions as to what all this comes to, and then end with a few critical remarks.

The overwhelming impression one receives from principles of the sort we have been considering is that Chisholm's position is one of "prima facie intrinsic credibility" of perceptual beliefs, in the tradition of Reid, Moore, and Price. Indeed, Chisholm often presents his position in this way, not infrequently with explicit reference to one or other of the philosophers just mentioned.[9] But there are also passages in which he characterizes the position quite differently.

As a background for this discussion, note that on the "prima facie intrinsic credibility" view, there is nothing other than the perceptual belief that provides prima facie justification for that belief. It is (prima facie) *self*-justified. But sometimes Chisholm gives quite a different impression of his position. First, in both the first two editions of *Theory of Knowledge* he treats perceptual beliefs under the rubric of the "indirectly evident," implying that they are rendered evident (or given some other positive epistemic status) by something else.

If perceptual beliefs derive their justification from something else,

what might that be? In 1989 we have two quite different suggestions. First there is the idea that my perceptual belief that a car is in my driveway is justified by my sensory experience, by "appearances."

> The philosophical problem of perceptual evidence turns on this question: how is it possible for appearances to provide us with information about the things of which they *are* appearances? (p. 42)

In other words, how is it possible for appearances to confer evidence (or other positive epistemic status) on beliefs about external objects?

> Being appeared to in such a way that, if one is appeared to in that way then one cannot resist believing that an F is appearing to one in that way, makes it evident that one is appeared to in that way by an F. (p. 44)[10]
> We have, then, certain principles telling us how facts about appearances may justify us in certain beliefs about the *external things* that present those appearances. (p. 66)

The principles referred to include the 1989 analogues of P5, a principle, which, as we have seen, tells us no such thing. P5 contains no suggestion that it is the *appearance* that confers justification on the belief that one perceives something that is F. The idea that perceptual beliefs about the external environment are justified by their relation to the sensory experience on which they are based is, of course, a very natural one, and hence one that repeatedly surfaces in the epistemological literature. But it would seem to be in stark conflict with the "prima facie intrinsically credible" theme that is reflected in most of Chisholm's principles.

There is still a third story in Chisholm as to the source of justification for perceptual beliefs about external objects—the classical foundationalist story. On this approach, perceptual beliefs about external objects are justified, if at all, by being inferentially related to *knowledge (justified belief)* about one's own sensory experiences (appearances). This differs from the second idea in making the epistemic status of *beliefs about* appearances the source of justification for the external beliefs, rather than finding that source in the appearances themselves—whether or not one has any beliefs or knowledge *about* them, and if one does, whatever epistemic status those "internal" beliefs may have. As the name "classical foundationalism" suggests, this has been a popular view, and some of Chisholm's formulations suggest that this is the kind of view he is advancing. I think especially of passages in which he takes everything except the directly evident (in empirical matters, the "self-presenting") to enjoy positive epistemic status by virtue of its relations to the directly evident.

> Our evidence for some things, it would seem, consists of the fact that we have evidence for other things. "My evidence that he will keep his promise is

the fact that he said he would keep his promise." . . . Must we say of everything for which we have evidence that our evidence for that thing consists in the fact that we have evidence for some other thing?

If we try Socratically to formulate our justification for any particular claim to know . . . , and if we are relentless in our inquiry . . . , we will arrive, sooner or later, at a kind of stopping place ("but my justification for thinking that I know that N, is simply the fact that N"). An example of N might be the fact that I think that something now looks blue to me . . . we may say that some things are *directly evident.* (1977, p. 2)

This certainly suggests that everything evident in empirical matters other than the self-presenting derives its evidence from the evidence of other beliefs.

It is true that as his thought developed Chisholm drew back from the classical foundationalist position. Indeed, in the very work, 1977, in which we find the last passage, Chisholm draws back from that program at the outset of chapter 4, "The Indirectly Evident."

What, then, of our justification for those propositions that are indirectly evident? We might say that they are justified in three different ways. (1) They may be justified by certain relations that they bear to what is *directly* evident. (2) They may be justified by certain relations that they bear to *each other.* And (3) they may be justified *by their own nature,* so to speak, and quite independently of the relations that they bear to anything else. (1977, p. 63)

(3) makes room for the prima facie intrinsic credibility of perceptual takings, though one is left wondering why Chisholm has clung to the term 'indirectly evident' for beliefs that fall under (3). (2) is exemplified by the way in which mutual support or "concurrence" raises the epistemic status of propositions. But one still wonders where (1), which Chisholm presents elsewhere as the whole show, is to be found in the system. None of the principles set forth in 1977 make the evidence of one proposition a condition for the evidence of another.[11] None of them are to the effect that if a proposition with a certain kind of content is evident to a subject, then a proposition with a certain related sort of content will thereby be evident for that subject.

Again, even though

P4 and P5 state conditions under which the self-presenting may make evident certain attributions that are not directly evident . . . application of the principles does not require that it be *evident* to the subject that he has the self-presenting properties in question—for they do not require that he *consider* his having them. It is the self-presenting, then, and not the directly evident, that may be said to justify that which is not directly evident. (1982, p. 25)

But although Chisholm has backed away from his earlier classical foundationalist program, even in 1989 we find more than one formulation that is naturally interpreted in those terms.

> [I]t is *by means of* what you know about the appearance, that you apprehend the object of perception. (42)

Not by means of the appearance, but by means of what you *know* about the appearance.

> Thus the proposition that I now see a sheep, for example, is evident for me and it derives its evidence from propositions about my present sense-experience and the conditions under which that experience occurs. (49)

This suggestion is clearly different both from the idea that it is the sense-experience (not propositions about it) from which the first proposition derives its evidence, and also from the idea that the first proposition is intrinsically credible if not overridden.

> In the case of being appeared to, there is something, one's being appeared to in a certain way, that one interprets as being a sign of some external fact. (67)

To *interpret* the appearance as a sign of something external, one, of course, has to be aware of it. The appearance itself isn't all that is responsible.

Thus we are confronted with three different, apparently incompatible, accounts of the source of justification for perceptual beliefs. Is there any way to reconcile them, and if not, what are we to say about the situation?

The obvious move with respect to the relation of the third story—classical foundationalism—to the other two is to take Chisholm's latest view to be that some, but only some, of the epistemic status of perceptual beliefs is so derived. I said earlier that none of the principles of justification in 1977 are of this form, but that is not true of 1982 and 1989. Looking back at our principles from the former, we see that P6 includes the condition that "it is evident for x that he perceives something that is F"; that is stated as a condition for its being evident for x that y is F. And the 1989 analogue of P4 (viz., MP8) includes the condition that "being appeared ——— to is evident for S" (p. 71), whereas P4 only requires that the way of appearing be self-presenting. P5, on the other hand, as well as its 1989 analogue, includes no such condition. Thus we might see Chisholm as leaving a partial place for the transfer of evidence from other propositions to perceptual propositions.

But what about the second story—that justification derives from the appearances themselves? P4 is the only one of our principles that is naturally read as presenting appearances as the source of justification for

a perceptual belief about external objects. Otherwise the territory is divided up between the first (intrinsic credibility) and the third stories, with the emphasis on the former. And P4 by itself hardly constitutes an underpinning for the rather extravagant statements that the whole epistemological problem of perception concerns the way in which appearances provide justification for perceptual beliefs about the external world. Here is the only way I can see of putting a good face on all this, without a wholesale jettisoning. Since perceptual taking is itself defined as involving appearances, in supposing perceptual takings to be intrinsically credible we are, in effect, committed to supposing appearing to have something to do with that credibility. I find this, however, to be a weak palliative. Appearing is functioning in the perceptual taking as a means of picking out the external object with which the belief (proposition) is concerned. The principle in no way says, or implies, that the appearance functions as a source of justification. Therefore, we are still left with only P4 as an implementation of the "Perceptual beliefs are justified by sensory appearances" story.

I conclude that Chisholm's position is basically one of the intrinsic prima facie justification of perceptual takings, a justification that can then be upgraded by mutual support. This being the case, he must be held guilty of false advertising in his persistent statements that suggest, or flatly state, that the account is of one of the other two sorts.

I have not yet said anything about the epistemic status of Chisholm's principles—why Chisholm thinks they are justified, warranted, acceptable, true, or whatever; and whether whatever grounds they have are adequate. Since these questions concern Chisholm's epistemology generally, since they will undoubtedly be addressed by other essays in this volume, and since I had best use my limited space for issues that are distinctively concerned with the epistemology of *perception,* I will leave their consideration for others.

IV

Having done what I can to elucidate Chisholm's position, my final task is one of critical assessment. I have already indicated some points of dissent from Chisholm. For example, I do not accept his "adverbial" reading of sensory experience. But I will not pursue that argument, in the interest of concentrating on the theory of justification. There is also the point that the theory of the justification of perceptual beliefs is restricted to beliefs concerning sensible properties, thus leaving for future treatment vast stretches of the territory. I won't belabor that point further,

confining myself to a consideration of the adequacy of the theory within its chosen limits.

My first dissatisfaction concerns the character of the items chosen for epistemic assessment. P5 lays down conditions for the epistemic status of propositions to the effect that S *perceives* something of a certain sort; and if we can take perceiving x to be equivalent to X's appearing to one in a certain way (as I would and, as we have seen, Chisholm sometimes does), the same is true of P4. I have no objection to one's being concerned with the epistemology of such propositions. But they strike me as the wrong place to start an epistemology of perception. Beliefs to the effect that one perceives something are relatively sophisticated; they are far from the most basic, the most primitive perceptual beliefs. Very small children form innumerable perceptual beliefs concerning things in the environment well before they acquire even a rudimentary concept of seeing or hearing, much less a general concept of perceiving. It is at a later stage of cognitive development that one becomes aware of oneself as a perceiver, as well as of what it is one is perceiving.[12] Therefore an account of what it takes for the justification of perceptual beliefs should start with these more elementary types, and then build up to their more advanced cousins.

So far as I can see, this objection could be handled very simply. Just change the bearer of epistemic status in P5, for example, from *he perceives something that is F* to *there is something that is F*. One might think that it should be *something that is F is appearing to him,* but that is disqualified for the same reason. The concept of appearing is also lacking from the most primitive perceptual beliefs. And if it is felt that a mere belief that *something is F* is too unspecific to count as a perceptual belief, we have to remember that the basic condition of justification here is that "x perceptually takes there to be something that is F," thereby ensuring that it is a *perceptual* belief attributing F to something that is in question. I will not attempt to deal here with the question of what more is needed to provide justification for *S perceives something that is F.*

My next quarrel with the theory concerns its radically "unexplanatory" character, the way in which it sticks resolutely to the surface of the subject matter. To oversimplify, the view is that perceptual takings are justified in the absence of sufficient reasons to suppose them false. This may very well be true. But it leaves totally unexplored what is behind this. What is it that renders perceptual takings intrinsically credible, whereas beliefs of many other kinds are not? It must have something to do with what makes them *perceptual takings.* But what is that, and by virtue of what does it have this epistemic efficacy? It is certainly a reasonable expectation that an epistemology of sense perception should

throw light on such questions. Chisholm, however, is content to lay down principles that accommodate what he takes to be intuitions concerning particular cases of justified and unjustified belief. By considering particular cases he is, presumably, convinced that perceptual takings are justified whenever sufficient overriding reasons are lacking. And that's that. But this leaves one wondering what is responsible for this state of affairs. Note that the need to answer questions like this explains why the "sensory appearances confer justification" approach is so appealing. If Chisholm's principles of justification really did throw light on how perceptual beliefs get justified by virtue of their relation to sensory appearings, that would contribute to solving the problem I am now presenting. But, as we saw, the programmatic announcements of this approach turned out to be hollow. Nothing was done to carry it out. Hence we are left in the dark as to what it is about perceptual takings that render them intrinsically credible, and why we should suppose that feature, whatever it is, to have this efficacy.

I think I can see why Chisholm evades this task. To tackle it, he would have to get into matters he has declared out of bounds for epistemology. To explain what gives perceptual takings the status Chisholm assigns them (assuming they do have that status) we would have to allude to the way in which they spring from and are based on sensory appearances. It is because a "perceptual taking" of something to be snow arises from my being appeared to "snowily" that such a taking is justified in the absence of reasons to think it false. Our confidence in the intrinsic credibility of such beliefs is intimately tied to, indeed derived from, our confidence that normal processes of perceptual belief formation yield mostly true beliefs and hence carry with them a presumption of truth for their products. Or so it seems to me. If this is the sort of thing we have to get into in order to delve more deeply into the roots of perceptual justification, we can understand why Chisholm declines to do so. For he holds that "according to the internalistic theory of justification that is presupposed here, epistemic *justification is* not a function of the *causes* of one's belief" (1989, p. 66). Causes are off limits for the internalism, because it restricts what can affect justification (what can be taken account of in ascribing epistemic status) to what can be ascertained just on reflection, without the need for any further research. And causes cannot, in general, be spotted in this way.

One might think that Chisholm could bring sensory appearances into the picture otherwise than as causes of the belief. Why not just say that when one is appeared to snowily one is prima facie justified in supposing there to be snow in the vicinity? But is mere copresence sufficient to do the job? Suppose that while being appeared to snowily I believe there to

be snow in the area, but not on the basis of the appearance. Perhaps I
have an *idée fixe* that snow is everywhere. Or perhaps a hypnotist has
implanted the idea that there is snow on the ground here. The sensory
appearance is playing no role in generating and sustaining my belief. I
would believe there is snow around even if I weren't being appeared to
this way; and in the absence of the other factor(s), the sensory appear-
ance would not generate the belief. In that case would my belief that
there is snow here be justified? It would seem not. The belief has a
thoroughly disreputable provenance and hence has nothing going for it
epistemically. Chisholm might say that in this case the belief is not a
perceptual taking. But if the cause of the belief, more specifically *what it
is based on,* is what makes it a perceptual taking, then this is what we
have to explore in order to get more insight into why we should suppose
such takings to be prima facie credible. That is just my point. To get
below the surface of the situation we have to go into matters, the bases of
beliefs, that Chisholm avoids on principle.

Our final criticism is this. Chisholm makes no place, even in his
programmatic remarks, for the role of background beliefs in the justifica-
tion of perceptual beliefs. Although I am shoulder to shoulder with
Chisholm in opposing those who would construe perceptual justification
as purely inferential, purely a matter of the perceptual belief being
supported by other beliefs, and in insisting on an essential role for
sensory appearances (which are not themselves propositional or doxastic
in character), I also recognize that background beliefs often play a role,
along with sensory experience, in the generation and the determination
of the epistemic status of perceptual beliefs. I don't always identify
things solely by their look, sound, feel, or other appearance. Not
infrequently I "assess" or "interpret" those appearances in the light of
other things I know, believe, and/or justifiably believe. Thus when
looking for your house I identify it at least in part by the way it looks.
But, for all I know, there may well be many houses that look indistin-
guishable from it. Hence I also take account of where I am at the
moment. I can rely on its being the only house on this street, or on this
block of this street, that looks like that. And my justification for
supposing it to be your house derives from this knowledge of where I am
as well as from the way the item looks. Again upon hearing a sound
emanating from the next room I take someone to be playing a flute. But
the sound itself could have other sources—the radio, a tape, a recorder,
an extremely expert whistler, etc. My confidence that it is a flute, and my
justification for that confidence, is bolstered by my knowledge that you,
an inhabitant of the house, own a flute, and not infrequently play it. A

complete epistemology of perception would bring matters like this into the account of the justification of perceptual beliefs.

To be sure, Chisholm does not aspire to present a complete epistemology of perceptual belief. We have already noted the rather severe restriction of his account to beliefs that ascribe sensible properties. And it seems reasonable to suppose that background beliefs play a smaller role there than in the identification of objects as being of certain kinds or as being a particular instance of a kind. Nevertheless, background beliefs have some place even here (other than as overriders of prima facie justification, a role that Chisholm does emphasize). For example, even though a house looks very tiny to me, I won't take it to be tiny if I realize that I am viewing it from thirty-five thousand feet in the air. Here my justification for supposing the object to be a normal-sized house derives not just from the look but also from the background belief. Hence background beliefs need attention even within Chisholm's chosen limits.

V

I have been emphasizing difficulties and ambiguities in Chisholm's theory. But I want to end by emphasizing its virtues. Chisholm has from the outset of his career kept his eye firmly on the crucial role of sensory experience in the epistemic role of perception. And although I have given reason for supposing his development of this guiding idea not to be wholly free of defects, there is much to admire and to emulate in that development. The importance and viability of intrinsic "noncomparative" concepts of ways of appearing is given a spirited and effective defense. As against all forms of coherence theory, there is a salutary insistence on the point that perceptual beliefs enjoy, ipso facto, a measure of positive epistemic status, while at the same time the value of coherence considerations (mutual support) are given their due. Different degrees of positive epistemic status are distinguished and interrelated in a systematic fashion. Perception itself is subjected to a searching analysis, as the basis for the development of an epistemology thereof. Any further advances in this area will ignore Chisholm's pioneering work at its peril.

WILLIAM P. ALSTON

DEPARTMENT OF PHILOSOPHY
SYRACUSE UNIVERSITY
FEBRUARY 1993

NOTES

1. For opposite positions on this issue see Dretske 1969 and Runzo 1977, 1982.

2. In his formulations concerning "no sufficient overriders" clauses like this, Chisholm has persistently concentrated on what I call "rebutters"—reasons for thinking the proposition in question to be false—to the exclusion of "underminers"—reasons for denying that the justification one has accepting the proposition is, in this instance, adequate. I will illustrate this distinction with respect to perceptual beliefs. Let's say that my visual experience provides (overrideable) justification for supposing that there is a giraffe in my front yard. Sufficient reason for supposing that there are no giraffes in the vicinity would be a rebutter. Sufficient reason for supposing that I am subject to zoological hallucinations would be an underminer.

3. In the definitions of epistemic terms I gave above (taken from 1982) I translated Chisholm's talk of direct and indirect attribution into talk of attitudes to propositions.

4. There are various differences between these definitions. I will largely ignore them in this discussion. As for the restriction of P4 to "sensible properties" we may take that to be implicit in this latter definition. The focus on uniqueness in the 1989 definition, and the epistemic requirement in (2), are differences I would attend to if I had space to go into such fine points.

5. See 1957, chap. 10, for a fairly full discussion of this.

6. To be sure, the principle does not remain wholly on the objective level, since one of the conditions for the status of being evident is that it is evident for x *that he perceives something that is F,* the proposition involved in P5.

7. This is the phrase used at that stage instead of "perceptual taking."

8. 1977, p. 76.

9. See, for example, 1966, pp. 46–49; 1977, pp. 76–78; 1989, pp. 46–48.

10. To be sure, Chisholm objects to this principle, but only on the grounds that it includes "makes it evident" rather than "tends to make it evident."

11. See pp. 139–40 of 1977.

12. One might also think that these candidates are disqualified by reason of containing epistemic components that raise further questions. For in 1989 Chisholm defines "S perceives that there is an F" as follows.

S *perceives* that there is an F = Df. (1) There is an F that is appearing in a certain way to S; (2) S takes there to be an F that is appearing to him in that way; and (3) it is evident to S that an F is appearing to him in that way. (p. 41)

Thus to justify believing that one perceives that there is an F one would need whatever it takes to justify an attribution of "evident" to a proposition. But this is to ignore the difference between this definiendum and *S perceives something that is F.* Immediately after the formulation of P5, Chisholm distinguishes the latter from perceiving that something is F (p. 22).

BIBLIOGRAPHY

Chisholm, Roderick M. 1957. *Perceiving: A Philosophical Study.* Ithaca, N.Y.: Cornell University Press.

_____. 1966. *Theory of Knowledge.* 1st ed. Englewood Cliffs, N.J.: Prentice-Hall, Inc.

_____. 1977. *Theory of Knowledge.* 2d ed. Englewood Cliffs, N.J.: Prentice-Hall, Inc.

_____. 1982. *The Foundations of Knowing.* Minneapolis: University of Minnesota Press.

_____. 1988. "The Evidence of the Senses." *Philosophical Perspectives* 2: 71–90.

_____. 1989. *Theory of Knowledge.* 3d ed. Englewood Cliffs, N.J.: Prentice-Hall, Inc.

Dretske, Fred. 1969. *Seeing and Knowing.* London: Routledge and Kegan Paul.

Runzo, Joseph. 1977. "The Propositional Structure of Perception." *American Philosophical Quarterly* 14: 211–20.

_____. 1982. "The Radical Conceptualization of Perceptual Experience." *American Philosophical Quarterly* 19: 205–17.

REPLY TO WILLIAM P. ALSTON

An adequate reply to William Alston's challenging paper would require a paper that is longer than his. I will restrict myself, therefore, to what seem to me to be the most fundamental issues.

Alston's task is a difficult one since, as he suggests, I keep changing my views on the relation of appearing to perceiving. Naturally I would prefer to put the matter by saying that I keep refining upon and improving those views.

I would now defend the view that appearances may be reduced to ways of sensing, or being appeared to; this view, as Alston points out, has been called "the adverbial theory." But the technical term, "the adverbial theory," has two senses. (1) In one of its two senses, it refers to the view just mentioned. And (2) "the adverbial theory" is also used to refer to the view according to which sensing cannot be said to have such spatial characteristics as extension, shape, and number. This twofold use of "adverbial" may be misleading, for I would accept "the adverbial theory" in the first sense but not in the second.

I can only sketch my present view here. A fuller statement may be found in my book, *A Realistic Theory of Categories: An Ontological Study.* Consider the hypothesis that the objects of sensing are *surfaces* within the *subject's own body.* This hypothesis does not require us to say that the subject is identical with his body. Nor does it require us to say that he is *not* identical with his body. But let our hypothesis be one implying that the subject needs a body in order to sense. If the subject is sensing a red triangle being at the left of a blue circle, then what is being sensed is a constituent of one of the body's surfaces.

There is a distinction between sensing and perceiving which our ordinary language habits tend to conceal. One would like to put the distinction by saying that sensing, unlike perceiving, is always such that its content is veridical: "If you sense that something is green then

something *is* green, but you may perceive that something is green even though what you are perceiving is not veridical." But the problem that is made for us by our ordinary language is this: if the object is not green, then we will not *say* that you "perceived" that something is green. Perhaps we will say, not quite accurately, that you "*thought* you perceived" something to be green—or we may introduce a technical term and say that you "took" something to be green.

And so we should try to straighten out our philosophical terminology. We first say what it is to be "appeared to" by something.

D1 S is appeared to by x = Df. S is sensing in a way that is a function of a process in x; i.e., systematic variations of a process within x will produce systematic variations in a way in which S is sensing.

D2 S veridically perceives x to be F = Df. S is appeared F to by an F.

D3 S unveridically perceives x to be F = Df. S is appeared to, but not veridically appeared to, by an F.

What of the more general "S perceives x"? Given the distinction between "veridical" and "unveridical" perception, the more general sense of "perceives" turns out to be equivalent to the "is appeared to by" that is defined in D1.

D4 S perceives x = Df. S is appeared to by x.

"But doesn't it violate our ordinary language to speak of 'unveridical perception'?" No; we violate only the linguistic use of the theoretician, who, unlike the nontheoretician, doesn't want to say that anyone can in any sense, perceive "what isn't there."

Alston suggests that, in emphasizing the "self-presenting" character of sensory properties, I have neglected the self-presenting character of nonsensory qualities. He also suggests that, where in my earlier writings I was prepared to recognize the evidential character of certain nonsensory qualities, I have "obviously become more cautious with the passing of years." I quote from pages 19–20 of the third edition of *The Theory of Knowledge,* one of the books to which Alston restricts himself.

> Some self-presenting properties pertain to our *thoughts*—thinking, judging, hoping, fearing and wishing. And some of them have to do with the ways in which we *sense,* or are *appeared to.* The first may be called *intentional* properties and the second may be called *sensible* properties. It was characteristic of philosophers in the empirical tradition to stress those self-presenting properties that are sensible and to neglect those that are intentional. But both types must be taken into consideration in any adequate theory of knowledge.

Most of the other issues that divide Alston and me seem to be metaepistemological, an area of inquiry which is obviously of consider-

able interest to him. I have space to comment only on the most fundamental of these issues.

It seems to me that Alston does not sufficiently appreciate the difficulties that are involved in the ancient problem of the criterion. One's starting point can only be arbitrary. Yet Alston *seems* to say: "Chisholm's starting point is arbitrary; therefore he should start where I do." I say only that he *seems* to say this. But he does point out that "small children" do not start where I do. And here one must be on guard.

Alston asks: "What is it that renders perceptual taking intrinsically credible, whereas beliefs of other kinds are not?" I picture a wicked Pyrrho waiting with his trap. For if one were to answer the question saying something like, "It's that the perceptual beliefs are so-and-so," Pyrrho will be able to reply with equal force: "Aha! And what is there about so-and-so beliefs that enables *them* to do it?"

Alston has very important views of his own on all the questions that we have been discussing. I wish that he had told us how *he* would deal with the problems. Then the reader could have compared two different treatments of the same problems and he would not have been wondering, as Alston puts it in one place, just "what all this comes to."

 R.M.C.

5

Susan Haack

"THE ETHICS OF BELIEF" RECONSIDERED*

The topic of this paper is one that has long concerned Professor Chisholm: the relation of epistemic to ethical appraisal.

Possible accounts of this relation include:

(1) that epistemic appraisal is a subspecies of ethical appraisal—henceforth, for short, the special-case thesis;
(2) that positive/negative epistemic appraisal is distinct from, but invariably associated with, positive/negative ethical appraisal—the correlation thesis;
(3) that there is, not invariable correlation, but partial overlap, where positive/negative epistemic appraisal is associated with positive/negative ethical appraisal—the overlap thesis;
(4) that ethical appraisal is inapplicable where epistemological appraisal is relevant—the independence thesis;
(5) that epistemic appraisal is distinct from, but analogous to, ethical appraisal—the analogy thesis.

This list seems to exhaust the serious options.[1] But refinements will be needed to take account of the fact that each of the positions listed has both a completely general form ("for every dimension of epistemic appraisal"), and a variety of specific forms (for example, "where epistemic appraisal of someone as completely, or to some degree, justified, or as unjustified, in believing that . . . is concerned"). The correct account may be different with respect to different dimensions of epistemic appraisal. But the logical relations among the positions listed are the same whether one considers each in its general form, or each in the same specific form. The special-case thesis is incompatible with any of the others. The correlation thesis is incompatible with the overlap thesis and with the independence thesis. The analogy thesis, however, though incompatible with the special-case thesis, is compatible with the correlation thesis, with the overlap thesis, and even with the independence thesis.

In "Firth and the Ethics of Belief," published in 1991, Chisholm writes that since 1938, when he and Firth both enrolled in Ralph Barton Perry's seminar on value theory, "Firth's inclination was to say that [epistemic justification] is merely an analogue [of ethical justification]; and my inclination was to say that it is a subspecies. . . . I still find myself inclined to accept the original view."[2] For most of this paper I shall concentrate, like Chisholm and Firth, specifically on the relation of epistemic to ethical justification. Here, as I see it, the special-case thesis is too strong, the analogy thesis (not false but) too weak; the relation of epistemic to ethical justification is as stated in the overlap thesis: less intimate than partial identity, more intimate than analogy.

Interwoven with my arguments for this specific version of the overlap thesis will be some speculations of a more historical character: that in the celebrated debate between Clifford and James, it is their shared failure to distinguish epistemological from ethical justification which creates the false impression that one must choose either the morally overdemanding account proposed in "The Ethics of Belief," or the epistemologically overpermissive account proposed in "The Will to Believe." And interwoven with these speculations will be an argument that locates Chisholm closer to the Jamesian side of that debate, significantly more permissive epistemologically than Clifford—and somewhat more permissive epistemologically than myself.

Finally, I shall turn my attention briefly to the relation of epistemic to ethical appraisals of character, which, I shall suggest, seems more intimate than the relation of epistemic to ethical justification. This will suggest a friendly, if revisionary, reinterpretation of what is plausible in Clifford's, and Chisholm's, talk of "the ethics of belief."

Like Chisholm, I take for granted the essentially evaluative character of epistemological concerns, the focus on what makes evidence better or worse, what determines to what degree a person is justified in a belief, how inquiry should be or is best conducted. But when one thinks about the different ends on which epistemological and ethical appraisal are focused, it looks likely that their relation is to be expected to be at least as complex and oblique as the relation of knowledge to human flourishing. This expectation is confirmed by reflection on such questions as: Is all knowledge conducive to human flourishing, or is there some knowledge we should be better off without? Is it always morally, as it is epistemologically, best to seek out all available evidence, or are some means of obtaining evidence unethical? Is it always harmful to believe unjustifiedly, or is it sometimes harmless or even beneficial?[3]

If it is possible that there should be cases where a person believes

unjustifiedly, but where the appropriate moral appraisal is favorable or indifferent, the claim that to say that a person believes unjustifiedly is *eo ipso* to make an unfavorable moral appraisal—henceforth, the special-case thesis$_j$—is false. Unless, therefore, it is incoherent to claim that believing unjustifiedly is sometimes simply harmless, or, as some philosophers have done, that there is moral merit in faith, or in a husband's believing that his wife is faithful even if the evidence indicates otherwise, the special-case thesis$_j$ is false. And, whether or not they are true, such claims are surely coherent.

This argument is not quite conclusive, however, for a defender of the special-case thesis$_j$ might reply that the coherence of these descriptions is insufficient to refute his thesis; in the cases described, he might argue, there is a prima facie moral failing (believing unjustifiedly), but it is so slight as to be negligible, or has been overridden by weightier considerations (the moral value of trust between husband and wife, for example).

Another argument against the special-case thesis$_j$ appeals to the fact that "morally ought" implies "can," and hence that "epistemically ought" cannot be a subspecies of "morally ought," since it does not imply "can"; for believing, and hence believing unjustifiedly, is not in any straightforward sense voluntary.

If this argument were conclusive, it would rule out, not only the special-case thesis$_j$, but also the correlation thesis$_j$ and the overlap thesis$_j$. But it is not conclusive. Chisholm observes that, though indeed one cannot stop believing that p or start believing that p *now,* no more can one fulfill all one's [as the special-case thesis$_j$ would have it, all one's other] moral obligations *now;* what is required is only that one *can in due course.*[4] Of course, the sense in which one can't just stop believing or start believing that p now is quite unlike the sense in which one can't, say, answer all one's correspondence now; the difficulty isn't that one hasn't time just now to stop or start believing that p, but that one can't simply stop or start believing that p at any time. Believing that p is a condition one finds oneself in, not something one does. However, as Chisholm pointed out in an earlier discussion of this issue,[5] one *can* sometimes bring it about that in due course one believes . . . ; one can sometimes *induce* a belief, by bringing about the circumstances in which that condition is likely to arise. One cannot believe at will; nevertheless, sometimes the wish is father to the thought;[6] and this may be enough for moral appraisal to be applicable.

A better argument against the special-case thesis$_j$ is that its being true that one is unjustified in believing that p, that one epistemically ought not to believe that p, is independent of whether or not it is true that, in this instance, the belief was willfully induced. One's belief is unjustified

if one's evidence isn't good enough; whether or not one willfully induced the belief is irrelevant.

If this argument is correct, the special-case thesis$_1$ is, in its most natural interpretation, false.

Of late, however, Chisholm has suggested a different interpretation, to which the arguments thus far would be irrelevant. "The distinguishing feature of *ethical* duty," he writes, "is not to be found in the considerations that impose that duty. Rather, an ethical duty is simply a requirement that is not overridden by any *other* requirement."[7] And so, he argues, when an epistemic requirement is not overridden by any other requirement, it is one's ethical duty. Even if this account of what it is to be an ethical requirement were acceptable, this would be insufficient to establish the special-case thesis$_1$; for it would show only that *some* epistemic requirements—those which are not overridden by other requirements—are ethical. And, in any case, it seems that "ethical" has been persuasively redefined, as "any normative requirement not overridden by some other requirement"; that this is a *re*definition becomes apparent when one considers that it implies, for example, that any requirement, of prudence, say, or of aesthetics, would thereby be classified as ethical provided only that it is not overridden by any other requirement.[8]

According to the correlation thesis$_1$, although to say that a person believes unjustifiedly is not *eo ipso* to say that he is morally at fault, nevertheless, whenever a person believes unjustifiedly, he *is* morally as well as epistemologically at fault. Two arguments against this thesis immediately suggest themselves. If it is ever *true* (not merely, as the first argument considered against the special-case thesis$_1$ required, possible) that believing unjustifiedly is beneficial or harmless, or if it is *ever* false (not necessarily, as the second argument considered against the special-case thesis$_1$ required, always) that a person is responsible for believing unjustifiedly, then the correlation thesis$_1$ is false.

There are cases in which a person's believing unjustifiedly is harmless or even beneficial. My believing, on inadequate evidence, that the apples I just selected are the best in the supermarket, is, like many inconsequential beliefs, harmless. Again, if a patient's believing, on inadequate evidence, that he will recover from his illness significantly improves the chances that he will recover, then he may properly be appraised neutrally from a moral point of view.[9]

Cases like this are sufficient to show it false that, whenever a person believes unjustifiedly, his so believing is always also subject, all things considered, to unfavorable moral appraisal. They are not sufficient,

however, to show it false that, whenever a person believes unjustifiedly, his so believing is always also subject to unfavorable moral appraisal prima facie. But if a subject is not always responsible for believing unjustifiedly, even a prima facie correlation thesis₁ is false.

Possible explanations of someone's believing unjustifiedly are: negligent incontinence[10]—he has been careless or perfunctory in inquiry, but, jumping to conclusions, has formed a belief anyway; self-deception—self-interest has skewed his perception of the weight or relevance of this or that evidence; *or* cognitive inadequacy—he has done his best, but on this matter his best cognitive effort isn't good enough, and has resulted in an unjustified belief. (The first two kinds of explanation are not really so distinct as this rather crude list makes them appear, since a sort of one-sided carelessness in inquiry is one of the forms in which self-deception manifests itself; but, though they may be, negligence in inquiry and incontinence in belief-formation need not be self-interested.)

One may distinguish two kinds of cognitive inadequacy: the personal—an individual's good-faith misjudgment of the weight of complex evidence—and the cultural. The latter arises because of the perspectival character of judgments of relevance, their dependence on background beliefs. Sometimes the explanation of someone's believing on skimpy evidence is that he doesn't realize that certain relevant evidence *is* relevant, because the background beliefs which determine what evidence he perceives as relevant are mistaken—background beliefs which are taken for known facts in his epistemic community, and which he may have no way of knowing are not so.

Where there has been no negligence and no covert operation of wishes or fears, where the explanation of the person's believing unjustifiedly is cognitive inadequacy, personal or cultural, unfavorable moral appraisal is inappropriate even if the belief is harmful.[11]

Perhaps it will be argued in defense of a prima facie correlation thesis₁ that, even in cases of unjustified believing explicable by cognitive inadequacy, the subject is still morally culpable in an indirect way; culpable, that is, not directly for believing unjustifiedly (*ex hypothesi,* that represents his best cognitive effort at the time), but indirectly, for not having cultivated better judgment. There are circumstances where this is appropriate—for example, in some cases where it is this person's (this doctor's, this lawyer's, this juror's, this academic's) particular responsibility to know about the matter at hand; but the correlation thesis₁ requires that it always be so. And this is not true. Even if one were morally required to cultivate one's capacity to judge evidence to the very

best of which one is capable (a very demanding assumption), still, for any person, there would be some degree of finesse which he could not, by even the most strenuous mental discipline, surpass.

Or perhaps it will be argued in defense of the correlation thesis$_j$ that, even in cases of unjustified believing explicable by cognitive inadequacy, the subject is still morally culpable by omission: he morally ought to be aware of his cognitive limitations. There are circumstances where this observation is appropriate too; but, again, the correlation thesis$_j$ requires that it always be so. And this is not true either. Even if one were morally required to be as aware as possible of one's cognitive limitations (again, a very demanding assumption), a complete grasp of those limitations may be beyond one's cognitive powers. If a person has done the best he can, not only to find out whether p, but also to determine that he is competent to find out whether p, he is not morally culpable even if his belief in his competence and his belief that p are, by reason of cognitive inadequacy, unjustified.

If these arguments are correct, the correlation thesis$_j$, even in its weaker, prima facie, form, is false.

Unlike the correlation thesis$_j$, which requires that unjustified believing be always (at least prima facie) harmful and always something for which the subject may properly be held responsible, the overlap thesis$_j$ requires only that unjustified believing *sometimes* causes (at least prima facie) harm and *sometimes* be something for which the subject may properly be held responsible.

And this is so. Acting on false beliefs sometimes causes either actual harm, or, at least, unacceptable risk of harm. Justified beliefs may be false, and unjustified beliefs may be true; nevertheless if, as we hope and believe they are, our criteria of justification are indicative of truth, justified beliefs are likely to be true, and unjustified beliefs are likely to be false. And so, acting on unjustified beliefs is also (though less) likely to cause harm, or, at least, unacceptable risk of harm.

And when unjustified believing is the result either of negligence or of self-deception, though it is not belief at will, it is willful—it is, as we say, a kind of "willful ignorance." One might reasonably feel that a person who knowingly causes harm reveals himself to be a more hardened character than a person who induces himself to believe, unjustifiedly, that his action will not be harmful. Nevertheless, the quasi-voluntary nature of willful ignorance seems to suffice, at least sometimes, for the ascription of responsibility.

In other words, believing unjustifiedly is sometimes a form of morally culpable ignorance. It is not, of course, the only form. Ignorance comes in at least three varieties: one may fail to know because one has no belief

on the matter at hand (agnosticism), or because the belief one has is false (misbelief), or because the belief one has is unjustified (overbelief). Agnosticism, in turn, comes in at least three subvarieties: one may have no belief because one hasn't investigated and has no evidence either way (plain agnosticism); because, though one has investigated and has evidence, that evidence seems insufficient to settle the matter (can't-tell agnosticism); or because one has failed to draw a conclusion which the evidence would support (underbelief). There are epistemologically and psychologically interesting similarities between the phenomena of underbelief and overbelief;[12] but it is the latter that concerns me here. Overbelief, unjustified believing, constitutes culpable ignorance when, as it sometimes but not invariably is, it is both harmful and peccable.

If these arguments are correct, the overlap thesis$_J$ is true.[13]

The arguments thus far put the strategy of W. K. Clifford's celebrated paper, "The Ethics of Belief,"[14] in a new perspective. The main thesis of that paper is that "it is wrong always, everywhere, and for anyone, to believe anything upon insufficient evidence" (p. 77). Neither here nor elsewhere in the paper does Clifford ever distinguish "it is epistemologically wrong" from "it is morally wrong."[15] But he offers no arguments for identifying the two, or even for the special-case thesis$_J$, that the former is a subspecies of the latter. Instead, extrapolating from a striking case where unjustified believing *is* culpable ignorance, he tries to persuade one that *all* cases of unjustified believing are, in some measure, both harmful and willful. He offers, in other words, only arguments that could, at most, establish the correlation thesis$_J$. It is illuminating, as a further test of the claim that the correlation thesis$_J$ is not true, although the overlap thesis$_J$ is, to show how Clifford's attempted extrapolation fails.

In the vivid case with which Clifford's paper opens, we are to imagine a shipowner who "knowingly and willingly" suppresses his doubts, doesn't check, manages sincerely to believe that his vessel is seaworthy, and allows the ship to depart. He *"had no right to believe on such evidence as was before him,"* Clifford observes; and he "is verily guilty" of the deaths of passengers and crew when the ship goes down (p. 70). The description of the shipowner's self-deception as "knowingly and willingly" undertaken (p. 71) is a bit lacking in subtlety; and it would have been desirable that Clifford say explicitly that it is the element of willfulness that justifies an unfavorable moral appraisal in this case, as in more straightforward cases where harm is knowingly caused—for example, if the shipowner knew full well that the vessel was unseaworthy and

allowed it to depart anyway. Nevertheless, Clifford's judgment of this case seems correct: it is a case of morally culpable ignorance, of failure in a duty to know.

But the case has a number of features which are not invariably found whenever someone believes unjustifiedly, and some of which are essential to the unfavorable moral appraisal appropriate here. The unjustified belief is false; the proposition concerned is of great practical importance; the person concerned is in a position of special responsibility; the false belief leads to dramatically harmful consequences; and the belief is willfully self-induced. The correlation thesis$_j$ is false unless the ignorance would still be morally culpable even if all these features were absent.

Clifford is aware that a belief held on insufficient evidence may be true, and clear that it is the belief's being unjustified, not its being false, that matters. There are two points to consider here, only one of which Clifford raises. The first, which he does not mention, concerns cases of false but justified belief. If the shipowner had investigated carefully and honestly, and had been justified in believing the vessel seaworthy, but his justified belief had been false, and the ship went down, the appropriate verdict from a moral point of view would surely be that he was not to blame for the false belief, nor, therefore, for what one would be inclined to describe as a tragic accident. The second point, which Clifford does discuss, concerns cases of unjustified but true belief. He first remarks that the shipowner would still be morally responsible even if his belief that the vessel was seaworthy was true, because "he had no right to believe on such evidence as was before him." This trades on his failure to distinguish epistemic from ethical justification, and hence fails. Later, however (p. 72), Clifford comes up with a better argument: by failing to investigate properly, and inducing himself to believe on inadequate evidence, the shipowner would have taken an unacceptable risk of causing harm. That seems correct. So far, so good, for Clifford and for the correlation thesis$_j$.

But what if the proposition concerned were not, as in the original case, a consequential one, or if the person with the unjustified belief were not the person responsible for deciding whether the ship is to be allowed to make the voyage? Where, then, is the harm, or, if the unjustified belief happens to be true, the risk of harm? Clifford offers what are in effect two kinds of answer to these questions about apparently harmless unjustified belief. The first is—urging that a belief must be connected to action somehow, however indirectly, to count as a belief at all—that no belief is really altogether inconsequential; there is always at least the potential that action might be based on it, and might prove harmful (p. 73). The second is to suggest that unjustified believing always discourages scrupu-

lous inquiry and strengthens the habit of "credulity"; it weakens the epistemic fiber, one might say, and hence carries, if not invariably a risk of harm, a risk of risk of harm (p. 76).

Clifford's responses depend on two false assumptions: that mere potential for harm, however remote, is sufficient for unfavorable moral appraisal (provided the subject is responsible for the unjustified belief); and that a subject is always responsible for unjustified believing. But remote potential for harm is *not* sufficient; if it were, not only drunken driving, but owning a car, would be morally culpable. And a subject is *not* always responsible for believing unjustifiedly; the cause, sometimes, is cognitive inadequacy.

Matters are confused by the way Clifford combines the two responses in the argument that unjustified believing encourages "credulity," and *thereby* carries potential for harm or risk of harm. It is true that sloppy inquiry, jumping to conclusions, wishful thinking, manifest undesirable dispositions—dispositions to which, no doubt, some people are temperamentally more inclined than others, but dispositions which one can either check and discourage in oneself, or allow to operate unchecked, and, by unchecked indulgence, encourage. They are bad habits which may, if unchecked, become inveterate. (It is not clear, however, that Clifford is right to suggest that any individual's indulgence in such habits is bound to encourage them in others.) But it is not true that unjustified believing is always the result of self-deception or negligence; so Clifford's oblique argument that unjustified believing is always harmful also fails.

These disagreements with Clifford by no means imply agreement with his most famous critic, William James.[16] Clifford holds that it is always wrong to believe on insufficient evidence. I have pointed out that Clifford fails to distinguish "epistemologically wrong" from "morally wrong," and argued that his thesis is not true if interpreted as an ethical claim. James holds that it is not always wrong to believe on insufficient evidence. He would be correct, therefore, if by "wrong" he meant "morally wrong" only; but this is not what he means.

Like Clifford, James never distinguishes these two possible ways of taking "ought," "justified," "our duty in the matter of opinion," etc. Some of the arguments in "The Will to Believe" seem to be intended as epistemological: that knowing the truth is no less valuable than avoiding error (pp. 17 ff.); that believing that p sometimes contributes to bringing it about that p is true (pp. 23–24). But others seem to be of an ethical character: that we should not condemn those who have faith for believing without adequate evidence, but should "respect one another's mental freedom" (p. 30); and the quotation from Fitz-James Stephen at the close of the paper, urging that we have faith because "[i]f death ends

all, we cannot meet death better" (p. 31). This suggests that the best way to read James is as holding that it is not always wrong *either* epistemologically *or* morally to believe on insufficient evidence.[17]

James's argument about respect for others' mental freedom deserves special comment. If, like James, one fails to distinguish epistemic from ethical justification, one can make room for (moral) tolerance of others' unjustified opinions only as James seems to, by weakening one's standards of epistemic justification. But if one distinguishes the two, one has no need of any such radical epistemological measures. In any case, one's judgment that another's belief is unjustified must, because of the perspectival character of judgments of justification, their dependence on one's background beliefs, be acknowledged to be thoroughly fallible. And, most to the present point, unjustified believing is not morally culpable if it results from cognitive inadequacy, whether personal or cultural.

Unlike both James and Clifford, I distinguish epistemological from ethical justification. Like James and unlike Clifford, I do not think it always morally wrong to believe on inadequate evidence. Clifford's position is overdemanding morally. Like Clifford and unlike James, however, I think it is always epistemologically wrong to believe on inadequate evidence—in the sense that believing on inadequate evidence is always epistemologically unjustified belief. James's position is overpermissive epistemologically.

Perhaps it will be objected that sometimes it is all to the good— *epistemologically* all to the good—that a person believe something even though his evidence is inadequate; for example, the scientist whose faith in an as yet inadequately supported theory motivates him to develop, articulate, and test it, and thus advances inquiry.

This objection is focused, not on the concept of epistemic justification, but on questions about the conduct of inquiry.[18] It is *irrelevant* to the claim that believing on inadequate evidence is always believing unjustifiedly; it argues, rather, that believing unjustifiedly is not always damaging, and may even be helpful, to the progress of inquiry. This, I think, is true. Not that overbelief is ever an optimal condition for the conduct of inquiry; the ideal, I take it, would be, not for our hypothetical scientist to have faith in the theory's truth, but for him to recognize it as, though thus far unworthy of belief, nevertheless promising enough to be worthy of serious further investigation.[19] Still, given human inquirers' inevitable frailties, a scientific community in which some are disposed to overbelief and others to underbelief may, by virtue of individuals' epistemic imperfections serendipitously compensating for each other, be a reasonable *ersatz* of a community of inquirers who conform to the

epistemological ideal. So, although overbelief is always epistemologically wrong both in the sense of "epistemologically unjustified" and in the sense of "not the ideal with respect to the conduct of inquiry," it is not always epistemologically wrong in the sei,se of "damaging to the conduct of inquiry."

So I do not mean to deny that, as James observes, "science would be much less advanced than she is if the passionate desires of individuals to get their own faiths confirmed had been kept out of the game" (p. 21). The point is, rather, that because James fails to distinguish the question whether believing on inadequate evidence is always unjustified belief, from the question whether believing on inadequate evidence is always damaging to the conduct of inquiry, he runs together a correct negative answer to the latter with an incorrect—overpermissive—negative answer to the former.[20]

Clifford and James simply fail to distinguish epistemic from ethical justification; Chisholm explicitly maintains that epistemic justification is a subspecies of ethical justification. James claims that it is sometimes legitimate to believe on insufficient evidence, suggesting that a man who has a moral duty to believe that p may thereby be epistemologically justified in so believing; Chisholm explicitly denies this, but he also protests that Clifford's "rigid evidentialism" is epistemologically overdemanding, suggesting, instead, that a belief is epistemologically "innocent until proven guilty." [21]

So Chisholm's position is further from Clifford's and closer to James's than his borrowing Clifford's title for part 1 of *Perceiving* might have led one to expect. And so my disagreement with Chisholm, like my disagreement with James, extends beyond the matter of the distinctness of epistemological from ethical justification to a more strictly epistemological issue. For, where the question of epistemic justification is concerned, my position is closer to Clifford's than to James's. Closer, but not identical: for I think it vital to acknowledge the gradational character of epistemic justification:[22] whether, or to what degree, a person is justified in a belief depends on how good—how supportive, how comprehensive, and how independently secure—his evidence with respect to that belief is.[23] Ideally, I should prefer to put this in terms which also acknowledge that belief, as well as justification, comes in degrees. But the point on which I am presently taking issue with Chisholm doesn't depend on these subtleties; it is that, by my lights, one believes that p unjustifiedly, even if one's evidence supports p over not-p, unless one's evidence includes enough of the relevant evidence.[24]

The goal of inquiry is substantial truth. When one focuses on guidelines for the conduct of inquiry, one must concern oneself with

substance as well as truth. But when one focuses on criteria of justification, one is *ipso facto* restricting oneself to the dimension of truth; for truth-indicativeness is the characteristic virtue of criteria of justification. Chisholm, noting, correctly, as James does, that "playing it safe" is not always the most successful course in inquiry, then suggests, incorrectly, as James does, that this motivates less-demanding criteria of justification.[25]

Complex as this has been, it has been, thus far, focused quite narrowly on the question of the relation of epistemic to ethical *justification* only—on which I find myself in disagreement with Chisholm. I want, by way of conclusion, to offer some more positive thoughts with regard to a different dimension of epistemic appraisal—the appraisal of a person *qua* inquirer or cognizer.[26]

Our vocabulary for epistemic appraisals of character is varied and subtle ("meticulous," "sloppy," "imaginative," "closed-minded," "brilliant," "obtuse," . . .). It is striking that a significant subclass of this vocabulary is shared with ethics: "honest," "responsible," "negligent," . . . , come immediately to mind. And I am not sure but that here the relation of epistemic to ethical appraisal may be as intimate as the special-case thesis maintains. While, to be sure, one might be otherwise a very decent person (kind to one's wife and dog, charitable, honest in one's financial dealings, etc.), a failing in intellectual integrity *is* a moral failing. To my ear, at least, "he is a good man but intellectually dishonest," if not exactly an oxymoron, really does need an "otherwise."

Recall that, if my earlier arguments are correct, it is precisely when a person's unjustified believing stems, not from cognitive inadequacy, but from self-deception or negligent incontinence—from a lack of intellectual integrity[27] on his part—that we hold him responsible for his belief. This suggests a friendly reinterpretation of what is most plausible in Clifford's condemnation of "the habit of credulity," and Chisholm's defense of the special-case thesis, as pointing to the *moral* importance of *intellectual* integrity.

Which prompts the following concluding observation. At the price of a little oversimplification, one might say that, as courage is the soldier's virtue *par excellence,* so intellectual integrity is the academic's. (The oversimplification is that intellectual integrity itself requires a kind of courage, the hardihood called for in relinquishing dearly held beliefs, or in resisting some conventional wisdom or fashionable shibboleth.) As C. I. Lewis writes, more eloquently than I could: "Almost we may say that one who presents argument is worthy of confidence only if he be first a moral man, a man of integrity. . . . [W]e presume, on the part of those

who follow any scientific vocation, . . . a sort of tacit oath never to subordinate the motive of objective truth-seeking to any subjective preference or inclination or any expediency or opportunistic consideration."[28]

SUSAN HAACK

DEPARTMENT OF PHILOSOPHY
UNIVERSITY OF MIAMI
FEBRUARY 1994

NOTES

* I wish to thank Richard Brandt, Peter Hare, Mark Migotti, Sidney Ratner, Harvey Siegel, David Stove, and Joanne Waugh for helpful comments on a draft of this paper; Howard Burdick and Risto Hilpinen for helpful conversations; and the audience at Washington State University, where the paper was read in February 1994, for helpful discussion.

1. In principle, there are two other possibilities: that epistemic appraisal and ethical appraisal are identical, that ethical appraisal is a special case of epistemic appraisal. But these seem too obviously false to detain us.

2. Roderick M. Chisholm, "Firth and the Ethics of Belief," *Philosophy and Phenomenological Research* 50, no. 1 (1991): 119–28 (the quotation is from p. 119).

See also R. M. Chisholm, "Epistemic Statements and the Ethics of Belief," *Philosophy and Phenomenological Research* 16 (1956): 447–60; *Perceiving: A Philosophical Study* (Ithaca, N.Y.: Cornell University Press, 1957); R. Firth, "Chisholm and the Ethics of Belief," *Philosophical Review* 68 (1959): 493–506; R. M. Chisholm, "'Appear', 'Take', and 'Evident'," *Journal of Philosophy* 53, no. 23 (1956): 722–31; R. Firth, "Ultimate Evidence," *Journal of Philosophy* 53, no. 23 (1956): 732–39; R. M. Chisholm, "Evidence as Justification," *Journal of Philosophy* 58 (1961): 739–48; R. M. Chisholm, *Theory of Knowledge* (Englewood Cliffs, N.J.: Prentice Hall, 1966) (second edition, 1977; third edition, 1989); R. M. Chisholm, "Lewis' Ethics of Belief," in P. A. Schilpp, ed., *The Philosophy of C. I. Lewis* (LaSalle, Ill.: Open Court, 1968), pp. 223–42; R. Firth, "Are Epistemic Concepts Reducible to Ethical Concepts?" in *Values and Morals,* ed. A. I. Goldman and J. Kim (Dordrecht: Reidel, 1978), pp. 215–30; R. M. Chisholm, "Self-Profile," in R. J. Bogdan, ed., *Roderick M. Chisholm* (Dordrecht: Reidel, 1986), pp. 3–77.

From time to time Chisholm writes of "analogies" between ethics and epistemology: see, e.g., *Perceiving,* pp. 12, 13, 18, 30; "'Appear', 'Take', and 'Evident'," pp. 723 ff.; *Theory of Knowledge,* p. 1 of first, 1966, edition and pp. 57–58 of third, 1989, edition; "Epistemic Reasoning and the Logic of Epistemic Concepts," in G. H. von Wright, ed., *Logic and Philosophy* (The Hague: Nijhoff, 1980), pp. 71–78. If, as it seems, his point is that there are structural analogies between the overriding of one moral requirement by another, and the inductive overriding of a certain body of evidence by further evidence, this is quite compatible with his commitment to the special-case thesis_I.

On p. 54 of his "Self-Profile" Chisholm writes that "epistemic concepts are not *moral* concepts"; by the final sentence of the section, however (p. 56), he writes that the concepts of epistemology are *reducible to* the concepts of ethics.

3. If, as I believe, the answer to the next-to-last of these questions is clearly "yes," this is sufficient to show the special-case thesis false in its most general form.

4. Chisholm, "Firth and the Ethics of Belief," pp. 125–27.

5. Chisholm, "Lewis' Ethics of Belief," pp. 223–24.

6. A phrase of which F. C. S. Schiller reminds us in his commentary on James's "The Will to Believe," *Problems of Belief,* Hodder and Stoughton, London, n.d., p. 111. See, besides Chisholm's discussion of the quasi-voluntary nature of belief referred to above, H. H. Price's, in "Belief and the Will," *Proceedings of the Aristotelian Society* (supplement) 28 (1954): 1–27.

7. Chisholm, "Firth and the Ethics of Belief," p.127; cf. *Theory of Knowledge,* third edition, pp. 58–59.

8. In his "Self-Profile" Chisholm suggests two arguments for the general form of the special-case thesis. The concept of requirement, Chisholm says, is central to ethics, and the concept of epistemic preferability can be defined in terms of requirement; to reach the conclusion that the concept of epistemic preferability is reducible to ethical concepts, however, one needs the stronger premise that the concept of requirement is *uniquely* ethical. Knowledge, Chisholm says, is, as Aristotle thought, intrinsically valuable; to reach the conclusion that epistemic concepts are reducible to ethical concepts, however, one needs the stronger premise that knowledge is intrinsically *morally* valuable.

9. *Perhaps,* if surviving his illness enables him to continue his morally admirable work, or to meet his obligations to others, a favorable moral appraisal is in order; but that issue need not be decided here.

In the case described, the person's believing that p makes it more likely that p will turn out true, but the point does not depend on that. Think of the kind of case Peirce envisages when he observes that he could not condemn a man who, having lost his wife, induces himself to believe in an afterlife in which they will be reunited, even though the belief is unjustified, if, without it, "his usefulness would be at an end." (C. S. Peirce, *Collected Papers,* ed. C. Hartshorne, P. Weiss, and A. Burks [Cambridge, Mass.: Harvard University Press, 1931–58], 5.583, 1898.)

10. A phrase adapted from J. Heil, "Doxastic Incontinence," *Mind* 93 (1984): 56–70.

11. This comports with the attractive conjecture (proposed by J. Shelton, "Contextualism: A Right Answer to the Wrong Question," *Southwest Philosophical Studies* 9, no. 2 (1983): 117–24) that the appeal of contextualist theories of epistemic justification may arise in part from a confusion of epistemological with ethical justification. The same conjecture might also serve to explain Goldman's claim that there are two concepts of epistemic justification, one objective and reliabilist, the other context-relative; see A. I. Goldman, "Strong and Weak Justification," in J. Tomberlin, ed., *Philosophical Perspectives, 2: Epistemology* (Atascadero, Calif.: Ridgeview, 1988), pp. 51–70.

12. See Chisholm, *Perceiving,* p. 14.

13. My arguments against the special-case thesis$_j$ and the correlation thesis$_j$ presuppose that harmfulness and responsibility are necessary for unfavorable moral appraisal; my arguments for the overlap thesis$_j$ presuppose that they are

sufficient. These assumptions, though fairly weak, are of course not vacuous. For example, as the argument against the correlation thesis, revealed, someone who maintained that one has a moral obligation to develop one's capacities, generally, or one's capacity to judge evidence, specifically, would reject the former presupposition.

14. W. K. Clifford, "The Ethics of Belief" (1877), in *The Ethics of Belief and Other Essays* (London: Watts and Co., 1947), 70–96.

15. Richard Gale ("William James and the Ethics of Belief," *American Philosophical Quarterly* 17, no. 1 [1980]: 1–14) claims (p. 1) that Clifford has to be read as proposing the ethical thesis, that it is always morally wrong to believe on insufficient evidence; he observes in a footnote, however, that Clifford's words also bear another interpretation, that it is always epistemologically wrong to believe on insufficient evidence.

16. W. James, "The Will to Believe" (1896), in *The Will to Believe and Other Essays in Popular Philosophy* (1897) (New York: Dover, 1956), pp. 1–31.

17. Cf. Jack W. Meiland, "What Ought We to Believe? or, the Ethics of Belief Revisited," *American Philosophical Quarterly* 17, no. 1 (1980): 15–24, which precisely, but more explicitly, follows James in this regard.

18. The distinction is articulated in more detail in my *Evidence and Inquiry: Towards Reconstruction in Epistemology* (Oxford: Blackwell, 1993), chap. 10.

19. *The Will to Believe* is dedicated "To My Old Friend, CHARLES SANDERS PEIRCE, to whose philosophic comradeship in old times I owe more incitement and help than I can express or repay." In a letter of thanks, Peirce writes to James that in practical affairs, " 'Faith,' in the sense that one will adhere consistently to a given line of conduct, is highly necessary. . . . But if it means that you are not going to be alert for indications that the moment has come to change your tactics, I think it ruinous in practice" (*Collected Papers,* 8.251, 1897). The next year one finds Peirce writing of the "Will to Learn," (5.583), and commenting that, where science is concerned, *"Full belief* is willingness to act upon . . . the proposition. . . . [The] accepted propositions [of science] are but opinions at most; and the whole list is provisional" (1.635).

20. The argument here raises an awkward question about the intended scope of James's Will to Believe doctrine. His initial statement, that "our passional nature lawfully may decide" any genuine option "that cannot by its nature be decided on intellectual grounds," strongly suggests that the doctrine is to apply only to hypotheses, for example, of a religious nature, which are in principle undecidable by evidence. (Which, however, raises the further awkward question, whether such hypotheses would qualify as meaningful by the standards of the Pragmatic Maxim.) James's later reference to the role of "faith" in scientific inquiry, however, suggests that the scope of the doctrine is intended to be much broader, applying also to hypotheses with respect to which we merely happen, thus far, to lack sufficient evidence.

21. Chisholm, *Perceiving,* pp. 9, 11, 100; *Theory of Knowledge* (Englewood Cliffs, N.J.: Prentice-Hall, 1966), pp. 18–19. (The reference to Clifford is, however, missing from the second and third editions of *Theory of Knowledge.*) Chisholm's disagreement with Clifford on this matter seems to have escaped the attention of some commentators; see, e.g., L. Pojman, "The Ethics of Belief," *Southwest Philosophical Studies* 9, no. 2 (1983): 85–92, who describes Chisholm as subscribing to "rigid evidentialism," according to which "one ought to believe propositions if and only if they are backed by sufficient evidence." Pojman

attributes this account of Chisholm's position to Meiland, "What Ought We to Believe?"; but the attribution is incorrect, since Meiland is careful to distinguish a stronger evidentialism (one has a right to believe that p only if the evidence is sufficient) from a weaker (one has a right to believe that p provided one does not have sufficient evidence for not-p), and does not say which, if either, he takes Chisholm to hold.

22. Chisholm too seems to acknowledge the gradational character of epistemic justification, most clearly in the third edition of *Theory of Knowledge*. But the fact that epistemic justification comes in degrees, whereas (I take it) ethical justification does not, suggests a further argument against the special-case thesis$_j$.

23. It is because I take comprehensiveness to be only one of three determinants of degree of justification that I shifted, above, from Clifford's favored expression, "insufficient evidence," to writing of "inadequate evidence," which is, I hope, less likely to suggest failure of comprehensiveness alone.

24. My account of the determinants of degree of epistemic justification— one of which is, how much of the relevant evidence the subject's evidence includes—is spelled out in detail in *Evidence and Inquiry,* chapter 4.

My comprehensiveness requirement is motivated in part by an analogy between the structure of empirical justification and a crossword puzzle; as the reasonableness of one's confidence that a crossword entry is correct depends in part on how many of the intersecting entries one has completed, so one's degree of justification in a belief depends in part on how much of the relevant evidence one's evidence includes. So my neglect of the analogy thesis does not stem from any prejudice against analogies, nor, I should add, from the belief that there are no interesting analogies between metaepistemology and metaethics. For explorations of such analogies, see (besides the papers of Firth's referred to above) R. B. Brandt, "Epistemology and Ethics, Parallels Between," in the *Encyclopedia of Philosophy,* and "The Concept of Rational Belief," *Monist* 68, no. 1 (1985): 3–23, and W. P. Alston, "Meta-Ethics and Meta-Epistemology," in Goldman and Kim, eds., *Values and Morals,* pp. 275–98.

25. Chisholm, *Perceiving,* p. 22; *Theory of Knowledge,* 3d ed., pp. 13–14.

26. There remain, of course, many other important questions which I shall have to put aside: for example, whether Chisholm and Firth are correct in supposing that justification is as central a concept in ethics as, I agree, it is in epistemology.

27. An expression which comports with the plausible idea that thinking is well-construed as inner dialogue, and self-deception as involving distracting one's own attention from inconvenient evidence, just as the deception of another involves distracting his attention. Cf. Peirce, *Collected Papers,* 5.421, 1905.

28. C. I. Lewis, *The Ground and Nature of the Right* (New York, N.Y.: Columbia University Press, 1955), p. 34. Of course, Lewis is using "scientific" in a broad sense, equivalent to "intellectual." The reference to a "tacit oath," by the way, suggests that the special-case thesis$_j$ may seem more plausible than it really is to those who are bound by such an oath, and thus have a special moral duty to objective truth-seeking.

REPLY TO SUSAN HAACK

I can best deal with Susan Haack's challenging criticisms by saying something about the general context in which I have viewed "the ethics of belief." Haack and I have been using the expression, "the ethics of belief," to refer to different subject matters. In the sense in which she uses it, which is its ordinary philosophical sense, it refers to the type of question that divided W. K. Clifford and William James. I have been using it to refer to certain *normative* questions about the *justification* of belief.

I have been concerned with two quite different epistemological concepts—*epistemic justification* and *requirement.* I have written at length on the logic of each of these concepts, noting in particular the remarkable resemblance between the logic of requirement and the logic of probability, or confirmation. To understand this resemblance one must understand which of the two usual senses of "probability" is intended. As Carnap pointed out, one of the two senses presupposes the concept of *evidence* and the other does not. It is only the former sense that is important for the theory of knowledge.

Haack's comments also presuppose the concept of *evidence.* Although she discusses this concept in detail in other writings, she does not do so in the present essay. Her readers might gather, mistakenly, that neither of us has been concerned with this concept. And so I would want to emphasize (1) that I have taken the analysis of the concept of the evident to be the central question of epistemology and (2) that the concept is a *normative* one. Hence the analysis has to do with "the ethics of belief."

Taking *epistemic justification* as undefined, one can construct a hierarchy of epistemic concepts. I begin with an account of what it is to say that a proposition is *probable* for a given subject at a given time. Then I go on to (epistemic) *acceptability,* then to *being beyond reasonable doubt,* then to *being evident*, and, finally, to *being certain.* One cannot

answer the questions that I was trying to answer without making such distinctions.

Some contemporary epistemologists (not Haack) have called themselves "evidentialists" and seem to pride themselves in being able to treat epistemology without asking what evidence is. But what can they tell us about what we know?

These days you can hire a contractor to build a "modular home" for you. You pick out, for example, the rooms, closets, windows, floors, and ceilings that you need. A contractor will then order them from the company that makes such things and, when they arrive, he will assemble them for you, almost without pounding any nails at all. The first time, at least, that he does this he will need to consult a manual. Possibly, unlike most assembly manuals, this one is beautifully clear. But—and this is the moral of the story—it would not be a treatise on the essentials of carpentry. And I like to think that, replacing "carpentry" by "epistemology," this is what I have been doing all these years. Haack would agree with me in rejecting any such "prefabricated epistemology."

After reading Haack's comments, however, I realize that there is a lot that I have left undone. There is a good-sized bundle of epistemological questions that I have been unclear about.

I had said in my essay on Firth: "One's duty at any time is to fulfill those of one's requirements that are not overridden at that time." Even the most sympathetic reader will find that this statement leaves many urgent questions unanswered. One such question could be directed upon *fulfillment:* "Don't you mean *try* to fulfill, or *try one's best* to fulfill?" Another could be directed upon the *time* of the fulfillment, or attempted fulfillment: "Don't you mean that you should try to do it at the *most opportune time*?" And the most fundamental epistemological questions remain unanswered. "Don't you mean that you should try to fulfill those requirements that you *know*—or are *justified in believing*—to be such that they are not overridden?"

These questions cannot be answered without having an adequate theory of our *knowledge of moral philosophy.* Such a theory could also be said to deal with the ethics of belief.

Haack is especially concerned about what she calls "the relation of epistemic to moral justification." But we should take care to distinguish that question from several closely related questions. I here formulate some of the questions that one might ask and I suggest my answers to them. (A) Moral justification is a *special case* of epistemic justification— in the sense in which I have been using "epistemic justification." (B) Moral requirement is a *special case* of requirement. And (C) epistemic

justification is *analogous to* requirement; I refer here to what I have said about the analogy between the logic of confirmation and the logic of requirement.

So far as the questions of epistemology are concerned, Haack and I, as well as Firth and I, agree with respect to what is fundamental and disagree about other points.

R.M.C.

6

John Haldane

FORMS OF THOUGHT

Aristotle taught that, in knowing, the soul "receives the form of the object" and that "actual knowledge is identical with its object." . . . This doctrine which was developed by Thomas Aquinas and his commentators . . . could be taken to say that, when [a] man perceives a dog, then the man, or his soul, takes on all the characteristics of the dog, though without becoming identical with the matter of the dog, and that when the man perceives a dog and a bird together, then the man becomes "formally identical" with the dog, and also with bird. There have been many attempts to make this doctrine intelligible, but I cannot feel that they have been successful.

Roderick M. Chisholm, *The Foundations of Knowing*

I. INTRODUCTION

Like many others, my first introduction to the idea of intentionality, as that had been discussed by Brentano and earlier by the medievals and neo-Scholastics, was through writings of Roderick Chisholm. Because of his use of semantic ascent these writings have often been characterized as examples of logico-linguistic analysis (as, in a sense, they are); but what immediately struck me as a student was the idea that intentionality is ontologically significant, and subsequent reading led me to see that ontology is central to Chisholm's own understanding of philosophy. As he writes in the introduction to a collection of his essays, *On Metaphysics:* "reflection on the self and on what it is to think provides us with the key to understanding the fundamental categories of reality."[1]

In his book *Perceiving* and elsewhere, Chisholm refers us to Brentano who cites medieval ideas about intentionality. But as my opening quotation suggests, Chisholm himself is doubtful as to the intelligibility of Scholastic and neo-Scholastic views, and his words stand as a challenge to anyone disposed to favor them. In other places I have argued that Aquinas provides an attractive theory of intentionality that identifies the kinds of processes involved in the genesis of thought and gives

account of the nature of the subject and the objects of knowledge.[2] As in Chisholm's philosophy, ontology and epistemology stand together in the Thomist scheme. Indeed, in a sense the latter is contained within the former, for according to Aquinas cognition is a way of being. Something is thought of only insofar as an aspect of it is 'in' the thinker. To most contemporary philosophers this claim will sound very odd; not just because it is unfamiliar, but more importantly because it seems to invoke peculiar notions of nature and existence. Nonetheless, I want to respond to Chisholm's challenge and try to render the doctrine intelligible, or at any rate to make a start on that task.

Outright rejection of Scholastic epistemology often results from consideration of its ontological aspect, but this is frequently a reaction to misrepresentations of the classical theory, or else is aimed at obscure versions espoused by late Scholastics. What these representations suggest is the view that, again quoting Chisholm:

> [the word] 'unicorn' in 'John is thinking about a unicorn' . . . is being used simply to designate a unicorn . . . but a unicorn with a mode of being (intentional inexistence, immanent objectivity, or existence in the understanding) that is short of actuality but more than nothingness.[3]

While some *may* have held this view it should be clear to anyone who reads him that Aquinas does not imagine that what 'inexist' in thought are particulars, real or otherwise. Intentional being is not a mode of existence of *substances* but a kind of *predicational* existence—that in which, it is claimed, the form of the thing thought of also characterizes the intellect, thereby giving content to its acts.

Even if the most obvious objection can be easily deflected difficulties remain, for it has yet to be shown that the belief in the existence of forms and in the possibility of their distinct realizations is coherent. In what follows, then, I shall argue first, and in somewhat Chisholmian spirit, that it is necessary to admit universals into our ontology and to distinguish two classes of these, corresponding (in part) to Aquinas's distinction between substantial and accidental forms. Second, I will explicate and defend the claim that forms can be exemplified naturally and intentionally. Third, I shall address a question concerning the intentionality of thought; and to finish I shall offer some brief remarks about how best to understand the Thomist account of cognition.

Throughout my aim will be to offer an adequate theory inspired by Aquinas's writings rather than to engage in textual exegesis, and as will become clear I believe it is sometimes necessary to reject aspects of Thomas's stated view and to go beyond it. In short this is a philosophical defense not a historical study; an exercise in 'Analytical Thomism'.

2. THE FORMS OF THINGS

In many respects St. Thomas is an Aristotelian but rarely, even when he follows him, does he simply reaffirm Aristotle's claims.[4] Thus, while he agrees with the rejection of Platonic realism he does not take the view that universals exist in particular things, but instead holds to a theory according to which universals only exist *as such* in the intellect. This is not meant as a version of nominalism. Aquinas is not denying that there are common properties, but he maintains that while the nature of X may be formally identical to that of Y, nevertheless the two natures are numerically distinct.

While one may respect the anti-Platonic motivation of this theory the favored alternative seems incoherent, at any rate as it stands. In trying to locate a *via media* between extreme realism and nominalism Aquinas ends up with an impossible doctrine which threatens to fall into conceptualism but which can, I believe, be collapsed to an interesting and plausible version of the Aristotelian *universalia in rebus* view.

Aquinas's major work on this topic is *De Ente et Essentia,* in which he links the affirmation of the existence of natures with the denial of extramental universals by introducing the idea of individualized forms. To speak of 'F-ness' on this account is always to refer to the f-ness of some particular—save where F-ness features qua universal in thought.[5] Thus while Plato and Aristotle are both men and thereby have specifically identical natures, the form *Humanity* does not exist save in the intellect where it has been formed from the contents of sense-experience. The *humanity-of-Plato* is not that of Aristotle, just because they are distinct individualized forms. Aquinas writes:

> There is nothing common in Socrates, whatever there is in him is individuated. . . . It remains, then, that human nature happens to have the character of a species only through the being it has in the intellect, [and elsewhere he observes] Form is made finite by matter inasmuch as form, considered in itself, is common to many; but when received in matter the form is determined to this one particular thing.[6]

A form is a principle of determination; that in virtue of the possession of which an individual has such and such a character, be it a *substantial nature,* for example, humanity, or an *accidental feature,* for example, whiteness. Considered as such a form is general, but, pace the Platonist, humanity or whiteness do not exist qua universals independently of men and white things. It is his insistence on this point that leads Aquinas to deny that even when whiteness, say, does exist as a characteristic of a thing, what exists is something universal. There is only

the whiteness of this and of that, these 'whitenesses' being numerically distinct natures. Of course, it can hardly be denied that F-ness is a general feature, but Aquinas argues that it only exists as universal when it has been extracted from particular individuating conditions through intellectual abstraction.

The main problem for this view is that it appears to make sense only on the basis of an assumption it denies. The notions of individualized forms or particularized qualities are themselves acceptable, or so I believe;[7] but if one holds that the f-ness of X and the f-ness of Y are specifically alike, though numerically distinct, this surely amounts to the claim that they are instances or cases of the *same* nature. The humanity-of-Plato may be something different in *rerum natura* from that of Aristotle; and the account of this difference may be as Aquinas claims, namely, that humanity is determined to distinct occurrences by virtue of informing different quantities of matter. Yet it remains the case that the nature of Plato qua man is identical with that of Aristotle qua man. As men they have something in common, specifically, human nature.

If talk of 'individualized forms' is taken as a way of referring to the f-ness of X, the f-ness of Y, etc., it is unobjectionable: there is one form F-ness and many cases of it. One can also combine this with the claim that F-ness does not exist extramentally apart from the particulars it characterizes. What is problematic, however, is the claim that there are *many* F-nesses. If distinct whitenesses were distinct natures there could be no more reason for speaking of them as whitenesses than there would be for terming different colors 'whiteness'. Unless individualized forms are instances of general, and thereby multiply exemplifiable, features they must be distinct natures; and if the latter then there is no ontological basis for our ways of grouping things. The association of X and Y in point of their characteristics can only be the work of the mind, which is in effect the common underlying thesis of nominalism and conceptualism.

Aquinas rejects nominalism, for he sees that unless there are repeatable structuring principles and characterizing features, then both ontological and epistemological individuation would be impossible. The distinctness of things and the possibility of our identifying different entities depend upon the existence of common elements. In order to secure reference we need to invoke some principle of classification supplied by concepts expressed by the use of general terms; and the application and reapplication of such a term in different contexts presupposes sameness in respect of those features that invite its use. To deny this implies that thought and talk are arbitrary.

The existence of mental universals is implied by the fact that different mental episodes can have the same content either in part or in whole. Indeed, the creativity of thought entails that not every mental act could be semantically simple. There must be conceptual components out of which thoughts are structured; components which are general in nature and can recur in thoughts of the same or of different types. This commitment to the existence of both concepts and occurrences of them parallels the distinction between natural universals and their cases: individualized forms. On this qualified version of the Thomist view an encounter with Socrates might involve three different items: a) the individual *Socrates;* b) the individualized form *the-humanity-of-Socrates;* and c) the general nature *Humanity*. As before, it need not be assumed that *Humanity* is a Platonic idea; universals exist apart from cases but only as such in the intellect.

Here two objections might be raised. First, Aquinas holds that all natures exist as ideas in the mind of God, and given that he also believes that the universe had a beginning in time it follows that there was a point at which Forms existed though they had no instances. Second, the claim to be espousing a moderate realism may seem to be falsified by the view that thought is a way of being. For if the general model of cognition is that to think of some F requires the occurrence of F-ness *in esse intentionale,* then in the case in which one is thinking of a unicorn, say, it seems that the form *Monocericity* must feature. If so, then the claim that there is nothing in the intellect that was not first in the senses is false, and there are (as Chisholm believes) uninstantiated universals. This conclusion seems to be confirmed by Aquinas's treatment of the role of a species as a *forma exemplaris,* or blueprint, in creative activity which, as in the case of the Divine ideas, suggests that some forms first exist in the intellect and are only later, if ever, realized in the world.

The first objection has some force so far as Thomas's own theory is concerned, for there are strains of Platonist ultrarealism in his thought. These are generally strongest in his theology but find their way into other areas. This element may be inessential and detachable, but in any case one should note that the commitment to the preexistence of forms in the mind of God is compatible with the claim that universals do not exist as such save in the intellect. In reply to the second objection it should be recalled that thought must involve construction if creativity is to be explained; and this process is not limited to the production of novel arrangements of given concepts but involves the formation of new elements out of the products of sense-experience. Aquinas gives an example at a fairly basic level of the 'combining and dividing of forms'

when he writes: "from the form of gold and the form of a mountain we compose the one form of a golden mountain."[8] Similarly the concept *Unicorn,* or as above, the form *Monocericity,* is plausibly to be thought of as a complex; and while one may maintain that its component forms could not be in the mind were they not first in the world, it would be inappropriate to require the same of the complex qua complex. The implication, then, is that thoughts involve either simple concepts or structures composed of these, and that empirical concepts are derived from cases, either directly or by a process of construction worked upon concepts abstracted from the world.

3. PROBLEMS OF SUBSTANCE AND INDIVIDUATION

So much for the modified Thomist ontology of natural forms; it remains to be shown that this is plausible. The admission of concepts is a recognition of the existence of properties of a kind, and the nominalist's suggestion that concepts are the only universals is challenged by the claim that what underlies their exercise in application to the world is the recognition of commonness among things. However, the acceptance of the general in both thought and world falls short of the view that it is the *same* universals that occur in both; or that the distinction between sortal and characterizing concepts has a parallel in the world in the difference between substantial and other forms.

One argument for the first of these doctrines—that concerning intentional and natural modes of exemplification—is suggested by considerations concerning the conditions for reality-intending thought. Reflection upon Cartesian and Lockean representationalist theories of cognition indicates the need for an explanation of cognitive presence which the introduction of mental surrogates, *ideas,* fails to provide. An appeal to formal identity between mental act and object looks more promising; but this appeal presupposes the possibility of distinct kinds of exemplification: intentional and natural. The problem with this argument in the present context, however, is that someone who believes that the *esse intentionale/esse naturale* distinction is incoherent is bound to reject the assumptions that yield it; and since the argument depends upon the elimination of alternatives he or she is likely to insist that some other explanation of cognition must be available. Thus rather than try to show that the only possible account of thought is the Thomist one, and that one must accept whatever it entails, it will be better to try to demonstrate the coherence of the implied ontological claim, and so

remove that obstacle to acceptance of this theory of cognition. I shall postpone this task, however, until I have discussed the distinction between forms. Only if there are substance universals does it make sense to inquire whether they inform thought as well as things.

A short route to the existence of substantial forms seems to be offered by reflection upon the fact that there are substance concepts, together with the principle that the structure of thought reflects that of reality. But even if there is reason to accept this principle for some areas of thought it does not follow that it applies in the present case; and it is open to someone of even realist persuasion to offer a reductionist account of substance concepts. There is, however, a less direct path which leads if not exactly to the desired conclusion, then to a position which favors its adoption, and involves the rejection of reductionist theories of substance. Recall Aristotle's question in the *Metaphysics* of what it is to be a particular substance, a *'this thing'*.[9] So put, it seems that two issues have been raised. First, that of particularity which calls for a theory of individuation; and second, that of substancehood requiring a theory of things. These categories are not obviously the same and I agree with Chisholm that there are nonsubstantial particulars, for example, events and/or states of affairs, which though they often involve substances do not do so essentially.[10] Nonetheless the two concerns overlap since substances form a large and important category of particulars and it is proper to ask what makes them such.

Familiarly, talk of 'individuation' is ambiguous between epistemological and ontological concerns: bearing, respectively, on the questions of how we pick things out, and of what, if anything, makes things to be diverse. With regard to the latter issue two opposing theories of substance have been advanced which also claim to offer an explanation of particularity. First, there is the thesis that what we regard as particular objects are just groupings or clusters of characteristics standing in some Russellian or other relation of 'compresence',[11] and that individuation is secured by variation in respect of such constituent properties. Second, and set against this, is the theory that underlying any feature, or collection of properties, is a featureless bearer or substratum, the individuality of distinct substances being secured by the presence in each of numerically distinct bare particulars.

Clearly both views are reductionist, holding that what we identify by substance concepts such as *man, horse, table,* etc., are not themselves basic entities but are composed of more primitive elements. This conclusion is contrary to reflective common sense, and whatever their initial appeal both theories face considerable objections. Consider first

the substratum view. It claims support from the thought that predication entails the existence of a property-bearing subject that is not itself a property. Similarly the fact of persistence through change implies the existence of an unchanging component which constitutes the identity of the substance over time. Finally, the apparent conceivability of qualitatively indistinguishable yet diverse substances seems to favor the substratum over the bundle theory, since it implies that a substance is more than a complex of characteristics. However the incoherence of the substratum view is exposed by the consideration that the arguments in its favor all lead to absurdity: in order for certain conditions to be satisfied there must be resident in each thing a something that is not anything. Predication, diachronic identity, and individuation are explained by the introduction of a constituent the very notion of which is contradictory: *it* can have no qualities because *it* is what has all the qualities; alteration consists in *it,* the subject of change, not changing; and finally, what makes substances distinct is the presence in each of a propertyless element which yet has the property of being distinct from all other such elements.

Against this background the cluster theory can seem to gain plausibility. In experience we encounter instances of sensible characteristics, and one may argue that the idea of a substance is that of a group of coinstantiated features. Differences in constituent characteristics thereby entail the diversity of groupings (recall that on this view properties are the only constituents there are), and this implies some version of the principle of 'substance' individuation entitled by McTaggart the *dissimilarity of the diverse,*[12] the contraposition of Leibniz's *identity of indiscernibles.*[13] On reflection, however, the cluster theory is troubled by objections parallel to those confronting its rival. Identity through change seems to be excluded: if there is change in respect of some constituent characteristic of a substance S the resultant set S* is different and hence S has ceased to exist. Predicative judgments are rendered (directly or indirectly) either tautologous if true or contradictory if false: the attribution of f to S converts to the claim that what is f is f, and the ascription of \neg f is equivalent to the assertion that what is f is \neg f. Most pressing, however, is the problem of individuation. The substratum account having failed to explain the particularity of substances, the question arises as to whether the present alternative theory can succeed, which is equivalent to asking if properties suffice to diversify the particulars they are taken to constitute. Clearly it is not sufficient that the diversity of dissimilars be contingently true. Doubtless there are no distinct though qualitatively indistinguishable substances, but the issue

concerns whether something of this sort is necessarily (i.e., metaphysically) true. In support of the claim that there *cannot* be diverse indiscernibles Leibniz offers the following:

> If two individuals were perfectly alike and equal and (in a word) *indistinguishable* in themselves, there would be no principle of individuation; and I even venture to assert that there would be no individual distinction or different individuals under this condition. That is why the notion of atoms is chimerical, and arises only from incomplete conceptions of men. For if there were atoms, i.e. bodies perfectly hard and perfectly unalterable or incapable of internal change and capable of differing among themselves only in size and shape, it is plain that in the possibility of their being of the same shape and size they would be indistinguishable in themselves, and could be distinguished only by means of external denominations without an internal basis, which is contrary to the highest principles of reason.[14]

This, though, simply begs the question in favor of the theory that substances are clusters of characteristics and against the view that diversity is attributable to some other source.

Notwithstanding that further complexities could be introduced, enough has been said to cast doubt on both theories. The absurdity of the substratum position is evident, and reflection on the issue of individuation suggests the falsity of the cluster theory, since, pace Leibniz, it is surely conceivable that there could be diverse but indiscernible atoms. This objection assumes what Leibniz grants, namely, a restriction on the relevant kinds of properties. Thus while there is little if any room to contest the identity of indiscernibles when f, in the formulation $(\forall x)(\forall y)(\forall f)[(fx \leftrightarrow fy) \rightarrow (x = y)]$, includes both nonrelational and relational characteristics, the latter presuppose the prior individuation of at least one item in relation to which others may be individuated.[15] Accordingly, the unrestricted principle cannot serve as part of a reductive analysis of substances and of an associated theory of property individuation. If, on the other hand, the principle is held in the nontrivial Leibnizian version with f having as values only nonrelational characteristics, it is open to the objection of being at most only contingently true; no matter how complex the grouping of general characteristics particularity is not guaranteed.

4. Substantial Forms

> Numerically distinct substances do not differ merely by their accidents, but also by matter and form. If one asks why one form differs from another of the same kind, no other explanation can be offered except that they are

in different determinate matters. Nor can it be discovered how matter comes
to be earmarked otherwise than by quantity. Therefore matter as subject to
determinations is indicated in the principle of this diversity.

St. Thomas Aquinas, *Philosophical Texts*

One lesson of the failure of bare particular and cluster theories is that
one ought not to look for a reduction of the idea of a substance to that of
some more basic ontological category. With this in mind it is appropriate
to return to Aquinas. On the Thomist view particular objects are made
to be the things they are by substantial forms. These are the designata of
sortal predicates, and an individual substance is a case of such a nature.
Further, each object instances only one *substantial form* but possesses
other *accidental forms,* that is to say, it exhibits several characterizing
features, or characteristics. To be an instance of a substance universal is
simply what it is to be an individual thing. Every substance belongs to a
kind and substance kinds diversify their extensions.[16] The range of
substantial forms as here conceived of includes both natural and
synthetic kinds, e.g., both universals such as *Horse, Man, Tree,* etc., and
House, Table, Shoe, and so on, i.e., those providing principles of organic
and functional organization; but it excludes analytically introduced
types. The concepts *bachelor,* and *prime minister,* are both sortals, but
they only provide principles of identity and individuation insofar as they
presuppose another sortal concept, i.e., 'man', the referent of which is a
substance universal, namely, *Humanity* and/or its instances (individual-
ized forms).

It is now important to distinguish between substantial and character-
izing attributes, for, as was indicated, the latter do not constitute the
particularity of objects but presuppose prior individuation. The former,
therefore, must be viewed as universals of a unique and fundamental
sort. It would be a mistake, therefore, to read the present proposal as a
version of the cluster theory. To exemplify a characteristic f is to *have* the
property f; to instance a substance universal S is to *be* an S. The latter is
the prior mode of universal instantiation. This emerges in the Thomist
view in the claim that while both incidental and substantial forms are
particularized in their natural exemplification, the individuality of the
former depends upon the prior individuation of the latter. The whiteness
of a certain man is only *this* whiteness in virtue of *this* case of humanity;
and there is no further source of individuation contrary to the substra-
tum theory. Thus while we identify substances *by* their characteristics it
is the mistake of the cluster theorist to identify them *with* their
characteristics, a mistake carried over into one interpretation of the
identity of indiscernibles.[17]

This said, there is a sense in which for Aquinas a substantial form is a 'component' of an object: but misunderstanding the meaning of this has led many commentators to conclude that he is an advocate of the bare substratum theory. Considered in one way, the question, what makes two men to be two? is unintelligible. Men are diverse by being men; the species *man* diversifies its membership. One who grasps the concept *man* knows that (outside the intellect) *humanity* only exists in men where it is particularized. As I argued, however, the doctrine of individualized forms is only coherent if we suppose that these are instances of universals. Thus, Socrates exemplifies *Humanity* and has as an aspect the particularized form: *the-humanity-of-Socrates.* The latter entity is something unique to Socrates, the former is shared by Plato, Aristotle, and all other men. In considering the individuality of any given man, therefore, we must appeal to the concept of an occasion or ground for the occurrence of *humanity,* and this Aquinas does by the introduction of the notion of matter. Here again, though, there is need for clarity since two notions of matter feature in the texts: *materia prima* and *materia signata quantitate,* 'prime matter', and 'a quantity of designated matter', respectively.

Aquinas's claim that matter is the principle of individuation may give rise to two objections. First, that it is part of an attempt to reduce the category of substance to two more basic ontological categories—those of *Form* and *Matter;* and secondly, that he believes individuality is attributable to the presence in substances of the latter formless substratum. These inferences are encouraged by some passages and certainly are made by Thomist commentators, but they misrepresent Aquinas's thought as expressed in *De Ente et Essentia* and elsewhere. In the former he makes it clear that his position is neither reductive nor a version of the bare particular theory:

> What we must realise is that the matter which is the principle of individuation is not just any matter, but only designated matter *(materia signata quantitate).* By designated matter I mean that which is considered under determined dimensions.[18]

This notion of matter corresponds to that of the stuff of which a thing is made: a man—flesh and bones; a house—bricks and mortar, and so on. The sense in which matter individuates is simply that in which different men, say, are composed of different quantities of stuff. But these quantities are not portions of a featureless substratum. All *materia signata* is stuff of one kind or another. The other notion of matter as 'prime' is simply a philosophical abstraction. Different men have in common human nature yet they are distinct, and this involves different

quantities of physical material exhibiting the same constitution. Yet we can abstract from the idea of kinds of natural ingredient the notion of matter in general, i.e., of the potentiality for the natural instantiation of a substantial form. As Aquinas writes: "Now matter is in a way made finite by form . . . inasmuch as matter, before it receives form, is in potentiality to many forms, but is terminated by that one."[19] What is invoked here is not the idea of a kind of stuff; in this sense of the term, *materia* is not anywhere and is not anything *a fortiori,* it is not that in virtue of which substances are distinct. The idea of *materia prima* involves the properties of individuality, potentiality for change in respect of features, and spatiotemporal location,[20] but what have these properties are substances and not some mysterious superelement, 'prime matter'; and the consignments of matter of which things are composed are not identifiable as unities other than *via* reference to the substances they physically constitute.[21]

5. FORMAL IDENTITY

The application of the ontology of forms to the theory of cognition requires not only that there are natures but that these are open to radically different manners of exemplification; more particularly, that one and the same form can exist both naturally and intentionally. This claim is not unproblematic but I shall try to suggest the lines along which a coherent account might be developed.

First, a distinction is called for between *natures* or forms, and *actuality.* This contrast corresponds roughly to that implied by the medieval distinction between *essence (quidditas)* and *being (esse).*[22] For Aquinas an act of being *(actus essendi)* or an 'existing' is what realizes an essence. Correlatively, the latter is what gives the act the content it has— it specifies it as the existence of such and such a nature. As before there is a risk of misunderstanding. It is not being suggested that actuality or existence is a kind of quantity bits of which detach themselves and are dressed in certain forms; or conversely that there are natures somehow awaiting 'animation' by an act of being. The legitimacy of the distinction does not depend on such a dualism. There is no *actus essendi* that is not the existing of something or other: nor any nature that does not exist somehow. By the same token the contrast is not merely verbal but relates to different ontological aspects of things. One might properly point to a man in answer to the question: is humanity existent anywhere? And similarly respond to the inquiry, what existence is *this?* (in which a man

is indicated), by saying: 'it is that of an instance of humanity'. The idea that 'exists' might ever be a genuine (as opposed to a 'logical') predicate is denied by a tradition deriving from Kant. But that denial is usually related to opposition to versions of the ontological argument according to which existence is a perfection, and it is not at all clear that the notion of existence involved therein is the same as the one employed here, which is best thought of as equivalent to the idea of actuality or occurrent being. To cease to be actual is to cease to be—to perish.

There is, however, one important point at which the distinction I want to employ and that discussed by Aquinas differ. Generally I have spoken of 'substantial forms' or 'natures', and 'essences', as if they are equivalents; but as Aquinas uses them, and it will be useful to respect that usage here, *form* and *essence* defer to distinct kinds of entity. Consider the form *Humanity*. This is a substance universal which in its natural realizations specifies quantities of matter, and this involves the formation of stuff into flesh and bones, limbs and organs, etc. It belongs to the essence of a man qua man to have this type of material constitution. However, flesh and bones (i.e., matter) are not part of the form *Humanity* but are aspects of its instantiation in nature. Essence in this context is what belongs necessarily to a substance that instances a substance universal. As Aquinas writes: "The word essence in regard to (composite) substances signifies that which is composed of matter and form."[23]

This development of the distinction between form and actuality needs to be made if the claim about distinct modes of exemplification is to be stated coherently. What is common to world and thought cannot be something the existence of which necessarily involves the organization of matter as does a Thomist essence. What follows on this view is that a particular man, John, say, exemplifies the form *Humanity,* and the instance or case of this form, *the-humanity-of-John*, is not independent of that by which John is a man, i.e., his actuality *(actus essendi).* For if the latter ceases, John and the case of humanity that is an aspect of him no longer exist. There is, however, a real distinction between the universal and John's actuality, evident from the fact that the annihilation of John is not the destruction of *Man* as such. Equally the perishing of this case of *Humanity* does not involve the ceasing to be of all other instances. In short, the f-ness of X is inseparable from X and its existence, but F-ness itself is distinct from, though exemplified by, X.

Since the central tenet of this version of moderate realism is the claim that forms exist in their exemplifications, what has to be made sense of is the idea that there are different kinds of exemplification. Here, then, it

may be useful to set out a table of the relevant entities and relationships since they comprise a more complex ontology than familiar expressions of the doctrine of *universalia in rebus*.[24] First, the three different kinds of existents, and following them four relations:

1. *F-ness*—the universal, or form
2. *The f-ness of X*—a singular case, or instance
3. *X*—a particular subject
4. X *exemplifies* F-ness, or X is an *exemplification* of F-ness
5. X *possesses* F-ness but not the f-ness of X
6. The f-ness of X is an *aspect* of X
7. The f-ness of X is a *case* or *instance* of F-ness

The motive for postulating (1)–(3) is that developed earlier; (4) is simply a statement of *universalia in rebus;* (6) and (7) are expressions of the thesis of individualized forms; and (5) follows from this, since what are *exemplified, possessed,* and *exhibited* are universals and not particularizations of them. The latter are aspects of the subjects in which they inhere and cannot be shared. A consequence is that *exemplification* and *instantiation* are different phenomena, as is illustrated by the example of John. While he exemplifies Humanity, it is not he but that essential aspect of him, the-humanity-of-John, that is the corresponding instance of the form.

Previously it was suggested that the existence of individualized forms is to be explained by reference to the matter which they specify—and in the case of characterizing properties by reference to the substances they qualify. This suggests the possibility that the form *Humanity* could be exemplified but not instanced. Since being a case of *Humanity* involves the organization of matter, should this be absent then while instantiation would be ruled out exemplification could still occur. One might perhaps settle for this conclusion and suppose that in thought the conditions for exemplification without instantiation are met. Such a view would seem to presume two things. First, that there is just one kind of exemplification and that the question of why in thinking of a horse one is not oneself a horse is to be answered by reference to the failure of what might be termed 'instance generation'. Second, and presupposed by this, is the idea that thoughts cannot be material states—or else given only one form of exemplification, and the presence of matter a case of equinicity ought to be generated.

Aquinas certainly does maintain that thought is not a physical process and his arguments for this conclusion involve the doctrine of *esse intentionale;* but there is a different, and I believe better, interpretation of these issues which recognizes the point about the involvement of

matter in the generation of cases, but which nevertheless invokes distinct kinds of exemplification. After all what exemplifies Humanity is not John's case of this nature but John himself, and John is a (psycho)-physical substance. This follows from the general claim that all natural objects are kinded, i.e., each material continuant exemplifies a substance universal. When John thinks of a horse, equinicity is exemplified, and what exemplifies it is either John or an event incorporating John as a constituent. Certainly in this example no aspect of John is an instance of *Equinicity* but the explanation of this seems to reside not just in the conditions of exemplification but in the character of (the) exemplification itself.

Consider cases in which what John is thinking of is a man, or the universal *Humanity*. These entail that the same form is exemplified twice and it is John that does the exemplifying on both occasions. We might say that the generation of the-humanity-of-John is something additional to exemplification as such; but we cannot escape tying some exemplifications to the existence of individualized forms. Consequently there is reason to distinguish between that sort of exemplification which occurs when so much stuff exhibits a certain nature, and which entails the existence of a singular form—a particular entity distinct from other specifically identical cases—and another kind of exemplification which involves the occurrence of the form as such, and not the generation of a case. This distinction, I suggest, provides a coherent interpretation of the theory of *esse naturale* and *esse intentionale*.

Of course intentional exemplifications of universals are numerically distinct, just as are their natural exemplifications. But the latter have an additional distinctness associated with the establishment of different cases and owing to the individuation resulting from the involvement of quantities of matter. Relatedly, the exemplification of F-ness in thought is not logically tied to any case of F-ness, for none is generated by the occurrence of the form in the intellect. Certainly the explanation of the subject's capacity to exemplify universals in this way presupposes prior contact with instances of them, or of constituent forms, but this link is a species of causal one—though not, I believe, one reducible to efficient causation alone.[25]

Through experience and reason the subject comes to acquire concepts that are intentional counterparts of naturally existing substantial and accidental forms, and thereby an intrinsic connection between mind and world is established. Concepts or intentional forms provide the basis of mental and derivative forms of content, but since they are universal they fail to yield singular reference which is achieved (directly and indirectly)

via perceptual states. If, like Chisholm, we take intentionality seriously, resisting attempts to reduce it to the shadow of linguistic meaning, or to the expression of a stance taken in response to behavior, and insist that in thought the world is cognitively present (what Chisholm terms 'presence in presence'),[26] then an appeal to the occurrence in thought of the same entities as structure the world is indicated. This in turn implies the applicability of a set of ontological distinctions: between individuals and general natures; form and actuality; and natural and intentional exemplification. For only if thought has access to the forms of things, and thereby to things themselves, can it be true that thought is immediately directed upon the world. The claim that this is so is that which is figuratively rendered by the idea that when a man thinks of a dog, then the man becomes formally identical with the dog.

6. INTENTIONALITY AND INTENSIONALITY

The aspects of Chisholm's writings on intentionality that are best known are the attempts to produce criteria by which to identify intentional phenomena and the claim that the intentional is prior to the semantic. As regards the former, two tests have endured: first, failure of existential inference, and second, failure of coextensional substitution. In concluding, I want to say something about the latter from the perspective of the Thomist account and in doing so to rectify an omission in previous presentations and defenses of that view.[27]

Earlier I mentioned that Aquinas has an argument for the immateriality of thought based on the claim that forms occur in the mind with intentional being. The idea is simple enough and now easy to make sense of. Material conditions individualize forms, so if they exist in the mind as universal, that is to say unindividualized, this must be because there they occur apart from material conditions, i.e., immaterially. This proof deserves greater attention than it has received, even if one accepts the recommended modifications to the Thomist ontology developed earlier. But without going into this issue one can construct another antiphysicalist argument on the basis that thought involves concepts and this second proof has parallels with reasoning advanced by Chisholm in connection with his criteria of the intentional. However the argument in question seems to rely upon assumptions that are in tension with the account of concepts suggested above. I shall try to show that this appearance is deceptive.

First, then, the argument. Describing and interpreting persons in-

volves treating them as subjects of intentional states, events, and processes. Accounts of thought and agency seek to represent the ways in which the subject is related to the world, that is to say the modes of presentation and action through which he or she engages with other things. Accordingly, such descriptions are intensional in the respect that substitution of coextensive terms within them is not guaranteed to preserve truth. Thus, insofar as physicalism is committed to the possibility of a descriptively adequate extensionalist theory of human beings the ineliminability of intentional characterizations is problematic.

One response, for which the logical character of explanations in the natural sciences provide independent motivation, is to abandon pure extentionalism in favor of a more discriminating semantics for predicates, i.e., one that distinguishes between coinstantiated properties. Significant though it is, however, this does not go far enough to meet the requirement imposed by intentionalist descriptions. For interpreting the meaning and determining the truth of content ascriptions involves appeal to entities more finely individuated than natural properties. Just as two expressions may serve to pick out the same object but do so in virtue of different properties of it, so two expressions may designate the same property but do so via different conceptions. Thus, parallel to the failure of extensions, classically understood, to provide identity conditions for predicates, there is a failure of natural properties to yield identity conditions for concepts. Nothing less than fully intentional entities will serve the needs of psychology and the existence of fully intensional entities is incompatible with the truth of physicalism.

No doubt replies will suggest themselves, but for my own part I find this argument persuasive. However, having presented and defended it in a paper that appeared about the same time as another in which I argued the case for the Thomist account of cognition, I came to recognize that there appears to be a tension between the two lines of reasoning.[28] Put bluntly, whereas the antiphysicalist argument proceeds on the assumption that concepts cannot be identified with natural properties, the core of the Thomist account is that concepts are (formally) identical with them. The expression "a tension" hardly seems adequate to the problem. But I think there is a solution which, agreeably, draws upon an aspect of the Thomist account, though one which I have done no more than mention. This is the claim that mental reference to the empirical world involves the conjunction of conceptual and experiential components; or recalling again neo-Fregean terminology, conceptual and perceptual 'modes of presentation'.

The problem is one of identity and difference. The identity of the

known and the knower holds that properties and concepts are the same entities existing in different modes of actualization. How then to accommodate extensional identity combined with intentional difference: one and the same property thought of in intentionally nonequivalent ways? Consider the following catalogue of terms:

1. Terms that are not cointensive but are coextensive in virtue of contingently coinstantiated properties; for example, "creature with a heart" and "creature with kidneys."
2. Terms that are not cointensive but are coextensive in virtue of necessarily coinstantiated properties; for example, "triangular object" and "trilateral object."
3. Terms that are not cointensive but are coextensive in virtue of property identities; for example, "vixen" and "female fox."

In the case of (1) and (2) we might advert to the difference between properties to account for the intensional difference between terms and the concepts they express. However, unless one adopts an intentional (i.e., cognitive) criterion of property identity and difference, one will allow that "vixen" and "female fox" are satisfied by one and the same property. A standard account will now invoke the idea of conceptual differences; but as before the combination same property/different concepts appears to undermine the Thomist theory. One solution might proceed by attributing the difference to the level of mental syntax. That is to say, one might argue that "vixen" and "female fox" express one and the same entity at the *natural, intentional,* and *semantic* levels (a *property,* a *concept,* and a *sense* respectively) but maintain that the difference at the syntactic level is sufficient to explain failures of substitution in intentional contexts.

I doubt, however, that this is satisfactory by itself; and it implies what may be an unwelcome commitment to a syntactic theory of thought. Accordingly it is worth entertaining another possibility. Consider two aspects of concepts as they feature in the Thomist scheme. First, concepts in respect of their objective relation (of formal identity) to extramental features—*concepts$_e$;* second concepts in regard to their cognitive employment by thinkers in association with mental and verbal imagery—*concepts$_m$.* In considering two concepts, F and G, which are candidates for being distinct, though they intend one and the same property, one can now recognize the following possibility. Concepts F and G are formally identical with some natural property; but considered with regard to a thinker (or thinkers) they are cognitively distinct because associated (perhaps through the history of their intentional formation and/or the context of their exercise) with different mental and verbal

imagery—what Aquinas terms 'phantasms' *(phantasmata)*. This suggests an account of concepts as functions whose arguments are thinkers, images (in the broad sense), and objects, their values being individual forms. Thus, concept F (thinker T_1, image I_1, object O_1) yields as a value a case of F-ness, the f-ness of O_1. A concept G is objectively the same as F $(F_e = G_e)$ if for the same object it gives the same value, the f-ness of O_1; but is cognitively different $(F_m \neq G_m)$ if it takes as an argument a different image I_2.[29]

These last reflections are speculative but the general response should be clear. The claim that when a man perceives a dog he (i.e., his intellect) becomes "formally identical" with a dog (is given conceptual content by the same form as structures the animal), is compatible with the claim that the content of his cognition is intentionally distinct from that of another man who is enabled to perceive the same dog by virtue of possessing, *in esse intentionale,* the same general form. The nonequivalence is attributable to differences in the 'phantasmic' modes of presentation to which the two men are subject. Recall once again that the idea of phantasms, at least as I wish to deploy it, is a broad one encompassing all kinds of contents and products of sense-experience; and I would add the anti-Cartesian note that it is no part of this idea that a subject is necessarily authoritative with respect to his own phantasms.

7. CONCLUSION

It is commonly supposed that the Thomist theory of thought, and of much else, is obscure and esoteric; and this impression is encouraged by the scholastic vocabulary of substantial and accidental forms, quiddities and acts of being, intrinsic and extrinsic denominations, active and passive intellects, impressed and expressed species, sensible and intelligible forms, formal and instrumental signs, and so on. Many of these terms and notions are late Scholastic accretions and my own considered estimate is that, like Thomas Reid writing five hundred years later,[30] Aquinas himself is simply trying to identify at the level of a metaphysical description what is implicit in our everyday dealings with the world. Contrary to the impression created by the philosophical vocabulary, his is, in Strawson's terms, more a descriptive than a revisionary metaphysics. Put even more directly I would say that it is a philosophical defense of common sense. In defending the obvious, however, one may be led to speak in unfamiliar terms; but that of which one speaks when talking of the formal identity of concepts and natures may yet be as familiar as

perceiving a dog; and if true, then, in a sense, it is neither more nor less intelligible.

JOHN HALDANE

DEPARTMENT OF MORAL PHILOSOPHY
UNIVERSITY OF ST. ANDREWS
MARCH 1994

NOTES

1. R. M. Chisholm, *On Metaphysics* (Minneapolis: University of Minnesota Press, 1989), p. vii.

2. See J. Haldane, "Brentano's Problem," *Grazer Philosophische Studien* 35 (1989); "Reid, Scholasticism, and Current Philosophy of Mind," in M. Dalgarno and E. Matthews, eds., *The Philosophy of Thomas Reid* (Dordrecht: Kluwer, 1989); "Aquinas on the Active Intellect," *Philosophy* 67 (1992); "Mind-World Identity Theory and the Anti-Realist Challenge," in J. Haldane and C. Wright, eds., *Reality, Representation, and Projection* (New York: Oxford University Press, 1993); "The Life of Signs," *Review of Metaphysics* 47 (1994); and "Whose Theory? Which Representations?" *Pacific Philosophical Quarterly* 75 (1994).

3. Chisholm, "Intentionality," in P. Edwards, ed., *Encyclopedia of Philosophy* (London: Macmillan, 1967), vol. 4, p. 201.

4. See J. Haldane, "Aquinas on the Active Intellect," where I argue that Aquinas's use of the idea of *nous* departs from that presented by Aristotle in the *De Anima.*

5. Aquinas maintains that, in general, concepts, i.e., abstracted forms, are not objects of thought. The exception to this is reflexive cognition. He writes, "The intelligible species is to the intellect what the sensible species is to the sense. But the sensible species is not *what* is perceived, but rather that by which the sense perceives. Therefore the intelligible species is not what is actually thought of, but that by which the intellect thinks." *Summa Theologiae,* 1a, q. 85, a2.

6. Aquinas, *De Ente et Essentia,* trans. A. Maurer, as *On Being and Essence* (Toronto: Pontifical Institute of Medieval Studies, 1968) 3: 5 and 6; and *Summa Theologiae,* trans. Fathers of the English Dominican Province (London: R. and T. Washbourne, 1912), 1a, q.7, a1.

7. Peter Geach has argued for a view of this kind connecting it with Frege's claim that concepts are incomplete; see "Form and Existence," in P. Geach, *God and the Soul* (London: Routledge and Kegan Paul, 1969), p. 42. Like Aquinas, from whom he derives his view, he argues that predicates stand for natures existing individualized in things. A somewhat similar theory is advanced by G. F. Stout who maintains that a substance is a set of properties, and so thinks it necessary to deny the universality of features in order to retain the particularity of the objects they constitute. He writes: "Of two billiard balls, each has its own particular roundness separate and distinct from that of the other, just as the billiard balls themselves are distinct and separate"; see G. F. Stout, "Are the

Characteristics of Particular Things Particular or Universal?" *Proceedings of the Aristotelian Society, Supplementary Volume 3* (1923): 95–113. The criticisms offered above of Aquinas's view also have application to Geach and Stout. The central point is general: the notion of an individualized universal, or particularized quality, presupposes that of a multiply exemplifiable item of which the former is a case or instance.

8. Aquinas, *Summa Theologiae*, 1a, q.78, a4.

9. Aristotle, *Metaphysics*, 1028a12.

10. For a summary statement of Chisholm's ontology see "The Categories" in R. Chisholm, *On Metaphysics.*

11. B. Russell, *Human Knowledge* (London: Allen and Unwin, 1948), pp. 312–17.

12. J. M. E. McTaggart, *The Nature of Existence* (Cambridge: Cambridge University Press, 1927), 1: 100–101. In connection with this see P. Geach, *Truth, Love, and Immortality: An Introduction to McTaggart's Philosophy* (Berkeley: University of California Press, 1979).

13. That is to say: $(\forall x)(\forall y)(\forall f)\ [(x = y) \rightarrow \neg\ (fx \leftrightarrow fy)]$ is equivalent to $(\forall x)(\forall)(\forall f)\ [(fx \leftrightarrow fy) \rightarrow (x = y)]$.

14. Leibniz, *New Essays Concerning Human Understanding,* trans. A. G. Langley (London: Macmillan, 1896), bk. 2, ch. xxvii, sec. 3, p. 239.

15. This is a necessarily compressed statement of a familiar point discussed in P. F. Strawson, *Individuals* (London: Methuen, 1959), 1: 1–3.

16. This doctrine provides an ontological underpinning for the sortal dependency of identity statements: the claim that talk of sameness in respect of a substance invites the question "same what?"

17. In *Truth, Love, and Immortality* (pp. 47–48) Geach maintains the identity of indiscernibles regarding denial of it as proceeding from an inclination towards the bare particular or substratum view; but his attitude presupposes a nonreductive, noncluster view of substance not very different, I think, from that presented here.

18. Aquinas, *De Ente et Essentia*, 2: 4.

19. Aquinas, *Summa Theologiae*, 1a, q7, a1.

20. For an interesting discussion of Aquinas's notion of matter which nonetheless inclines to a substratum interpretation see H. Veatch, "Essentialism and the Problem of Individuation," *Proceedings of the American Catholic Philosophical Association* (1974).

21. The irreducibility of substancehood as Aquinas explains it is evident when one considers that an individualized substantial form is the nature of a particular body, while a quantity of matter designated is necessarily a thing of a certain kind. At one point he writes: "Matter cannot be said to be, it is the substance itself which exists." Aquinas, *Summa Contra Gentiles* (London: Burns, Oates and Washbourne, 1924), 2, 54.

22. For interesting discussions of this distinction see Geach, "Form and Existence" and A. Kenny, "Form, Existence, and Essence in Aquinas," in H. Lewis, ed., *Peter Geach: Philosophical Encounters* (Dordrecht: Kluwer, 1990). Geach replies in the same volume. Notwithstanding significant points of difference, I am indebted to Geach's stimulating and insightful writings.

23. Aquinas, *De Ente et Essentia*, 2: 1.

24. A somewhat similar ontology is developed in Nicholas Wolterstorff, *On Universals: An Essay in Ontology* (Chicago: University of Chicago Press, 1970),

especially chap. 6. An admirably clear discussion of theories of universals and substances is provided by M. Loux, *Substance and Attribute: A Study in Ontology* (Dordrecht: Reidel, 1978). I am indebted to both works.

25. See Haldane, "Mind-Word Identity Theory and the Anti-Realist Challenge," section 7.

26. See Chisholm's "Presence in Absence," in *On Metaphysics,* chap. 11.

27. I address the issue of failure of existential inference in "Brentano's Problem" and in "Intentionality and One-Sided Relations," *Ratio* 9 (1996).

28. See J. Haldane, "Brentano's Problem" and "Naturalism and the Problem of Intentionality," in *Inquiry* 32 (1989).

29. This use of the idea of functions differs from that of Geach in discussing Aquinas's doctrine of individualized forms (see note 7 above); but it parallels a technical treatment of the ontology of substantial forms proposed by Gyula Klima; see Klima, *Ars Artium: Essays in Philosophical Semantics, Medieval and Modern* (Budapest: Hungarian Academy of Sciences, 1988).

30. There are significant resemblances between the accounts of intentionality provided by Reid and Aquinas, and I believe that Reid was influenced by Scholastic sources; see Haldane, "Reid, Scholasticism, and Current Philosophy of Mind" and "Whose Theory? Which Representations?"; also "Putnam on Intentionality," *Philosophy and Phenomenological Research* 52 (1992).

REPLY TO JOHN HALDANE

John Haldane's "Forms of Thought" is a criticism of my metaphysics from the point of view of St. Thomas's metaphysic. If I were to attempt a reply to any particular thesis of St. Thomas's philosophy, Haldane could easily "refute" what I have to say by setting forth *other* theses of St. Thomas's philosophy and without taking into consideration whether those other theses contain anything that might constitute a common ground for discussion. For the most part, however, Haldane does not seem to do this. How, then, are we to *have* such a discussion? I would suggest the following procedure.

Consider the theory of categories. Bracketing St. Thomas, then, let us ask whether we can find a common ground by asking what *exists* in the strictest and most philosophical sense of *existence.*

Unlike St. Thomas, I would say that, *in addition to individual things,* there are also *attributes* (or *properties*)—things that are capable of being believed to be exemplified by other things.

There is no place for "forms" in my theory of categories and therefore use of "formal identity" would not enable us to succeed.

The next step would be to see how Haldane and I would actually fare in our efforts to have a philosophical discussion.

R.M.C.

7

Gerald E. Myers

SELF-AWARENESS AND PERSONAL IDENTITY

A professional hazard for philosophers is loss of faith in their subject matter. Philosophical issues once felt to be engagingly significant begin to look, not uncommonly, strained and jejune. Uncertainty about philosophy's merits, besides quietly dispiriting this or that philosopher, can produce movements to eliminate the field's alleged waste and nonsense, thus inevitably dividing the profession between defenders and challengers of philosophical traditions.

Such was the developing state of post-WWII philosophy, with increasing acrimony exhibited between the two camps. It was in this kind of atmosphere that Roderick M. Chisholm became recognized as one of America's most distinguished philosophers, and an important factor in Chisholm's deserved eminence is his ability, rare indeed, to inform contemporary-oriented issues with analyses taken from historical sources. Chisholm's work, whether focused on counterfactuals or sense-perception and whether invoking Sextus Empiricus or Thomas Reid, is a model of how instructive intersection of traditional and contemporary argumentation is achievable.

Chisholm's influence has been as beneficial as it has been notable, given the prevailing atmosphere, not only for preserving appropriate respect for relevant sources in the history of philosophy but also for accentuating the subtlety and intractability of ancient but surviving philosophical problems. Chisholm's skill in displaying the stubborn authenticity of a philosophical question, shown partly through the originality of his own argument and partly through the reputability of the question's historical origins, is admired by currently analytic and more traditional philosophers alike. He is especially impressive in rebutting overly facile solutions offered for controversies that define philosophy's career.

The longstanding question—What constitutes personal identity?—

got a new life in post-WWII discussions that intensified in the 1960s and 1970s, and Chisholm's own response to it, reformulated over many years, illustrates my preceding characterization. Many philosophers, in step with ongoing Cartesian-bashing, sought a dissolution of the problem—How to understand the first-person pronoun's referent?—along nontraditional lines. Or, one might say, they sought to demystify the issue totally; that done, the issue could be historically shelved.

Chisholm, characteristically, stands apart from the contemporary crowd, a somewhat lonely dissenter, regretting seemingly heavy-handed treatments of issues that, being so finely grained or nuanced, are quite tender intellectually. His approach to the topic of personal identity is, accordingly, idiosyncratic, meant to indicate among other things the real complexities of the topic. Both the route and the destination of the argument enjoy a kind of elusiveness that, for Chisholm and his admirers, attests to rather than detracts from the topic's worth.

Like Wittgenstein, Chisholm underscores the difficulties of finding the right route by taking us down many blind but tempting alleys, incidentally demonstrating how the pleasures of philosophizing cannot be had apart from the frustrations of working through each alley's seductive murkiness. Since in what follows I cannot begin to reproduce the scope and complexity of Chisholm's arguments on self-awareness and personal identity, my observations' limitations have to be understood; they don't pretend to summarize his detailed reasonings on the topic.

Current philosophical opinion identifies one's person or self with one's physical body, and personal identity (sameness of self through time) is equated with sameness or continuity of change in one's body. This might not seem surprising because of its courting common sense. But this is a starry philosophical issue about which, when probed far enough, common sense can falter such that Chisholm, in defying the popular side, can claim common sense equally well for his side. If at his conclusion personal identity retains a certain elusiveness, then, curiously, that may seem what, on his argument, common sense itself demands.

In the late 1960s, when Chisholm wrote on personal identity, his bibliography included Quine, Goodman, and Shoemaker alongside St. Augustine, Hobbes, Hume, Locke, Bayle, McTaggart, Peirce, Whitehead, and Russell (among a host of others). His leading question there is inherited from Bishop Joseph Butler who had contended that whereas physical objects are only "loosely" the same over time, persons are somehow "strictly" the same during their existence. Chisholm's question:—What verdict to give Butler's thesis?

Essentially correct, is Chisholm's answer. The apparent enduring sameness of physical objects like ships and human bodies is of a "loose" sort insofar as such objects, over enough time, may change in every respect but will be called the same so long as the changes are gradually continuous; discontinuous changes mark one thing's termination, another thing's beginning. What to think, then, about the project of defining personal identity as continuous bodily changes and/or, for that matter, as psychological continuity (intact memory, cognition, etc.)?

Not very good, Chisholm suggests, if we reason like this: suppose, already assuming that you will be totally transformed tomorrow, physically and psychologically, that you are now offered the choice of doing A, which will reward your transformation with bliss, or of doing B, which will punish your transformation with torture. Given the bodily and psychological discontinuities that, on the popular view, make your transformation into a different person, should you care in the slightest (except altruistically) about these offered choices and their results? Those disagreeing with Bishop Butler would seem obliged to say "No," but that, for Chisholm, is patently unreasonable. If you choose B, for example, then, he says, "It will be *you* who undergoes that pain, even though you, Jones, will not know that it is Jones who is undergoing it and even though you will never remember it. But although this seems quite obvious to me, I must concede that I cannot supply you with an *argument* for it. I am afraid I can say only that either you see it or you don't" ("The Loose and Popular and the Strict and Philosophical Senses of Identity," in *Perception and Personal Identity,* Norman S. Care and Robert H. Grimm, eds. [Cleveland, Ohio: The Press of Case Western Reserve University, 1969], pp. 82–106).

Chisholm's conclusion here, I believe, is undeniable, although it may leave us uneasy about exactly what is being asserted due to the elusiveness of the *I* and the *you,* truly mysterious entities seemingly independent of any concatenation of bodily/psychological characteristics. It is puzzling that, when I try to articulate in what respect I will be the same as my hypothetical transformation, I'm thoroughly stumped. Chisholm's conclusion, consequently, seems finally to rest on intuition (or introspection) rather than argument. Maybe that is how it is, but I do wish that he might have explored more persistently for us possible introspective grounds for his conclusion; doing so might reduce the self's elusiveness to some degree. For instance, the transformed self in Chisholm's imagined situation does appear to retain its sameness with your present self not because it thinks the same, behaves the same, or expects the same—but because, as the subject experiencing pain or pleasure, in this respect alone does it look convincingly the same. If so, might we

introspectively follow this lead for possibly identifying somewhat more robustly the entity that allegedly endures "strictly" the same?

Chisholm is of course concerned about the elusiveness referred to, and he begins his *Person and Object: A Metaphysical Study* (La Salle, Illinois: Open Court, 1976) with a discussion of "the direct awareness of the self," of whether one is ever directly aware of the *subject* of experience. Noting that both Sartre and Carnap, for example, had denied direct self-awareness, that in his opinion both phenomenologists and logical analysts had therefore gone astray, Chisholm maintains that, certainly, we are directly acquainted with ourselves (pp. 23–24). His analysis, not reproducible here, is technically intricate and revolves around adapting Meinong's concept of "self-presenting" propositions; that is, propositions that are true and necessarily that if they are true, then one to whom they are presented knows they are true. Direct acquaintance with oneself, Chisholm argues, presupposes direct knowledge of a self-presenting proposition such as, say, the proposition that I *seem* now to see many people (p. 24).

As I follow him, Chisholm here equates self-awareness with cognition of a certain class of propositions, leaving us the question of whether awareness of oneself is ever nonpropositional; my experience of pain, as a special variety of awareness, seems to occur without my having to consider any propositions including self-presenting ones. Can't self-awareness occur similarly? Some thinkers have supposed that awareness of oneself, if it occurs, does reveal a self-intimating quality, that gives that awareness a recognizable "feel" all its own. Chisholm also defines self-awareness via propositional cognition in denying that one identifies or individuates oneself through references to one's own body. "I do so in virtue of my awareness of being this particular person. This awareness is a knowledge of propositions implying my individual essence or haecceity and is implicit in each of my self-presenting states" (p. 37). Because I find it hard to conceive of self-awareness as being exclusively a knowledge of propositions, again I wish that Chisholm might have elaborated introspectively the kind of experience he has in mind.

That Chisholm may be reluctant to offer a simpler, nonpropositional account of self-awareness, attempting to give us a better sense of its "feel," is indicated by his response to Hume. In concluding that I can't be directly aware of myself, as Chisholm interprets him, Hume's premises were that I can't be directly aware of any object unless that object is an impression, and I'm not an impression. But a mind, person, or self, Chisholm responds, is not an impression like sadness or happiness but is instead a *something* that is sad or happy (p. 38). This, in addition to the apparent self-refutation contained in Hume's claiming

that self-acquaintance fails because he finds himself not finding himself but other things instead, takes care of Hume's argument.

In claiming against Hume, as Chisholm does, that oneself is a substance, the subject that is sad and not merely the sadness nor any complex of such impressions, the danger of course is that oneself becomes a *je ne sais quoi.* Chisholm's response is that the self *is* an object of "inner perception" (pp. 46–52). I may, for instance, perceive ("innerly") myself to be thinking. If I understand him, Chisholm then explains that there are two different senses in which we may be said to inwardly perceive ourselves. The first is illustrated by Hume's report that (despite its confusion as noted above) although he did not find himself as he did hot and cold impressions, yet, to repeat, he did find *someone* finding heat and cold. Secondly, if one's feelings, moods, etc. are called "appearances" or "modifications" of oneself who is appeared to or modified, and if substances are known through their modifications, then *"what* one apprehends when one apprehends heat or cold etc. is simply oneself. Whether one knows it or not, one apprehends *oneself* as being affected or modified" (p. 52).

My recapitulation here is bareboned, giving sparse hints of the depth of Chisholm's analyses, of the erudition and skill used to make his case. There is also in this work, *Person and Object,* a return to Bishop Butler's thesis and its defense. Trying to pluck the item of self-awareness from the dense context of Chisholm's exposition for independent focus is risky, but I believe that in adhering so closely to his texts we rightly continue in asking whether he has reduced or not what Ryle called "the systematic elusiveness of the I" and of personal identity.

The centrality of *oneself* in Chisholm's mature philosophy is shown by his proposal that "the primary form of all reference is that reference to ourselves that we normally express when we use the first-person pronoun. In the case of believing, this reference may be called 'direct attribution'. . . . The primary form of believing is not a matter of accepting propositions; it is a matter of attributing *properties* to oneself. I am the primary *object* of my own attributions and the properties are the content" (*The First Person: An Essay on Reference and Intentionality* [Minneapolis: University of Minnesota Press, 1981], p. 1). The implications of this are enormous, affecting our thinking on first-person sentences, indirect attribution, demonstratives, proper names, and other major topics including the unity of consciousness. Again, I'll attempt an accurate extraction of what interests me from so much ingeniously interwoven material.

Chisholm says he has changed positions here, now interpreting the propositional attitude of believing, for example, no longer as the

acceptance of propositions but rather as being a relation between a believer and a property; the property is attributed by the believer to himself. But this in no way alters the self's elusiveness in self-awareness. In fact, it may be that here Chisholm has clarified somewhat for himself that elusiveness, because now, if all my beliefs are self-attributions, then "I am the *object* of those attributions, but no part of their *content* [the content being the attributed properties]" (p. 74). On this analysis, oneself is necessarily excluded from the content of a proposition—providing immediately at least one explanation for its elusiveness.

For further observations about self-awareness and personal identity, we need to refer to Chisholm's concepts of self-presenting properties and the unity of consciousness. Self-presenting properties are such that if you have them (certain important refinements aside) you'll believe that you have them, and these include attitudes, feelings, etc. Chisholm concurs with Brentano that when one sees something and is aware of it and is simultaneously aware of hearing something, then one is also aware that oneself is both hearing something and seeing something. Thus this: "The person's self-presenting properties, then, are such that he can be absolutely certain that they are all had by one and the same thing—namely, himself. And this is the closest he comes—and can come—to apprehending himself directly. But this awareness that there is something having the properties in question is what constitutes our basis, at any time, for all the other things that we may be said to know at that time" (p. 89). And this: " 'How do I know that "I" is not ten thinkers thinking in unison'? The answer I would say, is this: we know it in the same way as we know that there is at least one thinker" (ibid.).

We might offer at this point that, on Chisholm's view, it seems that oneself and its intact identity through time and at any given time are simply "given" directly to one's awareness. My guess is that while this traditional-sounding statement is not unacceptable to him, yet, because of its own susceptibility to argument, it invites the kind of further analysis that Chisholm offers in his successive writings. One wonders, for instance, how much the notion of the "given" in self-awareness, or in any direct awareness, relies for its interpretation in Chisholm's view on some concept or other of intuition. I think I approach an answer here when reflecting upon some things written in his *The Foundations of Knowing* (Minneapolis: University of Minnesota, 1982).

My interpretive confidence strengthens after focusing on Chisholm's remarks about *Verstehen* or "intuitive understanding" in *The Foundations of Knowing*. While again having to omit essential links in his reasoning, I believe certain of his claims, even though out of context, speak for themselves. *Verstehen* is declared essential for the foundation

of knowledge, extending from knowledge that is "directly evident" to "transcendent" knowledge of other minds, etc. (p. 86). The doctrine of *Verstehen,* as Chisholm affirms, echoing Reid and Scheler, is required for founding knowledge-claims in addition to principles of evidence, rules of deductive and inductive logic, principles of perceptual evidence, and considerations of mnemic evidence.

This gives direction to subsequent discussions of "self-justifying" statements. These are statements about one's own psychological states, illustrated for example by "I believe that Socrates is mortal." If asked to justify my saying this, all I can do, Chisholm urges, is to reiterate it; my justification is simply that I *do* believe that Socrates is mortal. We can assert that such statements are self-justifying, or we can equally correctly characterize them as neither justified nor unjustified, meaning that to call a statement self-justifying is tantamount to declaring it neither justified nor unjustified just because any challenge for justification is pointless or out of order. Reminiscent of the ancient doctrine that if some statements are evident some must be self-evident, Chisholm's position appears here to be that if some statements are justified or not then some must be self-justifying or excluded from the justificatory process.

Unless I have overlooked it, he does not explicitly explicate self-justifying statements via the *Verstehen* doctrine, but I presume that "I believe p" is, along previously argued lines, to be conceived not as an intuitive acceptance of a proposition wherein oneself is part of the content but rather as a direct attribution of a certain property to oneself as object; and the self-awareness demanded in the attribution is explicable as an instance of *Verstehen,* indeed its most important instance epistemically. Hence, if my reading of the various texts cited here basically fits Chisholm's intentions, then we have a philosophy that envisions self-awareness at the cornerstone of all knowledge, that oneself is known to be an intact unity, that it endures "strictly" the same in some respect or other, and such knowledge throughout is intuitive, a case of *Verstehen.*

But, we may ask, how much do we really know about the self or self-awareness in Chisholm's depiction of it? We do know quite a lot about its functions and important role in acquiring knowledge, and, admittedly, if we are intuitively aware of being a unified consciousness (or of whatever that translates into) and of enjoying an enduring personal identity, then to complain that it is only a *je ne sais quoi* would seem hypercritical if not hypochondriacal. Still, it is hard not to sympathize with Hume (and others) who felt that, compared to what we detailedly perceive around us, the kind of traditional philosophical self to which Chisholm seems to

return us mostly eludes our attempt to fix our gaze upon it. Of course, that may not be Chisholm's or anyone's fault, just the way things are. But however that be decided, I have two questions for deliberation.

The first, which perhaps betrays a philosophical bias of my own, namely, a proclivity for importing introspection into discussions about self-awareness and personal identity, is this: Might Chisholm have given us a fuller introspective picture of what it is like for himself to be self-aware? Is the elusiveness of it due to the lack of a detailed report of the *experience* of self-awareness, to not attempting such a report? My second query is this: If introspecting experience is unhelpful, failing to reduce the elusiveness, what shall we think about Chisholm's knowledge-claims about self-awareness and personal identity? The two questions, we'll see, really overlap.

I wonder if Chisholm deliberately refrains from undertaking a frankly introspective scrutiny of the experiences that are his candidates for self-awareness, possibly to avoid "psychologism," and its confusion of philosophical and psychological issues. On the other hand, he may reply that some of his analysis is introspectively based, pointing to his discussion of "inner perception" in *Person and Object* as an example of such. What I mean, however, is that in general he does not seek out and clarify psychological details of philosophically relevant experiences; at least, he does not present us such, typically declaring instead that "nothing more can be said, you either see it or not." In the absence of such an attempt—say, along the lines of a Hume, Sartre, or James—one wonders whether Chisholm regards an introspective effort to be clearly wrongheaded at the outset, or if he believes that introspection deserves an opportunity but, given such, fails to deliver, or—perhaps surprisingly—that introspection, in failing to deliver what Hume looked for, has more than negative results to offer, namely, Chisholm's own conclusions. Maybe, come to find, his (unpresented) introspections are in fact what ultimately support those conclusions as we have previously summarized them?

What introspection (as usually understood) is expected to yield, I would guess is Chisholm's assumption, are (in Hume's sense) impressions, and Chisholm, as we have seen, explicitly excludes oneself from being an impression, being its subject instead. *How* does he know that? His words may suggest that there is no "how," no experiential criteria, no inferential process based on observational data—a case of "knowledge without observation." When feeling depressed, say, one finds more than depression; one finds it characterizing oneself. And, as I understand Chisholm, more than that, little or nothing can be said.

Finding oneself depressed, as distinguished from merely being or

feeling depressed, without considering it or being at all self-conscious about it, fits my use of "introspecting," so that in that use Chisholm may agree that he does introspectively discover himself within a self-awareness experience. Any such "discovery," in my use of the word, would appear to be an introspective one. But he tends to report or present the introspective result only, not the introspective process leading to it, and I think that here I might persuade him that acknowledging such a process would clarify, at least for "introspectionists" like myself, his intentions. My idea is that when Chisholm examines Hume's failure to stumble inwardly upon himself, he probably reflects upon an ongoing or imagined experience, then notes its ingredients, asks questions about it, and pays special attention to its details for determining whether anything has been overlooked. If so, then I see him involved in something like an introspective process.

Now, I guess that Chisholm, like Hume, does not find himself as an ingredient standing out within that process, for that would have himself being a Humean impression. Nor, I guess further, does he find introspectively anything to be called an "I-quality" that as an impression uniquely correlates with his nonsensory awareness of self; that is, no sensory datum serves as a reliable introspective clue for self-apprehension. And we could lengthen the list of what he could find or not introspectively, elaborating this picture of an inferential introspective process—but mainly unpresented or unreported—which, I'm speculating, is the larger source or context of Chisholm's distinctive conclusions about self, self-awareness, and personal identity.

In wondering if Chisholm's analysis is introspectively based, perhaps more than his texts might lead us to think, I'm conjecturing that his distinctive statements regarding our topic are not quite as self-evident, self-justifying, or "out of the blue" as they initially seem to be. The kind of reasoning required, as in so-called "experiments of the imagination," may well include introspective searchings of relevant experiences and what these, through their own peculiarities, seem to signify. Philosophers resolved to avoid "psychologism" and to keep philosophical and psychological kinds of arguments strictly separate may overlook those places, often quite imperceptible to casual attention, where introspective data filter into one's reflections. The origin or source of a philosopher's outlook, consequently, may be more complex and more "experientially" based than what his published account, couched abstractly and dialectically, may indicate.

But, in fact, my conjectures here about a possible introspectionism in Chisholm's argumentation are motivated by some occasional hints in his texts (some of which have already been cited). An especially provocative

instance occurs in his *The First Person* where reference is made to Jean Paul Richter and what Richter said about "the birth of my consciousness of self" *(Selbstbewusstein),* about a sudden experience or "inner vision," a discovery that "I am me." Richter's discovery, Chisholm writes, "is the discovery one makes when one is first aware of the unity of consciousness; it is thus a discovery about those things one has been directly attributing to oneself. One suddenly becomes aware of the fact that there is a single thing that has all one's self-presenting properties and that is the thing to which one makes all one's direct attributions. And *how* does one come to see this—It would be correct to say: 'One has only to consider it to see that it is true.' But it is, apparently, something that many people never happen to consider" (p. 90).

It would be rash to hold that the only context in which such a "discovery" or sudden awareness could occur is an introspective one, where psychological details of an experience are being attended to with special care, but I would be considerably less confident about claims made without the benefit of introspective scrutiny on behalf of any such "discovery" or sudden dawning awareness. If the stage is set for a certain kind of eventful episode by asking questions such as Hume's or Richter's and then, as it were, introspectively looking at one's appropriate experiences for ascertaining whether *anything* in those experiences helps towards answering those questions, then an eventful or culminating experience of the sort alluded to by Richter and Chisholm may occur. Without some such experiential context to back up one's sense of discovery or insight and the philosophical formulation given to it, not only confidence in it but the point of it get lost. What is claimed empirically as being "intuitively certain," "self-justifying," or "true just upon consideration" may be, more often than suspected, the formulation *suggested* by an experience in which an introspective process culminates.

I emphasize what is "suggested" by an experience because statements like "I *find* myself in an experience of self-awareness," "I experience myself as a unitary consciousness," and "I endure as the same person" differ greatly from statements like "I am sad, happy, etc." They are notoriously more problematic than the latter kind, hard to defend as being direct readings of one's experience. They seem at best "suggested" by one's introspective experience rather than a direct literal report of it. And, even conceding that, on Chisholm's analysis, oneself is not entirely a *je ne sais quoi,* yet, it is frustratingly elusive. This is further evidence for the idea that what is being claimed is "suggested" and thus on the shy side of even subjective certainty.

But, even if I'm right on this, and a lingering uncertainty, perhaps insufficiently admitted by Chisholm, haunts the kinds of statements in

question, I hasten to note that one of the important effects (appreciated by introspectionists) of introspecting experience is what gets strongly suggested. Introspection is to be encouraged because of its suggestions; scrutinizing one's own feelings, sensations, etc. tends to generate, among other things, convincingly suggestive self-reports. In the absence of anything better, these experiential suggestions, aroused so convincingly or provocatively, are often part of what we have to go on in understanding ourselves and are arguably innocent until proven guilty.

In support of the above, consider perhaps the most common kind of suggestion that introspective experience produces, namely, the conclusion that something *is* the case simply because it *seems* or *feels* to be so. My self-congratulatory judgment "I am courageous" may be strongly suggested by the truth of "I feel courageous," and, depending upon the circumstances, my feeling may be the best evidence for my judgment. On the other hand, in some contexts my behavior may clearly outweigh my feelings as evidence, and the apparent fallibility of introspective suggestions led Peirce, among others, to stress the gap between "is" and "feels." But being cautious about such suggestions is one thing, discarding them altogether is another. Cosmologists have recently devised a "many worlds" interpretation (an alternative to the Copenhagen theory) of quantum physics that sees the universe dividing at each quantum event, with the apparent implication that we along with everything else are endlessly dividing. What to think of this? Introspective suggestions apparently have a negative vote here, because Stephen Hawking is reported to have said "People object to this because they just don't *feel* themselves splitting" (quoted by Timothy Ferris, "On the Edge of Chaos," review article of Murray Gell-Mann's *The Quark and the Jaguar,* in *The New York Review of Books* vol. 42, no. 14, September 21, 1995, p. 43). And that may be for the time anyway the best that can be said, just as Chisholm contends.

My comments have been tentative, invitations for clarification rather than outright criticism, because Chisholm's texts, read with certain emphases, may indicate a basic sympathy with the spirit of those comments. While uncertain about his response to my seeking a lurking introspectionism in his analyses and the implications of that, including a more elusive self and more enigmatic conclusions about it and personal identity than he may acknowledge, I can appreciate how, given certain qualifications, he might reply that my thoughts here more echo than contradict his intentions. His making the self and its self-attributions the foundation of knowledge, accompanied by such doctrines as *Verstehen* and the like, makes for a distinct "subjectivism," and the historic relation between subjectivism and introspectionism is well known. Of

note is that in *The Foundations of Knowing,* Chisholm remarks that if other thinkers begin with initial data and "basic statements" that conflict with his own *Verstehen*-based starting points, and the question then arises about how to arbitrate such conflicts at the outset, then "I am afraid I cannot answer this ancient question—beyond saying that what may be said about the correctness or validity of rules of evidence should also hold, mutatis mutandis, of the rules of logic, ethics, and the theory of rational decision" (p. 85).

Among the various ways of doing philosophy, there is the way of Descartes, Russell, C. I. Lewis, and I believe Chisholm, of building stepwise an intricate philosophical edifice on an idiosyncratic foundation. Philosophy is "personalized" when done this way, being the frank working-out of a distinctly personal point of view, represented by the choice of initial data announced at the outset. For myself, this approach is appealing because, unlike tested reasoning in the natural sciences, philosophizing inevitably becomes personal and subjective, thus relying, I've intimated, on introspections that may or may not be presented publicly or even placed squarely before oneself.

Chisholm became one of our prominent and influential philosophers, I believe, in part because of his judiciousness and nonpolemical posture. As he developed his own personal orientation systematically, he was always alert to a vast literature historical and contemporary, testing his own inclinations against that literature in a gracious, fair-minded manner. For this, among other reasons, he has won his profession's appreciation.

Chisholm's style and approach, candid and congenial, I like to think, are due to his concern not for winning debates but for meticulously unfolding points of view for peer examination in public forum. In rejecting glib solutions and returning the problems for our deliberations, however frustrating that might be, he demonstrates how in the end each of us is thrown back on our own intuitions/introspections. The process becomes intensely technical and intellectually demanding, but, in Chisholm's case, the equally intense personal search on show animates what might otherwise be lifeless detail. Chisholm has shown us how pleasurable and engaging philosophizing, even when demanding, can be when it is a serious quest guided by logic and learning—but also by personal appraisals as well. His own lifetime devotion to that quest continues to secure our admiration.

GERALD E. MYERS

DEPARTMENT OF PHILOSOPHY
CITY UNIVERSITY OF NEW YORK
OCTOBER 1995

REPLY TO GERALD E. MYERS

I cannot find any serious criticism to make of Gerald Myers's "Self-Awareness and Personal Identity." He has put my views on these questions in a broad perspective, discussing accurately their historical development and the types of philosophical objections to which they might give rise.

Following Meinong, I had called them "self-presenting states."

I would now reject the view that such experiences involve the concept of a personal haecceity. I am aware of the haecceity of at least some abstract objects. It is of the essence of the property of being-red that it is exemplified in all and only those things that are red. And everything is necessarily such that there is something that has that property. But I cannot conceive of any property which is necessarily such that I and only I have that property—or any property which is necessarily such that you and only you have that property. Some will ask "What of the property of *being this thing* or *being that thing?*" Isn't everything necessarily such that *it* has the sole property of *being just that thing?*" Such statements are subject to the following objection: "You are saying that there are many things and each of them is the sole thing that has the property of *being that thing.*"

But nothing that Myers says is subject to this objection.

I would recommend this paper to anyone who wanted to have an accurate statement of my views on self-awareness and perception.

R.M.C.

8

Nicholas Rescher

CHISHOLM'S ONTOLOGY OF THINGS

This discussion seeks to clarify Roderick Chisholm's ontological position regarding substances and their origination by bringing its presuppositions into sharper relief. The methodology will be that of a contrast and comparison. Following up Chisholm's own contrast/comparison between his substance-metaphysic and an alternative process-oriented metaphysic, our discussion will try to bring to clearer view his basic assumptions regarding the metaphysical lay of the land.

With Chisholm, substances may undergo changes of (or in) their properties, but such changings are not themselves *properties* of things—though they are "attributes" in the wider sense of being correctly attributable in discourse about them (p. 103).[1] The cardinal defect of process metaphysics from Chisholm's point of view lies in its claim that all true assertions that are (seemingly) about things and their attributes are rooted in (emerge from, are reducible to, supervene upon) matters that lie outside the category of good old honest things and their properties—namely in states and affairs and their changes and continuities. The only "events" that are ontologically respectable for Chisholm are alterations in the properties of things (or of "sums of things" [p. 152]). Attributes or changes that do not represent properties of things, thing-complexes, or pseudothings ("the social or economic *system*") are dismissed by him as being somehow suspect—perhaps even occult.

Given his commitment to substances as traditionally conceived, Chisholm's treatment of coming into being and passing away pivots on these theses:

1. What exists—and *all* that exists—are things (substances) and their descriptive features (properties, relations). Accordingly, apart from the origination and termination of substances themselves, the only sort of change that occurs is an alteration in their properties and relations, in the descriptive *(secundum quid)* condition of substances.

2. Consequently, existing persons, "you and I—are real things, *entia realia.*" In fact, for Chisholm persons represent the quintessential or paradigm substances.
3. Things in general, and persons in particular, must come into (and go out of) existence all at once. They cannot originate gradually, initiating through a process of some sort. For to accept this would be to hold of something that there was a time when it did not fully exist—a juncture at which it did not and yet somehow did exist— which is absurd. If a thing is available to do anything whatsoever, emerging into existence included, then it must actually exist then and there.
4. Hence while persons might change over time in point of their properties, their relations, and even their mode of existence—say in their individual development from a subhuman status of some sort into full-fledged human beings—they cannot change over time from nonbeings to beings (from nonexistents to existents):

> I am certain, then, that this much is true: that if I am a real thing and not just a *façon de parler*, then neither my coming into being nor my passing away is a gradual process—however gradual may be my entrance into and my exit from the class of *human* beings [my entrance into or exit from the class of beings (of existents) must be abrupt and instantaneous]. (p. 59)

For Chisholm, as for Aristotle, origination *(genesis)* is something altogether different from change *(metabolê).*
5. In consequence substances cannot undergo change of identity. One substance cannot possibly ever change into another. The closest we could possibly get to this would be the origination of one substance following instantaneously on the termination of another, descriptively and spatial-temporally related, one.

As these considerations indicate, Chisholm's metaphysical stance is that substance-origination must be instantaneous: there is an instant prior to which the substance as such never existed and after which the substance always exists up to some subsequent time of its expiry.

It is clear, however, that such instantaneous origination is not the only theoretically available possibility. An alternative view would contemplate the prospect of an interval of concrescence—a noninstantaneous emergence into existence. This alternative model would see origination as a *process*, envisioning a gestation period between nonexistence and existence—an interval during which the thing at issue comes into being, that is, literally emerges into existence. And if coming-into-being is genuinely a process, then there has to be a juncture of transition—of reification or concrescence—during which it can neither

be said truly that the thing at issue actually exists nor on the other hand that it does not exist at all.[2] This contrasting way of looking at the matter of origination characterizes the position of such process philosophers as, for example, A. N. Whitehead.

Three salient facts must be noted about such an interval of substance-origination:

1. It is a "fuzzy" interval that has no definite, specifiable temporal beginning or end.
2. During this interval we can say neither that the thing (already) exists nor that it does not (yet) exist; during the gestation period the substance's existence is *indeterminate.*
3. If the world had been annihilated during this interval, then it would neither be correct to say that the thing has (ever) existed in the world nor that it has not (ever) existed. The theses that the thing has existed (at some time or other) would also have to be classified as indeterminate. (From the ontological point of view it could be said that, figuratively speaking, the world "has not managed to make up its mind" about the existence of the doing. The world itself is, in this regard, indeterminate.)

As these observations make all too clear, a rigorous implementation of the idea of reification as a process—of a thing's coming into existence over a course of time—requires the deployment of two distinctly unorthodox items of concept-machinery:

i. A "fuzzy logic"—or at any rate a fuzzy mathematics that puts the conception of indefinite (imprecisely bounded) intervals and regions at our disposal[3]
ii. A semantics of truth-value gaps, serving to countenance propositions that are neither (definitely) true nor (definitely) false but indeterminate in lacking a classical truth value[4]

Neither of these unorthodoxies is inherently absurd; both represent theoretical resources that are today well known and widely employed in logic and in the theory of information management. (Indeed, the second idea goes back all the way to Aristotle himself—the sea-battle example of the discussion of future contingency in chapter 9 of *De interpretatione.*)

From this contractual vantage point, Chisholm's position emerges into a clearer light. In particular, the following choices lie before us in the context of ontological theorizing:

1. Whether to adopt an ontology of substances (things) or one of processes (state-changes):

	ITEM	ASPECT	CONNECTION BETWEEN ASPECT AND ITEM
Substance Account	thing	property or relation	belongs to, characterizes
Process Account	process	subprocess	part/whole (processually interpreted)

2. Whether to adopt a logic (and mathematics) that is descriptively hard-edged and binary or one that countenances fuzzy boundaries.
3. Whether to adopt a semantics that is classically bivalent or one that countenances indeterminate propositions which lack a classical truth-value (true or false).

Chisholm's approach is based on certain particular choices that are not altogether explicit in his discussion, but seem to issue from the idea that only one workable course is available to sensible people. However, the actual situation is more complex and ambiguous.

Chisholm's position reflects a deeply conservative, classical world view in which there is no room for process ontology, fuzzy logic, and a semantics of truth-value indeterminacy. It involves an undefended and indeed even largely unstated commitment to a classicism which, though widely shared, is certainly not so urgently compelling that sensible people cannot but go along. Our hand is not forced in matters of ontological systematization to the extent that his treatment of the issues would indicate. The fact is that we do have alternatives—each associated with certain costs and benefits, certain assets and liabilities.

Chisholm's restrictively conservative view of the nature of coming to be and passing away of things also colors his position on the issue of substantial change. For Chisholm is emphatic that one substance cannot change into another (as a caterpillar might transform into a butterfly) or two substances unite to form a third (as two corporations might merge to start a new one). To say that x has changed into y is for Chisholm absurd—a simply flawed formulation of the idea that one ongoing substance z has changed from an x-condition to a y-condition. For Chisholm, a mutation change of substance-identity must be glossed as a change in a single substance descriptive condition. As he sees it, all change is alteration, change in the descriptive, *secundum quid* condition of substances.

However the pivotal *argument* that Chisholm gives for this rejection of identity-change is deeply problematic. It runs as follows:

> Suppose there is something, say the G that is identical with the H today and will be diverse from the H tomorrow. If the H is now identical with the G, then anything that is [now] true of the G is also [now] true of the H.

Therefore if the G will be diverse from the H tomorrow, then the H will be diverse from the H tomorrow. But this consequence is absurd. (p. 55)

It is clear that this reasoning has its problems. If we are going to bring time and change into the orbit of our deliberations, then we have to be careful about keeping track of our time indices. Thus let $T_t(p)$ = "it is true at time t that p," and let n = now = today. Then Chisholm's argument runs as follows:

1. $T_n(G = H)$ by supposition
2. $T_{n+1}(G \neq H)$ by supposition
3. As of n = now: $G = H$ from (1)
4. $T_{n+1}(H \neq H)$ from (2) via (3) by identity substitution

Now (4) is indeed absurd. But of course its derivation depends upon *combining* of (2) and (3), a step which is, in the circumstances, clearly inappropriate in its mixing of temporal indices. Chisholm's reasoning is in fact question begging since it hinges a recourse to the thesis: "once identical is always identical," which is exactly what is in question. In the temporal contexts all attributions of properties and relationships must be time-qualified, identity relationships included.

There may considerably be some plausible metaphysical reasons why identity changes in substances should not be contemplated. But this would have to be established explicitly on substantive metaphysical grounds. It would be quite unrealistic to expect—with Chisholm—that mere logic as such should put this sort of metaphysically substantive conclusion at our disposal.

Chisholm's implicit commitment to a position of "once-identical always identical" again betokens a very conservative perspective—a commitment to an emphatically classical perspective that leaves out of sight the complexities introduced by the emergence of modern tense logic as an alternative approach.

One could, of course, envision a definitional strategy to omnitemporalize identity. That is, one could insist on a construction of identity that assures:

$$G = H \text{ iff } (A_t) T_t (G = H)$$

On this basis we would have it that $T_t(G = H)$ iff $T_{t'}(G = H)$, for any t, t'. Identity now becomes a sempiternal, time-irrelevant relationship rather than one that is (like so much else in this world) transitory and changeable. But of course this is something that cannot simply be assumed. It must be argued directly—over and above any purely logical

considerations. It represents an overt *decision* about the way in which we propose to construct our temporal logic and semantics. It represents one particular choice within a range of theoretically available alternatives. And so it is not something that one theorist can simply impose on another. Accordingly, Chisholm's denial of any prospect of changes in identity is yet another deeply problematic aspect of his substantialistic metaphysic.

It is unquestionably true that the ontological bias of Western philosophy since the days of Aristotle has run in favor of things (substances). Within the ambience of this bias, those metaphysicians who have not altogether denied the reality of process and change (as did Parmenides and F. H. Bradley) have generally sought to minimize its role. And Chisholm stands squarely in this tradition. For, abstractly speaking, one can contemplate process and change as operating at somewhat different ontological levels:

1. Processes of change in the *properties of things*
2. Processes of change in the *existence of things*
 a) coming to be and passing away (i.e., change in point of existence) as a process
 b) change of identity as a process
3. Processes of changes in *states of affairs* independently of things (and their properties and relations)

Now, to be sure, Chisholm is not Parmenides. He is prepared to acknowledge the occurrence of genuine change in relation to the properties of things. But this is as far as he is willing to go: he refuses to move beyond level 1. And the *reason* for this (as apart from any philosophically extraneous issue of *motive*) lies ultimately—as best I can see—in the domain of logic and semantics. Chisholm sees himself as impelled to his position by inexorable logical and semantical considerations. But as the preceding considerations have suggested, this stance is in the final analysis deeply problematic. It is questionable precisely because of the narrowness of Chisholm's logico-semantical traditionalism—his reluctance to move beyond the classical sector of the domain.

It may be, of course, that such a traditionalism is the way not just of conservatism but also of wisdom. Conceivably, leaving the straight and narrow path of logico-semantical traditionalism leads ultimately to difficulties and obstacles that make the price of our new-found freedoms too steep. But this, surely, is something that has to be established explicitly and in great detail before one could be justified in foregoing the rich resources and opportunities of these fertile innovations.

To bring the issue into a more concrete focus, let us consider one

particular ontological problem: that of a *gappy* existence. Here we contemplate the prospect of an individual whose history involves lapsing from existence. On such a view of "intermittent existence," the substance at issue vanishes for a time into an ontological tunnel—as it were—from which it emerges, the same item as before, after a certain interval of nonexistence. Such a situation is easy to describe, though not easy to illustrate in the world's ordinary course of physical things existing at a level of scale above that of subatomic particles. On the other hand, legal entities (nations, corporations, publication series, and the like) afford numerous illustrations of entities that can display the phenomenon of intermittent existence. Here Chisholm avails himself of the convenient recourse of dismissing the sense of identity at issue when one claims that "the thing that existed before the lapse is identically the same thing as the thing that exists after the lapse" is "loose and popular" in contrast to "strict and philosophical."[5] But this dismissal is, surely, little more than tendentious invective. The actual situation seems to be one of there being two different constructions of "is the same thing that existed before"—a less restrictive one that permits interruptions, and a more restrictive one that precludes them. And nothing in the abstract nature of things logical or metaphysical dictates that one must grant to continuous existence a status somehow *superior* to that of intermittent existence.

At this point, we come to Chisholm's treatment of the "Ship of Theseus" problem of the vessel rebuilt over time plank by plank, yet with those old planks saved up and eventually reassembled. (Is the resultant vessel still the actual Ship of Theseus?) This example points beyond the question of *interrupted* existence to encompass also the problem of a *divided* existence. Chisholm's position here is as follows:

> When the existence of such a borderline case does thus require us to make a choice between "Yes" and "No," the decision is an entirely pragmatic one, simply a matter of convenience. . . . The important thing here is this: The convention of the courts, or of the proper authorities will settle the matter. . . . It would make no sense to say: Well, it just might be, you know, that they are mistaken. (pp. 32–33)

Chisholm thus draws a clear line. With questions of *descriptive* sameness of the form "Is it the same *X*?" (the same ship, the same stocking), we have the "loose and popular" sense of sameness/identity, and the situation here is one of a conventional decision—though not necessarily an arbitrary one, but one that is pragmatically based on contextual convenience. But with a question of *substantial* sameness, "Is it the same item?" (the same thing, the same object), we encounter the "strict and philosophical sense of sameness," and the situation is seen as one of factual correctness based on the ontological/semantical realities which—

as Chisholm has it—preclude eccentricities along the lines of interruptions and splittings.

However, Chisholm's insistence that there is a night-and-day difference between the two cases raises three problems:

1. Just what is it about *substantial* sameness (the same thing) that sets it so sharply and categorically apart from *descriptive* sameness (the same ship) that the former is something "strict and philosophical" while the latter remains merely "loose and popular"? In particular,

2. Why is it that descriptive sameness is "merely pragmatic" while substantial sameness is something hard and fast? Why should one not take the line that sameness/identity is not pragmatic "all the way down," ruled by considerations of procedural convenience just as much in substantive as in descriptive cases?

3. Even granting for the sake of discussion that substantial sameness ("the same thing") is something hard-and-fast distinguishable for descriptive sameness ("the same ship"), why is it that person-sameness ("the same person") should be assimilated to strict substantial rather than to loose descriptive sameness?

The impetus of such questions indicates that Chisholm's position is far more problematic than his own discussion would give one any reason to suspect.

This carries us back to Chisholm's perspective of seeing persons as paradigm things (substances). And one is entitled to ask: What Ptolemaic verity is it that puts us humans at the center of the ontological universe? Why see people, rather, say, than atoms, as quintessential substances? After all, there is no reason of fundamental principle why persons themselves could not or should not be conceptualized in other, nonsubstantival terms (and especially as processes). And at this juncture we come to Chisholm's critique of the process approach (pp. 94–95).

The fact is that process philosophy does not evoke much interest or sympathy for Chisholm. He dismisses it in one brief paragraph:

> There are "process"-philosophers who say that such things as human bodies and matchbooks are really processes. But, so far as I know, no one has ever devoted any philosophical toil to showing how to reduce such things to processes. In the absence of such a reduction, I would agree with C. D. Broad . . . : "It is plainly contrary to common sense to say that the phases in the history of a thing are parts of the thing. . . ." [A former person] is an individual who once had the shape and size of a man, but no process or career can have the shape and size of a man. (pp. 94–95)

These dismissive remarks afford a far-reaching indication of the basis for and motivation of Chisholm's ontological position. For Chisholm, the

idea of persons as processes is a metaphysical horror. He is unwilling to take seriously the prospect that traditional physical objects—let alone persons!—should be understood in terms of something as inherently temporal and transitory as processes. But in the light of this negativism, his position does process philosophy less than justice.

Chisholm sees the issue of persons and their identity as his ace in the hole. His commitment to a substances-geared ontology is to all available appearances heavily motivated by a conviction that persons and their identity can be understood, and can *only* be appropriately understood, through conceiving of them as substantial things. But this qualifies as a rather dubious proposition.

If one is committed to conceiving of a *person* within the framework of a classical thing–metaphysic, then one is going to be impelled inexorably towards the materialist view that the definitive feature of a person is his body and its doings: this is the only readily available person-relative item that is readily conceptualized as a thing, since, of everything that appertains to us, it is clearly one's *body* that is most readily and apprehensibly assimilated to the substance paradigm.[6] Think here of David Hume's ventures into self-apprehension:

> From what (experiential) impression could this idea [of self] be derived? This question is impossible to answer without a manifest contradiction and absurdity; and yet it is a question which must necessarily be answered, if we would have the idea of self pass for clear and intelligible. . . . For my part, when I enter most intimately into what I call *myself,* I always stumble on some particular perception or other, of heat or cold, light or shade, love or hatred, pain or pleasure. I never can catch *myself* at any time without a perception, and never can observe anything but the perception.[7]

Surely Hume is perfectly right here. Any such quest for *observational* confrontation with a personal core substance, a self or ego that constitutes the particular person that one is, is destined to end in failure. The only "things" about ourselves that we—and others—can get hold of *observationally* is the body and its activities and sensations. But is this where we really want to place our bets or regard the issue of personal identity? After all, it feels decidedly uncomfortable to conceptualize *people* (persons) as *things* (substances)—oneself above all—because we resist flat-out identification with our bodies. Aristotle already bears witness to this difficulty of accommodating the self or soul into a substance metaphysic. It is, he tells us, the "substantial form," the *entelechy* of the body. But this accommodation strategy raises more problems than it solves, because the self or soul is so profoundly unlike the other sorts of entelechy examples that Aristotle is able to provide.

The self or ego has always been a stumbling-block for Western philosophy because of its resistance to accommodation within its favored framework of substance-ontology. The idea that "the self" is a *thing* (substance)—and that whatever takes place in "my mind" and "my thoughts" is a matter of the activity of a thing of a certain sort (a "mind"-substance)—is surely no more than a rather blatant sort of fiction—a somewhat desperate effort to apply the "thing" paradigm to a range of phenomena that it just doesn't fit.

The fact is that people instinctively dislike being described in thing-classificatory terms. As Sartre indicates, a wrongdoer may be prepared to say "I did this or that act" but will resist saying "I am a thief," "I am a murderer."[8] Such attributions indicate an objective fixity that we naturally see as repugnant to ourselves. People generally incline to see themselves and their doings not in terms of objects and their properties but in processual terms—as manifolds of teleological, agency-purposive activities geared to the satisfaction of needs and wants as they function in the circumstances of the moment. In application to ourselves, at any rate, thing-classifiers have a status mien that is naturally distasteful to us.

However, from the angle of a process metaphysic, the situation has a rather different look. We have difficulties in apprehending what we *are*, but have little difficulty in experiencing what we *do*. Our bodily and mental activities lie wide open to our experiential apprehension. There is no problem with experiential access to the processes and patterns of process that characterize us personally—our doings and undergoings, either individually or patterned into talents, skills, capabilities, traits, dispositions, habits, inclinations, and tendencies to action and inaction are, after all, what characteristically define a person as the individual he or she is. And what makes my experience mine is not some peculiar qualitative character that it exhibits, but simply its forming part of the overall ongoing process that delineates and constitutes my life. We face no insuperable obstacle in seeing ourselves defined—in processual terms—as constituted by the systemic utility of our actual and potential actions, by what we do (by our *career* to use Chisholm's own aptly chosen word).

Chisholm insists (p. 123) on seeing "feeling depressed" and "being appeared to redly" as *properties* (i.e., nonrelational qualities) of a person. But why not see "going through a period of depression" or "experiencing an appearance of red" as processes in particular, as subprocesses that constitute part of the macroprocess that constitutes a person? What legislates that we must see such items as descriptive *properties of substances* rather than—surely more naturally—as *components of processes*?

If we take a person's identity to inhere (wholly or primarily) in physical (bodily) continuity, then we encounter all of those gradual replacement problems dear to philosophers (not to speak of the brain transplantation envisioned by science-fiction writers), and that are reflected in Chisholm's concern with the shape of the setting and its difficulties. But, if we see a person's identity in terms of a processual unity—as a macroprocess constituted through a mutually integrated system of component subprocesses—then many of these difficulties can be averted.

Once we conceptualize the core "self" of a person as a unified manifold of actual and potential process—of action and capacities, tendencies, and dispositions to action (both physical and psychical)— then we have a concept of personhood that renders the self or ego experientially accessible, seeing that experiencing itself simply *consists* of such processes. On a process-oriented approach, the self or ego (the constituting core of a person as such, that is, as the particular person he or she is) is simply a megaprocess—a *structured system of processes*, a cohesive and (relatively) stable center of agency. The unity of person is a unity of experience—the coalescence of all of one's diverse microexperiences as part of one unified macroprocess. (It is the same sort of unity of process that links each minute's level into a single overall journey.) The crux—and principal attraction—of this approach is its shift in orientation from substance to process—from a unity of hardware, of physical machinery, to a unity of software, of programming or mode of functioning.

Miguel de Unamuno asserted that Descartes got it backwards—that instead of *cogito, ergo sum res cogitans* it should be: *sum res cogitans, ergo cogito.*[9] But this is not so. Descartes's reversal of Scholasticism's traditional substance-prioritizing is perfectly in order, based on the sound idea that activity comes first *("Im Anfang war die Tat")*—that what we do defines what we are. The fundamentality of psychic process for the constitution of a self was put on the agenda of modern philosophy by Descartes, even though he himself remained deeply enmeshed in the work of the theory paradigm.[10]

The salient advantage of a view of the self as an internally complex process of "leading a life (of a particular sort)"—with its natural division into a varied manifold of constituent subprocesses—is that it does away with the need for a mysterious and experientially inaccessible unifying substantial *entity* (on the lines of Kant's "transcendental ego") to constitute a self out of the variety of its experiences. The unity of self comes to be seen as a unity of process—of one large, integrated megaprocess that encompasses many smaller ones in its make-up. Such

an approach wholly rejects the thing-ontologist's view of a person as an *entity* existing separately from its actions, activities, and experiences. We arrive at a view of mind that dispenses with the Cartesian "ghost in the machine" and looks to the unity of mind as a unity of functioning—of operation rather than operator. A "self" is viewed not as a thing but as a unified though internally complex process.

On this basis, the Humean complaint—"One experiences feeling this and doing that, but one never experiences *oneself*"—is much like the complaint of the person who says "I see him picking up that brick, and mixing that batch of mortar, and cementing that brick into place, but I never see him building a wall." Even as "building the wall" just exactly *is* the complex process that is *composed* of those various activities, so— from the process point of view—one's self just is this complex process *composed* of those various physical and psychic experiences, actions, and responses taken as subprocesses in their systemic interrelationship within one overarching superprocess. The process-based approach in philosophical psychology doubtless has difficulties of its own. But there is no good reason to think that they decisively outweigh those of the traditional substantival approach.

There yet remains Chisholm's charge that process philosophers have expended insufficient philosophical toil. There is much justice in this charge. Yet, all the same, it seems to be true—universally and invariably—that a philosophical position is never developed as fully as its opponents would require. For, of course, these opponents standardly see the position as replete with difficulties and defects—real or imagined—which, to *their* mind, its proponents have not resolved satisfactorily. Chisholm is no doubt right that process philosophy stands in need of further development. But what philosophical position— traditionalistic substance/attribute metaphysics included—is exempt from this stricture? In philosophy there is always more to be done.

And, in any case, is the situation that obtains here really as bad as Chisholm suggests? Perhaps it is true that ordinary language favors the grammar of object and property over that of subject and verbs—though there is room for doubt here. But matters surely stand otherwise with the machinery of differential equations, the language of process. In this regard as in so many others, Leibniz had insight far beyond his time. Important though subject-predicate discourse may be (and he stresses that they are *very* important), it is the *mathematical* language of process—of transformation functions and differential equations—that process philosophers from Leibniz to Whitehead—both of them first-rate mathematicians—have always emphasized.

To be sure, if Chisholm were right and insurmountable difficulties

ensued for a process approach at the level of something as fundamental as logic and semantics, then the substance ontologists would be within sight of an easy victory. But the present deliberations suggest that no such facile triumph is available to them, the process approach affording an available option to a far greater extent than Chisholm's treatment of the issue would lead his readers to suspect. Chisholm's metaphysical deliberations exaggerate the merits of a traditionalistic ontology of things. A case can be made out for the claim that there is more vitality and more promise to process ontology than is dreamt of in Roderick Chisholm's ingenious philosophy.

NICHOLAS RESCHER

DEPARTMENT OF PHILOSOPHY
UNIVERSITY OF PITTSBURGH
NOVEMBER 1993

NOTES

1. Unless explicitly noted to the contrary, all references to Chisholm's discussions are to his *On Metaphysics* (Minneapolis: University of Minnesota Press, 1989).

2. See the essay "Exists from Paradox" in the author's *Satisfying Reason* (Dordrecht: Reidel, 1994).

3. See George J. Klir and Tina A. Folger, *Fuzzy Sets, Uncertainty, and Information* (Englewood Cliffs, N.J.: Prentice Hall, 1988).

4. See the author's *Many-Valued Logic* (New York: McGraw Hill 1969; reprinted Godstone, UK: Gregg Revivals, 1994).

5. Chisholm, "Identity Through Time," in *On Metaphysics*, pp. 25–41.

6. Chisholm himself views with favor (p. 123) G. T. Fechner's double-aspect theory that while intrinsically, "to ourselves" persons are psychical, extrinsically "for others," they are material (physical). But it is all too clear that others always constitute an overwhelming majority.

7. David Hume, *A Treatise of Human Nature*, bk. 1, pt. 4, sec. 6, "Of Personal Identity." In the appendix, Hume further elaborates: "When I turn my reflection on myself, I never can perceive this *myself* without some one or more perceptions; nor can I ever perceive anything but the [sensory] perceptions. It is the composition of these, therefore, which forms the SELF."

8. J. P. Sartre, "Bad Faith," in *Being and Nothingness*, trans. Hazel Barnes (New York: Washington Square Press, 1966), pp. 107 f.

9. Miguel de Unamuno, *Del sentimiento trágico de la vida*, ed. P. Felix Garcia (Madrid: Espasa-Calpe, 1982), p. 52.

10. On this theme see Gilbert Ryle's *Concept of Mind* (London: Hutchinson, 1949).

REPLY TO NICHOLAS RESCHER

Nicholas Rescher, in "Chisholm's Ontology," contrasts what I have said about ontology with "process ontology." What, then, is a process?

I assume that every process is a change and that every change is a change in something. Is there a sense in which a given process can be said to be a change *in that process itself?* There is no sense in which a process can be said to be a change in itself. (The reasoning presupposed by this remark is the same as that presupposed by St. Thomas Aquinas's remark to the effect that an act of will cannot have itself as its object.)

Can a process involve a change in that process itself? The only sense in which a process involves a change in that process itself is that in which the process involves a change *in everything*. (If you stand up then *everything* becomes such that you stand up.)

But Rescher concludes his paper by saying: "A case can be made for the claim that there is more vitality and more promise in a process philosophy than is dreamed of in Roderick Chisholm's ingenious philosophy."

I am sure that the difference between Rescher and me lies in our preanalytic assumptions about what philosophy is and about what philosophy ought to do. I would like to think that, if we were to talk about these things, then we would become much closer than we now seem to be.

R.M.C.

9

David H. Sanford

CHISHOLM ON BRENTANO'S THESIS

One of Roderick Chisholm's earliest publications on intentionality begins with the following passage:

> Franz Brentano wrote, in a well-known passage, that *intentionality* is peculiar to psychical phenomena. No *physical* phenomenon, he said, shows anything like it; hence intentionality affords us a criterion of the mental or psychical. Let us refer to this view as "Brentano's thesis." (Chisholm 1952, p. 56)

Although he mentions Russell, Chisholm does not mention *The Analysis of Mind* in which Russell quotes exactly the passage from Brentano that Chisholm later makes influential:

> We may take as one of the best and most typical representatives of this school the Austrian psychologist Brentano, whose *Psychology from the Empirical Standpoint*, though published in 1874, is still influential and was the starting-point of a great deal of interesting work. He says (p. 115):
> "Every psychical phenomenon is characterized by what the scholastics of the Middle Ages called the intentional (also the mental) inexistence of an object, and what we, although with not quite unambiguous expressions, would call relation to a content, direction towards an object (which is not here to be understood as a reality), or immanent objectivity. Each contains something in itself as an object, though not each in the same way. In presentation something is presented, in judgment something is acknowledged or rejected, in love something is loved, in hatred hated, in desire desired, and so on.
> "This intentional inexistence is exclusively peculiar to psychical phenomena. No physical phenomena shows anything similar. And so we can define psychical phenomena by saying that they are phenomena which intentionally contain an object in themselves."
> The view here expressed, that relation to an object is an ultimate irreducible characteristic of mental phenomena, is one which I shall be concerned to combat. (Russell 1921, pp. 14–15)

Chisholm defends what Russell and others combat. He later examines attempts by Russell, Reichenbach, Ayer, Braithwaite, Carnap, James, Osgood, and Morris to combat Brentano's thesis (Chisholm 1955–56, 1957). These philosophers would explain intentionality away. Given an

intentional, psychological sentence *I,* they attempt to find some non-intentional sentence *S* that is equivalent to *I.* Chisholm, in case after case, either argues that the equivalence fails or argues that *S* is itself intentional. In these cases, his defense of Brentano appears to be decisive.[1]

In the first letter of the exchange on intentionality between Wilfrid Sellars and himself, Chisholm sums up his position with a question:

> (1) Can we explicate the intentional character of believing and of other psychological attitudes by reference to certain features of language; or (2) must we explicate the intentional characteristics of language by reference to believing and to other psychological attitudes? (Chisholm and Sellars 1958, p. 215)

Chisholm had already (in 1955–56) answered (1) with a clear negative and (2) with a clear affirmative. In the 1950s, Chisholm confronted Reichenbach, Carnap, and Sellars directly on issues of language, belief, and intentionality. From the 1970s onward, philosophic attention to intentionality has only increased. There are efforts to explain how intentionality is possible, to naturalize it, to find its place in nature, and to connect it with the causal order.[2] Most of these writers are not so explicit as Russell about their relation to Brentano's thesis. Many of them pursue projects that are contrary to Brentano's thesis. Chisholm's primary concerns since the 1960s do not include an ongoing close defense of Brentano's thesis from current ingenious innovations in the philosophy of mind.

My purpose in this paper is neither to defend nor to refute Brentano's thesis. Nor shall I address the importance and implications of Brentano's thesis, except to comment that its incompatibility with physicalism depends on what you mean by "physicalism." Brentano's thesis does not imply dualism.[3] It does seem to imply that intentional psychology is conceptually autonomous from pure physics. In this paper I attempt the following: to distinguish proposals about intentionality that are often confused, both by those who support and those who oppose Chisholm's project; to generalize the notion of logical independence; and, based on this notion of independence, to revise some of Chisholm's criteria of intentionality.

Chisholm's formulations of Brentano's thesis have two parts, definitions of certain linguistic items as *intentional,* and proposals about the general relations between intentional linguistic items and the psychological. "Intentionality and the Theory of Signs" defines certain uses of language as intentional (Chisholm 1952, p. 57). "Sentences about Believing" and several subsequent articles provide a definition of *intentional sentence* (Chisholm 1955–56, pp. 32–35). Later articles,

including Chisholm 1967a and 1967b, define *intentional modal prefix*. After looking at Chisholm's proposals about the relations between intentionality and the psychological, I return to these definitions. The success of Chisholm's enterprise depends not only on these two components separately, the definitions of intentionality and the proposals about the intentionality of the psychological, but also on the relations between them.

The passage from "Intentionality and the Theory of Signs" that begins this paper proposes a straightforward thesis: "Intentionality is peculiar to psychical phenomena. No *physical* phenomenon . . . shows anything like it." Substituting 'psychological' for 'psychical', we may restate this version of "Brentano's Thesis" as follows:

(1) All psychological sentences are intentional.
(2) All intentional sentences are psychological.

Another way of putting (2):

No nonpsychological sentences are intentional.

These formulations do not explicitly use the notion of the *physical* and thereby avoid the question whether everything physical is nonpsychological.

In "Sentences About Believing" (and elsewhere, such as Chisholm 1957), Chisholm formulates a thesis with a significantly different logical form:

> We may now formulate a thesis resembling that of Brentano by referring to intentional language. Let us say (1) that we do not need to use intentional language when we describe non psychological, or "physical," phenomena; we can express all that we know, or believe, about such phenomena in language which is not intentional. And let us say (2) that, when we wish to describe certain psychological phenomena—in particular, when we wish to describe thinking, believing, perceiving, seeing, knowing, wanting, hoping, and the like—either (a) we must use language which is intentional or (b) we must use a vocabulary which we do not need to use when we describe non psychological or "physical," phenomena. (Chisholm 1955–56, p. 35)

Again avoiding reference to the physical, I restate and renumber these claims as follows:

(3) Every intentional nonpsychological sentence is equivalent to a nonintentional sentence.
(4) No intentional psychological sentence is equivalent to a nonintentional sentence.

(3) and (4) leave something out of Chisholm's formulation that I now state as a separate requirement:

(1A) The sentences that we use to describe thinking, believing, perceiving, wanting, hoping, and the like, are intentional.

Brentano's examples of intentionality are paradigms. "In presentation something is presented, in judgment something is acknowledged or rejected, in love something is loved, in hatred hated, in desire desired," and so on. Later I will comment on *knowing*, which I omit from Chisholm's list. The label '1A' indicates that it is an alternative to (1). Chisholm does not really assert or imply (1) in the passage quoted. Without exerting heavy pressure on the notion of the *psychological*, it is difficult to produce a definition of *intentional sentence* on which (1) and (2) are both true. The following version of Brentano's thesis holds more promise:

> The Coextension Thesis (abbreviated "Coextension"):
> the conjunction of (1A) and (2).
> Intentionality is Peculiar to the Psychological.

There is also the second thesis resembling that of Brentano:

> The Autonomy Thesis (abbreviated "Autonomy"):
> the conjunction of (1A), (3), and (4).
> *Irreducible* Intentionality is Peculiar to the Psychological.

In the psychological realm, intentional attributions and explanations are autonomous, not reducible to anything nonintentional. This thesis might also be called the Indispensability or the Irreducibility Thesis.

Philosophers who respond to Chisholm on the topic of intentionality often fail to distinguish these two theses.[4] Chisholm himself sometimes appears not to distinguish them. Sometimes one thesis is treated as an interpretation of the other. The Coextension Thesis and the Autonomy (or Irreducibility) Thesis are distinct. Although (1A) increases the plausibility of both theses, I omit it temporarily in order to pose a question about logical independence, a notion that is important both for distinguishing different theses about intentionality and for formulating criteria for intentionality. The question "Are (1) and (2) logically independent of (3) and (4)?" is unclear even though it is clear enough what it means to ask about the logical independence of *two* statements A and B. Consider these four conditionals:

> If A, then B.
> If B, then A.

If A, then not-B.
If not-A, then B.

A and B are logically independent if none of the conditional statements above is true only in virtue of the meaning and logical form of the statements A and B. So one can interpret the above question in several ways. It can be about two statements, both conjunctions, the first [(1) and (2)] and the second [(3) and (4)]. It can be about all the combinations of pairs of statements. Statements that are pairwise independent, however, can be jointly inconsistent. For example:

All psychological statements are intentional.
"I have a headache" is a psychological statement.
"I have a headache" is not intentional.

The general notion of logical independence need not detain us if our main interest is locating the respects of dependence and independence of the component statements of Coextension and Autonomy. My more general interest in logical independence, however, pertains to the project of this paper. I will restate Chisholm's most familiar criteria of intentionality in terms of logical independence. Near the end of the paper, I will revise Chisholm's later criteria of intentionality in a way that requires generalizing the notion of logical independence so that it applies to more than two statements at once.

To deal with more than two statements at once, we generalize the notion of logical independence as follows: A conjunction C is an *elementary conjunction of n statements* A_1, A_2, . . . A_n just when C has exactly n conjuncts; each conjunct of C is either a statement A_i, or its negation, and each statement A_i, or its negation, is a conjunct of C. The identity of the basic conjuncts determines the identity of an elementary conjunction. The order and grouping of the conjuncts are immaterial. N statements A_1, A_2, . . . A_n *are logically independent when no elementary conjunction of these statements is false only in virtue of the meaning and logical form of its components. For n* statements, there are 2^n distinct elementary conjunctions. Each elementary conjunction of n statements corresponds to a row in a truth table. N statements are logically independent if every row of its truth table represents a possibility not precluded by meaning or logical form. To know just how statements are related that are not logically independent requires knowing just which elementary conjunctions are logically false.[5]

The pairs of conjunctions we initially considered, "(1) and (2)" and "(3) and (4)," are logically independent. The two revised theses, Coextension and Autonomy, are also logically independent. The *con-*

juncts of the two theses are not logically independent, of course. (2) entails (3), and (1A) is a conjunct of each thesis. The two conjunctions are nevertheless logically independent of each other, for every combination of the values *true* and *false* is possible: TT, TF, FT, FF.

These claims about independence do not appeal to the meaning of *intentional sentence*. It remains to be seen whether there is a meaning of *intentional sentence* on which (1A) is true and, in addition, either (2) is true, or both (3) and (4) are true. I now turn to the project of defining *intentional sentence*. The following paraphrase three criteria by Chisholm (1955–56, 1957, and elsewhere):

Existence Independence. A simple declarative sentence S that contains a substantival expression E is intentional if S and the corresponding sentence 'There is an E' are logically independent. The sentence "Martha Jane was afraid of wolves" is intentional because it and "There were wolves" ("There was a wolf," "Wolves existed") are logically independent.

A broader version of this criterion requires only that the sentence S does not entail the corresponding sentence "There is an E." Consider (S_{nz}) "New Zealand is devoid of unicorns," an example from Chisholm 1967a, p. 203a. It does not entail (E_{nz}) "There are unicorns." On the other hand, S_{nz} is not logically independent from E_{nz} because not-E_{nz} entails S_{nz}. If the universe is devoid of unicorns, then so is New Zealand. The sentence S_{nz} about the nonexistence of unicorns in New Zealand does not count as intentional on the stronger version of the criterion of existence independence in terms of logical independence. If it did count as an intentional sentence, it would be a counterexample to (2) and thus a counterexample to Coextension. It would be merely a potential counterexample to (3) and to Autonomy. If S_{nz}, a nonpsychological sentence, is intentional on some acceptable criterion, then the question is whether it is equivalent to some nonintentional sentence. The example falsifies (3) only if there is no such equivalence.

Truth-Value Independence. A noncompound sentence S that contains a propositional clause C is intentional if S and C are logically independent. The sentence "Martha Jane thought that wolves were closing in on her" is intentional because it and "Wolves were closing in on her" are logically independent. (Years after the frightening event, my pioneer great-grandmother came to doubt that the wolves on either side of the road were actually closing in on her. At the time, though, she definitely thought they were.)

Logical truths and logical falsehoods can be objects of belief and interest, yet they are logically independent of nothing. "Judith believes

that there is no largest prime number" is not logically independent of "There is no largest prime number" (which is necessarily true). Similarly, "Thomas believes that it is possible to square the circle" is not logically independent of "It is possible to square the circle" (which is necessarily false). Although the criterion of truth-value independence is not an adequate necessary condition for intentionality, that is no difficulty so long as some criterion, such as the following, picks up the sentences this criterion misses that we want to classify as intentional.

Referential Opacity, or *Indirect Reference*. Given an identity statement "$A = B$," and sentences S and T that differ only in that A occurs in S in one or more places where B occurs in T, S and T are intentional if they are logically independent. Given that R. E. Hobart = Dickinson S. Miller, "Bernard knows that R. E. Hobart wrote an article on determinism" and "Bernard knows that Dickinson S. Miller wrote an article on determinism" are intentional because they are logically independent.

Chisholm's version of this criterion requires a single failure of implication rather than full independence. There is a formal reason in favor of stating criteria of intentionality in terms of logical independence. A sentence and its contradictory are logically independent of exactly the same sentences. On a criterion of the form "Sentence S is intentional if it is logically independent of X," S is intentional if and only if the contradictory of S is intentional. The Autonomy Thesis requires this result. Suppose some psychological sentence, such as "William desires Maud" is intentional, but its contradictory "William does not desire Maud" is not intentional. Chisholm specifies that "a compound declarative sentence is intentional if and only if one or more of its component sentences is intentional" (Chisholm 1957, p. 172). So the compound "It is not the case that William does not desire Maud" counts as nonintentional. It is equivalent to the original "William desires Maud," so it is a counterexample to (4) and is what I call a *cheap refutation* of Autonomy. Although such a counterexample provides no theoretical insight into how intentionality is possible, it is still a real counterexample.

"Bernard knows that R. E. Hobart wrote an article on determinism" is not intentional according to the criterion of Truth-Value Independence because of the logic of *know*. Whatever one knows is so because knowledge requires truth. Each criterion provides a sufficient condition of intentionality. None purports to give a necessary condition. There is no problem with a sentence that satisfies one but not another.[6]

Chisholm presents the three criteria of intentionality formulated above in connection with the Autonomy Thesis. If there are clear,

uncontroversial counterexamples to Autonomy that use these three criteria as individually sufficient and disjunctively necessary for the intentionality of a sentence, I am not aware of them. Chisholm's central claim about these criteria, so far as I know, is unrefuted. There are difficult (and controversial) cases. One can argue that "That lady resembles a mermaid" (Chisholm 1967, p. 203a) is really intentional since it refers to a creature of fiction, something that has intentional inexistence. Other resemblance statements can receive different treatment. "That lady resembles a manatee," which mentions no fictional entities, is equivalent to a nonintentional sentence, or so one can argue. If this approach to resemblance becomes unattractive, we can qualify Autonomy to exclude resemblance statements from consideration. (See Chisholm 1957, p. 172, note 4.)

On these criteria of intentionality, Autonomy is promising and Coextension fares poorly. Replacing (1) by (1A) protects Coextension from counterexamples of one kind, but abundant counterexamples to (2) remain. "It is not probable that a comet will strike Providence in the twenty-first century," for example, is logically independent from "A comet will strike Providence in the twenty-first century." This nonpsychological sentence satisfies the criterion of Truth-Value Independence.

As I said earlier, many critics of Chisholm fail to distinguish Coextension from Autonomy, and Chisholm himself sometimes appears to be among them.[7] "Brentano's Thesis" quietly becomes Coextension rather than Autonomy in Chisholm 1967a and 1967b where Chisholm develops new criteria of intentionality appropriate to Coextension. These apply at the base level to modal prefixes or operators rather than to complete sentences.

Chisholm says, "We may think of a modal operator (somewhat broadly) as a phrase which, when prefixed to a complete statement, yields a new complete sentence" (Chisholm 1963–64, pp. 75–76). Chisholm 1967a, p. 203b, uses instead the phrase *sentence prefix*. A simple modal operator or sentence prefix contains no sentence functions or complete sentences. "If Daria stays out past midnight, then I will start to wonder whether . . ." is a nonsimple modal prefix. Examples of simple modal prefixes are "It is true that . . . ," "It is false that . . . ," "It is probable that . . . ," "Kate is absolutely certain that . . . ," "Martha Jane was afraid *(p)*," and "Everyone believes *(p)*." The last two examples adopt Chisholm's convention of using parentheses and a propositional variable instead of *that* and an ellipsis.

This is Chisholm's criterion of *Contingency:* "We may say that a

(simple) prefix M is *intentional* if, for every sentence p, M(p) is logically contingent" (Chisholm 1964–65, p. 95. See also Chisholm 1967a, p. 203b).

"It is true *(p)*" clearly does not satisfy this definition. "It is true that there is no largest prime number," for example, is not contingent. Whenever *p* is noncontingent, whether true or false, so is the corresponding "It is true *(p)*." "*S* believes *(p)*" appears to satisfy the definition. "*S* knows *(p)*," "*S* can see *(p)*," and many such prefixes that are psychological success-words obviously do not satisfy it. So long as the list of psychological verbs in (1A) makes appropriate exclusions, however, the Contingency criterion and Coextension appear to be mutually well-adapted. Autonomy, however, is subject to cheap refutation. "William does not desire that Maud returns his affection, which he most ardently desires" is self-contradictory, not contingent, so the prefix 'William does not desire *(p)*' is nonintentional, as is the compound 'It is false that William does not desire *(p)*' which is equivalent to 'William desires *(p)*'.

Autonomy and Coextension differ in philosophic importance. Autonomy by itself preserves Brentano's insight. Autonomy and Coextension together preserve this insight in a stringent combination that is difficult to defend. Although Coextension by itself locates a characteristic that is peculiar to the psychological, it is a dispensable characteristic, nothing that is necessary to describe the psychological.

The final *Tabular* criterion, compared to the other criteria, is more complicated. Taking *'M(p)'* as a modal prefix, and using standard notation of predicate logic, we can distinguish the following four forms. These four forms are the functions of two differences. Chisholm indicates one difference, between universal and existential quantification, by the letters 'U' and 'E'. He indicates the other difference, between the modal prefix coming before the quantifier and the reverse order, with the quantifier first, by the letters 'C' and 'D' which stand for the medieval technical phrases *in sensu composito* and *in sensu diviso:*

(UC) $M[(x)(Fx)]$.
(UD) $(x)[M(Fx)]$.
(EC) $M[(\exists x)(Fx)]$.
(ED) $(\exists x)[M(Fx)]$.

For example, let the modal prefix be 'Janet believes *(p)*,' let the predicate '*Fx*' be '*x* is a native plant,' and let the universe of discourse be plants that grow on a certain mountainside in the Slickrock Wilderness. Instead of substituting mechanically into the formulae above, I write somewhat more idiomatic sentences:

(UC) Janet believes that everything is a native plant.
(UD) For every plant, Janet believes that it is a native plant.
(EC) Janet believes that something is a native plant.
(ED) There is a plant that Janet believes is a native plant.

Chisholm uses a table to represent implications and nonimplications between UC, UD, EC, and ED statements. A minus sign at the intersection of a column and a row indicates that the statement at the top of the column does not imply the statement to the left of that row. The absence of a minus sign indicates that the implication holds. Self-implications always hold, no matter what the content of the statement. In the first of the following tables, I indicate these vacuous self-implications with a 'V'.

	UC	UD	EC	ED
UC	V		–	–
UD		V	–	–
EC			V	
ED				V

I. It is true *(p)*

	UC	UD	EC	ED
UC				
UD	–			–
EC	–			–
ED				

II. It is false *(p)*

	UC	UD	EC	ED
UC		–	–	–
UD	–		–	–
EC	–			
ED	–		–	

III. *S* believes *(p)*

Chisholm is the author of these tables. He proposes that table III defines the intentionality of *believes that* and many other psychological verbs.[8] When we take this particular pattern of implications and nonimplications to characterize intentionality, Coextension is plausible.

But there is again a problem with the cheap refutation of Autonomy. The pattern of implications for '*S* does not believe *(p)*' diverges in several respects from the pattern for '*S* believes *(p)*'. The fact that EC implies UD is perhaps the most conspicuous difference. If (EC) Janet does not believe that something is a native plant, then (UD) for everything, Janet does not believe that it is a native plant. If '*S* does not believe *(p)*' counts as nonintentional, it is all too easy to produce a nonintentional reduction of the intentionality of belief. In order to preclude such lightning attacks on the Thesis of Autonomy, I will suggest a version of the tabular criterion of intentionality that counts a prefix '*M(p)*' as intentional if and only if it also counts the corresponding prefix 'not-*M(p)*' as intentional.

Chisholm's 4-by-4 table has sixteen intersections of which four represent vacuous self-implications. For pairs of statements, *A* and *B*, the table indicates whether or not *A* implies *B* and *B* implies *A*. There is no indication of whether or not ~*A* implies *B* and *A* implies ~*B*. (At this point, '~' [tilde] abbreviates 'not-'.) Treating the logical relations of four statements pairwise, Chisholm's table considers half of the twenty-four combinations. Consider treating the logical relations of four statements together as a foursome. In the manner I outlined above, investigate the

logical independence of four statements by examining sixteen elementary, four-conjunct conjunctions. Most modal prefixes, if not all, yield a variegated pattern. Some elementary conjunctions are logically false, and some are not. (For every implication Chisholm's table indicates, there are four logically false elementary conjunctions. If UD implies UC, for example, each of the four conjunctions with UD and ~UC as conjuncts is logically false.)

For any pair of contradictory modal prefixes, $M(p)$ and $\sim M(p)$, the tests for the logical independence of the corresponding UC, UD, EC, ED statements are identical. This is not so of just any four forms that bear some structural analogy to UC, UD, EC, and ED. The specific structure of these forms makes a difference. Using obvious abbreviations, I indicate some equivalences:

$$\sim UC(M) = \sim M[(x)(Fx)] \qquad\qquad = UC(\sim M)$$
$$\sim UD(M) = \sim(x)[M(Fx)] = (\exists x)[\sim M(Fx)] = ED(\sim M)$$
$$\sim EC(M) = \sim M[(\exists x)(Fx)] \qquad\qquad = EC(\sim M)$$
$$\sim ED(M) = \sim(\exists x)[M(Fx)] = (x)[\sim M(Fx)] = UD(\sim M)$$

The table for 'It is true (p)' indicates the following four nonimplications:

EC does not imply UC.
EC does not imply UD.
ED does not imply UC.
ED does not imply UD.

By the $M/\sim M$ equivalences above, and the contraposition of nonimplication, these are equivalent respectively to the following nonimplications for 'It is not true (p)':

UC does not imply EC.
ED does not imply EC.
UC does not imply UD.
ED does not imply UD.

The table for 'It is false (p)' indicates exactly these four nonimplications. Although in some contexts we might distinguish 'false' from 'not true', in this exercise, they are interchangeable. In one discussion of his tabular criterion, Chisholm writes:

> We will find that most of the other familiar modalities have the following property in common with "true" and "false": the pair consisting of the modal prefix and its negation (i.e., the modal prefix preceded by "it is false that") are such that one of them has at least the four failures of "true" and the other has at least the four failures of "false." (Chisholm 1967b, p. 15)

Logical considerations explain why the regularities of these patterns are

not a sheer coincidence. Perhaps many of Chisholm's readers find obvious what I discovered in writing this paper. The four failures for 'true' and the four failures for 'false' are logically equivalent. The prefixes do not, of course, have the same patterns of nonimplication. For example, UC implies UD for 'true' and not for 'not true'. Still, the nonimplications of 'true' and of 'not true' are logically equivalent. Each diagram is derivable from the other.

As I said earlier, EC implies UD for 'S does not believe (p)', but EC does not imply UD for 'S believes (p'). Let us reexamine this difference.[9] As the above table of equivalences indicates, EC (does not believe) is equivalent to not-EC (believes). For example, "Janet does not believe that something is a native plant" is equivalent to "It is not the case that Janet believes that something is a native plant." Similarly, UD (does not believe) is equivalent to not-ED (believes). For example, "For every plant, Janet does believe that it is a native plant" is equivalent to "It is not the case that there is a plant that Janet believes is a native plant." So the implication of UD by EC, for "does not believe," is equivalent to the implication of not-ED by not-EC for "believes." This is equivalent in turn to the implication of EC by ED for "believes." And this implication is indicated by Chisholm's table for 'S believes (p)'. What looked at first like a troublesome discrepancy turns out to be logically equivalent to one of the implications that the original table indicates.

A thesis about intentionality that resembles Brentano's should include the Autonomy Thesis or something similar. Autonomy requires that a statement is intentional if and only if its negation is intentional. One can use the generalized notion of logical independence to assure this result. The moral of the logical exercise with 'true' and 'not true' applies generally to a full-scale test of logical independence for any prefixes 'M' and 'not-M'. The test of the logical independence (and dependence) between UC, UD, EC, and ED statements for '$M(p)$' and the test of the logical independence (and dependence) between the corresponding statements for 'not-$M(p)$' are the same. The sixteen elementary conjunctions relevant to '$M(p)$' and the sixteen relevant to 'not-$M(p)$' are logically equivalent. Any pattern that shows the intentionality of '$M(p)$' also shows the intentionality of 'not-$M(p)$'.

The results of this paper, I hope, can help any philosopher who argues either for or against Brentano's thesis in the style of Chisholm.

DAVID H. SANFORD

DEPARTMENT OF PHILOSOPHY
DUKE UNIVERSITY
JANUARY 1995

NOTES

1. This claim is unsupported here. In this essay I use footnotes mainly to comment on projects appropriate to a discussion of Chisholm on intentionality that I do not attempt or complete.

2. Chisholm himself turns to the project of explaining how intentionality is possible. He devotes *The First Person* to this project and defends the following position: "The primary form of believing is not a matter of accepting propositions; it is matter of attributing *properties* to oneself" (Chisholm 1981, p. 1). I do not discuss this project in this essay.

3. See Chisholm 1955–56, where he denies that the linguistic thesis about intentionality indicates "that there is a ghost in the machine" (p. 50).

4. I make and support this claim in Sanford 1968, which contains several references not repeated here. Here I also forgo direct discussions of critical treatments of Chisholm on intentionality published in the past quarter century. If I were to start acknowledging debts and registering disagreements, I would not know where to stop.

5. I do not address skepticism about appeals to meaning or attempt a theoretical treatment of logical form. Some philosophic enterprises such as defining a *disjunctive predicate* as one equivalent to a disjunction of independent predicates require additional restrictions in the definition of logical independence.

6. The contrast with respect to truth-value independence between sentences about believing and sentences about knowing nevertheless raises some questions. Brentano's examples satisfy our criteria because to insure (1A) we formulate our criteria to fit the examples. This paper does not attempt to explain why sentences that are intentional on these criteria are also intentional in the sense of being directed toward an object.

7. I do not include a catalogue of criticisms of Chisholm that fail to distinguish Coextension from Autonomy. See note 4.

8. Chisholm appears to assume that patterns for psychological modal prefixes are independent of the propositional content of particular instances so that, for example, determining the pattern of the four statements about Janet's believing that the plants are native plants thereby determines the pattern of anyone's belief about anything. The generalization of this assumption to the nonpsychological certainly fails. The prefix 'It is true (p)' forms logically true or logically false statements as the component 'p' is logically true or logically false. The (UC, UD, EC, ED) patterns for contingent and noncontingent 'p' differ. The criterion of contingency, so far as it is adequate, helps to explain why the tabular patterns for psychological prefixes are independent of specific propositional content. This paper will not examine further the assumption that patterns for psychological prefixes are independent of content.

9. The discussion that followed my reading a version of this paper at Wake Forest University led me to this reexamination. After I delivered an earlier version to the Intermountain Philosophical Conference at Cullowhee, North Carolina, Professor Jeffrey Geller made some remarks about the organization of this paper that helped me try to improve it.

REFERENCES

Chisholm, Roderick M. 1952. "Intentionality and the Theory of Signs." *Philosophical Studies* 3: 56–63.

———. 1955–56. "Sentences about Believing." *Proceedings of the Aristotelian Society* 56: 125–48. Reprinted with revisions in Feigl 1958, pp. 510–20. Page references are to the version reprinted in Marras 1972, pp. 31–51.

———. 1957. "Intentional Inexistence'." Chapter 11 in *Perceiving: A Philosophical Study*, pp. 168–85. Ithaca, N.Y.: Cornell University Press.

———. 1963–64. "Notes on the Logic of Believing." *Philosophy and Phenomenological Research* 24: 195–201. Page references are to the version reprinted in Marras 1972, pp. 75–84.

———. 1964–65. "Believing and Intentionality: A Reply to Mr. Luce and Mr. Sleigh." *Philosophy and Phenomenological Research* 25: 266–69. Page references are to the version reprinted in Marras 1972, pp. 91–96.

———. 1967a. "Intentionality." In *The Encyclopedia of Philosophy*, ed. Paul Edwards, vol. 5, pp. 201–4. New York: Macmillan.

———. 1967b. "On Some Psychological Concepts and the 'Logic' of Intentionality." In *Intentionality, Minds, and Perception*, ed. Hector-Neri Castaneda, pp. 11–35. Detroit: Wayne State University Press. This is the proceedings of a symposium that took place in 1962.

———. 1981. *The First Person: An Essay on Reference and Intentionality.* Minneapolis: University of Minnesota Press.

Chisholm, Roderick M. and Wilfrid Sellars. 1958. "Chisholm-Sellars Correspondence on Intentionality." In Feigl 1958, pp. 521–39. Page references are to the version reprinted in Marras 1972, pp. 214–48.

Feigl, Herbert, Michael Scriven, and Grover Maxwell, eds. 1958. *Minnesota Studies in the Philosophy of Science.* Vol. 2, *Concepts, Theories, and the Mind-Body Problem.* Minneapolis: University of Minnesota Press.

Marras, Ausonio, ed. 1972. *Intentionality, Mind, and Language.* Urbana, Ill.: University of Illinois Press.

Russell, Bertrand. 1921. *The Analysis of Mind.* London: Allen and Unwin.

Sanford, David H. 1968. "On Defining Intentionality." *Proceedings of the 14th International Congress of Philosophy* 2: 216–21. Vienna: Herder.

REPLY TO DAVID H. SANFORD

To what extent have I been successful in showing that there is a *logical* mark of the intentional? After reflecting upon David Sanford's careful analysis, I feel entirely convinced. Sanford discusses *all* the criteria of intentionality that I have put forward. Referring to the criterion I had proposed in the article on that topic in Paul Edwards's *Encyclopedia of Philosophy*, he writes:

> Chisholm says, "We may think of a modal operator (somewhat broadly) as a phrase which, when prefixed to a complete sentence yields a new sentence." . . . This is Chisholm's criterion of *Contingency:* "We may say that a modal prefix is intentional, if, for every sentence p, (Mp) is logically contingent."

"A prefix" is here understood as a phrase which, no matter how long it may be, will yield a new sentence when prefixed to any given sentence. My earlier expression, "modal operator," was misleading. The argument appeals to what I will now call a *"contingency-making prefix."*

The definition and resulting thesis may now be put this way:

D1 C is a contingency-making prefix =Df. C is an expression which, when prefixed to any given sentence, will yield a sentence that is logically contingent.

D2 Every sentence that begins with a contingency-making prefix is intentional.

Anyone who wants to understand what I have been up to in trying to formulate criteria of intentionality, should read Sanford's paper.

R.M.C.

10

Nicholas Wolterstorff

OBLIGATIONS OF BELIEF—TWO CONCEPTS

I

I well remember the astonishment I felt when first reading Roderick Chisholm's account of knowledge in his *Theory of Knowledge*. That *knowledge* is a deontological concept was not only a thought which had never previously occurred to me; when presented to me, it took me aback.

The pattern of Chisholm's thought on the matter is by now well known. He begins by having in mind a certain relation which he calls "being more reasonable than." It's a relation holding among the believings, and the withholdings of belief and disbelief, of a person at a time. Then, by referring to this relation, he identifies a variety of different relations of a person to a proposition. For example, he picks out that relation of a proposition *P* to a person *S* which holds when it is more reasonable for *S* to believe *P* than withhold *P*. So as to have a convenient terminology, Chisholm resolves to say that when that particular relationship holds between a proposition *P* and a person *S*, *P* is *beyond reasonable doubt* for *S*. One can think of the overall strategy in the following way. The ways in which we are related to propositions, by virtue of our believings and withholdings, constitute a continuum of grades of epistemic excellence, or preferability. Chisholm's project is to identify various loci on this continuum—including then the locus where those believings which constitute knowledge are to be found. A belief, to be a case of knowledge, must be what Chisholm calls "evident" for the person at the time; and he identifies the relation of a proposition to a person, of the former *being evident for* the latter, by composing a definition which makes reference to the relation with which he began, that of *being more reasonable than.*

What exactly is that relation which functions as basic in the whole chain of definitional identifications—the relation which Chisholm calls "being more reasonable than"? Obviously Chisholm hopes and expects that the reader's knowledge of the sense of these words in standard English will go a long way toward bringing it about that he or she has the same relation in mind that he, Chisholm, has in mind. In addition, though, he makes a few observations about the "logic" of the relation; for example, that it is transitive. And then he says the following, in a passage which brings to the surface the deontological component in his thought and has become a sort of *locus classicus* in contemporary epistemology:

> Let us consider the concept of what might be called an "intellectual requirement." We may assume that every person is subject to a purely intellectual requirement—that of trying his best to bring it about that, for every proposition *h* that he considers, he accepts *h* if and only if *h is* true. One might say that this is the person's responsibility or duty *qua* intellectual being. . . . One way, then, of re-expressing the locution "*p* is more reasonable than *q* for *S* at *t*" is this: "*S* is so situated at *t* that his intellectual requirement, his responsibility as an intellectual being, is better fulfilled by *p* than by *q*."[1]

It follows that, other things being equal, if *S* believes *q* rather than *p*, he is violating his intellectual responsibilities. He is doing what he ought not to do. He is not permitted, by his intellectual obligations, to believe as he does.

The presence of this deontological component in Chisholm's account of knowledge has been widely criticized in recent years. For example, in his recent book *Warrant: The Current Debate,* Alvin Plantinga develops a couple of formidable lines of attack. The one in which I am interested on this occasion goes as follows. Suppose a person both feels sad and considers whether he does. Chisholm would say that, for that person in that circumstance, the proposition that he feels sad has the maximal degree of positive epistemic status; it is *certain* for him. And that is because, again in Chisholmian terminology, the proposition is *self-presenting* for the person. The question before us then is whether this person's believing this proposition in this circumstance is also as good a way of trying to fulfill his intellectual duty as any way ever. Not at all, says Plantinga. Believing it cannot even *be* a way of this person's trying to fulfill his intellectual duty, for the reason that believing it cannot be a way of trying to bring about anything at all. So it cannot be a way of trying to bring about the state of affairs of fulfilling one's intellectual duty.

> [S]uppose I feel sad, at *t:* could it really be that believing that I feel sad is any way at all (let alone a maximally excellent way) of trying to fulfill my

epistemic duty? In any case I can think of, if doing something A is a way in which I can try to bring about some state of affairs, A will be such that it is at least logically possible for me to consider it and carry it out, and also at least logically possible for me to consider it and fail to carry it out; there will be possible worlds in which I consider it and carry it out, but also worlds in which I consider it and do *not* carry it out. This is not so in the present case. For the proposition that I am sad is self-presenting; hence (according to Chisholm) it is not possible in the broadly logical sense that I should in fact be sad and consider whether I am, but refrain from believing that I am. But if that is how things stand, how could this proposition be such that at t I can better fulfill my epistemic duty—my duty to try to achieve epistemic excellence—by accepting it than by rejecting or withholding it?

The mesh between Chisholm's claim and Plantinga's objection is not quite perfect. In the first place, Chisholm does not officially conceive self-presentation in quite the way Plantinga reports him as conceiving it. Plantinga reports the following as Chisholm's official conception: a proposition p is *self-presenting* for a person S if and only if necessarily, if S considers p and p is true, then S believes p. What Chisholm says, instead, is that p is *self-presenting* for a person at a time just in case p is then true and it is impossible that at that time p be true and not be evident for the person. The concept of a proposition *being evident for* a person does not include the condition that the person *believe* the proposition. It's just that, at the time in question, it's not only more reasonable for him to believe it than not, but no other proposition could ever be more reasonably believed by him than the proposition in question at the time in question. Whether he does in fact believe it doesn't enter the determination of whether the proposition is evident for him. I don't think, though, that there's any point in tarrying longer than we already have over this point of discrepancy between Chisholm's definitions and claims and Plantinga's understanding of those. For all Plantinga need do is claim, entirely in his own voice, that there are triples whose members are a proposition, a person, and a time, such that it is impossible that the proposition be true at the time, that the person at that time consider whether it is true without believing it, and that a person considering the proposition 'I am sad' at a time when he is sad be an example of such a triple.

This revision has the consequence that a second point of lack of perfect mesh between Chisholm's claim and Plantinga's objection is also a point of lack of perfect mesh within elements of Plantinga's own thought. What we have now is Plantinga's claim that, for example, when I'm sad, it's impossible that I not believe that I'm sad if I consider the proposition that I'm sad. I myself find that an eminently plausible claim. In his argument, however, the act of consideration that Plantinga cites is

not the act of considering *the proposition that I'm sad*, but the act of considering *believing the proposition that I'm sad*. He argues that for some action *A* to be a way of my *trying to bring about some state of affairs S*, it must be logically possible for me both to consider *doing A* and do it, and consider *doing A* and not do it. But as a matter of fact, when I am in the circumstance of being sad, it's not possible for me both to consider believing that I'm sad and believe it, and consider believing that I'm sad and not believe it. The latter is not possible.

Once again, though, the discrepancy does not blunt the force of Plantinga's central argument. That argument is this: If my believing *p* is to be a way of my trying to fulfill my intellectual duty, then both of the following must be possible: that I consider believing *p* and believe it, and that I consider believing *p* and not believe it. But there are lots of propositions and circumstances such that, if I'm in that circumstance, my considering believing the proposition couldn't be accompanied by my not believing it. Accordingly, if my believing the proposition nonetheless has positive epistemic status—as very many of such believings will, including believing that I am sad when I am—that value cannot consist in my believing it having been a way of my trying to fulfill my intellectual duty. The ineluctability of the believing prevents it from being a way of carrying out, or trying to carry out, one's duties.

I wish to argue one thesis in this paper and to suggest another. The thesis I wish to argue is that there are two distinct concepts of obligation applicable to our believings—*responsibility-obligation* and *paradigm-obligation* I shall call them. The thesis I wish to suggest, without on this occasion fully arguing, is that though in *Theory of Knowledge* Chisholm had responsibility-obligation in mind, as is clearly indicated by his rhetoric of "trying to fulfill one's intellectual duties," he would have been well-advised instead to have had paradigm-obligation in mind. Had he had that in mind, observations about the ineluctability of beliefs would not touch what he says. And the claim that knowledge is an intrinsically deontological concept—though not a concept which has anything in particular to do with trying to fulfill one's duties—would have withstood most if not all the attacks. In some of his writing after *Theory of Knowledge,* Chisholm, in response to the criticisms, backs away from a deontological account of knowledge. That backing away brings him somewhat closer to accounts such as Plantinga's. I think he should instead have kept the main contours of his original thought but replaced responsibility-obligation with paradigm-obligation. The result would have been that—ironically perhaps—whatever differences there might be between Plantinga's proper functioning account of knowledge

and his own deontological account would prove to be differences in the details and not in the big picture. For as we shall see, Plantinga's account, on scrutiny, turns out to be a deontological account!

II

No doubt what made a deontological approach seem plausible to Chisholm in the first place is that we do all apply concepts of obligation to the believings of our fellow human beings. "You should never have believed him," we say. It would be natural to assume that this is just elliptical for, "You should never have *decided* to believe him." But on second thought, it's perfectly clear that you *didn't* decide to believe him. Your believing him just happened to you. Let's generalize that last point. Belief is almost entirely—if not indeed entirely—the outcome of the dispositional side of our nature, not of the volitional side. At any moment in the lives of each of us we are richly endowed with dispositions to believe this and that. Then along comes some event which activates some disposition; and thereupon appears a belief. One didn't decide to have it; having it happened to one. But if this is right, how can obligation attach to our believings? Believings are pretty much like startle-reflexes on this picture. Given the combination of the firing of the gun and the fact that her startle-reflex mechanism was in good working order, there was nothing she could do but jump. She didn't *decide* to be startled, not even to let herself be startled. She just was startled. Startling happened to her. And now notice that no one would ever think of saying to the person who startled that she should not have startled, when unexpectedly the gun was fired off a few feet away from her.

So there's a puzzle which is by now familiar in the philosophical literature. Beliefs are formed in us by the activation of dispositions. Yet we apply concepts of obligation to them. It seems as inappropriate as applying concepts of obligation to startling!

Not everything is quite as it initially appears, however. To see how things are instead, let's make a pair of assumptions. Later I will question the assumptions. But I think the best way to get to the point where we can question them is to work with the assumptions for a while. Here's the first: If one is obligated to do something, then one is accountable, responsible, for doing or not doing it. If then one doesn't do it, one is on that account culpable; and if culpable, blameable. Conversely, if one does do it, then one is on that account meritorious; and if meritorious, praiseworthy. Obligation carries along with it accountability, responsi-

bility; and depending on what one does and doesn't do, culpability and blameworthiness, or meritoriousness and praiseworthiness. That's the idea.

The second assumption is this: Obligation, thus understood, attaches to intentions—actual and possible. By "intentions" I mean both *intentions to do,* and *intentional undertakings and doings.* It's to intentions and only to intentions that the required, the prohibited, and the permitted attach—actual intentions and possible intentions. What's required, prohibited, or permitted of me is the forming of intentions to do things, along with intentional undertakings and doings. If I did in fact do something that was required, prohibited, or permitted of me, one can be assured that it was either the forming of an intention to do something or an intentional undertaking or doing. Conversely, if I didn't do something that was required of me, one can be assured that it was either the forming of an intention to do something or an intentional undertaking or doing.

We concluded just above—with no argument, actually (it seemed obvious)—that for the most part if not entirely, believings are the outcome of the dispositional rather than the volitional side of our nature. One has a disposition to believe so-and-so, the disposition gets activated, and the belief gets formed. This crude statement conceals all sorts of interesting and important issues: how does it come about that we have these dispositions, under what circumstances do they get activated, etc. Still, that's the basic picture.

But now it occurs to us that it doesn't follow that intention has no role whatsoever in the formation of beliefs. I can decide to look to the left or the right. If I look to the left, I'll perceive certain things and my perception will ineluctably evoke certain beliefs in me; if I look to the right, I'll perceive other things and my perception will ineluctably evoke other beliefs in me. So even though my beliefs do get formed by the activation of dispositions, yet it's to a considerable extent the consequence of intentions I form that such-and-such activators occur. So maybe intentions do after all play a role in belief-formation sufficient for concepts of obligation to attach to our believings—through the mediation of those intentions. That's the idea to be explored for a while.

As a preliminary, let me highlight a Chisholmian point: of the propositions that we consider, we not only *believe* some and *disbelieve* others, but from some we *withhold* both belief and disbelief. We suspend judgment. And notice too that, with respect to the propositions that we do either believe or disbelieve, we don't *just* believe or disbelieve them, but we do so with a certain *degree of firmness.* Some things we believe with great confidence; some, with very little. Putting these observations

together invites us to regard our mental lives, at any moment in their history, as displaying a continuum of *levels of confidence* in the truth of propositions, with each of our believings, disbelievings, and withholdings occupying a place somewhere on that continuum. And it invites us to think of the *history* of our mental lives as displaying a mixture of constancy and flux in levels of confidence adopted toward particular propositions. For a considerable time I have no level of confidence whatsoever in a particular proposition; it's just out of the picture for me. Then it enters into my purview and I entertain it without either believing or disbelieving. Then I believe it for a while. Later, I come to disbelieve it. And so forth, on and on, in all the variations.

Here, then, is the question that I will be pursuing for quite some time: Is it in our power, for a given proposition and a given level of confidence, to carry out the intention to hold that level of confidence in that proposition? Scratching my nose is something that falls within the scope of intentional action for me: I can carry out the intention to do it. Is believing very firmly that it will snow here this afternoon likewise within the scope of intentional action for me? Can I carry out the intention to *begin* believing it firmly? If I'm already believing it firmly, can I carry out the intention to *continue* believing it firmly? Etc.

The reference to a *certain* proposition is important. No doubt I can look up the article on China in a good recent encyclopedia with the intention of coming to believe firmly *something or other* concerning China's population. Likewise the reference to a *certain* level of confidence is important. No doubt I can also read the article on China with the aim of arriving at *some level of confidence* or other in a figure that a friend gave me for China's population. The question, however, is whether I can also form and carry out the intention to come to believe very firmly that the current population of China is 1,230,562,000, plus or minus ten thousand.

As a matter of fact, I don't see how I myself could carry out that particular intention. And I dare say nobody holds that, for any level of confidence whatsoever and for any proposition that one grasps, it's always in one's power to carry out the intention to believe that proposition with that level of confidence. That would be a bizarre view. I cannot now—or ever—carry out the intention to believe firmly that 13 = 3.5. The question which bears considering is this much more cautious one: Is it ever the case that there is a person and a pair, consisting of a certain proposition and a certain level of confidence, such that that person has it in her power to carry out the intention to hold that proposition with that level of confidence? We do rather often say such things as "Early on I decided that he was the culprit" and "Make up your

mind; is it blood or isn't it?" These give the impression that believing rather firmly a particular proposition is something that we do sometimes perform intentionally. The question is whether that impression is misleading.

III

There's a very helpful discussion of these matters in a recent article by William P. Alston which he calls "The Deontological Conception of Epistemic Justification."[2] It's helpful in two ways. Alston introduces some distinctions, and some terminology to go with them, which help in getting a clear picture of the lay of the land. And it's helpful because Alston gives a far more subtle defense of the position I want to oppose than any other with which I am acquainted. It's the position that though the concept of obligation has some application to beliefs, its applicability is so marginal as to make it pointless for the epistemologist to pay any attention to it.

Let me say a word first about the conceptual framework within which Alston sets his discussion. I don't accept that framework. But having it before us and seeing why it won't do will help to display the conceptual framework with which I will be working.

Alston takes for granted in his article that there is such a thing as *the concept* of justified belief; and that a central concern of epistemologists, if not indeed *the* central concern, is to explicate the nature of that concept and to formulate general criteria for its application. His main question in the article pertains to the nature of the concept: Does justification in essence have anything to do with obligation? He concedes that in ordinary language, the word "justified" and its cognates often are used to discuss obligations (p. 143). But his conclusion in the article is that what the epistemologist, shaped by the tradition of epistemology, has in mind when he speaks of "justified belief," is something different from what lay people have in mind, and in its essence, unrelated to obligation.

This approach seems to me misguided in a number of ways. In the first place, I very much doubt that the word "justified," *even within the epistemological tradition,* expresses a single concept, and that the fundamental disputes within epistemology are to be understood as disputes about the proper analysis of that concept and the correct formulation of criteria for its application.[3] But be that as it may: The fundamental point I wish to urge is that our believings exhibit a variety of distinct merits and defects, that a great many of the confusions in epistemology are due

to the fact that when philosophers *think* they are giving *competing* analyses and application-criteria for the *same* merit in believings, viz., justification, they are *in fact* giving *noncompeting* analyses and application-criteria for *distinct* merits.

The understanding having done its work, we can evaluate in various ways the manner and the outcome of its workings. We can determine that here it's working *properly* and that there it's producing beliefs *reliably.* That here it's producing *knowledge* and that there it's producing what the Aristotelian medievals called *'scientia'.* That here it's producing *rational* beliefs, in one or another of the many senses of 'rational', and that there it's producing *justified* beliefs, in one or another of the many senses of 'justified'. That here it's producing *entitled* beliefs and there, *warranted* beliefs. Here, *optimal* beliefs and there, *true* beliefs. All of those determinations—and many more besides—we can make. All are determinations of merits in the working or the yield of our understandings. And if we are philosophers, we can go beyond determining the presence or absence of one and another such merit and try to explain what exactly the merit in question is, and try to formulate in a general and informative way the conditions under which it is present and absent. All this we can do. But if, after excluding truth, we lump all these merits together—or even a selection—and call the lump "justification," we can be assured of confusion.

The fact that the conceptual framework within which Alston discusses "belief and the will" is thus flawed by no means implies, however, that his skeptical arguments need not be considered, nor that his taxonomy of the issues is useless. So it's to that that I now turn.

Alston taxonomizes the domain under consideration with a pair of distinctions: That between *basic* actions and *nonbasic* actions, and that between direct control and *long-range* control. The introduction of these distinctions into the discussion marks a distinct advance over earlier discussions of these issues. So let's use them.

Start with the basic/nonbasic distinction—a distinction to be found already, much earlier, in some of Chisholm's work on action. Some of the things we do intentionally are done by way of our doing something else intentionally; those are *nonbasic* actions. I shove the cup aside by moving my hand. Others of our intentional doings are not done in that way; we do them right off. Those are *basic* actions. Though we may do something else by way of doing them, we don't do them by way of doing something else. When I intentionally started thinking about the topic of "belief and the will," I didn't start thinking about that topic by way of intentionally doing something else than start thinking about it; I just intentionally started thinking about it. And when I shoved the cup aside

by moving my hand, I didn't move my hand by way of intentionally doing something else than that. Or if I did, then I didn't do that other thing by way of intentionally doing yet something else. Or if I did . . . , etc. The sequence culminating in my shoving the cup aside has to begin somewhere with a basic action.

Given this distinction, let's start our investigation by considering whether we ever have it in our power to carry out the intention to hold a given level of confidence in a given proposition, when holding that level of confidence in that proposition is *a basic action*. Could I ever decide to believe firmly a certain proposition, and just do it, without there being something else that I did intentionally *whereby* I did that? We should see this question for what it is: It's the question whether there are exceptions to our earlier generalization that beliefs are formed in us by the activation of some belief-disposition. Are there cases in which we decide to believe something—and then just do so, without the intervention of the activation of any belief-disposition?

The most famous defense of the view that there are such cases is that by William James in his article "The Will to Believe." James was cautious. He thought that only if a person is related in just the right way to a proposition of just the right sort is it possible for that person to come to believe that proposition just by deciding to do so; accordingly, he devoted most of his article to spelling out those right sorts. His conclusion comes through, well enough for our purposes, in this vivid passage: "Are there not," he asks, sometimes

> forced [and live] options in our [momentous] speculative questions, and can we (as men who may be interested at least as much in positively gaining truth as in merely escaping dupery) always wait with impunity till the coercive evidence shall have arrived? It seems a priori improbable that the truth should be so nicely adjusted to our needs and powers as that. In the great boarding-house of nature, the cakes and the butter and the syrup seldom come out so even and leave the plates so clean.

In such cases, it's possible to come to believe just by deciding to believe. To which James added that one would be within one's rights in so doing.

I'm dubious; I think James has mistaken something rather like belief, for belief. To believe something is to accept it. The converse is not true, however. It's possible to accept something, in a perfectly standard sense of the word "accept," without believing it. I think James mistook nonbelieving acceptance for belief: The distinction is particularly important in the case of religion—which was, of course, the focus of James's discussion. One of the striking features of the literature surrounding religious conversion is that some of it is cast predominantly in the language of *being overcome*, whereas some is cast predominantly in the

language of *decision*. Augustine's self-description in the *Confessions* is a good example of the former; the literature surrounding camp revival meetings provides good examples of the latter. I suggest that the clue to the difference of rhetoric is not that the former party has the right views about belief and the will, and the latter party, confused views. No doubt there is some confusion. But most of the difference in rhetoric is due to the fact that the latter party has its eye on a different kind of acceptance from that on which the former has its eye. The latter has its eye on *nonbelieving* acceptance. Whereas Augustine, after enormous inner struggle, *found* himself believing, the revival preacher urges the members of his audience to *make the decision* to accept Jesus Christ. What he means by "accept" is *play the role of a believer.* To "put on" Jesus Christ. Not insincerely, of course. With full sincerity to engage in, and to let oneself be engaged in, the role of believer. To say "Yes" to Jesus Christ, and then to make and to let that "Yes" play the role in one's emotional, motivational, and intellectual life that believing would play. To endeavor to feel and think and act as a believer would feel and think and act.

Obviously one can *decide* to accept something in this nonbelieving sense of "accept." But I very much doubt that we ever do have it in our power to carry out the intention to hold a particular level of confidence in a particular proposition, when the holding is a basic action. We can't hold a particular level of confidence in a particular proposition by just deciding to do so. All the purported cases seem to me to have other more plausible analyses. Insofar as decision plays a role in the formation, maintenance, and disappearance of belief, it does so by, in one way or another, *steering* our belief-dispositional nature.

Many discussions of belief and the will have dropped the discussion at just this point—having argued the pros and cons of the thesis that it is possible to come to believe something just by deciding to do so, or, among those who think it's not possible, the pros and cons of the thesis that it's a necessary truth that we cannot do that. Alston's taxonomy makes clear that there's more to the issue.

So let's turn to nonbasic actions. It's here that Alston's distinction between *direct control* and *long-range control* comes into play. An agent has direct control over some act or state when "the agent is able to carry out the intention 'right away', in one uninterrupted intentional act, without having to return to the attempt a number of times after having been occupied with other matters" (129). Examples would be

> opening a door, informing someone that *p*, and turning on a light. To succeed in any of these requires more than a volition on the part of the agent; in each case I must perform one or more bodily movements and these movements must have certain consequences, causal or conventional, in

order that I can be said to have performed the nonbasic action in question. (128)

Long-range control, by contrast, is

> simply the foil of immediate control. It is the capacity to bring about a state of affairs, C, by doing something (usually a number of different things) repeatedly over a considerable period of time, interrupted by activity directed to other goals. One has this sort of control, to a greater or lesser degree, over many things: one's weight, cholesterol concentration, blood pressure, and disposition; the actions of one's spouse or one's department. (134)

So much for the distinction between direct control and long-range control—a distinction, let us recall, within the class of nonbasic actions. Whether the actions one performs so as thereby to bring about one's intended goal of holding a certain level of confidence in a certain proposition, are spread out over a considerable length of time, or whether they occur in the blink of an eye, either way, the totality is an action-plan with a means/end structure—the end, the goal, being a nonbasic action.

Alston holds, so far as I can tell, that there is no person and no circumstance, no proposition and no level of confidence, such that that person in that circumstance can in short order carry out the intention to hold that level of confidence in that proposition. I don't wish to contest the claim.[4] What interests me is his concession that there definitely are some persons and some circumstances, some propositions and some levels of confidence, such that it's possible for that person in that circumstance to accomplish that goal over the long haul. People, he says,

> do set out on long-range projects to get themselves to believe a certain proposition, and sometimes they succeed in this. Devices employed include selective exposure to evidence, selective attention to supporting considerations, seeking the company of believers and avoiding nonbelievers, self-suggestion, and more bizarre methods like hypnotism. By such methods people sometimes induce themselves to believe in God, in materialism, in communism, in the proposition that they are loved by X, and so on. (134)

Alston then poses the obvious question: "Why doesn't this constitute a kind of voluntary control that grounds" the propriety of attaching concepts of obligation to belief? His answer is that it would, if control of this sort were fairly reliable; but it isn't. "It is very dubious," he says,

> that we have reliable long-range control over any of our beliefs, even in the most favorable cases, such as beliefs about religious and philosophical matters and about personal relationships. *Sometimes* people succeed in getting themselves to believe (disbelieve) something. But I doubt that the

success rate is substantial. To my knowledge there are no statistics on this, but I would be very much surprised if attempts of this sort bore fruit in more than a very small proportion of the cases. (135)[5]

Suppose we mean by "an ethic of belief" a *set of rules specifying when one is required to, when one is prohibited from, and when one is permitted to, form and carry out the intention, for a certain proposition and a certain level of confidence, to hold that level of confidence in that proposition.* Alston's conclusion is that such an ethic will have at best minimal application. People do now and then form and try to carry out intentions of that sort, sometimes successfully; they could form and try to carry out more of that sort than they do. But all in all it doesn't come to much. For one thing, only a tiny proportion of any person's beliefs will actually have been formed in that manner. And secondly, it's so unpredictable whether a person can actually carry out such an intention that the concept of *requiredness* has virtually no application here: Seldom will it be *required* of a person that he or she form, and seriously try to implement, such an intention. So it's just not worth the time and energy of the epistemologist trying to formulate such an ethic. And in any case, *requiredness* cannot be what epistemologists have in mind by "justification," since the merit of justification is pervasive among beliefs, whereas entitlement, though perhaps not absent, is rare.

IV

Those are Alston's claims. It seems to me that the claim he makes about the facts is mistaken; and that even if it weren't, his inference to the absence of obligation isn't valid. First, the claim about the facts. I think that we human beings do rather often form and try to carry out intentions of exactly the sort in question. And that—pace Alston—we are rather often successful—which is why we keep trying. William K. Clifford begins his famous article on "The Ethics of Belief" with a little story. Since it's well told, let me quote the whole of it:

A shipowner was about to send to sea an emigrant-ship. He knew that she was old, and not over-well built at the first; that she had seen many seas and climes, and often had needed repairs. Doubts had been suggested to him that possibly she was not seaworthy. These doubts preyed upon his mind, and made him unhappy; he thought that perhaps he ought to have her thoroughly overhauled and refitted, even though this should put him to great expense. Before the ship sailed, however, he succeeded in overcoming these melancholy reflections. He said to himself that she had gone safely through so many voyages and weathered so many storms, that it was idle to suppose she would not come safely home from this trip also. He would put his trust

in Providence, which could hardly fail to protect all these unhappy families that were leaving their fatherland to seek for better times elsewhere. He would dismiss from his mind all ungenerous suspicions about the honesty of builders and contractors. In such ways he acquired a sincere and comfortable conviction that his vessel was thoroughly safe and seaworthy; he watched her departure with a light heart, and benevolent wishes to the success of the exiles in their strange new home that was to be.[6]

Is the story bizarre? It doesn't seem so to me.

Notice that the intention the shipowner forms is that of *altering* the level of confidence he has in the proposition that the ship is seaworthy, from disbelief to belief. I think what happens much more often in human life is that we form and try to carry out the intention to *maintain* or even *strengthen* the level of confidence we have in a proposition: To maintain our belief in Marxism, to maintain our atheism, to hold fast to our Presbyterianism, etc. The strategies are familiar: Associate only with one's fellow believers, pay only enough attention to one's opponents' arguments to knock them down, work hard at developing the implications of one's own belief, dwell on the unsavory motives of one's opponents, etc. I submit that they're familiar because, all in all, they're quite successful! I think that what led Alston astray in his analysis of the facts of the matter—and has led many others astray as well—is that he concentrates all his attention on undertakings to acquire or get rid of beliefs. Perhaps those are rather unusual. I submit that what's not at all unusual in human affairs is undertakings to maintain one's beliefs and disbeliefs.

But even if Alston were right in his claim that undertakings to hold certain propositions with certain levels of confidence are relatively unusual because we all know that they don't have a very high success rate, it doesn't follow that the concept of obligation has only minimal application. First, the matter of success and nonsuccess. It's true that if the means available to me for bringing about a certain end don't very often yield success, then I shouldn't be held accountable for not bringing about that end; I might, though, be held accountable for *not trying*. Though the chances may not be very high of keeping victims of certain sorts of accidents alive, we certainly ask of ambulance attendants that they *try*; they're not blameable if they don't succeed, but they are blameable if they don't try.

And then there's the other side of the matter. Even if it were seldom the case that a person is *obligated to try* to bring it about that she holds a certain proposition with a certain level of confidence, it might nonetheless be the case that very often it's *wrong*—prohibited. This might just be

one of our human perversities: To be trying over and over to do this sort of thing when almost always we shouldn't. To be trying to hang on to our Marxism, our atheism, our Presbyterianism in the somewhat disreputable ways mentioned, when we shouldn't.

In short: Alston has not succeeded in defending his claim that an ethic of belief, in the sense explained, has only minimal application in human affairs. And I judge Alston to have made the best case of anyone to date. But let me now add this: If obligation attaches to belief only in the way we have uncovered, it doesn't really come to all that much. Significantly more than Alston concedes. Still: not much.

V

Are we missing something? Well, I announced at the beginning of our inquiry that I would be assuming that for a person to be under obligation with respect to certain states or actions is for that person to be responsible for those—accountable. And that I would be assuming that obligation, thus understood, attaches to intentions; consequently we've spent all our time thus far scrutinizing intentions to believe—or more generally, intentions to adopt a particular level of confidence in a particular proposition. But maybe one or both of those assumptions is mistaken; maybe that's why the results of our quest are so sparse. Could it be that the applicability of obligation-concepts to our believings, disbelievings, and withholdings doesn't have anything in particular to do with forming intentions and with intentional undertakings and doings? Could it even be that it has nothing directly to do with accountability— and thus with blameability and praiseability?

One of the best cases for this point of view is that made, in defense of Chisholm, by Richard Feldman in his article "Epistemic Obligations."[7] So let me carry on in my strategy, of getting to the points I want to make by way of negotiating a path through some of the literature on this topic, by looking at Feldman's argument.

Feldman holds that there definitely are obligations to believe and obligations not to believe. Here are three of the examples he offers:

1. A student should not believe that he will pass an examination if he knows that the failure rate on this particular examination is 90% and he has no particularly good information about his own abilities on the material to be tested.
2. A person with good eyesight (and possessing the concept of 'table') should believe that he's seeing a table when he's looking straight

at one and has no reason to suppose that what he's seeing is illusory.

3. A person with considerable accomplishments to her credit should not believe that she is without talent.

Let me elaborate the latter two cases just a bit. We are to suppose that the person in (3) is of such a nature that there's nothing she can do to overcome her negative thoughts about herself; she has proved incapable of accomplishing any of the intentions formed over the years of getting rid of her negative self-estimate. Perhaps it was her obligation for some time to form such intentions and *try* to carry them out; then we applaud her for having tried. But her negative self-esteem has proved so impervious to all her intentions that we're no longer inclined to enjoin any such undertakings on her. Yet this remains true: Given her accomplishments, she *shouldn't* think about herself in such a negative way.

And we are to suppose that the person in (2) does in fact believe that he's seeing a table. But of course he doesn't hold that belief because he formed and carried out the intention to hold it; and if for some odd reason he now formed the intention to now not hold it, he couldn't carry out that intention. So intentions to believe and not believe aren't in the picture. Yet it remains true: In the circumstances in which he finds himself, he *should* believe that he's seeing a table.

In both cases, the obligation has nothing at all to do with forming or not forming intentions to believe—nothing to do with carrying out such intentions or even with trying to carry them out. It appears that we have obligations to believe things when we're incapable of not believing them, and when we know that intentionally undertaking not to believe them will get us nowhere; and that we have obligations to believe things when we're incapable of believing them, and when we know that intentionally undertaking to believe them will get us nowhere.

The case seems to me decisive. There are such obligations and prohibitions as these which Feldman and others call "epistemic obligations." What's not so obvious is what we are to make of them. Notice, in the first place, that they have nothing to do with accountability; and accordingly, nothing to do with the praiseworthiness and blameworthiness that ensue from our judgments of accountability. We don't *blame* that person for having those negative beliefs about herself, because we don't think she's accountable for having them; and we don't *praise* that other person for believing that he's seeing a table, because we don't think he's responsible for having that belief.

Feldman at one point speaks of the "propriety" of a person in that situation having that belief (236). I think that's the clue to understand-

ing such obligations as these. We are dealing here with proprieties and improprieties. To see in what way that might be so, let me offer some other examples of the use of "should" and "ought" which have nothing to do with accountability, and so, nothing to do with praise and blame.

1. "You ought to be walking on it in two weeks"—said by a physician as he finishes binding up a person's sprained ankle.
2. "It should have black spots all over its shell, not just around the rim"—said by one person, ladybug in hand, explaining to another person what ladybugs look like.
3. "That's strange; you ought to be seeing double"—said by a psychologist to his subject while conducting an experiment in perception.
4. "Here your poem ought to have some breathing room; it's too dense"—said by a teacher of creative writing to a fledgling poet.
5. "That's puzzling; you should have believed it was in the other dish"— said by a psychologist to his subject in the course of conducting an experiment on induction.

In none of these cases would there be any inclination whatsoever, on the part of the person speaking, to *blame* the person or object being spoken about. The patient is not to be blamed if after two weeks his foot is still too painful to walk on; the ladybug is not to be blamed for lacking some spots; etc. And of course in none of the cases is there a relevant intention even in view. The language of 'should' and 'ought' is used in such cases to point to what a properly formed specimen of the type in question would be like, or to how a properly functioning specimen would operate—or conversely, to point to a feature of the specimen in hand which marks out it, or its functioning, as malformed. Clearly this is a standard use of such language.

I suggest that what Feldman calls "epistemic obligation" is a species of this more general type—call it "paradigm-obligation." There's a malformation of some sort operating when a person, no matter what her accomplishments, continues to believe that she is a person of little talent; there's proper functioning at work when the person, in the situation described, believes that he's seeing a table. In speaking of "proper functioning" and "malformed functioning" I have, of course, deliberately been alluding to Plantinga's "proper functioning" theory of knowledge, thereby suggesting that it is a deontological theory. We now know, however, that that is an ambiguous comment. The concept of obligation relevant to Plantinga's theory is that of *paradigm-obligation*. If it had been paradigm-obligation which Chisholm had in mind in *Theory of*

Knowledge, then, as I suggested earlier, the differences between Plantinga
and himself would be only in the details. Of which, admittedly, there
would be many.

VI

One is naturally inclined to think of responsibility-obligation—
obligation connected with accountability—as just *moral* obligation. I
think there are good reasons for resisting that inclination. If moral
obligation is obligation whose nonsatisfaction reflects negatively on the
moral worth of the person in question, then I think we have to conclude
that though all responsibility-obligation is moral obligation, there's some
moral obligation which is not that but is, instead, paradigm-obligation.
(Though obviously not all paradigm-obligation is moral obligation.)
Moral obligation comes in both species.

What I have in mind is examples of the sort recently discussed by
Robert M. Adams under the heading of "cognitive sins."[8] Adams
remarks that "There are many cognitive failures that we regard as
morally reprehensible. Some examples are: believing that certain people
don't have rights that they do in fact have; perceiving members of some
social group as less capable than they actually are; failing to notice
indications of other people's feelings; and holding too high an opinion of
one's own attainments" (10). We "regard the failure to notice other
people's feelings or one's own deficiencies as a fault—and in some sense
an ethical or moral fault." He concludes that "There are at least two ways
of being a sinner: one is to have done a bad thing; the other is to be, in
some respect and in some degree, a bad person. The second way is no less
dreadful and no less fundamental than the first" (11–12). And bad
beliefs, along with bad desires, contribute to making one a bad person.

Of course it's true that "not all cognitive failures are moral faults. A
false mathematical belief, for example, would not normally be regarded
as an ethical fault." This poses the question of how we are "to draw the
line between those cognitive failings that are ethical faults and those that
are not?" Adams confesses that he does not have "a complete or general
answer to this question." In place of offering that, he delineates three
distinct types of cognitive error that seem to him "morally culpable."
About the second of his three types I'll have nothing to say here; they are
beliefs whose moral wrongness is grounded in the fact that they are the
consequence of morally culpable negligence or performance. What is
relevant here are the other two types. These are beliefs which reflect
negatively on the person's moral character without there being any

intention in the region which the person ought to have formed nor any that he ought not to have formed.

One type consists of believings whose contents are false ethical principles. Adams argues that such believings contribute to making the person's moral character defective just on account of having such principles as their content, whether or not the person ever acts on those false ethical principles, and whether or not the person's believing those principles derived from culpable performance or negligence on his part. For example: "the cruel graduate of the Hitler *Jugend* is in terrible sin, even if he is also a victim of his education, and even if he has no opportunity to act on his corrupt beliefs. Bad moral beliefs can make a bad man or woman, no matter how we came by the beliefs" (11). The second type consists of believings which manifest bad *desires*. These, says Adams, contribute to making the person morally defective just on account of manifesting such desires, this in spite of the fact that desires, like beliefs, are not things that one can decide to have or not to have: "One reason why it is morally offensive to hold too high an opinion of oneself is that that usually manifests a desire to aggrandize oneself at the expense of others" (12).

These claims seem to me correct: Certain believings are indeed moral defects in the person just because their contents are false ethical principles, or just because they manifest morally bad desires. Where Adams goes wrong, I think, is when he moves beyond describing such a believing as "morally reprehensible," "an ethical or moral fault," "morally culpable," "a cognitive sin," to describe it as "morally (ethically) blameworthy." That seems to me not correct. The Hitler *Jugend* is indeed of bad moral character, just on account of believing those heinous moral propositions. But it's not appropriate to *blame* him on that account, to hold him responsible and accountable, because he isn't. It would be right to do that only if one believed that he was not purely a victim in this regard. If one believed, for example, that he too had a conscience telling him otherwise, to which he could and should have been attentive and responsive. Some moral faults are blameworthy; some are not.

I suggest that what we're dealing with in the cases Adams cites is *moral* malformation. What makes it *moral* malformation is that the malformation reflects negatively on his *moral* character; it displays that something has gone wrong there, rather than in his psychological, sensory, or physical makeup. Should one say in such a case, as well one might, that the person *ought not* to hold that belief, one would be applying the concept of paradigm-obligation. Blaming a person for a belief he has is appropriate only when he's accountable for having that

belief; malformation is not sufficient for that. "It's through no fault of his own," we say. What he's accountable for is the intentions he forms and tries to act upon, and for the intentions that he could have formed and could have tried to act upon.

VII

Let's review. Two distinct concepts of obligation have come to light, both applicable to our believings, disbelievings, and withholdings. One I have called *paradigm-obligation.* A person is accountable neither for those beliefs that satisfy paradigm-obligations nor for those that violate them; accordingly, violations of paradigm-obligations win one no blame, and satisfactions of paradigm-obligation, no praise. The beliefs in question may even be morally reprehensible, and one's holding them, a blight on one's moral character; nonetheless, one is not to be blamed, because one is not responsible. The other concept of obligation which pertains to our believings is our familiar concept of responsibility-obligation. One is responsible, hence blameable, for the violation of such obligations. One is likewise responsible, hence praiseworthy, for their satisfaction. Responsibility-obligation attaches to beliefs through the mediation of the intentions we form and try to act upon—and through the mediation of those we don't form and try to act upon but could.

Feldman sees clearly the difference between responsibility-obligations on the one hand, and that species of paradigm-obligations which are epistemic obligations, on the other; and he insists that epistemic obligations alone are the proper business of the epistemologist. Alston, by contrast, recognizes neither epistemic obligations in particular nor paradigm-obligations in general as distinct species of obligation; and he argues that, in the realm of intentions-to-believe, there is so little for the concept of responsibility-obligation to latch onto, that it's best for epistemologists to drop the word "obligation" and its cognates from their lexicons. Coming from different directions, they join in saying: Be done with an ethic of belief. Leave it to the moralists. To which Alston adds: There's very little to leave! It's thin gruel.

I have tried to show that the gruel is thicker than Alston supposes. But it's also a great deal thicker than I have here tried to show. My attention has been focused on intentions to hold some specific level of confidence in some specific proposition. One has a certain proposition in one's sights, and a certain level of confidence; and one then forms and tries to carry out the intention to believe *that* proposition with *that* degree of firmness. That's far from the only way in which responsibility-obligation

gets a hold on our beliefs, however. We say: "You've got no right to believe that that's how it went if you've only listened to the professor's side of the episode and not talked to the student." Clearly there's accountability and blameworthiness in view here; so it's not epistemic obligation which has been violated. But rarely will it be the case that the person who's being chastised for his beliefs in this sort of case holds them because he formed and carried out the intention to do so. Even more clearly is that the case when, say, a teacher chastises a student with the words, "But you should have known." Culpability in such cases stems from failure to use some relevant *practice of inquiry*. It's for that failure that the person is accountable, and blameworthy. Entitlement sometimes attaches to beliefs through the mediation of intentions to believe. More often it attaches to beliefs through the mediation of practices of inquiry.

I have suggested that if Chisholm's fundamental commitment was to developing a theory of knowledge, then it is the concept of paradigm-obligation that he should have used, rather than that of responsibility-obligation. When faced with the choice, however, he might have decided that he was more deeply committed to exploring the role of accountability in believing than to articulating a theory of knowledge. That would have resulted in a theory of *entitlement*. Or he might have pursued both projects, recognizing them as distinct: developed a theory of knowledge and developed a theory of entitlement—each theory being a deontological theory, yet fundamentally distinct on account of the two different concepts of obligation being used. In my last comments I have suggested that a full exploration of entitlement in beliefs would have led him, in turn, into an exploration of practices in inquiry.

NICHOLAS WOLTERSTORFF

DEPARTMENT OF PHILOSOPHY
YALE UNIVERSITY
SEPTEMBER 1995

NOTES

1. Roderick Chisholm, *Theory of Knowledge,* 2d ed. (Englewood Cliffs, N.J.: Prentice-Hall, Inc., 1977), 14.
2. The article is to be found in William P. Alston, *Epistemic Justification* (Ithaca, N.Y.: Cornell University Press, 1989).
3. In a recent article, Alston retracts his earlier assumption and argues for the points I am making. See his "Epistemic Desiderata," in *Philosophy and Phenomenological Research* 53, no. 3 (Sept. 1993).

4. Though I think that when one's aim is to *maintain* the level of confidence that one presently has in a proposition, the distinction between direct control and long-range control isn't helpful; often it's just hard to make out.

5. The rest of his argument goes like this:

> Note that people could properly be held responsible for their attitudes toward propositions in a certain range only if those who set out to intentionally produce a certain attitude toward such a proposition, and made sufficient efforts, were frequently successful. For only if we are generally successful in bringing about a goal, G, when we try hard enough to do so, do we have effective control over whether G obtains. And if I don't have effective control over G, I can hardly be held to blame for its nonoccurrence. Even if I had done everything I could to produce it, I would have had little chance of success; so how could I rightly be blamed for its absence? (134–35)

6. The article can be found in Gerald D. McCarthy, ed., *The Ethics of Belief Debate* (Atlanta: Scholars Press, 1986). The passage I quote occurs on p. 19.

7. The article is in *Philosophical Perspectives, 2: Epistemology, 1988*, ed. James E. Tomberlin (Atascadero, Calif.: Ridgeview Publishers Co., 1988).

8. Robert M. Adams, "The Virtue of Faith," in Adams, *The Virtue of Faith, and other Essays in Philosophical Theology* (Oxford: Oxford University Press, 1987).

REPLY TO NICHOLAS WOLTERSTORFF

In "Obligations of Belief—Two Concepts," Wolterstorff sets forth many of his own views on the theory of knowledge. These include formulation of a paradigmatic sense of obligation and a characterization of other senses of obligation, duty, and requirement in terms of that paradigmatic sense. In his discussions Wolterstorff has many useful things to say. (For example: "Whereas Augustine, after enormous inner struggle, found himself believing, the revival preacher urges the members of his audience to *make the decision* to accept Jesus Christ.")

Wolterstorff also discusses in detail the view of William P. Alston, Richard Feldman, and Alvin Plantinga. But he does not confront any of *my* views in detail. He does not try to show that any of them is mistaken or confused. He cites no passages and does not even mention any of the writings in which they are set forth. In saying these things, I am not criticizing Wolterstorff, I am simply pointing out that, strictly speaking, he has not given me anything to *reply* to.

I regret this very much, for I would have profited by the opportunity of confronting Wolterstorff on the issues of the theory of knowledge.

R.M.C.

11

Richard Foley

CHISHOLM'S EPISTEMIC PRINCIPLES

It is now more than fifty years that Roderick Chisholm has been at work on the problems of epistemology. In 1942 he published "The Problem of the Speckled Hen" in *Mind* and since then he has addressed every major problem in epistemology. The most important of his writings on epistemology are the 1957 book *Perceiving,* the 1982 book *The Foundations of Knowing,* and of course, most famously, the 1966, 1977, and 1989 editions of *Theory of Knowledge.*[1]

The result of all this work is an epistemological system whose scope and subtlety are unsurpassed in the twentieth century, and at the heart of this system are Chisholm's epistemic principles. My purpose is to examine these principles.

Chisholm intends his principles to complement one another. Together they should generate intuitively acceptable results about what we are justified in believing. But it is not always obvious at first glance exactly how they are supposed to work with one another. So, my first task will be to explain, at least briefly, the intricacies of Chisholm's system. I will then be in a position both to point out some of the problematical consequences of his principles and to make some suggestions about how the principles might be revised.

However, my main concern will not be with such revisions. Rather, it will be with the status of the principles, both their epistemological status (How do we come to know them?) and their metaphysical status (Are they necessary or contingent, and what is it that makes them true?). Understanding the status of Chisholm's principles provides the key to understanding his general approach to epistemology. I will look at what Chisholm himself has to say about these matters, but I will also make my own suggestions about the status of his principles. Given the central role of the principles in Chisholm's system, my suggestions in effect will be ones concerning how his project in epistemology is best understood.

1. How the Principles Work

In coming to grips with Chisholm's system, it is best to begin with his terms of epistemic appraisal. He helps himself to an undefined notion of justification in order to give definitions of these terms of appraisal. The following are simplified versions of the definitions that appear in the third edition of *Theory of Knowledge* (hereafter *TK3*):

 p is certain for you = nothing is more justified for you to believe.

 p is evident for you = you are at least as justified in believing *p* as withholding judgment on that which is counterbalanced for you. (Note that this is the level of justification needed for knowledge).

 p is beyond reasonable doubt for you = you are more justified in believing p than withholding judgment on *p*.

 p is epistemically in the clear for you = you are at least as justified in believing p as withholding on *p*.

 p is probable for you = you are more justified in believing *p* than disbelieving *p*.

 p is counterbalanced for you = you are as justified in believing *p* as believing not-*p*, and vice versa.

Chisholm intends the first five of these terms to be such that the higher ones imply the lower ones, and he introduces axioms to ensure this (*TK3*, 12, 13, and 17). So, if a proposition is certain for you, it is also evident for you; and if it is evident for you, it is also beyond reasonable doubt for you; and so on down the list.

Making use of these terms, Chisholm proposes a number of epistemic principles. The principles are expressed as conditionals, whose antecedents describe sufficient logical conditions for the application of these terms of epistemic appraisal (*TK3*, 62). In the most straightforward case, a principle will assert that if certain nonepistemic conditions are satisfied (e.g., conditions about what you are experiencing, believing, etc.), then a proposition *p* has a certain epistemic status for you (e.g., it is evident or beyond reasonable doubt for you).

Thus, Chisholm's project in epistemology is closely analogous to one traditional project in ethics, a project that seeks to describe a set of nonmoral conditions that is sufficient to make an action morally right. Utilitarians, for example, say that the nonmoral conditions are ones having to do with the production of pleasure and the avoidance of pain. If of all the alternatives available to you, alternative *x* will produce the greatest balance of pleasures over pains, then you are required to do *x*.

Utilitarians think that this, or at least something resembling this, is *the* fundamental principle of morality. For them, there is but one source of moral obligation. Others disagree, insisting that there are other sources as well, ones that are not directly concerned with the maximization of happiness. Equality and fairness, for example, are among the usual candidates. If doing X would produce a fair result, then, according to this view, you have a prima facie obligation to do X even if doing so would not maximize happiness. There may be other sources as well, and corresponding to each of these sources will be an ethical principle, asserting that the source in question produces a prima facie moral obligation.

This is the counterpart of Chisholm's view in epistemology. He thinks that there is more than one source of epistemic justification (unlike some coherentists, for example), and corresponding to each of these sources is an epistemic principle describing the conditions under which the source produces justification. There is a wrinkle, however. According to Chisholm, some of these sources produce justification only in conjunction with other sources. Thus, the epistemic principles corresponding to these sources must make reference to the workings of other principles. The result is a collection of principles that are interdependent in complex ways.

Among the most important of these principles are the following (again, these are simplified versions of what appears in *TK3*):

1. If F is a self-presenting property and if you have F and if you believe yourself to have F, then it is certain for you that you have F.
2. If it is evident to you that you are appeared to ———— and it is epistemically in the clear for you that something is appearing to you in this way, then it is evident for you that something is appearing ———— to you.
3. If it is evident to you that you are appeared to ———— and if you believe that it is a G that is appearing to you in this way and if this proposition is epistemically in the clear for you, then it is beyond reasonable doubt for you that you perceive a G.
4. If you believe a proposition that is not disconfirmed by the set of propositions that are evident for you, then the proposition is probable for you. (Note: p disconfirms q = p tends to make not-q probable.)
5. If you believe a proposition that is not disconfirmed by that which is probable for you, then the proposition is epistemically in the clear for you.
6. If there are three or more concurrent propositions and if each of them

is epistemically clear for you and if in addition one of them is beyond reasonable doubt for you, then they all are beyond reasonable doubt for you.

7. If there are three or more concurrent propositions and if each of them is beyond reasonable doubt for you and if in addition one is evident for you, then they are all evident for you.

Principle 1 deals with what Chisholm calls 'self-presenting properties'. The loose way to think about these properties is that they are purely psychological. From the fact that you have a property of this sort, nothing logically follows about how you are related to the nonpsychological world. Thus, for example, from the fact that you have the property of thinking about riding a bicycle, it does not follow that you are riding a bicycle. It does not even follow that there are bicycles. Nor, according to Chisholm, does anything else follow about the nonpsychological world. On the other hand, from the fact that you have the property of thinking about riding a bicycle while being stuck in a traffic jam, something does follow about the nonpsychological world. It follows that there are traffic jams, that you are in one, and so on. So, this property is not a self-presenting one.

More formally, Chisholm says that a property is self-presenting provided that every property that it entails includes the property of thinking. Both 'entails' and 'includes' are technical terms for Chisholm. To say that one property F includes another G is to say that F is necessarily such that anything that has F also has G, and to say that F entails G is to say believing something to have F includes believing something to have G (TK3, 19).

According to Chisholm, there are of two sorts of self-presenting properties: intentional properties (ways of thinking, hoping, fearing, wondering, wishing, desiring, intending, etc.) and sensible properties (ways of being appeared to by the various senses). Principle 1 says that if you have a self-presenting property and if you believe that you have it, then the proposition that you have the property is maximally justified for you. Nothing is more justified for you to believe.

The self-presenting provides a foundation on the basis of which other contingent propositions can come to have justification for you. One way of this happening is described in principle 2. For example, if it is evident to you that you are having a visual experience of the sort that is involved in seeing a cat and if in addition it is epistemically in the clear for you that something is appearing to you in this way, then these two things combine to make it evident for you that something is appearing to you in this way. It may not be evident to you what it is that is appearing to

you—i.e., it may not be clear whether it really is a cat or a dog or a bush or whatever—but it is evident for you that something is doing so. It is evident, in other words, that you are not hallucinating.

Chisholm also proposes principles of what he calls 'perceptual taking'. The above principle 3 is a variation of the perceptual principle that he proposes (*TK3*, 65). I have merely expressed it in such a way as to emphasize its continuity with (2). Principle 3 says that if it is evident to you that you are appeared to in a certain way and if you believe that it is a cat that is appearing to you in this way and if moreover this proposition is epistemically in the clear for you, then these three things combine to make it beyond reasonable doubt for you that you perceive a cat.

There is also a principle analogous to (3) for memory, expressed in terms of what you think you remember (*TK3*, 68).

Notice that the antecedents of principles 2 and 3 make use of two epistemic notions, that of a proposition being evident and that of a proposition being epistemically in the clear. Since the propositions that are supposed to be evident for you are ones concerning self-presenting states, principle 1 describes how they might come to have this status for you. But how do the other propositions, the ones that are supposed to be epistemically in the clear for you, get their status? Chisholm intends for the set of such propositions to be larger than the set of evident propositions. Thus, (1) alone won't do. There must be some other source of epistemic justification for them. What is this other source?

According to Chisholm, it is belief itself. He says that one way in which a proposition can obtain a degree of epistemic justification for you is by being believed by you. Principle 4 is meant to describe how: if you believe a proposition that is not disconfirmed by the set of propositions that are evident for you, then the proposition is probable for you. What are these propositions that are evident for you? We already know if you have a self-presenting property and believe that you have this property, then this proposition is certain and hence also evident for you. Principle 4 says to collect these propositions and anything else that is evident for you into a set and then ask whether this set of propositions disconfirms the proposition that you happen to believe. If not, then the proposition is probable for you.

A large number of propositions can become probable for you in this way, by virtue of your believing them. They will have this weakly favorable epistemic status even if there is no other positive source of justification for them—from self-presentation, perception, or memory, for example.

Chisholm also proposes a related principle that allows such

propositions—ones whose only positive source of justification is belief in them—to rise to an even higher epistemic status. This is principle 5: if you believe a proposition that is not disconfirmed by the set of other propositions that are probable for you, then this proposition is epistemically in the clear for you. What are these propositions that are at least probable for you? In large part, they are propositions that satisfy the antecedent of principle 4—believed propositions that are not disconfirmed by that which is evident for you. So, (4), as it were, creates much of the material for (5) to do its work.

One way to construe principles 4 and 5 is as principles of what is sometimes called 'negative coherence'. Together they imply that if a believed proposition is not incoherent with the set of other propositions that are probable for you (many of which get this status by the fact that you believe them and they are not disconfirmed by that which is evident for you), then it is acceptable for you to believe the proposition.

With these principles in hand, reconsider principles 2 and 3. The question, remember, was how the propositions mentioned in the antecedent of these two principles get the status of being epistemically in the clear for you. Principles 4 and 5 provide an answer. They can get this status by being believed by you. If you believe a proposition of the sort mentioned in the antecedent of (2), say the proposition that something is appearing to you in a catlike way, and if the set of propositions that are probable for you does not disconfirm this proposition, then the proposition is epistemically in the clear for you. And then, principle 2 says that this in conjunction with the fact that it is evident to you that you are appeared to in a catlike way makes it evident that something is appearing in a catlike way to you. It is evident that you are not hallucinating.

Similarly for propositions of the sort mentioned in the antecedent of (3): if you believe that it is a real cat appearing to you in this catlike way and if this proposition is not disconfirmed by the set of other propositions that are probable for you, then the proposition is epistemically in the clear for you. And then, principle 3 says that this in conjunction with the fact that it is evident for you that you are appeared to in a catlike way makes it beyond reasonable doubt that it is a cat—and not, say, a dog or a bush—that you are perceiving.

Principles 4 and 5, as I have said, are principles of negative coherence, but Chisholm also thinks that positive coherence relations among a set of propositions, or what he calls 'concurrence relations', are an important source of empirical justification. A set of propositions is concurrent just if the propositions are logically independent and mutu-

ally supportive; each proposition in the set is such that the others tend to make it probable.

Chisholm defends two principles of concurrence. Principle 6 says that if there is a set of concurrent propositions each of which is epistemically in the clear for you and at least one of which is also beyond reasonable doubt for you, then they all become beyond reasonable doubt for you. Principle 7 says something similar for concurrent propositions of the next highest epistemic status. According to (7), if there is a concurrent set of propositions each of which is beyond reasonable doubt for you and at least one of which is evident for you, then they all become evident for you.

So, despite his reputation as the leading foundationalist, Chisholm is also a coherentist. But unlike a pure coherentist, he does not think that positive coherence relations are the only source of empirical justification. Indeed, he does not think that positive coherence is capable of generating justification for propositions that have nothing else to recommend them. It cannot create justification *ex nihilo.* On the other hand, it can ratchet justification up a notch for propositions that already have some other source of justification.

This then is a very quick overview of some of the more important of Chisholm's principles. Together they describe what he takes to be the principal sources of empirical justification—namely, self-presentation, perception, memory, belief coupled with a lack of negative coherence, and, finally, positive coherence among propositions with some antecedent positive epistemic status.

2. Some Difficulties for the Principles

Before discussing the general status of these principles, I want to mention a few of the problems that they encounter as formulated. At least some of their implications are doubtful.

Begin with principle 1. It together with the definition of certainty implies that there can be no difference in epistemic status among self-presenting propositions. Each such proposition is maximally justified. So, take any two self-presenting properties A and B. If you have both A and B and believe that you have each, then you *cannot* be more justified in believing that you have A than you are in believing that you have B, or vice versa. Moreover, you cannot be more justified in believing any other proposition—not even, say, the proposition that $2 + 1 = 3$—than you are in believing either of these propositions.

This seems questionable, and it seems questionable even if we brush aside more fundamental worries about principle 1. There will be worries, for example, about whether Chisholm's way of picking out self-presenting properties is acceptable, and worries as well about whether our introspective abilities are as trustworthy as the principle suggests that they are. But as I say, even without these worries, the principle seems questionable. After all, self-presenting properties can be more or less complex. It would thus seem as if you might be at least somewhat less justified in believing that you have the complex ones than in believing that you have the simple ones, and likewise it would seem as if you might be somewhat less justified in believing that you have the complex ones than in believing that $2 + 1 = 3$.

Consider the limiting case—the conjunction of all those self-presenting properties $F_1, F_2, F_3, \ldots, F_n$ that are such that you both have them and believe yourself to have them. From the fact that you believe yourself to have each of these individual properties, it does not follow that you also believe yourself to have their conjunction. You need not believe the conjunction of everything that you believe. But suppose that you do believe that you have the conjunctive property $(F_1, F_2, F_3, \ldots,$ and $F_n)$. This property will itself be a self-presenting property; it will be such that every property that it entails includes the property of thinking. Thus, according to principle 1, you must be as justified in believing that you have this property as you are in believing that you have, say, F_1. You must be as justified in believing the former as the latter, no matter how large this conjunction of properties is and no matter how much or how little care you have exercised in coming to believe that you have the conjunction. Indeed, you must be as justified in believing that you have this conjunction of properties as you are in believing any proposition whatsoever, even the proposition that $2 + 1 = 3$. But this, as I have said, seems questionable.

There are also pressing problems for the other principles. Consider, for example, principle 5. According to it, if you believe that something is appearing to you in a catlike way and if in addition the set of propositions that are (at least) probable for you do not positively disconfirm this (i.e., do not tend to make it probable that nothing is appearing in a catlike way to you), this is enough to make the proposition epistemically in the clear for you. And then, on the assumption that it is evident to you that you are being appeared to in a catlike way, principle 2 will lift the proposition up to an even higher status, that of being evident for you.

But this cannot be quite right. Think of cases where the propositions

that are probable for you do not positively disconfirm that something is appearing to you in a catlike way but instead counterbalance it for you. Suppose, for example, that one of the propositions that is evident for you (and hence also probable for you) is the proposition that you have been given a drug that produces massive hallucinations in exactly 50% of the people who ingest it. But you ignore this evidence. So, when you are appeared to in a catlike way, you come to believe that something is appearing to you in this way. Indeed, you believe that it is a real cat that is doing so. You believe these propositions despite your evidence about the drug. But notice, this evidence does not disconfirm that something is appearing in a catlike way to you. It does not make it probable that you are hallucinating. The evidence only indicates that there is a fifty-fifty chance that you are hallucinating. Moreover, it may be that nothing else that is evident or probable for you disconfirms that something is appearing in a catlike way to you either. If so, according to principle 5, the proposition that something is appearing in a catlike way to you is epistemically in the clear for you. And then, principle 2 can lift this proposition up to an even higher status, that of being evident for you. It is evident for you even though, by hypothesis, you have evidence indicating that there is a fifty-fifty chance that you are hallucinating.

This case raises similar problems for the proposition that it is a cat that is appearing in this catlike way to you. Given the formulation of 5, this proposition may be epistemically in the clear for you, since you believe it and since nothing that is evident or probable for you positively disconfirms it. But if so, principle 3 can make this proposition beyond reasonable doubt for you. It can be beyond reasonable doubt for you despite the fact that given your evidence, there is a fifty-fifty chance you are hallucinating.

These examples show that principle 5 needs to be revised, and since similar examples can be brought against (4), it will need to be revised as well. One way to do so, while remaining faithful to their spirit, is roughly as follows. Revise (4) to say that your believing a proposition p tends to make p probable for you. Then add that p is in fact probable for you only if this prima facie tendency is not defeated by anything that is evident for you (where counterbalancing evidence of the sort that I have described—evidence to the effect that you've taken a drug that produces hallucinations 50% of the time—would defeat this tendency). An analogous revision can be made on (5), a revision to the effect that believing p tends to make p epistemically in the clear for you, where this tendency can be defeated by anything that is probable for you.

Even with these revisions, a larger issue remains of whether belief in a

proposition really does tend to make that proposition justified. More-over, this issue becomes all the more urgent when it is clear how these principles of negative coherence work in tandem with Chisholm's principles of positive coherence.

To illustrate these problems, consider the following three concurrent propositions, which are variants of an example that Chisholm gives of concurrent propositions (*TK3*, 70): x = most of the people at the party are tall and John is at the party if and only if Mary is at the party; y = Mary is tall and is at the party; z = John is tall and is at the party. The three propositions are concurrent because they are logically independent of one another and because any two of them, according to Chisholm, tends to make probable the third, i.e., any two at least weakly supports the third.

Suppose that you have just entered the party and that the first two people you see are John and Mary, both of whom are tall. Suppose, moreover, that the situation is such that upon seeing them, propositions y and z become evident for you. They have the status required for knowledge. Suppose also that upon seeing them, you come to believe x, even though John and Mary are the only two people at the party that you now see. Your believing x, according to our revised version of Chisholm's principle 5, tends to make x epistemically in the clear for you. Suppose, finally, that nothing that is probable for you defeats this tendency. Then x is epistemically in the clear for you. The lack of negative coherence plus the fact that you believe it makes it so.

In addition, x positively coheres with y and z, both of which are evident for you and hence also beyond reasonable doubt for you. Accordingly, Chisholm's first principle of concurrence, principle 6, implies that x gets bumped up a notch in epistemic status, to beyond reasonable doubt. But notice, Chisholm's second principle of concur-rence, (7), can now come into play. It tells us that these very same coherence relations, the relations among x, y, and z, can be used to bump up x still a notch further, so that it becomes evident for you. This is so because after the application of principle 6, proposition x has been lifted to beyond reasonable doubt. Thus, it is now a member of a concurrent set, each member of which is at least beyond reasonable doubt and at least one member of which is evident. So, the very same concurrence relations get used twice, first to ratchet x up to beyond reasonable doubt and then once it has reached this status, to ratchet it up yet again to the status of evident.

This is much too strong a result. Remember the situation. You arrive at a party and the first two people you see are John and Mary, both of

whom are tall. On the basis of this very small sample, you come to believe x. Nevertheless, according to Chisholm's principles, relations of negative coherence and positive coherence lift the epistemic status of this proposition up to the level required for knowledge.

What has gone wrong? I am inclined to say that what has gone wrong is that Chisholm is neither a strong enough foundationalist nor a strong enough coherentist. Unlike a pure coherentist, he allows coherence relations among even a very small set of propositions to be epistemically significant. Pure coherentists are typically sensitive to the charge that their approach is too permissive, and thus they ordinarily insist that the only coherence relations that matter are those among all of the propositions that an individual believes. Aphoristically put, they admit that small circles of belief don't count for much epistemically but they insist that large circles do.

By contrast, Chisholm apparently thinks that the foundational constraints of his system will prevent it from being overly permissive, despite the epistemic significance that the system grants to coherence relations even among a very small set of propositions. But in fact, the foundational constraints of his system are not sufficiently strong to correct for this. Thus, either the system must be revised so as to make it more purely coherentist or it must be revised so as to make it more purely foundationalist.

By 'foundational' I mean a system implying that epistemic justification has a tiered structure. At the bottom is your evidence, and then other propositions acquire whatever degree of justification they have for you by virtue of the degree of support they receive from your evidence. There are, of course, a range of things that foundationalists can say about the nature of these evidential propositions and the nature of these support relations. At one end of this range are those foundationalists who insist that these notions be understood in such a way that they will provide some sort of guarantee of truth, or at least a guarantee of the likelihood of truth. At the other end of the range are those foundationalists, such as myself, who understand these notions in a more subjective fashion.[2] In either case, the leading idea is that the degree of justification that a proposition has for you is proportional to the degree of support that it receives from your evidence.

Despite his reputation as the stalwart of foundationalism, this is an idea from which Chisholm seems to have departed. In his system, with its principles of negative and positive coherence, a believed proposition can have a degree of justification for you that far exceeds that which is provided by your evidence, and it is this that makes his system

susceptible to problems of the above sort. More precisely, it is this combined with Chisholm's refusal to accept a more purely coherentist picture of epistemic justification that accounts for the problems.

3. THE EPISTEMOLOGICAL AND METAPHYSICAL STATUS OF THE PRINCIPLES

Chisholm uses a basic notion of justification to define his terms of epistemic appraisal, and he then uses these terms of appraisal to formulate his epistemic principles. So, an obvious place to begin in thinking about the metaphysical status of his principles is with the basic notion of justification.

According to Chisholm, this is a notion that we bring to epistemology (*TK3*, 5). We have at least a vague idea of what it is for a belief to be justified, and this idea guides the epistemological project. It is only because we have a prephilosophical idea of justification that we are able to identify instances of beliefs that are clearly justified, and it is this, he says, that allows the epistemological project to get off the ground. He is a particularist when it comes to matters of epistemological method (*TK3* 7). He begins by examining particular instances of beliefs that he takes to be justified, and he then tries to abstract out of these instances general conditions of justification, which he expresses in the form of epistemic principles.

Chisholm also makes an important presupposition about this notion of justification that he brings to epistemology. He presupposes that we can improve and correct our beliefs by reflection, eliminating those that are unjustified and adding others that are justified (*TK3*, 1 and 5). This presupposition acts as a constraint when we try to use particular instances of justified belief to formulate general conditions of justification. It forces us to look for conditions to which we have reflective access, since otherwise there would be no reason to think that we could eliminate unjustified beliefs and add justified ones simply by being reflective. Or as he himself puts the conclusion: justification "is internal and immediate in that one can find out directly, by reflection, what one is justified in believing at any given time" (*TK3*, 7). This is one of the senses in which Chisholm is an internalist, an especially strong epistemic sense. There is also a weaker sense in which he is an internalist, which I will discuss in a moment.

But for now, the point to be stressed is that the vague notion of justification that Chisholm brings to epistemology not only allows him to identify particular instances of justified beliefs, it also guides him as to

what sort of conditions are responsible for making these beliefs justified. This notion need not remain vague, however. On the contrary, the hope is that in the process of trying to formulate epistemic principles, the basic notion will become less and less obscure, so that eventually we will be in a position to give a precise general characterization of it. And indeed, Chisholm does try to give such a characterization. He does so in ethical terms. Epistemic justification is ultimately to be understood in terms of ethical requirements on our believings and withholdings.

Chisholm acknowledges that this approach will worry many philosophers. They will argue that it is misguided to try to understand epistemic justification in terms of what we are required to believe. After all, something cannot be ethically required of us unless we have control over whether or not it occurs, but we don't always have control over what we believe. Even if I wanted to believe that Jimmy Carter was the most successful American president of the twentieth century, I cannot simply make myself believe this by an effort of will; at least I cannot do so now.

To deflate such worries, Chisholm proposes that epistemic justification be understood in terms of a requirement to prefer. To say that you are more justified in believing p than withholding on p is to say that you are required to prefer the former over the latter (*TK3*, 59). Chisholm goes on to claim that requirements to prefer are best explicated in a negative way. The requirement to prefer believing p over withholding on p is a requirement not to choose between believing and withholding without choosing the former, and this, he points out, is a requirement that can be satisfied even if you do not have direct control over your believings and withholdings. Indeed, it is a requirement that can be satisfied quite effortlessly (*TK3*, 59).

But insofar as the original worry was that we cannot be required to believe something if we don't have control over whether or not to believe it, it is hard to see how Chisholm's proposal helps. According to the proposal, saying that you are more justified in believing p than withholding on p is equivalent to saying that you are required not to choose between believing and withholding without choosing the former. But if you don't have control over whether or not to believe p, will you have any more control over whether you have this complex property, the property of not choosing between the two options without choosing the former? If not, the same problems arise once again. The critics will insist that it is a mistake to talk of your being required not to choose without choosing the former, since you lack control over whether or not you will have this property.

On the other hand, perhaps Chisholm's view is that you somehow do have control of whether or not you will have this property. The most

direct way of having such control is by having control over whether or not you believe p. You could then bring it about that you have the property simply by choosing to believe rather than withhold. But of course, this merely brings us back to the original worry. The original worry was that often we cannot choose whether or not to believe something.

A second and less direct way of bringing it about that you have this complex property is by bringing it about that you don't choose between believing and withholding—in effect, by choosing not to choose. But this would be a trivial way of satisfying the requirement. If epistemic justification is to be understood in terms of ethical requirements, we don't want to allow the requirements to be satisfied in such a back-handed way.

Consider an example. Suppose that you have strong evidence for p— strong enough that given Chisholm's principles, you would be more justified in believing p than either withholding on it or disbelieving it. According to Chisholm's present suggestion, this is to say that you are required not to choose among these three options without choosing the first. Now suppose, for the sake of argument, that you can choose not to choose between these options. Perhaps, for example, this is a matter of choosing not to deliberate about p. In effect, you choose to allow yourself to remain on a kind of automatic pilot, letting your normal belief mechanisms do their work. But suppose that as a result of this, you come to disbelieve p—i.e., believe not-p. Then you have satisfied the require-ment not to choose among the three options without choosing the first. You have satisfied it by choosing not to choose. But this cannot be right. By hypothesis, you have strong evidence for p, and we don't want you to be able to satisfy the ethical requirement that this evidence supposedly imposes on you simply by refusing to choose.

The lesson is that if Chisholm insists on understanding epistemic justification in terms of ethical duties, he has two main options. The first is to argue that contrary to appearances, we really do have sufficient control over our beliefs that ethical requirements can always apply to them directly. Chisholm could then say that when our evidence makes it more justified for us to believe p than withhold on p, we are required to choose the former over the latter. There would be no need to introduce the more complex requirement, that of not choosing between believing and withholding without choosing the former. The problem with this option, of course, is that Chisholm has not given us such an argument and there is little reason to think that he could. In numerous cases, we seem to have little if any control over our beliefs.

The other option is to continue to understand epistemic justification

in terms of a requirement to prefer one doxastic attitude over another (e.g. believing over withholding) but to find some other, less problematical way of explicating this kind of requirement. But whatever the explication, it would have to be one that allowed us enough control over these preferences that talk of ethical requirements with respect to them would not be out of place.

I will pass over the question of which, if either, of these options is plausible, since the most important points for my purposes here are, first, that Chisholm conceives of justification in terms of some kind of ethical requirement, however this is to be understood, and, second, that he in turn conceives of such requirements as supervening on non-normative states. Specifically, they supervene on your conscious states (*TK3*, 60). As such, a proposition could not have an epistemic status different from the one it does have for you without your conscious states being different.

This provides us with what we need in order to understand what Chisholm takes to be the metaphysical status of his principles. He thinks that they are necessary truths, and the truths that they express are ultimately ones about the relationship between your conscious state at a time and some sort of ethical requirement about your believings and withholdings.

This illustrates the other, weaker sense in which Chisholm is an internalist, a metaphysical sense. The conditions that make a proposition evident or beyond reasonable doubt or probable for us are internal conditions. They are our own current, psychological states, not nonpsychological "external" states and not past psychological states. Chisholm's strong epistemic internalism requires something in addition to this. It requires that we always have reflective access to these internal conditions.

In a moment I will return to the metaphysical status of Chisholm's principles and offer an alternative way of thinking about these principles. But first, I want to argue that the epistemic internalism that he endorses is too strong and that neither his particularist methodology nor his epistemic principles require an internalism of this strength. On the contrary, his epistemic principles fit uncomfortably with it.

Begin by considering those beliefs that Chisholm initially takes to be justified and from which, as a particularist, he wants to draw out general conditions of justification. Do these beliefs really have to be justified? It may look as if Chisholm, as a particularist, has no alternative but to say 'yes', but in fact I think that the answer is 'no'.

Take principle 3, for example. How does Chisholm come to formulate and defend this principle? According to his particularist metho-

dology, he begins by identifying a set of his perceptual beliefs that he regards as justified, and then by reflecting upon these beliefs, he comes to see that principle 3 is true. How does he come to see this? Chisholm is not entirely explicit about this matter, but one way to understand the process is in terms of it being akin to what he has sometimes called 'intuitive induction' (*TK2*, 38). He says that an individual comes to understand what it is for something to be blue, for example, by 'seeing' in a direct intuitive way what a number of blue things have in common. The individual abstracts out blueness from the particular instances. And so it may be with the particular instances of justified perceptual beliefs with which Chisholm begins: out of these instances he is able to intuit the truth of principle 3.

The alternative is to understand the process as involving something more akin to an inference to the best explanation. He comes to see that the conditions described in the antecedent of (3) are satisfied by the beliefs he regards as justified and that, thus, these conditions can account for those beliefs being justified. On the first view, the intuitive induction view, the particular instances of justified belief provide the occasion for seeing that (3) is true. On this second view, they serve as data, and the truth of (3) is inferred to account for this data.

But on either view, the result is a complex principle—namely, principle 3. Part of its complexity, as we have seen, is due to the fact that its antecedent makes use of epistemic notions, the notion of a proposition being evident and that of a proposition being epistemically in the clear. So, to know whether its antecedent is satisfied, one has to appeal to still other epistemic principles, such as (1) and (4) and (5), but these principles can also be complicated to apply. It will not always be immediately obvious whether or not their antecedents are satisfied. Indeed, to determine that the antecedent of (4) is satisfied, one needs to survey everything that is evident for one, and to determine that the antecedent of (5) is satisfied one needs to survey everything that is even merely probable for one. And then one will also have to determine what it is that these propositions disconfirm. This is an immensely complicated business, and thus it would not be surprising if one were to make mistakes, perhaps even substantial mistakes, in carrying out such a survey. One can make mistakes even if one is careful. Chisholm himself might make such mistakes. He might very well be mistaken about whether certain propositions really are epistemically in the clear for him. But in turn, this means that he might also make mistakes in determining whether his perceptual beliefs meet the conditions laid down by (3). He might even be mistaken in thinking that the beliefs with which he began satisfy these conditions.

Thus, there is a tension between Chisholm's strong internalism on the one hand and his principles on the other. According to the internalism, "one can find out, by reflection, what one is justified in believing at any given time." This may not commit Chisholm to the idea that we are infallible in our judgments about what we are justified in believing, but it does suggest that there must not be systematic barriers in the way of our making accurate judgments about these matters. In particular, it suggests that we will be able to make accurate judgments about which of our beliefs are justified if we are sufficiently sophisticated and sufficiently careful. For if we are sufficiently sophisticated we will know what kinds of conditions make our beliefs justified, and if we are sufficiently reflective we will be able to determine in our own case whether or not these conditions obtain.

On the other hand, the complexity of the principles suggests just the opposite. It suggests that there might very well be barriers that prevent us from distinguishing our justified beliefs from the unjustified ones. This is so even if we are sophisticated in matters of epistemology. After all, according to the principles, the conditions that make our beliefs justified or unjustified are complicated, rooted in much if not all of what we believe and experience. But the more complicated these conditions are, the more implausible it is to suggest that there cannot be obstacles that prevent us from accurately determining whether or not these conditions obtain.

Moreover, it is not as if the possibility of there being such obstacles is a remote one. We don't have to imagine demons who are prepared to interfere with our introspective efforts. If the conditions of justified belief are complicated enough, as they are on Chisholm's view, then the sheer enormity of the task may itself be an obstacle for creatures with our kinds of cognitive abilities. Reflect as we might, we can make mistakes, even substantial ones, in trying to decide whether or not these conditions obtain. Indeed, there is an increasing amount of empirical evidence that suggests we regularly and systematically make errors when engaged in even relatively simple introspective tasks.[3] The obstacles are bound to be more severe when the task is the complicated one of determining whether our beliefs meet conditions of the sort laid down in Chisholm's principles.

The easiest way to relieve this tension between Chisholm's internalism and his principles, while retaining the overall spirit of his thought, is to weaken the internalism. It is to say that although the conditions that make our beliefs justified are internal, psychological conditions, there is nothing that assures us of having reflective access to these conditions. Hence, there is nothing in principle to prevent us from thinking, even

after careful reflection, that a belief is justified when it is not. Indeed, there is nothing in principle to prevent us from making such mistakes with some regularity.

At first glance, this seems to conflict with Chisholm's particularism, since particularism is committed to the idea that we get the epistemological project off the ground by assuming that the beliefs that we initially take to be justified really are justified. But now, we are saying that even after we have done some epistemology and have the precision of Chisholm's epistemic principles to aid us, we might make a number of mistakes about which of our beliefs are justified. *A fortiori* it would seem as if our initial judgments about these matters, the judgments on the basis of which we formulate the epistemic principles, might also be widely mistaken. In turn, this might seem to undermine Chisholm's particularist strategy. It seems to show that he cannot simply assume that the beliefs he initially takes to be justified really are justified.

But in fact, there is only the appearance of conflict here, since our initial judgments about what beliefs are justified can play the methodological role that particularists want them to play even if these judgments are false. Suppose, for the sake of illustration, that Chisholm was mistaken in taking the beliefs with which he began to be instances of highly justified beliefs. Does this mean that a principle such as (3) can no longer be regarded as a correct principle? No. Principle 3 is a conditional: if such-and-such conditions are met, then it is beyond reasonable doubt for Chisholm that he perceives a cat or whatever. Unbeknownst to him, Chisholm's actual perceptual beliefs, the ones that led him to principle 3, might not satisfy these conditions, but in itself this does not show that there is anything wrong with (3). It may only show that he is mistaken in thinking that these beliefs satisfy the antecedent of (3).

Consider an analogy. Suppose that in hopes of formulating some criteria for rational-theory acceptance in science, I decide to study the development of quantum theory in the early part of this century, my working assumption being that this is a good example of rational theorizing. After studying the history, I conclude that quantum theorists were implicitly using criteria C, and that this is what made their theorizing rational. But now suppose that a revisionist historian of science establishes to my satisfaction that the quantum theorists did not in fact use C. Instead, their theorizing was shaped by social and political pressures irrelevant to the truth of their theories. What does this show? Does it show that I no longer have any reason for thinking that C is an acceptable criterion of rational theorizing? Not necessarily. I might continue to say that C is acceptable, insisting that had the quantum theorists used C, their theorizing would have been rational. It is just that

I now doubt whether they in fact did use C, and perhaps as a result I now also doubt whether their theorizing was in fact rational.

In effect, this is just to say that hypothetical cases can sometimes serve the needs of the philosopher of science as well as actual cases. And so it is with the instances of justified belief with which particularists begin their more general epistemological project. As a working hypothesis, they take these beliefs to be justified. They then use this hypothesis to formulate criteria of justified belief. If at a later time they discover that these beliefs do not in fact meet these criteria, this does not necessarily show that there is anything wrong with the criteria. It may only show that these beliefs in fact have characteristics quite different from what they originally took them to have.

This may seem like a relatively minor point, but in fact it shows that contrary to what Chisholm and others often suggest (*TK3*, 6–7), particularism is compatible with a broad-ranging skepticism. Particularists can insist that the proper way to begin the epistemological project is with the hypothesis that certain of their beliefs are justified. On the other hand, they can also admit that they accept this hypothesis only against a backdrop of vague assumptions about the conditions under which they hold these beliefs. Particularists can then reflect in more detail about these conditions in hopes of identifying the ones that are responsible for making the beliefs justified. But of course, even if they are careful in their reflections, they can make mistakes. They may think that certain conditions obtain that in fact do not, or vice versa. However, this need not mean that they are mistaken in thinking that these conditions would have been sufficient to make their beliefs justified had they obtained. It does not mean that their epistemology is mistaken. It might only show that they were mistaken in their original working hypotheses. They were mistaken in assuming that the beliefs with which they began are actually justified. But this does not necessarily undermine their particularist strategy. In epistemology as in the philosophy of science, our theoretical purposes can sometimes be served as well by hypothetical cases as actual cases.

This is a welcome result for particularism. We do not want our methodology for doing epistemology to guarantee in advance that what we initially take to be justified beliefs really are justified. Indeed, any methodology that purported to give us such a guarantee should be rejected as implausible for this very reason. After all, we do not have pretensions of infallibility with respect to other matters. Why think that our opinions about epistemic matters are any different? They clearly are not, and particularists need not claim otherwise, since for their purposes hypothetical instances of justified beliefs will sometimes do as well as

actual instances. Particularism is thus compatible with a wide-ranging skepticism, and this, as I say, is a welcome result for particularism.

On the other hand, it is also a result that has implications for the presupposition that Chisholm uses to argue for internalism—namely, the presupposition that we can improve and correct our beliefs by reflection. For if, even after careful reflection, there are no guarantees that we might not make widespread mistakes about what we are justified in believing, there are likewise no guarantees that we will always be able to improve and correct our beliefs by reflection. But once again, this is as it should be. The only readily apparent way to provide such guarantees would be to insist that we have incorrigible access to the conditions that make our beliefs justified, but of course this has a familiar and unpromising ring to it.

Even so, this is not so much to say that Chisholm's presupposition is altogether implausible. It is only to say what perhaps should have been obvious from the start—namely, that the presupposition's plausibility depends upon it being regarded as a working hypothesis rather than a necessary truth.

So far, I have been trying to defend Chisholm's particularist methodology for doing epistemology. I have been doing so, in effect, by deflating the strengths of its claims. But even after deflation, the methodology does have its share of problems. One problem is especially underappreciated. It concerns Chisholm's claim that we bring to epistemology at least a vague idea of what it is for a belief to be justified, as if there were merely one such vague idea. His suggestion, as I have said, is that this vague but univocal idea informs our intuitions about which of our beliefs are justified and that we can then squeeze out of these intuitions general conditions of justification.

Of course, Chisholm is not alone in adopting this as a strategy for doing epistemology. It is common strategy. But the problem, as I see it, is that neither the vague ideas that we bring to epistemology nor the intuitions that these ideas shape are anywhere near as unified as this strategy presupposes. Quite the opposite; the more we reflect on various instances of beliefs, the more we seem forced to the conclusion that there are different senses of justified or rational belief.

My view is that we have inherited subjective as well as objective notions of rationality, justification, and the like. The subjective notions are concerned (roughly) with whether we have met our own deepest epistemic standards. In this sense, being rational or justified is essentially a matter of being invulnerable to a certain kind of criticism, either self-criticism or criticism by one's peers. It is a matter of getting one's own intellectual house in order. By contrast, the objective notions are

concerned (again, roughly) with whether we have used procedures, methods, etc., that result in our having knowledge; in this sense, rationality or justification is essentially the condition that when added to true belief produces knowledge.

The fact that there are these two clusters of notions is not in itself a cause for alarm. A problem arises only if we assume—with Descartes, Locke, and a good many other of the great figures in epistemology—that there is in fact only one notion here, a notion that, to be sure, has both a subjective and an objective side but one which nonetheless can be given a univocal explication. Descartes, for example, thought the explication could be given in terms of clarity and distinctness, while Locke thought it could be given in terms of some notion of what is required of us if we are to be responsible believers. But both seemed to assume that rationality was a kind of bridge notion that provides a guaranteed link between our subjective internal states and the truth about the external world.[4]

This kind of assumption dooms epistemology in advance, because no matter how we try to finesse it, the subjective and objective can come radically apart. Put crudely, the problem is that the subjectively persuasive is not objectively guaranteeing. It is possible for us to do an altogether adequate job of meeting our own deepest epistemic standards and yet still not be in a position to know much of anything. We can meet our own standards and yet still get things terribly wrong, so wrong that even the few true beliefs we manage to have are not particularly good candidates for knowledge. This is one of the lessons of evil-demon hypotheses and brain-in-a-vat hypotheses. The demon deprives us of an opportunity of having knowledge, or at least perceptual knowledge, but in at least one important sense, the demon does not thereby deprive us of an opportunity of being rational.

But if so, there are at least two distinct notions of rationality or justification, notions that must be given distinct explications. Accordingly, when we are doing epistemology, we must make a choice as to whether we are trying to give an explication of the more subjective notion, the notion that is essentially a matter of meeting our own deep standards, or an explication of the more objective notion, the notion that is primarily concerned with what it is that turns true belief into knowledge.

This way of viewing the current situation in epistemology leads me to think of Chisholm's principles very differently from the way in which he himself thinks of them. Although I have qualms about the exact formulations of some of his principles, I also think that most of them have a general aura of plausibility. After all, most roughly expressed, what the principles imply is that in general it is rational for us to trust

memory, perception, introspection, and the like, and of course most of us think that this is sound intellectual advice. On the other hand, there is no absolute assurance that following this advice will result in our being in a position to know much of anything. But if so, Chisholm's principles are not best interpreted as being concerned with a notion of rationality or justification that turns true belief into knowledge.

Once again, skeptical hypotheses can help illustrate this. Imagine a situation in which we rely on our senses in the usual ways but in which the environment has been altered so that we are fooled into having massively mistaken perceptual beliefs. Still, we may have a few true perceptual beliefs. Imagine, for example, that a demon has control over our environment and that red tables are the only midsize physical objects that the demon allows to exist. The demon permits us to perceive these red tables in the normal way, without interference. On the other hand, the demon also manipulates us so that we seem to see many more nonred tables than red ones. In addition, the demon deceives us about most other perceptual matters as well. So, on most occasions our perceptual beliefs are false; even most of our perceptual beliefs about tables are false. Only when we are in the presence of red tables are they true. These few isolated true perceptual beliefs are not particularly good candidates for knowledge. They are not good candidates for knowledge even though, given Chisholm's principles, they may well be evident for us.

This problem cannot be avoided with some minor technical adjustment in Chisholm's system, an adjustment of the sort that might be needed to handle standard Gettier problems, for example. The problem is more basic than this. It is that our perceptual beliefs, and our other beliefs as well for that matter, can meet the requirements of justification laid down by Chisholm's principles even though those beliefs are so massively mistaken that the occasional true belief cannot be regarded as a serious candidate for knowledge.

This is not to say that it is impossible for Chisholm to find a fourth condition that when added to the justified true belief p is sufficient to yield knowledge. But it is to say that any such condition, if it is to be plausible, must somehow rule out the possibility that the belief p is an isolated true belief. To put the matter loosely, and it may be that it cannot be put any other way, the condition must rule out our being massively deceived about related matters. But then, it is not the justification condition that is doing the brunt of the work here. After all, we can be highly justified in believing what we do and yet be nowhere near knowledge. Most of the work is being done by the fourth condition,

since it is the condition, we are assuming, that rules out the possibility of our being massively deceived about related matters.

Points of this sort raise the suspicion that justification in Chisholm's sense may not even be a necessary condition of knowledge, much less one that when combined with truth is nearly sufficient. Of course, there are a number of contemporary epistemologists who have marshaled examples that they think can be used in support of just such a claim. There is the example of the chicken sexer who is somehow able to identify reliably the sex of young chickens, and the example of the boy who when he gets on his rocking horse is somehow able to identify the winners at the local track. The intuition is that in these cases, and in others like them, the individuals have knowledge. Neither we nor they may understand how it is that they come to know what they do, but they nonetheless do somehow manage to have knowledge. On the other hand, there are no assurances, given Chisholm's principles, that the beliefs of these individuals are justified. But if so, being justified in Chisholm's internalist sense is not even a necessary condition of knowledge.

In any event, whatever one thinks of these examples, the main point here is that we can do a perfect job of conforming to Chisholm's principles and yet the resulting beliefs can still be massively mistaken, so mistaken that the isolated few true beliefs are not even in the vicinity of knowledge. Still, as I have said, Chisholm's principles generally do instantiate what most of us would regard as sound intellectual procedures. My proposal, then, is that it is just this that makes it rational for most of us to have beliefs of the sort that the principles recommend. In one important sense of rationality, it is rational to ——— if we have a goal X and if on suitably careful reflection we would think that ——— is an effective way to satisfy X. This applies to our epistemic goals as well our other goals. Thus, it is in general rational for us to have beliefs that conform to Chisholm's principles, because in general Chisholm's principles, or at least something similar to them, reflect our own deep epistemic standards. They reflect our own deep views about how best to reach our primary intellectual end—that is, truth.[5]

So, there is this difference between Chisholm and me about the proper interpretation of his principles. We might come to some kind of agreement about the details of these principles—about how exactly they are to be formulated—but Chisholm will insist on regarding them as necessary truths. As such, he will say that they apply even to people whose reflective, stable views about how to seek truth are quite different from those held by most of us. The principles describe what such people are justified in believing. I disagree. I regard his principles as plausible

generalities. They, or at least something like them, reflect the deep epistemic standards of most of us. Intellectual procedures that conform to Chisholm's principles are procedures that we on reflection would take to be generally reliable. Ultimately it is this that makes it rational for us to have the kind of beliefs that the principles recommend. On the other hand, were there to be people whose stable, reflective views about how to seek truth are very different from ours, then the principles would not describe what it is rational for them to believe. What it would be rational for them to believe would depend upon their deep standards, not ours.

RICHARD FOLEY

FACULTY OF ARTS AND SCIENCES
RUTGERS UNIVERSITY
SEPTEMBER 1995

NOTES

1. Chisholm, "The Problem of the Speckled Hen," *Mind* 51 (1942): 71–79; *Perceiving: A Philosophical Study* (Ithaca, N.Y.: Cornell University Press, 1957); *The Foundations of Knowing* (Minneapolis: University of Minnesota Press, 1982); *Theory of Knowledge* (Englewood Cliffs, N.J.: Prentice-Hall, editions in 1966, 1977, and 1989).

2. See Richard Foley, *Working without a Net* (New York and Oxford: Oxford University Press, 1993).

3. See, for example, Hilary Kornblith, "Introspection and Misdirection," *Australasian Journal of Philosophy* 67 (1989): 410–22.

4. Many contemporary epistemologists also assume this, and none of them has put the matter more straightforwardly than Laurence Bonjour. Bonjour insists that "being epistemically responsible in one's believings, is the core notion of epistemic justification," but he also insists that "the basic role of justification is that of a *means* to truth, a more directly attainable mediating link between our subjective starting point and our objective goal. . . . If epistemic justification were not conducive to truth in this way, if finding epistemically justified beliefs did not substantially increase the likelihood of finding true ones, then epistemic justification would be irrelevant to our main cognitive goal and of dubious worth." *The Structure of Empirical Knowledge* (Cambridge: Harvard University Press, 1985), 7–8.

5. For more details, see Richard Foley, *Working without a Net.*

REPLY TO RICHARD FOLEY

I cannot do justice to Richard Foley's careful study of epistemic principles. He touches upon almost every important question to which such principles may give rise. And *almost* everything that he says about them seems to me to be true.

He is concerned with the modal and normative status of the epistemic principles that I have formulated. Where I have taken truths that are both normative and necessary, he takes them to be non-normative empirical generalizations.

He knows exactly what he is talking about. Indeed he knows more about the various possibilities than I now do. Sometimes, however, he seems to be saying simply: "You should be doing such-and-such instead of doing so-and-so." And he seems to be saying this, not because doing such-and-such would be a more effective way of performing some further function than doing so-and-so would be, but simply because, what seems to me to be intended in an absolute foundational sense, it simply *is* better. And, of course, he cannot make this point without using a normative expression. Thus he concludes by saying:

> On the other hand, were there to be people whose stable, reflective views about how to seek truth are very different from ours, then the principles would not describe what it is rational for them to believe. What it would be rational for them to believe would depend on their deep standards and not ours.

I would ask Foley whether what he is here expressing would be a necessary truth or a contingent truth.

R.M.C.

12

Ernest Sosa

CHISHOLM'S EPISTEMOLOGY AND EPISTEMIC INTERNALISM

Roderick Chisholm's thought "quite properly dominated episte-mology for more than 30 years."[1] Accordingly, his work has been amply discussed by some of the best epistemologists active today. What follows takes up main issues in Chisholm's epistemology by examining recent critiques by Mark Kaplan, Richard Foley, and Alvin Plantinga.

I

One facet of epistemology is the methodology of inquiry, or, more generally, an account of the proper ways to conduct our intellectual lives, in whatever ambit. Methodologists regard methodology as key to what is involved in being justified, "epistemically" justified, when one holds a belief. To their way of thinking, beliefs are justified when they result from the believer's employment of appropriate methods.

Mark Kaplan is an epistemologist very much interested in method-ology, in the conduct of inquiry, which colors his view of the Gettier problem and of epistemology as a whole, in two papers that together constitute a probing critique of the presuppositions and the substance of Chisholm's work in epistemology.[2]

Unlike Chisholm, who has repeatedly proposed solutions for the Gettier problem, Kaplan dismisses that problem as follows, in the first of the two papers cited. (Parenthetical references just below are to that paper.)

(a) Defining knowledge (i.e., propositional knowledge) does not help advance or clarify the proper conduct of inquiry. [This is the main thesis defended in the paper.]

(b) Nor can we see any other practical or intellectual value that would be

well served by defining knowledge and solving the Gettier problem:
we have no good answer to the question of what the solution would
be good for. (363)
(c) So, the project of solving the Gettier problem is "not important."
(350)

On a charitable interpretation, conclusion (c) may be supposed to follow
from premises (a) and (b); and premise (a) may be granted for the sake of
argument (though one might well wonder how an inquiry at the heart of
the first great classic of epistemology gets ruled out from the elite class of
inquiries that can be properly conducted). So we focus on premise (b).
What exactly are we asked to accept here? Is satisfying curiosity a
practical or intellectual desideratum? If it is, then presumably those who
have puzzled over how to define knowledge will after all have a good
answer for Kaplan's question: "Because we want to know what knowl-
edge necessarily involves."

Some want to know what led to the decline of the Mayan civilization,
some the kinship system of the Ik, some the causes of the French
revolution, some the influences on Shakespeare in his creation of
"Hamlet." Consider in fact just about any research project in the
humanities and many in the social sciences. Consider even astronomical
research into the age of the universe, or mathematical research into
Fermat's Last Theorem. What practical or intellectual values might serve
to motivate such inquiries while unavailable to those who want to
understand propositional knowledge? Perhaps some special features set
apart this latter question but, if so, they have yet to be specified.

Activities zestfully pursued by many are prima facie worthy. To
defeat this requires a reason, not just a declaration. Despite its pursuit by
many, astrology is still a waste of time, for example, but there is a specific
reason for that: astrology is based on demonstrably false presupposi-
tions. We are offered no such reason for denigrating the Gettier project.

II

One valuable aspect of Kaplan's work is its emphasis on issues of
methodology, which prompts us to distinguish clearly between method-
ology and epistemology. Methodology concerns intellectual methods,
including those to be followed in the study of theory of knowledge. This
includes even the methods to be used in properly arriving at both
methodology itself and epistemology. Epistemology, on the other hand,

encompasses questions about the nature and extent of knowledge. So epistemology would take up the project of defining knowledge, and it would seek to elucidate the nature of truth and that of belief, since these are necessarily involved in knowledge. In that connection it might also take up questions about the nature of the other conditions, besides true belief, involved in a subject's knowing that p. What is epistemic justification? Is epistemic justification necessary for knowledge? Is it, together with true belief, sufficient for knowledge? If not, what else is required? Must we countenance some other general epistemic status, besides justification, requisite for knowledge? If so, what is the relation between justification and this other status (call it "aptness" of belief)? Are there principles that explain how a belief gets to be justified, what its justification derives from or supervenes upon? Are there principles that explain how a belief gets to be apt? These are all questions of epistemology.

What methodology might one adopt in the study of epistemology? One might be a particularist or one might be a methodist. A particularist begins with assumptions about particular actual or hypothetical cases of justified belief, and tries to derive general principles on that basis. A methodist begins with general principles and derives implications about the extent of our particular knowledge in hypothetical or actual situations. Of course, there could be a mixed strategy as well.

Chisholm is a particularist, and by means of that methodology he reaches principles detailing conditions within which beliefs attain positive epistemic status. Because these principles are complex, and because one can make mistakes on whether a given belief meets the conditions they specify, it has been thought that Chisholm is involved in an incoherence. Particularism requires us to assume that beliefs we initially take to be justified really are justified. But now it turns out that whether or not a belief is justified depends on very complex conditions such that it is no simple matter to determine whether they are satisfied. So, even aided by Chisholm's own theoretical results, we cannot be sure that we have not made mistakes, maybe even a lot of mistakes, in taking beliefs to be justified. How much more liable to mistake must we be when initially, unaided by the theory, we assume, particularistically, that certain of our beliefs are justified.

One might defend against this objection by pointing out that even if beliefs that help launch epistemology—beliefs that certain of our beliefs are justified—turn out to be false, that would have little effect on our endeavor. For we can always shift from actual examples to hypothetical examples. We can argue as follows: "Our actual beliefs initially viewed as

justified were in reality unjustified, because of overlooked features of them, or because we had implicitly attributed to them features that we now can see they lacked. Nevertheless, the hypothetical situation in which someone has beliefs with the combination of features that we had implicitly attributed to our own beliefs is still a hypothetical situation in which the subject is justified in holding those beliefs."

However, that defense must have its limits. Would we be interested in an epistemology with application only to certain hypothetical beings and not at all to ourselves? Besides, why should the complexity of the principles yielded by particularist methodology dampen our confidence that we do well in the initial stages of our inquiry to regard as justified certain beliefs about actual or hypothetical situations? Why should this be any more problematic here than is its apparent correlate in, for example, linguistics? Are grammatical intuitions shaken by the complexity of the grammar to which they lead?

Against Chisholm's methodology and epistemology, one might also object to its apparent presupposition that there is just one sort of "justification" pertinent to knowledge, whereas in reality there are at least two. There is "subjective justification," and there is "objective justification." Being subjectively rational or justified is being safe from one's own internal criticism, whereas the objective rationality or justification of a belief requires rather that it be based on the use of procedures or methods that result in our having knowledge. Traditionally it has been assumed or hoped that a kind of rationality guarantees a link between our subjective states and the truth about external reality, a necessary link between a kind of subjective rationality and an objective counterpart. But evil-demon and brain-in-a-vat scenarios refute that assumption. So we must now decide where to focus our attention. Which sort of justification or rationality will we try to understand: the subjective or the objective?

Some philosophers focus mainly on "subjective" justification: Richard Foley, for example; some on the "objective" variety: Alvin Goldman, say; and others yet pay close attention to both: Alvin Plantinga, for one (though in the end he, too, sides with the objectivists—that is, with those who, without denying that there is some interesting notion of subjective justification, nevertheless focus their attention mostly on more objective varieties). And there are those still willing to assume that the two main sorts of justification, the subjective and the objective, must be bound together in some important way. In any case, Foley suggests how from his own subjectivist standpoint he can accept something very much like Chisholm's principles. This he does in an excellent overview of Chisholm's epistemology. Although there is much to admire in that paper, its

position on Chisholm's principles seems to me problematic. The position has two components, as follows.

> F1 [M]ost roughly expressed, what the principles imply is that in general it is rational for us to trust memory, perception, introspection, and the like, and of course most of us think that this is sound intellectual advice. On the other hand, there is no absolute assurance that following this advice will result in our being in a position to know much of anything. But if so, Chisholm's principles are not best interpreted as being concerned with a notion of rationality or justification that turns true belief into knowledge.[3]

Foley proposes reinterpreting Chisholm's principles in line with his own subjectivism:

> F2 [I]t is in general rational for us to have beliefs that conform to Chisholm's principles, because in general Chisholm's principles, or at least something similar to them, reflect our own deep epistemic standards. They reflect our own deep views about how best to reach our primary intellectual end—that is, truth.[4]

However, F1 and F2 do not sit well together, especially if in our view "there is no assurance" that following Chisholm's advice will give us knowledge—if there is no such "assurance" at least in part because there is no assurance that following such advice will yield true beliefs. If there really is no such assurance then how can we, compatibly with our recognition of that, yet harbor deep views about how best to reach the truth, deep views according to which following Chisholm's advice *will* after all yield true beliefs. Hence there is reason to doubt that Foley can be right both in his critique of Chisholm's epistemology and also in his proposed reinterpretation of it.

III

In the second of his two papers cited, Mark Kaplan extends his critique of contemporary epistemology and this time targets Chisholm for nearly all his critical fire.[5] In this paper Kaplan's argument is twofold. First comes the part in which he argues that Chisholm and other recent epistemologists must be using some "extraordinary" sense of justification. Second there follows the argument that such an "extraordinary" sense must be adrift from any intuitions we could invoke, and that any "theory" of such justification must be little more than arbitrary stipulation. We consider these parts in turn.

What does Kaplan mean by his "ordinary" sense of justification? Here are some relevant passages.

In ordinary contexts, questions about whether one is justified in one's belief
are questions about one's intellectual responsibility in holding the belief,
about one's entitlement to persist in the belief, about the propriety of one's
methodology. (138)

The only source of intuitions concerning justification we have is reflection
upon those canons which govern our day-to-day conduct of inquiry and
criticism. It is to our practice of inquiry and criticism, in contexts both
ordinary and scientific, that we turn in order to arrive at and test our
conceptions of good argument and evidential support. (139)

What anchors our intuitions about the nature of justification as we ordinar-
ily understand it is the role ascriptions of justification play in the conduct of
inquiry and criticism. Questions about justification, as the term is ordinarily
understood, are questions about the propriety of methodological commit-
ments and the propriety of adopting (retaining) the beliefs these commit-
ments sanction. (148)

A justified belief is apparently in this sense a belief that is intellectually
honest, responsible, and proper, one that the believer is entitled to
believe, one that meets the requirements of "methodological hygiene"
(136).

Why then is it that contemporary epistemology cannot be viewed as
trying to elucidate *such* justification, and should be viewed as concerned
only with some "extraordinary" sense. Problems arise for contemporary
epistemologies generally, acccording to Kaplan, if we interpret them as
concerned with such justification; and this applies not only to Chis-
holm's foundationalism but also to coherentism, reliabilism, and even
skepticism. The problems

have their origin in one and the same assumption—an assumption that
Chisholm shares with his coherentist, reliabilist, and even skeptical col-
leagues. The assumption is that, even after our students have satisfied us that
they have done everything that intellectual responsibility and methodologi-
cal hygiene demands of someone who believes that P (in their
circumstances)—that they have met all the challenges that need to be met on
pain of withholding the belief that P—we can still sensibly say to them,
"Yes, yes, but you haven't yet finished saying what (if anything) justifies your
belief that P." The assumption is that there is something more to say. (151)

And what is to be said in support of the foregoing assessment of
"contemporary epistemologies"? Here is the gist of the argument:

[When] we have examined what more is supposed to be left to say, it has
invariably turned out to be something that, read flatly, offends against
uncontroversial tenets of sound methodology and, read with the aid of the
sort of distinction required to prevent the offense, succeeds in so doing only
by employing some sense of justification about which we can claim no
intuitions at all. We could continue our survey of what more there is

supposed to be left to say, in the hope of finding some account that will succeed where foundationalism, coherentism, reliabilism, and skepticism have failed. But there would be no point.

We have already learned that, on pain of losing our intuitive bearings entirely, we have no choice but to read our talk about justification flatly. But, read flatly, we cannot claim that our students have not yet finished saying what (if anything) justifies their belief that p without thereby accusing them of having failed to have done all that methodological hygiene and intellectual honesty demand of someone who believes that P. Thus, once we have conceded that our students have met all legitimate methodological challenges to the propriety of their belief that P, we have conceded that they are finished saying what justifies their belief that P. (152)

Chisholm and other contemporary epistemologists suppose that even after one has met all legitimate methodological challenges to the propriety of one's believing that p, there may still remain a question as to what justifies one's belief that p. And indeed it may then be that, although something does justify your belief that p, nevertheless you are at the moment unable to produce that justification. Moreover, according to such contemporary epistemology, the fact that you are then unable to produce that justification does not mean that your belief is improper or dishonest or unhygienic or that it should be withdrawn. Kaplan is troubled by this because he thinks that it entails an "unacceptable methodological precept," as he tries to show by means of his "Case of the Wild Accusation":

[Imagine] that you are sitting in a doctor's crowded waiting room. The novel you have brought to read while you wait has just become interesting when the man sitting three seats to your left rises, points to you, and declares, in a voice loud enough for all to hear, "This person is a traitor to our country!" Needless to say, you are taken aback. "What, if anything, justifies your belief that I am a traitor?" you ask the man. Your accuser is calm. He explains that, although he recognizes that in accusing you of treason he has made the sort of claim that may well require justification, he cannot at present produce the justification for you. Nonetheless, he continues, he is confident that he is indeed justified in his belief that you are a traitor and, thus, he is confident that, with enough time and effort, an appropriate justification for this belief can be elicited from him. . . .

Something has gone very wrong here. And what seems to be responsible is a methodological precept that your fellow patients have extracted from [passages in Chisholm's *Theory of Knowledge*]—a methodological precept they have taken very much to heart. That precept [call it UMP: the "unacceptable methodological precept"] holds that, even if you are very confident that a belief you harbor may stand in need of justification, your inability to produce a satisfactory justification need not undermine your entitlement to persist in that belief. So long as you are confident in the propriety of the belief, you are entitled to believe that, only given enough

time and energy, you could elicit an appropriate justification for the belief. That is, you are entitled to believe that your inability to produce such a justification, either now or in the foreseeable future, is of no methodological concern. (135–36)

> To repeat: UMP *Even if you are very confident that a belief you harbor may stand in need of justification, your inability to produce a satisfactory justification need not undermine your entitlement to persist in that belief.*

Why is contemporary epistemology committed to UMP? Because of the particularist way in which it tries to derive general principles of justification from particular instances of beliefs that seem to us justified even though the believer has not provided any justification and perhaps *could* not provide such justification, at least not without Socratic questioning. Contemporary epistemology seems committed to holding that the believer is then justified, intellectually honest, etc., and is entitled to his belief even though (a) there is something in virtue of which the believer is justified, but (b) the believer could not say what it is without the aid of Socratic reflection.

Note, however, to begin with, that UMP comes in two degrees of strength: (weak) UMP-w and (strong) UMP-s. UMP-s claims that *every* justified belief is as described by UMP above, whereas UMP-w claims only that *some* justified beliefs are as thus characterized. Contemporary epistemology is clearly committed *at most* to UMP-w or some modestly strengthened version of that. It is certainly not committed to anything as strong as UMP-s. Yes, UMP-s would seem highly questionable in the light of the Case of the Wild Accusation. Given that contemporary epistemology is not generally committed to UMP-s, however, that is of doubtful relevance. Absent that commitment, moreover, the case described opposes only an epistemology committed to the accuser's being justified *specifically in a belief such as the one featured in the case,* despite lacking any ability to adduce reasons in its behalf. While prepared to be surprised, I can think of no contemporary epistemology that allows a believer justification for beliefs like that of the Wild Accuser even in the absence of any rational basis. (At least a rational basis would be required at some stage of the life of the belief, though memory might preserve justification at later stages even after the earlier justifying basis is lost.) Chisholm's epistemology is no exception.[6]

In any case, we can bypass much of that controversy by just echoing talk of "entitlement to believe," or "responsible belief," or, for short, "proper belief." As we are given to understand (in the passages cited above):

(K) One is entitled to one's belief that p, and that belief is a proper belief if one meets all legitimate challenges to it.

But here we must ask: *Which* legitimate challenges must be met? Ones that are actually made, or also ones that *could* be made? The former answer is too weak, since many of one's beliefs might go unchallenged only because unspoken. So we turn to challenges that *could* be made.[7] And now presumably we may reach beliefs to which there would be *no* legitimate challenges: perhaps the belief that one has a headache or even the belief that there is a hand before one. This is in agreement with "philosophers of pragmatic and/or Austinian and/or Wittgensteinian bent who had argued that asking someone for the justification of an everyday perceptual belief is perverse and/or an abuse of language" (153).

Let us hence consider this claim of PAW philosophers (those of pragmatic and/or Austinian and/or Wittgensteinian bent):

(PAW-C) If B is an everyday perceptual belief, then it would be perverse (illegitimate, wrong, bad) to challenge it.

A lemma follows from that:

(PAW-L) If B is an everyday perceptual belief, then there are no legitimate challenges to it.

And from K and PAW-L, we may derive:

If B is an everyday perceptual belief, then the believer is entitled to that belief B, and it is a proper belief.

Or, put another way:

(PAW-P) If B is an everyday perceptual belief, then the believer is justified in that belief B.

Note well: such a belief B is not justified by certain further beliefs that the believer appeals to in answer to legitimate challenges. There are no such challenges! And yet consider again the ordinary concept used by Kaplan—the concept of proper, intellectually honest belief to which the believer is entitled. In that sense the holder of such an everyday perceptual belief B might properly be said to be still "justified" in that belief. Is there room for a question, posed to such a believer, as follows: "What justifies your belief B?" What do PAW philosophers have to say about this?

What is it about everyday perceptual beliefs that renders them safe from legitimate challenge? Is there some other feature, besides their

being everyday perceptual beliefs, that secures them against such challenge? What might this feature be? Can it be just contingently correlated with the feature of being an everyday perceptual belief? In any case, even if there is such a feature, does its securing such beliefs preclude the possibility that their feature of being everyday perceptual beliefs *also* secures them? Given PAW-P, isn't an everyday perceptual belief B justified *because* it is an everyday perceptual belief? Isn't it *this* that explains to us why that belief is justified, why there are no legitimate challenges to it? Isn't B then justified in virtue of *being* an everyday perceptual belief? And isn't it good English usage to put this by saying that what *justifies* B is precisely that it *is* an everyday perceptual belief?[8]

If so, then PAW philosophers like Kaplan *do* after all think that a question can sensibly remain even after one has met all the challenges that need to be met on pain of one's withholding one's belief that p. Even then, it can still be asked what justifies one's belief that p. And there is after all something additional to say, and, what is more, PAW philosophers are quite willing to say it, as is shown by their PAW-P.[9]

<center>IV</center>

What then is the nature of epistemic justification that it can derive from factors other than the meeting of epistemic challenges? What does it take for a belief to be epistemically justified? What sort of status does a belief have in being epistemically justified? Important in contemporary epistemology, these are main questions posed by Alvin Plantinga in his penetrating three-chapter discussion of Chisholm's epistemology.[10] What follows first presents the core results of that discussion, which it then examines critically.

A. Chisholm Interpreted, Internalism Defined—Plantinga's Way

1. From p. 19 of *Warrant: The Current Debate:*

> According to Locke and Descartes, epistemic justification is *deontological* justification. And here they are clearly thinking of *subjective* duty or obligation; they are thinking of guilt and innocence, blame and blamelessness. If I do not have certainty but believe anyway, says Descartes, "I do not escape the blame of misusing my freedom." Locke, clearly enough, is also thinking of subjective duty ("This at least is certain, that he must be accountable for whatever mistakes he runs into"). But then the first internalist motif follows immediately:

M1. *Epistemic justification (that is, subjective epistemic justification, being such that I am not blameworthy) is entirely up to me and within my power.*

All that is required is that I do my subjective duty, act in such a way that I am blameless. All I have to do is my duty; and, given that ought implies can, I am guaranteed to be able to do that. So justification is entirely within my power; whether or not my beliefs are justified is up to me, within my control.

2. From p. 20:

[There is a] . . . second internalist motif:

M2. *For a large, important, and basic class of objective epistemic duties, objective and subjective duty coincide; what you objectively ought to do matches that which is such that if you don't do it, you are guilty and blameworthy.*

And the link is provided by our nature: in a large and important class of cases, a properly functioning human being can simply see whether a given belief is or is not (objectively) justified for him.

3. From pp. 20–22:

The second internalist motif has three corollaries.

First: if it is your subjective duty to regulate your belief in this way, then you must be able to see or tell that regulating belief this way is indeed your duty. . . .

C1. *In a large and important set of cases, a properly functioning human being can simply see (cannot make a nonculpable mistake about) what objective epistemic duty requires.*

To grasp the second corollary, we must note first that (according to both Descartes and Locke) I do not determine *directly,* so to speak, what it is that I am obliged to believe and withhold. . . . I have a way of determining when a belief is justified for me; to use a medieval expression, I have a *ratio cognoscendi* for whether a belief is justified for me. . . . So the second corollary:

C2. *In a large and important class of cases a properly functioning human being can simply see (cannot make a nonculpable mistake about) whether a proposition has the property by means of which she tells whether a proposition is justified for her.*

[For Descartes and Locke] . . . the ground of justification (the justification-making property) is identical with the property by which we determine whether a belief has justification: *ratio cognoscendi* coincides with *ratio essendi.* (This is not, of course, inevitable; in the case of measles, velocity, blood pressure, weight, and serum cholesterol our *ratio cognoscendi* does not coincide with the *ratio essendi.*) . . . So the third collorary:

C3. *In a large, important, and basic class of epistemic cases a properly functioning human being can simply see (cannot make a nonculpable mistake about) whether a proposition has the property that confers justification upon it for her.*

4. From pp. 22–23:

There is still another and somewhat less well defined internalist motif here. According to Locke and Descartes, I have a sort of guaranteed access to whether a belief is justified for me and also to what makes it justified for me: I cannot (if I suffer from no cognitive deficiency) nonculpably but mistakenly believe that a belief is justified or has the justification-making property. This is the source of another internalist motif; for it is only certain of my states and properties to which it is at all plausible to think that I have that sort of access. . . . These states are the ones such that it is plausible to hold of them that I cannot make a nonculpable mistake as to whether I exhibit them. But they are also, in some recognizable, if hard to define sense, internal to me as a knower or a cognizing being. Thinking of justification in the deontological way characteristic of classical internalism induces *epistemic* internalism: and that in turn induces internalism of this different but related sort [which he calls 'personal'].

5. From pp. 32–34:

Chisholm endorses a fundamental intuition of the classical internalist tradition: there are epistemic duties; and justification, being justified in one's beliefs, is the state of forming and holding beliefs in accord with those duties. Here Chisholm endorses, at least by implication, the First Internalist Motif. . . . The basic idea . . . is that our epistemic duty or requirement is to try to achieve and maintain a certain condition—call it 'epistemic excellence'—which may be hard to specify in detail, but consists fundamentally in standing in an appropriate relation to truth. . . .

So my obligation is to try to achieve epistemic excellence, and the way to do so is to act on what I believe is the way to achieve that state. But then the Second Internalist Motif and its corollaries . . . are also satisfied. The ground of warrant, that which confers warrant upon a proposition for me, is the aptness for fulfilling epistemic duty of my accepting that proposition. But in the typical case the degree of that aptness will depend upon the degree to which the proposition in question seems to me to be true; and that is something to which I have a sort of guaranteed access. Thus C2 . . . is satisfied. But so is C3. . . . For what is my *ratio cognoscendi* here; how do I tell whether a given proposition is such that accepting it will contribute substantially to the fulfillment of duty to try to achieve epistemic excellence? Well, one way would be by determining how much or how strongly it seems to me to be true. The more strongly the proposition in question seems to me to be true, the more apt accepting it is for fulfillment of my epistemic duty. *Ratio essendi* and *ratio cognoscendi,* therefore, coincide. And of course the third motif is also exemplified: for *trying to do something or other is* surely in an important and recognizable (if hard to define) sense internal.

B. Critique of Plantinga on Chisholm and Internalism

1. Plantinga argues that deontology, (epistemic) justification, and internalism are closely connected, and that we can understand Chisholm's internalism if we are clear on the connections.

 a. By 'internalism' he means mostly 'epistemic internalism', i.e., the view that we have special epistemic access to the epistemic status of our beliefs (or at least to the status of being justified). And the special access he (and Chisholm) seem to have in mind is access by means of unaided armchair reflection.
 b. According to the deontological view of epistemic justification, such justification consists in an appropriate relation to one's epistemic obligations or duties. Thus (as emerges from Plantinga's two "internalist motifs"):
 D. One is epistemically justified (and one is not blameworthy) in ϕ'ing if and only if in ϕ'ing one does one's epistemic duty—or, at least, that is so for a large, important, and basic class of epistemic duties.

2. According to Plantinga, for a correspondingly large, etc., class of cases where one adopts a belief, one is justified in believing as one does iff one does one's duty. Thus, in such cases one is culpable, blameworthy, iff one fails to do one's duty. And this implies, on plausible assumptions, that for such a class of cases (as emerges from his three "corollaries"):

 a. One cannot make a nonculpable mistake about what one's duty requires with regard to the relevant belief options.
 b. One cannot make a nonculpable mistake about whether a belief option has the property by means of which one can tell whether it is a justified option (the *ratio cognoscendi*).
 c. One cannot make a nonculpable mistake about whether a belief option has the property that makes it a justified option (the *ratio essendi*).

Moreover, if the foregoing is right, we are told, it "induces" not only epistemic internalism, but also "personal" internalism: namely, the view that the justification-making properties will be constituted by states that are "in some recognizable, if hard to define sense, internal to" the believer.

According to Plantinga, then, if Chisholm means such *deontological* justification when he speaks of 'epistemic justification' and of other such epistemic statuses, then we can understand thereby his commitment to internalism, to the idea that we must have special access, by pure reflection, to the justification of our beliefs. And Plantinga adduces strong textual evidence that Chisholm does view epistemic justification as something very much like our deontological justification.[11]

3. In order to distinguish among three grades of justification, we define first two preliminary concepts:

 a. In φ'ing, S *abides by* an objective duty iff given S's circumstances and past, S ought to φ and S does φ.
 b. In φ'ing, S *violates* an objective duty iff in φ'ing S *culpably* fails to abide by an objective duty.

Here now are the three grades:

 c. S is *justified₁* (justified to the first degree) in φ'ing iff in φ'ing S does not violate an objective duty.
 d. S is *justified₂* (justified to the second degree) in φ'ing iff in φ'ing S is justified₁, and S then has a choice on whether to φ; that is, whether to φ or not is then within S's control.
 e. S is *justified₃* (justified to the third degree) in φ'ing iff in φ'ing S abides by an objective duty through a knowledgeable choice or at least through a choice based on a correct belief as to what one ought then to do (which implies that S then *has* a choice on whether or not to φ, and implies also that in φ'ing S is justified₂).

4. People might now in various ways *nonculpably* fail to abide by their epistemic duty. This might happen, for example, because (a) they cannot help believing that p, (b) nor could they earlier have helped getting into a situation where they would now be unable to help believing that p, while yet (c) in believing that p they are not abiding by any duty; nor, given their lack of choice, are they *culpably* failing to abide by any duty.[12] Consequently they are not *violating* any duty, and hence they are justified to the first degree in believing that p. Circumstances might make inevitable someone's believing something epistemically crazy, in which case they would be justified to the first degree in their (crazy) belief.

 However, people cannot be justified to the second degree in that way. In order to be justified to this higher degree in φ'ing, φ'ing must be within your control. How might someone be justified to the second degree in believing something? Consider first a second way in which someone might be justified to the first degree in believing something epistemically very questionable: namely, through nonculpably failing to realize what their epistemic duty then requires. It might still be up to them whether they believe that p or not; it might be a matter within their control and subject to choice. Yet they might nonculpably do the wrong thing simply through nonculpable failure to identify the right choice in the circumstances. And this is a way in which people might be justified not only to the first degree, but to the second degree as well. People might thus be justified both to the first and also to the second degree in believing something even though they neither know

nor even believe correctly that they are so justified. Hence neither of *these* grades of epistemic justification will yield epistemic internalism.

Recall the deontologism identified by Plantinga:

D. One is epistemically justified (and one is not blameworthy) in φ'ing if and only if in φ'ing one does one's epistemic duty—or, at least, that is so for a large, important, and basic class of epistemic duties.

It is only if we interpret 'epistemic justification' here as justification to the *third* degree that D is most plausible and that the corollaries (2a)–(2c) can be derived most plausibly. Alternatively we can restrict the class of beliefs and/or believers involved so as to rule out the possibility of failure of control over what one believes and the possibility of failure of knowledge or correct belief as to what one ought to believe and as to what one would be justified in believing. For that restricted class of cases, as soon as one has justification to the lowest degree, one has it also for each of the higher degrees.

5. But where's the *internalism?* Even if we grant (2a), for example, how do we arrive at the result that when one knows what one's duty requires, and when one believes correctly (without mistake) what one's duty requires, one knows this *by reflection,* or in any such "internalist" way?

One might appeal here to the intuition that the evil demon's victim would be as well justified as we are, and indeed to the intuition that the solipsist heroine might be equally justified in the absence of any demon's intervention—there being no demon—and indeed in the absence of any externalia whatever. Our heroine must be justified in virtue of properties *internal* to her, or so it might be argued. And since for any actual flesh and blood thinker there is such a corresponding demon's victim or solipsist heroine, indistinguishable in all internal respects, therefore the justification of actual people must also derive from properties of theirs that are *internal* to them.

So, if (2a)–(2c) still apply to our victim or heroine, as they may well be meant to apply, then she must know about her own justification, and about its sources, on the basis of knowledge of properties that she has *internally.* That's fine, but still: how do we get that this knowledge must be *by reflection?* Well, what does 'by reflection' (or 'by armchair thought') mean? It usually means approximately the following: "by some combination of introspection and memory, along with intuitive and inferential reason." But how do we know that the solipsist heroine would know about her own justification and its sources by means of *such* faculties only? Actually, on reflection, this

seems less than serious for our internalist, since he might just define reflection as "cognitive processes involving only a priori thought, along with introspective knowledge of one's own internal properties, aided by memory and reason."

More problematic for Plantinga is the fact that this line of reasoning, from a deontological conception of epistemic justification to an epistemic internalism, makes essential use of an *assumption* of personal internalism. This line of reasoning *assumes* that the solipsist heroine would be no less justified than her flesh and blood counterpart, and that the justification of the heroine would (of course) derive at most from her internal properties. It is only on the basis of that assumption that we are able to invoke the (2a)–(2c) corollaries of the deontological conception and derive from them a doctrine of epistemic internalism: the doctrine that one could always know *by reflection* how things stand with regard to one's own epistemic justification. On this line of reasoning, therefore, one could *not* just start with a deontological conception of epistemic justification, and derive *both* epistemic internalism *and* personal internalism from that. On the contrary, it is only by first assuming personal internalism that one can go on to derive epistemic internalism from the view of epistemic justification as deontological.[13]

6. Moreover, the conception of epistemic justification as deontological has certain further limitations that emerge more clearly in light of the fact that it amounts to a notion of justification *in the third degree.* Plantinga sets up things somewhat differently, but this is the upshot anyhow. Plantinga delimits the scope of his claim that epistemic justification is subject to the three corollaries, (2a)–(2c). He delimits the scope of that claim to a "wide and important class of cases"—in effect cases in which the subject is functioning properly, which means: (a) that he is knowledgeable enough about the particulars of his situation and about the abstract requirements of epistemic duty, and (b) that he is smart and alert enough that he can put that knowledge to use appropriately in determining what epistemic duties are in fact binding on him at the time, as to whether he is to accept the belief in question or not.

However, few would deny that if we delimit thus the class of relevant cases, then in *any such case* the subject will be justified only if he knows that he is justified. What is more, consider the large and important class of cases where epistemologists generally would agree that one would be equally justified in solipsistic isolation. Epistemologists would agree generally that, in any such case, one's knowledge or

awareness of one's own justification will be internalistic, by reflection. Most epistemologists, of whatever persuasion, externalist or not, will surely grant that for a large and important class of cases, what Plantinga claims on behalf of the internalist is likely to be true. Take any case where one knows something or one is epistemically justified in believing something purely on the basis of reflection. Many epistemologists, externalist or not, will agree that in any such case one can know internalistically, by reflection, that one's belief has its positive epistemic status. Real disagreement will begin to arise over cases where one's knowledge is perceptual or depends essentially on perceptual knowledge. Of course, even here one might argue that one must be able to know or believe correctly, simply on the basis of reflection, that one's belief is justified, but now the argument will have to rely on an independent claim that *personal internalism is* true; or so it was argued above.

7. The conception of epistemic justification as deontological is subject, therefore, to some serious limitations. Moreover, there are further important limitations of that conception. The problem is not so much that there isn't such a notion, nor is it that its scope is too narrow, given our very limited control over what we believe. These are problems, I believe, but they are not the main problems I wish to highlight. My main problem is rather that of whether this notion of "epistemic justification" captures an epistemic status of primary interest to epistemology, *even to "internalists" generally.* Don't we fall short in our effort to throw light on internalist epistemic justification if we stop with the explicated deontological justification in the third degree? After all, there are other desirable statuses for our beliefs to attain. Thus it is good that one's beliefs not derive from a deliberate effort on one's part to believe what is false, from a sort of "epistemic masochism." And it is a good thing that one's beliefs not derive from uncaring negligence. These are moreover sorts of things that one could know about the derivation of one's beliefs on the basis of armchair reflection. So one could secure epistemic internalism by defining a sort of internalist "epistemic justification," even without invoking the full deontological machinery. But surely we would then fall short in our attempt to throw light on matters epistemic. Avoiding epistemic masochism and uncaring negligence are only two of the things involved in epistemic excellence. And a similar question could now be pressed against the deontologist: In opting for a deontological conception of epistemic justification, are we capturing all relevant aspects of "internal" epistemic excellence that we wish to illuminate?

Or are we falling short in ways analogous to the ways in which we fall short if we stop with mere masochism-avoidance or negligence-avoidance conceptions of justification?

8. Let us focus on epistemic justification of the third degree—the sort of epistemic justification used by Plantinga to defend deontologism as a route to epistemic internalism. If we focus on the content of epistemic justification to that degree, I believe we can see that it will inevitably miss respects of epistemic excellence, of internal epistemic excellence.

 a. Consider our correct beliefs about what duty requires in various circumstances, and our correct beliefs about the particulars of our own situation in terms of which we would need to determine our epistemic duties in that concrete situation. Presumably, these beliefs are also assessable as epistemically justified or not. What is more, one could hardly attain deontological *epistemic* justification if the duty-specifying beliefs that govern one's epistemic choice are wholly *unjustified*. So there must be an assumption that these beliefs are epistemically justified in some sense. But, on pain of vicious circularity, the sense involved cannot be that of deontological epistemic justification.

 b. Secondly, what are we to say of beliefs that do *not* result from a knowledgeable choice on the part of the believer? Take, moreover, beliefs that one is in no way responsible for and could not have avoided, *or* could not have known to be wrong beliefs to hold in the circumstances, so that one bears no responsibility for lack of pertinent control *or* lack of pertinent knowledge or correct belief as to one's choice of cognitive attitude. This could presumably happen even with wholly internal beliefs that are introspective or reflective and independent of perception. If we restrict ourselves to justification in the third degree as our only conception of epistemic justification, then all such beliefs turn out to be indistinguishable in respect of epistemic justification—they are all equally unjustified. But can there be no difference in relevant epistemic status between the following two classes of beliefs? Consider, *on one hand:*

C1 The belief that $1 + 1 = 2$, or the belief of someone with an excruciating headache that she suffers a headache, beliefs which presumably one cannot help having—and the great class of such obvious, nonoptional beliefs;

and, *on the other hand:*

C2 The convictions of the victim of a cult who has been brainwashed; or the beliefs of a *naif* with a crude conception of what justification requires in a certain ambit, who acquires his beliefs in ways that he is convinced are methodologically sound, simply because he was raised in a culture where such ways are instilled, so that now, through no fault of his own, our *naif* does not properly know what to believe and what not to believe in that ambit.

These two classes of belief can hardly count equally as beliefs internally unjustified in any sense of much importance for episte-mology. Clearly, we must go beyond the concept of deontological justification in the third degree, if we wish to explicate the fact that the beliefs in C1 are internally justified while those in C2 are not. The claim *is not* that there is *no* sense in which both sets of beliefs are on a par in respect of internal justification: indeed, *both* do fail to be "deontologically justified in the third degree," and that does seem an understandable sense of internal justification. The claim is *rather* that there is likely some further important sense of internal justification that remains uncaptured by the notion of deontological justification in the third degree. With this notion we fall short, in a way in which we would fall short in our effort to explicate internal justification if we were to stop with just the notion of belief non-negligently acquired and sustained. The broader notion of internal justification would perhaps need to take account both of the avoidance of negligence and of the securing of deontological justification in the third degree—these would both be relevant, in different ways, to internal epistemic justification. But, as we have seen, the broader notion would need to go further. The contours of that broader notion have yet to be traced.[14] Nevertheless, to the extent that we find it plausible that in some sense the beliefs in C1 are internally justified while those in C2 are not, we should be willing to hold open the possibility, worth exploring, that there is such a broader notion, even if its contours remain indistinct.[15]

Chisholm's epistemology (as developed by Plantinga) thus an-swers some questions while leaving others open for further reflection. This is not something Chisholm would hide. He would instead pick up some chalk and invite us to join him.[16]

ERNEST SOSA

DEPARTMENT OF PHILOSOPHY
BROWN UNIVERSITY
DECEMBER 1995

NOTES

1. Alvin Plantinga, "Justification in the Twentieth Century," *Philosophy and Phenomenological Research* 50 (1990): 760.
2. Mark Kaplan, "It's Not What You Know that Counts," *Journal of*

Philosophy 82 (1985): 350–63; and "Epistemology on Holiday," *Journal of Philosophy* 88 (1991): 132–54.

3. Richard Foley, "Chisholm's Epistemic Principles," this volume: 261.

4. Ibid., 263.

5. Mark Kaplan, "Epistemology on Holiday"; parenthetical references in the present section are to this paper.

6. A further distinction is required in assessing Kaplan's case, though we shall not pause here to consider fully all of its relevant implications. I mean the distinction between the requirements for intellectually responsible *dialogue* and the requirements for justified *belief*. The latter can of course remain in *foro interno*, where dialogic requirements are not in play.

7. And for present purposes we can ignore the fact that it is obviously too much to require that the believer actually meet all challenges that could be made, even those that are not in fact made. The issues we go on to discuss now will remain no matter how we resolve this problem, which is why we can allow ourselves to ignore it for now.

8. Moreover, even if it is not their being everyday perceptual beliefs that secures such beliefs against legitimate challenges, even if some other features are at work, it remains that these other features will presumably, again in an acceptable sense, "justify" such beliefs—that is, in the sense of constituting sufficient conditions that serve as a sufficient source of their status of being epistemically justified.

9. Whether PAW-P is true and acceptable is another matter: one that requires, precisely, epistemology beyond methodology.

10. Alvin Plantinga, *Warrant: The Current Debate* (Oxford: Oxford University Press, 1993), chaps. 1–3. The discussion to follow overlaps my "Plantinga on Epistemic Internalism," in J.L. Kvanvig (ed.), *Warrant in Contemporary Epistemology* (Lanham, MD: Rowman & Littlefield, 1996).

11. Plantinga also alleges that Chisholm's epistemic principles are then deeply flawed and do not come close to explaining how we attain epistemic justification in our beliefs. Here we shall not enter that issue, which Plantinga raises as follows. Consider the sort of principle that involves self-presenting properties. When one attributes such a property to oneself, according to one of Chisholm's principles we are thereby very highly justified. But, argues Plantinga, how can this be so if, by Chisholm's own account, self-presenting properties are properties that one cannot possibly fail to attribute to oneself as soon as one has them? What Chisholm proposes about the beliefs in question then seems as implausible as it would be to suppose that once one jumps off a cliff, one then fulfills certain duties by obeying the law of gravity. On the contrary, says Plantinga, once in free fall, whether one continues to fall or not is not something that could possibly lie within the scope of any duties. One then cannot help falling, and the question of duty simply does not arise, and there is no conceivable duty that could then be requiring one to continue to fall. Absent any real choice, there can be no such duty.

12. Recall Plantinga's observation: Once in free fall, whether one continues to fall or not is not something that could possibly fall within the scope of any duties. One then cannot help falling, and the question of duty simply does not arise, and there is no conceivable duty that could then be requiring one to continue to fall. Absent any real choice, there can be no such duty.

13. Actually, it is not ruled out that personal internalism receive some independent support; the important point is that, so far as we have been able to

determine, it seems needed as a prior premise for any argument we have been able to devise that moves from deontologism of justification to epistemic internalism.

14. Some suggestions towards this project may be found in chapters 8 and 16 of my *Knowledge in Perspective* (Cambridge: Cambridge University Press, 1991).

15. These other issues in Chisholm's philosophy were discussed in a seminar at Brown, "The Philosophy of Roderick M. Chisholm," that I offered jointly with Jaegwon Kim in 1994–95. My warm thanks to Kim, and also to the members of the seminar, among whom I mention especially Matt McGrath, Brie Gertler, and Jason Kawall.

16. I have often accepted his invitation, in our many years as close colleagues, with rich rewards. I have learned more from him than from anyone else.

REPLY TO ERNEST SOSA

What I now can say about epistemology is due in large part to an extraordinary number of devastating counterexamples which Sosa has directed upon my attempts to deal with its problems. He is far more gentle in "Chisholm's Epistemology and Epistemic Internalism."

In order to describe the place of my writings in contemporary epistemology, he contrasts my views with those of three distinguished epistemologists. The contrast sometimes involves, not only different solutions, but also different problems. I would not presume to suggest to another philosopher that that philosopher discuss the problems I discuss rather than discuss the problems that he or she discusses.

I shall discuss two related questions together. May the several senses of justification be reduced to a single sense? And in what respect must our access to such justification be external?

The fundamental problem that I have been concerned with is that of answering the Socratic question, "What can I know?" More specifically: "As a rational being, what can I do to correct and to improve my present set of beliefs and to replace them with a more reasonable set of beliefs about the same subject matter?" As a rational being, I presuppose a certain faith in myself—a faith in my ability to solve such problems.

It is impossible to set about to answer these questions unless one has some idea of what the questions are. Moreover, one must know what *justification* is. Consider the following example, adapted from one suggested by Roderick Firth.

I find that the doctor who is assigned to me in the emergency ward does not satisfy my criteria of medical competence, but I cannot alter the situation and I know that hope for recovery depends upon believing that the doctor is competent. Is my duty to believe that he is competent a different type of duty from that of accepting the standards of medical competence I had arrived at earlier?

One can begin to deal with these philosophical questions only by making use of such access as one has to oneself. There is no *external* authority or source of knowledge with which one *can* begin. How is one to know when one has access to such a source of knowledge?

The following, then, is what I would say.

There are several types of requirement. For example, there are the requirements of *etiquette*, or *good manners*—what Thomas Hobbes called "Small Moralls." If the hostess is discoursing, perhaps the social situation requires that you not interrupt her. But this requirement is easily overridden; it is overridden if you see that the house is on fire.

There are also *aesthetic* requirements. Aesthetic considerations may require that, if the painter puts colors of one sort here, then he put colors of another sort there. He shouldn't put a red circle, say, on a purely orange background. But such a requirement is easily overridden. It is overridden if the painter is hastily painting an exit-sign so that the guests can escape from the fire in the safest possible way. Aesthetic duties may be overridden by nonaesthetic considerations, just as epistemic duties may be overridden by nonepistemic considerations.

The distinguishing feature of *ethical* duty is not to be found in the considerations that impose that duty. Rather, an ethical duty is simply a requirement that is not overridden by any *other* requirement.

If I am subject to a requirement of etiquette—of Small Moralls—and if nothing overrides this requirement, then doing what I am thus required to do is my *duty*, my "*absolute ethical duty*." So, too, for the requirements of aesthetics. And so, too, for epistemic requirements— the requirements of reasonable belief. In Firth's example, the patient is epistemically required to believe that the doctor is *not* competent. He is absolutely required to believe that the doctor *is* competent. Hence this is his absolute duty.

R.M.C.

13

Maria van der Schaar

JUDGMENT AND NEGATION

Introduction

The first question one should ask when speaking about negative judgments is: Are negative judgments possible at all? The second question is: Is there a real distinction between negative and positive judgments? Unless both questions can be answered in the affirmative, the question, What is a negative judgment? is not a real question. The most famous negative answer to the first question is that of Parmenides: he denies the possibility of negative judgments. According to Parmenides, we cannot say or know what is not. His thesis appears to be contradicted not only by ordinary judgments, such as 'Theaetetus is not flying', but also by the formulation of the thesis itself. How can we express it without using any form of negation? There are several ways to solve this paradox: either we say that on those occasions when we seem to pass a negative judgment, we are in fact doing something else, that is, we reduce the concept of *negation* to some other notion; or we take *negation* seriously, that is, as an irreducible notion. If it is conceded that negative judgments are possible, we have to answer the second question: Are we able to give a criterion to distinguish negative from positive judgments?

In this paper I want to show that Chisholm has put forward some important, either original or forgotten, theses concerning negative judgments. Chisholm's theory of judgment, that is to a certain extent influenced by Brentano's philosophy, gives a criterion to distinguish negative from positive judgments and gives sense to such a distinction. This is possible in so far as the fundamental notions in Chisholm's theory, such as *proposition* and *state of affairs*, are defined by intentional notions, such as *a thinking* or *judging person*.

In section 1, I distinguish several senses that might be given to the term 'negative judgment'. Because the term is ambiguous, the theses that philosophers have defended concerning 'negative judgment' seem to be

incompatible. The moment we see that they speak about different things, we see that those theses are not necessarily incompatible.

1. DIFFERENT SENSES OF THE TERM 'NEGATIVE JUDGMENT'

Is there a way to make sense of the idea that there are no negative judgments at all; that is, of the Parmenidean idea that we cannot say or know what is not? This question should be dealt with together with Parmenides' thesis that *knowledge* and *being*, or *truth* and *being*, are one. Although there is a sense of 'truth' such that we have to concede that there are both truths and falsehoods, there is also a notion of truth or being which makes the distinction between true and false propositions possible. This notion of truth cannot itself be a property of propositions; therefore, it cannot be said to have a counterpart in there somehow being nonbeing or that which is not. On this level there is neither falsehood nor negation.

The notion of *negative judgment* has an important place in the traditional theory of judgment. For example, in Locke's *An Essay Concerning Human Understanding* (bk. 4, chap. 5) a mental proposition, that is, a complete judgment, is conceived of as a joining or separating of mental signs, that is, of ideas—a separating of ideas being a negative judgment. This idea has a long history stretching back to the famous passage in Aristotle's *De Interpretatione*, where a negation is defined as a statement denying something of something (17a25). A central question when we consider the notion of *negative judgment* is whether such a notion makes sense in any other theory of judgment; if not, the question whether the traditional theory of judgment still makes sense becomes relevant.

An important distinction, which is not clearly present in this traditional theory of judgment, is that between a subjective act of judgment or attitude of belief, on the one hand, and a judged content (Bolzano, Frege) or judged object (Brentano), on the other hand. Given this distinction, we are able to distinguish two different meanings of 'negative judgment': a judgment in which the judged content is negative, to be dealt with below, and a negative judgmental act or negative belief-state. There is another ambiguity in so far as a negative judgmental act and a negative belief-state are not to be identified, as is argued by Reinach. According to him, there are special states of negative conviction or disbelief. In contrast to this, a negative judgmental act is nothing but the affirmation of a negative content. Positive and negative judgmental acts do not differ on the act-side (TNU, 134). According to Reinach, a negative conviction

of something positive and a positive conviction of its contradictory are different, not only from a psychological point of view in so far as the acts are different, and from an ontological point of view in so far as the objective contents differ, but also from an epistemological point of view (TNU, 109 ff., 122–95). A negative conviction, for example 'This is not yellow', has its ground in a so-called 'negative evidence', which is dependent upon the being evident to us of a state of affairs, say, *that this is red*, which stands in conflict with the one that is disbelieved, that this is yellow. Whereas a positive conviction can be got by 'reading off' a state of affairs, a negative conviction of a state of affairs presupposes some other attitude, such as doubting or questioning, towards that state of affairs. To summarize, Reinach rejects the distinction between positive and negative in so far as momentaneous acts of judgment are concerned, but he believes such a distinction to be relevant when we consider states or attitudes.

In Brentano's theory of judgment there is not such a clear distinction between states and acts as in Reinach's writings. I think that when Brentano is speaking about judgments he mainly has judgmental acts in mind. For Brentano, there are two types of such judgmental acts: to accept *(Anerkennen)* and to reject *(Verwerfen)*. To judge that God exists is to accept God; to judge that God does not exist is to reject God. For Brentano all basic judgments are of such existential forms. In the case of more complex judgments like 'God is almighty', Brentano says that we accept a complex object, the almighty God. Later, Brentano acknowledges the existence of so-called *double judgments*. In a judgment like the one just mentioned we first accept God, and then affirm of him that he is almighty. Here a new type of judgment is acknowledged, that of affirming something of something else *(Zusprechen)*. This act of affirming also has a negative counterpart, denying something of something *(Absprechen)*. In judging 'God does not know everything in advance' one accepts God and denies of him having foreknowledge. Any affirming or denying something of something is dependent upon an act of accepting: we cannot affirm or deny something of something unless we have acknowledged the existence of the latter.

Frege argues more vehemently against the traditional theory of judgment than Brentano. He says that it is not useful to have a theory in which there is a type of acts of denial besides one of acts of affirmation. The judgment that there are centaurs and the judgment that there are no centaurs have something in common. In both cases we hold something to be true; in both cases we assert something. According to Frege, negation finds its place not on the act-side. But he does not mean to say that negation may find its place on the side of the object: what can be negated

is the content judged to be true. The negation of what we judge to be true in the judgment 'The square root of 2 is rational' can be expressed by the clause 'that the square root of 2 is not rational'. What is judged to be true, whether positive or negative, is a proposition *(Gedanke),* a notion comparable to Bolzano's concept *Satz an sich.* A proposition is a kind of entity that is preeminently proper for negation. The primary function of a proposition is its being judged to be true or false, presumably; it fulfills the role of being the bearer of truth and falsehood. Therefore, the negation of a proposition may be defined in terms of truth and falsity: the negation of a proposition is the proposition that is true when the negated proposition is false, and is false when the latter is true.

Frege has a strong argument against the thesis that there are negative acts of judgment. Take the inference 'If the accused has not been in Berlin at the time of the murder, then he has not been the murderer. The accused has not been in Berlin at the time of the murder. Therefore, he has not been the murderer'. Suppose the thesis that there are negative acts of judgment is true, then the second premise is the result of a negative act of judging which has the proposition *that the accused has been in Berlin at the time of the murder* as its content; in the first premise, on the other hand, *that the accused has not been in Berlin at the time of the murder* is not judged at all, which means that the negation must form part of the content; this antecedent is a proposition which is clearly not the same as the proposition which is denied in the second premise. This means that the inference cannot be accounted for by the rule of *modus ponens.* If the supposed thesis is true, we need an extra inference rule. In all those cases where propositions are not asserted, for example when they are members of disjunctions or implications, we need negation on the side of the propositional content; if we also acknowledge the existence of negative acts, this leads to unnecessary complications (Verneinung, 153, 154). Another problem if we do not acknowledge negation on the side of the propositional content is that we would need to acknowledge not only negative acts of judgment but also negative acts of asking, supposing, ordering, etc. Strictly speaking, these arguments are not arguments against the acknowledgment of the existence of negative acts of judgment, but arguments for the thesis that negation is at least in some cases a part of the judged content.

From Frege's point of view, the term 'negative judgment' might be said to mean a judgment with a negative proposition as its content. But because such a negative proposition is defined only relatively to another proposition, it is not decided yet that negative judgments form a category of their own. That there is such a special category is denied by Frege, for, he says, we cannot give any criterion to distinguish negative

from positive judgments. In case we say with Brentano that there is a special act of denial besides one of affirming, it is implied that the distinction is not merely relative; this means that a criterion to distinguish them is needed.

A less obvious way to call a judgment 'negative' is to say that a judgment is negative insofar as the way in which it is verified is different from the way in which a positive judgment is. To generalize this point, we might say that the contents of negative and positive judgments are made true in different ways; that they have different 'truth-makers'.

2. Chisholm's Theory of Judgment

a. Chisholm's Propositional Theory of Judgment

In his writings in the sixties and seventies Chisholm associates his theory of judgment with the tradition that follows the propositional theory of Frege and Bolzano. Instead of using the term 'proposition' which we are now used to giving as a translation of the terms *Gedanke* and *Satz an sich*, Chisholm uses, like C. I. Lewis, the term 'state of affairs'. Already in 1888 Stumpf used the term *Sachverhalt* to refer to the content of our judgments, and in 1911 Reinach used *Sachverhalt* for timeless and objective judgmental contents with a propositional structure (for example, *that the rose is red*), which he contrasts with something he calls a *Tatbestand* (here: the red rose). For Chisholm, too, a state of affairs is an abstract, timeless entity, which exists necessarily, whether or not it obtains; it is in no way dependent upon any concrete, individual thing, and it is such that, for example, 'The author of Waverly being knighted' expresses a different state of affairs than 'The author of Marmion being knighted' does, although each of the descriptions involved stand for the same person. Chisholm has a reason not to use the Fregean terminology. For Frege, propositions are primarily bearers of truth and falsity, and a proposition does not change its truth-value. Chisholm, on the other hand, says that states of affairs that now obtain may no longer obtain at some time in the future. The judgment 'Some mammals live in the sea' is no longer correct when whales have become extinct. Whereas Frege would say that the judged content has changed, Chisholm says that the content is still the same, but that its truth-value has changed as time went on. Chisholm uses the term 'proposition' only for those states of affairs which are not dependent on time for their obtaining or nonobtaining, such as *two and two being five*. All other judgments have a state of affairs that is not a proposition as their content.

Because it is artificial to call states of affairs true or false, Chisholm proposes other candidates for being the bearers of truth and falsity. He conceives of judgments—not in the sense of judged contents—as the primary bearers of truth and falsity (Replies, 205). He also says that such judgments are "used with truth" (*FP*, 44). Here Chisholm probably does not mean to say that the actual acts of judgment are the bearers of truth, for then we have a truth-bearer only when someone actually judges; it is better to conceive of the results of those acts as being the bearers of truth. It is hard to imagine, though, that judging is something different from holding something to be true (or false), which means that this something is the bearer of truth and falsity; a judgment can only be said to be correct or right. Chisholm might answer: Judging is accepting something, or attributing a certain property to something. Applied to states of affairs this gives the following analysis of my judgment that some whales are white: I accept the state of affairs that some whales are white. Under this analysis it is more natural to call the judgment true or false. I think, though, that the notion of acceptance is ambiguous; we should ask: Accept as what? Accept as true, I think. But, then, it cannot be the act or its result which is the bearer of truth. What the truth-bearer is in the case of an attribution will be dealt with in the next subsection.

For Chisholm, the primary role of a state of affairs is that it may be conceived or accepted by someone (*FP*, 9). He defines *a state of affairs* partly by this role. The second part of the definition of *a state of affairs* is that whoever conceives it, necessarily conceives something which is possibly such that it obtains. *There being round squares* is a state of affairs, because *there being squares* is necessarily conceived if *there being round squares* is conceived, and *there being squares* is possibly such that it obtains.

A state of affairs p and a state of affairs q are identical if and only if they entail each other. This means that p and q are necessarily such that if the one obtains, then the other obtains, and whoever accepts the one accepts the other (EPS, 30, 31). This identity criterion is very similar to Frege's principle for individuating propositions: two sentences express the same proposition if and only if it is not possible for anyone who understands those sentences to judge the one to be true and the other to be false.[1] Those sentences are standing in a relation of *Äquipollenz*. Frege adds to this that these sentences should not contain any parts which are immediately evident. Such a criterion cannot be used to determine that two judgments have the same content; it can only be used in a negative sense, to determine that two judgments have different contents. The

criterion makes it possible to distinguish necessary truths, such as mathematical truths, from one another. No calculation is allowed between the two acts of judgment; the second must immediately follow from the first. Chisholm uses the criterion to make sense of the intuition that 'It is not the case that whales are not mammals' and 'Whales are mammals' express the same state of affairs. (Chisholm presupposes here that negation has a classical meaning.) This example shows that there is not a precise one-to-one correspondence between sentences and the states of affairs they express.

On Chisholm's account, the predicates *being true* and *obtaining* do not apply to different types of entities; for him, propositions are merely a special case of states of affairs. Although Chisholm conceives of propositions as a subclass of states of affairs, I will often use the terms 'states of affairs' and 'propositions' interchangeably, because his notion *state of affairs* has much resemblance with what is often called 'proposition'. A state of affairs expressed by a certain declarative sentence obtains, or a proposition is true, if and only if the object (which may be a set consisting of objects) denoted by the subject term exemplifies the property (which may also be a relation) expressed by the predicate (SP, 28). It is clear that this definition only makes sense in the case of states of affairs that may be expressed by atomic sentences. Further, states of affairs are reducible to properties: we can replace *that x is F* by *being such that x is F*. The obtaining of the state of affairs *that whales are mammals* can be conceived of as the exemplification by whatever individual of the attribute *being such that whales are mammals*. In the case of nonobtaining states of affairs no individual exemplifies the property, say, *being such that whales are fish*. This leaves us with *object*, *property*, and *the relation of exemplification* as primary concepts.

b. Chisholm's Nonpropositional Theory of Judgment

In his earlier theory of judgment Chisholm drew a distinction between two types of judgment: those where a proposition is judged to be true, called *de dicto* judgments, and *de re* judgments, which are attributions of a property to an object (*PO*, 165ff.). And he argued that de re judgments are reducible to de dicto judgments. At the end of the seventies, Chisholm introduced a new type of judgment. At first sight the judgments falling under this type seem to be a special case of de re judgments, for a property is attributed to an object. But this object is a special one; it is the judging person himself. According to Chisholm this means that these judgments are different from de re judgments. What he

has in mind can be explained by making a distinction between the following two judgments. Suppose I am in a store and I see on a television screen that someone is dropping her shawl, at which time I judge: 'That woman is dropping her shawl'; the next moment I realize that I am that woman and I judge 'I myself am dropping my shawl'. The latter type of judgment Chisholm calls a *direct attribution*; an attribution which we express by a 'he, himself' locution. I will call them *first-person judgments*.

These judgments cannot be conceived of as normal de re judgments, for in that case it would be possible for anyone else to make the same judgment about me; neither can they be considered as de dicto judgments, because in that case I judge something about myself under a certain conception. Chisholm does not believe in abstract I-presentations ('*Ich-Vorstellungen*' as Frege calls them) as parts of propositions or states of affairs. He agrees with Brentano that we never grasp any individuating properties (*FP*, 16), that is, properties which belong essentially to one individual *(haecceitas)*. Neither do individuals themselves form part of propositions. Conceiving states of affairs as abstract entities, Chisholm believes that they cannot be dependent upon a concrete entity. It is true that the terms 'I', 'he', 'that', or any proper name do not have meaning in the same way as, for example, 'the highest mountain' has, but that does not imply that the meaning of these entities is identical with the individual they stand for.

For Chisholm, sentences containing indexicals, demonstratives, or proper names do not express states of affairs or propositions at all. Judgments like 'Jones is brave' or 'That horse is a stallion' do not have a proposition or state of affairs as their content. In a loose sense, we might say that they are attributions of a property to an individual thing: respectively, the man called 'Jones' and the horse pointed at. To be more precise, for Chisholm, *being a stallion* is only the indirect content of such an attribution, and the horse pointed at is only the indirect object. The ultimate or direct object of all attributions is the judger himself. The way we refer to ourselves is essentially different from the way we refer to others. To myself I refer directly; there is no doubt that the reference to myself succeeds when I judge that I feel pain. The knower and the object about which we know something are in this case identical. To someone or something else I can refer only indirectly, namely by attributing a property to myself which implies an identifying relation by which I am able to single out the horse from all other objects around me, and which implies that the object singled out is a stallion. Being a description, it may fail to pick up the right object, or it may pick up no object at all. By

attributing something directly, I attribute something indirectly (*FP*, chap. 4).

This conception is comparable to what Brentano says: we apprehend or accept something *in obliquo* by apprehending or accepting something *in recto* (*PES*, 3: 37ff.). What we accept *in recto*, we accept as existing; this is not the case when we accept something *in obliquo*. Brentano says that when I judge that someone believes in the devil, then I accept the one who believes in the devil *in modo recto*; the devil I accept *in modo obliquo*. Or, when I experience something and accept what I experience, then there is an acceptance of myself as experiencing *in modo recto*, and what I experience I accept *in modo obliquo*. Brentano believes that all and only psychical phenomena are experienced in inner consciousness with immediate evidence (*PES*, 1: 128). Or, as Chisholm says, in every judgment we have direct access to ourselves as judging persons. There is a certain kind of reflexivity which characterizes all mental acts.

Not only all attributions, but also all de dicto judgments can be reduced to first-person judgments. The indirect object in the case of a de dicto judgment is the proposition judged; the indirect content is the property *being true*. The judgment 'All men are mortal' is a direct attribution whose content entails an identifying relation by which I single out the proposition *that all men are mortal*, and which entails that this proposition is true. Here *being true* is conceived of as a predicate among others.

Chisholm's attributional theory is not confirmed by our intuitions. When I judge 'Whales are mammals', my judgment is not about myself. There are other problems with this theory. Suppose that when I judge that elms are trees, I attribute to myself a certain property; if you then judge that elms are not trees, you attribute to yourself another property. These judgments do not contradict each other, of course. How then can it be accounted for that you were contradicting what I was saying? A possible answer is that the propositions entailed by the attributions contradict each other. This can be defended for de dicto judgments. But it leaves us with the problem how it can be accounted for that 'The British Library has a copy of *Das Kapital*' and 'It is not the case that the British Library has a copy of *Das Kapital*' contradict each other, for these judgments do not contain any propositions or states of affairs on Chisholm's account. If one defends that (the results of) attributions contradict each other, we have to assume that there is a Being who judges everything—both what is true and what is false; this is probably not what Chisholm wants to defend, if it is defensible at all, for even God cannot judge contradictory things.

A second problem is how hypothetical and disjunctive judgments may find a place when nothing but attributions are admitted. Chisholm would probably answer that the attributed contents are hypothetical or disjunctive. A judgment of the form 'If the British Library has a copy of *Das Kapital*, then there is still a Marxist in London' might be analyzed as an attribution to the judger himself of the property *being such that if* . . . , *then*. . . . This analysis presupposes the concept of a *proposition*, because the property must be analyzable into an antecedental and a consequential part. Another way to analyze the judgment is to conceive of it as an indirect attribution: to the British Library the content *being such that if having a copy of Das Kapital, then there is a Marxist in London* is attributed. Here *having a copy of Das Kapital* is a kind of antecedental property; it is hard to explain, though, what this is without introducing the notion of a truth-bearing entity like a proposition.

What is the form of 'the British Library has a copy of *Das Kapital*', when it is not judged? And, has this form something in common with the judgment 'The British Library has a copy of *Das Kapital*'? This problem shows itself in such an inference as: 'If the British Library has a copy of *Das Kapital*, then there is still a Marxist in London. The British Library has a copy of *Das Kapital*. Therefore, there is still a Marxist in London.' If we want the inference to be valid according to *modus ponens*, the antecedent of the first premise must have something in common with the second premise (compare Frege's argument against negative acts of judgment dealt with in the first section of this paper). But what can this common thing be if the first premise is an attribution whereas in the antecedent nothing is attributed. If we take the answer as given above, that the common part shows itself in the antecedental part of the attributed content, *being such that if having a copy of Das Kapital*, it is properties as exemplified by a certain individual, or individuals as exemplifying a certain property, that stand in logical relations. These might also be said to be the common element in judging, asking whether and supposing, say, I am in France. But what is an individual as exemplifying a property? It cannot be meant in any actual sense, for premises and conclusion may be false.

Further, the two judgments 'I am in Leiden' and 'Someone is in Leiden' must have enough in common to explain that the latter, which expresses a state of affairs, may be inferred from the former, which does not express a state of affairs. We should not have a theory with two types of entities fulfilling the role of being truth-bearer. Indeed, for Chisholm all judgments can be conceived of as attributions. 'Someone is in Leiden' can be analyzed as: I attribute to myself the property *being such that*

someone is in Leiden obtains. Now it becomes very difficult to explain what this attribution has in common with the attribution to myself of *being in Leiden.* It will be a severe complication if we have different inference rules for concluding 'Someone is in Leiden' from 'I am in Leiden' and for drawing the same conclusion from 'Peter is in Leiden'.[2]

A third problem concerns the analysis of (negative) existential, singular judgments. Chisholm gives as an example an analysis of 'Tom does not exist': "The properties I thought enabled me to single out one thing and a thing that I called 'Tom' don't point to anything" (*FP*, 69). It is not easy to use this analysis for the judgments 'I exist', 'I do not exist', or 'I did not exist, then'. Do we have to say that in judging 'I exist', I attribute *existence* to myself; that is, that we have to treat *existence* as a first-order predicate? Or is 'I exist' not a judgment at all? Of course, these judgments are not easy for any theory to analyze.

A last, important problem which any theory of attribution has to face is a variant of the problem of the unity of the proposition. Every act of attribution, in the sense in which it is a complete act of judgment, consists of partial acts: the act in which the subject is posited, which is the underlying act, and an act of attribution or denial of the predicate. Even in the case in which the subject is himself the judger, an act must be carried out by which the subject of attribution is posited. The awareness of the subject which is an essential part of every intentional act, and which forms therefore a unity with every such act, cannot fulfill this role because an *underlying* act is needed upon which the act of predication depends. There can be an act of judgment only if there is a unity of the two partial acts of subject-positing and attribution of the predicate; further, this act of judgment has a content of its own, which has a unity that makes it possible to be judged (compare Husserl [*LU*, vol. 5, §18]). I believe that the partial act which posits something as subject, cannot but posit it in a certain manner. In the case of 'I, myself . . .', it is me presented by way of self-reference; this is something repeatable for it is present in all my self-referring judgments. This means that it has a general content, although not generalizable to other judging persons, and that it may form part of a proposition.

The above-mentioned arguments are not so much arguments against a theory of attribution, but rather against a theory which does not acknowledge a proposition in all cases of judgment.

In the changeable world there are not only entities which have an independent existence *(ens per se),* but also entities which depend for their existence on something else, like this ball's being blue or this leaf's falling off a tree. The latter category of entities is called *the category of*

states. States are not repeatable, although they might be said to recur: Yeltsin's being angry may have disappeared and be there again to-morrow.

The primary role of a state is that of being a truth-maker. Further, states are the entities which are related by causation. The judgment 'I have a toothache' is made true by my state of having a toothache, but it is also made true by my general state or by the state of the actual world. This means that the notion of truth-maker needs some restriction. The notion Chisholm uses is tightly connected to the attribution used by the judger. We might call my having a toothache the minimal truth-maker of 'I have a toothache'. It seems to be artificial to say that 'Jones is brave', which is an indirect attribution about Jones and a direct attribution about the judging person, is made true by a certain state of the judging person. For that would mean that a judgment of that form has as many truth-makers as there are people who make the judgment, which is a happy situation for judgments about oneself, but not for judgments about other things. Therefore, it is more likely that the truth-maker is determined by the indirect attribution, if there is any.

3. CHISHOLM'S THEORY OF NEGATION

a. Negation As Something Irreducible

The central question concerning any theory of negation is whether *negation* is an irreducible concept. If it is, it may find its place on the side of the act or attitude in our judgments, beliefs, questions, wishes, etc.; it may form part of the content of our judgments; or it may find a place on the level of truth-makers.

According to Plato, if we say 'Something is not great', we do not assert something which simply is not, we assert that this particular in as much as it partakes in the Form Other is other than those particulars which partake in the Form Great. Other philosophers have defended the thesis that a negative sentence such as 'this ball is not blue' really means that this ball has a color which is incompatible with blue. The incompatibility is a logical one if it is assumed that any colored thing can have only one color under the same circumstances. On this analysis it is presupposed that it makes sense to say that something is not blue only if it is a colored thing. Therefore this type of negation is called the *relative* sense of negation, relative to a certain *genus* or determinable (like *color* or *shape*).

In a judgment like 'Happiness is not blue' we do not say that

happiness has a color which is incompatible with being blue. Either we have to say that there is no real judgment because 'Happiness is not blue' makes no sense, or we have to take another meaning of negation into account. Anyway, the relative sense of negation, and, thus, the incompatibility analysis, is not enough to explain other types of negative judgment, such as 'God does not provide', 'John does not love Mary', 'Unicorns do not exist', or the order 'Do not close the window'. In these cases we use a more radical meaning of negation, called the *absolute* sense of negation. We cannot analyze such judgments with the notion *incompatibility* because there is no generic property of which the denied property is a specification. When we use these types of judgments, we do not mean to assert that an individual has a property which is incompatible with the one negated in the judgment. In the absolute sense of 'not', things which are said to be 'not red' are said to be 'anything but red', so that all things are either red or not red, whether colored or not. The negation-sign in our inference rules has this absolute sense. We might conclude that the incompatibility analysis captures only a part of the meaning of negation. Besides, the relation of incompatibility or exclusion can only help to explain what negation is. As a reduction of negation to something else it fails, because it contains the concept of negation in the *definiens*: two propositions exclude each other if and only if they cannot both be true.[3]

It seems natural to apply the incompatibility analysis in the case of truth-makers. On this account, 'This ball is not blue' is true in virtue of the actual color of the ball. Here, too, we need to assume that there is a relation of incompatibility or exclusion, namely between states. Two states exclude each other, if an object cannot have both states but can have neither. Again, we can ask: Which state could exclude that there are unicorns, or that God provides?

Chisholm gives the following example to show that the incompatibility analysis of negation will not do: the judgment 'I do not believe that it is raining in Graz' is not made true by a psychological state of mine which is incompatible with that belief, for what state could fulfill this role? According to Chisholm, we need both positive and negative truth-makers: my state of not believing that it is raining in Graz is such a negative truth-maker; it is a state with a negative content, not believing that it is raining in Graz, and can thus be called a negative state. Independent evidence for the existence of negative states is that they can stand in causal relations: if John feels affection only for red-haired girls (and only in so far as they are red-haired), Mary's not having red hair— and not her positive state of having grey hair—causes John's not being attracted to her. Further, we sometimes want to attribute something to a

state, as when I judge 'Not being in love is a quiet state we sometimes long for'. Negative states should not be confused with nonoccurring states and events. For Chisholm, the latter simply do not exist. For example, if 'This ball is not red' is a correct judgment, the state 'the ball's being nonred' is the truth-maker; there is not a nonoccurring state 'the ball's being red'. Nonactualized possibilities form no part of Chisholm's ontology. If a judgment is incorrect, the false-maker is simply the truth-maker of the contradictory judgment.

b. Negative States of Affairs or Properties and the Relation of Involvement

As is shown above, negative sentences often cannot be said to express a positive proposition or state of affairs together with a relation of exclusion; therefore, we have to acknowledge negative propositions or states of affairs. As I already observed in the first section, according to Frege, we do need a counterpart for 'not' on the side of propositions, but we have no means to distinguish negative from positive propositions: being negative is only a relative property of propositions, namely, relative to another proposition. Any theory which says it has a criterion to distinguish negative from positive propositions should be able to answer Frege's question: Which of the following sentences expresses a positive, and which expresses a negative proposition: 'Christ is immortal', 'Christ is mortal', 'Christ does not live forever', 'Christ does not live in eternity'? (Verneinung, 150).

Chisholm says that it is possible to distinguish positive from negative states of affairs. The first question to be asked here is: What is the importance of a criterion by which we are able to draw the distinction? In classical logic we need only a relative conception of negation. The question therefore cannot be dealt with independently of another question: To what extent can logic be conceived of as independent of other areas where the distinction between positive and negative is not merely relative? What I have in mind here is that the distinction has some importance from an épistemological point of view, because positive judgments are not verified in the same way negative judgments are. I will come back to this point in section 4. In Chisholm's writings the importance of the criterion finds its reason in his philosophy of *personal realism*, as he calls it, or to use another term, in his *intentional ontology*. In defining the more basic notions of his philosophy such as *property* and *state of affairs*, Chisholm makes use of intentional notions such as *conceiving* and *attributing*. In contrast with most analytic philosophers, Chisholm does not use the notion of a *sentence* or of any other linguistic

entity as an undefined term in those definitions. From an intentional point of view the distinction between positive and negative judgments or thoughts is not merely relative. This means that a criterion can be given if intentional notions are used.

Chisholm gives the following criterion to distinguish positive from negative states of affairs: "a state of affairs is *affirmative* if and only if it does not involve its own negation; otherwise it is *negative*" (EPS, 37). Two important notions are used here, that of *involvement* and that of *being the negation of something*. Chisholm presents his relation of involvement as a counterpart to Bolzano's relation between a *Vorstellung an sich* (an objective concept) and its parts. Bolzano says that the concept *a land that has no mountains* has the concept *mountains* as a part, and the concept *the eye of a man* has the concept *man* as its part; in contrast to this the object 'land without mountains' has no mountain as a part, and the object 'the eye of a certain man' does not have this man as a part (*WL*, §63). In the examples given the parts of a concept can be determined linguistically; but is this always the case? Whereas the concept *racehorse* contains the concept *horse*, the concept *Sunday* does not contain the concept *sun*; we can only determine that the concept *sun* is not a part of the concept *Sunday* if we know the meaning of 'Sunday'. (If this example still causes some doubts because of the etymology of 'Sunday', ask yourself whether *arch* forms a part of *anarchist*, or *art* of *article*.) This means that the parts of a concept cannot be determined linguistically. The way Twardowski, Brentano, and Stumpf conceived of the notion *being part of a concept* was certainly not linguistic, for they considered the concept *color* to be part of the concept *red*.

On the other hand, the notion *involvement* should not be taken in a subjective, psychological sense. Such a subjective conception of *being part of a concept* is to be found in Twardowski's work, as Husserl has rightly pointed out (BT, 354, 355). Twardowski defends, with reference to Bolzano, the thesis that we can use another term for 'the eye of a man' in which the term 'man' does not appear. Then, he says, we immediately see that the concept *man* is not a part of the concept *the eye of a man*. For Twardowski, such a concept as man is only an auxiliary concept *(Hilfsvorstellung)* for the concept *the eye of a man* (*IGV*, 14). In contrast to this, Twardowski says that the concept *being extended* is part of the concept *red*. Twardowski uses the term *Vorstellungsinhalt*; in his words; the *Vorstellungsinhalt* which is the meaning of the term 'red' cannot be without the *Vorstellungsinhalt* which is the meaning of 'extended' (*IGV*, 11). I think that the necessary relations between these two contents are of a genetic-psychological kind; these relations are not internal relations holding between the concepts *red* and *extended* themselves.

Both Bolzano and Chisholm use intentional criteria to determine the parts of a concept; that these intentional criteria are not psychological or subjective has to be argued for. Bolzano says to this: all that has to be thought necessarily in order to think of a certain concept, is a part of that concept.[4] This means, he says, that the concept *equality of all sides* is part of the concept *equilateral triangle*, but the concept *equiangularity* is not part of the latter. It may be the case that whenever we think of the concept *equilateral triangle*, we think of the concept *equality of all angles*, but here the relation concerns only the subjective thinking of these concepts, it does not concern the concepts *an sich* (*WL*, § 64, p. 83). Bolzano says he owes these ideas to Kant's distinction between analytic and synthetic truths, and he refers to the definition of analytic truths as those truths of which the predicate is contained as a part in the concept of the subject (*WL*, § 65, anm. 7). Indeed, for Kant the judgment 'An equilateral triangle is equiangular' is a truth that is not analytic; as a geometric judgment it is a synthetic a priori. A tautologous judgment such as 'An equilateral triangle is equilateral', or to use Kant's example, 'Der Mensch ist Mensch', is not a typical example of an analytic truth (*Logik*, § 37). More interesting cases of analytic truths contain the predicate in the concept of the subject in a concealed or implicit way, as in the judgment 'Bodies are extended'. It is clear that in such cases it cannot be determined linguistically whether a concept is part of another one; and neither is the relation between the concepts *body* and *extended* a genetic-psychological one.

If someone introduces the notion *being part of a concept or involvement*, we should ask whether he thinks that the concept *extension* is part of the concept *body*; whether the concept *color* is part of the concept *red*; and whether the concept *equiangular* is part of the concept *equilateral triangle*. Chisholm does not give any explicit answer to these questions; but his criteria to distinguish negative from positive states of affairs and properties give some clues how he would answer these questions.

Chisholm introduces the relational concept *involvement* as follows: "The state of affairs *p* involves the state of affairs *q* = Df. *p* is necessarily such that, whoever conceives it, conceives *q*" (*FP*, 124). According to the criterion for negative states of affairs, 'It is false that balls are round' expresses a negative state of affairs: its negation, *that balls are round*, must be thought of when entertaining it. Does the state of affairs expressed by 'It is not the case that it is not the case that balls are round' involve the one expressed by 'it is not the case that balls are round'? As I mentioned before, for Chisholm, there is not a one-to-one correspondence between sentences and the states of affairs they express; further, every state of affairs has only one negation. This means that the state of

affairs expressed by 'it is not the case that it is not the case that balls are round', being the negation of *that it is not the case that balls are round*, expresses the same state of affairs as 'balls are round'. A state of affairs expressed by 'it is not the case that not p' does not involve the one expressed by 'not p'; it is rather the other way round.

This is in accordance with Chisholm's identity criterion for states of affairs: whoever accepts *that it is not the case that not p*, necessarily accepts *that p*. This identity may be contrasted with the following nonidentity: '(x) $(x = x)$' expresses a positive state of affairs, whereas '$-(Ex)$ $-(x = x)$' expresses a negative state of affairs, as conceiving the latter implies conceiving (Ex) $-(x = x)$. Although the two states of affairs are logically equivalent, they are not identical.

Whether a certain state of affairs involves another one, can be seen only when we express it in its proper form. Chisholm says that a sentence mirrors the structure of a state of affairs provided that the principal subordinate components of the sentence express the principal subordinate components of the state of affairs (EPS, 30, 37); 'a state of affairs is the principal subordinate component (p.s.c.) of another one' means that the latter properly involves just what the former involves ('p properly involves q' means that p involves q but q does not involve p). For example, p is a p.s.c. of $-p$ and of p & q. (It is not so clear, though, what the p.s.c. of a certain sentence is: do we really have to entertain the sentence 'There are dogs' in order to entertain the sentence 'There are no dogs'? And why is 'no' not a p.s.c. of the latter sentence?) According to Chisholm, each state of affairs can be expressed by a sentence which shows the real structure of that state of affairs; expressed in a proper way we can see whether the state of affairs concerned is a negative one. But how do we know whether we have caught the proper form of a certain state of affairs? For example, according to Chisholm, p is not a p.s.c. of p v q, because such a disjunction really has the form $-(-p$ & $-q)$, which means that the p.s.c. is $-p$ & $-q$. Chisholm gives no independent argument, but he does not stand alone in this analysis; Brentano classifies disjunctions as negations, too (*WE*, 80). In accordance with his idea to conceive conjunctions as positive and disjunctions as negative, Chisholm gives another criterion to distinguish positive from negative states of affairs: all and only affirmative states of affairs imply their principal subordinate components.

Chisholm defines 'p is a negation of q' as either p denies q, or q denies p; 'p denies q, means that p contradicts q and p properly involves just what q involves; and 'p contradicts q, means that p is necessarily such that it obtains if and only if q does not obtain. Because a negation is used in the last definiens, a reduction of negation is not intended. I wonder

how the following problem can be solved: $-[(2 + 2 = 5) \& -(2 + 2 = 5)]$, which is a logical truth, is (a denial, and therefore) a negation of $[(2 + 2 = 5) \& -(2 + 2 = 5)]$. The latter is (a denial, and therefore) a negation of $-(2 + 2 = 5)$, because it contradicts and properly involves just what the mathematical truth $-(2 + 2 = 5)$ involves (I take these examples from Chisholm [EPS, 35]). Because a state of affairs has only one negation, $-[(2 + 2 = 5) \& -(2 + 2 = 5)]$ and $-(2 + 2 = 5)$ really are the same state of affairs. But this is not in accordance with the identity criterion for states of affairs: someone who has no knowledge of arithmetic may judge $-[(2 + 2 = 5) \& -(2 + 2 = 5)]$ to be true, because it is a logical truth, but may not know the truth-value of $-(2 + 2 = 5)$. When you are in doubt about the latter point you may exchange $2 + 2 = 5$ for a more complex mathematical falsehood. If we hold on to the restriction Frege proposed that the sentences concerned do not contain any immediately evident parts, we can avoid this problem.

According to Chisholm, if the Fregean sentences, like 'Christ is immortal' etc., should be read as 'Christ is such that (not) . . .', they are all affirmative. Because the sentence contains a proper name, it does not express a state of affairs. Instead we can take as an example 'Someone is such that (not) . . .'. According to Chisholm, sentences of the latter form all express positive states of affairs; for him, such concepts as being mortal and being immortal are both positive (see below). On the other hand, if Frege's sentences are read as 'It is false that Christ (someone) is (not) . . .', they are classified as negative (EPS, 33).

As I mentioned in section 2, in his later theory Chisholm says that states of affairs are reducible to properties. This means that properties form an essential part of Chisholm's later theory of judgments. Further, it should be noted that for him all states of affairs have a negation, but that not all properties have one (see subsection 3.c). The thesis that there are negative attributes or negative universals has been argued against by David Armstrong (*Universals*, chap. 14). One has to give a criterion to distinguish negative properties from positive ones even if one rejects negative properties; the arguments against negative universals given by Armstrong make sense only when such a criterion can be given. Chisholm gives a criterion to distinguish negative properties comparable to that for negative states of affairs: P is a negative property if and only if there is a Q such that P contradicts Q, and P properly involves Q. Besides, Chisholm gives two other criteria to distinguish negative from positive properties. "Being-F is a negative attribute = Df. One cannot conceive an attribute that excludes being-F without conceiving an attribute that contradicts being-F" (*OM*, 154). 'Two attributes exclude each other' means that it is impossible for anything to exemplify both;

and 'two attributes contradict each other' means that it is necessary that everything is either and that it is impossible that anything is both. It is clear from these definitions that we must already know what negation is.

In case we can conceive an attribute that excludes a certain attribute *being-H* without conceiving an attribute that contradicts *being-H*, we can conclude that *being-H* is positive. The remaining attributes can then be classified as negative. For example, *being red* is classified as positive, for *being blue* excludes *being red* without contradicting it. This conception of a negative attribute presupposes that negative terms are applicable to things which fall under a *genus* different from that of the negated attribute. If 'being nonred' meant 'being any color but red', the attribute expressed would not be classified as negative—for we could then conceive an attribute that excludes *being nonred*, say *being a concept*, without conceiving an attribute that contradicts *being nonred*. The attribute expressed by 'being nonred' is classified as positive, because we can conceive an attribute that excludes it, namely *being blue*, without conceiving an attribute that contradicts it; the attribute expressed by 'being non-nonred' is identical with the one expressed by 'being red'.

What other attributes exclude *being nonred? Being crimson* and *being scarlet* do. Because *being crimson* does not contradict *being nonred*, it seems as though the criterion says that being nonred is not negative. If we want to save the criterion, we have to say that we cannot conceive *crimson* or *scarlet* without conceiving red; for, if we want the criterion to classify *being nonred* as negative, we have to say that we necessarily think of *red*, when we think of *crimson* or *scarlet*. This, I think, is what Chisholm would like to defend. Similarly, someone who thinks of *horse*, necessarily thinks of *animal*. In general, all determinates involve their determinables, and all *species* involve their *genus*. It follows that the relation of involvement is not a purely linguistic or formal one.

Is *being nonextended* a negative attribute according to the above-mentioned criterion? An attribute which excludes it is *being a body*. If Chisholm wants to defend the idea that *being nonextended* is a negative attribute, he has to say that *being a body* contradicts being nonextended, which means that the relation of contradiction is not a formal relation; or he has to say that *being a body* involves an attribute which contradicts *being nonextended*, that is, that it involves *being extended*. The latter fits in beautifully with the tradition. But the next example shows that it is a rather arbitrary decision how strong we take the relation of involvement to be.

What would Chisholm answer to the question whether the attribute *being an equilateral triangle* involves the attribute *being equiangular? Being not an equiangular triangle* is not excluded by *being equilateral*, for

any square exemplifies both properties. The attribute *being not an equiangular triangle* can be classified as negative only if an attribute which excludes it, say *being an equilateral triangle*, involves one that contradicts it. Chisholm has to say either that *being not an equiangular triangle* and *being an equilateral triangle* contradict each other, or that *being an equilateral triangle* involves *being an equiangular triangle*. Probably he will choose the first alternative, although, as said above, this implies that the relation of contradiction is not a purely formal relation.

Properties such as *being immortal, being mortal, being straight, being crooked* are all classified as positive, because none of these pairs of attributes forms contradictory attributes or involves them: nonliving things are neither mortal nor immortal.

So far we can give a definitive answer as regards relations of involvement only with respect to subdeterminates, like *being red*, and their determinables, here *being colored*; these are the classical relations of one-sided detachability (*'einseitige distinktionelle Abtrennbarkeit'* [see BOD]), as put forward by Brentano, and which he expresses sometimes by saying that (seeing) color is a *logical part* of (seeing) red (*DP*, 18–21). An analysis of the criterion for negative properties implies that *species* also involve their *genus*. This is also in accordance with Brentano in so far as he believes that someone who judges that there is a horse, immediately is able to judge that there is an animal.[5] In Chisholm's terminology: the content of the latter judgment is entailed by the content of the former. Dealing with the paradox of analysis Chisholm is perfectly clear concerning the point that not all predicates which are in the Kantian sense contained in the notion of the subject are involved by the notion of the subject; for if that were the case, no analytic judgment would be informative. The *definiens* of a cube, that it is a regular solid with six equal square sides, is not thought of when we think of a cube (SP, 34); according to Chisholm, the concept 7 is analyzed by the concept 8 − 1, but neither involves the other. Because *being extended* is part of the definition of *being a body*, Chisholm would probably say that the latter does not involve the former. Certainly, *being equiangular* should not be considered as being involved by *being an equilateral triangle*; the judgment that all equilateral triangles are equiangular extends our knowledge in the strong Kantian sense that it is a synthetic judgment.

The other criterion Chisholm gives is: a negative property does not entail any property other than itself (*OM*, 147). "P entails Q = Df P is necessarily such that, for every x and y, if y attributes P to x, then y attributes Q to x" (*OM*, 144) (see subsection 2.a). I will not deal here with the notion of de re modality; for Chisholm it is an undefined notion.

Attribution is for Chisholm an undefined notion, too; and he gives few examples of necessary relations between different attributions. A clear relation of entailment is that between *p* & *q* and *p*; probably there is not such a relation between *p* and *p* v *q*, because the entailment of *p* v *q* by *p* seems to imply that *p* involves *p* v *q*, which is not the case. Thus, most likely, *being red* entails *being colored*, and can therefore be classified as positive. Probably, *being nonred* does not entail *being noncrimson*. Although *being nonred* implies *being noncrimson*, it does not involve the latter; I can perfectly well think of *nonred* without having the concept *noncrimson*.

Do those, like myself, who think that Chisholm's criterion for negative states of affairs and properties is sound, have to conclude that Frege was wrong? I do not think so. What Frege meant is that no logical or linguistic criterion can be given to distinguish between negative and positive propositions. Chisholm's criterion is not a purely logical one; for example, the relation of involvement between *being red* and *being colored* cannot be accounted for in a purely formal way.

The criterion presupposes a hierarchy of concepts, not a type-hierarchy, but a hierarchy as we may find in the Porphyrian tree. Such a hierarchy cannot fit within an atomistic framework; but I do not think that it brings with it any general philosophical problems. Further, the criterion presupposes the important notion *involvement*. Using this notion it is possible to give a more fine-grained identity criterion for propositions; logically equivalent propositions need not be identical. Further, the criterion presupposes a proper, essential form of a proposition—or 'state of affairs' as Chisholm calls it—but not in such a way that there is a one-to-one correspondence between propositions and sentences. The problem is: How do we know this essential form? The intentional point of view alone cannot determine this; it gives no answer to the question whether *p* v *q* really has the form $-(-p \& -q)$, rather than the other way round. If we say that *p* v *q* must be negative because it does not imply its principal subordinate components, we end in a circle, for we have no independent arguments for considering negative propositions as not implying their principal subordinate components.

c. Attribution and Denial

The central question in this subsection is whether Chisholm acknowledges the existence of judgmental negation, besides the existence of propositional negation and property negation. The answer to this question is only implicitly present in Chisholm's writings.

As I noted before, whereas all states of affairs have negations, not all properties have negations. Not all predicates express properties of their own. An example—given by Chisholm—is the predicate in the sentence "The word 'French' is inapplicable to itself": 'being inapplicable to itself' cannot express a property of its own, for the assumption that there is a property *being inapplicable to itself* leads to paradoxical results—try to apply it to itself. There is only the property *being applicable to itself*. On which level is the negative part to be found here? There are two types of judgment we have to take into account: those which have states of affairs as their content, and those which attribute a property to an individual. An example of the former type of judgment is 'Some words are inapplicable to themselves'. Because the attribute has to be *being applicable to itself*, a more proper form of this judgment is: 'It is false/ It is not the case that some words are applicable to themselves'. I deal with this type of judgment below.

If we take "the word 'French' " not as a name of an abstract, timeless entity—as the word did not exist before Great Britain became inhabited—the judgment "The word 'French' is inapplicable to itself" is an attribution. It cannot be the case that the property expressed by the predicate 'being inapplicable to itself' is affirmed of the word 'French', for there is no such property. It must be the corresponding positive property which is attributed, the property *being applicable to itself*. Therefore the only way to analyze this judgment is by conceiving of negation as a part of the act of judging. The property *being applicable to itself* is *denied* of the word 'French'. Chisholm at one place explicitly says that he acknowledges two types of attribution. Denying something of something has the form '*x* is not such that it is *F*'; and affirming something of something has the form: '*x* is such that it is *F*' (OPR, 324). The similarity with Brentano's later theory of double judgments, which I have mentioned in the first section, is striking (cf. also BTJ). Such a theory of negation can be combined with the thesis that there are no negative attributes, if it is able to answer the question what the denial of a denial consists in. But contrary to that position, Chisholm admits negative properties in most cases.[6]

There is also some resemblance with the theory of judgment proposed by Ducasse. Ducasse presents his theory of judgment as a propositional one, defining a proposition as a particular entity, a pair consisting of a certain physical place and an attribute. Such a type of entity Chisholm would not conceive of as a proposition or 'state of affairs'. But Ducasse's theory of judgmental acts has much resemblance with Chisholm's theory of attribution, for Ducasse says that the assertion

of a proposition is the assertion of one of the constituents, the attribute, about the other constituent, a place, or any thing indicated by a name. The latter constituent is identifiable ultimately by indication. Further, there are different ways of attributing: affirmatively, negatively, or in any other 'mood', such as questioningly, optatively, hypothetically (see his FTK).

The idea that there are two types of judgmental acts cannot simply be extended to judgments with propositions or states of affairs as their content. In those cases Chisholm does not acknowledge a special negative act of judgment. In contrast to the de dicto judgments Chisholm has dealt with, which have the form 'p is true', such a judgment would have the form 'p is false'. For Chisholm these types of judgment are really attributions, with p as the indirect object and being true as the indirect content. There is no essential extension of his theory if the form 'p is false' is added. The question is whether there is any difference between a judgment of the form 'p is false' and one of the form '$-p$ is true'. Since Chisholm says that the state of affairs expressed by 'it is false that p' expresses the negation of the one expressed by 'p', he seems not to make any distinction. For him, the proper form of 'p is false' is: '$-p$ is true'.

Here we might contrast Chisholm's position with that of Brentano who explicitly defends the thesis that there are two types of judgmental acts, *Anerkennen* and *Verwerfen*. Brentano says that the judgment 'A is' is equivalent to 'it is false that A is not', but that the two judgments do not stand in a relation of identity to each other. Such a relation holds between two judgments only if they have the same matter and the same form; that is, the object judged *(das Beurteilte)* must be the same, and so must be the type of act (*LrU*, § 34). According to Brentano, the two judgments 'A is false', or in existential form 'A does not exist', and '$-A$ is true' cannot be identified. 'A is false' is a direct judgment; it is a rejection of a certain object. Only judgments of this type can be immediately evident. For example, I apodictically reject a square that is not a rectangle when I judge 'All squares are rectangles'. The judgment '$-A$ is true' is an indirect judgment. Here we can judge only with mediate evidence.

Brentano's theory does not imply that there is a one-to-one correspondence between sentences and the judgments which they intimate; judgments which stand in a relation of identity may have different linguistic forms. But there must be some kind of structural similarity if two judgments are related by identity, for in that case both matter and form of the two judgmental acts must be the same. Here Brentano's conception of identity for judgments deviates from the identity-criterion

proposed for propositions by Frege and Chisholm. Congruence cannot be a criterion for the identity of propositions, as Frege says in a letter to Husserl dated 30 October–1 November 1906. On the other hand, Brentano's conception of structural similarity is not the same as Carnap's notion of *insentional isomorphy*. In the first place Brentano's conception concerns judgments and not propositions. Further, in so far as the matter of a judgment is concerned, it may be expressed in nonisomorphic ways; for example, Brentano says that the parts of a complex matter may exchange their places. The two expressions 'Some *S* are *P*' and 'Some *P* are *S*' intimate the same existential judgment (*LrU*, § 34, section 95).

The question remains what the importance is of the distinction between the judgments '*A* is false' and '*−A* is true'. Is the distinction merely psychological, as Brentano sometimes suggests (*LrU*, 119)? Or is it also of importance from an epistemological and logical point of view? It is clear that the answer to this question cannot be dealt with in isolation. When we try to answer these questions the notion *truth-maker* especially has to be dealt with.

4. A RECONSIDERATION OF THE PROBLEMS CONCERNING NEGATIVE JUDGMENTS

If we take a judgment such as 'God does not exist', we might say that what makes the content of this judgment, the proposition that God does not exist, true is the nonexistence of God. 'The nonexistence of God' is an ambiguous phrase. Either it stands for a propositional entity, in which case we have an infinite regress in the explanation of what it is that makes a proposition true; or it stands for a state or moment of a nonactual object. The latter conception involves two problems: we cannot consider 'being nonexistent' as a state or moment for that would imply that (*non*)*existence* is a first-order predicate; further, this conception presupposes that there are possible objects.

Chisholm rightly argues that we cannot take a positive state together with a relation of incompatibility as the truth-maker for negative, existential judgments. Similarly, the truth-maker for 'John does not love Mary' cannot be one of John's positive states, for it is not necessary at all that John's love for another girl excludes his love for Mary.

Peter Simons (in his LA) proposes as a truth-maker for the proposition that there are no unicorns, the actual world, the totality of facts. But in that case we are no longer able to distinguish the truth-makers for different negative existentials: *that there are no unicorns* and *that there*

are no mermaids have the same truth-maker. In the case of 'John does not love Mary', he says, all the facts involving John's emotions make it true that he does not love Mary. Again, this theory cannot distinguish between the truth-maker for 'John does not love Mary' and that for 'John does not love Sue'. On such an account there must be a good reason why truth-makers for negative existentials are so different from truth-makers for other propositions.

'The nonexistence of God' or 'there not being unicorns' can be taken also in the sense of the nonexistence of a fact. Or, when we do not want to be committed to an ontology of facts, we can say with the early Brentano: the judgment 'There is no God' is true in virtue of there being no God. For Brentano, the nonexistence of an object is nothing more than a correlate of a correct rejection, just as the existence of an object is a correlate of a correct acceptance. The later Brentano explicitly takes the notion of *correctness of a judgment* as prior to that of *existence of an object judged* and to that of *truth of a judgment*: truth belongs to the judgment of someone who judges in the way someone would judge it, who judges it as being evident. Someone's judgment is true if he asserts what an evidently judging person would assert (*WE*, 139; *LrU*, § 42). This conception of truth implies that I may judge correctly, even if that judgment is not evident to me; but in order to be true, it must be evidently judgeable by someone. Brentano takes this primary notion of evidence not in any subjective or psychological sense.

Applied to the question whether there is a distinction between '$-A$ is true' and 'A is false', we can now say not only that they are distinguished from a psychological point of view insofar as the acts are different, but that their truth-makers differ, too. According to Brentano, 'A is false' is a direct judgment. The rejection of A is a correct judgment if there exists no A. Because, for Brentano, *the truth of a judgment* cannot be explained by *the nonexistence of the judged object*, it is better to define this correct rejection in terms of evidence: 'A is false' is correct if an evident judger would reject A. '$-A$ is true' is an indirect judgment; it is a judgment about a judgment, or about a judging person. If someone judges '$-A$ is true', he thinks of someone who rejects A, and he declares that he, insofar as he thinks of the so-judging person, thinks of a correctly judging person. Such a judgment cannot be immediately evident, because the judgment of someone else can never be evident to me; it can be mediately evident, though. In Brentano's theory the notions *truth* and *truth-maker* are not knowledge-transcendent. In general, his theory is relevant to those theories that define *truth* in terms of *provability*, for example the theory of Per Martin-Löf, where it is said that the judgment 'A is false' is correct if the proposition A cannot be verified (is

unprovable); and '$-A$ is true' is correct if the proposition $-A$ can be verified (is provable).

When we concede, on the one hand, to Brentano that there is a special act of *judgmental negation*, and, on the other hand, to Frege, that there is *propositional negation*, we acknowledge two forms of negation. Brentano's position as regards negative judgmental acts implies that there is an absolute distinction between positive and negative acts, and that we have to find a criterion to distinguish negative from positive judgments. Here we might use Chisholm's criterion. The advantage of using the criterion here over using it for propositions is that the latter application presupposes a proper form for each proposition. The criterion as used for distinguishing negative from positive judgmental acts presupposes some structure of judgments, but not more than that it consists in a positive act and a content, or a negative act and a content.

If we acknowledge negative acts, why not say that there are hypothetical, conjunctive, and disjunctive acts, too? The problem is that in these cases we do not merely need two propositions and an act which unifies them in a certain way; what is judged must have a unity of its own, for this unity is the truth-bearer. In contrast with this, the content of a negative act is a proposition which already has a unity; this proposition is said to be false. Further, positive and negative acts are acts of holding true and acts of holding false. In contrast to this, we do not have a special hypothetical truth-value or a disjunctive truth-value.

A theory which takes the notion of *evidence* or *proof* as a primary notion, that is, primary to *truth* and *existence*, has to keep clear of the company of relativists. This can be done only by introducing a notion of *correctness* which accounts for the difference between real evidence and apparent evidence, and between real proof and apparent proof. Without such a notion we are not able to distinguish between true and false propositions, and we cannot account for the fact that we may err. This notion of correctness is what I have called the *Parmenidean notion of truth*.

An interesting question is whether Chisholm has a comparable notion in his philosophy. That is, a notion of *truth* or *existence* which does not have a counterpart, that is, a notion of *asymmetric truth*. Chisholm's notion of *obtainment* cannot fulfill this role. Both obtaining and nonobtaining states of affairs exist in the same way. Is there a more fundamental notion on Chisholm's account; that is, a notion which makes the distinction between true and false propositions, or that between obtaining and nonobtaining states of affairs, possible, and which has no opposite? For Chisholm, *exemplification* is one of the most fundamental notions. It has no opposite: a simple state of affairs obtains,

if an object exemplifies a certain attribute. In the case of a nonobtaining state of affairs, there is not a parallel situation, because there is no relation of nonexemplification between the object and the attribute concerned: there is just nothing. Therefore, I think that *the relation of exemplification* is meant to fulfill the role of Parmenidean truth in Chisholm's writings.

Maria van der Schaar

Department of Philosophy
University of Leiden
February 1994

NOTES

1. Gottlob Frege, 'Kurze Übersicht meiner logischen Lehre' (1906) (Hamburg: Nachgelassene Schriften, 1976), 213.
2. Chisholm's answer to the problem, which is not exactly the same as the one I propose here, can be found in *FP*, 42–44.
3. According to Brentano, this holds also for the otherness analysis: "Die Verschiedenheit erkennen heißt erkennen, daß von zweien eines *nicht* das andre ist" (*WE*, 58).
4. "Denn meinem Sinne nach ist alles dasjenige, was man sich nothwendig denken muß, um eine gewisse Vorstellung wirklich gedacht zu haben, auch ein Bestandtheil derselben" (*WL*, § 65, anm. 2).
5. "Aus dem Urteil 'es gibt ein Pferd' läßt sich also das Urteil 'es gibt ein Tier' ohne jede Vermittlung folgern" (*LrU*, 209).
6. That is to say, in most of his writings. In the article 'Ein zurückhaltender Realismus', *Freiburger Zeitschrift für Philosophie und Theologie* 23 (1976): 190–97, Chisholm says that there are no *Negativa* at all in 'Plato's heaven'.

BIBLIOGRAPHY

Armstrong, David. *Universals and Scientific Realism.* 2 vols. Cambridge, 1978 *(Universals)*.
Bolzano, Bernard. *Wissenschaftslehre* (1837). Ed. J. Berg. In *Bernard Bolzano-Gesamtausgabe,* ed. E. Winter and J. Berg. Stuttgart-Bad Cannstadt, 1987 *(WL)*.
Brentano, Franz. *Deskriptive Psychologie.* Ed. R. M. Chisholm and W. Baumgartner. Hamburg, 1982 *(DP)*.
———. *Die Lehre vom richtigen Urteil.* Ed. F. Mayer-Hillebrand. Bern, 1956 *(LrU)*.
———. *Psychologie vom empirischen Standpunkt.* Vols. 1–3 (1924–1968). Ed. O. Kraus and F. Mayer-Hillebrand. Hamburg, 1971–1974 *(PES)*.

————. *Wahrheit und Evidenz.* Ed. O. Kraus. Hamburg, 1958 *(WE).*

Chisholm, Roderick M. "The Basic Ontological Categories." In *Language, Truth, and Ontology,* ed. Kevin Mulligan, 1–13. Dordrecht, 1992 (BOC).

————. *Brentano and Intrinsic Value.* Cambridge, 1986 *(BIV).*

————. "Brentano and One-Sided Detachability." *Conceptus* 21 (1987): 153–59 (BOD).

————. "Brentano's Theory of Judgment." *Brentano and Meinong Studies,* Amsterdam (1982): 17–36 (BTJ).

————. "Events, Propositions, and States of Affairs" (1976), with a discussion. In *Ontology and Logic,* ed. Paul Weingartner and Edgar Morscher, 27–57. Berlin, 1979 (EPS).

————. *The First Person.* Sussex, 1981 *(FP).*

————. "Objects and Persons: Revision and Replies." *Grazer Philosophische Studien* 718 (1979): 317–88 (OPR).

————. *On Metaphysics.* Minneapolis, 1989 *(OM).*

————. "On the Positive and Negative States of Things." *Grazer Philosophische Studien* 25–26 (1985–1986): 97–106 (PNS).

————. *Person and Object.* London, 1976 *(PO).*

————. "Replies." In Roderick M. Chisholm, ed. Radu J. Bogdan, 195–216. Dordrecht, 1986 (Replies).

————. "Self-Profile." In *Roderick M. Chisholm,* ed. Radu J. Bogdan, 3–77. Dordrecht, 1986 (SP).

Ducasse, C. J. "Facts, Truth, and Knowledge." A Symposium on Meaning and Truth. *Philosophy and Phenomenological Research* 5 (1945): 320–32 (FTK).

Frege, Gottlob. "Die Verneinung." In *Logische Untersuchungen,* ed. G. Patzig, 54–71. Göttingen, 1976 (Verneinung).

Husserl, Edmund. "Besprechung von K. Twardowski." In *Aufsätze und Rezensionen,* Hua 22, ed. B. Rang, 349–56. The Hague, 1979 (BT).

————. *Logische Untersuchungen.* Hua 18. Ed. E. Holenstein. The Hague, 1975; Hua 19. Ed. U. Panzer. The Hague, 1984 *(LU).*

Kant, Immanuel. *(Jäsche's) Logik: Schriften zur Metaphysik und Logik.* Vol. 2. Ed. W. Weischedel. Stuttgart, 1977 *(Logik).*

————. *Kritik der reinen Vernunft.* Stuttgart, 1980.

Mulligan, Kevin, Peter Simons, and Barry Smith. "Truth-Makers." *Philosophy and Phenomenological Research* 44 (1984): 287–321.

Pasquarella, Lynn. "Brentano and the Direct Attribution Theory." *Brentano Studien* 1 (1988): 189–97.

Reinach, Adolf. "Zur Theorie des negativen Urteils" (1911). In *Sämtliche Werke,* ed. K. Schuhmann and B. Smith, 95–140. München, 1989 (TNU).

Simons, Peter. "Logical Atomism and Its Ontological Refinement: A Defense." In *Language, Truth, and Ontology,* ed. Kevin Mulligan, 157–79. Dordrecht, 1992 (LA).

Twardowski, Kasimir. *Zur Lehre vom Inhalt und Gegenstand der Vorstellungen* (1894). München, Wien, 1982 *(IGV).*

REPLY TO MARIA VAN DER SCHAAR

I find myself in agreement with most of what Professor van der Schaar says in her paper "Judgment and Negation." She has obviously studied my writings with great care and she has set my views in what for me is a new and enlightening perspective. Space limitations make it necessary that I discuss only some of the many questions that she raises.

I will emphasize the problem of *negative attributes*, therefore I will not discuss the later theory∘of direct attribution. For that theory is not strictly relevant to the problems about negative attributes. And I will not hesitate to speak of *propositions*, even though it will be clear from the discussions of other papers that I think that these entities are not included among the ultimate constituents of reality.

It may be useful to the reader if I summarize my present views. Like van der Schaar, I find Twardowski's fourfold terminology of *act, subject, content,* and *object* especially useful. It is by means of the *content* of *an act* of judging that the *subject* whose act it is directs the act upon its *object*. We do not need to make the matter any more complex than this. Hence we can avoid such concepts as Husserl's "*noema.*"

I begin, then, with the concept of *content:*

D1 x has being-F as the *content* of an act of believing =Df. x believes there to be something that is an F.

We may distinguish attributes that are *contingent* (being red, being a unicorn) from attributes that are *noncontingent* (being red or not red, being a round square). It is relatively easy to make a distinction between *positive* and *negative* in the case of contingent attributes. It is more difficult in the case of noncontingent attributes.

D2 P is a contingent attribute =Df. (1) P is not necessarily such that everything has it; and (2) P is not necessarily such that everything fails to have it.

D3 The attribute N is the negation of the attribute P =Df. P and N are necessarily such that: (a) nothing can have both at once; and (b) whoever can have N as the content of an act of a believing can have P as the content of an act of believing; and (c) N is possibly such that it is exemplified by everything.

A *negative* attribute is an attribute that is the negation of an attribute. A *positive* attribute is an attribute that is not a negative attribute.

The final clause in the definition of the negation of an attribute (D3) is suggested by Aristotle. He pointed out, in effect, that if nothing had the positive attribute, *being red*, then everything would exemplify the negative attribute, *being nonred*. See *De Interpretatione*, 17a75.

DISJUNCTIVE AND CONJUNCTIVE ATTRIBUTES

Our account of disjunctive and conjunctive attributes makes use of the following definition of conceptual entailment:

D4 The attribute P *conceptually entails* the attribute Q =Df. P is an attribute which is necessarily such that whoever has it as the content of an act of believing has Q as the content of an act of believing.

D5 The attribute D is a *disjunction* of attributes P and Q =Df. (1) D is necessarily such that it is exemplified if and only if: either P is exemplified or Q is exemplified; (2) P does not conceptually entail D; and (3) Q does not conceptually entail D.

Van der Schaar raises the following question about disjunctive attributes: How do we decide whether the form of a given disjunctive attribute is $p \vee q$ or $-(-p \& -q)$? I would say that the question is like: How do we decide whether the form is $p \vee q$ or whether the form is $q \vee p$? The question has to do only with the language in which we happen to be expressing ourselves. The contents of the linguistic expression tell us nothing about the content of the judgment. I suspect that van der Schaar may agree, for she emphasizes that the nature of the *linguistic act* does not affect the *unity* of the content of the *judgment*.

D8 The attribute C is a conjunction of the attributes P and Q =Df. C is the negation of that attribute which is the disjunction of the negation of P and the negation of Q.

Since my views with respect to states of affairs have undergone a kind of "Kopernikanishe Wendung," I should make clear one terminological point in order that that the reader will not be misled. In earlier writings I

had thought that *states of affairs* could be regarded as a type of abstract object and that abstract objects could perform all the functions that others were assigning to "concrete events." But I now believe that *attributes* (properties) are the only things that are abstract. And I believe that contingent things may be divided into those that are *states* and those that are *individual things*. But van der Schaar, in discussing my views, sometimes uses "state of affairs" to refer to what I now call "states."

Professor van der Schaar begins and ends with a reference to the problems that had concerned Parmenides. For example: How can we think *that which is not*? And she concludes by comparing my view with that of Parmenides. I cannot resist the temptation to quote what she says:

> An interesting question is whether Chisholm has a comparable notion in his philosophy; that is a notion of *truth* or *existence* which does not have a counterpart, that is, a notion of *asymmetric truth*. Chisholm's notion of *obtainment* cannot fulfill this role. Both obtaining and nonobtaining states of affairs exist in the same way. Is there a more fundamental notion on Chisholm's account; that is, a notion which makes the distinction between true and false propositions, or that between obtaining and nonobtaining states of affairs, possible, and which has no opposite? For Chisholm, *exemplification* is one of the most fundamental notions. It has no opposite: a simple state of affairs obtains, if an object exemplifies a certain attribute. In the case of a nonobtaining state of affairs, there is no parallel situation, because there is no relation of nonexemplification between the object and the attribute concerned: there is just nothing. Therefore, I think that *the relation of exemplification* is meant to fulfill the role of Parmenidean truth in Chisholm's philosophy.

Everything, of course, exemplifies something. There *are* things that are not exemplified: certain attributes and everything that's not an attribute. Can we think of that which is not? Only in a roundabout way—by thinking of that which *is*. Those who looked for the Fountain of Youth were looking for *something* but there *wasn't anything that they were looking for*. This is the puzzling thing about intentionality.

We need not say, as Brentano and Reinach had done, that there are *negative acts of judging*. We may *withhold* judgment, but withholding is not judging. And *deliberate withholding*—deciding not to affirm—is itself an affirmative act.

My alternative to Parmenides, so far as nonbeing is concerned, is Platonic and intentional. I am inclined to think that Professor van der Schaar is right in what she says about the role of *exemplification* in my philosophy.

R.M.C.

14

Robert Audi

CHISHOLMIAN JUSTIFICATION, CAUSATION, AND EPISTEMIC VIRTUE

K nowledge is of truths and is thereby supposed to connect us with reality. Justification is supposed to indicate that we may take beliefs that possess it to be true and thereby to connect us with reality. A natural explanation of these apparent facts, at least for empirical knowledge and belief, is that both knowledge and justified belief are produced or sustained, in a broadly causal way, by some element in reality.[1] Commonly, the cause is thought to be closely connected with the content of the knowledge, or of the justified beliefs, that are produced or sustained by that cause. I may know that a squirrel has dashed across the roof because of the rapid patter I hear: presumably, the squirrel's dashing across the shingles causes this distinctive patter, which, in turn, produces my auditory sensations of that sound; and those sensations cause me to believe that a squirrel has just dashed across the roof overhead. The same pattern of events seems equally well suited to produce justification for belief that a squirrel has just dashed across the roof, and it might be thought that one reason for the close association between justification and knowledge is precisely that both are causally grounded in the sort of way this example illustrates. In the epistemology of Roderick M. Chisholm, however, causal conditions of knowledge and, especially, justification, play what appears to be a minor role. It is interesting to ask why this should be. It is also interesting to ask whether causal conditions

might play a larger role in his epistemology without undermining anything fundamental in it. These are my main questions. Given the scope and richness of Chisholm's epistemological work over the years, I cannot pursue these questions in the detail they deserve. To make the task manageable, I shall concentrate more on justification than on knowledge and take as main texts, though not my only texts, Chisholm's far-reaching essay, "A Version of Foundationalism," and his latest edition of *Theory of Knowledge*.[2]

I. THE ROLE OF CAUSAL REQUIREMENTS IN CHISHOLM'S EPISTEMOLOGY

Let us start with justification. In "A Version of Foundationalism" (and elsewhere) Chisholm takes as undefined the locution '—— is more reasonable than —— for s at t'.[3] Consider next another crucial Chisholmian notion, the self-presenting: "The mark of a self-presenting property is this: every property it entails is necessarily such that, if a person has it and also considers whether he has it, then *ipso facto* he will attribute it to himself."[4] My apparently hearing squirrel sounds is like this: if, when I have the indicated property of—as we might put it for brevity—hearing squirrelishly, I consider whether I have it (e.g., ask myself whether I do hear in this way), then I attribute this property to myself (which is at least roughly equivalent to my believing myself to have it). It is natural to think that my having such a property (causally) produces or sustains such an attribution in me when I consider whether I have it; but Chisholm says nothing committing him to this, and so far as I can see he consciously avoids making any such commitment.

 None of the various epistemic principles Chisholm proposes in "A Version of Foundationalism" clearly commits him to any causal conditions on the justifiedness of belief, and I believe that the same may be said for the entire list of principles he endorses in *Theory of Knowledge* (the second edition of which contains a convenient list as an appendix). Since falsehoods cannot be known and (propositional) knowledge by its very nature has truths as its objects, one might think that Chisholm would have a causal condition on knowledge even if he applies none to justification. But consider the following definition from the third edition of *Theory of Knowledge*: h is known by S = Df. (1) h is true; (2) S accepts h; (3) h is evident for S; and (4) if h is defectively evident for S, then h is implied by a conjunction of propositions each of which is evident for S but not defectively evident for S.[5] The explication of the crucial

locutions here will not, I think, yield the conclusion that Chisholm is committed to any causal conditions for knowledge, at least for any elements in knowledge other than those implied by the mere truth of the belief constituting the knowledge and, of course, by possession of that belief. *Roughly*, the point is that he seems uncommitted to any causal conditions on whatever it is that distinguishes knowledge from mere true belief. Let me develop this last point.

Plainly, if what I know is that a lighted match is causing a piece of newspaper to ignite, there is a causal condition on my knowledge of this proposition; for I cannot know what is not the case, and here the proposition I know is a causal truth: a truth that holds only if the world actually contains the causal situation described by that truth. But this point has no bearing on whether causal conditions must figure in either (1) the *grounds* of knowledge or justification or (2) the production or sustenance of justified belief or of belief insofar as it constitutes knowledge. The crucial question is whether causal conditions may, for Chisholm, figure importantly in the epistemic status of knowledge or justified belief, not whether they may be essential, as just illustrated, to the truth of the proposition known or justifiedly believed. One might think that insofar as perception is required for knowledge or for certain justified beliefs, Chisholm might impose a causal requirement on the application of the latter concepts. If, for instance, the squirrel's dashing across the roof does not play any causal role in my believing that it is doing so, then I apparently do not *hear* it do so, and hence do not know, through my hearing the relevant sounds, that it has dashed across the roof.[6] But it is not altogether clear that Chisholm so conceives perceptual justification and knowledge, at least in recent published works. In the third edition of *Theory of Knowledge*, for example, he defines the perceptual locution he thinks most important for perceptual knowledge in terms of perceptual taking, and the latter in terms of being appeared to. The key definitions are these:

> *S takes* there to be an F = Df. (1) S is appeared —— to; (2) it is evident to S that he is appeared —— to; and (3) S believes that there is only one thing that appears —— to him and that thing is F.

and

> *S perceives* that there is an F = Df. (1) There is an F that is appearing in a certain way to S; (2) S takes there to be an F that is appearing to him in that way; and (3) it is evident to S that an F is appearing to him in that way.[7]

One cannot perceive there to be an *F* unless there *is*, but nothing said here entails, or is said by Chisholm to imply, that the *F* must produce or sustain, say, one's being appeared to in a certain way; nor is it implied that one's belief constituting perceptual knowledge must be causally grounded in any such phenomenal state in order to qualify as such knowledge.

One might think, however, that a thing cannot appear a certain way to *S* unless it is causing something in *S*; and in at least one place Chisholm comes close to implying this:

> Can we then, characterize "y appears redly to x" in terms of being appeared to redly and certain causal concepts? Here we must presuppose the concept of *functional dependence*: if y appears in a certain way to x, then the way x is appeared to will be functionally dependent on the nature of y. . . . y will be so related to x that, merely by varying y continuously with respect to certain of its properties, one can vary continuously the way in which x is appeared to. . . . And analogously for the other sense-modalities.[8]

Chisholm does not say here that the functional dependence is causal, but he certainly seems to allow that it is. If it must be causal, we may conclude that he does take, as essential to *perceptual* knowledge, a causal connection between that knowledge and the object(s) it is about. This in no way implies, however, that any such causal connection is essential to the *justification* of the belief in question, the one that will constitute perceptual knowledge in the absence of any defeater; and in the light of the literature since the Gettier problem came to prominence it has become clear that no such condition (one linking the person in question to an external object) is appropriate for justified beliefs of this kind. Even where one has a hallucinatory "perceptual" belief that a squirrel dashed across the roof, the sensory elements grounding its justification may be phenomenally indistinguishable from those that, if one actually heard the squirrel, would be functionally dependent in the right way on the animal's movements and would enable one to know that a squirrel dashed across the roof.

The kind of justification one has through an hallucinatory experience may be defective (to use Chisholm's own quite appropriate term), but it is still a kind of justification crucial for understanding both justified belief and knowledge. There is, I think, an important distinction here, and to make it we might speak of *perceptual justification* of a belief in reference to the kind of nondefective justification Chisholm has in mind as a component in perceptual knowledge, and of *sensory justification* in reference to the kind one has when one's experience is phenomenally indistinguishable from a kind through which one does or would have perceptual justification. We may then say that, on Chisholm's view (at

least in many recent works) sensory justification, though always a constituent in perceptual justification, does not entail perceptual justification.

The functional dependence that Chisholm cites as essential in being appeared to by an external object is not only not necessary for sensory, as opposed to perceptual, justification; it is not sufficient either. I would maintain (and I think Chisholm would agree) that the mere fact of a functional dependence between perceptible properties of an object and how I am appeared to does not give me the relevant kind of justification. I could be hooked up to a machine which creates such a dependence between what is projected on a movie screen in the next room and my visual sensations. But even if, for this reason, it suddenly looks to me as if a column of battle tanks is passing before my eyes just outside my window, this visual experience may not—given my background beliefs and the absence of supporting auditory sensations—justify me in believing that there are tanks before me. One way to see this is to notice that insofar as I am an epistemically rational person, I will not believe, in this case, that things are as they seem, and will indeed tend to disbelieve that. One might reply that I do have some degree of prima facie justification, but it is so overwhelmingly overridden that I appear to have no justification whatsoever. Perhaps this is a reasonable way to view the matter; but even if it is two points remain unaffected. First, there can be a functional dependence on random processes that produce such irregular experiences as to make it questionable that I would even acquire prima facie justification for the corresponding propositions. Second, and more important, our chief concern here is justification simpliciter, which (for our purposes here) we may take as roughly the kind such that, when one believes p on the basis of it, then if there is no "Gettier problem" one knows that p. Alternatively and again roughly, S justified (simpliciter) in believing p provided S has the kind of justification appropriate to serve as the basis on which an epistemically rational person believes p.[9]

I bring in the notion of an epistemically rational person in part because so much of Chisholm's work bears on it and in part because it is of great general interest in epistemology. It is also a device by which to narrow our discussion to a manageable topic, namely the place, if any, of causal requirements in Chisholm's conception of justification, as opposed to (though not entirely abstracted from) knowledge. *One* way to put this is to say that I want to focus on justification internally conceived. As we shall see, this internalist conception accords well with the Chisholmian approach to justification.

II. Epistemic Internalism and Causal Requirements on Justification

As Chisholm himself characterizes internalism in epistemology, "The internalist assumes that, merely by reflecting upon his own conscious state, he can formulate a set of epistemic principles that will enable him to find out, with respect to any possible belief he has, whether he is *justified* in having that belief."[10] Now it is easy to see how one might, by such reflection, find out how one is appeared to; and, if we allow reflection on one's "conscious state" to include conceptual reflection, we might also grant that one might discover such principles as this: if one is appeared to redly, then one is justified in believing that there is something red before one. But it is far from evident that reflection on one's conscious state would enable one to find out that one's belief that there is something red before one is causally produced or sustained by an appearance state. After all, it might turn out, as Hume certainly would have argued, that all one is aware of in such a case is a *conjunction* of the belief with its justifying ground and perhaps of a constant conjunction of beliefs of this sort with grounds of that sort.

This and similar points probably explain why Chisholm says that "according to the internalist theory of justification that is presupposed here, epistemic *justification* is not a function of the *causes* of one's belief."[11] In appraising what seems to be Chisholm's overall position here, I want to note a possible ambiguity. When he speaks of being "*justified* in having" a belief, of being justified in believing, and of epistemic justification, his locutions can be applied both to (a) a proposition's being justified for a person—for short, *p*'s being justified for *S*—and to (b) a person's justifiedly believing a proposition. As I have elsewhere argued,[12] (a) does not entail believing that *p*; but (b) does. Call the first case *situational justification*, since what is essential is the presence of a justification for *p* in *S*'s epistemic situation; an appearance of red, for example, can justify, for *S*, believing there is something red before one, whether *S* in fact believes this or not. Call the second case *doxastic justification* (now a common term for it), since it is a property of an actual justified belief. To my knowledge, Chisholm does not explicitly work with this distinction nor, more important, discuss whether a causal requirement might be necessary for one, but not the other, of these two cases of justification.

It seems to me quite clear that there is one kind of causal connection that is a good candidate for a condition on doxastic justification, but not a good candidate for a condition on situational justification. This is the relation of causal production or sustenance of a belief by at least one

ground that is evidentially sufficient to justify the proposition in question. Let us take situational justification first.

Very much as one can be justified in drawing an unflattering conclusion about a friend and yet not draw it, one can be justified in believing *p* without in fact believing it. Moreover, here as elsewhere one can be justified by the evidence one has, say in the form of information in one's active memory, without that evidence playing any causal role regarding one's believing *p*. There are two cases that are especially relevant here: in the first, one does not believe *p* at all; in the second, one believes it entirely for "reasons"—for example, jealousy—utterly independent of one's evidence. The reasons here are explaining, but not justificatory, reasons—reasons *why* one believes it, not (adequate) reasons *for* believing *p*, or reasons for believing *p* at all.

By contrast, causal production or sustenance by an adequate ground—evidential *causal grounding*, for short—is a good candidate for a necessary condition on doxastic justification. There is a quite substantial literature on this topic,[13] and here I will have to settle for simply giving an example that will evoke some of the important intuitions. Recall jealousy. Jay, from jealous feelings rather than on the basis of the evidence, believes an unflattering proposition about Faye. Compare a case in which he has an obligation to pay Jorge $100 but Jorge does not know it (either because he has forgotten a loan to Jay or because, though there was no loan, unbeknownst to Jorge, Jay is obligated to pay it to him only because Jay promised a third party to pay it to Jorge). If Jay then gives Jorge a $100 going-away present in order to curry favor with him, this is, as Kant would put it, acting in conforming with duty, but not from it. It is not acting *dutifully*, but only doing what duty demands. Similarly, it may be argued, Jay's believing what the evidence requires, but not at all for an evidential reason, is believing in conformity with the evidence, but not *evidentially*—and not *justifiedly* so far as that requires responding to the evidence in the way an epistemically rational person would.

Supposing Chisholm could be convinced that there is a kind of justification that requires evidential causal grounding, would he have to choose between endorsing it and giving up his internalism? It seems not unlikely that he has thought so, or tended to think so. But is it obvious that I cannot tell, just by reflection—though perhaps very extensive reflection—on my (total) conscious state, including what I bring into it by asking myself questions relevant to the grounds for believing *p*, and on the concepts required to describe *p* adequately from an epistemic point of view, both whether I have adequate grounds for *p* and whether

those grounds are at least partial producers or sustainers of my belief that p?

There are three questions here: first, whether I can tell by reflection what grounds I have for p; secondly, whether I can tell by reflection if these grounds are adequate; and thirdly, whether I can determine by reflection if one or more of the grounds in question are at least partial producers or sustainers of my belief that p. I want to give a qualified positive answer to the first two questions, and to that extent I join Chisholmian internalism: normal, rational adults can, at least in many cases, tell by reflection whether they *have* grounds for a proposition they believe, what those grounds are, and whether they are adequate; for example, they can note what they are experiencing or what they believe that seems to provide grounds relevant to it, and can often see that these grounds clearly imply that p or bear some other adequately strong evidential support relation to p. There are many descriptions under which one might be able to describe one's adequate grounds. One might be aware of something one thinks of as showing p, telling one that p, making it clear that it, confirming that it, and so forth. No particular espistemic concept need be involved in such awareness; indeed, apparently none at all need be: it is enough to be able to see that if the ground in question obtains, say if there are those squirrelish pattering sounds on the roof, then p (a squirrel dashed across the roof).

The second question—whether the grounds I have for p are at least in part what produces or sustains my belief that p—is more difficult. But I think that normally, at least for the beliefs I hold which seem justified, I can, by reflection, readily know, or at least form justified beliefs about, why I believe the propositions in question. Granted, I am fallible here; but we need not take fallibility to imply the impossibility of knowledge or, especially, justified belief, and I do not see why anything central in Chisholm's epistemology requires him to hold otherwise. Indeed, if it is reasonable to grant Chisholm a positive answer to the first two of our questions, then the situation is less serious than I have been suggesting. For suppose I know that I have adequate grounds for believing p. Why should the question whether one of them produces or sustains my belief that p be any more difficult than the question whether, say, my making rolling movements on a tire is causing its movement along the pavement? Nonskeptics will allow knowledge or at least justified belief in both cases, and it is arguable that the "inner view" of apparent causal connections is in fact more nearly complete and, overall, more favorable to knowledge and justification, than the outer view, such as I have of the relation between my hands and the tire. To be sure, the tire may be on a slightly downward path, which would make it more difficult to ascertain

what contribution I am making to its movement; similarly, one's evidential grounds may be accompanied by a nonevidential tendency to believe it, for instance a tendency due to deep-seated prejudice. But, in my experience at least, the pull of prejudicial and other nonevidential factors feels different from that of evidential ones, even if the difference is less pronounced than that between pushing a tire and merely following it with one's hands. Here, then, is a line of argument by which (with suitable qualifications) Chisholm might accommodate an evidential causal requirement on doxastic justification.

There are, however, some elements in his view which would incline him to proceed otherwise. One is his objectivity principle, which may be as close as he comes to endorsing the principle that knowledge implies knowledge that one knows:

> The *objectivity* principle tells us what *kind* of justification we can have for beliefs *about* justification:
>
> If S knows that p, then, if S believes that he knows that p, then he knows that he knows that p.[14]

Two points are noteworthy here. The first is that Chisholm is closely associating justification and knowledge in a way implying that knowing one knows encompasses both knowing one is justified (at least situationally) and justifiably believing one is justified. The second point is directly relevant to the question why Chisholm might reject the evidential (causal) grounding requirement: if any such requirement is true, how could one plausibly think that merely truly believing one knows implies knowing one knows? It is difficult enough to see how the objectivity principle is plausible without such a requirement—since, for one thing, without any need for causal grounding of a belief constituting knowledge, one might believe, for the wrong reasons or for none—for example, from wishful thinking—that one knows. (Chisholm probably has in mind, however, *reflectively* believing that one knows p, and this would be unlikely to occur if one did not believe *for* some reason.) If, on the other hand, one holds a causal grounding requirement, one may be less likely—or at least an internalist may be less likely—to hold the objectivity principle. For if something apparently "outside" the mind must be true (beyond the external requirements for the truth of itself) in order for one to know or be justified in believing that one knows, it will seem unlikely that mere reflective belief that one knows will, where one does know, imply that one knows.

I speak of the causal elements crucial for the evidential grounding requirement as 'apparently outside the mind' because, if the grounds of knowledge or at least justification are internal, then their producing or

sustaining a belief justified by them may also be construed as internal (though, of course, not necessarily as phenomenal). I do not propose to defend the objectivity principle, or even to show how it might be consistent with an evidential grounding requirement; but the next section will suggest how the two standards might jointly hold, or at least how some of what seems to be Chisholm's antiskeptical motivation for the principle can be preserved if he should adopt an evidential grounding requirement.

III. A QUALIFIED CAUSALIST INTERNALISM

It will be helpful at this point to return to the notion of internalism introduced by Chisholm and to compare it with a weaker notion that fits with most of his overall views in "A Version of Foundationalism" and at least the third edition of *Theory of Knowledge*. For it seems clear to me that given how good a case there apparently is for an evidential grounding requirement, it would be desirable to know how much an important epistemology like Chisholm's would have to be modified to accommodate it.

It is essential here to distinguish first- and second-order internalist views. The former maintain that what justifies a first-order belief—its evidential ground—is in some sense internal; thus, what justifies my belief that a squirrel dashed across the roof is my auditory sensations (given suitable background beliefs). The latter hold that there are internal grounds of the justification of second-order beliefs—such as (in Chisholm's view as quoted above) epistemic beliefs—regarding one's first-order beliefs, to the effect that they are or that they are not justified. Thus, I might be justified in believing that I am warranted in believing a squirrel dashed across the roof, because I have a sense of my internal ground for it and I know an epistemic principle licensing the first-order belief on the basis of that ground. The second view is not plausible apart from the first, but the converse does not hold. Why should we need the second view? If, by reflection—and, in that important sense, internally—I can become aware of what justifies any given justified belief of mine, then (assuming I have a working grasp of a concept of justification and a sense of what sorts of factors confer justification) I can, through reflection, give a justification for a justified belief I hold if asked for one, seek a justification for a belief I hold for which I think I lack one, assess whether I often harbor beliefs for which I have no such justifier, and maintain a self-critical attitude appropriate to the results of such inquiries. These pursuits are important elements in what Chisholm

has aptly called "critical cognitivism." What more do we need to incorporate an evidential (causal) grounding requirement into a plausible internalist epistemology?

If we are preoccupied with the skeptic, we may certainly want more. For even if we think that the skeptic's case against our having knowledge and justified belief fails, we want to show that we do in fact have them. But to show this, we must apparently invoke epistemic principles: if, for instance, one wants to show that one justifiedly believes there is something red before one, it is not enough to cite being appeared to redly; one needs a principle such as this: if S is appeared to redly, then S is justified in believing that there is something red before S. Now it is plausible to hold, and Chisholm might allow, that given first-order internalism and the possibility of arriving at epistemic principles by reflection on the concepts we may plausibly suppose are involved in first-order reflection, one could show that we have situational justification (a possibility for which I have argued in detail elsewhere).[15] But showing this would fall short of showing that we have doxastic justification—if such justification requires that the belief in question be causally based on a sufficient ground. When we have doxastic justification, we justifiedly believe, where *justifiedly* believing is believing *with justification*, as opposed to simply *justifiably* believing, i.e., believing while *having* a justification (which might or might not be "used"). And if doxastic justification is subject to an evidential grounding requirement, showing that we have good grounds, and thereby have justification *for* believing *p*, is not sufficient for showing that we have doxastic justification *in* our belief that *p*.

This last point brings us back to the question whether we can, by reflection, know or justifiedly believe the needed propositions about the causal basis of our justified beliefs. I have indicated some reasons for a positive answer. Chisholm is not (so far as I can see) precluded from giving such an answer by anything major in his system, but there is also nothing major in the system that requires a positive answer. What I want to do now is explore the merits of a positive answer in relation to an important notion that has so far remained in the background—that of epistemic virtue.

IV. The Causal Dimension of Epistemic Virtue

I have pointed out that an epistemically rational agent who has a good reason for believing *p* and a nonevidential inclination to believe it will (other things being equal) believe it at least in part *for* (and so in some

causal sense because of) the good reason. If we want to name the relevant trait of intellectual character, we should of course call it epistemic virtue. Particularly in connection with the causal elements in justification, there is much to be learned from comparing moral and epistemic virtue. The comparison is also particularly apt in connection with the work of Chisholm, who has at many points drawn fruitful analogies between epistemology and ethics.[16]

Let us start with a kind of case that raises difficulties for the view that by reflection we can know the sort of thing we need to know if we are to have "internal access" to causal conditions of justification. If I give a grade of A in the interest of getting a better teaching evaluation, I exhibit a moral vice. But suppose that I have a good academic reason to give an A, but would also like a positive teaching evaluation from the student in question. As Kant saw, it would still be exhibiting a moral vice to give an A *in order to* get the evaluation. But it could be hard to tell, by reflection, whether I have been influenced by that nonmoral desire (and Kant apparently thought one could never tell). I can, however, ask myself what I would have done without the academic reason and also without the other motive; I can consider the academic reason and note how cognitively moved by it I feel—roughly, how persuasive the reason seems; I can even remind myself of my ideals and commitments and note the extent to which they reduce the felt pull of the improper reason and enhance the sense of the persuasiveness of the academic one. It seems to me that in at least most such cases careful reflection will give me justified beliefs about whether the academic reason was necessary and (given supporting conditions such as noninterference from ill-health and from demonic brain manipulators) sufficient to produce my action.

It is more difficult to determine whether an improper reason I have is an *influence* on my belief, but not a major producer or sustainer of it; but I would maintain that if a good reason is necessary and sufficient, then the additional influence of an improper reason does not prevent my action from being virtuous overall. It is not purely or paradigmatically virtuous, but I am at least acting from virtue and, in one sense, "fully" for a good reason. For instance, if I am influenced at all toward giving a grade of A by the desire for its contribution to higher teaching evaluations, then my giving it is not an action purely from virtue; but if my academic reasons are necessary and sufficient, and the nonacademic factor simply adds to my total motivation (and so, for example, to my resistance to being deterred if competing considerations arose, such as pressure to give lower grades to reduce grade inflation), then my action is academically responsible. To be sure, I should *try* to be entirely uninfluenced by nonacademic reasons, as an epistemically rational person

should try to be uninfluenced, in forming or retaining beliefs, by nonevidential factors. But this is mainly because these factors can easily overshadow good reasons; it is not because, even when they are over-shadowed by good reasons and are merely influences on action, they still undermine the justificatory force of those reasons. Much the same holds in the domain of belief.

So much for the most difficult kind of case. It is important to see that very commonly we do not have (in the relevant internal sense) nonevi-dential grounds for our beliefs, or are at least not inclined to believe on the basis of them. Here the sense that one believes on the basis of a ground one has is surely far more reliable. If the only ground I am aware of (or can become aware of with reflection) for my believing a squirrel dashed across the roof is my auditory sensations, and it seems to me that I believe this *on* that ground, it is at least very likely that I do. For normal persons, this may indeed be a noncontingent truth.

In one way, our fallibility about the extent of our moral virtue is good: properly appreciated, it keeps us from becoming self-satisfied and it provides an incentive to be self-critical. It also provides an incentive to gather reasons that are more than merely adequate. For on the plausible assumption that we are more likely to act for good reasons the better (and more vivid) they are, it conduces to virtue to have more and better reasons available in the context of decision. Similarly, it conduces to virtue to be clearer on what our standards of conduct are and to be ever more aware of, and more keenly devoted to, those standards. Knowledge of virtue, then, has at least two sides: there is the scope and reliability of our cognitive access to what our reasons for a given action are and the scope and reliability of that access to their effects on us. Fortunately, we are not merely passive in this matter. There is also our own influence on the sorts of reasons that get into this field; we may search out relevant considerations and identify additional reasons, pro and con, regarding our options. In this way, we may bring out, by contrast with the new reasons, the identity and apparent influence of the reasons we already had. If we are rational, then the better our reasons are, the better our cognitive access (other things equal) to the reasons why we act.

Epistemic virtue is surely parallel to moral virtue in all the respects I have noted. The most important parallel, however, concerns the scope of our knowledge and justified belief regarding the causal role of our evidential grounds for belief. The techniques by which we may deter-mine, through reflection, why we believe a certain proposition are much like those by which we may determine why we have performed a certain action. Indeed, when it comes to justified belief, we *may*, if we are rational, be better off: moral agents will commonly encounter self-

interested reasons aligned with their moral reason(s), where the former are not without weight from the point of view of rationality, yet are improper or suboptimal from a moral point of view, say because they are selfish; but there are fewer reasons to believe (and perhaps even fewer potential nonevidential influences on belief) that are both improper from an evidential point of view *and* aligned with evidentially good reasons in the way self-interested reasons are often aligned with moral ones. Morality takes a dim view of a huge range of common and even natural influences on action: we are to try to avoid acting on them and, so far as possible, even being swayed toward action on them. Consider epistemic rationality, by contrast: the gambler's fallacy, jealousy, and the need for self-esteem can certainly influence belief, but these align with good reasons for belief much less often than, say, selfish motives align with morality. So where we have justified belief, and to that extent exhibit epistemic virtue, if we can, as Chisholm insists, know by reflection what justifiers we *have*, it is not likely to be often that we even have to wonder whether bad reasons we have might explain our belief and thereby (given the causal requirement on evidential justification) undermine its justification. We will not very often *have* aligned bad reasons; and even if we do, this will not imply that the good reasons are not sufficient to explain the belief in question. Chisholm might allow, as indeed seems reasonable, that even if believing in part owing to a bad reason detracts from epistemic virtue, believing for an evidentially adequate reason influential enough to be also psychologically sufficient is thereby a case of justified belief. And just as a moral person who has nonmoral reasons aligned with moral ones, tends to act substantially *for* the moral ones, an epistemically virtuous agent who has bad reasons for *p* aligned with good ones, tends to believe substantially for the good ones.

Perhaps this contrast between the moral and doxastic cases reveals an optimistic view; and certainly it is possible for a person to be whole-heartedly devoted to morality yet suffer from many irrational influences on action, and wholeheartedly committed to rational standards of belief, but often swayed to believing by irrational factors. Moreover, some irrational influences are more important than others: one sufficiently controlling irrational belief might affect a person's life far more than a whole series of irrational or immoral actions. This is an interesting issue I cannot pursue. I simply want to suggest that *for* rational persons, in the main, rational belief seems threatened by aligned irrational forces that may preempt one's evidential grounds less often, or at least less signifi-cantly, than moral action is threatened by aligned immoral influences that may overshadow one's rational grounds.

Whatever we decide on this comparative matter of degree, it is plain

that our reflective access to why we believe and to why we act is, even if quite extensive, fallible. This limits the force of any attempt to *show*, whether for our own satisfaction or against the skeptic, that we have knowledge or at least justified belief. But unless we grant far more to skepticism than I would, or, I think, Chisholm would, I cannot see that all such attempts must fail. We allow that often one can know that one is or that one is not acting from virtue, but not that we can always know or justifiedly believe this of one's morally significant actions. This is possible even if a strong second-order internalism such as Chisholm, in places, is attracted to, cannot be sustained. I believe that in epistemology, as in ethics, a first-order internalism is sufficient both for purposes of rooting justification "in the mind" and as a bulwark against skepticism, one that is arguably better than can be provided by leading externalist views.[17]

If this conclusion is mistaken and a second-order internalism is required to provide internalists with an adequate bulwark against skepticism, there is still the question of whether we are fallible about what our grounds for believing *are* and about how good they are. I think we are fallible about both even when we reflect carefully on the matter, and, secondly, that our justification in such cases is probably no better than our justification for beliefs about the causal conditions relevant to doxastic justification, so that we might as well be willing to live with a similar fallibility concerning why we believe what we do when we have reasons that seem to be both our causal and our evidential basis. Chisholm might well dissent from at least the second claim. He might then have to reject the attempt to incorporate an evidential causal requirement into his overall internalist view. If he should do that, then I think he would be providing an account only of believing in accordance with epistemic virtue, and not of believing *from* such virtue. That would be highly significant, but would yield a less comprehensive epistemology. We might be able to say what it is to believe within one's epistemic rights, so to speak; but we would not provide a good way to discriminate between those who do so from epistemic virtue and those who do so from good fortune, such as the good fortune of not having the actual causes of their beliefs lead them to form too significant a set of beliefs not matched by adequate grounds.

To review the overall work of this paper, I have addressed what seems to me a missing element in Chisholm's epistemology: an account of the place of causal connections in knowledge and, especially, justification. I have suggested why such an account is needed and have outlined a causal condition on justification which seems compatible with Chisholm's major epistemological tenets. There are some difficulties in squaring

such a condition with internalism, but I think that they can be overcome, and that indeed Chisholm's own view can overcome them without major revisions. He would not even need to give up a second-order internalism, even if he might have to modify his thesis at that level to take account of the extent—whatever it is—of our fallibility about the causal connections between our justifying grounds and the beliefs they justify. If he has not given us all that is needed for a full account of justification and knowledge, he has certainly laid out a good set of foundations. My proposal here is that, given their strength, he can build on them more than he so far has.[18]

ROBERT AUDI

DEPARTMENT OF PHILOSOPHY
UNIVERSITY OF NEBRASKA
MARCH 1994

NOTES

1. Alvin Plantinga is a recent writer who appeals to causal connections in this way. See *Warrant and Proper Function* (Oxford: Oxford University Press, 1993). An especially useful aspect of Plantinga's discussion is his consideration of the possibility of a causal connection even between objects of a priori knowledge and its possessors.

2. "A Version of Foundationalism" originally appeared in *Midwest Studies in Philosophy* 5 (1980), but is reprinted, with some revisions, in Chisholm's *The Foundations of Knowledge* (Minneapolis: University of Minnesota Press, 1982). *Theory of Knowledge* has appeared in its 1st, 2d, and 3d editions, respectively, from Prentice-Hall (Englewood Cliffs, N.J.), in 1966, 1977, and 1989.

3. See pp. 6–7. Cf. the definitions of key terms in chapter 2 of *Theory of Knowledge*, 3d edition.

4. Ibid., p. 10.

5. See p. 98. The absence of causal requirements seems equally prominent in Chisholm's other characteristic definitions of Knowledge. See, for example, chapter 6 of the 2d edition of *Theory of Knowledge*.

6. I do not think it is self-evident that perception, and hence perceptual knowledge, entails some such causal connections; but this seems highly plausible, as I have argued in *Belief, Justification, and Knowledge* (Belmont, Calif.: Wadsworth, 1988), chapter 1. It should be noted, however, that some accounts of perception, such as the theory of appearing, do not entail such a causal connection. For a recent defense of this theory see William P. Alston, *Perceiving God* (Ithaca and London: Cornell University Press, 1991).

7. Chisholm, *Theory of Knowledge*, 3d edition, p. 41. Cf. "A Version of Foundationalism," pp. 18–20.

8. Chisholm, "A Version of Foundationalism," pp. 16–17.

9. I am not claiming that these two conceptions of justification are equivalent. Whether they are seems to me a quite interesting question.

10. Chisholm, *Theory of Knowledge*, 3d edition, p. 77.

11. Ibid., p. 66.

12. For instance in "The Causal Structure of Indirect Justification," *Journal of Philosophy* 80 (1983).

13. My own case for such a causal condition is developed in, for example, "Causalist Internalism" and "Rationalization and Rationality," both reprinted in my *The Structure of Justification* (Cambridge and New York: Cambridge University Press, 1993).

14. Chisholm, *Theory of Knowledge*, 3d edition, p. 15.

15. In "The Old Skepticism, the New Foundationalism, and Naturalized Epistemology," chapter 12 of *The Structure of Justification*, cited above.

16. There is a growing literature on epistemic virtue. See, e.g., Ernest Sosa, *Knowledge in Perspective* (Cambridge and New York: Cambridge University Press, 1991), Jonathan Kvanvig, *The Intellectual Virtues and the Life of the Mind* (Rowman and Littlefield, 1992), and James Montmarquet, *Epistemic Virtue and Doxastic Responsibility* (Rowman and Littlefield, 1993).

17. I argue for this comparative claim in "The Old Skepticism, the New Foundationalism, and Naturalized Epistemology," cited above.

18. For helpful comments I thank William P. Alston, Eric Kraemer, and Matthias Steup.

REPLY TO ROBERT AUDI

Audi has interpreted me entirely accurately in his careful and provocative essay. He offers the following summary, in which there are essentially two points, (1) "I have discussed what seems to me to be a missing element in Chisholm's epistemology: an account of the place of causal connection in knowledge and, especially, justification." And (2) "I have suggested why such an account is needed and have outlined a causal condition on justification which seems compatible with Chisholm's major epistemological tenets." I will attempt to adjust my views to what Audi points out in the case of (1). In so doing, I will call attention to some of the difficulties in the concept of *causing*. So far as (2) is concerned, I will note the ways in which my present views differ from the views that he criticizes.

I begin with causation. Audi does not hesitate to say that his hearing of the squirrel walking on the roof is *"caused"* by the squirrel's walking there. And he might become impatient if I asked, "Shouldn't you say, more strictly, not that the squirrel's walking there *caused* the hearing, but rather that it *contributed causally to*, or *was a partial* cause of, the hearing? After all, if you hadn't had a tin roof, you would not have heard the squirrel—so the nature of the roof had something to do with it, too." Audi wouldn't say to me, "That is being pretty petty, isn't it?" But he might well think it.

Joel Feinberg wrote an excellent essay on this point more than twenty years ago which had a profound effect on my thinking. He depicted a situation in which one might literally say: "That was the straw that broke the camel's back" and then he described the kind of discussion to which such an assertion could give rise. Prosaic people might say: "It was just the addition of the extra straw that did it." But others will claim to look more deeply. Some will say: "No, it was the stupidity of the man who led the camel" (I believe that Feinberg called him "Omar"); "he should have

known that the poor beast was about to cave in." Others will say: "No, the real cause was the greed of the camel's owner who didn't give him enough to eat." And others will blame the social system: "*That* was the real cause, you know."

What is the moral of the story? It is very important to realize that the moral of the story can *not* be put merely by saying: "Use 'contributes causally to' instead of 'causes'." For if we say that, then we must say that Omar's wife causally contributed to the breakdown by making sure that he got to work on time. And the man who raised the straw *also* contributed causally to the breakdown—and so did the fact the camel wasn't lying down. One could go on, *ad indefinitum*, in finding contributing causes for the breakdown—just as one can go on *ad indefinitum* in finding contributing causes for the fact that Audi heard the squirrel on the roof.

I can do better at the moment with perception, or perceptual belief, than I can do with the causation of other types of belief. In the case of perception, one can talk of the causal properties of *sensing*, or *being appeared to*. Audi reminds us of what I had opened the door to—such talk as "He is appeared to squirrelly," but I no longer accept "the adverbial theory of appearing." I would now say that appearances—both visual and nonvisual—are individual things. An appearance is a spatial object; it may contain a red circle that is to the left of a green rectangle.

In setting forth my views about this, I will begin with a notational abbreviation.

D1 S's sensing of an appearance is conditioned by 0 =Df. (1) S senses an appearance A; and (2) the internal properties of A are causally conditioned by those of Q.

Being-F is an *internal property* of a thing x, provided only that x has every property that being-F implies. If the exemplification of one property is thus causally dependent upon that of another, then variations in the first are causally dependent upon variations in the second.

D2 S perceives an external substance 0 =Df. (1) S's sensing of an appearance A is conditioned by 0; (2) 0 is a substance that is external to S's body; and (3) there is no M such that (a) M is external to S's body, (b) M is entirely discrete from 0, (c) S's sensing of A is conditioned by M, and (d) S's sensing of 0 is conditioned by M.

Two individual things are *entirely discrete* from each other if they have no constituents in common.

The definition is concerned with the *nonpropositional* sense of

"perception." It is presupposed by the *propositional* sense of perception ("S *perceives that* x is F"). The latter use is *doxastic* since it implies belief and *epistemic* since the belief that it implies is both justified and true. Analysis of "S perceives that x is F" constitutes the most difficult problem of theory of knowledge. I have summarized my solution elsewhere in the present volume.

The nonpropositional sense of *internal* bodily perception is completely analogous to that of external perception. We may define it as follows:

D3 S perceives a substance within S's body =Df. S's sensing of an appearance A is conditioned by 0; (2) 0 is a substance that is internal to S's body; and (3) there is no M such that (a) M is internal to S's body, (b) M is entirely discrete from 0, (c) S's sensing of A is conditioned by M, and (d) S's sensing of 0 is conditioned by M.

In this way we describe the role of appearances in perception. What we have said provides for the possibility of both external and internal perception.

What I have given here is an account of the basic *nonpropositional* sense of "appearing." The *propositional* sense, as in "S perceives x to be F," is *epistemic* and *doxastic*. The result is closer to Audi's theories than my previous views have been.

R.M.C.

15

Bruce Aune

CHISHOLM ON STATES OF AFFAIRS
AND REFERENCE

In appearance Chisholm's philosophy is deceptive: It seems to embody an exceedingly rich ontology, and it appears to be set forth in definitions designed to be carved in stone. The reality is that Chisholm is devoted to simplicity, holding that his ontology is the simplest he knows of that can accommodate the relevant data, and he advances his definitions in an admirably tentative spirit, frequently revising them to accommodate second thoughts. In this paper I shall focus my attention on the simplicity of his ontology and on views he has recently expressed on reference, thought, and the attribution of properties. My aim is critical but also constructive; I hope to see our thinking on these matters move a bit closer together.

1. ONTOLOGY AND SIMPLICITY

Chisholm has been concerned, over the years, to defend an ontology of states of affairs, one that includes attributes (qualities and relations) and individual substances. In defending this ontology he has endeavored to reduce such things as propositions, facts, possible worlds, and concrete events to states of affairs.[1] He spoke freely of classes, places, and times in *Person and Object*, his systematic book on metaphysics; but he made it clear in a footnote that he thinks classes can be reduced to attributes in the way that Russell proposed,[2] and he has recently argued that he thinks times are reducible to world-states, which are states of affairs.[3] His reductive approach to times makes it difficult to believe that he is really happy with places as irreducible realities. Since he is willing to follow Russell in dispensing with classes, he may also be willing to follow him in dispensing with numbers and other mathematical exotica. Although I am not sure what he wants to say about the forces and fields of contemporary

physics, which appear quite distinct from substances, attributes, and states of affairs, I have no doubt that he is quite happy with these latter entities. Substances, attributes, and states of affairs seem to make up at least the heart of what he considers the ultimate furniture of the world.

It seems to me that an ontology containing substances, attributes, *and* states of affairs multiplies entities beyond necessity. Chisholm has not been as informative as he might have been about what he takes the constituents of states of affairs to be, but the theory of properties is so powerful that one should expect a complex such as *men being mortal* to be reducible to such things. Also, the basic predicates Chisholm applies to states of affairs seem to be definable by predicates applicable to attributes. According to his most recent account, the concept of a state of affairs is definable by reference to three basic predicates: "entertains" (or "considers"), "accepts," and "obtains." But to entertain the state of affairs *men being mortal* is presumably just to conceive of attributes corresponding to "men" and "mortal" and to think of the first as included in the second; and to accept that state of affairs is to be in a mental state that represents the first of those properties as actually included in the second (I shall develop this last suggestion later on).[4] As for the supposed "occurrence" of this state of affairs, it seems sufficient to restrict one's attention to things and attributes and to say that everything exemplifying the property *man* also exemplifies the property *mortal*.

These last remarks require support and development, of course; but before attempting to provide them, I want to explore some points pertinent to Chisholm's conception of a state of affairs. As I noted, he has never been entirely explicit about what he takes the constituents of such a thing to be—a matter clearly bearing on the question of what states of affairs might be reducible to—and he has recently changed his mind about many sentences that he once took to express states of affairs: in fact, he now thinks "most" sentences express something else.[5] The line of thought leading to Chisholm's change of mind on this matter might prefigure a willingness to abandon the entire category of these supposed entities. This is a possibility I intend to explore.

When he wrote *Person and Object*, Chisholm had no doubt that "Socrates refuting Thrasymachus" and "Thrasymachus refuting Socrates" represented states of affairs. Suppose he was right about this. The states of affairs he assigned to these sentences would appear to possess at least three constituents, two of which are the same in both states of affairs, although they enter into them in different ways. But what kind of entities are these constituents? What corresponds to "Socrates," for instance? It is natural to say "The person, Socrates," for if *Socrates's*

flying obtains, that actual person would be the thing that flies. Yet Chisholm seemed explicitly to disallow this alternative in *Person and Object*, insisting that states of affairs are not dependent for their being on the being of concrete, individual things, which the person Socrates assuredly is.[6] Obviously, if Socrates never existed, does not exist, or will never exist, a complex including him cannot exist either.

What constituent of a state of affairs can "Socrates" then represent, if it does not represent the ancient philosopher bearing that name? When he wrote the words I quoted, Chisholm might have identified an individual concept of Socrates (a property he uniquely possesses, as he put it then)[7] or an essence of Socrates (a property he said Socrates necessarily and uniquely possesses if anything possesses it)[8] as the appropriate constituent; but he rejected this view in a later publication, where he cast doubt on the existence of essences and asserted that "the primary function of sentences containing demonstratives, indexicals, or proper names is *not* that of expressing propositions or states of affairs."[9] "Socrates refuting Thrasymachus" is not, of course, a sentence but a gerundial nominalization of a sentence; but Chisholm does not discriminate between these linguistic structures in assigning semantic values. As it happens, he made a point of emphasizing that not all gerundial nominalizations of indicative sentences designate states of affairs.[10] The ones that do not are the ones that contain demonstratives, indexicals, and proper names.

When Chisholm abandoned the view that sentences containing names and demonstratives express propositions or states of affairs, he claimed that such sentences express attributions of properties to objects. Utterances of first-person sentences such as "I am wise" are of primary importance to his new view, for he holds that the objects to which properties are attributed by utterances of other sorts of sentences are identifiable only by reference to the attribution of some property by some person to herself. (Chisholm calls a person's basic self-attributions of a property *direct attributions*; he describes other attributions of properties as *indirect*.)[11] The attribution of a property to an individual is an action, however; and actions, Chisholm has said, are states of affairs or "concretizations" of them.[12] Do states of affairs of this kind have subjects? If I, in saying "Socrates is wise," attribute wisdom to Socrates, a state of affairs describable in Chisholm's earlier terminology as "Aune attributing wisdom to Socrates" should, in that terminology, be said to occur. But this sentence-nominalization contains a proper name, and the corresponding sentence, "Aune attributes wisdom to Socrates," does not express a proposition. Doesn't this warrant the conclusion that there can be, for Chisholm, no such state of affairs as *Aune's attributing wisdom to*

Socrates, or, better, that no state of affairs corresponds to the singular expression "Aune's attributing wisdom to Socrates"?

It seems to me that Chisholm must say yes to this last question if he holds to his latest remarks on states of affairs and sentences containing singular pronouns, proper names, and "other demonstrative expressions."[13] This raises a difficulty, however, that he must find an acceptable means of avoiding. Since people clearly do, in his view, attribute properties to subjects, he must concede that these attributions are either concrete events or reducible to something else. As I noted earlier, he argued against concrete events in *Person and Object*, insisting that they are reducible to corresponding states of affairs, the appropriate instances of which he now repudiates. Thus he cannot adopt the concrete-event interpretation without seriously compromising his rejection of such things. I have espoused the other alternative myself, arguing that talk about ostensibly concrete events is to be understood as a mere *façon de parler* equivalent to talk about individual things: "*S*'s attributing *F* to himself occurred" being, for example, a wordy way of saying "*S* attributed *F* to himself."[14] If Chisholm cannot accept this deflationary view because he wants some entity corresponding to expressions seemingly denoting self-attributions to individuals, he might plump for Russellian singular propositions, as Kaplan has called them.[15] These entities are taken to be ordered n-tuples consisting of individuals and attributes—for example, <Socrates, wisdom> or <Believing, Aune, <Socrates, wisdom>>. Chisholm should be happy with such things because he does countenance classes (as I observed, he regards them as reducible *à la* Russell to attributes) and ordered couples can be understood as classes.

I am now in a position to return to the question for which I have been preparing the reader: If Chisholm can dispense with states of affairs in analyzing what is expressed by some or, as he admits,[16] most sentences, might he not dispense with states of affairs generally? In considering this question, a key point to keep in mind is the general character of the sentences that do, in his opinion, express states of affairs. Since these sentences do not contain names, pronouns, or other indexical expressions, they must be general in import. The simplest such sentences will no doubt have the logical form of universally or existentially quantified formulas containing single predicates followed by one or more bound variables. More complicated sentences will contain logical operators connecting simple sentences; even more complicated sentences will contain logical operators between predicates whose variables are bound by quantifiers; and sentences of the most complicated sort will contain complex sentences in the scope of logical operators. The question is: Can

sentences with these kinds of logical structure be plausibly understood as expressing something reducible to attributes?

It is reasonable to suppose so, I believe, if one holds, as Chisholm does, that predicates express attributes. (By "attributes" I mean, of course, "properties and relations.") This supposition can be supported by the analysis Quine provides in his paper, "Variables Explained Away."[17] As the title of this paper suggests, quantifiers and variables are dispensable logical symbols: they are invaluable in practice, but they are in theory eliminable from a notation adequate (as Quine put it) "for theories generally, mathematical and otherwise."[18] In place of variables, quantifiers, and singular terms, a functionally equivalent language can consist "purely of predicates, comprising just . . . six operators [which Quine defines] and any arbitrary predicates as generators for them to operate on." A language consisting "purely of predicates" is a natural means of representing a domain of properties; and if individuals are not actually constituents of states of affairs, such a domain should be an adequate base to which states of affairs and, therefore, propositions (as Chisholm understands them) can be reduced. The result will be a simpler ontology which will permit Chisholm to continue using the language of states of affairs and propositions as mere *façons de parler*.

The notion of a language consisting only of predicates and operators on predicates may be confusing to some readers, so some illustrative remarks may be helpful. It is advisable to begin with a notation that is less forbidding than Quine's. Carnap has proposed one that accommodates many general statements in a very suggestive way. Take the universally quantified formula, "$(\forall x)(Fx)$." In Carnap's Language C[19] the counterpart to this is "$U(F)$," which can be used to attribute the property of universality to the property represented by "F." Carnap's Language-C counterpart to the existentially quantified formula "$(\exists x)(Fx)$" is "$\exists(F)$," which can be used to attribute the property of nonemptiness to the property represented by "F." The function of Carnap's operators here, "U" and "∃," can thus be understood as devices by which one attributes properties to properties. In speaking of attributing properties to properties in this way I am applying a Chisholmian strategy to the interpretation of sentences containing Carnap's "U" and "∃" operators. As I suggested earlier, what corresponds to singular attribution-sentences so interpreted are not propositions, states of affairs, or irreducible acts of attribution. If anything plausibly corresponds to them, it is Kaplan's Russellian propositions. Since these entities are understood as ordered couples or sets, Chisholm can view them as reducible to attributes.

Although a lot can be said in Carnap's predicate language, he did not

provide a general procedure by which one can eliminate the quantifiers and variables of every formula belonging to a standard language. Quine did provide such a procedure. For an example of how it is applied, consider the sentence "Chimps are more intelligent than some animals but less intelligent than others," which would normally be translated into technical notation by a formula containing multiple quantifiers and variables, namely: "$(\forall x)[Cx \rightarrow (\exists y)(Ay \& Mxy) \& (\exists z)(Az \& Lxz)]$." The translation of this sentence in Quine's predicate language contains five unfamiliar operators. The one equivalent to Carnap's "\exists" is "Der," a expression meant to recall the English noun "derelativization" rather than the German definite article. Another operator, "Ref," is used to convert a predicate "$Rx_1 \ldots x_{n-1}x_{n-1}$," into a predicate with one less argument, "$(\text{Ref}R)x_1 \ldots x_{n-1}$"; an inversion operator, "Inv," is used to change the order of a predicate's arguments, putting the first one last; and the other two operators, "x" and "Neg," are used to form predicates from formulas containing "and" and "not." If we use these five operators to eliminate the quantifiers, variables, and sentential connectives from the formula about chimps, beginning with the simplest subformulas and working outward, we shall obtain the following translation:

Neg Der Ref (C x Neg Ref {[Der Ref Inv (A x M)] x [Der Ref Inv (A x L)]}).

The symbols "C," "A," "M," and "L" here are the predicates of the quantified formula that is translated into the predicate language; they are translations of the vernacular "is a chimp," "is an animal," "is more intelligent," and "is less intelligent."

Do the complications of Quine's general procedure for eliminating quantifiers and variables from formulas of standard languages require one to abandon the reductive strategy I suggested for the interpretation of sentences containing Carnap's "U" and "\exists" operators? The answer is no. Syntactically speaking, Quine's predicate operators generate complex predicates out of simpler expressions; if predicates express properties, as Chisholm believes, the result of applying such operators to primitive predicates and their adjoining symbols will not move us away from the domain of properties. To support his claim that a language to which his eliminative strategy has been applied consists "purely of predicates" Quine treated the sentences of such a language as zero-place predicates. If it seems odd to attribute truth or falsity to a mere predicate (however complex its structure may be), one can proceed as I did with Carnap's Language C formulas and say that sentences containing predicate operators express attributions of properties to properties expressed by elementary predicates occurring in them. Such an attribution, which

can be associated with a Russellian proposition or attribute, is easily identified with the aid of lambda abstraction. For example, the Quinean formula about chimps that I gave in the last paragraph could be said to be a means of attributing the property represented by "(λF)[Neg Der Ref $(C$ x Neg Ref {[Der Ref Inv $(F$ x $M)$] x [Der Ref Inv $(F$ x $L)$]})]" to the property of being an animal.

As I noted, Quine said that his predicate language provides a notation adequate "for theories generally, mathematical and otherwise." The theories he had in mind when he said this do not include metaphysical theories of the kind Chisholm propounds. A striking feature of the latter is the frequent use of the modal operators "it is necessary that" and "it is possible that." Operators of this kind are often thought to introduce propositional entities not reducible to properties, but Chisholm uses them with an explicitly de re reading that seems to connote attributes of individuals and/or other attributes. It is true that he sometimes applies predicates involving "necessary" or "possibility" to states of affairs; but if states of affairs are reducible to attributes in the way I have suggested, these predicates will connote attributes of attributes in those cases. Unless, therefore, there are indispensable operators that introduce something not reducible to substances and attributes, the door seems open to saying that states of affairs are dispensable entities—not irreducible instances of ontological furniture.

2. Attributing and Considering

One question about Chisholm's general ontology that he has not, to my mind, adequately answered is "What is involved in *considering* a state of affairs?" In earlier writings Chisholm took the notions of considering, believing, and endeavoring as primitive, and he therefore had nothing to say about what is involved in having these attitudes. More recently, he has, as I noted, rethought the nature of these attitudes, taking them now as having primary forms (in terms of which the other forms are analyzable) in which a person attributes a property to herself. This more recent account throws no light on the matter at hand here, for in developing it Chisholm takes the locution "x directly attributes to y the property of being F" as undefined—and thus offers no account of *how* one manages to attribute something to oneself. This matter is pertinent to the subject of ontological simplicity because understanding it will help us understand what is plausibly meant in speaking of "accepting" a state of affairs—a subject whose relevance I emphasized at the beginning of this essay.[20]

Chisholm did not attempt to offer an account of this last matter because he seemed to think that such an account cannot be given. He said that the question "How does one succeed in making oneself the object of one's direct attribution?" is a strange one, having an analogue in any adequate conception of believing.[21] Any such conception will imply, he says, that *some* thing or other is the object of any believing; and if one asks of such an object "How does one succeed in making *that* thing the object of one's believing?" the answer, he says, can only be "One does." Such an answer may seem unsatisfactory, he admits. But one should realize, he says, that for *any* theory of believing there is a point at which the question "And how does one make *that* the object of one's belief?" can be answered only in this way.

In part, at least, this last claim by Chisholm is clearly erroneous: "One does" is *not* an answer to the question asked. It is a response to that question but not an answer because it does not say how the relevant deed is done, which is what was asked. Chisholm's response has the effect of rejecting the question, and of doing so in an obscure, unhelpful way. If he had come right out and said, "There is no *way* in which one succeeds in doing such a thing," his claim would have been highly puzzling and certainly unconvincing. How could something be done but not be done in any "way"? If he had said "I don't know how to answer this question," one could hardly object, but his claim would not be very exciting. If he had added "and I don't think anyone else does either," his claim would have been exciting—and his thought might be true as well. But he did not actually say this.

As I see it, the how-question Chisholm identified is not strange or idle; in fact, it is easily and instructively answered in certain cases. Suppose one is speaking to another person. One might then directly attribute a property to oneself by saying "I am wise" or "I exemplify wisdom." In this case one refers to oneself with a pronoun and attributes a property to that self by attaching a verb phrase to the pronoun: one makes a certain statement about oneself. I am convinced that something similar takes place when one attributes a property to oneself without saying anything—when one makes the attribution silently, in thought. If I think to myself "I am wise" or, taking myself to be Bucy (as I did when I was a child), think "Bucy is wise," I shall attribute a property to myself without uttering any words. Some philosophers will insist that I do *use* words in this case (even though I do not utter them) because silent thought *is* inner speech. Chisholm will almost certainly not agree with this, and I will not oppose him on the matter: I will concede (for the sake of argument, anyway) that nonverbal thought is at least possible. I do insist, however, that if I think to myself "I am wise," elements of my

thought must play the referring and attributive roles of the words "I" and "am wise." Descartes and other conceptualists called these elements "ideas";[22] they may be unlike words empirically, but they have similar, if not identical, semantical properties.

I have just said that if I use certain words or think certain thoughts, I shall thereby attribute a property to myself. I now say that I can attribute a property to myself only in this way: I must refer to myself, identifying the subject of my attribution, and predicate something of the subject thus referred to. If one doesn't use words for this purpose, one must "use" something functionally similar—something that can denote a subject and something that can attribute something to it. My conviction on this point should be initially plausible, for it has been accepted by every major figure in the history of philosophy.[23] It also seems required by the fact that referring and attributing can take place in the absence of an existing object of reference or attribution. Obviously, one can attribute properties to nonexistent beings—to things that have, as Descartes put it, only objective reality. Since some of the ostensible constituents of what one "considers" in such cases do not actually exist (or have formal reality), they cannot possibly be literally present to mind when one does the considering or referring-and-attributing. What is immediately before one's mind (or what immediately occurs) in such cases is, if not explicitly verbal, a series of "ideas" (an articulated thought) or an ideational sequence. Since direct referring-and-attributing is merely a special case of referring and attributing, it takes place, I should say, by the same mechanism. The objects of even direct attributions are referents of words (names, pronouns) or ideas (ideational states).

Before he changed his mind about singular propositions, Chisholm held that so-called de re attitudes are reducible to de dicto attitudes—that, say, the attribution of a property to a thing is a matter of accepting an appropriate proposition about that thing. What I call an appropriate proposition here is one implying the subject of the attribution to have a certain essence or *haecceity*. Chisholm's idea, before he changed his mind, was that "all reference is by way of states of affairs or propositions."[24] An attitude can be truly said to *be about*, or *refer to*, an entity *e*, he said, just in case any bearer of that attitude is psychologically related to a proposition implying that *e* and only *e* has a certain (essential) property. He changed his mind because he came to doubt that individual essences actually exist.

I do not challenge Chisholm's change of mind on this matter. What I want to insist upon is only that, if one has an attitude toward a certain entity (believing it to be wise, for example), one must use or at least have

an idea or term that represents that entity for one. I do not claim—indeed, do not believe—that one's use or possession of an idea or term that represents an individual, *e, for one* implies that *e* is the unique possessor of some property one can identify; in fact, I am convinced that *e* may fail to exemplify such a property. I may think of (or mentally represent) a person, John, as the person across the room drinking a martini when that person is actually drinking water in a martini glass. As Donnellan observed in his famous paper,[25] things may be the referents for certain speakers of certain definite descriptions even though they do not satisfy those descriptions, and the same holds, I contend, for nonverbal "ideas" that designate particular entities for specific individuals. Such "ideas" may not be constituents of propositions or states of affairs, but one must have them, or a corresponding verbal symbol, in order to attribute a property to a particular thing.

In making this last claim I must concede that I cannot answer a question corresponding to the why-question Chisholm brushed aside. The question I cannot answer is "By virtue of what does a particular idea or word refer to a particular object for a particular person?" I do not think this question cannot be answered; I simply cannot answer it myself. Kripke has (at least to my satisfaction) shown that a proper name like "Aristotle" does not have the referent it does because it has a sense or is associated with a description that is satisfied by that referent; his claim was that the referent of a name is "fixed" by a process that is fundamentally causal.[26] I cannot (as it happens) improve on Kripke's claim about ordinary names, and I cannot produce the sort of definition of "*n* refers to *x*" that I know Chisholm would like to see. But I am convinced that Kripke's criticism of the associated-description-or-sense view of a name is fundamentally correct.

When Kripke wrote about the reference of the name "Aristotle," he was, as I said, dealing with an ordinary name, not with a term that a solitary or idiosyncratic thinker might use in ascribing a property to himself. Some philosophers have supposed that every thinker refers to herself with an egocentric expression such as "I," "ich," "je," or the first-person inflection of a Greek or Latin verb, but this is incorrect: when I was a child, I referred to myself as "Bucy" before I learned to use pronouns or any other egocentric expression. I can't explain (at least in useful detail) why "Bucy," as I used it, referred to me; I have not worked out the relevant theory of reference. But I have no doubt about the case: I do not think it is anomalous, and I am sure that the reference of "Bucy" was not secured by a sense or description that I satisfied. Whatever general facts made "Bucy" in the mouth of young Bruce Aune refer to me

could equally determine the reference of a singular "idea" in the mind (or consciousness) of a silent thinker.[27]

In the correspondence on intentionality that he had years ago with Wilfrid Sellars, Chisholm remarked that words have meaning because they express thoughts that people have.[28] Today he might say that names have a particular reference because the people who use them have a particular referent in mind. I don't dispute this. My claim is that if people have a particular referent in mind because they have an "idea" of that referent, their idea applies to the referent because it refers to it. How, or by virtue of what, the idea refers to the referent I cannot say. I believe, however, that it refers to the referent for the same general reason that "Bucy" referred to me.

According to Chisholm's revised account of belief, I can have a belief with respect to you only if you stand uniquely in a certain relation to me and I believe with respect to myself that you are thus related to me.[29] It should be clear to the reader that Chisholm is here presuming that a belief can be about or (as one might say) refer to something, x, other than the believer, only if the believer can single out x by an informative conception or description that x uniquely satisfies—that is, by a conception or description that, unlike "the thing to which my belief refers," is useful in identifying x. But this presumption is vulnerable to the criticism Kripke directed to Fregean theories of reference for proper names. To believe something with respect to Aristotle (e.g., that he studied at Plato's Academy) one does not have to have a conception or description that uniquely relates him to oneself. What one does have to have is a term or idea by which one refers to him. It is not enough (and not required) that one has available a term (a name or definite description) that has Aristotle as its standard or proper referent. What is enough (and is required) is that one has a term or idea that is *one's* means of referring to Aristotle—a term or idea that refers to him *for one* as "Bucy" referred to me *for* the child that I was.

When Chisholm wrote *Person and Object*, he alluded to Quine's suggestion that belief is a relation between a person and an inscription or sentence-token, saying "It is difficult to know what to say about this view."[30] (The implication of his statement was that it is difficult to know what to say about Quine's view because it is so outlandish that words fail him.) It is worth noting that if what I have just been saying is correct, an apt response should be very easy for Chisholm to identify. If, in believing that p, one directly attributes some property to oneself, and if, in doing this, one refers to oneself and characterizes oneself by means of a sequence of particular ideas, one will be cognitively related to a thought-

token—one that is expressible in words by a sentence-token. One will, in this case, be related to an attribution and even a property, but one will also be related to an inscription: this is assured by the logic of relations. (If aR^1b and bR^2c, then there is an R^3 such that aR^3c.) Granting what I have argued should therefore require Chisholm to concede that Quine's suggestion was not so outlandish after all: its defect, if it has one, lies in its incompleteness—in its omission of another entity to which believers are related (an attribution, a property, or a state of affairs).

As a philosopher in the Cartesian tradition, Chisholm thinks of himself as an individual substance, one that is a person; if he concedes that he thinks by means of ideas, he will have a problem about ideas that is analogous to a problem such philosophers have with images and sense-impressions: he will want to think of them as (in traditional language) "modes" of a self, not individual things. Chisholm has described the realities that some philosophers have called "impressions" or even "images" as "states of sensing": instead of saying that one senses a red triangle, he would say that one senses redly and triangularly. If he allows that we think by means of ideas—if we refer to things and characterize them by means of such things—he might want to say something to the effect that, when (as the vulgar say) we think of this and think that of this, we ideate thisly and thatly-of-thisly. I am not trying to be facetious or critical in using this peculiar language, for I have no doubt that a nonobjectual account of thinking could be set down in technical language that does not sound so wild or barbaric. A possible strategy is to use the language of properties. An idea could be described as a mental property, and a sequence of ideas could be said to be reducible to a property on the ground that sequences are reducible to sets and sets are reducible to properties. A person actually thinks that S is P on this view just when he exemplifies the property of thinking such a thing.

3. STATES OF AFFAIRS AGAIN

In my first section I noted that Chisholm describes states of affairs by two sorts of predicates, one intentional and one not. The nonintentional predicate is "obtains," an expression that, I said, is a cousin of "true" and appears to be contextually definable by reference to "exemplification," which relates attributes to the items that have them. The intentional predicates are "entertains" (or "considers") and "accepts." I suggested earlier that "entertains" (or "considers") seems to be contextually definable by reference to conceptions of properties and thoughts about their relations; and I suggested that "accepting a proposition" is

understandable as descriptive of a mental state that represents properties as actually related in a certain way. The suggestions I initially made about these intentional predicates (or concepts, as Chisholm calls them) obviously needed development and qualification. The remarks I have just made put me in a position to provide some of that development and qualification now.

If we can think of things only by representing them verbally or mentally, and if we can attribute properties to things only by verbally or mentally predicating something of them, accepting a proposition is then a complex mental act consisting of simpler acts, verbal or mental, of (basically) referring and predicating. I add the qualifier "basically" here because propositions (or the items Chisholm recognizes as propositions) have a complexity that corresponds to the complexity of sentences. Just as sentences can have an enormously complicated structure, extending (not just in principle) for many pages of text, propositions can have an enormously complicated structure, requiring many minutes to comprehend. Thus, it is only the acceptance of simple propositions that could consist in simply referring to a thing and predicating something of it.[31] The constitutive acts involved in "accepting" complex propositions may be extremely numerous.

In case someone is tempted to suppose that I am here erroneously or at least needlessly shifting the complexity of an eternal item to successive acts of the mind, I should say that if some complex nonmental object were simply before one's mind, one would have to attend to its various details (which would be exceedingly numerous if the object were expressed by a sentence made up of 995 words) in order to *take it all in* and know what one is entertaining. Considering a proposition is no doubt simpler than accepting one, for we accept what we consider to be thus and so; but even the simpler act of considering involves attending to details, and this is a complex process when complex thoughts are considered.

Chisholm has often acknowledged the influence of Descartes on his thinking, and it is worth observing that, where Chisholm speaks of accepting a proposition, Descartes spoke of making a judgment. I mention Descartes here because he claimed that judging involves a volitional element: when we judge that p, we assent to the proposition that p.[32] Although I would deny that believing (and, therefore, genuine assenting) is within our immediate voluntary power, I agree that assenting is something that distinguishes accepting a proposition from merely entertaining it. It is an act that, in addition to referring and predicating, takes place when one occurrently thinks that S is P. It may also enter into such states as being disappointed that p, being pleased

that p, and being upset that p. It is missing, I should say, from such activities as supposing that p, suspecting that p, doubting that p, wondering whether p, hoping that p, and fearing that p.

If Chisholm's notions of entertaining, accepting, and obtaining are, as I believe, contextually definable by reference to mental (or verbal) acts of referring, attributing, denying, accepting, conjoining, and the like, and, ultimately, to the exemplification of properties, then the concepts Chisholm introduces in his discussion of the structure of states of affairs will be reducible to, or be ultimately definable by, concepts applicable to persons, mental properties, attributes of other kinds, and the so-called relation of exemplification. The result is a fairly sparse ontology. It is richer than the austere one I favor, but it is also, in many ways, easier to defend.[33] It would please me if Chisholm finds it acceptable.

BRUCE AUNE

DEPARTMENT OF PHILOSOPHY
UNIVERSITY OF MASSACHUSETTS AT AMHERST
APRIL 1994

NOTES

1. In *Person and Object* (London: Allen and Unwin, 1976), p. 122, he "suggested" that "concrete events, like facts and propositions, may be reduced to states of affairs," and in "Objects and Persons: Revision and Replies," *Grazer Philosophische Studien* 7/8 (1979): 359, he dealt with possible worlds.

2. See Chisholm, *Person and Object*, p. 217, n. 21.

3. For details, see Chisholm, "Objects and Persons," pp. 357f.

4. The notion of inclusion I have in mind has been applied to properties by Rudolf Carnap in *Introduction to Symbolic Logic and its Applications* (New York: Dover, 1958), p. 108. His notion is essentially this: the property F is included in the property G iff anything exemplifying F also exemplifies G.

5. Chisholm, "Objects and Persons," p. 336.

6. See Chisholm, *Person and Object*, p. 114.

7. See ibid., p. 28.

8. See ibid., p. 29.

9. Chisholm, "Objects and Persons," p. 334.

10. Ibid., p. 343.

11. Ibid., pp. 326f.

12. See Chisholm, *Person and Object*, pp. 124f.

13. See Chisholm, "Objects and Persons," p. 334.

14. To make this view credible, one has to deal with a representative sample of predicates that are applied to ostensible events. My example in the text, "occurred," is just one of the possibilities that has to be considered. For further discussion, see chap. 1 of my *Reason and Action* (Dordrecht: Reidel, 1978).

15. See Kaplan, "Dthat," in Peter Cole, ed., *Syntax and Semantics* (New York: Academic Press, 1978), pp. 221–52.

16. See Chisholm, "Objects and Persons," p. 336.

17. See W.V.O. Quine, "Variables Explained Away," in Quine, *Selected Logic Papers* (New York: Random House, 1966), pp. 227–35.

18. Quine, p. 235.

19. See Carnap, pp. 107f.

20. See pp. 2f. above.

21. See Chisholm, "Objects and Persons," pp. 326f.

22. See Descartes, "Principles of Philosophy," principle 13, in John Cottingham et al., *The Philosophical Writings of Descartes*, vol. 1, p. 197.

23. Even Plato recognized thought as a "dialogue in the soul." See *Theaetetus* 190, where Socrates says "the soul when it thinks is simply carrying on a discussion in which it asks itself questions and answers them itself, affirms and denies."

24. Chisholm, "Objects and Persons," p. 318.

25. Keith Donnellan, "Reference and Definite Descriptions," *Philosophical Review* 75 (1966): 281–304.

26. See Saul Kripke, *Naming and Necessity* (Cambridge, Mass.: Harvard University Press, 1980), pp. 29–30 and passim.

27. Although I cannot identify the facts that made "Bucy" refer to the young Bruce Aune, I can say how the referent of such a name is reasonably identified. This is done, roughly speaking, by discovering who in the circumstances is truly described, or reasonably thought by the speaker to be truly described, by the predicates the speaker uses in conjunction with the name.

28. R. M. Chisholm and Wilfrid Sellars, "Intentionality and the Mental," in Herbert Feigl et al., *Minnesota Studies in the Philosophy of Science*, vol. 2, *Concepts, Theories, and the Mind-Body Problem* (Minneapolis: University of Minnesota Press, 1958), p. 524.

29. Strictly, Chisholm's definition explicitly requires that I attribute a property to myself which a thing can have iff it is uniquely related to you; it doesn't explicitly require that I believe or realize that the property I thus attribute to myself can be had only under this condition. I believe, however, that Chisholm intends his definition to have this implication because in introducing his definition he says, "if I can thus have a belief with respect to you [i.e., believe of you that you have a certain property], then you stand uniquely in a certain relation to me . . . and I have a belief with respect to *me*—a direct attribution—to the effect that I *am* thus uniquely related to something." See "Objects and Persons," p. 329.

30. *Person and Object*, p. 214.

31. What I say here is not inconsistent with my earlier claim that complex sentences such as the one I cited about the intelligence of chimps can be understood as expressing the attribution of a property to a property. In such cases one of the properties will be complex and be referred to only by means of a number (possibly large) of referring acts.

32. See René Descartes, *Principles of Philosophy*, in Cottingham et al., p. 204.

33. I have expounded my view in Bruce Aune, *Metaphysics: The Elements* (Minneapolis: University of Minnesota Press, 1990).

REPLY TO BRUCE AUNE

Bruce Aune's essay is entitled "Chisholm on States of Affairs and Reference." I have to agree with most of what he says in criticism of my views about states of affairs. In the book, *Person and Object* (1976), I had considered states of affairs as being abstract objects, believing that in this way I could restrict the category of contingent things to *individuals*, thus avoiding commitment to so-called "concrete events." But subsequently, in *On Metaphysics* (1989), I abandoned the concept of states of affairs as abstract objects. And so my position since that time has been the same as Aune's.

Concerning reference, I have defended two quite different theses, neither of which depends upon the other. The first has to do with "the primacy of the intentional," the thesis according to which linguistic reference is to be explicated in terms of intentional reference. The other thesis is that according to which intentional reference is a matter of attributing properties directly to oneself. I have defended this second thesis in *The First Person* (1981).

In what follows, then, I will first discuss states of affairs and concrete events. Then I will discuss what I have called "the primacy of the intentional."

States of Affairs and Concrete Events

How, then, does Aune criticize the second view—"the direct attribution view?" He writes:

> For Chisholm such states of affairs as *Aune's attribution of wisdom to Socrates* exists, or better . . . no state of affairs corresponds to the singular proposition, Aune's attributing wisdom to Socrates.

It appears, then, that in abandoning the state-of-affairs in *On Metaphysics*, I cut the ground from under what was to be Aune's criticism of the direct attribution view.

The Primacy of the Intentional

Aune writes in detail about the issues that Wilfrid Sellars and I had discussed in our published correspondence some years ago. In that correspondence I had defended what I was later to call "the principle of the primacy of the intentional." What I meant by this may be put, somewhat imprecisely, by saying that the aboutness (meaning, objective reference) of words is dependent upon the aboutness (meaning, objective reference) of thoughts, and not conversely.

By "words" I meant linguistic entities—those things, written or uttered, that are nouns, predicate expressions ("is red"), articles, prepositions, quantifiers and their variables ("there exists an x such that"), and connectives.

By "thoughts" I meant such intentional states and activities as believing, wondering, deciding, wishing, hoping, fearing, liking, and disliking.

I wrote:

> I think it was John Hospers who proposed this useful figure: that whereas both thoughts and words have meaning, just as the sun and the moon send light to us, the meaning of the words is related to the meaning of the thoughts just as the light of the moon is related to the light of the sun. Extinguish the living things and the marks and the noises wouldn't shine any more. But if we extinguish the noises and the marks, people can still think about things, but not so well, of course.[1]

I must confess that all this seems completely obvious to me. Indeed I am not at all sure that Sellars would have denied it. Yet Aune isn't sure about it. He writes:

> The question I cannot answer is: "By virtue of what does a particular word refer to a particular object to a particular person?" I do not think this question cannot be answered: I simply cannot answer it myself.

Unfortunately he doesn't even give us a hint as to how it *might* be answered.

R.M.C.

NOTE

1. The citation is from the correspondence published by Wilfrid Sellars in "Intentionality and the Mental," *Minnesota Studies in the Philosophy of Science* 2 (1957): 507–38. The quotation appears on page 574.

16

Jaegwon Kim

CHISHOLM ON INTENTIONALITY: *DE SE, DE RE,* AND *DE DICTO*[1]

I

R oderick Chisholm's work on intentionality is certainly among the many outstanding, and lasting, philosophical contributions he has made over the years. It was Chisholm who in his early works during the 1950s introduced the problem of intentionality into the mainstream of Anglo-American philosophy. His first published work on the topic, as far as I know, is "Intentionality and the Theory of Signs" (1952);[2] however, the work that became widely known and helped to establish intentionality as a new *Problematik* within contemporary analytic philosophy was his 1956 paper "Sentences about Believing,"[3] which formed the basis of chapter 11 ("Intentional Inexistence") of his much admired book *Perceiving* (1957).[4] True, Chisholm drew on the ideas originated by Franz Brentano who had proposed "intentional inexistence," or the "inclusion of an intentional object within itself," as a criterion of the mental—in fact, the essential characteristic that distinguished the mental from what is merely physical. However, Chisholm stamped his own distinctive mark on the problem by reformulating it as one of characterizing a class of sentences which he called "intentional sentences." Brentano's thesis was then put as the claim that mental phenomena, unlike physical phenomena, can be described only by the use of intentional sentences. Moreover, Chisholm added the crucial further claim that the notion of an "intentional sentence" can be defined in terms of logico-linguistic concepts alone, without recourse to any mentalistic, or intentional, terms. This is tantamount to the claim, which in retrospect should strike us as highly provocative, that the notion of mentality is at bottom a logico-linguistic one, and that there is no need to invoke such potentially problematic concepts as subjectivity and absolute epistemic certainty in characterizing the mental. In any case, by recasting Brentano's thesis this

way, Chisholm gave it a form that was very much in tune with the philosophical temper of the times—a form that positively abetted the application of the newly available philosophical tools of logic and linguistic analysis.

In "Sentences about Believing" Chisholm proposed three criteria for "intentional sentence"; each was to be a sufficient condition for a sentence to be an intentional sentence, and any intentional sentence must meet at least one of the three. Chisholm's proposal drew many critical responses, which provided further rejoinders and counter-responses,[5] thereby establishing the project of formulating a logico-linguistic characterization of the intentional, and hence of the mental, as one of the more prominent problems of analytic philosophy during the 1960s.

The three criteria Chisholm proposed attempted to exploit some well-known peculiarities of sentences about psychological phenomena, especially those reporting propositional attitudes. The first criterion is based on the point that the truth of sentences reporting beliefs or other mental attitudes does not entail the existence, or nonexistence, of the entities that the mental attitudes are "about" or "directed upon." Thus, the truth of "Ponce de Leon looked for the fountain of youth," unlike that of "Ponce de Leon drank from the fountain of youth," does not depend on the existence of such a fountain. The second criterion makes use of the fact that sentences reporting beliefs and other propositional attitudes entail nothing about the truth or falsehood of the embedded content sentences. Just as the first criterion reflects the ability, often touted as special and even mysterious, that our thoughts could be "about" or "directed upon" things that do not exist, so the second criterion invokes the mind's capacity to *misrepresent* as well as (correctly) represent—a phenomenon that has recently been much discussed in connection with the causal/correlational approach to mental content.[6] The third criterion is based on the fact, again widely known, that the substitutivity of coreferential or coextensive terms fails in contexts governed by psychological operators—in particular, propositional-attitudes terms such as "believe" and "intend." Why this is so is again suggestive: it points to the Fregean theme that we necessarily think of things under a particular "mode of presentation," so that one and the same thing could, unbeknownst to us, be presented to us under two or more unrelated modes of presentation.

What this shows is that Chisholm's project of finding logico-linguistic criteria of the mental was based on a set of intuitively plausible ideas. But this in itself was no guarantee that the project would succeed, and

the series of failed, or at best only partially successful, attempts by Chisholm and others to formulate such criteria has pretty convincingly shown that no such project would succeed. Remember especially the fact that Chisholm's philosophical methodology, which might be called "definitionalism," requires precisely stated definitions for the concepts under analysis, ideally in terms of conditions that are both necessary and sufficient. In retrospect, it would have been surprising if his project had succeeded, given the huge variety of types of mental phenomena, the logical/grammatical complexity of natural languages, and the variety of types of discourse (for example, modal, ethical, epistemic, and so on, in addition to mental) that language must accommodate. Whatever one thinks of the ultimate fate of Chisholm's initial project on intentionality, however, there can be no denying that its pursuit, by Chisholm and others, has brought us a deeper and sharper understanding of how our mental language works and how it resembles and differs from modal, ethical, and other types of discourse.

In his entry on "Intentionality" in the Macmillan *Encyclopedia of Philosophy*[7] Chisholm strikes out in a new direction on behalf of the logico-linguistic project. The definition he offers here is essentially this: for a psychological sentence operator, such as "Jones believes that," the result of prefixing it to any sentence p, i.e., "Jones believes that p," results in a *contingent* sentence. This contrasts with, for example, modal operators: "It is possible that there are round squares" is necessarily false and "It is necessary that $1 = 1$" is necessarily true. The motivating idea here appears to be that any proposition is such that it is possible, but never necessary, for a psychological subject to believe it, doubt it, desire it to be true, and so on. Thus, a sentence operator M is psychological just in case for every sentence p, $M(p)$ is contingent. Whether or not this is an adequate criterion is debatable: for example, given our notion of belief and the practice of belief ascription that underpins it, is it really conceivable that a belief sentence with a manifestly contradictory content sentence, like "Jones believes that snow is both white and not white," can be true? Are there conceivable circumstances in which our concept of belief permits us to attribute such an obviously contradictory belief to a cognizer, someone with the conceptual and intellectual resources to entertain (or "conceive," to use one of Chisholm's favorite terms in his later work) propositions like the one in question here and who, therefore, must have a grasp of logical operators like "and" and "not"? Similar questions can be raised for beliefs with manifestly true, tautological content sentences, such as "$1 = 1$."[8]

In any event, during the 1970s, Chisholm's interest in intentionality

turned in a different direction. In his "Knowledge and Belief: 'De Dicto' and 'De Re' "[9] and the Carus Lectures published as *Person and Object: A Metaphysical Study*,[10] he began to address in a serious way the problem of characterizing *de re* reference—how our beliefs and other psychological attitudes could refer to, or be about, particular objects. His primary concern was no longer with the question how it is possible for us to think and talk about nonexistent objects and how the fact that this is possible might be related to the fundamental nature of mentality, although he has never entirely abandoned the project of finding a criterion of the mental.[11] His principal attention now turned to the more basic question how our thoughts can be about things, *the existing ones*, to begin with— that is, the problem of objective reference. This question of course is fundamental to both issues about the mind and those about language, and Chisholm's reflections on it find their mature expression in *The First Person* published in 1981. Although Chisholm has continued to sharpen and improve his formulations further in his "Self-Profile,"[12] the fundamentals of his views have remained the same. In what follows, I shall focus on his theory of intentionality as presented in *The First Person*.

II

Chisholm's theory of intentionality developed in *The First Person* is shaped by three fundamental doctrines: *the primacy of the psychological, the primacy of de se*, and *the primacy of properties*. The first doctrine, which Chisholm usually refers to as "the primacy of the intentional," is the thesis that the intentionality of mentality is primary and basic, and that the intentionality of language, or the capacity of language to refer and represent, should be explained in terms of the capacity of the mind to refer and represent. This has been one of Chisholm's long-standing philosophical commitments, evident from his earliest works, and sharply separates his approach from those of the philosophers who take linguistic intentionality as the more basic, or those who take mind and language as interdependent and see neither as definable in terms of the other. The second doctrine, the primacy of *de se*, is the thesis that the thinker's reference to himself, that is, self-reference, in which he takes himself as an intentional object, is the primary and irreducible form of referential intentionality, that it must constitute the basis of explaining other forms of intentionality—that is, *de re* and *de dicto*. The third, and final, doctrine concerns the content of belief, judgment, and other intentional acts and attitudes. According to it, the primary form of judging, or believing, is not judging of a proposition that it is true, or accepting a

proposition as true; rather, the primary form of believing, or judging, is the attribution of a *property* to an intentional object. The last pair of principles imply, then, that the most fundamental form of belief is one in which a person takes himself as an intentional object and attributes a property to the self. Although belief is the focus of Chisholm's attention in *The First Person*, I believe he would take self-attribution of properties to be the basic form of all intentional acts and attitudes.

Many self-professed "naturalists" have attempted to explain intentionality on the basis of purely "naturalistic" terms.[13] What is to count as a "naturalistic" term has never been made clear, but it is clear enough that a naturalistic analysis of intentionality is not allowed to presuppose any intentional concepts. Again, what is to count as an "intentional" concept isn't entirely clear, but it is generally supposed that overtly psychological (save perhaps those that refer to nonintentional sensory states) and semantical concepts are to be excluded from naturalistic analyses. (However, nonextensional terms—in particular, modal and causal terms and counterfactual constructions—are standardly allowed.) On this understanding, Chisholm's approach, at least in its initial setting, is worlds apart from the popular naturalistic programs: the ontology within which he develops his theory of intentionality already includes "x conceives y" as one of its undefined primitives, and the intentional relation of *conceiving*, in which a cognizer can stand in relation to abstracta ("eternal objects"), such as properties and propositions, plays a crucial role in the development of his theory. "Conceive" is not the only intentional concept taken as primitive in Chisholm's theory. As his commitment to the primacy of *de se* indicates, Chisholm takes *de se* intentionality, the subject's ability to *take herself as an intentional object*, as fundamental and unanalyzable. Moreover, it is a fundamental fact about mentality that a believer can, by taking herself as an intentional object and conceiving a property, *attribute* that property to herself. This is fundamental in that it resists, and is not in need of, further explanation or analysis. The act of attributing a property is also intentional; for Chisholm, it is the most basic cognitive act that we are capable of performing.

This means that Chisholm's approach to intentionality underwent a significant change when he abandoned the project of giving a purely logico-linguistic criterion of intentionality, or at least of "intentional sentence," presupposing no intentional expression as a primitive. This project is clearly in accord with the constraints of any naturalistic approach to intentionality; in fact, a successful execution of Chisholm's earlier program would have counted as a triumph of some magnitude for naturalism—it could even have been taken as a successful *reduction* of

intentionality to logic and grammar,[14] since the attempt to find a purely logico-linguistic criterion of intentionality is essentially a reductionist project. In accepting *de se* reference and conceiving as his philosophical primitives, therefore, Chisholm has come to accept the position that intentionality is a basic and uneliminable feature of the world. In fact, not only his philosophy of mind and language but his general ontology itself is now based on an intentional foundation.

Chisholm's main project, then, has become one of explaining *de re* and *de dicto* in terms of *de se*. But before we examine Chisholm's execution of this project, we should briefly look at his "purified ontology" within which his theory of intentionality is developed. Chisholm's ontology includes in its domain both concreta ("individual things") and abstracta. Individual things comprise material objects and their aggregates (but presumably not things like boundaries, surfaces, and the like) and also minds or souls, if such exist. They are "concrete" objects existing in space and time (at least in time if souls are outside physical space). Abstracta include properties and relations, and also states of affairs.[15] As I take it, Chisholm calls his ontology "purified" because his properties (and relations) are "pure," or "purely qualitative," and cannot involve individual things. Thus, he disallows what might be called "mixed universals," such as *being identical with Socrates* and *being taller than Socrates* (although Chisholm would allow, I believe, the property of being taller than *some* philosopher). Also expunged are "indexical properties" or "haecceities," like *being identical with that thing* and *being identical with me*. All abstracta must be purely Platonic, and his ontology tolerates no admixtures of abstracta and concreta. The same prohibition is also applied to states of affairs: these must also be entirely "pure" and abstract. Thus, Chisholm rejects singular propositions[16]—not only those involving indexicals (e.g., "first-person propositions" like the proposition that I am standing), but also ordinary third-person propositions, such as the proposition that Socrates is standing. Thus, all states of affairs must either exclusively concern abstract objects (for example, that $2 + 2$ is identical with 4) or have the logical form of a generalized sentence with no names of individual things (for example, there being horses, all horses being mammals), etc. Chisholm appears to think of states of affairs as constituted wholly by properties and relations (and logical operations like conjunction and quantification), and if this is the case, the purity of states of affairs is a consequence of the purity of properties and relations.

But why this insistence on "purity"? Because, I think, he takes it to be of the essence of abstracta that they be *conceivable*. His very first

postulate, P1,[17] of *The First Person*, is: *Every property is possibly such that there is someone who conceives it*. Moreover, his second postulate, P2 (p. 7), requires that properties be conceivable in worlds in which they are not exemplified. I believe that Chisholm wants, and implicitly assumes, a related principle to the effect that individual things, spatiotemporally bounded particulars, are not conceivable—they simply are not the sort of things that can be the object of the intellectual act of conceiving.[18] To be sure, individual things enter our cognitive world, but not by being conceived. In any case, conceiving is the fundamental intentional relation that we bear to abstracta; Chisholm says, "The primary way, then, of referring to an eternal object is to *conceive* it" (p. 37).

But what is it to "conceive" (or "grasp," which Chisholm sometimes uses interchangeably with "conceive") something? What is the nature of this fundamental intentional, referential relation cognizers can bear to abstracta? Here we do not get much help from Chisholm. We get the impression that he merely takes it as one of his primitives and leaves it at that. Taking a term as a primitive is a declaration that one is not going to produce a definition for it in the theory being constructed; it need not mean, however, that one cannot, or should not, attempt to provide an explanation, or some illumination, in other ways. Definition isn't the only way, or even always the best way, of explaining a concept. One wishes, for example, that Chisholm had said something about how his understanding of "conceiving" is related to Frege's idea of "grasping" (*"begreifen," "erfassen"*) a thought or the sense of an expression, something that Frege somewhat despairingly called "the most mysterious process of all."[19] The text of *The First Person* makes it abundantly clear that Chisholm's conceiving and Frege's grasping are closely related. In the same ballpark are Plato's notion of "contemplating" Forms, Gödel's talk of directly "apprehending" numbers and their relationships, and Russell's notion of being "directly acquainted" with universals.

Unlike Frege (but perhaps like Plato and Gödel), however, Chisholm does not seem bothered by the "mysteriousness" of conceiving or grasping—how we are able to pull off this intellectual feat—an act of identifying and singling out, and thereby referring to, an object that is "eternal" and entirely outside space and time. Many specific questions come to mind, such as: What makes it the case that I am now conceiving F-ness rather than G-ness? In what does one's capacity of conceiving F-ness consist in? Can I make an error in grasping—for example, think that I have grasped F-ness but in fact I have grasped G-ness, or failed to grasp anything at all? What makes it the case that you and I have grasped

the same property, and how do we know it? To be sure, we may very well have a serviceable understanding of "conceiving," from its ordinary (both colloquial and general philosophical) uses, for the term to be usable in philosophical context. But when a term plays a central role in theory construction, as Frege's "grasping" and Chisholm's "conceiving" do in their respective systems, the situation may well be different.

For example, I do not believe we have a clear enough understanding of conceiving properly to assess Chisholm's P2, to the effect that properties can be conceived even in worlds in which they are not exemplified. Consider a phenomenal property, say the painfulness of pains. According to P2, it is possible that—or there is a possible world in which—no one experiences pain and yet someone "conceives" this property, that is, "conceives" painfulness. Is this possible? Does this make P2 problematic, or should we conclude that "qualia" fall outside the intended domain of Chisholm's properties? I do not believe that we have been given a determinate enough grasp of "conceiving" to answer this question. Questions about such properties have been much debated in recent philosophy of mind,[20] and one would like to know how they might fare within Chisholm's ontology. Here is another question: consider me and twin-me on twin earth in Hilary Putnam's thought experiment. Do I and he "conceive" the same property (corresponding to our use of the expression "water"), when we express our beliefs by uttering, say, "I am standing in water?" Or consider Tyler Burge's man who says to his doctor, "I think I have arthritis in my thigh." Does he succeed in "conceiving" the property of having arthritis, or some other property? How should we report the content of his belief? Whether or not our answer to this last question is consistent with Chisholm's theory of belief as self-attribution of properties obviously depends on the answer to the earlier question about what property is conceived by the patient in Burge's example. The general tenor of Chisholm's discussion in *The First Person* clearly suggests that he is committed to a fairly strong version of content internalism, but in any case it would help us sharpen our understanding of Chisholm's ontology if he were to address some of these issues.

III

With these preliminaries out of the way, let us now turn to Chisholm's account of *de re* and *de dicto*. His "basic doxastic locution," the primitive that has the central role in his theory, is the expression "*x*

directly attributes property F to y." He then stipulates that whenever x directly attributes something to y, $x = y$. It isn't clear why he didn't choose "x attributes F to x" as his primitive, to begin with. Actually, it seems to me that the simplest primitive to adopt would be "x (directly) self-attributes F." The reason becomes clear when we consider Chisholm's first definition, D1, which presumably explicates the "he himself" locution, what Chisholm calls the "emphatic reflexive" (p. 28):

D1. x believes he himself is F = df. x directly attributes the property of being F to x.

Consider the wonderful example cited by Chisholm (p. 18): Ernst Mach, on entering a bus one day, observes a man apparently boarding from the opposite side, and says to himself, "What a shabby pedagogue!" As it turns out, what Mach saw was his own reflection in a mirror hung on the opposite side of the bus entrance. Now, it is false, we may assume, that, at the moment he sees his own reflection in the mirror, Mach believes that he (himself) is a shabby pedagogue, although he does believe that the man he sees as entering from the opposite side is a shabby pedagogue (and it is true in the pure *de re* sense that he believes of himself that he is a shabby pedagogue). But how does Chisholm's definition fare with this example? For Chisholm's definition to come out right, it must be the case that Mach does not directly attribute the property of being a shabby pedagogue to Mach. But Mach = the man Mach sees as entering the bus from the opposite side. From this it follows then that Mach does not directly attribute the property of being a shabby pedagogue to the man he sees as entering from the opposite side. Is this an intended consequence of D1? Is it true?

Note that this problem arises only because the variable x occurs twice in "x attributes F-ness to x," and given "$x = y$," we may substitute y for x but not necessarily uniformly—that is, at each of its occurrences. By adopting "x directly self-attributes F-ness"—or what is even simpler, "x self-attributes F-ness"—we can simply bypass this problem, without losing any expressive power. This is a mere notational observation; there is, however, a more troubling question the Mach example raises. How do we decide whether or not "Mach directly attributes the property of being a shabby pedagogue to the man he sees as entering from the opposite side" is true? And how do we know, indeed, whether or not "Mach directly attributes to Mach (or: Mach self-attributes) the property of being a shabby pedagogue" is true? That is, how do we test whether or not Chisholm's D1 is a "correct" definition of the "he himself" locution? The problem of course is that "direct attribution" is an unexplained

technical primitive, and the only real handle we have on it comes from our *prior* understanding of the "he himself" locution. "Attribution" (of properties), like "conceiving," is part of ordinary English that we understand well enough; even in philosophical contexts we freely use it without having to worry about the precise structure and contour of the concept involved. In most such contexts, the lack of precision doesn't matter; it may in fact be an advantage. However, when such terms are used in theory construction, as a basis of precisely formulated definitions for problematic expressions that are targets of our analysis, the situation is different: we need to understand our primitives at least with the kind of precision required for a proper assessment of the proposed definitions and analyses. These remarks need not be taken as criticisms of Chisholm; their main point is only that it would be a mistake to take Chisholm's D1 as an "analysis" or "explication," in any deep sense, of "he himself" (as far as the order of understanding goes, we should probably read D1 backward). In any case, I would prefer to view D1 as a statement of Chisholm's project, namely that of taking "he himself," or *de se* reference, as basic and going from there, to analyze *de re* and *de dicto*. Whether we use the "he himself" construction or "direct attribution" construction, I think, is largely immaterial. It might be thought that Chisholm's adoption of the "direct attribution" idiom was connected with the doctrine of the primacy of properties as content—that it was particularly well suited, or perhaps even required, for stating the doctrine that in the act of believing or judging, we *attribute properties* rather than accept or judge propositions. But we can use the "he himself" locution for this purpose as well: for example, "Mach believes, or judges, of him himself to have the property of being a shabby pedagogue," etc. Moreover, as my next paragraph will show, the "attribution" locution is only one of the many, many primitives that will be needed for a full implementation of the doctrine of the primacy of properties.

Evidently, the "he himself" expression is used not only with "believe" and "judge," but with psychological verbs of all kinds: for example, "Fred *hopes* that he (himself) will win the windsurfing race," "Fred *doubts* that he (himself) got a good price for his old truck," "Fred *wonders* whether he (himself) will have to pay for the septic tank repair," and so on. In the case of believing or judging, the "self-attribution" locution seems entirely appropriate. But when Fred *hopes* that, *doubts* that, or *wonders* whether he himself has property F, what mental act takes the place of self-attribution? What is it that Fred does with property F in regard to himself when he hopes, doubts, or wonders that he has F? As I take it, the doctrine of the primacy of properties as content is intended to apply to all intentional, or content-bearing, mental states,

not just to doxastic states such as believing and judging.[21] Self-attribution of properties, therefore, is prima facie not enough to accommodate all intentional states, and any property-attribution theory that aspires to be a general theory of intentional attitudes should say something about this problem.

We now turn to Chisholm's analysis of *de re* on the basis of *de se*. He distinguishes between two senses, or kinds, of *de re* relation to an object: the weak, "latitudinarian" sort and the stronger relation that requires "epistemic intimacy" with the object. Let us first look at the latitudinarian *de re*. What is it for me to direct my thought, in the latitudinarian sense, upon an object other than myself (including non-*de se* reference to myself)? Chisholm's basic strategy is this: "I make you my [intentional] object by attributing a certain property to myself," a property that "in some sense, singles you out," thereby making you the object of an "indirect attribution" (p. 29). How is this done? Consider: I believe of Fred that he is wise. This first goes into: I *indirectly attribute* to Fred the property of being wise. The problem now is to define "indirect attribution," which Chisholm does in two stages:

(i) *Identifying relation*:

R is an *identifying relation* that S bears to x = df. x is the unique thing to which S bears R (that is, $R(S,x)$ and $\forall y[R(S,y) \rightarrow x = y]$).

(ii) *Indirect attribution*:

S *indirectly attributes* F to y = df. There is a relation R such that (1) R is an identifying relation that S bears to y, and (2) S directly self-attributes a property P such that P entails the property of bearing R to just one thing, and to a thing that is F.

(I have slightly reshaped Chisholm's D2 and D3 [p. 31].) So "I believe that Fred is wise" ultimately goes into:

There is a relation R such that (1) R is an identifying relation that I bear to Fred, and (2) I directly self-attribute a property P such that P entails the property of bearing R to just one thing and to a thing that is wise.

What could an R and P be in the present case? "$R(x,y)$" could be "x is standing directly to the right of y" (Fred is the only person standing directly to the left of me); the property P that I attribute to myself might be the property of standing directly to the right of just one person, a person who is wise. This means that my belief that Fred is wise implies a *de se* belief on my part, namely my belief that I (myself) am standing

directly to the right of just one person, who is wise. We should keep in mind Chisholm's special notion of entailment (p. 31): property P entails property just in case necessarily (a) if P is exemplified so is Q, and (b) whoever conceives P conceives Q. Note that, according to (a), P and Q need not be exemplified by the same individual (thus, being a husband and being a wife satisfy (a), taken in either direction), and that (b) requires an intentional/epistemic relationship between the two properties. As I take it, condition (b) on entailment, as this relation is used in clause (2) of the definition of indirect attribution above, is to insure that the believer is aware, in some sense, of the fact that the self-attribution of P involves the indirect attribution of F (in our example, that of being wise) to some object he has singled out with the relation R, although whether transmission of conceiving from P to F can effect this is another question—that is, another question about the nature of conceiving. Moreover, the believer must not only be aware, or believe, that R singles out his intentional object; clause (1) requires also that R must *in fact* single it out for him—that is, it must in reality be an identifying relation correctly relating the believer to the object of her belief.

I believe that, given Chisholm's notion of entailment as just stated, especially its clause (a), his definition of indirect attribution is subject to a difficulty. The problem, briefly, arises as follows: the intended idea is that I indirectly attribute F to y just in case I believe that y is F. F has an "owner," namely y. But clause (2) of Chisholm's definition, under his notion of entailment, does not seem to insure this. I self-attribute property P, and P entails *the property of bearing R to just one thing, which is F*. But, given Chisholm's notion of entailment, the italicized property has no specified owner: I am the (intended) owner of property P, which entails this property, but that doesn't mean that I have this property. And this means that there is no guarantee that property P is being attributed (indirectly) to the right object, y. Examples can easily be constructed to illustrate this difficulty. There is, however, a simple way of fixing it: Use a slightly different notion of entailment by replacing (a) by the more standard (a*): necessarily whatever exemplifies P exemplifies Q.[22]

Some philosophers will find Chisholm's account of *de re* both too strong and too weak. Take Keith Donnellan's well-known example of the man with a martini glass.[23] At a party you see a man holding a martini glass, and think to yourself: the man drinking martini is going bald. But it turns out that the martini glass holds water, not martini, and behind this man there is another man who is drinking a martini. It would seem that on Chisholm's account this second man, not the first man, turns out

to be your intentional object—that is, you indirectly attribute baldness to the second man who is unseen by you, not the first man to whom you fail to bear the identifying relation that is apparently involved in your self-attribution. In ruling out the first man as your intentional object, says the critic, the account is too strong, and making the second man your intentional object, the account is too weak. The latter complaint, that on Chisholm's analysis it is much too easy to establish an intentional relation between a thinker and an object, can properly be dealt with only in connection with Chisholm's proposals for a stronger, nonlatitudinarian relation of *de re*. Accordingly, we will put off discussion of this issue for later. As for the first objection, to the effect that the man that you take to be drinking a martini fails to be your intentional object, this consequence does not strictly follow from Chisholm's definition. For the definition only requires that there be *some* identifying relation *R* by which you single out that man. In the present case, *person I see over there holding a glass* (more exactly, *x sees y at some distance holding a glass*) may well do (this relation is likely to give us a nonlatitudinarian *de re* relation), or even something weaker, like *man in the corner with a glass in hand*, may suffice. As Chisholm says, finding such an identifying relation "is not difficult to do" (p. 31).

But it is not clear that this response is entirely satisfactory. Suppose that the property you *actually* self-attribute is not one that entails an identifying relation merely involving holding a glass but one that entails an identifying relation involving drinking a martini? (We are also supposing that you self-attribute no other property on this occasion.) That is, you are in fact *thinking* of the man *as the man over there drinking a martini*. Of course you could have self-attributed a property that entails a correct identifying relation,[24] but suppose you didn't. Would that make you lose him as your intentional object? Should it? To turn to another problem: Suppose you have, actively in your mind, several identifying relations for the man, only one of which correctly identifies him, others being incorrect. Chisholm's analysis implies that the incorrect ones don't count, as long as you have a single correct one. Is this a desirable consequence? Having too many false beliefs about a given object, one may argue, can lead to loss of its eligibility as the object of these beliefs.[25] A related question: If the property that I self-attribute entails two (or more) distinct identifying relations (say, I self-attribute the property of standing behind just one person, a person to whom I am married), how do we determine which is the object of reference and which is the content? That is, do I believe of my wife that I am standing behind her, or of the person behind whom I am standing that she is my wife? Chisholm's analysis implies that in all such cases I have both

beliefs. Or to put it another way: both these beliefs turn out to be the same instance of indirect attribution, and this threatens to abolish the distinctness of the two beliefs. This strikes me as an unintuitive consequence, although there is here room for further debate.

I now turn to a question of some importance that Chisholm, to my knowledge, has not explicitly addressed. The question concerns possible material constraints on identifying relations R. In particular, there is the following question: Should there be a restriction to the effect that R itself not be an intentional relation or imply one?[26] It seems to me that the answer one gives to this question is of critical importance to the interpretation of Chisholm's project in *The First Person*. We will return to this question in the final section, but for now we may note that the adoption of such a restriction would render some of Chisholm's examples of indirect attribution problematic; for example, the example involving the relation of *talking with* (p. 30) and one involving that of *looking at* (p. 31).

Before we turn to Chisholm's treatment of *de dicto* and nonlatitudinarian *de re*, I want to raise one further question without discussion: How does the self-attribution theory handle iterated intentional contexts in which beliefs and other intentional attitudes embed other beliefs and attitudes? For example, how does the self-attribution theory cope with:

Mary believes that Tom believes that he (himself) was poisoned by her (herself).[27]

IV

According to Chisholm, there are two ways in which we may hold a *de dicto* belief: (1) you can directly attribute to yourself, taking yourself as an intentional object, a property of the form, being such that p, where p is the proposition in question; or (2) you can take p as your *de re* intentional object (as something you *conceive*) and indirectly attribute to it the property of being true (p. 38). Chisholm calls these two conditions "quite different" (p. 39), the first being "less sophisticated" in that it does not presuppose the believer to be in possession of the concept of truth.

I find it difficult to gain an intuitive grasp of the difference between the two kinds of *de dicto* belief distinguished by Chisholm. How in a given case am I to determine whether my belief, say, that two is the smallest prime, is of kind (1) or kind (2)? How is it possible that a believer who can conceive, and understand, properties of the form, being

such that p, can still lack the concept of truth? But the main puzzle I have about Chisholm's account of *de dicto* is this: Chisholm, as we have noted, takes conceiving as the fundamental intentional, or referential, relation that a cognizer can bear to abstracta ("The primary way, then, of referring to an eternal object is to *conceive* it," p. 37). Even in the "less sophisticated" case of *de dicto* belief recognized by Chisholm, the cognizer grasps or conceives the "universal property" of being such that p, and the conceiving of this property necessarily involves, we must assume, the conceiving of the proposition that p. If so, why can't the cognizer take this proposition as her intentional object and attribute to it the property of being true? Why go through the roundabout way of self-attributing another property? Why isn't conceiving sufficient, in and of itself, to fix an abstract object as my intentional object, thereby enabling me to attribute properties to it, directly and without intermediaries? Chisholm's idea, as I understand it, is that my conceiving of a property gives me enough of a handle to do interesting things with it—in particular, attributing it to myself. The question I have is why my conceiving of a proposition isn't enough for me to attribute *to it* certain properties, including that of being true. In the case of concrete things, Chisholm's general approach makes good intuitive sense—it is based, I think, on an important philosophical insight: in taking a concrete individual, in space and time, as an intentional object of my thought, I must somehow "locate" or "identify" it, and I can, and must, do so only in relation to me—in relation to my own location ("my" in the "I myself" sense). I am "the zero point" of my intentional coordinate system.[28] But it is difficult to see this kind of intuitive rationale where reference to eternal objects is concerned, and it seems to me that Chisholm's general scheme in *The First Person* can generate a simpler account of *de dicto* than the one Chisholm actually provides.[29]

V

There are familiar reasons for thinking that the kind of *de re* relation, or "aboutness," explicated by Chisholm in terms of "indirect attribution" is "excessively latitudinarian," as he points out himself (p. 107). It makes it too easy for us to have beliefs and other attitudes about, say, "the tallest spy." Chisholm's response to this, which I believe is essentially correct,[30] is not to say that his "indirect attribution" is too weak as an explication of *de re*, but rather that we need to distinguish two *de re* relations, one stronger than the other. In his view, the weaker relation is adequately captured by his indirect attribution, and the essential compo-

nent that should be built into the stronger relation is "a certain degree of epistemic intimacy" (p. 109) between the believer and the object of her belief. More specifically, the believer must "identify" the object of her belief "as" the object she believes to be thus-and-so. Thus, the core of Chisholm's account of the stronger *de re* relation is his analysis of "identification."

There are three ways, Chisholm tells us, in which a believer can identify an object in the desired sense: *self-identification, perceptual identification*, and *identification by multiple indirect attributions* (as we may call it). The idea of using some notion of epistemic contact to generate a robust intentional relation is not new; it goes back at least to Russell and his "knowledge by acquaintance." Let us see how Chisholm's account works.

Chisholm is brief on the identification of the self: when I directly attribute a certain property to myself and "consider" my attributing to myself that property, then I have "identified myself as a thing I believe to have that property" (p. 109). Since identification is intended to yield the stronger, nonlatitudinarian *de re* relation, Chisholm is in effect saying that "taking oneself as an intentional object," which is involved in all cases of direct self-attribution, does not suffice to establish a nonlatitudinarian *de re* relation to myself, and that it does not suffice to give us the kind of epistemic intimacy required for this relation. Chisholm doesn't say why this should be so, and I have no clear idea why the fundamental relation posited by Chisholm, that of taking oneself as an intentional object, does not suffice for the stronger *de re*. What is "considering" and what does it add to this fundamental relation? Chisholm's "considering" appears to add something like the believer's self-reflection on her own belief. Whether such a self-reflective act is required for "the identification of the self" is a verbal issue; what isn't a verbal issue is whether it is required for establishing an appropriately strong *de re* relation with oneself. My own feeling is that where *de se* reference is concerned, the latitudinarian-nonlatitudinarian distinction makes no clear or obvious sense, and that self-reference in this fundamental sense is not a matter of "epistemic intimacy"; after all, the distinction originally arose for *de re*, to begin with, and *de re*, on Chisholm's approach, is only a special case of *de se*.[31] And, as far as I can tell, the concept of self-identification plays no further role in Chisholm's theory of intentionality.

Chisholm also thinks that when we *know* many things "about" an object on independent evidence, where this "about" is the weak, latitudinarian kind, and know, moreover, that one and the same object is involved in these independent pieces of knowledge, I can be said to have established the kind of epistemic intimacy required for the stricter *de re*

relation. This I find an interesting and plausible idea worthy of further exploration.

Let us finally turn to perceptual identification, which arguably is the most important kind for nonlatitudinarian *de re*. We first need the following definition (this is not an exact quotation from Chisholm; see p. 110):

> *A person perceives an object to have property F* just in case the object has *F*, and the person "perceptually takes the object to have *F*," and it is "evident" to him that the object has *F*.

Chisholm says: "If I thus *perceive* a thing to have a certain property, then I may be said to have identified the thing *as* a thing which I *believe* to have that property" (p. 110). This, then, is perceptual identification. But to understand it, we need the notions of "perceptual taking" and "evident." Let us here only consider the former, which Chisholm explains as follows (p. 96; again this is not an exact quotation):

> A person *perceptually takes an object to have property F* just in case *F* is a sensible property, the object "appears to" the person in a certain way; and the person indirectly attributes *F* to the object as the thing that "appears to" him that way.

Thus, my perceiving an object to have a certain property requires the object to *appear to me* in a certain way. But what is this "appearing" relation that an object bears to a person? Can this relation be explained without presupposing a strong *de re* relation involving epistemic intimacy? Tracing back the thread of definitions in *The First Person*, we find the needed material in the second section of chapter 8 on "Appearing and Being Appeared To." Being appeared to (for example, I am appeared to redly) is a state of sensing in a certain way, and involves no *de re* relation to an external object. Chisholm asks whether the relation of appearing, which is the crucial *de re* relation for us, can be defined in terms of the notion of being appeared to and certain causal concepts (p. 94). Chisholm sounds somewhat tentative here, but he defends an affirmative answer. The principal causal concept he makes use of is that of "functional dependence": when we vary certain features of the "stimulus object," the appearance it presents to us also varies systematically (that is, nomologically, as I take it). But there is this sort of dependence also between the medium of perception (for example, the condition of illumination) and perceptual experience, and to eliminate such cases, Chisholm requires the functional dependence to be also "structural" in the following sense: "The appearance is divisible into parts which correspond to different parts" of the stimulus object (p. 94).

This proposal elicits various questions. First, it seems that Chisholm is thinking mainly in terms of visual perception. One question is whether in formulating the requirement the way he does—in particular, in his talk of "the appearance" being "divisible into parts," etc.—he is unwittingly committing himself to sense-data, appearances as bona fide existents made up of "parts." Another question is whether the requirement makes clear sense when applied to sense modalities other than the visual sense—in particular, whether it makes sense for the olfactory and gustatory sense. Further, and more importantly, there is a very difficult unfinished task here: in giving a causal characterization of "perceptual object," we must distinguish "the stimulus object" not only from the "standing conditions" of perception, such as illumination, but also from its causal antecedents and the links in the intervening causal chain from the stimulus object to our perceptual experience (including physiological processes in our sensory receptors, and the like). It is difficult to see how the "structural dependence" condition could help separate the perceptual object from, say, cross-sections of the array of light rays impinging on the retina or the pattern of electrochemical activities in the receptor neurons.

VI

In this final section I want to discuss the nature of Chisholm's project in *The First Person*. Of the three fundamental doctrines underlying Chisholm's mature views on intentionality—the primacy of the psychological, the primacy of *de se*, and the primacy of properties—the second arguably is the most important. It is an innovative and intuitively powerful idea that plays a crucial role in giving Chisholm's theory its distinctive character. But what does it mean to say that *de se* is "fundamental" or "basic," or that it is "primary" or "elementary" (p. 27)? One thing that is clear is that Chisholm takes this to mean that *de se* can "throw light" on *de re* and *de dicto*, and that it can be used as a basis for characterizing these other forms of intentionality (p. 27). In fact, he talks of "reducing" all belief to direct self-attribution of properties (p. 37).

Our discussion in the preceding section of Chisholm's analysis of strict, nonlatitudinarian *de re* reference—in particular, his account of "perceptual identification"—makes one wonder whether the theory of *de se* is providing any real help in analyzing *de re*, or to what extent it is doing any illuminating of the nature of *de re* reference. For all the substantive problems and difficulties we are familiar with in explaining

the idea of an intentional object, semantic reference and the idea of a perceptual object seem to remain essentially unchanged. The main problem is that of explaining an appropriate relation of "epistemic" or "perceptual" contact with an object sufficient to establish a nonlatitudinarian intentional relation, and we are still faced with the familiar difficulties, for example, separating perceptual objects from perceptual conditions, characterizing "non-deviant" causal chains, separating out those links in the causal chain that, though causally essential, are not perceptually represented or experienced, and so on. These problems do not seem affected in any way by the adoption of the primacy of *de se*. We see that they must be dealt with independently; it seems inappropriate to look to the theory of direct self-attribution for help with *these* problems. The primary effect of the doctrine of the primacy of *de se*, therefore, is a reorientation of our philosophical perspective, not any technical help it brings to the analysis of *de re*. This reorientation consists in the appreciation of the insight, earlier referred to, that in locating or singling out an object as my intentional object, I do so by relating it to myself whom I locate directly—I am the anchoring point of my intentional space.

Formally, what the self-attribution theory does is to recast all sentences of the form "*S* believes with respect to *x* that . . . *x* . . ." or "*S* believes that *p*," where "*p*" stands for a (Chisholmian) proposition, into the "elementary" form "*S* directly self-attributes the property of being such that" In the material mode, then, having a belief in general is a matter of directly attributing a property to oneself. Thus, it is clear that Chisholm would accept the following two theses fleshing out the primacy of *de se*:

(1) *De se* intentionality is irreducible to other forms of intentionality; in particular, *de se* belief is irreducible to *de re* or *de dicto*.
(2) All intentional attitudes essentially involve *de se* intentionality; in particular, all beliefs are instances of *de se* belief.

Does the primacy of *de se* mean, for Chisholm, more than these two theses? I believe it does. For (1) and (2) are compatible with *de re* and *de dicto* remaining distinctive and indispensable intentional relations in their own right. The fact that (2) alone does not eliminate *de re* can be easily seen in Chisholm's attempt to explicate the nonlatitudinarian *de re* and the attendant problem of analyzing "identification" and "perceptual identification." For if (2) were all that Chisholm wanted to defend, all these difficult projects could be dispensed with, by recasting the *de re* belief sentence "*S* believes, of *x*, that *x* is *F*" into a self-attribution sentence of the form "*S* directly self-attributes the property of *referring*

to, having in mind, perceptually identifying, or (just plain) *identifying,*
one thing, a thing that is *F*" (*plus* the sentence affirming that the
identifying relation does in fact pick out a single thing). What we have
just done is to *build an overt de re relation into the identifying relation R.*
If I understand him correctly, this would be disallowed by Chisholm. As
may be recalled, this is precisely the question I raised earlier concerning
constraints on the identifying relation *R.* The question, therefore, is
whether Chisholm accepts the following condition on identifying rela-
tions:

> *The noncircularity condition:* identifying relation *R* must not
> itself be a *de re* intentional relation (of the nonlatitudinarian
> kind) or imply one.

My conjecture, based on the fact that Chisholm takes seriously the
project of constructing a relation of "identification" that can ground the
nonlatitudinarian *de re,* is that he accepts the noncircularity condition.
So we may now ask whether or not Chisholm's overall project in *The
First Person* is a reductionist one in the following sense:

(3) All intentional relations are reducible to the *de se* relation; in
particular, *de re* beliefs are reducible to *de se* beliefs.

I believe there is textual evidence that in *The First Person* Chisholm is
pursuing a reductionist project of just this kind. In addition to what I
have already said concerning his attempts to analyze "identification,"
the following quotations give presumptive support to such an interpreta-
tion:

> So, instead of trying to understand the "he himself" locution as a special
> case of the ordinary *de re* locution, we shall try to understand the ordinary
> *de re* locution as a special case of the "he himself" locution. . . . We should
> have given [the *de se* statement] the ordinary quantification notation, and we
> should have exhibited [the *de re* statement] as something that is obviously
> derivable from [the *de se* statement]. (p. 25)

> If, as I shall argue, all belief is reducible to direct attribution, there will be a
> sense in which we can say that the believing subject is the primary object of
> all belief, and analogously for the other intentional attitudes. (p. 37)

These and other things Chisholm says in the book, as well as what he
does (in particular, his analysis of perceptual identification), point
toward a reductionist project. This contrasts with what David Lewis
does with his self-ascription theory of belief. Lewis, independently of
Chisholm, came to advocate the thesis that the primary form of belief is
the attribution to the self of properties (rather than acceptance of
propositions).[32] But unlike Chisholm, in his explanation of how a self-

ascribed property can manage to give us *de re* reference to an object, Lewis simply resorts to the notion of "epistemic acquaintance" and essentially leaves the matter there.[33]

JAEGWON KIM
DEPARTMENT OF PHILOSOPHY
BROWN UNIVERSITY
AUGUST 1995

NOTES

1. Parts of this paper derive from my review of Chisholm's *The First Person* which appeared in *Philosophy and Phenomenological Research* 46 (1986): 483–507. For discussion of many of the issues taken up here, my thanks go to Ernest Sosa and members of a graduate seminar that I co-taught with him at Brown on "The Philosophy of Roderick Chisholm" in 1994. For specific suggestions and comments on the present paper I am indebted to Ernie Sosa, Gary Gates, Jim Van Cleve, and members of a discussion group in the summer of 1995 at Brown. I should also add that Rod Chisholm was directly responsible for my early education on intentionality, and that I have learned from him most of what I know (or think I know) about it.

2. *Philosophical Studies* 3 (1952): 56–63.

3. *Proceedings of the Aristotelian Society* 56 (1956): 125–48; a later version appeared in the *Minnesota Studies in the Philosophy of Science*, vol. 2, ed. H. Feigl, M. Scriven, and G. Maxwell.

4. *Perceiving: A Philosophical Study* (Ithaca, N.Y.: Cornell University Press, 1957).

5. To mention a representative sample, James Cornman, "Intentionality and Intensionality," *Philosophical Quarterly* 12 (1962): 44–52; Herbert Heidelberger, "On Characterizing the Psychological," *Philosophy and Phenomenological Research* 26 (1966): 529–36; Ausonio Marras, "Intentionality and Cognitive Sentences," *Philosophy and Phenomenological Research* 29 (1968): 257–63; W. Gregory Lycan, "On 'Intentionality' and the Psychological," *American Philosophical Quarterly* 6 (1969): 305–11.

6. See, for example, Fred Dretske, *Knowledge and the Flow of Information* (Cambridge: MIT Press, 1981); Jerry Fodor, *Psychosemantics* (Cambridge: MIT Press, 1987).

7. Paul Edwards, ed. (New York: Macmillan, 1967), vol. 4.

8. Sentences embedding such content sentences may be contingent because of the contingency of the existence of the believer. However, this point does not seem germane to the basic insight and significance of Chisholm's proposal.

9. *Philosophical Studies* 29 (1976): 1–20.

10. London: Allen and Unwin, and La Salle, Illinois: Open Court, 1976.

11. See, for example, his "On the Nature of the Psychological," *Philosophical Studies* 43 (1982): 155–64; reprinted in his *On Metaphysics* (Minneapolis: University of Minnesota Press, 1989). But his project in this article is no longer

that of finding a purely logico-linguistic criterion of the mental. The criterion he proposes makes explicit use of the intentional/mental concept of *conceiving* as a primitive (as Chisholm himself acknowledges). It seems that by this time he had abandoned the earlier project of defining intentionality or mentality in logico-linguistic terms alone; in fact, in his later works in metaphysics Chisholm assumes intentional idioms (in particular, such terms as "conceiving" and "attributing" of properties by a cognizer) among the primitives of his ontology. See especially his "Self-Profile" in *Roderick M. Chisholm*, ed. Radu Bogdan (Dordrecht: Reidel, 1986). Actually, in "Self-Profile" (pp. 36–37), Chisholm proposes what he calls "a logical characteristic" of the psychological; however, his definition, which characterizes the psychological as "purely qualitative," turns out to make use of the term "involve," which in turn is defined by the use of the intentional term "conceive" (p. 32). In view of this, this definition cannot be viewed as implementing his earlier logico-linguistic project.

12. In *Roderick M. Chisholm*, ed. Bogdan.

13. E.g., Fred Dretske, *Explaining Behavior* (Cambridge: MIT Press, 1988); Jerry A. Fodor, *Psychosemantics*, and *A Theory of Content* (Cambridge: MIT Press, 1990).

14. But of course not as a successful reduction of the mental to the nonmental. For it is not part of the project to provide nonmentalistic definitions of *specific* mental phenomena, such as belief, desire, and consciousness.

15. In his "Self-Profile," p. 29, Chisholm suggests reduction of states of affairs to attributes: roughly, the state of affairs (or proposition) that p is to be construed as the attribute of being such that p.

16. Propositions, for Chisholm, are a subclass of states of affairs.

17. *The First Person*, p. 7. Hereafter references to this book will be in the form of parenthetical page numbers inserted directly in the text.

18. Why else would Chisholm emphatically deny that properties could be conceived via individual things? He says, for example, "no property is such that it can be conceived only by reference to some individual things," *The First Person*, p. 7.

19. Gottlob Frege, "Logik" (1897), in *Posthumous Writings*, trans. P. Long and R. White (Oxford, 1979), p. 145. For further discussion of Frege's notion of "grasping" see Michael Dummett, *Origins of Analytical Philosophy* (Cambridge: Harvard University Press, 1993), especially chapters 7 and 10.

20. Since Thomas Nagel's "What Is It Like to Be a Bat?" *Philosophical Review* 83 (1974): 435–50. But the questions go back much further, at least to Locke.

21. Chisholm says, "What we have said about attribution and believing may be extended to the other intentional attitudes and, indeed, to thought itself" (p. 28), and goes on to mention "entertaining" (a proposition). Later he mentions "considering" (p. 39), which he appears to take to be synonymous with "entertaining."

22. It appears that Chisholm has seen this difficulty. His definition of "x judges y to be F" (which corresponds to "x indirectly attributes to y the property of being F"), in his "Self-Profile," is formulated in a way that avoids the problem.

23. See Donnellan's "Reference and Definite Descriptions," *Philosophical Review* 75 (1966): 281–304.

24. There is also Kripke's argument that we can refer to Aristotle even if we

are not in possession of *any* correct identifying description of him; see his *Naming and Necessity* (Cambridge: Harvard University Press, 1980).

25. See, for example, Donald Davidson, "Reality Without Reference," in *Inquiries into Truth and Interpretation* (Oxford: Clarendon Press, 1984). Note that on Chisholm's account every false belief you hold about anything is a fortiori a false belief about yourself.

26. A restriction of this kind should obviously be waived for cases that involve iterated intentional contexts in which, say, beliefs embed other beliefs. See next paragraph.

27. I am not suggesting that proposition theories will have an easier time with sentences like this.

28. Such is the idea that I believe motivates Chisholm's thesis, defended with marvelous clarity and insight in his earlier work, *Person and Object*, that I can "directly individuate" myself alone, and that all other things are "indirectly individuated" in relation to me. His theory in *The First Person* can be viewed as an extension of this idea to the general theory of intentional reference.

29. I can see situations in which Chisholm's approach to *de dicto*, especially his (2) in which a property is indirectly attributed to a proposition, can be appropriate. One such situation is when I believe, say, the last proposition in Plato's *Republic* to be true, *when I don't know what that proposition is*. But presumably in such a situation I am not able to "conceive" the proposition involved.

30. I say "essentially" correct because, given Chisholm's rationale for making the distinction, it would seem more natural and plausible to posit a graduated notion of referential relation that admits of degrees, rather than two, and only two, distinct kinds of referential relation.

31. The distinction does make sense when applied to non-*de se* reference to oneself. When Mach thinks of the man he sees as entering the bus "What a shabby pedagogue!" he was in a nonlatitudinarian referential relation with himself. And Mach could be in a latitudinarian *de re* relation with himself via the identifying relation given by "y is the tallest person in the bus with x." But this is an instance that falls under the standard distinction between the latitudinarian and nonlatitudinarian *de re*, and self-identification in Chisholm's sense appears not to be relevant to such cases.

32. In "Attitudes *De Dicto* and *De Se*," *Philosophical Review* 88 (1979): 513–43.

33. He mentions the possibility of analyzing acquaintance in terms of causal and informational concepts, but remains noncommittal. His final proposal contains an explicit reference to "the relation of acquaintance" between the believer and the object of his/her *de re* reference.

REPLY TO JAEGWON KIM

K im's paper, "Intentionality *De Se, De Re,* and *De Dicto*," is a high-powered discussion of intentionality and objective reference. He has set forth accurately what I have tried to do and he has discussed all the serious difficulties that my views on these matters involve.

My principal attempts to deal with the subject are contained in the three criteria formulated in "Sentences about Believing" and in the prefix criterion in "Intentionality" in Paul Edwards's Macmillan *Encyclopedia of Philosophy*.

I agree with Kim that the latter theory is the most promising. He writes:

> The definition he offers here is essentially this: for a psychological sentence operator *p*, such as "Jones believes that *p*," is a contingent sentence. This contrasts with, for example, the modal operators: "It is possible that there are round squares," is necessarily false, and "It is necessary that 1 = 1," is necessarily true.

The preanalytic data upon which I have based my philosophical writings—what, following Peirce, I have called "critical commonsensism"—include certain propositions of descriptive psychology: there are four types of psychological phenomenon: judging or accepting; considering or thinking about; liking and disliking; and trying (which is not here to be taken as connoting an effort).

Kim is considerably more skeptical in his attitude toward philosophy than I am. From the fact that, if we are to avoid circularity and infinite regress in our definitions, he seems to infer that we are left with terms that we do not grasp or understand. I would note that this conclusion is a non sequitur.

My writings on intentionality *de se*, *de re*, and *de dicto* are extremely problematic. I wish that I were able to write a second edition based upon Kim's criticisms.

R.M.C.

17

Keith Lehrer

THE QUEST FOR THE EVIDENT

R oderick M. Chisholm's epistemology may be interpreted as the quest for the evident. I should like to present my reconstruction of the historical development of the thought of Chisholm on matters of the evident. Some of what I shall say will be based on his published writings, some of it on what I heard him say in seminars from time to time, and some of it, finally, on my own conjectures based on the authors Chisholm has cited. Chisholm read Thomas Reid fairly early in his career—before 1957, at any rate, when we first met—and I will, consequently, note some parallels between their thought to find out whether Chisholm was conscious of the influence of Reid at points at which there is a similarity in their thought. Let us begin with the early work concerned with the critique of phenomenalism and the transcendence of it in Chisholm's first book, *Perceiving*,[1] a book so original that it would have earned him a place in the history of philosophy had he written nothing more. The problem phenomenalism was concerned to solve was the problem of perceptual knowledge. What was the problem? It was the problem of the evidence of perceptual beliefs. We consider many of our perceptual beliefs to be evident. We believe that we see things before us, things that really do exist and are not mere appearances, which really have the properties we perceive them to have and do not merely appear to have those qualities. But what makes those beliefs evident? Some philosophers might rush off to answer the question hunting for premises like a pig sniffing for truffles. Chisholm asked a Socratic question. What is it for something to be evident? What is the evident? The quest for the evident was begun.

The basic insight formulated in *Perceiving* was that the evidence of perceptual beliefs did not depend on inference from the way things appeared. Chisholm accepted the argument from Hume that inductive inference based on an empirical correlation between appearances and reality would be circular argumentation and, therefore, unacceptable.

One way to avoid circularity while maintaining at the same time that the evidence of perceptual belief was based on inference from appearance would be to accept the thesis of phenomenalism which affirmed that statements describing things can be analyzed without loss of meaning into statements describing only appearances. Phenomenalism was, therefore, a thesis about definitional reduction. If the thesis were true, then statements or the contents of beliefs must logically entail statements about appearances by definition. This allowed for inferences from statements about appearances to statements about how things are (a thesis defended by C. I. Lewis),[2] and, therefore, an inductive inference from appearances to reality, which would be a kind of hypothetico-deductive inference. Chisholm argued convincingly, however, that phenomenalism was false because no statement about how things are entails any statement about how anything appears to anyone. The relativity of the observer suffices for the argument. Any claim that a physical object statement P entails statements about appearances S will be subject to refutation by appending to P some statement about the condition of the observers C such that P and C will be consistent with falsity of R.[3] Thus, no inference based on an observed correlation or on a hypothetico-deductive correlation could account for the evidence of perceptual beliefs. Must we then give up on the attempt to analyze the evidence of perceptual beliefs? Chisholm simply took it as a challenge to deepen the quest for the evident. How are we to account for the evidentness of our perceptual beliefs without understanding what it is for a belief to be evident?

Before turning to Chisholm's answer it is enlightening to consider his relationship to Reid and Quine. There was agreement between Quine and Chisholm about the failure of phenomenalism, but they drew different conclusions from that failure. Quine assumed that the point of a theory of knowledge was to reduce statements about reality to statements about appearances in order to secure the verification of statements about reality in terms of statements about appearances. For Quine the purpose of reduction was verification, and the failure of epistemology to account for the verification of statements about reality on the basis of appearance statements by reductive phenomenalistic analysis meant that the theory of knowledge itself had failed and could only be replaced by some new enterprise. The new enterprise was the psychology of belief formation. If we cannot have a theory of knowledge that explains how beliefs about reality are verified by experience, we can at least have a psychology that explains how our beliefs about reality are generated by experience; but, Quine averred, that is all we can have, what he called epistemology naturalized.[4]

If, however, epistemology is to include an account of what makes our beliefs about reality evident, as Chisholm thought, then epistemology naturalized was epistemology abandoned. Moreover, it was abandoned without justification. For it is a fallacy to conclude from the falsity of phenomenalism that it is impossible to give an account of the evidence of perceptual beliefs. If, moreover, it is possible to account for their evidence, why should we assume that this is the task of psychology? To take an analogy, it is impossible to reduce the notion of validity to decidability in logic. The purpose of the reduction of validity to decidability was the verification of statements about theorems, but it would be fallacious to infer that the failure of logic to account for the verification of statements about theorems by reduction to decidability meant that logic failed and should be replaced by some new enterprise, the psychology of how we generate theorems. The parallel is an exact one. There is more to verification in logic than reductive decidability, and there is more to verification in perception than reductive phenomenalism. Many followed Quine around the fallacious turn of naturalism, but some of us were fortunate enough to be guided by Chisholm into the depths of the theory of knowledge rather than abandoning it for psychological speculation.

Chisholm frequently cites an eighteenth-century figure, Thomas Reid, who also saw that the failure of phenomenalism did not warrant the abandonment of the theory of knowledge as a theory of evidence. Reid also contended that premises about external objects including our organs of sense did not logically imply any conclusions about sensations for the simple reason that it is only a contingent fact that the excitation of our organs of sense and even their extension into the brain should produce the sensations they do. Stimulations of the retina might, for all logic tells us, have yielded sensations of taste rather than those of vision. We cannot, Reid agreed with Hume, reason from premises about our sensations to conclusions about the existence of material things. But Reid insisted that some of our perceptual beliefs concerning material objects were justified without reasoning from sensations because they were evident in themselves. Some of our perceptual beliefs, those evident in themselves, are justified, not because they are the conclusions of reasoning, but because they are the first premises of reasoning. Reid noticed that the evident in matters of perception did not have to arise from the justification of reasoning because those beliefs might be evident in themselves. As Reid put it, their evidence is their birthright.[5]

Chisholm became the champion of the claim that some of our perceptual beliefs about objects are justified without reasoning from appearances. Reid clearly saw the possibility of maintaining this posi-

tion, but Chisholm confronted the question of what there is about the nature of evidence that permits one to cogently argue that some perceptual beliefs concerning material objects are evident without being supported by reasoning. In short, he confronted the question—what makes perceptual belief evident even when unsupported by reasoning? And what was his answer? It was that epistemic predicates are predicates of evaluation, like the predicates of ethics, whose application is based on the application of nonepistemic predicates. Put in the material mode of speech, epistemic properties are properties of evaluation that are based on the nonepistemic properties. Epistemic predicates and properties are not reducible to the nonepistemic predicates and properties on which they are based, because evaluation, in epistemology as in ethics, is not reducible to the predicates and properties on which the evaluation is based. How could it be? How can my evaluation of some property as having value or worth be reducible to the property? If it were, then my claim that the property had value or worth, my positive evaluation of the property, would be no more than a repetitive claim that the thing that had the property had the property.

What, however, is the exact connection between evaluation and evidence? The answer to the question contained in *Perceiving* was that to have adequate evidence for believing something, that p, is to be analyzed in terms of the worth of believing it, of believing that p. Thus, he proposed that a person S has adequate evidence for believing that p if and only if p is more worthy of S's belief than the denial of p.[6] This analysis was one that Chisholm soon modified, no doubt because he found the analysis defective in detail. But the basic idea that the term 'evidence' and with it the term 'evident' are terms of epistemic evaluation or appraisal, irreducible to the predicates describing the conditions evaluated or appraised, remained a central feature of his thought, and, in my opinion, a fundamental insight concerning epistemology. We might put this by saying that the epistemic supervenes on the nonepistemic but is not reducible to it. One epistemic term may be reducible and definable in terms of others, but they are not reducible or definable in nonepistemic terms. In the analysis of 'adequate evidence' in *Perceiving* two basic ideas of Chisholm's theory of knowledge are introduced which are retained in his work. The first is that a term describing evidence is essential to the analysis of knowledge, and the second is that the term of evidence can be analyzed in terms of a comparative epistemic term, originally in *Perceiving* the notion of one thing being more worthy of belief than another, in later work, the notion of one thing being more reasonable or justified for a person than another. There is something important in this change from the notion of one thing being more worthy

than another to one thing being more reasonable than another, but the basic idea that a comparative notion is adequate to analyze the qualitative notions again remains constant.

In *Perceiving,* Chisholm offered an analysis of knowledge as true belief plus the adequate evidence, that is, as S knows that p is true if and only if S accepts that p, p is true and S has adequate evidence for p.[7] The last condition was analyzed as we have seen by saying that p is more worthy of S's belief than the denial of p. All of this gets modified as Chisholm deepened his original insight. The problem Gettier[8] raised caused him to modify the analysis, but I shall not follow Chisholm on our mutual journey into the solution of that problem. It is his quest for the evident that interests me, and, I think, that will prove most influential in the long run. Let us note, however, that, the Gettier problem aside, the analysis of evidence needed improvement and received it as the quest for the evident continued. Chisholm gave up his early analysis and moved on to another. It is clear that the analysis of evidence was too weak. Our epistemic options concerning p are not limited, as Chisholm noted, to believing p and believing the denial of p, for there is also the option of neither believing p nor believing the denial of p, which Chisholm called withholding p.[9] Now suppose that p is more worthy of my belief than believing the denial of p but that withholding p is more reasonable than believing either. If p is only very slightly more worthy of my belief than the denial of p, it may be more reasonable for me to withhold than to believe either p or the denial of p. At any rate, in such a case, I do not have adequate evidence that p. The evaluation of p, though more positive than the evaluation of the denial of p, is not a positive enough evaluation to convert true belief into knowledge. We need a stronger epistemic requirement for that purpose and, thus, to capture the needed notion of evidence.

In the next book, *Theory of Knowledge,* first edition[10] (hereafter, *TK*1), we note some major differences. First of all, the term 'adequate evidence' is replaced by the term 'evident', secondly, the comparative notion of one thing being more worthy of being believed than another is replaced by the notion of one epistemic attitude being more reasonable than another, and thirdly, the notion of the evident is analyzed more restrictively. Moreover, other epistemic notions are analyzed in terms of the comparative notion of one thing being more reasonable than another. I suspect that the expression 'adequate evidence' was not well suited to the claim that Chisholm wanted to defend in common with Reid, namely, that some perceptual beliefs were evident and, moreover, constituted knowledge without being based on reasoning from premises. It is consistent to say, as Chisholm did, that a person has adequate

evidence for a perceptual belief without appeal to reasoning. As Reid said, there is such a thing as the evidence of the senses, and this is not the evidence of reasoning, but the expression 'adequate evidence' suggests the support of premises, the premises constituting the evidence, and that suggestion is nicely avoided by the replacement of it by the word 'evident'. For if there is something a bit strange in saying that a person has adequate evidence for believing something without having any reasons for believing it, there is nothing amiss in saying that something is evident for a person without the person having any reasons for believing it. There must, after all, be some things that are evident for a person without appeal to reasoning from premises, one would think, or there will be nothing evident to use as premises in reasoning.

The substitution of the notion of one thing being more reasonable than another for the notion of one thing being more worthy of belief than another has a deeper basis. In *Perceiving*,[11] Chisholm spoke of the ethics of belief and left open the possibility that the ethics of belief was a part of ethics, and, therefore, that epistemic terms were ethical terms of a certain kind. The requirements of morals and those of reason appear to be different, however. It might be that p is more worthy of my belief than the denial of p for moral ends but not for epistemic ends, for example, if p affirms the fidelity of a friend when I have no evidence one way or the other concerning her fidelity. One might hold that trust is morally preferable to mistrust when one has no evidence that the other is untrustworthy. As a result, one might consider the belief that another is trustworthy to be more worthy of belief than the denial of it for moral considerations. But this does not imply that one has adequate evidence that the other is trustworthy. Thus, it appears that moral and epistemic matters should be distinguished, and the replacement of the expression of being more reasonable for that of being more worthy served to mark the distinction. Of course, the notion of reasonableness contains some of the same ambiguity, for what is reasonable to believe for the attainment of moral ends must be distinguished from what is reasonable to believe for epistemic ends. Nevertheless, whether one epistemic attitude is more reasonable than another seems in a primary sense to be epistemic and determined by matters of evidence.

It should be noted, however, that the substitution of the comparative notion of reasonableness does not preclude Chisholm from holding that epistemic reasonableness is a prima facie moral obligation, that is, that we have a moral obligation to be epistemically reasonable, and I suspect that Chisholm holds this view as well. Indeed, if my memory serves me correctly, I believe I heard it first from him in seminar. In short, it is

necessary to distinguish between epistemic reasonableness and moral requirement, but, having done so, one may, nevertheless, go on to argue that epistemic reasonableness is a moral requirement. Suppose, then, that we admit that epistemic terms are not reducible to nonepistemic terms. Can we, starting with the single comparative notion of one attitude being more reasonable than another, define all the rest? And is that the term it is best to use as a basis for defining all the rest? We can only conjecture as to why Chisholm should have begun with that notion. Perhaps it is because he thinks, as his analyses suggest, that our other epistemic evaluations are based on our comparative evaluations of reasonableness, or perhaps it is because of the intrinsic clarity of the comparative notion. However, having begun with comparative epistemic reasonableness, Chisholm proceeded with the quest for the evident.

There are two dimensions to the quest. The replacement of the expression 'more worthy than' with 'more reasonable than' and 'adequate evidence' with 'evident' does not solve the problem concerning the lack of restrictiveness considered above. It will not do to analyze 'p is evident for S' as 'it is more reasonable for S to believe that p than to believe the denial of p' for the reason considered above, to wit, that it can be more reasonable to withhold than to believe that p even though it is more reasonable to believe that p than to believe the denial of p. The problem can be looked at in the following way. There are various levels of reasonableness and various epistemic notions corresponding to these levels, and the evident is a very high level of reasonableness. Indeed, even if it is more reasonable to accept that p than to withhold that p, and not just more reasonable to accept that p than to accept the denial of p, we have not yet reached the level of reasonableness that corresponds to the evident. If something is evident for me it is more than just minimally more reasonable for me to accept it than not, it is very highly reasonable. But how should we define that high level of reasonableness that corresponds to the evident?

Chisholm proposed, quite naturally, in *TK*1 that the level of reasonableness that corresponded to the evident was the highest level of reasonableness. Thus, the next stop on the quest for the evident was to define the evident as follows:

E1. p is evident for S provided that it is more reasonable for S to believe that p than to withhold p and there is no q such that it is more reasonable for S to believe that q than to believe that p.[12]

This amounts to equating the evident with the maximally reasonable. It is noteworthy that this analysis is based on only one epistemic term,

comparative reasonableness. It is not entirely clear to me why Chisholm abandoned this analysis. My conjecture is that he considered this analysis to be too restrictive, for it is should be possible to say of two propositions that, although both are evident, one is more reasonable than another. For example, although it is evident for me that I was born in 1936, and although it is evident for me that I now exist, it is more reasonable for me to believe that I exist now than that I was born in 1936. Someone could, after all, have deceived me about when I was born but no one could deceive me about whether I exist, as Descartes would assure us, and we may conclude from that that it is more reasonable to believe the former than the latter. Or, perhaps it is more reasonable for me to believe that I believe I was born in 1936 than to believe that I was born in 1936, for even if I was not born then, there is no doubt that I believe I was, assuming the eliminative materialists are wrong, as surely they are. In short, among the things that are evident, there appears to be a difference in grades of reasonableness, and that difference may have been what induced Chisholm to abandon his definition of the evident as the maximally reasonable. Another motive may have been a desire to distinguish between the evident and the certain, that is, to be able to say there are things that are evident for a person but not certain for her. If that is so, then it would seem essential to distinguish between evident and the maximally reasonable because it is more reasonable to believe what is certain than what is only evident. Indeed, as Chisholm has suggested, it seems natural to equate the certain with the maximally evident. Therefore, if one chooses to distinguish between the evident and the certain, holding the latter to be more reasonable to believe than the former, one cannot equate the evident with the maximally reasonable as Chisholm did in *TK*1.

The next stage in the quest for the evident might be formulated as follows. We have the following two levels or grades of reasonableness.

R. It is more reasonable for S to believe that p than to withhold p.
C. It is more reasonable for S to believe that p than to withhold p and there is no q such that it is more reasonable for S to believe q than to believe p.

The level R is simple reasonableness of acceptance, or what Chisholm has called being beyond reasonable doubt,[13] while level C is naturally equated with certainty. Chisholm's quest for the evident led him to seek an analysis of the evident, E, that was a level or grade of reasonableness greater than R, being beyond reasonable doubt, which may, but need not, reach the level of C, being certain. The natural proposal, and the

next one proposed in the second edition of *Theory of Knowledge*,[14] *TK2*, is:

E2. p is evident for S if and only if accepting p is more reasonable for S than withholding p, and for any q, if accepting q is more reasonable for S than accepting p, then q is certain for S.[15]

This very plausible proposal in *TK2*, in effect, identifies the evident with those things that are reasonable to accept—as reasonable to accept as anything is except, perhaps, what is maximally reasonable to accept. This is a level of reasonableness that falls between R and C.

There is an objection to the proposal which may have been one that led Chisholm to extend his quest for the evident beyond E2. The objection concerns what we might call the continuity hypothesis, to wit, the hypothesis that for anything that is not certain, there is something more reasonable to accept that is also not certain. That is a strong hypothesis, though it is one satisfied by probabilities, and it is not easy to see why one should reject it. Moreover, there is some realism to the hypothesis, for it seems that for many things that are evident, one can find something that, though it is not certain, runs less risk of error. So, if, for example, there is an infinity of propositions that are evident for a person, p1, p2, and so forth, then one might conjecture that p1 is less reasonable to accept than the disjunction of p1 and p2, that this is less reasonable to accept than the disjunction of p1 and p2 and p3, and so forth, so that for anything it is reasonable to accept, it is more reasonable to accept the disjunction of it and something else. Probabilities are continuous as usually defined, and disjunctions are, for the most part, more probable than their disjuncts, the principle being that the probability of a disjunction is the sum of the probabilities of the disjuncts minus the probability of their conjunction.

This argument is not decisive, however. The weakness in the disjunction argument is that reducing the risk of error in this way also reduces the content of what you accept and, therefore, may not always increase the reasonableness of acceptance. It may be that the virtue of accepting something more informative offsets increased risk of error, and, hence that it is no more reasonable to accept a disjunction of two propositions that are each equally reasonable individually than to accept the disjuncts individually.

There is, however, a remaining problem which may have influenced Chisholm, namely, that the definition rules out the possibility that two things might both be evident, neither of them might be certain, and yet one might be more reasonable to accept than another. For example, it is

evident for me that I was born in 1936, it is evident for me that Thomas Reid was born in 1710, but it is more reasonable for me to accept the former than the latter because I have more direct evidence of the former. If we accept the continuity hypothesis or even the idea that two propositions that are evident for a person, though not certain, may differ in their degree of reasonableness, we must find some other way of defining a level of reasonableness between R and C. But what could that be?

Chisholm's answer to the question in the third edition of *Theory of Knowledge*,[16] *TK*3, depends on recognizing that one can compare the reasonableness of different epistemic attitudes as well as the reasonableness of the same epistemic attitude toward different propositions. We have already noticed this in the case of comparing accepting p to withholding p. However, we have also noticed that the mere fact that it is more reasonable to accept p than to withhold p, though necessary for p to be evident, is not sufficient. The reason was that it may be only slightly more reasonable to accept that p than to withhold that p, and that difference is not great enough to yield the evident. Suppose, however, that we compare the reasonableness of accepting p, not simply to the reasonableness of withholding p, but to the reasonableness of withholding anything else, q, where withholding q may be a maximally reasonable withholding such that there is no more reasonable withholding than withholding q. For example, suppose that a card has been drawn from a normal deck of half black and half red cards and that you have no idea what card has been drawn. Consider then the claim that the card drawn is black. That is a good candidate for a proposition q that it is maximally reasonable to withhold, for there is a perfect balance of reasons for and against the proposition. It seems perfectly reasonable to withhold this proposition q. Now suppose that there is some proposition that it is as reasonable to accept as it is reasonable to withhold q, that is, it is no more reasonable to withhold q, which is maximally reasonable to withhold, than to accept q. In that case, it must be very reasonable, indeed, to accept that p, for it is as reasonable to accept that p as to withhold q, and the latter is a maximally reasonable withholding. Chisholm suggested something similar to this as a solution to our quest for the evident in *TK*3.

In *TK*3, Chisholm replaced the comparative term 'more reasonable' with the comparative term 'more justified' and, thus, 'X is more justified for S than Y' for 'X is more reasonable for S than Y', but I shall not follow Chisholm in this change. I prefer to emphasize the continuity between the two editions, and, as far as I can see the two comparative

expressions are equivalent. The new definition of the evident in $TK3$ formulated in terms of comparative reasonableness is as follows:

E3. p is evident for S provided that for any q, believing p is at least as reasonable for S as withholding q.[17]

How does this analysis solve the problem of the earlier proposal, namely, that it appears possible that something a person accepts is evident for her even if there is something that it is more reasonable for her to accept that is not certain? The problem is solved if it is possible that there are two propositions such that accepting each of them is at least as reasonable as withholding anything even though neither of them is certain for her. The assumption may be put this way. Suppose that there are propositions that are not maximally reasonable for a person to accept but are as reasonable for her to accept as it is for her to withhold even those things that are maximally reasonable to withhold. Given this supposition, it seems that two things it is this reasonable to accept might be such that it is more reasonable to accept one than the other. This would leave open the possibility that there are two things that are evident for a person, even though they are not maximally reasonable for the person to accept, such that one is more reasonable for her to accept than the other. This proposal is, therefore, a brilliant attempt to find an appropriate niche for the evident below the level of the maximally reasonable or justified, that is, the certain.

Is the proposal a sound one? It depends on whether accepting something that is not maximally reasonable for a person to accept can be as reasonable for a person as withholding something it is maximally reasonable for the person to withhold. It is worth considering an objection that arises. Consider an epistemic pessimist, a moderate one, who thinks that withholding on some propositions is the most reasonable epistemic attitude of all. He is a fallibilist and thinks that the most noble epistemic attitude of all is to withhold when we are ignorant. He admits that some things are evident, that he thinks, that he feels, that he exists, perhaps even that he sees external objects, that he sees their qualities and, of course, sees that they exist. He admits that it is reasonable to accept those things that are evident and, indeed, unreasonable not to accept them, but the most reasonable epistemic attitude of all, he avers, is to show the restraint to withhold when withholding is more reasonable than accepting. We all feel inclined, he observes, to accept one answer or another to the questions we pose even when it is more reasonable to withhold. Withholding when withholding is more reasonable requires epistemic character, a readiness to be guided by

reason rather than inclination, and, consequently, withholding in some cases is more reasonable than accepting in any case. Thus, he would affirm that it is more reasonable for me to withhold on the proposition that there is life similar to human life outside the solar system, where I am truly ignorant, than to accept, and moreover, such withholding is the noblest work of reason and, therefore, more reasonable even than accepting the most evident things, for example, that I exist. It is, of course, highly reasonable to accept what is evident for us, but it is even more reasonable to withhold in some matters. What should we make of this objection?

I can only conjecture at the reply of Chisholm to the objection. It may be that he would object that the pessimist is claiming something necessarily false, though it does not seem to be so, and that it is as reasonable to accept things that are truly evident as to withhold even those propositions that it is the most reasonable to withhold. It seems to me that the pessimist is not claiming something necessarily false, but I think that my intuitions are influenced by a philosophical assumption I would make that Chisholm would probably reject concerning the modal status of claims that the pessimist has made. For, if I understand him rightly, and I would be grateful to learn if I do not, claims like that of the pessimist are either necessarily true or necessarily false, and, therefore, if the pessimist is wrong, he is necessarily so. Such epistemic claims, that one epistemic attitude is more reasonable than another, seem to me to be contingent. My reason is connected to an observation of Reid[18] that the evidence we have for accepting what we do seems to depend on the assumption that our faculties are trustworthy and not fallacious. If our faculties of belief were not trustworthy, then withholding would be more reasonable than acceptance. A line of reply to this objection would be to contend that the necessity of epistemic principles are conditioned on the assumption that our faculties are trustworthy, but I do not know whether that line of reply would be tempting to Chisholm.

The quest for the evident leads us, I think, to a contingent assumption of the trustworthiness of our faculties. Moreover, it seems to me that this assumption explains why Chisholm thinks the pessimist is wrong, and I agree that the pessimist is wrong, namely, that the trustworthiness of our faculties makes the acceptance of some of the deliverances of our faculties as reasonable as even the most reasonable of withholdings. We cannot prove that this reply is correct without reasoning in a circle, but, though we cannot prove that we are trustworthy, it is nevertheless more reasonable for us to accept that our faculties are trustworthy than to withhold.

This assumption of trustworthiness connects us with the original

conceptions of adequate evidence that Chisholm had proposed, to wit, that a person has adequate evidence for believing something just in case it is more worthy of his belief than its denial. I suggest, going beyond Reid, that the person must be trustworthy, and not just his faculties. For a person who was not trustworthy might misuse the most trustworthy faculties. If, however, a person is trustworthy in what he accepts and he accepts that p, then p is more worthy of his acceptance than the denial of p. Some clarification of the notion of trustworthiness might be useful for evaluating my argument. What does it mean to say that a person is trustworthy in what he accepts? It means that he does what he ought to do to obtain truth and avoid error in each thing that he accepts. This notion of trustworthiness is genuinely normative and is not to be confused with naturalistic notions of reliability construed as high truth frequency. A person might do what they ought to accept that p just in case p is true and fail to accept many truths. On the other hand, a person might do what he ought not to do and succeed in accepting mostly truths. We hope and, indeed, accept that doing what we ought will bring success in attainment of our goals of attaining truth and avoiding error, but we have no guarantee that this is so. In his earlier versions of *TK* Chisholm mentioned these goals as being the goals of acceptance, but in his latest work, perhaps with the intention of separating himself clearly from externalists, who define justification in terms of reliability and truth frequency, Chisholm has said the goal of acceptance is to accept what it is reasonable to accept and to avoid accepting what it is unreasonable to accept. I think we might formulate this idea in terms of his earlier views by saying the goal of acceptance is to accept what is worthy of acceptance and to avoid accepting what is not worthy of acceptance, and, therefore, to say that the goal of acceptance is to accept just those things a person would accept who was trustworthy in what he accepts. Finally, we may define the notion of trustworthiness in terms of what is worthy of trust as follows:

DT. S is trustworthy in accepting that p if and only if accepting that p is more worthy of the trust of S than withholding of p.

Suppose that I now accept the following principle: (A) I am trustworthy in what I accept. The truth of that principle seems to me to explain why acceptance is as reasonable as withholding, for we may, using (A) as a first principle, argue from our acceptance of (A) as follows:

A. I am trustworthy in what I accept.
1. I accept that p.
2. Therefore, accepting p is more worthy of my trust than withholding p.
3. Therefore, accepting p is more reasonable for me than withholding p.

This argument, though my own,[19] is one that is indebted to Chisholm, and I should be glad to know what he thought of it and the relevance to his own thought. The trustworthiness of the self has always seemed to me to be a presupposition of Chisholm's epistemology, and this argument is only intended to expose it. I should note, of course, that the principle A if accepted as p in (1) yields conclusion (3) concerning itself. In that way we might, borrowing an idea from Chisholm, say that the principle is directly reasonable.

I should say in conclusion that, though I have disagreed with Chisholm on a number of matters here and elsewhere, I disagree as a student with his master and with the confidence that I shall be instructed. The quest for the evident in the work of Chisholm, which I have only sketched in outline, is one that has inspired us by the clarity of his methodology and the profundity of his proposals. My remarks are intended to continue the quest.*

KEITH LEHRER

CREA, ECOLE POLYTECHNIQUE AND
DEPARTMENT OF PHILOSOPHY
UNIVERSITY OF ARIZONA
AUGUST 1994

NOTES

* The research for this paper was supported by a grant from the National Endowment for the Humanities.

1. R. M. Chisholm, *Perceiving: A Philosophical Study* (New York: Cornell University Press, 1957).

2. C. I. Lewis, *An Analysis of Knowledge and Valuation* (LaSalle, Ill.: Open Court, 1967).

3. Chisholm, *Perceiving*, appendix, pp. 189–97.

4. W. V. O. Quine, *Ontological Relativity and Other Essays* (New York: Columbia University Press, 1969), pp. 68–90.

5. T. Reid, *Inquiry and Essays*, eds. R. R. Beanblossom and K. Lehrer (Indianapolis: Hackett, 1983).

6. Chisholm, *Perceiving*, p. 5. This definition is the result of combining definitions (2) and (3) on page 5.

7. Chisholm, *Perceiving*, p. 16.

8. E. Gettier, Jr., "Is Justified True Belief Knowledge?" *Analysis* (1963): 121–23.

9. Cf. R. M. Chisholm, *Theory of Knowledge* (Englewood Cliffs, N.J.: Prentice Hall, 1966).

10. Ibid.

11. Chisholm, *Perceiving*, part 1.

12. Chisholm, *TK*1, p. 22.

13. Ibid.

14. R. M. Chisholm, *Theory of Knowledge*, second edition (Englewood Cliffs, N.J.: Prentice Hall, 1977).

15. R. M. Chisholm, *TK*2, p. 12.

16. R. M. Chisholm, *Theory of Knowledge*, third edition (Englewood Cliffs, N.J.: Prentice Hall, 1989).

17. Chisholm, *TK*3, p. 11.

18. T. Reid, *Inquiry and Essays*, pp. 275–77.

19. K. Lehrer, *Theory of Knowledge* (Boulder, Colo.: Westview Press and London: Routledge, 1990), pp. 122–24; and *Metamind* (Oxford: Clarendon Press, 1990), pp. 269–70.

REPLY TO KEITH LEHRER

Naturally it has been extremely gratifying to me to read Keith Lehrer's account of my theory of knowledge (properly called "the quest for the evident") and its development. If I should ever find myself committed to giving such an account, I would prepare for it by studying Lehrer's essay once again. And he puts a number of philosophical questions to me, each of which prompts me to say "I'm glad you asked me that!"

He begins with some questions about the relation between the evident and the certain that can best be answered by presenting what I now think of as the correct hierarchy of epistemic concepts.

In this summary I make use of the undefined locution: ——— is more reasonable for S than ———. I cite an instance and then a useful abbreviation.

> Believing that there are crested plovers is more reasonable for S than not believing that there are crested plovers.
>
> Bp F –Bp

To understand what is involved in the constructive stage of the theory of knowledge, I would now distinguish the following five *levels* of epistemic reasonability. These formulations do not use the concept of *withholding* to which Lehrer refers.

D1 It is *probable* for S that p =Df. Believing-that-p is more reasonable for S than believing-that-not-p.

> Bp R B-p

D2 Believing-that-p is (epistemically) *acceptable* for S =Df. It is false that not believing that p is more reasonable for S than believing that p.

$-(-Bp R Bp)$

D3 It is *beyond reasonable doubt* for S that p =Df. Believing-that-p is more reasonable for S than not-believing-that-p.

$Bp R -Bp$

D4 It is *evident* for S that p =Df. (1) It is beyond reasonable doubt for S that p; and (2) there is no q such that *not* believing q is more reasonable for S than believing p.

$(Bp R -Bp) \& -(Eq) (-Bp R Bp)$

D5 It is *certain* for S that p =Df. (1) It is evident for S that p; and (2) there is no r such that believing r is more reasonable for S than believing p.

$(Bp R -Bp) \& -(Eq)(-Bp R -Bq) \& -(Er)(Br R Bp)$

It is essential to the theory of knowledge that *being evident* does not imply *being true*. But I suggest that *being certain*, in the epistemic sense just defined, does imply *being true*.

It is definition D4 that formulates the result of my "quest for the evident." It is "anti-Pyrrhonian" in intent. Lehrer wonders whether the distinction between the evident and the certain requires that we distinguish between degrees of *being evident*. I believe that definition D4 is so formulated that it does not admit of such degrees.

The list of concepts just distinguished forms a hierarchy in that each one that appears later on the list implies the one that appears just before it.

Lehrer formulates an important philosophical argument at the end of his paper and asks me to comment on it. He thus gives me an opportunity to note certain points concerning which we differ and certain more basic points concerning which we are in agreement.

I would first note that, unlike Lehrer, I have called myself a "*critical*" commonsensist. Thus where Lehrer says "It is evident for me that Thomas Reid was born in 1710," I wouldn't say that this is evident for *me*. This has nothing to do with the fact that Lehrer knows far more about Reid than I have ever known. I would say that it isn't evident *for Lehrer* that Reid was born in 1710; but perhaps it is *beyond reasonable doubt* for him.

Lehrer's argument goes as follows.

A. I am trustworthy in what I accept.
1. I accept that p.

2. Therefore, accepting p is more worthy of my trust than withholding p.
3. Therefore accepting p is more reasonable for me than withholding p.

Given my "critical" commonsensism and the way in which I have just set forth the various levels of epistemic justification, I would not follow Lehrer with respect to step 3. But we are in agreement concerning the need for a concept that pertains to *trust*, to the fundamental points that he uses his argument to make.

His choice of the word "trustworthy" may be misleading. As he points out, if one says "I am trustworthy," in his sense, one is not claiming to be *reliable* in the externalistic sense in which "S's judgments are true." Perhaps we could say that "S's judgments are *epistemically worthy* of their subject matter. (Franz Brentano and Oskar Kraus used an analogous concept in ethics.)

Shouldn't we modify Lehrer's first premise—a premise that may be too tempting for the person who is epistemically promiscuous? It would be more commendable for a person to say: "My epistemically better self" tells me that I can be epistemically trustworthy *when I want to be*—and then only with respect to certain areas. ("Don't listen to him when he starts talking about so-and-so!")

So I suggest modifying Lehrer's argument to something like this:

A. There are propositions which are such that, when I want to, I can make judgments that are epistemically worthy of those propositions.
1. I can make such a judgment about p.
2. I accept p. Therefore my judgment is epistemically worthy of p.
3. Therefore p is *probable* for me (accepting p is more reasonable for me than not accepting p).

Lehrer asks how I would deal with the *modal* character of the argument. I would deal with it by using the phrase "I am necessarily such that" to prefix premise A. In this case, (A) could be rewritten as:

I am necessarily such that, for some propositions p, I can, when I want to, make judgments that are epistemically worthy of p.

This proposition, I would say, follows from the proposition that I am a rational animal.

The concept of a judgment being *epistemically worthy* of a given proposition p enables us to put clearly certain distinctions that are essential to any adequate *ethics of belief*. The concept of *epistemic justification*, although it is a normative concept, is not adequate for normative truths of ethics and the theory of value. I have tried to show that the concept of *requirement* is adequate to such truths. You have the

duty to perform a certain act A if you are "required" to perform A and that requirement is not overridden.

It may be my duty, as Lehrer notes, to give my friend the benefit of the doubt when I am considering serious charges that have been brought against him. In such a case the duty to believe that my friend is innocent may be distinguished from my epistemic duty to make a judgment that is epistemically worthy of the evidence that I now happen to have concerning the alleged misdeed. Making this distinction is necessary, but unfortunately not sufficient, for solving the problem about the ethics of belief. Concerning that problem, I am inclined to say that my ethical duty in this situation is nondoxastic. I am required to *act upon* the proposition that he is innocent—provided, of course, that *that* requirement is not overridden.

I hope that Lehrer will continue to work on this problem.

R.M.C.

18

C. Anthony Anderson
CHISHOLM AND THE LOGIC OF INTRINSIC VALUE

Writing about the theory of value and the logic of the emotions, Roderick Chisholm says, "I hope that those who work in the field will continue to follow in the footsteps of Brentano, Moore, and Meinong."[1] Chisholm and Sosa deserve to be included in this list of distinguished philosophers who have advanced the logic of intrinsic value, and the resulting hope is one I hereby endorse. In the present paper I will describe that logic and its limitations, and suggest an approach which seems to have some promise of resolving the difficulties. In this last I have tried to follow closely in the footsteps of the eminent founders of the logic of intrinsic value.[2]

I. THE DEVELOPMENT OF THE CHISHOLM-SOSA LOGIC OF INTRINSIC VALUE

Chisholm's first work on intrinsic value appears in "On the Logic of 'Intrinsically Better'" (hereafter: "Logic"). Here the basic ideas are established and a logical system is described in detail. The one primitive notion is a relation between states of affairs, symbolized as 'pPq', and read as 'p is intrinsically better than q'. (Here and elsewhere Chisholm sometimes reads the primitive symbolism as 'p is intrinsically preferable to q'. We shall find reason to distinguish these two readings). The basic definitions are:

(D1) pSq for $\sim (pPq)$ & $\sim (qPp)$

('p is the same in intrinsic value as q' means 'p is not intrinsically better than q and q is not intrinsically better than p'.)

(D2) Ip for $\sim(p P \bar{p})$ & $\sim(\bar{p} P p)$

> ('p is intrinsically indifferent in value' means 'p is not intrinsically better than its negation and the negation of p is not intrinsically better than p'.)

For ease in reading, we sometimes write a bar over a formula, rather than a tilde before, to indicate negation.

(D3) Np for $(\exists q)(Iq \ \& \ pSq)$

> ('p is intrinsically neutral in value' means 'There is a state of affairs which is indifferent and such that p is the same in value as it'.)

Here, and hereafter, we often drop the qualifier "intrinsically."

(D4) Gp for $(\exists q)(Iq \ \& \ pPq)$

> ('p is intrinsically good' means 'There is a state of affairs which is indifferent and p is better than it'.)[3]

(D5) Bp for $(\exists q)(Iq \ \& \ qPp)$

> ('p is intrinsically bad' means 'There is a state of affairs which is indifferent and it is better than p'.)[4]

Later, in "The Intrinsic Value in Disjunctive States of Affairs" ("Disjunctive"), Chisholm will add:

(D6) pAq for $\sim(qPp)$

> ('p is at least as good intrinsically as q' means 'q is not better than p'.)

These basic definitions are characteristic of the Chisholm-Sosa approach and they are retained throughout the corpus. Intrinsic goodness is given various informal explanations, often by referring to G. E. Moore's conception as described, for example, in his "Replies to Critics."[5] Such things as 'G$p \equiv pP\bar{p}$'[6] are refuted by the very simple, but powerful, idea of using Hedonism as a working assumption. That is, Chisholm and Sosa pretend that the only thing that matters to the value of a state of affairs is the pleasure (or happiness) or displeasure (or unhappiness) which the state of affairs entails, or "contains." So *There being no unhappy egrets* has no positive or negative value. Thus it is not intrinsically good or bad, modulo Hedonism. Its negation however is intrinsically bad, on that same assumption. Thus the suggested princi-

ple is rejected.[7] We will return to such methods for a (much) closer look in section V.

The basic system of axioms of Chisholm and Sosa in "Logic" is streamlined in Chisholm and Sosa's "Intrinsic Preferability and the Problem of Supererogation," and a bit more in "Disjunctive," but no essential changes are embodied in these modifications. We give the more elegant formulation from the last of these.

(A1) $pPq \supset \sim(qPp)$.

('If p is better than q, then q is not better than p'.)

We adopt the usual convention that universal closures are intended when axioms are stated with free variables.

(A2) $(qAp \ \& \ rAq) \supset rAp$.

('If q is at least as good as p and r is at least as good as q, then r is at least as good as p'.)

(A3) $(Ip \ \& \ Iq) \supset pSq$.

('Any two indifferent states of affairs are the same in value'.)

(A4) $(Gp \ v \ B\bar{p}) \supset pP\bar{p}$.

('A good state of affairs is better than its negation, and a bad state of affairs has a negation better than it'.)

To see that these two things are really involved here, one must note that tautologically equivalent states of affairs, e.g., p and its double negation, are interchangeable in the logic, by way of a principle of substitution.

Assuming an underlying propositional calculus,[8] Chisholm and Sosa prove, or sketch proofs of, forty-three theorems, and indicate proofs of twenty-eight more.

II. The Problem of Evaluating Disjunctions

The main obstacle for further development of the logic seems to center on the concept of *disjunction*. None of the principles so far adopted tell us anything about how a disjunctive state of affairs $p \ v \ q$ is related to the value of its disjuncts. Chisholm makes some suggestions for dealing with the evaluation of disjunctions in "The Defeat of Good and Evil," but his

first determined attempt is in "Objectives." In this last a fairly compli-
cated principle pertaining to disjunctions is stated informally, or semi-
formally. I first explain the intuitive idea which seems to be behind it. To
evaluate a disjunction $p \vee q$, consider how much "positive value" is
guaranteed by the two disjuncts—for the Hedonist this will be the
"amount" of happiness or pleasure—namely, the least of the amount
entailed by p and the amount entailed by q. (For it is only the least of
these two amounts which is *guaranteed* by the disjunction.) Similarly,
consider how much "negative value"—for the Hedonist, the "amount"
of displeasure or unhappiness—is involved in $p \vee q$. The amount of
negative value guaranteed by the disjunction will be the least of the
following two: the amount entailed by p and the amount entailed by q.
Well, suppose we "extract" from p or from q a proposition r which
"contains" the minimum positive value between the two and we extract
from p or from q a proposition s which contains the minimum negative
value between the two. Then, with some show of plausibility, the
conjunction rs gives us the intrinsic value of $p \vee r$. What if there is more
than one state of affairs contained in p or in q which is a measure of its
"worst" ("best")? Well, we might just pick one.[9]

This formula seems to have been suggested to Chisholm by reflecting
on his simple Hedonistic model. This procedure may give us pause.
Chisholm is certainly aware of Moore's Principle of Organic Unities in
"Objectives"; he there even offers a definition of "organic unity." But
then, with this principle in mind, one might well worry that the value of
the conjunction of r and s need not be a simple "sum" of the values in r
and s; instead it might be a unity. Well, apparently not if Hedonism is
correct. It is very difficult to think of anything that would count as an
organic unity on that theory. But then Hedonism is *not* correct, nor does
Chisholm think that it is. He repeatedly speaks of it as an "assumption"
and sometimes as "fictitious." It is clearly just a simple model against
which to test the principles of the logic of intrinsic value.

Again, the very idea of taking the best of the worsts and the worst of
the bests in the two disjuncts seems to be guided by the idea that these
indicate "amounts" of bad or good which can be simply added to get a
sum. Other theories of value, clearly better than Hedonism, do not so
readily suggest this conception.

In "Disjunctive," the principle is refined and altered so that the
conjunction rs is not necessarily to be identified in value with the
original disjunction, but one only assumes this: that any t, whose worsts
have the same value as r and whose bests have the same value as s, has
the same value as $p \vee q$. Here we must not assume that t just *is* the

conjunction of r and s, and in some cases it is supposed by Chisholm not to be. Conceivably this procedure might avoid the threatened conflict with the Principle of Organic Unities. Perhaps for every such r and s there are equi-valued states of affairs which can be simply "added" to get t. Still, one may wonder if every substantive theory of value will guarantee the existence of such a state of affairs t. And we may still be worried about the motivating idea that value comes in positive and negative "amounts" which can be added (or subtracted).

Let us make it official by stating Chisholm's system of definitions as given in "Disjunctive."

(D7) q is one of the bests in p = Df. (i) p logically implies q, and (ii) q is at least as good as anything which p logically implies.

(D8) q is one of the worsts in p = Df. (i) p logically implies q, and (ii) anything p logically implies is at least as good as q.

Here then is the proposed principle for evaluating disjunctions:

(A6) For every p, q, r, s, and t, if (a) r is a worst in p or a worst in q, and no worst in p or worst in q is better than r, (b) s is a best in p or a best in q, and no best in p or best in q is worse than s, and (c) the worsts in t have the same value as r, and the bests in t have the same value as s, then $p \vee q$ has the same value as t.

There is, in "Disjunctive," another principle designed to tell us about the values of disjunctions. It is this:

(A5) $\sim[pP(p \vee q)\ \&\ qP(p \vee q)]\ \&\ \sim[(p \vee q)Pp\ \&\ (p \vee q)Pq]$

('A disjunction cannot be exceeded in value by both of its disjuncts and a disjunction cannot exceed in value both of its disjuncts'.)

This too seems plausible in terms of the Hedonistic model and even seems more or less independent of the ideas of "quantities" or "amounts" of values. One might argue thus, "If the disjunction were to obtain by p's obtaining but not q, then that wouldn't necessarily be any better than p's obtaining alone. Indeed, it ought to be the same in *intrinsic* value as p. Similarly if q obtains but p does not. And, by the same token, in neither of these two cases will the disjunction exceed in value *both* p and q. Of course if *both* p and q obtained, *that* might be better than just one of p, q. But the disjunction doesn't *guarantee* that they both hold, only that at least one does." Or so one might reason.

We still have our vague worry about what seems to be a rather

dangerous reliance on the Hedonistic model in the formulation of these principles, especially in the case of (A6). In particular, we may still harbor some fears about a conflict with the Principle of Organic Unities. And, indeed, in an ominous footnote, Chisholm suggests that the values of nonhedonistic theories may be such that it will "be *impossible* to assess the value of certain 'mixed' states of affairs, having both good and bad consequences."[10] The immediate text to which the note is appended strongly suggests that Chisholm regarded his complicated disjunction principle (A6) as only usefully *applicable* to theories very like Hedonism, though perhaps he regarded the principle as still *true* in other cases. Perhaps pleasure and displeasure need not be the sole good and bad, respectively, but goodness and badness may have to come in 'quantities' and be subject to addition and subtraction in just the way threatened by the Principle of Organic Unities.

And there is another problem about the complicated disjunction principle. *One* of the consequences of p is $p \vee q$. So someone might complain that we cannot use the principle to "calculate" the value of $p \vee q$, for we must first know *its* value as a consequence of p in order to apply our principle.[11] Chisholm anticipates and answers this point, construed as an objection against the principle. We are, he says, merely seeking certain general principles about disjunctions and their disjuncts and we do not pretend to be producing an algorithm for the "calculation" of such values. Of course this reply is correct, as far as it goes. But one might still hope for, and seek, principles which *would* in some way facilitate the determination of the value of a disjunction by something like calculation.

It may have been these suspected limitations and, perhaps, doubts which led Chisholm, in "Intrinsic Value" ("Intrinsic"), to adopt a radically different approach to disjunctions, and indeed to the overall structure of the logic.

III. THE NEW APPROACH TO INTRINSIC VALUE

One crucial modification of the theory in "Intrinsic" is that strict implication is replaced by a more "fine-grained" relation between states of affairs, now called 'entailment', but distinct from Chisholm's previous use of that term. A state of affairs p *entails* a state of affairs q if and only if (1) it is impossible for p to obtain and q not to obtain *and* it is impossible for anyone to accept p without also accepting q. If we now attempt to evaluate a state of affairs p by considering what it entails, we

need *not* consider $p \lor q$. This promises some hope of dealing with the "calculation problem" noted above.

Another major change is designed to deal simultaneously with two closely related problems: how can one *define* intrinsic value using only a *generic* concept of value, and how can we explicate the idea of *isolating* a state of affairs in order to determine its intrinsic value, so as to make G. E. Moore's Method of Isolation precise? The idea of defining intrinsic value does not appear in any of Chisholm's earlier work on the subject, except in the form of suggested specifications or informal explications. To be more accurate, the concepts of intrinsic goodness and intrinsic badness (and, hence, intrinsic value) *are* defined in earlier works, but always by taking *intrinsic* betterness or preferability as primitive. Here the idea is to take *generic* betterness, which includes as a species instrumental or consequential betterness, as the basic idea and then to define intrinsic value and betterness in terms of it.

And Chisholm aims to do this using the concept of a state of affairs p *reflecting all the good and evil that there is in a state of affairs q*. This relation obtains if and only if (i) q entails (N.B.) p, and (ii) every state of affairs q entails, and which also entails p, has the same value as p. The intention is that p is a kind of value-state representative for q, which distills out just the essential value component in q.[12] And the use of entailment instead of strict implication prevents the "distillation" process from having to consider $q \lor r$ for arbitrary r—something which is plainly irrelevant to the evaluation of q itself.

The important case will be when a state of affairs, p, say, reflects all the good or evil that there is in a *possible world W*. Possible worlds are states of affairs, so that the definition is applicable. Perhaps we can get an intuitive grasp of the content of this definition in the following way. Think of a possible world as a vast conjunction of states of affairs saying how things are (and how they *aren't*). What will a possible world entail? Well, it's a bit difficult to say, but experimentally we might suppose that a possible world entails each of its conjuncts and perhaps also the existential generalizations of such conjuncts. Suppose a possible world contains the proposition *Jones is happy + 1*, call it 'p', and suppose that Jones is the only (morally relevant) inhabitant thereof. Any conjunction which contains p as conjunct will entail p—and the other conjuncts of the possible world, we are supposing, will not contribute anything of value—so such conjunctions containing p will have the same value as p. Any other independent states of affairs, say q = *Jones is wearing a hat*, will be such that pq is entailed by W—and pq will *not* have the same value as q. Hence q will not reflect all the value that there is in W. Other

propositions, say *Someone is happy +1*, also seem to reflect all the good or evil that there is in *W*. Plausibly *p* entails this, but the latter also has the same value as *p*.

Of course, conjunctions such as *Jones is happy +1 and Smith is unhappy −2* will also reflect all the value that exists in certain possible worlds. But, reasoning along the lines just described, we can see that in such a world *Jones is happy +1* will *not* reflect all the value therein.

Now Chisholm proposes to obtain a definition of *intrinsic value* by isolation. First we select states of affairs that reflect all the (generic) value that there is in some possible world and yet are not merely "extrinsically" valuable. Suppose (1) that *p* reflects all the good and evil that there is in a possible world *W*. And suppose (2) *if p* is not neutral, then every state of affairs that reflects all the good and evil in *W* either entails or is entailed by *p*. If there is such a world for a state of affairs *p*, then Chisholm calls *p* an *intrinsic value state*.

The second clause may be puzzling, but Chisholm explains the purpose it is supposed to serve. As a simple example, suppose that *p* is, as we would have said, intrinsically good, and that *q* is a means to *p*; perhaps *q* has *p* as a causal consequence in some possible world. And suppose that *q* is not otherwise of value. Then *p* and *q* have the same *generic* value! For example, suppose that *q = Jones thinks of egrets* and suppose *p = Jones is happy +1*—where it's the thought of egrets that causes the happiness. Then the generic value of *q* is the same as the (intrinsic) value of *p*. The second clause in the definition apparently rules out *q* as an intrinsic value state, but not *p*. Chisholm can't put the matter this way officially at this point—for he is endeavoring to define intrinsic value by way of generic value.

Chisholm next isolates the *bearers of intrinsic value*, those intrinsic value states whose negations are also intrinsic value states. This is important, since it will follow from the definition that in general, *disjunctions* of, say, intrinsic value states are not themselves bearers of intrinsic value. If *p = Jones is happy +1* and *q = Smith is unhappy −2*, then *∼p & ∼q*, being neutral *is* an intrinsic value state—for some possible worlds contain nothing of value whatever. But the negation of this, *p ∨ q*, is *not* an intrinsic value state. For consider any possible world *W in which p ∨ q* obtains. Then one or the other or both are entailed by *W*. And suppose, for simplicity, that no facts independent of *p* and *q* are value relevant in *W*. If only *p*, say, is true in *W*, then it will reflect all the value in *W* and neither entails nor is entailed by *p ∨ q*. (Here the narrow notion of entailment is needed). Similarly if only *q* obtains. If both *p* and *q* obtain, then *Someone is happy +1 and someone is unhappy −2* reflects all the good or evil in *W*, but neither entails nor is entailed by *p ∨ q*.

Hence $p \vee q$ fails the test and is not an intrinsic value state. One more epicycle. The definition of intrinsic betterness is:

> p is intrinsically better than q = Df. p and q are bearers of intrinsic value; and any world such that p reflects all the good and evil therein is better than any world such that q reflects all of the good and evil in it.

So here we have it. Only certain kinds of states of affairs are bearers of intrinsic value at all, certain "intrinsic value states," and we compare such states of affairs by comparing possible worlds whose value (and disvalue) is given entirely by the intrinsic value states in question. Here is a "method of isolation" and it seems to have been used to isolate intrinsic value, i.e., to define it in terms of generic value.

What of the problem of disjunctions? Plainly it is finessed. In general, disjunctions will not be bearers of intrinsic value. And the previous worry, that we are somehow confining ourselves to Hedonism, is eliminated, or at least assuaged. We do not seem to be building in any assumptions about the "quantitative" nature of value.

Alas, it doesn't work. Eva Bodanszky and Earl Conee[13] observe that *Jones is happy +1* does not even turn out to be a bearer of intrinsic value on the current analysis. For in any possible world where it reflects all good and evil therein, there will be other states of affairs, e.g., *Someone is happy +1 and is wearing a hat* (or *Someone is happy +1 and is* not *wearing a hat*) which also reflect all the good or evil in the world and yet neither entail nor are entailed by *Jones is happy +1*.

In "Defining Intrinsic Value," Chisholm acknowledges that the counterexample defeats the analysis and gives a new definition of intrinsic value based on the concept of *requirement*:

> p is intrinsically preferable to q = Df. p and q are necessarily such that, for any x, the contemplation of just p and q by x requires that x prefer p to q.

In itself there is nothing wrong with this idea. And there is no doubt that ultimately there must be a unification of the logic of intrinsic value with that of certain other normative concepts. But if this particular analysis is to be of much assistance in working out the logic of intrinsic value, we must first develop the logic of requirement—and indeed its logical relations to contemplation and preference. Now Chisholm has done some important research in this direction, but the logic of requirement is at this point not sufficiently detailed to throw much light on the questions we have been pursuing in connection with intrinsic value.[14] For example, we still have no clue as to the relation between the

intrinsic value of a disjunction and that of its disjuncts. Perhaps there is another way.

IV. PERFECT V-STATES

The basic idea of a state which somehow contains just the essential value elements of a possible world is certainly an attractive one. Surely there is some way to describe the value in a state of affairs which does not involve any value irrelevancies. And Chisholm's introduction of the narrow notion of entailment avoids certain problems, but at a cost. It would be better if we could somehow get along in the logic of intrinsic value just using the more standard and better-understood concept of strict implication.[15] Let us attempt to develop these ideas.

To guide our considerations, we follow Chisholm and Sosa and construct some very simple models to test proposed principles. Our first model we may call "Crude Hedonism." According to this theory, the only basic value-relevant properties are *happiness* and *unhappiness* (or pleasure and displeasure). We do not even suppose that these properties come in degrees or numerical "amounts."[16] Although there is no harm in assuming quantitative measures of happiness as a heuristic idealization with which to test theories, we wish to avoid principles which actually rely on that assumption. It may indeed turn out that some kind of general quantitative theory is possible, but that should be shown rather than assumed.[17] For brevity, we write "$H^+(a)$" to mean that a is happy and "$H^-(a)$" to mean that a is unhappy.

A second simple model we shall use adds to Crude Hedonism the value importance of considerations of *desert*; perhaps this theory should be called "Crude Desert-Qualified Hedonism." Here again we do not assume numerical values of any kind, but rather just the notions "a is deserving of happiness" and "a is deserving of unhappiness"— symbolizing these as "$D^+(a)$" and "$D^-(a)$," respectively. This model may help us to keep the Principle of Organic Unities before our minds.[18] We do not pause to fix details of exactly how these various things are to be weighted or compared on this second model-theory.

Now we attempt to define the notion of a "perfect V-state," a state of affairs containing exactly the value components of a possible world.[19] Suppose that a proposition entails that there exist exactly n individuals (finite n, for now). The sort of "individual" in question is supposed to be given by the substantive value theory. Persons, sentient beings, living things, ecosystems, or whatever; it is assumed that these individuals and their properties are the basic entities involved in situations containing

intrinsic value. Thinking of our first simple model (the domain is persons, let's say, or beings capable of happiness and unhappiness), suppose further that p entails how many of the individuals are happy and how many are unhappy. Then, according to Crude Hedonism, we know everything that is "value-relevant" about the state of affairs p. But for a proposition to give us all the relevant details on our second simple model, we must know which of the individuals are deserving and which are undeserving and how happiness and unhappiness are distributed among them.[20]

Let us say then that a "perfect V-state" is a proposition which states just (1) exactly how many individuals there are and, for each value-relevant (basic) property, whether or not each of the different individuals exemplifies these properties. A formal definition would, I suppose, take the idea of a *value-relevant basic property* as a primitive.[21]

Thus, if our underlying theory of value is Crude Hedonism,

$$\exists x \exists y \, [x \neq y \, . \, \forall z \, (z = x \text{ v } z = y) \, . H^+(x) \, . H^+(y)]$$

will be a perfect V-state, saying as it does that there are exactly two individuals, both happy. Observe that the idea of a perfect V-state is relative to the underlying theory of value. On our other, more complicated, model-theory, the following would be a perfect V-state:

$$\exists x \exists y \, [x \neq y \, . \, \forall z \, (z = x \text{ v } z = y) \, . H^+(x) \, . H^-(y) \, . D^-(x) \, . D^+(y)]$$

This says that there are exactly two individuals, one happy, one unhappy, but with no one getting his just deserts.

For technical convenience, we add as a perfect V-state a proposition asserting that there are no value-relevant individuals whatsoever. Plausibly this neutral state of affairs gives a complete description of a situation insofar as its value is concerned. Observe that perfect V-states are jointly exhaustive (given the empty V-state) and mutually exclusive. We may imagine then that the theory of value tells us which perfect V-states are better, intrinsically better, than which other perfect V-states. In some cases of perfect V-states, if the fixed theory of value fails to rank one over the other, as far as that theory is concerned, there is nothing to choose between them—hence they are equal in intrinsic value.[22]

V. Intrinsic Betterness and Objective Preferability

Now we generalize to arbitrary propositions. Let p be any such and consider the disjunction of all those perfect V-states each of which is compatible with p. This disjunction will be entailed by p. (To see this

observe that the disjunction consisting of all perfect V-states necessarily obtains and those whose negations are entailed by p are then ruled out by p.) The "possible value of p" is given by this disjunction of perfect V-states. If D^p is the set of all those perfect V-states which are compatible with p, then we let ΣD^p be the disjunction thereof. The suggestion is that ΣD^p is the, or an, appropriate state of affairs by which to evaluate p. For, assuming the theory of value is fixed, such a disjunction tells us every perfect V-state which is compatible with p, and so is not excluded by p's obtaining. Further, the disjunction itself is entailed by p. Thus, it appears that ΣD^p encodes all the value-relevant information about p (modulo the underlying theory of value). To decide which of two propositions p and q is preferable, it would seem that an "Ideal Observer"[23] need only consider the disjunctions ΣD^p and ΣD^q. Hence the general problem of evaluating and comparing states of affairs is equivalent to the problem of comparing disjunctions (!) of perfect V-states. But before attacking this, we need a distinction.

Let us consider a simple, but still problematic case: the disjunction of two perfect V-states as compared to one of its disjuncts. Reflecting upon this case reveals a kind of ambiguity, or unclarity, in the notions we have been using so far. Suppose that v_1 and v_2 are perfect V-states, that v_1 is neutral and that v_2 is good. What is the intrinsic value of $(v_1 \lor v_2)$? Well, no "amount" of good is *guaranteed* by the obtaining of the disjunction— after all, it might be that v_1 obtains and v_2 does not. So both v_1 and $v_1 \lor v_2$ are neutral and neither has to be preferred.

However, it still seems relatively clear that there is *a sense* in which such a disjunction might still be preferable to the neutral v_1. Suppose v_1 asserts that there exist no (value-relevant) things whatever and that v_2 asserts that there are one million people and they are all happy. Suppose that the Ideal Observer is required to choose between v_1 and the disjunction $(v_1 \lor v_2)$. There is some considerable force to the idea that the disjunction itself is preferable, even though it does not "contain," or guarantee, some positive amount of intrinsic value. And the intuition which is at work here is, I think, that there is some chance of the existence of an enormous amount of positive intrinsic value, a possibility not involved in the lesser disjunct. "Look," one might argue, "the obtaining of the disjunction of the two V-states certainly cannot be any worse and it could be enormously better—v_2 isn't *impossible*. So if I choose the disjunction and it obtains, things will be no worse and might be much better than if I choose the single disjunct. I'm going with the disjunction." When we are dealing with mutually exclusive disjuncts in a given disjunction, this argument seems to be entirely cogent.[24]

One can see two different *choice-strategies* at work here. The basic theory of value provides the ranking of perfect V-states on the basis of the value they contain. But when the Ideal Observer is required to choose between more complex propositions, disjunctions, say, then new factors, in addition to the contained intrinsic value, may come into play. Let us call the relation which holds between perfect V-states and which depends simply upon the fact that one contains more value than another, *intrinsic betterness*. Henceforth, I shall write such things as 'v_1Bv_2,' to mean that the perfect V-state v_1 contains more good or less bad than the perfect V-state v_2. Now given this relation and two disjunctions of perfect V-states, say, we are required to make a choice. How will we do it?

One strategy we might adopt, let's call it the 'C-strategy', is more or less implicit in Chisholm's complex principle for evaluating disjunctions, (A6). We determine what value or disvalue is *guaranteed* by the disjunction and use that value always to make our choices. So, for example, a disjunction of all good perfect V-states will have the value of the least[25] of them. And a disjunction of all bad perfect V-states will have the value of the best of them. If some are good and some are bad, or if at least one is neutral, then the disjunction is neutral—contains no positive or negative value overall. And these values are the sole determinants of the correct choice. In this explanation of the C-strategy we are assuming that the ideas of good, bad, and neutral perfect V-states are understood intuitively—and not necessarily via the Chisholm-Sosa definitions. In particular, the negation of a perfect V-state yields for evaluation a disjunction—the disjunction of all the other perfect V-states. How this is to be evaluated depends on a choice strategy and hence is not necessarily a simple value-containment matter. And the idea of indifference is consequently a choice-theoretical notion, rather than a matter of value-containment. So we may not want to accept the Chisholm-Sosa definitions which make use of negations until we have studied the matter more carefully.[26]

There are other, and perhaps better, ways of determining the choice between a disjunction of perfect V-states and one of the disjuncts than by using the C-strategy. An ideally rational and moral agent might well prefer, and hence any actual agent would be required to prefer, a disjunction of two perfect V-states over a single perfect V-state, not because of the value guaranteed by the former, but because of the *possibility* of more value than is contained in the single state.

Let us call the relation, which holds between disjunctions of perfect V-states and which asserts that one such is to be rationally preferred to another, *objective preferability*. (It seems a bit odd to call this "*intrinsic*

preferability," given that the preference need not be based simply on the intrinsic *value* that the state of affairs contains. Hence our terminology "*objective* preferability.") The objective preferability of p to q depends, in a sense, only on p and q, but need not be simply determined by the intrinsic value that p and q guarantee. We distinguish this relation from that of intrinsic betterness by writing "$p \succ q$" to mean that p is objectively preferable to q. As already explained, such general comparisons are to be made on the basis of the fact that the disjunction of perfect V-states corresponding to p is objectively preferable to the disjunction of perfect V-states corresponding to q.

We must emphasize that it is not really clear that it is this latter relation which Moore and Chisholm were trying to fix. But one might view our distinction as separating two concepts which were mixed together or grasped only somewhat confusedly by the founders of the logic of intrinsic value.[27]

Both conceptions may well play a role in the future science of ethics. Intrinsic betterness, as here conceived, holds only between perfect V-states, and a judgment between two arbitrary propositions p and q will derive, at least in part, from a comparison of the disjuncts of the disjunctions which encode the possible values of p and q. I suggest that Chisholm's latest analysis of intrinsic preferability really pertains to this latter notion. Recall that, on that definition, p is intrinsically preferable to q if and only if p and q are necessarily such that anyone contemplating just p and q is *required* thereby to prefer p to q. Thus, we might conclude, the Ideal Observer *would* prefer p to q—and this even if p does not contain more intrinsic value than q. It is not out of the question that the required preference of p to q be based on such facts as that p contains the possibility of a great intrinsic good, while q does not, or that q contains the possibility of a horrendous evil, while p does not.

It is quite plausible to maintain that the two relations, intrinsic betterness and objective preferability, coincide on perfect V-states. That is, the rational choice between perfect V-states depends solely and simply upon **B**. Making natural assumptions about **B** and extending objective preferability to arbitrary propositions (via their representative disjunctions of perfect V-states) using the C-strategy, all of the original Chisholm-Sosa axioms are clearly justified. I sketch how one might develop this line.

We assume the relation **B** is a primitive relation, holding only between perfect V-states. Also assume given a neutral perfect V-state, ν, perhaps it is the "empty" perfect V-state described above. Then intrinsic goodness, badness, and neutrality might be defined thus:

(D1*) $\mathbf{G}p$ for $p\mathbf{B}\nu$
(D2*) $\mathbf{B}p$ for $\nu\mathbf{B}p$
(D3*) $p\mathbf{A}q$ for $\sim(q\mathbf{B}p)$ (where p and q are perfect V-states)
(D4*) $p\mathbf{S}q$ for $p\mathbf{A}q$ & $q\mathbf{A}p$
(D5*) $\mathbf{N}p$ for $p\mathbf{S}\nu$

These are the "contained intrinsic value" notions. Then one can define the notions of "choice-indifference," "choice-goodness," "choice-badness," and so on, applying first to disjunctions of perfect V-states, and then to arbitrary propositions as represented by such disjunctions.

As before, let $\Sigma\mathrm{D}^p$ be the disjunction of the perfect V-states corresponding to some proposition p. Let "p is a minimum of D" mean that p is a member of the set of propositions D and for every proposition q therein, $q\mathbf{A}p$. And let "p is a maximum of D" mean that p is a member of the set of propositions D and for every proposition q therein, $p\mathbf{A}q$. Adopting the C-strategy, we say the choice-value of $\Sigma\mathrm{D}^p$ exceeds the choice-value of $\Sigma\mathrm{D}^q$ ($\Sigma\mathrm{D}^p \succ \Sigma\mathrm{D}^q$) if and only if (i) both D^p and D^q consist entirely of good (**G**) propositions and for some minimum of D^p, say p_0, and for some minimum of D^q, say q_0, $p_0\mathbf{B}q_0$, or (ii) D^p consists entirely of good propositions and D^q does not, or (iii) D^q consists entirely of bad propositions and D^p does not, or (iv) both D^p and D^q consist entirely of bad (**B**) propositions and for some maximum of D^p, say p_0, and for some maximum of D^q, say q_0, $p_0\mathbf{B}q_0$.[28] And, naturally, $p \succ q$ if and only if $\Sigma\mathrm{D}^p\succ\Sigma\mathrm{D}^q$.
Then we define:

(D6*) $p \succeq q$ for $\sim(q \succ p)$ ("p is at least as choice-worthy as q")
(D7*) $p \approx q$ for $(p \succeq q)$ & $(q \succeq p)$ ("Equality of choice-worthiness")
(D8*) $\mathcal{I}(p)$ for $(p \approx p)$ ("Choice-indifference")
(D9*) $\mathcal{G}(p)$ for $\exists q\,[\mathcal{I}(q)$ & $(p \succ q)]$ ("Choice-goodness")
(D10*) $\mathcal{B}(p)$ for $\exists q\,[\mathcal{I}(q)$ & $(q \succ p)]$ ("Choice-badness")
(D11*) $\mathcal{N}(p)$ for $\exists q\,[\mathcal{I}(q)$ & $(p \approx q)]$ ("Choice-neutrality")

Now we postulate that the basic intrinsic betterness relation **B** is asymmetric and that **A**, defined in terms of it, is transitive (both on perfect V-states). And if, further, we assume that the value-neutral perfect V-state ν is also choice-neutral, we can prove analogues of the Chisholm-Sosa axioms, formulated in terms of the choice-worthiness notions. That is, we can prove as theorems:

(A1#) $(p \succ q) \supset \sim(q \succ p)$.
(A2#) $(p \succeq q) \supset .(q \succeq r) \supset (p \succeq r)$.
(A3#) $(\mathcal{I}(p)$ & $\mathcal{I}(q)) \supset (p \approx q)$.
(A4#) $(\mathcal{G}(p)$ v $\mathcal{B}(\bar{p})) \supset (p \succ \bar{p})$.

All this seems quite nice, but one's enthusiasm for this procedure may well be dampened by the following observation. If we attempt to evaluate the proposition *Exactly one person exists and is happy* using these ideas and our simple models, we are enjoined to consider the perfect V-states with which it is compatible and to make our choices on that basis. Now on Crude Hedonism all is well. The state of affairs in question is itself a perfect V-state and so is the sole element of its "corresponding" disjunction set—hence it is quite reasonably taken to be choice-good on that theory. But when we consider Desert-Qualified Hedonism, the matter is not so simple. The state of affairs in question is compatible with the three following perfect V-states à la Desert-Qualified Hedonism:

$\exists x[\forall y(y = x).H^+(x).D^+(x)]$ (The sole individual is happy and deserves it)

$\exists x[\forall y(y = x).H^+(x).D^-(x)]$ (The sole individual is happy and deserves unhappiness)

$\exists x[\forall y(y = x).H^+(x).\sim D^-(x).\sim D^+(x)]$ (The sole individual is happy but deserves neither that nor unhappiness).

Now according to the strategy under consideration, if any one of these is value-neutral (or some are good and some are bad), then the disjunction, and hence our original state of affairs, is choice-neutral. Presumably the first and third disjuncts are counted as intrinsically good (on the theory of value at hand)—but what of the second? It might well be counted as value-neutral. If so, then this method of evaluation counts our original proposition *Exactly one person exists and is happy* as choice-neutral! This seems to be in conflict with the underlying intuitions and motivation for the logic of intrinsic value. In this particular case, I suppose that someone might insist that the second disjunct is also good. But this does not really help solve the general problem—as we add more value-relevant properties and more individuals the problem arises again.

Thus if we are to maintain that the given proposition is choice-good, then some alternative strategy must be adopted. Unfortunately I am able to make only some very sketchy suggestions as to what that strategy should be.[30] Two principles seem to be unexceptionable:

(V1) If every one of a set D_1 of perfect V-states is at least as intrinsically good as every one of a (nonempty) set D_2 of perfect V-states, and some members of D_1 are intrinsically better than every member of D_2, then ΣD_1 is choice-preferable to ΣD_2.[31]

(V2) If every member of a (nonempty) set D_1 of perfect V-states is at

least as good as every member of a (nonempty) set D_2 of perfect V-states, then ΣD_1 is at least as choice-worthy as ΣD_2 (i.e., $\Sigma D_1 \succeq \Sigma D_2$).

The qualifications of nonemptiness are to avoid the anomalous empty disjunction.[32] These principles decide some, but by no means all, of the questions about the choice-values of disjunctions of perfect V-states (and hence about the choice-values of arbitrary propositions). Indeed, our problem case, *Exactly one individual exists and he is happy*, is not settled by (V1) and (V2) to be choice-good. But its being so is compatible with them.

The analogues of the Chisholm-Sosa axioms, (A1*)–(A4*), read as principles about a choice strategy obeying at least (V1) and (V2), seem reasonable. Underlying axioms to the effect that **B** is asymmetric and that **A** is transitive are unaffected by a change in choice-strategy. Not so with the principle that ν is choice-indifferent, but it does still seem plausible. The negation of ν, $\bar{\nu}$, corresponds to an infinite disjunction of perfect V-states, namely all those except ν. Some of the disjuncts are gloriously good, some are horrendously bad, and some are neutral. None of these disjuncts is given as more probable than any other and they occur in "equal numbers," insofar as we can make sense of this latter notion applied to the present situation. It is very difficult to see how any rational choice-strategy could give ν and $\bar{\nu}$ different choice-values, but the point might be argued.[33] Similarly, (A3*) and (A4*), though still plausible, are less clearly acceptable than when they were interpreted according to the C-strategy. It would be very desirable to derive these less evident principles from more basic principles about choice strategies. Alas, I am unable at present to discover compelling principles which enable this.

The most definite proposal I can make then is this. Initially, take both **B** and \succ as primitive along with the notion of a value-relevant property. (It will not be necessary to adopt the neutral perfect V-state ν as a separate primitive.) Define the other notions in terms of these according to (D1*)–(D11*) and postulate that **B** is asymmetrical on perfect V-states and that **A** is transitive on perfect V-states. The relation of objective preferability is assumed to be asymmetrical on disjunctions of perfect V-states and \succeq is assumed to be transitive on such disjunctions. The principles (V1) and (V2) are assumed to connect the relations **B** and \succ. (A1*) and (A2*) then hold for arbitrary p and q, the choice-values of these being represented by the disjunctions of perfect V-states corresponding to them. It also seems that the empty perfect V-state ν should be choice indifferent and that (A4*) and (A5*) should hold, but some more definite principles of rational choice are needed to convincingly

secure these results. Possibly such principles will also permit \succ to be defined in terms of **B**.[34]

VI. DISJUNCTIONS AGAIN

As noted above, Chisholm once advocated a principle according to which the value of a disjunction was necessarily "between" its disjuncts, viz., (A5) above. Now, using just the principles (V1) and (V2), we can conclude that, for perfect V-states v_1 and v_2, $v_1 \vee v_2$ cannot exceed in choice preferability both of its disjuncts, nor can both disjuncts exceed the disjunction in preferability.[35]

The argument is this: Let v_1 and v_2 be perfect V-states. If v_1 is the *same* in intrinsic value as v_2, then we may apply the principle (V2) to the sets $\{v_1\}$ and $\{v_1,v_2\}$ to conclude that $\Sigma\{v_1\}$, i.e., v_1 is equal in value to $\Sigma\{v_1,v_2\}$, i.e., to $v_1 \vee v_2$. If v_1 is greater in value than v_2, then we can use (V1) and (V2) to prove that $v_1 \succeq v_1 \vee v_2 \succ v_2$. And if v_2 is better than v_1, then we can prove $v_2 \succeq v_1 \vee v_2 \succ v_1$—and these things together validate the principle:

$$(A5') \sim [v_1 \succ (v_1 \vee v_2).v_2 \succ (v_1 \vee v_2)].\sim[(v_1 \vee v_2) \succ v_1.(v_1 \vee v_2) \succ v_2]$$

This is an analogue of Chisholm's (A5) principle for the evaluation of disjunctions, but restricted to perfect V-states. There is reason to think that *the general choice-preference analogue of (A5) should not be valid*.

To construct a countermodel, use a possible-world semantics with four "V-worlds"—these are perfect V-states and the only possible worlds in the model.[36] Pretend that their intrinsic values are given by numerical values, and let the values be 2, 2', 3, and 4, respectively. (That is, there are two distinct worlds, but both with value 2.) And we let the choice-value of a proposition be its expected utility on the assumption of equal probabilities, i.e., the average of the values of the worlds therein.[37] Now let $p = \{2,4\}$, $q = \{2',4\}$, so that $p \vee q = \{2,2',4\}$. Here the disjuncts both exceed the disjunction in choice-value. To get an example where the disjunction exceeds both disjuncts, take the worlds to be just 2, 2', and 1. Let $p = \{2,1\}$ and let $q = \{2',1\}$. Then we have that $p \vee q = \{2,2',1\}$.

This doesn't really prove that the disjunction principle is not valid. Perhaps a complete theory of rational choice would contain principles which would rule out these models. But their existence should make us at least doubtful about the principle.[38]

Chisholm's complicated principle about disjunctions in "Disjunctive" will usually be inapplicable on the present approach. A state of affairs, say a choice-worthy perfect V-state, will entail, and thus contain,

more and more choice-worthy disjunctions of perfect V-states (perhaps the new disjuncts involve more and more happiness and justice) and so there will be no "best." Similarly there will typically be no worst.

So the overall picture is this. We have distinguished two ideas involved in the process of evaluating and comparing states of affairs: (1) intrinsic betterness as based on the intrinsic value "contained" in, and guaranteed by, a perfect V-state, and (2) the preferability of an arbitrary state of affairs over another, chosen on the basis of the disjunctions of perfect V-states representing the possible value in a complex states of affairs. A simple strategy based on "guaranteed value" has the consequence that certain intuitively choice-good states of affairs are choice-neutral. Two principles, (V1) and (V2), which seem acceptable, are proposed, but the general problem of the ideal strategy for rational choice is barely touched by these. Choice-preference analogues of the disjunctive principle (A5) and the more complicated principle (A6), are to be rejected. In some favorable cases comparison of disjunctions of perfect V-states (and hence of the propositions corresponding to them) are determined by our principles.

I hope that these suggestions have some merit and I will be quite considerably gratified if they constitute a sort of half-step forward in the project of formulating the logic of intrinsic value.[39]

C. ANTHONY ANDERSON

DEPARTMENT OF PHILOSOPHY
UNIVERSITY OF CALIFORNIA, SANTA BARBARA
NOVEMBER 1995

NOTES

1. Roderick Chisholm, "Objectives and Intrinsic Value," in Rudolf Haller, ed., *Jenseits von Sein und Nichtsein* (Graz: Skademische Druck–u. Verlagsonstalt, 1972), p. 263. Hereafter: "Objectives."

2. In what follows I may sometimes for brevity speak of "Chisholm" when "Chisholm-Sosa" would be more appropriate. Ernest Sosa was coauthor of "On the Logic of 'Intrinsically Better'," in which the basic ideas are developed, and should not be slighted in any history of the logic of intrinsic value. And Sosa is often mentioned in Chisholm's later papers as having been the source of many helpful suggestions.

3. The idea of using intrinsic betterness as a primitive concept can be found in A. P. Brogan's "The Fundamental Value Universal," *Journal of Philosophy, Psychology, and Scientific Methods* 16 (1919), but Brogan does not propose the Chisholm-Sosa definitions of goodness and badness.

4. The definitions (D1)–(D5) of these ethical concepts were suggested to Chisholm and Sosa by the definitions of analogous psychological concepts, e.g., the concept of a person's being indifferent toward a state of affairs, of favoring or opposing a state of affairs, and the like, in Chisholm's "The Descriptive Element in the Concept of Action."

5. In Paul A. Schilpp, ed., *The Philosophy of G. E. Moore* (La Salle, Ill.: Open Court, 1942).

6. Affirmed, for example, by Brogan, op cit., G. H. von Wright in *The Logic of Preference* (Edinburgh, 1963), and C. A. Baylis in "Tranquility Is Not Enough," *Pacific Philosophy Forum* 3 (1965).

7. Lennart Åqvist, in "Chisholm-Sosa Logics of Intrinsic Betterness and Value," *Noûs* 2 (1968): 253–70, rightly points out that the use of this clear and simple method of constructing counterexamples is itself an important contribution to clarifying the underlying conceptions.

8. The "underlying logic" is not strictly propositional calculus since propositional, or state of affairs, quantifiers are used. It is possible to simplify and avoid these quantifiers following Lennart Åqvist, op. cit., or Charles Parsons, "Axiomatization of Åqvist's CS-Logics," *Theoria* 36 (1970): 43–64.

9. Chisholm actually writes of "the" worst and "the" best in p and in q— but this is just a slip and is corrected in "Disjunctive."

10. My emphasis. Note 2, p. 308, "Disjunctive."

11. Indeed someone has, Warren Quinn in "Theories of Intrinsic Value," *American Philosophical Quarterly* 11 (1974): 123–32.

12. It is in fact a refinement of the notion of a "V-state" which is proposed by Chisholm, in "Objectives," as an explication of an idea of Meinong's. We suggest a variant of this idea below.

13. Eva Bodanszky and Earl Conee, "Isolating Intrinsic Value," *Analysis* 41 (1981): 51–53.

14. I actually believe that it may be possible to *both* analyze intrinsic value in terms of requirement, or some such, *and* to analyze requirement in terms of intrinsic value! And, indeed, I think that both of these things will very likely illuminate the concepts involved, but only (significantly) when the logics thereof are fairly well developed. This may sound quite odd, but the peculiarity dissipates when it is explained that I take the relation of "A is an analysis of B" to be rather weaker than is allowed by Chisholm. Essentially the thing need be only an informative, a priori, necessary equivalence with the goodness of the analysis varying with one's knowledge of the background theory of the concepts involved in the analysands. See my "Analyzing Analysis," *Philosophical Studies* 72 (1993): 199–222, for more details and a defense.

15. Or *concepts* of strict implication. In any case there are here well-developed systems of modal logic which we could employ within the logic of intrinsic value. My motivation here is similar to that expressed in note 14. The better developed the theory (here: logic) of the concepts used in the analysis, the more valuable the analysis.

16. David Hilbert is supposed to have said, "You must always start from the very simplest examples!" Quoted by C. A. Truesdell in *Great Scientists of Old as Heretics in The Scientific Method* (Charlottesville: University Press of Virginia, 1987), p. 91. Surely this is sage advice.

17. I have in mind the possibility of proving the existence of certain measurement scales, given the basic (nonquantitative) properties of intrinsic value.

18. A slightly more realistic model would include the consideration of equality of distribution. And if numerical measures are proved or postulated, then one might well add the existence of a "happiness floor," below which no one must be allowed to fall. These types of simple models were suggested to me by Nicholas Rescher's discussion of Utilitarianism in *Distributive Justice* (Indianapolis, New York, and Kansas City: Bobbs-Merrill, 1966). Of course we are still a long way from connecting up with such sophisticated theories as John Rawls's in his *A Theory of Justice* (Cambridge, Mass.: The Belknap Press of Harvard University Press, 1971)—and indeed such a theory, though to a certain extent "formal," is more substantive and much more ambitious than what we are attempting here.

19. This idea is a sort of elaboration, or descendant, of Chisholm's notion of a "V-state" mentioned in note 12.

20. Such a perfect V-state will also suffice for certain value theories where equality of distribution of happiness is taken into account.

21. Warren Quinn, op. cit., uses "basic proposition" as a primitive for the logic of intrinsic value and is followed in this by Edward Oldfield, "An Approach to a Theory of Intrinsic Value," *Philosophical Studies* 32 (1977): 233–49.

22. We have not really given a precise definition of "perfect V-state" using a specified collection of primitives. Ultimately, such a thing is clearly desirable. So we sketch here one such precisification. As noted, the idea of a *basic value-relevant property* will likely be a primitive whose extension is not fixed by the logic of intrinsic value, but rather is assumed given by the underlying substantive theory of value. Consider the simplest case, where there is a finite set of "value-appropriate individuals"—this idea too being fixed by the supplied substantive-value theory. Now imagine that all individuals are named a_1, a_2, \ldots, a_n; using distinct names for distinct individuals, form a conjunction which, for each basic value-relevant property Φ and value-relevant relation Ψ (binary, for illustration) has a conjunct asserting $\Phi(a_i)$ or $\sim\Phi(a_i)$ and a conjunct asserting $\Psi(a_i,a_j)$ or $\sim\Psi(a_i,a_j)$. (It may be that the value theory contains postulates which will enable one to simplify the conjunction.) Now add conjuncts of the form $a_i \neq a_j$, for distinct i and j, and a conjunct saying that everything is identical with some one of the a_i, namely $\forall z(z = a_1 \vee z = a_2 \vee \ldots \vee z = a_n)$. If we existentially generalize on the "names" therein, we obtain another perfect V-state. That is, form the existential generalization of the described conjunction with respect to distinct variables x_1, x_2, \ldots, x_n in place of the names a_1, a_2, \ldots, a_n. Let us adopt this last as our "official" form for perfect V-states. None of this presents any difficulty if we adopt a "possible worlds" approach to the underlying semantics.

23. We often use the idea of a morally and rationally ideal "observer," but only as a heuristic device.

24. Not so if the states of affairs in the disjunction are not mutually exclusive. It might be that p is the same in value as q, and so just as good as q, and that pr is preferable to q, but $p \vee pr$ is not preferable to q—for $p \vee pr$ is logically equivalent to p. It just isn't true in this case that "there is a chance that things will be better if $p \vee pr$ obtains." But it does correctly follow nevertheless that $p \vee pr$ is at least as good as q.

25. If there is one. One can conceive of cases where there are less and less good perfect V-states with no minimum. And similarly for less and less bad perfect V-states. (See, for example, note 3 of "Intrinsic.") If we take this idea seriously, these possibilities should be pursued using "limits" and possibly

infinitesimal goods and bads. But since we will soon reject the C-strategy, we do not follow this out.

26. One sometimes hears the reaction to the Chisholm-Sosa treatment of negations in the logic of intrinsic value that we simply *cannot say* what the value of the negation of "Jones is happy" is to be. It depends, some argue, on exactly how "Jones is not happy" obtains. I think that the intuition at work here is sensitive to the fact that a negation may present us with a vast disjunction of perfect V-states and some other considerations will be needed besides value containment to evaluate them.

27. For a remark on "mixtures of concepts," see Kurt Gödel as quoted by Hao Wang in *From Mathematics to Philosophy* (London: Routledge and Kegan Paul, 1974), pp. 85–86.

28. For simplicity, we ignore for now cases where there is no worst good or best bad.

29. We are still working, so far, under the simplifying assumption that every set of all good propositions has a worst and that every set of all bad propositions has a best.

30. A "maximin" strategy—choose that disjunction which has the least worst—seems no better than the C-strategy. Both essentially ignore all information contained in the disjunction except the value of a single perfect V-state.

31. Readers familiar with the literature of decision theory will recognize this as a kind of "Weak Dominance" principle.

32. What choice-values to assign to the impossible proposition and to the necessary proposition may well be partly a matter of decision, although choice-indifference is a priori attractive.

33. A maximin strategy would have us choose v over its negation on the grounds that this choice involves selecting the option with the "best-worst." But in the present context that same strategy would require that we choose a bad state of affairs over its negation, no matter how horrendous the given state of affairs might be—for the negation always involves possibilities that are still worse. This does not seem to be the correct result.

34. I am acutely aware of the fragmentary character of these ideas. Possibly they will take us a bit closer to the goal expressed by Nicholas Rescher: ". . . to develop the logic of preference in such a way as to build a bridge connecting these traditions: the logico-philosophical on the one hand, and the mathematico-economic on the other." ("Semantic Foundations for the Logic of Preference," in Nicholas Rescher, ed., *The Logic of Decision and Action* [Pittsburgh, University of Pittsburgh Press], p. 39). The reader familiar with that paper will see that I have derived a great deal of inspiration from it. It deserves also to be counted as one of the classics of the field. Following this idea, it seems clear that the next part of the project should appeal to the formal work on rational choice which has been done by decision theorists and economists.

35. We must assume comparability of any two perfect V-states, but this is unproblematic from the present point of view. Indeed, we are willing to assume the comparability of *any* two states of affairs via the comparability of the *disjunctions* of V-states which they entail. Either there is some rational principle by which an Ideal Observer would be enjoined to prefer one such disjunction to another or there is not. In the latter case, I can see no reason why we shouldn't just count the states of affairs as equal in value.

36. Strictly speaking, perfect V-states do not give us complete possible worlds but only the value-relevant aspects of such. So we are really now speaking here of equivalence classes of possible worlds, but this does not affect the point being urged.

37. This is the sort of model proposed by Nicholas Rescher, op. cit.

38. As noted, we get this result on the miniature model if we pretend that the perfect V-states are equiprobable and calculate the "expected (objective) utility" of the various propositions involved. No doubt the direction we are indicating for the logic of intrinsic value connects with the extensive literature of decision theory. But caution is necessary in that regard since (1) we will in real cases often be dealing with infinite disjunctions, and (2) because of Parfit's "Repugnant Conclusion Paradox," we should not assume the commensurability of values. In connection with this latter see Derek Parfit's *Reasons and Persons* (Oxford and New York: Oxford University Press, 1986), chapter 17, and Noah Lemos's *Intrinsic Value* (Cambridge, Cambridge University Press, 1994), chapter 4.

39. I am grateful to my colleague Kevin Falvey for guidance in connection with the literature on decision theory.

REPLY TO C. ANTHONY ANDERSON

Anthony Anderson considers the logic of intrinsic value that Ernest Sosa and I had worked out. Anderson discusses all the essentials and for the most part I agree with his enlightening comments.

Sosa and I had developed the following system. The locution p *is intrinsically better than* q is undefined. Then p *is the same in intrinsic value as* q becomes: neither is better than the other. Then p *is indifferent* becomes: *p* and not *p* are such that neither is intrinsically better than the other.

Each of these definitions yields a corresponding proposition that is logically necessary.

The same cannot be said for the concept of instrumental value (what is valuable as a means). Generally speaking, to say that a particular state of affairs is instrumentally valuable is to say that it occurs under conditions which are such that, under *those* conditions, it contributes causally to something that is *intrinsically* valuable. The presupposition is that, under *other* causally possible conditions, it would *not* be instrumentally valuable.

I would disagree with Anderson's suggestion that one might use generalizations about instrumental value in defining value, for definitions of intrinsic value in terms of instrumental value are not logically necessary.

The following analysis is suggested by the logic of intrinsic value that Ernest Sosa and I had set forth. In setting forth these principles we took the relation of *intrinsically better* as undefined. The relation is transitive and asymmetrical.

D1′ *p* and *q* are the same in intrinsic value =Df. *p* is not intrinsically better than *q* and *q* is not intrinsically better than *p*.

D2' p is indifferent in intrinsic value =Df. p is not intrinsically better than $\sim p$ and $\sim p$ is not intrinsically better than p.

D3 p is intrinsically good =Df. p is intrinsically better than anything that is intrinsically indifferent in value.

D4 p is intrinsically bad =Df. Anything that is indifferent in intrinsic value is intrinsically better than p.

D5 p is neutral in intrinsic value =Df. p is the same in intrinsic value as anything that is intrinsically indifferent.

Given these principles, we may go on to formulate certain material principles about intrinsic value. These are comparable to the special cases of value that are set forth in *The Origin of Our Knowledge of Right and Wrong*: (1) joy in another's sorrow is better than sorrow in another's pain; and (2) anything is better than joy in another's pain.

R.M.C.

19

Lynne Rudder Baker

PERSONS IN METAPHYSICAL PERSPECTIVE

Among contemporary philosophers, Roderick Chisholm stands out for his deep and careful work on the nature of human persons. Against the current tide of appeal to science—especially appeal to evolutionary biology and to neuroscience—Chisholm's approach to the human person is distinctly metaphysical in character. Beginning with the first-personal question, What is the relation between me and my body? he responds with what I shall later refer to as quotation Q:

> There are three possibilities. The first is that I am identical with my body. The second is that I am identical with a proper part of my body. And the third is that I am not identical with *any* body. (Surely, whatever else I may be, I am not identical with any bodily thing having parts that are not shared by *this* body.)¹

Regarding the first possibility, Chisholm has a straightforward argument, offered in several places, against the thesis that I am identical with my body.² In *On Metaphysics,* Chisholm explores the second possibility—that I am a physical entity, identical with a proper part of my macroscopic body (a part that remains uncorrupted as long as I exist). In "On the Simplicity of the Soul," Chisholm explores the third possibility—that I am a nonphysical entity, identical to an incorporeal soul. Chisholm's argument against the identity of person and body, as well as his exploration of the other two possibilities, all depend on the thesis that persons are *entia per se.* And the thesis that persons are *entia per se* depends on the coherence of the underlying distinction between *entia per se* and *entia per alio.* This distinction provides the framework for Chisholm's study of persons.

First, I shall try to make clear what the basic distinction between *entia per se* and *entia per alio* is, as I understand it, and then show the role that it plays in Chisholm's understanding of all three of the possibilities mentioned in quotation Q for the relation between person

and body. Second, I shall evaluate some of Chisholm's arguments that are based on the distinction, and try to show why I am dissatisfied with the distinction. Finally, I shall propose a different understanding from Chisholm's of the relation between persons and bodies, and then compare elements of the alternative (which I shall call the "constitution" view) to various tenets of Chisholm's. I shall suggest that much of what Chisholm wants to say about the nature of persons can be maintained with a leaner metaphysics.

CHISHOLM'S BASIC DISTINCTION

Chisholm contrasts *entia per se* with *entia per alio*. *Entia per alio* are "ontological parasites," like shadows or appearances. They are not entities in their own right, but rather "derive all their properties from other things—from the various things that do duty for them."

> An *ens per alio* never is or has anything on its own. It is what it is in virtue of the nature of something other than itself. At every moment of its history an *ens per alio* has something other than itself as its stand-in.
> But if there are *entia per alio,* then there are also *entia per se.*[3]

By contrast to an *ens per alio,* an *ens per se* exists in its own right; it is what it is in virtue of its own nature. So, it makes sense to say, with respect to an *ens per se,* that "in the strictest sense of 'is'," there is something that is identical to it—viz., itself. A "genuine thing," on Chisholm's view, is to be understood as an *ens per se.*

Perhaps surprisingly, ordinary material objects—tables, trees, ships—are not *entia per se* (and hence not genuine things). Such things are " 'fictions', logical constructions, or *entia per alio.*"[4] They are *entia successiva,* "successive entities." As individual things that are made up of different things at different times, *entia successiva* are logical constructions of the things with unchanging parts that "do duty" or "stand in" for them. What really exist (in the strict and philosophical sense) are only the things that constitute the *ens successivum,* the various *entia per se* that do duty for it at different times.

To illustrate with a famous distinction that Chisholm borrows from Bishop Butler, in a "loose and popular" sense of 'identity', it is true to say that this table is the same table I was writing on yesterday even though one of its legs has been replaced. "[W]e may say that 'x is the same F as y' is used in a loose and popular sense if it is used in such a way that it does not imply 'x is identical with y'."[5] Strictly and philosophically speaking, however, the table I write on today is not identical to the

one I was writing on yesterday. For speaking strictly and philosophically, if x = y, x and y have exactly the same parts. This is the doctrine of 'mereological essentialism', which Chisholm follows Thomas Reid in holding: "[W]henever there is a change of parts, however insignificant the parts may be, then some old thing ceases to be and some new thing comes into being. This presupposes that, strictly speaking, the parts of a thing are essential to it, and therefore when, as we commonly say, something loses a part, then that thing strictly and philosophically ceases to be."[6] More precisely, the principle of mereological essentialism may be formulated by saying that for any [genuine] whole x, if x has y as one of its parts, then y is part of x in every possible world in which x exists. The principle may also be put by saying that every whole has the parts that it has necessarily, or by saying that if y is part of x then the property of having y as one of its parts is essential to x. If the principle is true, then if y is ever part of x, y will be part of x as long as x exists.[7]

To sum up: An *ens per se* cannot survive a change in parts, but an *ens per alio* (and a fortiori, an *ens successivum*) can. On the other hand, only *entia per se* may be said to exist and persist in the strict and philosophical sense; *entia per alio* may be said to exist only in a loose and popular sense. The existence of an *ens successivum* at any given time depends on the existence of an *ens per se* (or *entia per se)* which stands in for the *ens successivum* at that time. My writing table (an *ens successivum*) is actually no more than a succession of the *entia per se* that do duty for it at the various times during which my table is said (in a loose and popular sense) to exist.

This basic distinction between *entia per se* and *entia per alio is* presupposed by almost everything that Chisholm has to say about persons. A subcategory of *entia per alio*, comprising *entia successiva*, is particularly important for Chisholm's account of persons. For one of Chisholm's chief tenets is that persons are *entia per se*, or at least, are *entia nonsuccessiva*. (An *ens nonsuccessivum* is characterized by "intact persistence," where "A thing is an intactly persisting temporal object if it exists during a period of time, and is such that, at any moment of its existence, it has the same parts it had at any other moment of its existence.")[8] Armed with this tenet that I am an *ens per se* (or at least an *ens nonsuccessivum*), Chisholm's argument that I am not identical to my body is breathtakingly simple. Like other familiar things with parts that change, my body is an *ens successivum*; the fact that it persists (in a loose and popular sense) in spite of constant replacement of cells guarantees that my body is not an *ens per se*. But I am an *ens per se* (or at least an *ens nonsuccessivum*). Hence, by Leibniz's Law, I am not identical to my body.[9]

So, the basic distinction between *ens per se* and *ens per alio* underwrites Chisholm's position on the question of the identity of person and body—the first possibility mentioned in quotation Q. The basic distinction underwrites Chisholm's construals of the second and third possibilities, mentioned in quotation Q, about the relation of person and body as well. Continue to assume for now that I am an *ens per se*, or at least an *ens nonsuccessivum*. In that case, if there is any time at which y is a part of me, then at all times I exist, y is a part of me. I have no parts that change. If I have no parts that change, then either (a) I have no parts at all or (b) I am identical to "some intact, nonsuccessive part that has been in this larger body all along."[10] (a) is the third possibility mentioned in quotation Q, according to which I am not identical to any body at all, but rather I am a metaphysically simple incorporeal soul; (b) is the second possibility mentioned in quotation Q, according to which I am identical to a proper part of my body, and hence I am an intactly persisting physical thing. So, all the possibilities that Chisholm countenances for the relation between persons and their bodies are elucidated in terms of the basic distinction between *entia per se* and *entia successiva*, a species of *entia per alio*.

PERSONS AS *ENTIA PER SE* (OR AT LEAST NOT AS *ENTIA SUCCESSIVA*)

We have seen that Chisholm's framework for discussing the nature of persons depends on his basic distinction between *entia per se* and *entia successiva*, a species of *entia per alio*. I now want to set out one of Chisholm's arguments for his substantive claim that persons are not *entia successiva*. Evaluation of that argument will lead to questions about the conception of *entia per se* and *entia per alio*.

An *ens successivum* is, by definition, "an individual thing that is made up of different things at different times."[11] Now some of the properties that an *ens successivum* has at any given time are such that it "borrows them from the thing that constitutes it at that time; but others are not. An example of a property of the first sort may be that of *being red;* an example of a property of the second sort may be that of *having once been blue*."[12] To formulate the argument that persons are not *entia successiva*, we need to know the conditions under which an *ens successivum* "borrows" a property from its current stand-in. For this, we need a couple of preliminary definitions.[13]

(D1) A property G is *rooted outside times at which it is had* = Df.
 Necessarily, for any x and for any period of time t, x has the

property G throughout t only if x exists at some time before or after t.

(D2) A property G *may be rooted outside times at which it is had* = Df. G is equivalent to a disjunction of two properties one of which is, and the other of which is not, rooted outside times at which it is had.

The property of being a widow or of being a future president are rooted outside the times at which they are had. The property of being such that it is or was red may be rooted outside times at which it is had: a successive table may have this property in virtue of presently being made up of something red or of formerly being made up of something red.[14]

Now an *ens successivum* and the thing that constitutes it at a given time "are exactly alike at that time with respect to all those properties which are such that they are not essential to either and they may not be rooted outside the times at which they are had." With suitable restrictions on predicates that replace the schematic letter 'F', here is an instance of the definition:

(D3) The successive table that is at place p at time t is F at t = Df. There is exactly one thing at place p at t that constitutes a successive table at t and that thing is F at t.[15]

So, according to (D3), the nonessential properties that are not such that they may be rooted outside the times at which they are had of an *ens successivum* at t are "borrowed" from the thing that makes it up at t. The successive table is red at t in virtue of the fact that the thing that makes it up at t, its stand-in at t, is red at t.

There is a slight complication, which I shall mention and then disregard. Chisholm notes that some of the properties at t of an *ens successivum* may not be derivable in this straightforward way from the properties of the thing that constitutes it at t. For example, if a table is constituted by AB on Monday, BC on Tuesday, and CD on Wednesday, we can say on Monday that the successive table, but not AB, will persist until Wednesday; and we can say on Wednesday that the table, but not BC, is at least two days old. "Nevertheless," Chisholm says, "all such truths about the successive table may be reduced to truths about AB, BC, and CD."[16] Chisholm goes on to add definitions to cover cases not covered by (D3). Since these will not affect my discussion, I shall overlook them here. The main point, reinforced by the further definitions, is that on Chisholm's view, the properties of an *ens successivum* derive from the properties of its constituents, where the constituents are

construed as "stand-ins" that "do duty" for the thing that they consti-
tute.

Now here is Chisholm's argument that I am not an *ens successivum:*
Suppose that I hope for rain. Hoping for rain is a nonessential property
that is rooted only in the times at which it is had. If I am an *ens
successivum*, then by a generalization of (D3), "I may be said to hope for
rain only in virtue of the fact that my present stand-in hopes for rain. I
borrow the property, so to speak, from the thing that constitutes me
now." But "there is no reason whatever for supposing that I hope for rain
only in virtue of the fact that some *other* thing hopes for rain—some
stand-in that, strictly and philosophically, is not identical with me but
happens to be doing duty for me at this particular moment."[17] So, I am
not an *ens successivum.*

Or, in a more compressed version: "Suppose (i) that I am now sad.
Now (ii) if there is an *ens successivum* that bears my name and is now
sad, then it is sad in virtue of the fact that one of its stand-ins is now sad.
But (iii) I am not sad in virtue of the fact that some *other* thing is doing
my feeling sad for me. Therefore, (iv) I am not an *ens successivum.*"[18]

Does either of these arguments show that I am not an *ens successivum*
(defined as "an individual thing that is made up of different things at
different times")?[19] I do not think so. Each has a tacit premise of the form
"If I am an *ens successivum* and am now F (for a certain kind of F), I am
F now only in virtue of the fact that my present stand-in is F now." The
plausibility of such premises depends on a generalization of (D3). So, let
us consider whether generalization of (D3) is acceptable. For ease of
exposition, let us call properties that are not such that they may be
rooted outside the times at which they are had 'present-rooted proper-
ties'. Now I think that (D3) and its generalization are unacceptable; for,
if we accept (D3), then many of what intuitively seem to be nonessential,
present-rooted properties of a given *ens successivum* turn out *not* to be
nonessential, present-rooted properties of it. For many intuitively nones-
sential, present-rooted properties of *entia successiva* are not borrowed
from the things that constitute it at the time.

For example, suppose that among your deceased aunt's possessions,
you find a small statue. You think that it is made of gold, and you don't
know whether the statue is worth any more than the gold that constitutes
it. The appraiser reports that the statue is made of gold, and is currently
worth $10,000; the chunk of gold that constitutes the statue at t has a
meltdown value of $1,000. Now, a statue, like other familiar objects, is,
according to Chisholm, an *ens successivum.* (It would survive a slight
chipping.) And, intuitively, being worth $10,000 at t is a nonessential,

present-rooted property of the *ens successivum*. It is surely not essential to the statue that it is worth $10,000 (the market could change any day, and the statue would survive); and being worth $10,000 is a present-rooted property: 'x is worth $10,000 at t' is roughly equivalent to 'If you tried to sell x at t, you'd get $10,000'. But, contrary to the appropriate generalization of (D3), the statue's property of being worth $10,000 at t is not "borrowed" from the properties of the chunk of gold that constitutes the statue at t. Indeed, one of the marks of a piece of fine art is that its value does not depend on the value of the materials that constitute it. So, I do not think that a generalization of (D3)—or any argument that depends on a generalization of (D3)—is acceptable.

Someone may object: the chunk of gold in its present condition of constituting the statue is worth $10,000; it is only its meltdown value (when it would no longer constitute the statue) that is $1,000. But this just illustrates the point that I want to make: the chunk of gold in its present condition is worth $10,000 in virtue of the fact that *the statue is worth $10,000, not the other way around.* The very same chunk of gold, in the absence of the statue, is worth only $1,000. The statue does not borrow its worth at t from the chunk of gold; the chunk of gold borrows *its* worth at t from the statue.

For many (nonessential, present-rooted) properties of a constituted thing, the direction of fit is the opposite of (D3): the constituting thing borrows its properties from the thing that it constitutes at t. For example, suppose that it were illegal to burn an American flag. The property of being an x such that it is illegal to burn x is a nonessential, present-rooted property; so, if a generalization of (D3) were acceptable, we should say that the flag borrows the property of being an x such that it is illegal to burn x at t from the piece of cloth that constitutes the flag at t. But clearly, the direction of fit is the other way: The piece of cloth that constitutes the flag at t has the property of being an x such that it is illegal to burn x derivatively, in virtue of the fact that the flag has that property. Legislators write laws to protect national symbols, not pieces of cloth. So, again, generalization of (D3) is not acceptable.

Or, to take another case, suppose that the oak table is set for dinner. A table is a paradigm case of what Chisholm calls 'an *ens successivum*'; being set for dinner is a nonessential, present-rooted property of the table. I suppose that one could insist that the pieces of oak that constitute the table at t are set for dinner. But if so, if pieces of oak can have the property of being set for dinner at all, they can have that property only derivatively. For being set for dinner is a property, in the first instance, of dinner tables, not of pieces of oak. So, even though the pieces of oak are

doing duty for the table at t, the table is not one of those "ontological parasites that derive all their properties from . . . the various things that do duty for them."[20]

This last example strikes at the heart of the conception of an *ens successivum*. For: tables are paradigm examples of *entia successiva*; all *entia successiva* are *entia per alio; entia per alio* are defined as "ontological parasites that derive all their properties from . . . the various things that do duty for them." Yet, the example shows that tables do not derive all their properties from the things that constitute them. In general, it seems not the case that things that are constituted by different things at different times (tables, statues, dogs, paintings) derive their properties at a time from the things (oak pieces, chunks of gold, canine bodies, painted canvasses) that constitute them at that time. So, if it is a necessary condition of *entia successiva* that they derive all their nonessential, present-rooted properties at t from what constitutes them at t, I do not know of a single example of an *ens successivum*.

Since all my counterexamples to generalizations of (D3) concern relational and intentional properties of *entia successiva*, it may be thought to be a simple matter to add a restriction to the predicates that can replace 'F': properties designated by such predicates not only must be nonessential and present-rooted, but also must be intrinsic or nonrelational properties of the thing. However, some relational properties of an *ens successivum* do seem to derive from the relational properties of the thing that constitutes it. For example, the diploma's relational property of being on the wall depends on the relation between the constituting piece of parchment, and the wall. The painting's relational property of having been defaced depends on the relation between the constituting canvas and a malicious person. The table's relational property of blocking the door depends on the relation between the constituting oak-assembly and the door. All of these are examples of relational properties of *entia successiva* that do depend on the relational properties of their current constituents. So, restriction of application of generalizations of (D3) to nonrelational properties of *entia successiva* would leave no account of these relational properties that intuitively should be covered by generalization of (D3).

Chisholm may respond that, however he handles relational properties, the only generalization of (D3) that he needs in order to establish that I am not an *ens successivum* is one in which 'hoping for rain' and 'being sad' are substitutable for 'F'. In addition to the fact that (unlike Chisholm) I think it false that hoping for rain is an intrinsic property of the one who hopes, I have this reaction: If any generalization of (D3) must be restricted so as not to apply to cases where it intuitively should

apply (for example, to cases involving properties like being three feet from the wall), then its acceptability is, in my opinion, severely weakened.

In short, I believe that the counterexamples to generalizations of (D3) show that Chisholm's arguments that I am not an *ens successivum* are unsound. But I do not believe that, therefore, I am an *ens successivum* (in the sense that Chisholm is concerned with).[21] For, as I shall try to show next, the counterexamples to generalizations of (D3) go to the heart of the basic distinction between *entia per se* and *entia per alio*.

As I understand it, the distinction between *entia per alio* and *entia per se* is to be exclusive and exhaustive. There are two necessary conditions for something to be an *ens per alio* and two necessary conditions for something to be an *ens per se*.

Ens per alio: 1. x is an ontological parasite.
 2. x does not have its parts necessarily.[22]

Ens per se: 1. x is not an ontological parasite.
 2. x has its parts (if any) necessarily.

Now the difficulty with the distinction is that the two necessary conditions on something's being an *ens per alio* (or an *ens per se)* come apart. As we have seen, a table is a paradigm case of an *ens successivum* for Chisholm, and hence a paradigm case of an important kind of *ens per alio*; but although a table satisfies the second condition of *entia per alio,* it does not satisfy the first: For an ontological parasite (in Chisholm's sense) borrows all its (nonessential, present-rooted) properties from its current stand-in. But we have seen in the case of the table, that its (nonessential, present-rooted) properties are not so borrowed. On the other side, I do not know of any uncontroversial examples of *entia per se*. As we have seen, the *entia per alio* are supposed to be the uncontroversial cases; belief in *entia per se* (like belief in Leibnizian simples) depends on prior belief in *entia per alio*. The obvious example of an *ens per se* is a person; but the status of a person as an *ens per se* is just what is in contention. In Chisholm's own example, the various constituents of the table (AB, BC, etc.) on successive days are said to be *entia per se*. But that can only be just a manner of speaking. For AB is constituted by A and B; and A and B would still exist even if they lost a splinter or two. Hence, A and B are not actually *entia per se*. Indeed, it would seem that nothing with which we can have sensory contact could be an *ens per se*. In any case, we have no clear cases of *entia per se*, so I can't show that the two necessary conditions for *entia per se* come apart in the clear way that the example of the table showed that the two necessary conditions for *entia*

per alio come apart. But I think that I have shown that the distinction between *entia per se* and *entia per alio* cannot be the exclusive and exhaustive basic distinction that it purports to be.

This discussion illustrates a general problem: Chisholm defines something one way, and then goes on as if everything that satisfies the definition necessarily meets some further condition (such as the condition of having its parts necessarily). This problem may be seen also in Chisholm's treatment of the distinction between 'identity' in the strict and philosophical sense and 'identity' in the loose and popular sense. The 'strict and philosophical sense of "identity"' is defined like this: 'x is the same F as y' is used in the strict and philosophical sense if it is used in such a way that it implies 'x is identical with y'.[23] That is, the strict and philosophical sense of 'identity' is simply the absolute (or nonrelativized) conception of identity. But, as we saw at the outset, Chisholm ties the strict and philosophical sense of 'identity' to mereological essentialism in the following way: If x and y are identical in the strict and philosophical sense, then, necessarily, x and y have all the same parts. Again, however, we may accept the absolute conception of identity without commitment to the substantive metaphysical thesis of mereological essentialism. Mereological essentialism is a further condition of identity, strictly and philosophically speaking—a further condition not entailed by the definition of the 'strict and philosophical sense of "identity."'

Finally, the discussion of *entia successiva* makes the same general point. Chisholm defines an *ens successivum* as "an individual thing that is made up of different things at different times."[24] Then he goes on as if that definition implied (a) that *entia successiva* borrowed their (nonessential, present-rooted) properties from the things that make them up, and (b) that *entia successiva* exist only in a loose and popular sense. But (a) and (b) do not follow from the definition; in fact, things that satisfy the definition—for example, Chisholm's paradigm cases of *entia successiva* such as tables—do not satisfy the further conditions (a) and (b).[25]

Chisholm thinks that persons are *entia per se* because they are genuine things. I agree that persons are genuine things, but I do not think that genuine things should be construed as Chisholm's *entia per se*. The only reason for thinking that genuine things should be understood as *entia per se* in the first place is the metaphysical argument given above, an argument reminiscent of Leibniz's argument for simples. Here is a paraphrase: "We know that there are ontological parasites, *entia per alio;* but if there are ontological parasites, there must be things that are ontologically nonparasitical. Therefore, there are *entia per se*." But this argument depends on the coherence of the distinction between *entia per*

alio and *entia per se.* We can all agree that shadows are ontological parasites, and that if there are parasites, there are things on which the parasites are parasitical;[26] but this agreement does not commit us to holding that persons (or tables) are parasitical unless they are *entia per se,* or at least *entia nonsuccessiva.*

To sum up: It seems to me that the distinction between *entia per alio* and *entia per se* is at least questionable as a metaphysical basis for understanding the nature of persons. On the one side, there are no uncontested examples of an *ens per se.* On the other side, the two conditions for being an *ens per alia (being ontologically parasitical* in the relevant sense, and *not having one's parts necessarily)* come into conflict. These matters suggest that a different framework may be useful for discussing the three possibilities mentioned by Chisholm in quotation Q—that I am identical with my body, that I am identical with a proper part of my body, and that I am not identical with any body. In the next section, I shall suggest another approach, which preserves many of Chisholm's intuitions and insights about the nature of the person.

AN ALTERNATIVE: THE "CONSTITUTION" VIEW

In this section, I shall briefly point to what I call a "constitution" view of persons, and then raise and answer objections to it from a broadly Chisholmian perspective. If the "constitution" view can be worked out in detail (and I have not yet done so),[27] it will offer a way to accommodate most of Chisholm's pretheoretical intuitions about the nature of persons, which I share, but based on a much thinner metaphysics than Chisholm's.

Let me set out the "constitution" view starkly. A person (human or other) is a being with a capacity for intentional states, like believing, desiring, intending. Some of these intentional states must be first-personal; a being that cannot think of itself in an irreducibly first-personal way is not a person.[28] A *human* person is a member of the species *Homo sapiens.* She must have a biological body that she can think of in the first-personal way.

(HP) x is a human person = Df. x is an entity which (i) is constituted by a biological body of a *Homo sapiens,* or by a body suitably related to such a biological body, and (ii) is such that at all times of x's existence, x can have intentional states, some of which make first-person reference to the body that constitutes x.[29]

Constitution, as I construe it, is a pervasive and familiar relation in nature: molecules constitute strands of DNA; pieces of gold constitute statues; oak boards constitute tables. These examples suggest the following. Constitution is a relation between things: things of one kind (colored canvas) constitute things of another kind (priceless portrait). Hence, constitution is not reflexive. Nor is constitution symmetrical: the canvas constitutes the portrait, not the other way around; in a world without art, there could be a colored canvas (qualitatively similar to the one that constitutes the portrait in our world) without there being any portrait. However, constitution is transitive: if the table is constituted by the oak boards, and the oak boards are constituted by certain molecules, then the table is constituted by those molecules.[30] Finally, constitution is not identity: As long as I exist, it is necessary for me to have a body; but it is not necessary that I have the body at t that actually constitutes me at t. I could have been constituted by another body. So, assuming with Chisholm an absolute conception of identity, I am not identical to my body. I shall try to make clearer how I construe constitution by replying to objections for the remainder of this section.

Objection #1: Assuming that x constitutes y, do x and y have exactly the same properties? If x and y do have exactly the same properties, then there seems to be no difference between saying 'x constitutes y' and 'x is identical to y'. If x and y do not have exactly the same properties, then we have a problem of "counting" properties. The problem may be illustrated by this: If AB constitutes the table and the table weighs 100 lbs., and AB weighs 100 lbs., and AB is not identical (strictly and philosophically) to the table, the scales ought to read '200' (the sum of AB's weight and the table's weight) when the table is set on them. But the scales do not read '200'; they read only '100'.[31] So, either way—whether we say that x and y have exactly the same properties or not—there is a problem.

Reply to Objection #1: Call first-order properties whose instantiation is independent of what is the case at other possible worlds and at other times 'ordinary properties'. Ordinary properties are typically designated in English by simple predicates: 'is red', 'belongs to you', 'is funny-looking'. If x constitutes y, then x and y have all the same ordinary properties: x is on the pedestal if and only if y is on the pedestal; you own x if and only if you own y; x is painted red if and only if y is painted red—and so on. But x and y do not have exactly the same properties *tout court*. If x (a painted canvas, say) constitutes y (a portrait), then, according to the view I am proposing, there is a property that distinguishes x from y: x could exist without being a portrait, but it is not the case that y could exist without being a portrait. So, constitution is not identity: x and y do not have exactly the same properties.

But now we seem to have the problem of "counting" properties: AB weighs 100 lbs., the table weighs 100 lbs., and the table is not identical to AB; yet, the scales read '100', not '200'. The solution to the problem of counting properties requires a distinction between borrowed and unborrowed properties.

To make the requisite distinction between borrowed properties and unborrowed properties, we need to define a new predicate, 'H*xy', to mean 'x has H independently of x's constitution relations to y'. Then, x borrows property H from y if and only if: (a) x and y both have H, but (b) x does not have H independently of x's constitution relations to y; and (c) either x constitutes y and, necessarily, anything with H that x constitutes has H independently of its constitution-relations with x; or y constitutes x and, necessarily, anything with H that constitutes x has H independently of its constitution-relations with x. To put this schematically:[32]

Definition of 'x's having H independently of x's constitution relations to y':

H^*xy = Df.
 (a) Hx and
 (b) x constitutes y or y constitutes x and
 (c) x would still have H even if y did not have H.

Definition of 'borrowing':

(BP) x borrows property H from y = Df.

 (a) Hx & Hy; and
 (b) $\sim H^*xy$, and
 (c) Either: (i) x constitutes y & it is necessary that: $(z)[(x$ constitutes z & Hz$) \rightarrow H^*zx]$, or
 (ii) y constitutes x & it is necessary that: $(z)[(z$ constitutes x & Hz$) \rightarrow H^*zx]$.

It is important to see that, on my view—in contrast to Chisholm's—borrowing properties is a two-way street. A constituting thing may borrow properties from the thing that it constitutes, as well as vice versa. For example, if a certain building, b, constitutes a certain school, s, then, building b borrows the property of being tax-exempt from school s. Intuitively, building b's tax-exemptness is not independent of b's constitution relations to school s, but the tax-exemptness of the school is independent of its constitution relations to b. (If the tax laws changed so that buildings in general were tax-exempt, then building b's property of being tax-exempt would not be borrowed from s; for if the tax laws were changed in that way, then building b would have the property of being

tax-exempt independently of its constitution relations to s, and [b] of [BP] would be false.)

On the other hand, if a certain piece of oak, o, constitutes a certain tabletop, t, then tabletop t borrows the property of being square from piece of oak o: Intuitively, tabletop t's squareness is not independent of t's constitution relations to piece of oak o (tabletop t would not be square unless it were constituted by something square); but the squareness of piece of oak o is independent of its constitution relations to tabletop t. Piece of oak o would still be square even if it didn't constitute square tabletop t.

The notion of x's borrowing a property from what x constitutes or from what constitutes x provides a way to solve the problem of counting properties: *weighing 100 lbs.* is a property that the table borrows from AB; and borrowed properties are not "additive." If the table borrows the property of weighing 100 lbs. from AB, then the table's weighing 100 lbs. is nothing over and above AB's weighing 100 lbs. To "add" a borrowed property to its unborrowed counterpart would be to count the property in question twice.[33] If x borrows H from y, then x's having H is simply a matter of y's having H, when certain other conditions are met.

For any quantitative property F: if x constitutes y or y constitutes x, and x borrows F from y, then x's property of being F cannot be "added to" y's property of being F. For example, if being F is the property of being worth $100, and if a certain piece of paper constitutes a certain U.S. hundred-dollar bill, then the U.S. hundred-dollar bill is worth $100 and the piece of paper is worth $100; but, since the piece of paper borrows the property of being worth $100 from the U.S. hundred-dollar bill, it does not follow that there is something that is worth $200.

Objection #2: Suppose that I am constituted by my body. My body has a nose as a part. Either my body's nose is a part of me or it is not. If my body's nose is not a part of me, then the "constitution" view seems to collapse into person/body dualism. But if my body's nose is a part of me, and I am not identical to my body, then I must have two noses. But I do not. Either way spells trouble for constitution.

Reply to Objection #2: My body's nose is a part of me; yet I do not have two noses. The relation between my body's nose and my nose is identity, not constitution. (I take constitution to conform to Locke's dictum that two things *of the same kind* cannot be in the same place at the same time; my nose and my body's nose are of the same kind [nose].) Just as I can borrow properties from my body, so too I can borrow parts. We may use the idea of borrowing a property to understand the idea of borrowing a part. I borrow nose n from body b, say, if and only if nose n is a part of body b and body b constitutes me.

Now, if x constitutes y, y's borrowed parts are identical to the parts of x from which they are borrowed. So, my nose (one of my borrowed parts) is identical to my body's nose. Since my nose = my body's nose, there is no question of there being two noses that spatially coincide.

Objection #3: But look what you have come to: my nose is part of me and part of my body, but I am not identical to my body, nor do I have any nonbodily parts. This result seems to violate the mereological principle that any collection of things has exactly one "fusion," where a fusion is the unique individual that consists of just those things as parts. For example, your left eyeball is part of the individual that is the fusion of your left eyeball and the Magna Carta. Mereological principles entail that there is exactly one fusion for any collection of parts.[34] To see the problem, let f be the fusion of your bodily parts; let b be your body, and S be you, the person. Now if b ≠ S, it seems that, on the "constitution" view that you propose, your bodily parts have *two* fusions, b and S.[35]

Reply to Objection #3: No. On my "constitution" view, there is only one fusion of my bodily parts. The fusion of my bodily parts is not identical to my body. (If it were, fusion would not be "automatic"; it would not be the ontologically innocent relation of any collection of objects that Lewis insists on.) The fusion of parts of a thing is not identical to that thing; rather, the fusion of parts of a thing constitutes the thing. For example, the fusion of a particular collection of molecules may constitute a particular piece of cloth, and that piece of cloth in turn may constitute a particular flag.

Since a thing and its parts may have different persistence conditions, I reject both f = b and f = S. The fusion of all the bodily parts constitutes a body, and the body constitutes a person. A plurality of objects can have only one fusion, but, since constitution is transitive, that fusion can constitute more than one thing.

So, there is no violation of the mereological principle that every collection of objects has exactly one fusion, nor is there violation of transitivity of identity. It is just that constitution is not wholly understandable in terms of mereology; but it would be unreasonable to demand that it should be understandable wholly in terms of mereology. Such a demand would be like requiring you to look under the street lamp if you've lost your keys—on the grounds that that's where the light is.

Objection #4: OK, suppose that my nose is a part of me. Then, if mereological essentialism is true, I could not survive the loss of my nose. But that is false: Surely I could survive loss of my nose.

Reply to Objection #4: Of course, I could survive the loss of my nose. All that follows is that mereological essentialism is false. One philosopher's modus ponens is another's modus tollens.

Objection #5: Rejection of mereological essentialism violates Leibniz's Law. As Chisholm said, "Leibniz's Law implies that nothing can change its identity. That is to say, it is impossible for there to be anything that is identical with a certain thing at one time and diverse from that thing at another time."[36]

Reply to Objection #5: I quite agree with the quotation from Chisholm. But it does not follow simply from Leibniz's Law that change of parts is change of identity. The (logical) concept of identity (in a strict and philosophical sense) must be combined with the (metaphysical) thesis of mereological essentialism for it even to *seem* that a (genuine) whole cannot survive a change of any parts. But mereological essentialism cannot be assumed as a premise in an argument that hopes to establish mereological essentialism. If one *defines* 'the strict and philosophical sense of "identity"' as entailing mereological essentialism, then one cannot appeal to the notion of identity in the strict and philosophical sense in order to *support* mereological essentialism.

What follows from Leibniz's Law alone is that a thing cannot change its identity; Leibniz's Law is silent on what counts as change of identity. As long as a thing can persist through change of any of its properties, there is no a priori bar to saying that it can also endure through change of parts. As we have seen, a "constitutionalist" insists that a thing may be constituted by its parts without being identical to them. The sorts of change through which a thing can persist depends, of course, on the kind of thing it is. This is part of what it means to say that different kinds of things have different persistence conditions. The piece of gold can survive some sorts of changes of properties (and parts); the statue can survive different sorts of changes of properties (and parts).

Objection #6: You have a problem counting objects. Consider Chisholm's table, constituted by AB on Monday, by BC on Tuesday, and by CD on Wednesday. How many tables are there? Chisholm's claim that the expression, 'There are four tables', which conflates the strict and philosophical sense of 'identity' with the loose and popular sense, provides a clear answer;[37] but you reject that approach.

Reply to Objection #6: There is one table (and it endures at least from Monday through Wednesday), constituted by three different board-assemblies from Monday through Wednesday.

Objection #7: But the question is this: How many *objects* are there altogether? Don't three plus one equal four?

Reply to Objection #7: Unsurprisingly, I agree that three plus one equal four, but say that that rule is irrelevant here. To count objects, one needs a "proper count noun," where a proper count noun both has the

grammatical form of a count noun, and expresses a criterion of individuation.[38] Since 'object' and 'thing' are not proper count nouns, there is not a determinate answer to the question how many objects are there in the room?

Moreover, Chisholm's answer to the question, "How many tables are there?" does not really answer the question, "How many objects in a strict and philosophical sense are there here (coinciding, in the loose and popular sense, with the table)?" For if Chisholm's view is correct, no one knows the answer to that question. As I've already noted, if a splinter is removed from A, then, in Chisholm's strict and philosophical sense (though not in his loose and popular sense), AB ceases to exist and is replaced by a different object, A'B. Considering the indefinitely many ways that splinters could be removed from A and from B without disturbing the relation between AB and the table, if we followed Chisholm, we would have to say that even on Monday alone, there may have been indefinitely many objects (in the strict and philosophical sense) coinciding with the table. Hence, I do not think that Chisholm (or anyone else) has any better answer to the question of how many objects are there coinciding at t with the table than I do.

CONCLUSION

The "constitution" view of persons, employing only the technical apparatus of the notion of 'constitution', can underwrite many of Chisholm's claims about human persons.[39] In particular, the "constitution" view can accommodate Chisholm with respect to the following theses:

1. A person is not identical to her body.
2. Persons, not brains, are the bearers of mental properties.
3. A person is a genuine thing,[40] not just a stage of something else (for example, being a person is not a property that a particular body might have at one time but not at another.)
4. A person cannot become something that is not a person.[41]
5. For any future person, there is a fact of the matter, independent of human decisions or conventions, as to whether I am that person— even if we cannot ascertain what the fact is.[42]

So, one may share many of Chisholm's intuitions about the nature of persons without being committed to his more general metaphysical picture.

Return now to quotation Q. If the "constitution" view of persons is correct, then I am not identical with my body, nor am I identical with a proper part of my body. Does it follow that I am not a material object, as quotation Q seems to imply? Suppose that we understand 'material object' like this: x is a material object if and only if x is a fundamental particle or x is wholly constituted by fundamental particles.[43] In that case, I am a material object.

This may seem puzzling: If I am a material object, then there is some material object with which I am identical.[44] If I am not identical with my body or with any proper part of my body, how could there be some *other* material object with which I am identical? The answer to this question seems to me obvious: The material object with which I am identical is myself; I am identical with myself and not another thing. I—the material object with which I am identical—am a material object in virtue of being constituted by my body. Similarly, Michelangelo's *David*—the material object with which *David* is identical—is a material object in virtue of being constituted by a piece of marble. If there is a mystery about my being a material object that is identical neither to my body nor to a proper part of my body, then there is an equal mystery surrounding *David's* being a material object that is identical neither to the piece of marble that constitutes it nor to a proper part of that piece of marble. But I, for one, think that the notion of *constitution* clears up a lot more questions than it raises. Although there is no doubt a great deal of work to be done on the "constitution" view of persons, I believe that that view promises to deliver much of what Chisholm wants.[45]

LYNNE RUDDER BAKER

DEPARTMENT OF PHILOSOPHY
UNIVERSITY OF MASSACHUSETTS AT AMHERST
SEPTEMBER 1995

NOTES

1. Roderick Chisholm, "On the Simplicity of the Soul," in *Philosophical Perspectives 5: Philosophy of Religion, 1991,* ed. James E. Tomberlin (Atascadero, Calif.: Ridgeview Publishing Co, 1991), 168.
2. Roderick Chisholm, *Person and Object: A Study in Metaphysics* (LaSalle, Ill.: Open Court Publishing Co., 1976), 104; and *On Metaphysics* (Minneapolis: University of Minnesota, 1989), 125.
3. Chisholm, *Person and Object*, 51, 101.
4. Ibid., 97.

5. Chisholm, *On Metaphysics*, 34.

6. Chisholm, *Person and Object*, 96. Also see Roderick Chisholm, "Parts as Essential to Their Wholes," *Review of Metaphysics* 26 (1973): 581–603.

7. Roderick Chisholm, "Parts as Essential to Their Wholes," *Review of Metaphysics* 26 (1973): 581–82.

8. Chisholm, *On Metaphysics,* 26. The category of *entia nonsuccessiva* (it seems to me) should be subdivided into two types: One type would comprise those things whose intact persistence is accidental—say, an artifact whose parts did not happen to change throughout its existence; such things would be *entia per alio.* The other type would comprise those things whose intact persistence is necessary—say, a person, if it turned out that a person was identical to "certain material particles or subparticles that are incorrupted and remain incorrupted as long as the person survives" (*On Metaphysics*, 126); such things would be *entia per se.* Since I do not know whether this is the right way to understand Chisholm's use of '*ens nonsuccessivum*', I'll hedge in the text and say that his view is that I am an *ens per se* (or at least an *ens nonsuccessivum*).

9. The argument could hare been formulated in terms of the alleged distinction between the 'strict and philosophical' and the 'loose and popular' senses of persistence: I persist in the strict and philosophical sense. My body does not persist in the strict and philosophical sense. So, I am not identical to my body. This distinction between 'strict and philosophical' and 'loose and popular' senses of persistence is subject to points parallel to those I shall make about the distinction between *entia per se* and *entia per alio*.

10. Chisholm, *On Metaphysics*, 126.

11. Ibid., 125.

12. Chisholm, *Person and Object*, 100.

13. Ibid., 100–101.

14. Ibid.

15. Ibid., 101.

16. Ibid., 102. The paragraph to which this note is appended is a close paraphrase of Chisholm.

17. Ibid., 104.

18. Chisholm, *On Metaphysics*, 125.

19. Ibid.

20. Chisholm, *Person and Object*, 104.

21. Although Chisholm defines '*ens successivum*' as 'an individual thing made up of different things at different times', he uses '*ens successivum*' in a richer sense—as if being an individual thing made up of different things at different times entailed being an ontological parasite.

22. At least this is a condition on *entia successiva*, the species of *entia per alio* relevant to this discussion.

23. Chisholm, *On Metaphysics*, 35.

24. Ibid., 125.

25. (b) does follow from the definition of '*ens successivum*', coupled with the claim that things that do not have their parts essentially may be said to exist only in a loose and popular sense.

26. Likewise, we can agree that we are speaking in a loose and popular sense in saying, "After her accident, she is not the same person as she used to be," and we can also agree that this loose and popular sense is not the sense that is relevant

to discussion of personal identity. But this agreement does not commit us to the further thesis that whatever exists in the sense of 'identity' relevant to discussions of personal identity has its parts necessarily.

27. I have made a beginning in "Need a Christian Be a Mind/Body Dualist?" delivered at the Notre Dame Conference on the Mind/Body Problem, November 1994; *Faith and Philosophy* 12 (1995): 489-504.

28. For a discussion of irreducible first-person reference, see my "On Making and Attributing Demonstrative Reference," *Synthese* 49 (1981): 245-73. In a series of articles beginning with "He: A Study in the Logic of Self-Consciousness," *Ratio* 8 (1966): 130-57, Hector-Neri Castañeda explored the significance of first-person reference. Also see Roderick Chisholm, who uses the ineliminability of the first-person as a reason for holding that persons are genuine entities, in *On Metaphysics*, 50.

29. The appropriate sense of 'can' needs to be spelled out. Chisholm, I think, would cash out 'can' as: "it is not contrary to the laws of nature that." See *Person and Object*, 137. I intend 'can' to be understood in such a way that an adult human being in an irreversible coma may still be a person unless her brain has so degenerated that it could never sustain intentional states again. For example, call Karen Quinlan's body 'b'. For a period after Karen Quinlan's accident, b still constituted a person—even though the person never had intentional states again. After her brain degenerated to a certain point, b ceased to constitute a person, Karen Quinlan or anyone else.

30. Thus, as I am using the term 'constitution', constitution is irreflexive, asymmetrical, and transitive. As Chisholm uses the term, constitution is reflexive, symmetrical, and transitive. See "Parts as Essential to Their Wholes," 588, 595.

31. This problem was raised by Alvin Plantinga at the Notre Dame Conference on the Philosophy of Mind, November 1994.

32. I'm not certain that the following definitions are free from defects, but they are the best that I could come up with at the time of writing. Whether they are technically correct or not, I think that the idea behind them is intuitive and fairly clear.

33. Borrowing is a kind of supervenience relation between x's having F and y's having F, where x constitutes y.

34. For a discussion of the mereology, see David Lewis, *Parts of Classes* (Oxford: Basil Blackwell, 1991); for a critique of Lewis, see Peter van Inwagen, "Composition as Identity," *Philosophical Perspectives 8, Logic and Language, 1994*, ed. James E. Tomberlin (Atascadero, Calif.: Ridgeview Publishing Co., 1994), 207-20.

35. Peter van Inwagen raised a version of this objection.

36. Chisholm, *On Metaphysics*, 55.

37. Chisholm, *Person and Object*, 102.

38. Gareth B. Matthews pointed this out to me.

39. Moreover, I agree with Chisholm on a number of more general metaphysical principles: Identity is absolute (not relative) and necessary (not contingent); Leibniz's Law holds of everything that there is; the world is populated in part by enduring three-dimensional objects.

40. Chisholm would construe 'genuine thing' in terms of the notion of *ens per se,* and I would not. The point of agreement here is that 'person' is not a

phase-sortal like 'child'. Nor is it a logical construction; nor does it designate a property or an abstract entity. Persons are real individuals.

41. A constitutionalist is also free to agree with Chisholm that a person cannot come into being gradually (*On Metaphysics*, 57). But constitutionalism is not automatically committed to that thesis. Let me just mention here that every other medium-sized thing, whether natural or artifactual—unless miraculously created *ex nihilo*—comes into existence during an interval of time, not all at once precisely at a particular moment. But there are extremely complex issues here, beyond the scope of this paper.

42. These theses may be found in *On Metaphysics*, 125, 126, 57, 55, 38, respectively.

43. If one balks at calling a fundamental particle a 'material object', the point may be cast like this: x is a physical object if and only if x is a fundamental particle or x is wholly constituted by fundamental particles. Then: x is a material object if and only if x is a physical object of a certain size.

44. Alvin Plantinga raised this objection.

45. I have had fruitful conversations about this paper with several people, including Fred Feldman, Gareth B. Matthews, Pat Manfredi, Kevin Corcoran, and Katherine Sonderegger.

REPLY TO LYNNE RUDDER BAKER

L ynne Rudder Baker's paper is entitled "Persons in Metaphysical Perspective." She is concerned primarily with what I have said about persons as being *entia per se* and not mere *entia per alio* as not satisfactory.

I have been a "personalist" in holding that the privileged access we have to our own natures provides us with a way of understanding the ultimate categories of reality. And I have been an "Aristotelian" in believing that the most significant results of metaphysical investigation are to be found in the writings of Aristotle. Looking to these writings, I concluded that distinguishing *entia per se* and *entia per alio* must be essential to metaphysics. An accident, if there were such a thing in Aristotle's sense of the word, would be what Bayle had called a "half-being" and what some Austrian philosophers would call "a parasite"— *ein Schmarotzer*. These constitute the most important example that he provides. I did my best to try to formulate an acceptable way of making Aristotle's distinction. And, as Baker makes clear, the results have been unsatisfactory.

I have since written a book, for Cambridge University Press, entitled *A Realistic Theory of Categories: An Essay in Ontology*. Here one finds the concept of ontological dependence, but not that of an *entia per alio*. Some objects are necessarily such that other objects exist; those dependent objects that are of special importance are individual things and states of individual things.

Baker, however, provides an alternative—a view that would appropriately be called "Castañedan." She writes:

> A person (human or other) is a being with a capacity for intentional states, like believing, desiring, and intending. Some of these intentional states must be first personal: a being that cannot think of itself in an irreducibly first personal way is not a person.

Since Baker's general topic is "Persons in Metaphysical Perspective," it is fair to note that the account seems to be circular: she is defining "persons" in terms of "first person." How, then, would she define "first person"? Since I have defended "the thesis of the primacy of the intentional," I would add that the linguistic concept should be explicated in terms of the intentional concept, and not conversely.

R.M.C.

20

Johannes L. Brandl
RECURRENT PROBLEMS—ON CHISHOLM'S TWO THEORIES OF EVENTS

Conceptual priorities, like the priority of intentional over linguistic notions, play a central role in Chisholm's philosophy. In this paper I want to explore a problem of priority which arises in regard to the concept of an event. The problem is how events are basically to be counted. Are they to be counted like particulars, when we ask, for example, how many faculty meetings take place during a certain period of time? Or should we better ask how often one and the same event happens, i.e., how often the faculty meets? Is the 'How often?' idiom to be analyzed in terms of the 'How many?' idiom, or is it the other way around? And why should there be any priority here in the first place?

In the light of these questions I want to compare Chisholm's earlier with his present theory of events. Up to the early eighties Chisholm treated events as a certain species of states of affairs, and hence as abstract, noncontingent entities. Meanwhile he defines them as a certain species of concrete, contingent states. This is a dramatic change on the ontological level. I want to investigate what consequences this change has for the conceptual issues raised above.

I begin in sections 1 and 2 by providing some general background for my comparison. In sections 3 and 4 I follow closely Chisholm's own reasoning, suggesting that there is a striking conceptual continuity in his

two theories of events. In section 5 I return to the more general perspective from which I start.

I. The Ontological Approach to Conceptual Issues

What does a problem of conceptual priority amount to? Is it a problem about the order in which we acquire certain concepts? This would be an empirical question of developmental psychology, not a question for philosophers. But if not the acquisition of concepts, what else could determine a priority relation between them?

The candidate to be examined here is ontology. Conceptual priority, one might say, is grounded in ontological priority. What could this mean? It seems to me that this approach could be based on the following principle:

(OC) If entities E_1 are ontologically prior to entities E_2, then concepts whose application commits us only to the existence of E_1s are more basic than concepts whose application commits us also to E_2s.

To see how this principle works consider the question whether the concept of number is more basic than the concept of equinumerosity. We know, thanks to Frege, that the former concept can be defined in terms of the latter and the latter independently of the first in terms of the notion of one-one-correspondence (Frege 1884, §68). Still one may ask why one should set up the foundations of arithmetics in this way. Here the above principle suggests itself. A Fregean could point out that judgments which involve the concept of number commit us to a special realm of abstract objects and functions, whereas judgments about a one-one-correspondence commit us only to concrete individual things. Given that concrete things are ontologically prior to functions, and functions prior to abstract objects, the respective concepts should be treated exactly in the order in which Frege does.

With this model in mind, let us turn to the problem whether the concept of frequency, which underlies the 'How often?' idiom, is more basic than the concept of number, which underlies the 'How many?' idiom. This requires three steps: (1) first we must establish that applying these concepts involves different ontological commitments, then (2) we must consider which of the entities presupposed by these concepts are ontologically prior, and (3) finally we must consider whether a conceptual priority can be defended on these ontological grounds.

2. THE COMMITMENT TO EVENTS

An answer to the 'How many?' question has the form 'there are n Fs', where 'n' represents a number-term and F a noun-phrase, e.g.: there are two female members, or there are two faculty meetings each term. In predicate logic these statements can be analyzed as: there is an x and a y such that x and y are female members (faculty meetings), x is distinct from y and for all z, if z is a female member (faculty meeting), then z is either identical with x or with y. This analysis is instructive, according to Quine, because the quantifiers carry the ontological commitment of our statements (cf. Quine 1948). On this view, the only entities to which we are committed by answering a 'How many?' question are countable particulars like individual people or individual meetings.

This Quinean picture is taken over by Davidson as a central part of his particularist theory of events:

> That it is dated, particular events that seem to be required if such sentences
> [as 'His first attempt at the North Face was his last'] are to be true is
> apparent from the principles of individuation implicit (for example) in the
> application of counting ('The third explosion was far more destructive than
> the first two', 'More than a third of all motorway accidents are caused by
> excess speed'). (Davidson 1970, p. 181)

This is the view which Chisholm opposes in a series of papers from the early seventies (Chisholm 1970, 1971b, 1975). There he presents a quite different view of how we are committed to the existence of events.

Consider an answer to the 'How often?' question. It has the form 'it happened exactly n times that p', where 'n' again stands for a number-term, but 'p' for a complete sentence, e.g.: it happened exactly twice that John opened the meeting. If we bring this statement into the form of predicate logic, we may quantify over times (time-points or intervals), but we need not quantify over events. Thus we could analyze this sentence as saying that there are past times t_1, t_2, t_3 such that t_2 is between t_1 and t_3, and it is true at t_1 and t_3 but not at t_2 that John opens the meeting, and there are no other past times at which this is true.[1]

How then does a sentence of the form 'it happened n times that p' commit us to the existence of events? It is not by some tacit quantification, Chisholm thinks, but by a that-clause. Chisholm here follows a tradition which takes that-clauses to be singular terms denoting certain objects. When we say 'John believes that he should open the meeting' or 'John hopes that the meeting will end soon', we describe a relation between John and the object of his belief or hope. We also refer to an object of this kind in statements of the form 'it happened n times that p'.

We are thus confronted with two very different approaches to ontology. On the one hand we have a theory which takes the quantificational form of sentences as its guide and introduces events as elements in the domain of quantification. On the other hand we have a theory of intentionality which assumes a special category of (possible) objects of intentional acts and treats events as a special kind of such objects.

In view of this difference it is no wonder that the debate between Chisholm and Davidson had to end in a deadlock. As Davidson puts it: "Both of us are happy to admit that we are talking about very different things" (Vermazen/Hintikka 1975, p. 222).

Still, there are points of agreement which are worth considering. Both Chisholm and Davidson agree on a principle of ontological parsimony which advises us to reject a notion of event that includes both event-types and event-tokens. According to such a view to say that an event recurs would simply be to say that different event-tokens 'realize', 'instantiate', or 'exemplify' the same event-type.[2]

How can one avoid such type-token dualism? This is exactly where Chisholm and Davidson differ. Davidson suggests that talk about event-types is ontologically uncommitting. It just means that we subsume particular events under a certain *description*. Davidson follows here the nominalist strategy to let linguistic entities do the work of abstract objects (cf. Davidson 1971, pp. 195f.).[3]

Chisholm's reaction is just the opposite. He suggests that we should take the talk about event-tokens as ontologically misleading. What counts for him are the intentional objects which are abstract entities like event-types. Let us take a closer look at his first theory now.

3. Events as States of Affairs

Chisholm's early theory, which he fully develops only in 1976, 1979a, and 1979b, puts events and propositions into a single category which he calls the category of 'states of affairs'. States of affairs may be said *to obtain, to occur, to happen, or to take place*. This must not be confused with saying that they exist. All states of affairs exist necessarily and eternally. Furthermore, all states of affairs are abstract entities, without this implying that they are instantiable like types or exemplifiable like properties. The obtaining or not-obtaining of a state of affairs is something peculiar, comparable only to the truth or falsity of a proposition (cf. 1970, p. 22; 1971b, pp. 180 and 188; 1976, p. 115).

How do events fit into this picture? Chisholm's idea is that states of

affairs can first be divided into propositions and nonpropositions, and that events then fall into the latter subcategory. He illustrates this classification with the following example:

> Thus the state of affairs which is John walking at 3 P.M., E.S.T., on February 5, 1970, will be a *proposition*, for it is necessarily such that either it or its negation does not occur. But that state of affairs which is John walking will be an event; for it is contingent, it is possibly such that both it and its negation occur, and it implies change. (1970, p. 20)[4]

Chisholm uses gerundive expressions of the form '*a* being *F*' for referring to states of affairs. I prefer to use the corresponding that-clauses or the sentences from which they are derived.[5] Thus I would make Chisholm's point by saying that of the following two sentences (that-clauses) the first one expresses (denotes) a proposition, whereas the second expresses (denotes) an event:[6]

(1) (that) John is walking at 3 P.M., on February 5, 1970.
(2) (that) John is walking.

Why should these sentences have different ontological correlates? The crucial notion to be considered here is the notion of the 'negation' of a state of affairs.

3.1. Negating States of Affairs

Chisholm distinguishes between saying that a state of affairs *A* does not obtain, and saying that the negation of *A*, call it *not-A*, does obtain (cf. Chisholm 1971b, p. 179). For instance, it is one thing to say that the state of affairs expressed by (1) does *not* obtain, and another thing to say that the state of affairs expressed by

(3) John is not walking at 3 P.M., on February 5, 1970,

does obtain. Chisholm explains the difference in intentional terms.[7] States of affairs are defined, as mentioned before, as the objects of intentional attitudes like 'accepting', 'entertaining', and 'considering' (cf. 1979a, p. 29; 1979b, p. 342). These attitudes have, Chisholm holds, the peculiarity that there is always *one thing* that is accepted, entertained, or considered. This provides states of affairs with identity conditions and also opens a gap between the not-obtaining of *A* and the obtaining of *not-A*.[8] Intuitively it is not the same to consider the state of affairs *A* and to reject its obtaining, or to consider the state of affairs *not-A* and to accept its obtaining. Each consideration may eventually lead to the same result, but the individual attitudes involved are different in each case.[9]

Chisholm's treatment of negation allows him to say that both a state of affairs and its negation may obtain. In fact that is characteristic of an event. Of course, this can only mean that a state of affairs and its negation may obtain *at different times*, otherwise this would involve a contradiction.[10] The state of affairs expressed by (2) obtains temporarily, not however the state of affairs expressed by (1); hence the first is an event and the second is a proposition.

One may object here that the definition of an event as a temporarily obtaining (or not obtaining) state of affairs is much too wide. Take for instance the sentence 'There is light'.[11] The state of affairs expressed by this sentence would qualify as an event, but intuitively it is not one. The response to this objection is that we have left out an important constraint, namely that events must imply some *change*. This and other criteria are suggested by Chisholm for excluding those nonpropositions which are intuitively not events (cf. Chisholm 1976, p. 128; and 1979a, p. 40f.).

But there is another problem that needs to be solved. Can we ever say consistently that the same state of affairs obtains at some time and does not obtain at some other time? Consider again the state of affairs expressed by sentence (2). Apparently it expresses a state of affairs that obtains when John is walking and does not obtain when he is resting. This cannot be true, however, if (2) says the same as:

(2*) John is walking sometimes.

The state of affairs expressed by (2*) obtains even when John is resting, provided that he was walking before or that he will be walking later. How can (2*) express a proposition, and (2) express an event, if both sentences say the same thing? What we must take into account here is Chisholm's treatment of tense.

3.2. Tensed and Untensed States of Affairs

Chisholm repeatedly says that in a theory of events "tense must be taken seriously" (1979a, p. 43; 1979b, p. 346; 1989, p. 151; 1990, p. 413). This requires that we avoid any reference to moments or intervals of time, and instead use a tensed language. Then sentence (2) gives way to a disjunction of differently tensed sentences which may all express different events:

(2a) John is now walking.
(2b) John was walking.
(2c) John will be walking.

According to this proposal we could say that tensed sentences express events, whereas tenseless sentences, like (2*), express tenseless states of affairs, i.e., propositions.

That this is what Chisholm has in mind is confirmed by his explanation of the tenseless 'is' in '*a* is *F*'. This form, he says, should be taken as an abbreviation of '*a* is, was, or will be *F*' (cf. 1979a, p.43 and 1979b, pp. 346ff.). Following this suggestion, sentence (2*) should be transformed into a disjunctive statement, whereas sentence (2), as well as the gerundive form '*a* being *F*', should be replaced by one of the disjuncts, namely by '*a* is now *F*', '*a* was *F*', or '*a* will be *F*'.

However, there is also an alternative view to be considered. We might retain sentence (2) as a tenseless sentence which lacks a definite truth-value. In this case (2) would be neither equivalent to (2*) nor to the disjunction of (2a), (2b), and (2c). Rather these three sentences would have (2) as their common core. On this interpretation they all express the same event, given the following equivalence:

(E1) Sentences of the form '*a* is now *F*', '*a* was *F*', '*a* will be *F*' are true if and only if the state of affairs expressed by their tenseless core '*a* is *F*' obtains now, did obtain, or will obtain respectively.

In order to introduce tensed states of affairs, one would have to accept in addition the following equivalence:

(E2) The state of affairs expressed by sentences of the form '*a* is *F*' obtains now (did obtain, will obtain) if and only if the state of affairs expressed by '*a* is now *F*' ('*a* was *F*' or '*a* will be *F*') obtains.

I can see no reason why we should make this further step. Events can be tenseless, and yet temporarily obtaining (or not-obtaining) states of affairs. What is tensed are their conditions of obtaining, not the states of affairs themselves. On this view neither moments of time nor tensed states of affairs are needed.[12]

After these clarifications let us turn to the explanation of recurrence in Chisholm's early theory.

3.3. The Notion of Recurrence

A theory of events, Chisholm says, should be "adequate to the fact of recurrence, to the fact that there are some things that . . . happen more than once" (1970, p. 15; cf. 1971b, p. 180). Perhaps Chisholm should have said more cautiously that such a theory should be adequate to the

fact that we commonly *talk* as if there were things that happen more than once: faculty meetings, opening ceremonies, etc. His demand is that we must not dismiss this way of speaking as 'loose and popular talk', as when we speak of taking the same train, meaning a train that leaves at the same time every day (cf. 1970, p. 21).

Now, what does it mean to say of an event A that it recurs? Starting from his definition of an event, quoted above, Chisholm proposes the following definition of recurrence: 'Event A recurs' means 'A occurs before A begins' (1970, p. 17).[13] This again would lead to a contradiction, unless a tensed language were used. Therefore I prefer the following definition:

D1 x recurs sometimes = Df. It is, was, or will be the case that: x did occur, x does not occur, and x will occur (1971a, p. 20).[14]

This still leaves out the possibility of an event presently recurring. Therefore we must add:[15]

D2 x is recurring now = Df. It is now the case that: x occurred before x did not occur, and x occurs.

Which states of affairs can recur in the sense just defined? This again depends on the treatment of tense. If there are tensed states of affairs, then most of them cannot recur. Consider for instance the state of affairs expressed by the sentence (2b). It did not obtain before John walked for the first time, but does obtain and always will obtain after that. Similarly for the state of affairs expressed by (2c). It will obtain until John walks for the last time, then it will cease to obtain forever. This may be the reason why Chisholm suggests at one point that past- and future-tense sentences do not express events at all (1979b, p. 353f.). No such restrictions threaten if events are expressed only by the tenseless core of tensed sentences.

The notion of recurrence serves an important purpose in Chisholm's theory: it is the basis of his account of *counting* events. This is the most striking feature of Chisholm's theory to which I turn next.

3.4. Counting Recurrences

On Chisholm's view we do not count events, but we count how often they recur. Thereby we follow an inductive strategy which he explains as follows:

> We first say what it is for something to occur during A's first occurrence, but without using any term purporting to designate A's first occurrence. In terms

of that, we next say what it is for something to occur during what is at least A's second occurrence, and so on, for any finite number n. And then we can say what it is for A to occur exactly n times. (1970, p. 17f.)

An example may illustrate this procedure. Suppose there was rain last week on two distinct days. What does this mean ontologically? According to Chisholm there are the following things involved: one is the state of affairs A which is expressed by the sentence 'it rains' (a tenseless state of affairs on my assumption). In addition to that there are three other events B, C, and D which need not be further specified, but which must satisfy the following condition: each of them occurred only once last week, none of them happened simultaneously, and two of them happened while it was raining, where of these two events one happened earlier and the other later than the third one. Suppose that I once went to the movies last week, that I once bought myself a new record, and that I once had to see the dentist. If it happens that it rained last week during my visit to the movies and during my shopping trip, but not while I was at the dentist, and if the event during which it did not rain occurred between the other two, then we can conclude that it did not rain continuously, and hence that it rained *at least* twice last week. And if there are no five nonsimultaneous events, each occurring only once, such that it rained during the first, the third, and the fifth, but not during the second and fourth, then we can conclude that it rained *exactly* twice.

So far we can explain how often the same state of affairs recurs at different times. What about multiple occurrences of the same state of affairs at the same time?[16] The state of affairs expressed by 'The movie starts' may obtain at a thousand theaters simultaneously. How do we count these multiple occurrences? Chisholm deals with this problem by introducing the notion of *concretization* (cf. 1976, pp. 129ff. and 1979a, p. 39). It denotes a relation which holds between abstract states of affairs and concrete things like movie-theaters, film-projectors, etc. The start of the movie is concretized by different things (projectors, screens, etc.) at different places at the same time. No concrete events need to be introduced in addition to the abstract states of affairs which are concretized.[17]

This method of counting is obviously much more complicated than the way in which we count particulars. That is the price which Chisholm must pay for taking events to be abstract states of affairs instead of concrete particulars. It may not be merely a question of complicating things, however.[18] There is a more general worry about this procedure that needs to be addressed.

3.5. A Problem for Chisholm's Early Theory of Events

Chisholm builds his early theory on the assumption that all events are like abstract event-types and not like concrete event-tokens. Therefore all references to particular events must be eliminated. This would seem to have important consequences on the conceptual level, because Chisholm must avoid the entire conceptual apparatus that goes together with the reference to particular events. But this requirement is not so easily satisfied.

When Chisholm explains what it means for an event x to occur n times he must presuppose that we can already count events by their number. After all, there must be exactly $n + (n - 1)$ events which occur only once, and it is the number of nonoverlapping 'one-shot events' which occur while x obtains that tells us how *often* this state of affairs recurs. It is true that these 'one-shot events' are states of affairs too, not concrete particulars. The fact remains however that Chisholm cannot do without the basic concept of counting events by their number.

At this point the assumption with which we started becomes relevant. We assumed that the two ways in which events may be counted, namely by their number or by their frequency, carry different ontological commitments. The first idiom, we said, commits us to events as unrepeatable particulars, the second to events as repeatable universals. If this is correct, Chisholm's project of eliminating event-particulars cannot succeed. Since he cannot avoid counting the number of 'one-shot events', it follows from our assumption that these 'one-shot events' are particulars.

Of course, Chisholm could drop the assumption that one counts particulars when one counts events by their number. Thus he could keep his ontology intact. What then has to go, however, is the conceptual priority contained in the claim that the 'How many?' idiom can be analyzed, without circularity, in terms of the notion of recurrence. This analysis requires that we can tell how many 'one-shot events' there are, thus presupposing the very notion which is the subject of analysis.

This is, as far as I can tell, the situation for Chisholm's early theory of events. In the meantime Chisholm has changed his ontology considerably. Let us see what effect this has on the conceptual questions which drive his early theory.

4. Events as States

Chisholm first presented his new ontological foundations for a theory of events in a paper entitled "On the Positive and Negative States of Things" (1985/86). At the center of this new theory we find two dichotomies that cut across each other: all entities are divided into contingent and noncontingent things, as well as into dependent and independent ones (cf. 1989, pp. 162ff. and 1990, p. 418). No place is left here for entities, like states of affairs, which exist eternally, but obtain only contingently. Whatever is contingent is "possibly such that it ceases to be" (1985/86, p. 102). Events are contingent entities, hence they cannot be eternally existing things. A new category has to be introduced.[19]

This new category is the category of states. States are contingent dependent entities. That they are contingent means that they can come into being and pass away. That they are dependent means that they cannot exist by themselves; they necessarily exist *at* something else (cf. 1985/86, p. 100 and 1989, p. 164). This is also true of dependent entities like surfaces and other boundaries. The specific character of *states* can be gathered only from the following principle (1989, p. 150; cf. 1985/86, p. 99):

(S) For every x, there is the state x-being-F if and only if x exemplifies being-F.

Another formulation of the same principle would be this:

(S*) For every sentence S of the form 'a is F', S expresses a state of a if and only if S is true.

This semantic formulation helps us to bring out the difference between the old category of states of affairs and the new category of states. States of affairs are expressed by sentences irrespective of whether they are true or false. Only true sentences, however, can describe the state of a thing. In this respect the *states* in Chisholm's new ontology are like the *facts* in the *Tractatus* and in Russell's *Logical Atomism*.[20] For all these ontologies the question whether a fact (or state) obtains does not arise, the answer being trivially 'yes'. This is why Chisholm can say now: "there is no need for us, in our theory, to introduce such expressions as 'takes place' and 'occurs'" (1990, p. 417).

Let us consider now some of the implications which this move from states of affairs to states may have for Chisholm's theory of events. I start with the topic of tense.

4.1. Tensed and Tenseless States

In Chisholm's early theory tense could be taken seriously in two ways: either by regarding states of affairs as themselves tensed entities, or by saying of (tenseless) states of affairs that they do, did, or will obtain. Once the notion of 'obtaining' has been dropped no such choice seems to be open any more. We seem to be forced to say that states are tensed entities with the consequence that different states are expressed by 'a is F', 'a was F', and 'a will be F'.

This would be an unfortunate consequence, for we could no longer express the state in which a thing was (or will be) without being in it right now. Suppose John was walking, but is no longer walking. Then he was in a state which is neither expressed by the sentence 'John was walking' nor by 'John is walking'. The first sentence does not express John's former state, but a state in which he is now, whereas the latter sentence, being false, does not express any state at all.

Chisholm has a solution to this problem, however. He introduces the notion of the *content* and the *substrate* of a state. When John is walking, he says, John is the substrate of a state which has the property *walking* as its content. If John stops walking and later walks again we can say that his former state and his future state share the same content. John exemplifies the same property, and yet he is in different states.

Chisholm also introduces so-called 'past-oriented' and 'future-oriented' properties (1990, p. 414). The property of *having been walking* would be an example of the first kind. A sentence like 'John was walking' expresses therefore both a former and a present state of John. It says that:

(a) John is now in a state with the content *having been walking*,

and also that

(b) John was in a state with the content *walking*.

Thus we see that, contrary to first appearances, states too can be tensed or untensed, because they can have a tensed or an untensed content. This distinction remains part of the theory even though the notion of 'obtaining' plays no role any more. And so we are not forced to distinguish between the tensed states expressed by 'a is F', 'a was F', or 'a will be F'. We can just as well say that they express a common state in which a is, was, or will be, provided these sentences are all true.

4.2. Recurrence Again

In 1985/86, p. 103, Chisholm proposes the following new definition of an event:[21]

D3 x is an event = Df. There is a y such that y is a contingent substance and x is a contingent state of y.

This definition seems to be at the same time too narrow and too wide. It seems too narrow because there may be events which are states of states, and not states of substances. Chisholm has taken care of this problem in the meantime by adjusting his definition appropriately (cf. forthcoming, p. 16 in manuscript).[22] Definition D3 may also seem too wide, however. It is satisfied by John's beginning or ceasing to walk as well as by his continuous walking, and also by John's motionless sitting and even by John's being tall. These are all contingent states of a contingent substance. To exclude at least the two last examples Chisholm would have to add some reference to change, as he did in his early definition of events as states of affairs. Thereby we would get a distinction between two kinds of *states* similar to the earlier distinction between events and propositions as two kinds of states of affairs.

There is one important advantage that Chisholm can claim for his new definition of events. It allows events to be part of the concrete world, i.e., to have temporal and spatial location and to enter into causal relations. That events have all these features Jonathan Bennett calls "a rock-bottom truth that a good metaphysics should imply to be strictly and literally true" (Bennett 1988, pp. 91).[23]

This advantage also causes a problem however. Can events which exist in space and time recur? Chisholm must deny this because he holds on to the principle that no entity can have more than one beginning of existence (1970, p. 17; 1989, p. 153). States and events, he says, are "one-time things" (forthcoming, p. 16 in manuscript). This seems to sacrifice the condition that a theory of events should be able to explain the fact of recurrence. But even here we find continuity.

Chisholm saves the idea of recurrence with the notion of a generic event:

> *Generic events* are events that may *recur* or *happen more than once*. And surely things can happen many times. *Jones's walking* has occurred many times. And it could be that, even if every walker will have walked only once, that event which is *someone walking* will have occurred many times. To deny such facts would cut the ground, not only from under the theory of probability, but also from the theory of causation. (Chisholm, unpublished, p. 12)

How does this go together with the metaphysical view that each entity has only one beginning? In his early theory Chisholm escaped this tension by distinguishing between the existence and the obtaining of a state of affairs. No state of affairs begins to *exist* more than once (because it does not begin to exist at all), but it can begin to *obtain* more than once. What replaces this solution now?

The proposal is that generic events may be identified with the "eternal objects that serve as the contents of states" (forthcoming, p. 16 in manuscript). The idea of reducing generic events to properties can already be found in 1979b, p.353. This requires denying that generic events are events in the strict sense: "Strictly speaking," Chisholm says, "what recurs are not events but rather those attributes that constitute the repeatable contents of events" (1989, p. 153; cf. 1985/86, p. 102 and 1990, p. 414). He can say this without giving up his inductive counting procedure. Instead of counting the frequency with which an event recurs, Chisholm now proposes to count in this way the frequency with which a property is exemplified. The locution 'it happens n times that p' is replaced by the locution 'x is F for the n-th time', everything else remains the same (cf. 1990, p. 424).

How close Chisholm's present theory of states and events remains to his earlier theory of states of affairs can finally be demonstrated by looking at the problem of individuating events.

4.3. Events Particularized

Although Chisholm now agrees with Davidson that states and events are 'one-time things', this does not mean that he also accepts his principles of individuation. Concerning the question what makes an event a particular, Chisholm still defends his own position.[24]

Suppose that John has taken a walk every Sunday for the last year. Then each Sunday there happened an event with John as its substrate and the property of *walking* as its content. What makes these different events distinct?

The answer would be easy if we had times and places in our ontology. Then we could say that the walks which John took are all different because even if John always took the same route his walks occurred on different days. But Chisholm has no days in his ontology and so he cannot give this answer. How does he solve the problem?

His solution is to introduce the notion of a *contemporary* (unpublished, p. 10). He defines it as follows:

D4 x has an instance of the property of being-F as a contemporary = Df.
 x is such that something is F.

The wording of this definition is somehow misleading. Chisholm does not appeal to property-instances or 'tropes', as Donald Williams called them. He finds these entities mysterious. When we talk about a particular fall, Chisholm says, "we are not saying that, in addition to the property of falling, there is also a kind of 'particularized property' or 'universal as particular' (1990, p. 417). He acknowledges that neither the content nor the substrate of a fall suffice to explain the particularity of the event, because the property of falling can be instantiated many times by the same thing.

What then makes an event a 'one-time thing'? To explain this, Chisholm suggests, we must appeal to *other* events which happen together with the event in question. What makes John's walk on the first Sunday of the year different from his walk on the second Sunday is, for instance, the barking of a dog that happened during his first walk, and the falling of a rock during his second walk.

There is a striking parallel between this answer and the way in which Chisholm solved the problem of counting the recurrences of a state of affairs. Formerly he would have said that the state of affairs expressed by 'John walks' occurs for the first time while a certain dog was barking, for the second time while a certain rock was falling, and so on for each time that John took a walk. Now he uses the same method for distinguishing between particular events that coincide in substrate and content.

This parallel may make it doubtful whether the notion of a 'contemporary' can really bear the weight of particularizing events. Can it rule out that the whole universe, with all temporal relations, repeats itself? Russell struggled with this problem when he tried to define instants of time as classes of overlapping events.[25] We cannot solve this problem by appealing to further contemporaries of contemporaries without starting a regress. Perhaps Chisholm can appeal to events whose content is such that there will never be an event with the same content in the future again.

5. A FINAL COMPARISON

I have pointed out now several respects in which Chisholm's present theory of states and events mirrors his early theory of states of affairs. But how can there be so much continuity, one may ask, if events were

formerly treated as abstract entities and now are said to be concrete particulars?

The similarities between these two theories result from the fact that properties take over the role which states of affairs played earlier, and properties are just as abstract and eternally existing as states of affairs. Viewed in this perspective, the following worry may arise: does Chisholm's theory of properties and states bring in through the backdoor a type-token dualism which he rejected for reasons of ontological parsimony?

It must be admitted that the relation between properties and states, and hence between the content of an event and an event particular, is not exactly like a type-token relation. Whereas an event-token may belong to many types, Chisholm demands that each event has exactly one content. It is thus excluded that a particular event should repeat itself, for instance, insofar as it is a walking, but not insofar as it is a shopping trip. On Chisholm's theory this can only mean that there is one event, a walking, whose content recurs, and a different event, a shopping trip, whose content does not recur. However this may be, both views are equally dualistic. Whether a dualism of properties and states is any better than a dualism of event-tokens and event-types, remains an open question.

In deciding this issue it is worth considering how rich the category of properties must be, if one wants to subsume generic events under this category. Suppose that John is walking only on Sundays and that Jim is walking during the week. Then there is an event, namely the event expressed by 'John is walking', which recurs only on Sundays, but the content of which also recurs on Mondays, namely as the content of an event which has Jim as its substrate. To distinguish the event-content that recurs on Sundays from that which recurs during the week, one must take the complex property *being John's walking* as the content of the one event, and the property *being Jim's walking* as the content of the other event. This move not only undermines the substrate/content distinction, it also brings back abstract event-types under a different guise. Why should anyone who rejects event-types accept such properties as *being John's walking*?[26]

Of course, one need not accept such a rich theory of properties. One might even consider a view which replaces abstract properties by concrete universals, thereby giving up the principle that 'things can have only one beginning of existence'.[27] Any change of this kind, however, would seem to undermine Chisholm's attribution theory of intentional states, and therefore is not available to him.

Chisholm's present ontology, I conclude, is in general line with a dualistic theory of event-tokens and event-types. Whereas his earlier theory of states of affairs was designed to oppose such a view, Chisholm now proposes a theory along this same pattern. That makes it hard to deny that the 'How many?' idiom and the 'How often?' idiom carry different ontological commitments. Whereas the first idiom commits us only to concrete events, the second commits us also to abstract properties. These different ontological commitments have no longer any conceptual implications however. As long as Chisholm argued for the elimination of concrete events, he needed an analysis of the 'How many?' idiom in terms of the 'How often?' idiom. Once concrete events are acknowledged, no need for such an analysis is left. It would arise again only if one could show that abstract properties are ontologically prior to concrete events. As long as no argument for such an ontological priority is given, no conceptual priority can be deduced from it.[28]

JOHANNES L. BRANDL

DEPARTMENT OF PHILOSOPHY
UNIVERSITY OF SALZBURG
APRIL 1996 (REVISED)

NOTES

1. Notice that the quantificational phrase 'there are past times' is ambiguous between 'there are times which are past' and 'there are times in the past', where the latter means 'there were times'. Which way the quantifier is taken depends on whether we use a tensed or an untensed language. More about this below.

2. Chisholm attributes this 'event-exemplification view' to C. I. Lewis and G. H. von Wright (cf. 1970, p. 23, n. 7; 1976, p. 121). He does not include in it Kim's 'property-exemplification view' which he considers to be close to his own position (cf. 1970, p. 22, n. 6; 1976, p.121; 1985/86, p. 103, n. 12; 1989, p. 155, n. 2; and 1990, p. 426, n. 3.). I shall argue in section 5, however, that the differences between the event- and the property-exemplification view may not run very deep.

3. This strategy would be open also to other particularists, like Brand and Lombard, who make use of a type-token distinction in their explanation of recurrence. See Brand 1976, p. 143; and Lombard 1986, pp. 63ff.

4. Chisholm uses here the term 'to occur' as short for 'to occur, hold, obtain, happen, or take place' (1970, p. 16). I shall not follow this usage but reserve the term 'to occur' for events and speak of states of affairs as 'obtaining' or 'not obtaining'. This is also Chisholm's usage in 1979a, p. 41.

5. One reason for this is that it is not clear whether Chisholm uses the

sentential gerundives as perfect or imperfect nominals (cf. Bennett 1988, pp. 4ff.). A second reason is that Chisholm does not think that every gerundial nominalization expresses a state of affairs, but he does not specify which of them do (cf. 1979b, p. 343).

6. The shift between saying that a sentence expresses, and saying that a that-clause denotes a state of affairs, I consider to be harmless.

7. This again shows that Chisholm's ontology in general follows his theory of intentionality, although there may be some feedback in the other direction too. For a discussion of these interdependencies see Butchvarov 1986.

8. Objections to Chisholm's identity conditions for states of affairs are raised in Davidson 1970, Davidson 1971, Corrado 1978, Lombard 1978, and Kim 1979. Replies are given in Chisholm 1971b, 1978, and 1979b.

9. It is worth noting at this point that Chisholm's account of events originally appeared as part of a larger paper dealing with the problem of identity over time. Since the very same thing can be entertained or accepted at different times, Chisholm seems to require that those things that are entertained or accepted must not change over time (cf. 1971a, pp. 17f.).

10. A contradiction could be avoided here also by appealing to the spatial, instead of the temporal location at which states of affairs obtain, but it is not clear how far space and time can be treated in a parallel manner in a theory of states of affairs (cf. Chisholm 1970, p. 16, n. 1). I deal with this question briefly when I come to Chisholm's notion of 'concretization'.

11. In Chisholm 1971a, p. 19, the state of affairs 'there being light' is counted as an event by Chisholm.

12. To retain the temporal aspect in the form of tenses is no guarantee that moments and intervals of time can be completely eliminated or that they can be reduced to relations among events. In 1979a Chisholm proposes to "withhold commitment with respect to the question . . . [whether] propositions ostensibly about times [may] be reduced to propositions about the temporal relations between events" (p. 44); but in 1979b, p. 357, he proposes such a reduction.

13. Here and in the sequel I have changed the style of the variables in accordance with my usage elsewhere in the present paper. In Johnson 1975 a 'logic of recurrence' is proposed on the basis of Chisholm's definition.

14. Curiously, Chisholm sets this definition aside because it makes essential use of tense. By his own lights, however, this would seem to be a virtue, not a defect of the definition.

15. A similar definition is suggested in Braude 1971, p. 195, but Braude's definition does not secure that the event x occurred before it did not occur.

16. This question is raised in Wolterstorff 1979, pp. 182f.

17. The view that there are both states of affairs and their concretizations falls under the verdict of "multiplying entities beyond necessity" (cf. Chisholm 1971b, p. 188). For a critical discussion of the notion of 'concretization' see Kim 1979, pp. 159ff.; Pollock 1979, pp. 163ff.; and Chisholm's replies (1979b, pp. 354ff.)

18. Counterexamples to this procedure are discussed in Johnson 1975 and in Wolterstorff 1979, p. 182. In Thomson 1977, pp. 107ff., an example is given that shows Chisholm's way of counting events to be in conflict with our intuitions concerning the parts of events.

19. The definition of events as states of affairs is already absent from 1975

although Chisholm there still holds on to states of affairs as a basic category. Later states of affairs are reduced to properties (cf. 1986, pp. 28f.).

20. Chisholm himself invites this comparison when he says that, once we have states, there is no need to "assume that there are also such things as 'facts'" (1985/86, p. 98; cf. 1990, p. 422).

21. The same definition, with minor variations is repeated in 1989, p. 152, in 1990, p. 419, and again in unpublished, p. 4.

22. Chisholm there also draws a distinction between events and processes according to this conception of an event, but I am not sure that I understand his distinction.

23. The concrete-event view is clearly weaker than the view that events are tropes. The first, not the second view is "hardly controversial," pace Bennett (cf. Bennett 1988, p. 93).

24. In this respect Chisholm's position differs considerably from Kim's theory. See n. 3 above.

25. I am grateful to Tony Anderson for having drawn my attention to this parallel between Russell and Chisholm. For a possible solution of Russell's problem see Anderson 1989.

26. Dean Zimmerman suggested to me that one could avoid properties like being John's walking by identifying the generic event with the ordered pair consisting of John and the property walking. This proposal, I think, is also unacceptable for someone who sets his face against a dualism of event-tokens and event-types.

27. I discuss this possibility in more detail in Brandl, forthcoming.

28. I am indebted to Roderick Chisholm for his advice in correspondence and for sending me unpublished material. I also would like to thank Marian David, Christian Piller, Peter Simons, Barry Smith, and especially Dean Zimmerman for their helpful comments on earlier drafts of this paper.

REFERENCES

Anderson, C. Anthony. 1989. "Russell on Order in Time." In C. W. Savage and C. A. Anderson, eds., *Rereading Russell: Essays on Bertrand Russell's Metaphysics and Epistemology*, 249–63. Minneapolis: University of Minnesota Press.

Bennett, Jonathan. 1988. *Events and Their Names*. Oxford: Clarendon Press.

Brand, Myles. 1976. "Particulars, Events, and Action." In M. Brand and D. Walton, eds., *Action Theory*, 133–57. Dordrecht: Reidel.

Brandl, Johannes L. Forthcoming. "Do Events Recur?" In *Proceedings of the Conference "Facts and Events in the Semantics of Natural Languages, Trento 1995."*

Braude, St. E. 1971. "Towards a Theory of Recurrence." *Nous* 5: 15–24.

Butchvarov, Panayot. 1986. "States of Affairs." In R. J. Bogdan, ed., *Roderick M. Chisholm*, 113–33. Dordrecht: Reidel 1986.

Chisholm, Roderick M. 1970. "Events and Propositions." *Nous* 4: 15–24.

―――. 1971a. "Problems of Identity." In M. K. Munitz, ed., *Identity and Individuation*, 3–30. New York: New York University Press.

————. 1971b. "States of Affairs Again." *Nous* 5: 179–89.

————. 1975. "The Structure of State of Affairs." In B. Vermazen and M. Hintikka, eds., *Essays on Davidson: Actions and Events*, 107–14. Oxford: Basil Blackwell.

————. 1976. *Person and Object*. London: Allen and Unwin.

————. 1978. "Replies." *Philosophia* 7: 597–636.

————. 1979a. "Events, Propositions, and States of Affairs." In P. Weingartner and E. Morscher, eds., *Ontologie und Logik*, 27–57. Berlin: Duncker und Humblodt.

————. 1979b. "Objects and Persons: Revision and Replies." In E. Sosa, ed., *Essays on the Philosophy of Roderick M. Chisholm*, 317–88. Amsterdam: Rodopi.

————. 1985/86. "On the Positive and Negative States of Things." *Grazer Philosophische Studien* 25/26: 97–106.

————. 1986. "Self-Profile." In R. J. Bogdan, ed., *Roderick M. Chisholm*, 3–77. Dordrecht: Reidel.

————. 1989. *On Metaphysics*. Minneapolis: The University of Minnesota Press.

————. 1990. "Events without Times: An Essay on Ontology." *Nous* 24: 413–28.

————. Forthcoming "Substances, States, Processes, and Events." Manuscript dated August 13, 1992. In G. Haefliger and P. Simons, eds., *Analytical Phenomenology*. Dordrecht: Kluwer.

————. Unpublished. "Events." Manuscript dated February 20, 1993.

Corrado, M. 1978. "The Case for State of Affairs." *Philosophia* 7: 523–36.

Davidson, Donald. 1970. "Events as Particulars." In D. Davidson, *Essays on Actions and Events*, 181–87. Oxford: Clarendon Press 1980.

————. 1971. "Eternal vs. Ephemeral Events." In D. Davidson, *Essays on Actions and Events*, 189–203. Oxford: Clarendon Press 1980.

Frege, Gottlob. 1884. *Die Grundlagen der Arithmetik*. Breslau: Wilhelm Koebner.

Johnson, Major L., Jr., 1975. "Events as Recurrables." In K. Lehrer, ed., *Analysis and Metaphysics*, 209–26. Dordrecht: Reidel.

Kim, J. 1969. "Events and Their Description: Some Considerations." In N. Rescher et al., eds., *Essays in Honor of Carl G. Hempel*, 198–215. Dordrecht: Reidel.

————. 1979. "States of Affairs, Events, and Propositions." In E. Sosa, ed., *Essays on the Philosophy of Roderick M. Chisholm*, 147–62. Amsterdam: Rodopi.

Lombard, Lawrence Brian. 1978. "Chisholm and Davidson on Events and Counterfactuals." *Philosophia* 7: 515–22.

————. 1986. *Events: A Metaphysical Study*. London: Routledge and Kegan Paul.

Pollock, John L. 1979. "Chisholm on States of Affairs." In E. Sosa, ed., *Essays on the Philosophy of Roderick M. Chisholm*, 163–75. Amsterdam: Rodopi.

Quine, W. V. O. 1948. "On What There Is." *Review of Metaphysics* 2: 21–38.

Thomson, Judith Jarvis. 1977. *Acts and Other Events*. Ithaca, N.Y.: Cornell University Press.

Vermazen, B. and M. Hintikka, eds. 1975. *Essays on Davidson: Actions and Events*. Oxford: Basil Blackwell.

Wolterstorff, Nicholas. 1979. "Can Ontology Do without Events?" In E. Sosa, ed., *Essays on the Philosophy of Roderick M. Chisholm*, 177–201. Amsterdam: Rodopi.

REPLY TO JOHANNES L. BRANDL

It has been a pleasure to read Brandl's paper, "Recurrent Problems: Chisholm's Theory of Events." He has quite obviously understood what I have written and has seen why it is that I have had to change my views again and again—and again.

He makes it clear that the writings that have been available to him leave us with questions about *recurrence*. And he concludes with this question: If recurrable states of affairs are no longer available and if concrete events cannot recur, then what things *do* recur?

To say of an event that it *occurs* is no more nor less than to say of it that it *exists*. Therefore to say of an event that it *recurs* is to say that it *exists more than once*. But *nothing* can exist more than once.

Some have held, however, that there are two kinds of events: (i) the "one-time things" that we have been discussing and that do *not recur*; and (ii) "generic events" that *do* recur. What *reason* do we have for thinking that there are such "generic events?" I would say that we have *no* good reason for supposing this.

To find the things that *recur*, we should look to *attributes*. I propose the following definition which allows us to attribute "recurrence" to *attributes* instead of to *events*.

D1 The attribute of being-F recurs in the case of x = Df. (1) x is F; and (2) x has been such that it ceased to be F.

We may also put the definiens by saying: "x has been such that it was F for the first time." And so we may *have recurrence* and yet say that *no event recurs*.

Using a scholastic terminology, we may say that recurrence does not require actual ceasing to be (ceasing to be *per se*); it requires only ceasing to be *per accidens*. It requires only that something *cease to have* certain properties.

We should also emphasize in this connection the *temporal orientation* of attributes. Thus there are attributes that point toward the future (for example, being such that it is going to walk) and there are attributes that point toward the past (for example, being such that it did walk). *Every* attribute that is exemplified points toward the present.

D2 P is an attribute that is oriented toward the present = Df. (1) P is an attribute which is necessarily such that whatever has it either did have or will have attributes; (2) P is possibly such that whatever has it had no attributes; and (3) P is possibly such that whatever has it will have no attributes.

D3 P is an attribute that is oriented toward the past = Df. (1) P is an attribute which is necessarily such that whatever has it had attributes; and (2) P is possibly such that whatever has it will have no attributes.

D4 P is an attribute that is oriented toward the future = Df. (1) P is an attribute which is necessarily such that whatever has it will have attributes; and (2) P is possibly such that whatever has it had no attributes.

Thanks to reflecting upon Brandl's paper, I have a much better understanding of recurrence than I had had before.

R.M.C.

21

Jong-Ho Ha

A DEFENSE OF CHISHOLM'S DIRECT-ATTRIBUTION THEORY OF OBJECTIVE REFERENCE

R oderick M. Chisholm's direct-attribution theory as a theory of objective reference has great philosophical significance, deserving comparison with Kant's Copernican revolution. His thesis of the primacy of the intentional and *de se* becomes a turning point in overcoming some theoretical defects of traditional theories of reference. In his book, *The First Person,* Chisholm explicates his views on reference and intentionality and applies them to philosophical problems of reference (for example, first-person sentences, demonstratives, and proper names) and to epistemic questions (for example, certainty, perception, evidence, belief *de dicto* and *de re,* and knowledge).[1] Despite his consistent and tight construction of the attribution theory, however, Chisholm comes under Jaegwon Kim's sharp questioning which can be said to offer the most powerful and persuasive criticism of the theory.[2] My purpose in this paper is to answer Kim's questions as a way of defending and clarifying Chisholm's direct attribution theory. But this project will not be a mere defense. Sometimes I shall modify Chisholm's scheme to meet Kim's critique.

I

On the basis of Brentano's rejection of the notion of "individuating property," Chisholm advocates abandoning the proposition theory which makes an attempt to explain our *de re* intentionality about objects in terms of our propositional attitudes and considers propositions to contain some individuating properties about those objects. The reason is that he thinks the theory cannot solve the problem of the "he himself" locution.[3] Against Chisholm's rejection of individuating properties, Kim

contends that such a property as "being the tallest man" can be an individuating property inasmuch as it cannot be exemplified by more than one thing at once.

First of all, let us examine Brentano's own remarks on the so-called individuating property, which provided Chisholm with a ground for questioning the notion:

> In the case of inner perception, no one can cite any attribute which individuates the intuition. If someone perceives himself making a judgment, there is nothing to prevent someone else doing so as well, and he may indeed perceive himself as someone making a judgment about the same thing in entirely the same way. (p. 311)

> No one who is having an inner perception of himself perceives anything different from what another person could at the same time have an inner perception of. It is proof enough of this that he is aware of no individuating factor. (p. 315)[4]

It appears to me that what Brentano wants to say in these passages is that one's inner perception cannot reveal any essential property belonging to oneself which makes one different from another. Suppose, as Kim suggests, that I find that I am the tallest man. There seems no significant difference between "my perceiving myself making a judgment" and "my perceiving myself being the tallest man" in respect of "inner perception." Is it then not possible for another person also to perceive himself being the tallest man? Brentano would answer, "Yes. Although the property 'being the tallest man' cannot be exemplified by more than one thing at once, it can be an object of numerous acts of inner perception." In interpreting Brentano's idea, therefore, it seems appropriate to say that, according to him, any property of mine that I am readily able to grasp is one which, theoretically at least, can be conceived by several different persons at once as theirs.[5]

To Kim's question, "Why is it not possible for me to be the tallest man (whether or not I know or believe it) and 'grasp' that property?" we can answer like this: Of course, you can grasp that property as yours, but that does not mean that you are entitled to regard it as your own individuating property. The reason is that other persons also can grasp it as their own property although you are the tallest man. Moreover, it is not clear how such a transient property can be one's individuating property which must constantly make one distinct from other beings. How can one be sure that he is the tallest in the world eternally, or at least in his life?

But Kim might report that our inability to perceive internally any property as our individuating property does not deny the existence of such a property. Although that contention is right, it cannot be said to

refute Chisholm's view on the notion of individuating property. Because he says, "It seems doubtful that I can ever be said thus to *grasp* my own individual essence or haecceity" (p. 16, the italics are mine). This remark may be reasonably interpreted as showing that he neither admits nor denies the existence of individuating properties or haecceities and that he denies only our ability to grasp a certain property as our own individuating property. In this sense, Chisholm's view is consistent with Brentano's because Brentano can be said to deny only our ability to have any inner perception of ourselves having such properties.

Hence it is natural for Kim to make the following observation on Chisholm's argument:

> It does not show, or require as a premise that haecceities, or indexical universals, in general are illegitimate qua properties, but only that we cannot grasp or conceive our own haecceities—more precisely, that some believers who have beliefs about themselves cannot conceive their own haecceities. This in itself says nothing about whether there are such things as haecceities. (p. 489)

This observation is in accord with just what Chisholm and Brentano wanted to say. So long as we cannot conceive such peculiar entities, we do not have to postulate them. Moreover, there seems no reason to regard their saying nothing about the existence of haecceities or individuating properties as a defect of their theories.

II

According to Kim's interpretation of Chisholm's view on the ontological status of haecceities, they cannot be regarded as "properties" in Chisholm's sense. The reason is that, while Chisholm stipulates that properties should be "conceivable" even in worlds in which they are not instantiated, haecceities can be conceived if and only if the relevant objects which are supposed to instantiate them exist. But Kim confesses that it is not obvious to him what it is for such entities to be conceived by reference to the contingent objects.

In reply, recalling Chisholm's remark, "It seems doubtful that I can ever be said thus to grasp my own individual essence or haecceity" (p. 16), I am not sure that Chisholm would admit that haecceities can be conceived by reference to their bearers. In other words, from his viewpoint, my haecceity cannot be conceived even by reference to me.

Suppose that I refer to my haecceity by using the locution "being identical with me." But you also can refer to your haecceity in terms of the same locution. Then there must be something else differentiating my

haecceity from yours despite the same manner of their expression. Suppose that there are such differentiating elements, and call mine X and yours Y. Then Chisholm would say, "Unless we can specify what X and Y are, X cannot be conceived by reference to me and Y cannot be conceived by reference to you. But I haven't the faintest idea what they might be." Thus, inasmuch as Chisholm regards the notion of haecceity as "extraordinarily empty" (p. 16), Kim's questions relate to that notion and Chisholm's conceivability principle of properties do not appear to be serious.

<p style="text-align:center">III</p>

Kim's first question about Chisholm's notion of direct attribution results from his observation that we had better interchange the definiendum with the definiens in Chisholm's following definition:

D1 x believes that he himself is F = Df. The property of being F is such that x directly attributes it to x. (p. 28)

In this definition, the "emphatic reflexive" is defined in terms of the direct attribution. But Kim argues that what must be defined first is the allegedly primitive concept of direct attribution and that such a task can be performed on the basis of our "pretheoretical" understanding of the definiendum in the definition. After citing Chisholm's example of Mach, Kim asks, "Is there anything, except D1 and the association of 'taking oneself as an object' with 'direct attribution', that prevents us from saying that Mach 'took himself as an intentional object'—that he 'directed his thoughts upon himself'—when he thought 'What a shabby pedagogue!'?" (p. 492). Thus Kim suggests that the term "directly attribute" be independently explained.

Kim seems to think that the "he himself" expression is more basic than the "directly attribute" expression in that we understand the former "pretheoretically," while the latter is an unfamiliar locution introduced technically. In a sense, Kim's observation is right because we usually say, "I believe that I myself am such and such," rather than "I directly attribute to myself the property of being such and such."

In analyzing or defining our ordinary expression, however, there seems no reason for philosophers or scientists to use only more familiar and ordinary expressions. Although the "directly attribute" expression is not familiar, it can be regarded as more accurate than and implied implicitly in the "he himself" expression. When Chisholm presupposes the "directly attribute" expression to be the most basic, furthermore, he

does not seem to give any special or technical meaning to the verb "attribute." That is, we may understand "pretheoretically" the "direct attribute" expression, too.

Thus the question about Chisholm's definition, D1, becomes whether it can play any significant role as an analysis of the "he himself" expression. Despite his doubt about the proper status of the "directly attribute" expression as the definiens of the "he himself" expression, Kim appreciates the remarkable value of the definition by mentioning that the point of D1—the point of replacing the "he himself" expression with the "attribution" expression—is that the latter makes manifest the significant logical form of the emphatic reflexive (p. 493).

In addition to this merit, I want to point out that the definition as an analysis of the "he himself" expression successfully satisfies Chisholm's analysis of analysis.[6] According to the analysis of analysis, the analysans should be conceptually richer than the analysandum in that it entails something that the analysandum does not involve.[7] Let us take the emphatic reflexive to be the analysandum and the direct-attribution locution the analysans. Then we may paraphrase Kim's question in this way: what is that the analysans entails and the analysandum does not involve? In other words, is the analysans conceptually richer than the analysandum, indeed?

Although Chisholm gives no concrete answer to such questions, I surmise that the conceptual richness of the analysans consists in its implicit assertion of "an identity between the one who refers and the thing to which he refers" (p. 37) as a requirement of the primary form of reference. By exhibiting the property of our belief, "the believing subject is the primary object of all belief" (p. 37), which the analysandum does not involve, but implies; furthermore, Chisholm's analysis of the emphatic reflexive in terms of the direct-attribution locution can be said to extend our knowledge and thus to satisfy another condition of analysis: the analysis should be able to extend our knowledge by exhibiting certain nonuniversal properties that are implied—but not involved—by the analysandum. Therefore there seems no trouble with constructing the direct attribution theory on the basis of D1 so long as it has the aforesaid merits.

IV

In the case of indirect attribution, Chisholm introduces the notion of identifying relation "by means of which the believer singles out the object of his indirect attribution" (pp. 29–30). Kim observes that there

can be many identifying relations between a subject and a given object and that the subject can have various such relations in his mind. The problem is that it is possible that he is wrong about a substantial number of those relations although he is correct about some of them. In view of such cases, Kim maintains, it is too weak as an answer to say that the subject has a belief about the objects so long as at least one of these identifying relations in fact holds.

When one supposes that the complex property one attributes to oneself entails two identifying relations, another query related to the notion of identifying relation can be raised: "Which relation singles out the object of one's belief? Which relation, on the other hand, is the content, i.e., the property one attributes to the object singled out?" Kim claims that Chisholm's analysis seems unable to discriminate between the two alternatives. Kim cites a counterexample:

> Suppose that I attribute to myself the property of being such that I am standing behind just one person, a person who is my secretary. In this case, do I believe of the person standing in front of me that she is my secretary, or of my secretary that she is standing in front of me? (p. 497)

It seems reasonable to complain about Chisholm's way of stipulating the notion of identifying relation, because he did not concretely consider any possible question about it. Although I also find this stipulation of the notion unclear, I want to explore some possible answers on Chisholm's behalf.

To begin with, suppose that I believe with respect to Mr. Bush that he is old and experienced; also suppose that, because of my inability to get any information about American political events after he had been elected, I have not heard that Mr. Bush was defeated by Mr. Clinton in the last presidential election. Thus I believe that the U.S. president is Mr. Bush. In this case, one of the identifying relations between me and him may be that of "having obtained a degree of doctor in philosophy in the country where he is the president." But this relation holds between me and Mr. Clinton, not Mr. Bush. Thus I cannot attribute the property of being old and experienced to Mr. Bush on the basis of such an incorrect identifying relation.

Someone may ask, "What about the relation of 'having obtained a degree of doctor in philosophy in the country where he is believed to be the president by me'?" Although this relation correctly holds between me and Mr. Bush, I cannot single him out as the object of my indirect attribution only by means of that relation. Because, to believe Mr. Bush to be the president of the U.S., I need another identifying relation by

means of which I can single him out as the object of this belief. If there is any other relation which holds properly enough to do so, I would be able to use it to attribute to him the property of being old and experienced as well as that of being the president of the U.S.

Without such a correct relation, then, can I believe with respect to Mr. Bush that he is old and experienced? From Chisholm's viewpoint, I cannot. This is so because Chisholm requires that my direct attribution of the property of bearing a certain identifying relation of one object to myself be "correct" in order that I may succeed in indirectly attributing a property to that object.[8] Now let us consider Kim's questions on the basis of this exposition.

Kim's first question about the notion of identifying relation may be paraphrased like this: "Suppose that the (complex) property I attribute to myself entails possible identifying relations (which I believe to hold between me and a putative object of my belief), and suppose further that only one of these identifying relations in fact holds or 'is correct'. Chisholm's definition seems to imply that in such a case I have a *de re* belief with respect to the object. I am asking whether this result is correct."[9]

First, I want to point out that the notion of the complex property which is supposed to be directly attributed to the subject and to entail the identifying relations between him and the object is not made clear in Chisholm's definition of indirect attribution. Chisholm uses the notion in the definition as follows:

D2 Y is such that, as the thing that x bears R to, x indirectly attributes to it the property of being F = Df. x bears R to y and only to y; and x directly attributes to x *a property which entails the property of bearing R* to just one thing and to a thing that is F. (p. 31; the italics are mine)

What is the property which entails my property of bearing an identifying relation to the object? Why does Chisholm need such an additional property in defining the indirect attribution? I can find no answer to these questions and Chisholm does not explain why he inserts that notion into the definition. When Chisholm gives an example of indirect attribution, moreover, he does not mention such a complex property at all:

Suppose, for example, that I am talking with you and only with you, and that I believe with respect to you that you are wearing a hat. Then the property of being F—the property I indirectly attribute to you—would be that of wearing a hat; the identifying relation R that I bear to you and only to you

would be that of talking with; and *the property that I directly attribute to myself* would be the property of talking with exactly one person and with a person wearing a hat. In thus indirectly attributing a property to you, I directly attribute a certain two-fold property to me. The first part of my direct attribution (that I bear the relation R to one and only one thing) will be *correct* for I can attribute a property to you *only if* the identifying relation by means of which I attempt to single you out is a relation I bear to you and only to you. But the second part of the direct attribution (that the thing to which I bear R is a thing that is F) may or may not be correct. In either case, we may say you are such that, as the person I am talking with, I indirectly attribute to you the property of wearing a hat. (p. 30; the italics are mine)

As we see, it is the property of bearing the identifying relation, "talking with," not another property, that the subject is supposed to attribute directly to himself in indirectly attributing the property of wearing a hat to the object. In this case, moreover, I can hardly figure out what kind of property is such that, if it is exemplified, then the property of bearing the identifying relation is exemplified and whoever conceives it conceives the latter property. And I think that, although such a notion is omitted, Chisholm's definition of indirect attribution can work quite well. Thus, in order to prevent any misunderstanding, it seems desirable to replace D2 by the following definition:

D2* Y is such that, as the thing that x bears R to, x indirectly attributes to it the property of being F = Df. x bears R to y and only to y; and x directly attributes to x the property of bearing R to just one thing and to a thing that is F.

This definition is expected to dissolve Kim's question. That is, there may be no property which he directly attributes to himself and which entails many possible identifying relations some of which are incorrect and one of which is correct.

How can Chisholm answer the question, "When a person is wrong about some of the identifying relations between him and his object, can he indirectly attribute a certain property to the object on the basis of the incorrect relations?" To this question, as I already explained above, he would answer that the subject can have the belief about the object only in the case that he bears the correct relation to that thing—not "so long as at least one of the various identifying relations in fact holds." When a person thinks that there are ten relations (r1, r2, . . . , r9, r10) between him and an object and, unknown to him, only one of them, say, r5, is correct and others are incorrect, for example, his indirect attribution of a certain property to the object can hold only if the attribution act is based on the correct relation, r5. Hence I want to supplement Chisholm's

stipulation of "identifying relation" by suggesting that *any identifying relation should correctly hold in fact and be able to be ascertained by its bearer.*

Kim's second question can be easily answered. It is up to the subject to decide which one of the properties of the object is the property he wants to attribute to his object, or the identifying relation he wants to use for his indirect attribution of another property to that object. If Kim wants to attribute to his secretary the property of being the person standing in front of him, then the identifying relation between him and her would be that of hiring as a secretary. On the other hand, if he wants to attribute the property of being hired as a secretary to that lady, then the identifying relation could be that of being the person standing in front of him. In case he wants to attribute the two properties to his secretary at once, he had better try to find another identifying relation, for example, being the person sharing the office with him, etc.

V

In connection with Chisholm's thesis of the primacy of *de se* and his alleged reduction thesis,[10] Kim points out that, unless *de re* relations are excluded as identifying relations, Chisholm cannot hold that *de se* is the only uneliminable intentional relation by means of which we can reduce all belief to *de se* belief, and that, moreover, Chisholm's stipulation of the notion of identifying relation comes to commit a sort of circularity. Kim's following example shows his convincing insight well:

> Suppose I believe of Mt. Sorak that it is beautiful. Should Chisholm's account allow this belief to obtain in virtue of the following fact: there is one unique mountain that I am now *thinking of*, and I attribute to myself the property of now *thinking of* a unique mountain, a mountain that is beautiful? Here, the identifying relation itself includes a de re relation, that of *thinking of:* I "single out" Mt. Sorak as the unique mountain I am now *thinking of*. . . . It would be flatly circular if the identifying relation singled out the object as "the thing I have in mind," "the thing I am referring to," and the like. It would be equally circular to use a relation that implies a relation like these. . . . (p. 505)

On Chisholm's behalf, someone might retort, "Why don't you use such an identifying relation between you and Mt. Sorak as 'being the mountain I climbed in Korea' or 'being the mountain whose picture I saw,' etc., instead of the relation of 'thinking of'? With such identifying relations, you can single out Mt. Sorak as the object of your indirect

attribution to it of the property of being beautiful without committing any circularity." Since Kim's question is whether a certain relation R can work as an identifying relation, however, it is no answer to that question to say that another relation R1 or R2 can do the job. Thus the proponent of Chisholm's theory should take one of the following alternatives in answering Kim's question: (1) approve using the intentional relations as the identifying relation and propose a way of getting rid of the fallacy of circularity; (2) exclude the intentional relations from the category of identifying relation.

I think that the second alternative is more reasonable in that it gives Chisholm a way of retaining the doctrine of the primacy of *de se* which is the most important and valuable aspect of his theory, and that there is no plausible way for us to pull this theory out of the fallacy of circularity, while allowing such an intentional relation to play a role as an identifying relation. To take the second alternative, however, we need to characterize the notion of intentional relation concretely and to make clear the reason why such a relation commits the fallacy of circularity whenever it is used as an identifying relation in the indirect attribution acts.

I want to characterize the notion of intentional relation as follows:

> A relation, R, is an intentional relation between a subject, S, and an object, O = Df. R is a relation between S and O which is such that it takes place only when S consciously intends O.

We can find without difficulty that the relations which Kim mentioned (for example, "thinking of," "having in mind," "referring to") have the characteristic of the definiens in common and that, thus, they can be classified as intentional relations.

The reason why we commit the fallacy of circularity in using the intentional relation as the identifying relation is that Chisholm defines the identifying relation in an intentional (i.e., *de re*) way.[11] In other words, once Chisholm admits intentional relations as identifying relations, there is no way for him to keep us from using the relation "singling out" as an identifying relation.

In addition to the problem of circularity, any inclusion of intentional relations in the class of identifying relation will engender the problem of infinite regress. As far as Chisholm defines the indirect attribution by reference to the identifying relation, the intentional relation between a person and an object which the indirect attribution implies cannot be explained away if the identifying relation also is intentional. The reason is that we need another identifying relation to explain the indirect

attribution related with the former identifying relation. If the new identifying relation also is intentional, we need the third identifying relation. If this is intentional again, we need the fourth identifying relation, *ad infinitum*. A case of this kind would occur if Kim's belief about Mt. Sorak were allowed to be analyzed as his indirect attribution of the property of being beautiful to the mountain by reference to the identifying relation "believing," which is intentional. Therefore, any intentional relation must be excluded as an identifying relation.

On the basis of my discussion of the identifying relation in this section, we can concretely characterize that notion as follows:

(IR) A relation, R, between a subject, S, and an object, O, becomes S's identifying relation in his indirect attribution of a relevant property to O = Df. R is a relation which is such that (i) S can single out O as the object of his indirect attribution by means of R, (ii) R holds correctly in fact and is able to be ascertained by S, and (iii) R is not an intentional relation.

Now Kim's question becomes answered like this: You cannot indirectly attribute to Mt. Sorak the property of being beautiful by means of the relation "thinking of" because it is not an identifying relation.

When Chisholm accepts my refined notion of identifying relation, however, he would come to find himself in a predicament owing to his own remark about the indirect attribution of eternal objects:

What is it to have a *belief* about an eternal object—say, a belief about the property blue? If we look to our formula for indirect attribution, we will say that one has a belief about the property blue provided that one indirectly attributes some further property to the property blue—considered as the thing to which one bears a certain relation. What kind of relation, then, might I bear to the property blue and only to the property blue? There are many possible relations, all involving the conception of the property blue. . . . If now I *believe* with respect to the property blue that, say, it can be exemplified by many different things, then I'm asking an indirect attribution of the following sort: the property of blue, as the property that I'm now conceiving (or the colour property I'm now conceiving, or the property I'm now contrasting with the property of green) is such that I indirectly attribute to it the property of being capable of exemplification in many different things. (pp. 37–38)

Here we can witness that Chisholm permits us to use such a relation as "being the thing I'm now conceiving" for the indirect attribution of a certain property (for example, "being capable of exemplification in many different things") to eternal objects like properties, relations, and states of affairs.

Although Kim interprets this remark as showing that Chisholm does not want to apply the *de se* reduction thesis to the case of eternal objects, I want to diagnose this case as Chisholm's mistake resulting from his failure to notice the aforesaid feature of the notion of identifying relation. My reason for the diagnosis is that once Chisholm allows such an intentional relation to play a role as an identifying relation in the case of eternal objects, he becomes utterly unable to prevent us from using the same kind of relations for singling out noneternal objects. Thus he should have used another kind of identifying relation in this case, say, "being the color of my shirt," etc.

VI

Chisholm defines *de dicto* belief as follows:

> D4 The state of affairs that p is accepted *(de dicto)* by x = Df. There is one and only one state of affairs which is the state of affairs that p; and either (a) x directly attributes to x the property of being such that p, or (b) x attributes to the state of affairs that p, as the thing he is conceiving in a certain way, the property of being true. (p. 38)

As the definition shows, *de dicto* belief can hold in two ways: (a) the believer can directly attribute to himself, taking himself as the direct intentional object, a property of the form "being such that p," where "p" represents the dictum in question; (b) the believer could take the dictum p as his intentional object and indirectly attribute to it the property of being true. Here Kim points out that Chisholm says little about the mutual relationship between the two ways of holding *de dicto* beliefs, or how in a particular case we could know in which of these two ways someone accepts a proposition. Kim says:

> I haven't the faintest idea whether in believing that frugality is a virtue I directly attribute to myself the property of being such that frugality is a virtue, or I indirectly attribute to that proposition the property of being true. (p. 496)

Chisholm's reason to disjunctively add clause (b) to (a) in the definiens seems to be to show how to comprehensively explain *de dicto* belief in terms of our attribution acts even when philosophers insist on using the notions of proposition and truth. In other words, (b) may be omitted once we can dispense with propositions. In reply to Kim's question, thus, Chisholm might say, "Your *de dicto* belief that frugality is a virtue can be explained both ways. But, if you want to insist on

explaining the belief by reference to the notions of proposition and truth, then choose the second way. Otherwise, the first way is desirable."

Although Kim's question can be answered, there remain a couple of unclear points in Chisholm's definition. First, in the case of (a), Chisholm uses the notion of "universal property" that he thinks can be expressed by the locution "being such that p" (p. 39). I cannot understand why Chisholm leaves this special notion unexplained. When we consider the following examples of the universal property, we come to find that Chisholm's concrete elucidation of that notion is needed: 'being such that frugality is a virtue', 'being such that Mr. Bush talks with Mr. Clinton', 'being such that there is a unicorn', etc. According to Chisholm's definition of *de dicto* belief, when I believe that frugality is a virtue, or that Mr. Bush talks with Mr. Clinton, or that there is a unicorn, I may be regarded as directly attributing to myself such properties. But I cannot imagine how the above properties can be my properties. Once those properties are accepted as mine, we have to take the following statements to be correct: 'I am such that frugality is a virtue', 'I am such that Mr. Bush talks with Mr. Clinton', 'I am such that there is a unicorn'. Are these statements meaningful? What do they mean? Admittedly, to say that a property belongs to one thing is to say that it exemplifies the property. Thus such properties as 'being frugal', 'talking with Mr. Clinton', 'being sure that there is a unicorn' may be said to be my properties, as far as I can exemplify those properties. But I can hardly fathom how the universal properties can be exemplified by me. In order to use the notion of universal property, Chisholm should have considered these questions.

As Kim suggests (p. 495n), one plausible way to make clause (a) in Chisholm's definition meaningful is to interpret it as saying that x directly attributes to x the property of "inhabiting a world in which p." Thus it may be said that, in the case of Kim's *de dicto* belief, "I believe that frugality is a virtue," Kim directly attributes to himself the property of inhabiting a world in which frugality is a virtue. It is not certain that Chisholm will accept this interpretation because his acceptance would render the notion of universal property useless. However, Chisholm should admit that there is no other way than Kim's suggestion for the clause in question to make sense.

Second, it is not clear what kind of relation between x and the state of affairs (or proposition) that p holds as an identifying relation in the case of (b), if no intentional relation can be used as an identifying relation. Since Chisholm defines the indirect attribution in terms of the direct attribution with the notion of identifying relation, Kim would need an

identifying relation between him and the state of affairs that frugality is a virtue in order for him to attribute indirectly to the state of affairs the property of being true.

Someone might suggest using such a relation as 'being the sole proposition which I am thinking about'. But this relation is circular as an identifying relation because of its containing the intentional relation 'being thinking about'. As I mentioned earlier, if we consider that relation to be an identifying relation, there is no reason to disapprove of using the relation 'being the sole proposition which I am singling out' as an identifying relation which was defined as a relation used for singling out the object. Thus we have to find nonintentional relations between us and states of affairs (or propositions).

However, it seems very difficult for us to find nonintentional relations which can single out a certain state of affairs (or proposition). Considering Chisholm's assumption that states of affairs exist like everything else (p. 10), someone may contend that such relations as 'being coexistent with' or 'being in the same world' hold between us and states of affairs. But these relations are not sufficient to single out the state of affairs in question because there may be a lot of states of affairs (or propositions) which are coexistent with us in this world.

At this point, Chisholm should take one of the following alternatives: (1) use intentional relations as identifying relations only in the case of states of affairs (or propositions); (2) propose nonintentional relations which can work as identifying relations in this case. As I mentioned in section 5, Chisholm should persuasively explain how to use intentional relations as identifying relations without committing the fallacy of circularity if he wants to choose the first alternative. Unless Chisholm himself answers these questions, the second clause of the definiens of his definition cannot be accepted. So long as the first clause can hold, however, there is no trouble with Chisholm's direct attribution theory in analyzing *de dicto* belief.

VII

Another question of Kim's about Chisholm's account of *de dicto* belief concerns Chisholm's fundamental idea of the differentiation between direct and indirect attribution:

> If a believer can take himself as his intentional object and directly attribute to himself a property, why can't he take a proposition as an intentional object and directly attribute to it the property of being true just by

conceiving the proposition? . . . Why is conceiving something not enough to give it to us as an intentional object to which properties can then be directly attributed? (p. 496)

As Kim recognizes, Chisholm's motive of constructing the attribution theory consists in his departure from the proposition theory which he thinks contains serious theoretical defects, for instance, its inability to solve the problem of the "he himself" locution. From his viewpoint, it is possible for us to overcome such difficulties of the proposition theory by asking ourselves ("the believing subjects") to be "the primary objects of all belief" on the ground of our "privileged access" to ourselves. Thus any object of the direct attribution of properties must be ourselves, not anything else. Chisholm maintains:

> Hence we may say that each of us has a kind of privileged access to himself: each person is such that he can directly attribute properties to himself and he cannot directly attribute anything to anything other than himself. (p. 43)

This can be Chisholm's answer to Kim's question. Propositions cannot be the objects of our direct attribution. But we can *indirectly* attribute to propositions or states of affairs the property of being true as Chisholm admits in his definition of *de dicto* belief.

Meanwhile, I submit that Chisholm should correct the phrase referring to the identifying relation in the second clause of the definiens of his definition of *de dicto* belief (D4) and add the adverb 'indirectly' to that clause in the following way to prevent misunderstanding the definition: (b) x indirectly attributes to the state of affairs that p, as the thing he is related with in a certain way, the property of being true.

VIII

Concerning the notion of indirect attribution related to that of *de dicto* belief, Kim asks the following question:

> How does the self-attribution theory of belief handle iterated belief contexts in which beliefs embed other beliefs? How could Chisholm analyze, for example, statements like the following: Mary believes that Tom believes that he (himself) was poisoned by her (herself). (p. 498)

It seems not impossible for Chisholm to analyze such an iterated belief statement on the basis of his definition of *de dicto* belief although the analysis becomes somewhat complicated. There may be two ways of rendering the given statement in terms of the direct or indirect attribution as follows: (1) Mary directly attributes to herself the property of

being such that Tom directly attributes to himself the property of being poisoned by Mary; (2) Mary indirectly attributes the property of being true to the state of affairs *Tom's directly attributing to himself the property of being poisoned by Mary.*[12]

JONG-HO HA

DEPARTMENT OF PHILOSOPHY
KOREA UNIVERSITY
FEBRUARY 1994

NOTES

1. Roderick M. Chisholm, *The First Person: An Essay on Reference and Intentionality* (Minneapolis: University of Minnesota Press, 1981). Henceforth all parenthetical page references of Chisholm's remarks are to this book.

2. Jaegwon Kim, "Chisholm on *De Se, De Re,* and *De Dicto,*" *Philosophy and Phenomenological Research* 46 (1986): 483–507. Although this paper appears with no title as a critical review in *PPR,* I want to use the title of Kim's manuscript for convenience. Henceforth all parenthetical page references of Kim's remarks are to this paper.

3. The problem of "he himself" locution is supposed to result from the following situation: "Suppose that a person S is the tallest man in a room. Then it is possible that, although S believes that the tallest man in the room is wise, he does not believe that he himself is wise. This is the case where the formulation 'There is an x such that x is identical with the tallest man and x is believed by x to be wise' is true, while 'The tallest man believes that he himself is wise' is false." See Chisholm, *The First Person,* pp. 17–20.

4. Franz Brentano, *Psychology from an Empirical Standpoint,* ed. L. L. McAlister (New York: Humanities Press, 1973), pp. 311–15.

5. Compare this remark with Chisholm's: "According to him, any property of mine that I am readily able to grasp is one which, theoretically at least, can be exemplified in several different things at once" (p. 16).

6. Roderick M. Chisholm, *The Foundations of Knowing* (Minneapolis: University of Minnesota Press, 1982), pp. 100–106.

7. Chisholm's definitions of the terms 'imply', 'involve', and 'entail' are as follows: (1) P implies Q = Df. P is necessarily such that if it is exemplified then Q is exemplified; (2) P involves Q = Df. P is necessarily such that whoever conceives it conceives Q; (3) P entails Q = Df. P is necessarily such that whoever attributes it attributes Q.

8. See *The First Person,* p. 30.

9. This remark is quoted from Kim's comments on an early version of this paper.

10. Kim expresses this thesis as follows: "Every intentional attitude is either a *de se* attitude or reducible to one; in particular, all belief is reducible to *de se* belief" (p. 503).

11. Recall Chisholm's definition of the identifying relation: An identifying relation is a relation by means of which we can single out an object.

12. I am grateful to Roderick M. Chisholm, Jaegwon Kim, and Ernest Sosa for helpful comments on an early version of this paper.

REPLY TO JONG-HO HA

Jong-Ho Ha's defense of my theory of objective reference is essentially an account of how, according to Ha, I should reply to Jaegwon Kim's criticisms of that theory. (Ha is referring, not to Kim's contribution to the present volume, but to an earlier critique.) I shall here take on the role of devil's advocate and ask how Kim might reply to Ha.

A key question in all of this is the question, "What *is* an attribute or property?"

Taking as undefined the intentional concept of *believing*, I would say than an attribute is whatever may be attributed. More exactly:

D1 x attributes being-F = Df. x believes that there is an F.

Here "F" functions as a schematic letter that may be replaced by any predicate. Now we may say:

D2 x is an attribute = Df. x is possible such that someone attributes it.

Ha now raises the philosophically important question whether what is expressed by "being me" (or "being identical with me") refers to an attribute that any person could have. Such an attribute, he points out, would be a haecceity—an attribute which is necessary to whatever has it and, in the medieval phrase, repugnant to anything else. And Ha concludes that there is no reason to believe that human beings have such haecceities. Here, I believe, Ha is right.

Kim raises one question, however, to which, I believe, Ha's reply is not adequate. Kim asks how I could deal with reiterative belief statements such as: "Mary believes that Tom believes that he (himself) was poisoned by her (herself)." Ha's reply is: "Mary directly attributes being true to the state of affairs *Tom's directly attributing to himself the property of being poisoned by Mary.*" But this answer presupposes, what

Kim's question does not presuppose—namely that Tom, like Ha and Kim, is a sophisticated philosopher.

I would like very much to know what the results would be if Ha and Kim were to continue their discussion.

R.M.C.

22

Andrew J. Reck

SUBSTANCE AND CHISHOLM'S CONCEPT OF THE PERSON

Philosophy in the twentieth century has undergone an extensive gravamen against the concept of substance. This gravamen has been operative in nearly all branches of philosophy: logic, epistemology, ontology, philosophy of nature, philosophy of mind, and philosophy of language. Process philosophers, like Bergson and Whitehead, have erected their systems of thought upon philosophical principles derived from the life sciences, mathematics, and physics. Philosophical logicians, like Whitehead and Russell, have stressed the liberation of logic from the subject-predicate structure of ordinary language which had traditionally bolstered the concept of substance. Analytically inclined thinkers in the empirical tradition of Hume have found no basis for substance either in the presentations of the senses or in the inner reflection, dismissing things and selves as nothing more than logical constructions of sense data and bundles of perceptions. Philosophers of language have further pointed out that since many languages do not depend upon the subject-predicate grammatical structure, the vitality that the concept of substance has obtained from ordinary, standard, average European languages has been sapped. Against this multidimensional gravamen have stood, of course, several recent philosophers. Singular among them is Roderick Chisholm. His book, *Person and Object*,[1] is a metaphysical restoration of the concept of substance consonant with the most rigorous methods of philosophical analysis that prevailed in the English-speaking world in mid-twentieth century. Employing a minimal philosophical vocabulary, Chisholm formulates eighty-six definitions, all collected in a summary appendix E. His philosophical style may dishearten those uninitiated in philosophical analysis. Replete with hypothetical examples and counterexamples, it leans heavily on ordinary language usages, sometimes teased beyond

ordinary recognition, to carry even heavier metaphysical freight. But his work offers a profound reconsideration of basic metaphysical principles.

The concept of substance in the great metaphysical tradition from Aristotle ordinarily means the nuclear idea of unitary, continuant, and independent being. The logical corollary to the thesis of the metaphysical ultimacy of substance is the theory that it is the subject of judgments that comprise the foundations of knowledge. This concept is articulated in Aristotle's account of first substance in the *Categories*. First substances "underlie everything else, and . . . everything else is either predicated of them or present in them."[2] Substances are individuals: "all substance appears to signify that which is individual."[3] A third trait of substance is that it "does not appear to admit of variation of degree," so that one substance cannot be more truly substance than another.[4] Next, substances are continuants: "The most distinctive mark of substance appears to be that, while remaining numerically one and the same, it is capable of admitting contrary qualities."[5] A fifth hallmark of substance is independent existence. Intimately linked with the idea of substance as logical subject, the independence or self-existence of substance is expressed by Aristotle's assertion that if primary substances "did not exist, it would be impossible for anything else to exist."[6]

Chisholm's restoration of the concept of substance draws inspiration from many other philosophers besides Aristotle—Leibniz, Reid, Brentano, to mention a few—but it is Aristotle alone whom Chisholm names by his medieval appellation "the Philosopher."[7] However, Chisholm's restoration of the concept of substance proceeds by means of the employment of the analytic techniques of striving to solve puzzles in direct awareness rather than by metaphysical speculations concerning nature. Nor is he preoccupied with proleptical arguments against the assaults on the concept of substance, although in passing such arguments surface as when, for example, Chisholm says: "It has often been pointed out that, although Indo-European languages have a subject-predicate grammar, there are other languages that do not. But what are we to do with this fact?"[8] What we should not do, Chisholm advises, is conclude that there is no substance, inasmuch as argument and evidence independent of grammatical structure may justify the concept. Thus Chisholm undertakes a metaphysical investigation which begins with immediate awareness and, by meticulous analysis and laborious reflection, he endeavors to establish substantial being as self, agency, and identity through time.

Whereas philosophy begins for the Philosopher and for Chisholm in the same sort of situation, termed "awe" or "wonder" by the Greek and "puzzlement" by the American, they differ radically in specifics. The

Philosopher was aroused by prospects of an entire cosmos crowned by the starry heavens; the American by the questions stimulated in self-reflection, triggered by conflicts in intuitions. The introversion of the American is alien to the Greek. For Aristotle the primary example of substance is the Unmoved Mover(s), although lesser beings, such as this man or this horse, are also substantial in derivative senses by reference to God(s). For Chisholm, substance is, in the strict philosophical sense, the "self" or the "person," terms he uses interchangeably.

Chisholm contends that we are directly aware of ourselves. This contention conflicts with the philosophical tenets of Hume, on the one hand, and Kant, on the other. Much of chapter 1, "The Direct Awareness of the Self," consists of detailed critiques of Hume's arguments on behalf of the doctrine of the self as a bundle of perceptions and of Kant's paralogism denying the possibility of the cognition of the self. Chisholm's positive argument rests on the concept of substance. He invokes this concept in his appeal to Leibniz's strictures on Locke's conception of a thing as just a collection of its properties; the thing is a concretum that has its properties or is qualified by them.

Chisholm applies Leibniz's line of reasoning to the self. Beginning with such simple reflections as, for example, "I feel depressed," he maintains that there is direct awareness of the self in that there is an "I" who feels the depression, and that in being aware that one is depressed, one is directly aware of oneself. Chisholm extends this argument even to sense perceptions. Rather than posit an order of sense appearances or sense data he considers the appearances or data to be modifications of the self experiencing them. The self, moreover, is the entity that has or is qualified by its states, in these cases "feeling depressed" or "seeing red." Chisholm's claim of self-awareness as direct or immediate may be challenged by the consideration that reflection or retrospection are indispensable to awareness of self or consciousness of consciousness.

To illuminate the concept of the self Chisholm introduces the expression "individual concept." While this expression generically embraces all sorts of concepts of individuals, Chisholm specifies its application to individual essence, "a property which is such that, if anything has it, then that thing has it necessarily."[9] He resurrects the medieval term "haecceity" to designate the individual essence, and urges, for illustration, "that being identical with me *is* an individual essence or haecceity."[10] After examining the claims that things other than oneself are haecceities, Chisholm concludes that such claims are problematic. The sole haecceity of which he is certain is himself. Only the individual self is an individual or *ens per se*; he alone is able to pick himself out and individuate himself *per se*.

Chisholm's argument veers in the direction of epistemological solipsism when he allows that the thesis that there are selves other than oneself is dependent on things that are individuated *per alio* and ultimately by reference to oneself. He overemphasizes the status of the egocentric predicament in cognition. That knowing always requires a subject that knows is insufficient basis for the inference that only this subject is real or individual. Further, the "I" or "me" that he establishes appears to be vacuous, although it is his intention to establish it as a *concretum*, with the properties that it is aware of. Nonetheless, it is a pure mental act, analogous to a transcendental subject as an abstract function. Otherwise it would be a mere passing Thinker wholly immersed in the thinking of the moment.

Agency is the key principle Chisholm invokes initially to enhance the concreteness of the self. For no entity with the capacity to act is reducible to a pure mental act, a subject that is wholly an abstract function of feelings and sense presentations. Agency, moreover, is a trait of selfhood that involves mind and morality, and Chisholm meticulously examines concepts in the philosophy of mind and moral philosophy—for example, intention, responsibility—to illuminate agency.

As agency in the ethical context is linked to responsibility and the concept of the latter entails the idea that the agent could sometimes do otherwise than he does do, it is pertinent to elucidate, as Chisholm does, the concept of "could do." Now this concept contains the idea of capacity or power or potentiality. The self as agent is, therefore, the possessor of power or potentiality. The void of the self as subject is partially filled with power or potentiality. In his clarification of this concept of power Chisholm quotes Aristotle and St. Thomas.[11] Chisholm is careful to show that this power of the agent is tantamount neither to logical possibility nor epistemic possibility. Instead, it involves physical necessity, the causal contribution of the agent, and the agent's intentional acts of undertaking or endeavor.

By means of this analysis the self is understood to be an active entity with the mental property of intentionality yet situated within a framework subject to natural laws to which it can contribute causally. All sorts of contingent events may intervene between the intended action and the actual outcome, as Chisholm relates, somewhat amusingly by his examples, the trajectory from intention to endeavor to action to outcome. Nonetheless, the metaphysics of substance with its concepts of potentiality and actuality, articulated extensively by the Philosopher and in Aristotelian philosophies generally, underlies Chisholm's argument. From this account the self as the possessor of powers and mind is actualized in action, whether foiled or successful. Prior to action, then,

the self is potentiality—to be or not to be something qualified in some way, to act or not to act. Upon acting the self is merely its act—failed or successful. It remains to be seen how all the properties and acts can be woven together to constitute a concrete self. And Chisholm is clear that the sort of entity he deems the self to be is not a ghost, as when he cites approvingly Locke's remark that free agency is not freedom of the will but freedom of the man.[12]

Persistence through time is an essential trait of substance. Chisholm's examination of this trait pivots on the concept of identity.

He explores analytically Bishop Butler's distinction between "the loose and popular sense" and "the strict and philosophical sense" of the term "identity through time." He also employs such classical examples of the problem of identity as the case of the ship of Theseus, all the planks of which are exchanged through time. He forecloses the possibility of designating identity as enduring form despite change of matter by entertaining Hobbes's supposition that the original planks may be reshaped into another ship with the same form as the ship of Theseus, giving rise to the incoherent consequent that the two numerically different ships would be identical with each other if form is the root of identity, even though it is possible to imagine their collision at sea. Additional examples and counterexamples are posed to support Chisholm's view that, with regard to things that allegedly endure through time while their parts change, they are *entia successiva* in the strictly philosophical sense: their parts are exchanged in a temporal sequence such that the thing$_{t1}$ is not thing$_{t2}$, and thing$_{t2}$ is not thing$_{t3}$, because thing$_{t2}$ lacks a part of thing$_{t1}$ but gains a part, while thing$_{t3}$ lacks the part that thing$_{t1}$ and thing$_{t2}$ have but has a part that thing$_{t2}$ has and another part as well. Although, then, they are three things, loosely and popularly they may be called by the same term. Hence Chisholm's mereological approach renders intelligible Butler's distinction.

While Chisholm denies that changing physical things persist through time such that a thing at one time is strictly identical with the thing at another time despite the change, he holds that the self alone persists through time so as to be at a later time identical with itself at an earlier time. Chisholm makes his case by employing the Scholastic distinction between *entia per alio* and *entia per se* which he used earlier in his investigation of individuation. Things, he says,

> are *entia per alio*. They are ontological parasites that derive all their properties from other things—from the various things that do duty for them. An *ens per alio* never *is* or has anything on its own. It is what it is in virtue of the nature of something other than itself. At every moment of its history an *ens per alio* has something other than itself as its stand-in.[13]

Chisholm adds: "but if there are *entia per alio*, then there are also *entia per se*."[14] The metaphysics of substance inherited from Aristotle and developed by the medieval Scholastics requires nothing less. Indeed, the modality should be rectified such that there must be *entia per se*. Having said that there are, Chisholm next asks: "Am I an *ens per alio* or an *ens per se*?"[15] His answer, subtly circuitous, is that he (the self or person) is an *ens per se*. This response invites interpretation and critique.

Chisholm's argument for the claim that the self or person is an *ens per se* covers the usual counterclaims that cite amnesia and multiple personality, refuting them even in their most intricately embroidered forms. It rests on the claim that the self as *ens per se* can pick itself out of the masses of other things—i.e., can, in the metaphysical idiom, individuate itself. His treatment of amnesia is illustrative of his dialectical strategy. He says, "if, as a result of amnesia I forget the events of my past, I may still know that I am now in doubt about my past."[16] But surely this dialectical strategy offers little solace to the victim of amnesia or other personality disorders. Chisholm's self is, as he admits, "transparent."[17] But such a self, a mere ego, is hardly the stuff of drama, psychiatry, and quotidian humanity marked by agonizing quests for self-identity. The self that Chisholm's philosophy offers is not the concrete human being, but a philosophical ghost, a Cartesianized ego separated from its body, an Aristotelian form without matter, an angel without the act of existence. The problem of the relation of this sort of self to the body, so troublesome to generations of philosophers and psychologists since Descartes, is trivialized. As Chisholm says, "we need *some* way of expressing that intimate relation I bear to my body and 'I have a body' is as good a way of expressing this relation as any other."[18] It might be inferred that, therefore, the body is known to be a part of the self, an inference checked by Chisholm's admission of ignorance on this issue: "it is not true that, whenever I perceive myself to be thinking I thereby perceive what I can *know* to be a part of myself."[19]

Chisholm's self or person is an *ens per se* in the order of knowing solely. It is a pure subject of intentions and endeavors. Even its direct acts are changes only within itself. His definition D.IV.15 is pertinent:

> x is a person = Df x is an individual thing which is necessarily such that it is physically possible that there is something which it undertakes to bring about.[20]

Since the self or person or subject of intention and endeavor is identical throughout its life, it neither undergoes nor activates developmental change in the sense of material potentialities becoming actualized. Indeed, it remains self-same.

The ethereal nature of Chisholm's self or person, despite the initial supposition that it is substantial, is further aggravated by the ontology of states of affairs. Neither propositions nor events, they are presented as eternal objects for selves or persons. They exist in Chisholm's usage of the term "existence"; they *are* whether or not they occur in time. Chisholm's doctrine of states of affairs is Platonic in character. Questions may be raised as to the coherence of this doctrine with a substantialist theory of the self or person. At most they are possibilities amenable to actualization only so far as they are objects for selves or persons. Their reality is thin almost to the point of nothingness. However, they provide relational matrices often neglected in substantialist metaphysics, although their anchorage in the thicker realities of substantiality is insecure. Such insecurity is heightened by Chisholm's collapsing of *de re* beliefs within the class of *de dicto* beliefs. The Aristotelian theory of predication, used by Chisholm in the opening pages of his metaphysics, affirms the existence of substances as the ultimate logical subjects, and this implies the primacy of some *de re* beliefs.

Chisholm allows that the self or the person is subject to the sort of change that the Scholastics considered as coming into being and passing away. He asserts that as a logical consequence of his definition,

> if an individual thing x is a person, then, in every possible world in which x exists, x is a person from the moment it comes into being until the moment it passes away.[21]

Apart from the restrictions this position places on personal development, it opens a wide vista on realities before and after and beyond any self or person. In this order of realities or of being, no human self or person is an *ens per se*. In the order of being, everyone except God is an *ens per alio*. Then the vacuity of Chisholm's self or person begins to be filled, but with the assistance of further distinctions and clarifications.

The first distinction is between "self" and "person." The fundamental sense of "self" is the psychophysical organism. In the Aristotelian idiom it is a hypomorphic substance, its matter its body, its form its soul. The term "self" may be applied to consciousness, Chisholm's subject of intention and endeavor, only in the derivative sense that the psychophysical organism, which is unequivocally the self, is or may be conscious. Consciousness of consciousness, especially as it is operative in analytic philosophy of mind, is a very special cognitional activity; quite rare, it is unnecessary to the existence of the self. The self, conscious of others, develops personality. A person is a social role or cluster of social roles a self performs. A person, too, may be termed a "self," but only in a

derivative sense. The psychophysical organism is the concrete substance, but its existence in time and space is contingent. As long as the psychophysical organism exists, the self exists, whether or not this self is known by itself or others. The problem of self-identity is complex, sometimes because of equivocations on the term "self," but also because of the vicissitudes of human existence. When the senses of the terms are kept clear, a beginning is made in ascertaining what the identity of the self through time is. The criteria are several, with bodily identity being basic among them. No philosophical theory should trivialize the classical commandment: "Know thyself."

ANDREW J. RECK

DEPARTMENT OF PHILOSOPHY
TULANE UNIVERSITY
FEBRUARY 1996

NOTES

1. Roderick M. Chisholm, *Person and Object: A Metaphysical Study* (La Salle, Ill.: Open Court Publishing Company, 1976).
2. Aristotle, *Categories*, chap. 5, 2b 15–18. (The Oxford translation of this work used in the present paper is contained in Richard McKeon, editor, *The Basic Works of Aristotle* [New York: Random House, 1941], pp. 7–39.)
3. Ibid., chap. 5, 3b 10.
4. Ibid., chap. 5, 3b 32–35.
5. Ibid., chap. 5, 4a 10–12.
6. Ibid., chap. 5, 2b 5–6.
7. Chisholm, p. 39.
8. Ibid., p. 19.
9. Ibid., p. 29.
10. Ibid.
11. Ibid., pp. 62–63.
12. Ibid., p. 66.
13. Ibid., p. 104.
14. Ibid.
15. Ibid.
16. Ibid., p. 32.
17. Ibid., p. 47.
18. Ibid., p. 17.
19. Ibid., p. 47.
20. Ibid., p. 137.
21. Ibid.

REPLY TO ANDREW J. RECK

A ndrew Reck, in "Substance and Chisholm's Concept of the Person," has made a thoroughgoing investigation of what I have said about that concept in *Person and Object*. He has seen, I think, all the objections a philosopher could make to what I have said about that concept in that book. My principal disagreement with him is methodological.

What is the significance of the charge of vacuity? There is a sense in which *any* philosophical theory may be said to involve vacuity. The theory must use *some* undefined technical terms. The author must presuppose that his terms are understood by his reader. But in many cases that presupposition is false. Fortunately Reck seems always to have understood me. Unfortunately he does not always tell us what *his* solutions to the philosophical problems with which I have been concerned would be. Had he done so, we would have made further progress.

Reck's paper is a provocative one.

R.M.C.

23

Johann Christian Marek

PROPERTIES AS OBJECT AND CONTENT OF THINKING: ON CHISHOLM'S THEORY OF INTENTIONAL REFERENCE TO PROPERTIES

A. PROPERTIES INTENTIONALLY AND PLATONISTICALLY CONSIDERED

Properties (attributes, universals)[1] occupy an outstanding place in Chisholm's ontology; actually, they are basic to his whole theory of categories. Chisholm is an extreme realist, a Platonist, because his ontology presupposes the existence of properties as abstract and necessary objects, independent of any contingent entity. Properties exist, even if they are not exemplified. *Being a unicorn* is an example of such an unexemplified property. Presupposing the concept of exemplification and modality *de re*, Chisholm defines properties as follows:

> x is a property = Df x is possibly such that there is something that exemplifies it.[2]

In stating that a property is a thing which can be exemplified, however, Chisholm excludes unexemplifiable properties like *being a round square*.[3] In his later works, Chisholm avoids this consequence in suggesting a wider definition of properties—an intentional one: a property is something which can be attributed.[4] A more elaborated version of this definition is presented in the following sequence in his paper entitled "An Intentional Explication of Universals":[5]

> D1 x's believing has being-F as its content = Df x believes that there is an F
>
> D2 x is an attribute = Df x is possibly such that it is the content of someone's believing

In the abstract of this paper Chisholm summarizes concisely what is intended by this wider definition:

> The term "universal" is here taken to mean the same as "attribute" or "property." It is contended in this paper that attributes should be understood both intensionally and intentionally. I say "*intension*ally," meaning that these entities should *not* be taken *extension*ally; for attributes that have the same instances may yet be different attributes. And I say "*intention*ally," meaning that *intentionality* is essential to the concept of an attribute. The nature of an attribute lies in the fact that it is an *ens rationis*—the kind of entity that can be grasped and made the content of thinking and believing. Criteria of identity for attributes require the concept of the intentional content of an act of believing: an attribute A is identical with an attribute B, if and only if, A and B are necessarily such that whoever has A as content also has B, and whoever has B as content also has A as content.[6]

Chisholm thinks that properties are universals and not particularized qualities, independent of contingent, concrete particulars, and, furthermore, they are necessary, i.e., noncontingent, entities. (Contingent entities are thought to be possible noneternal entities, that is to say they are possibly such that they are coming into being or have just passed away.)[7]

The aim of my paper is to investigate Chisholm's important answers to the question of how it is possible to refer intentionally to properties. Chisholm's answers present solutions to the problem of intentionality and reference. They are, however, ones I wish to dispute.

B. Two (or Three) Kinds of Intentional Reference to Properties

There are at least two forms of intentional reference to properties Chisholm has in mind.

First, you can refer to a property when it constitutes the content of your belief, i.e., when you attribute the property to something.[8] When you judge that the rose is red, for example, you attribute *being red* to the rose—*being red* is the content of your attribution.

Second, you can refer to properties when you have them as object of your attribution. You are referring to the property of being red, for example, in believing *being red* to be exemplified, or to be a necessary entity, or to include the property of being colored.[9]

After he has introduced the distinction between the object and the content of an attribution in his "Self-Profile," Chisholm finds, concerning properties, that:

[i]t is important to note that from the fact that a certain property constitutes the *content* of a per[s]on's belief, it does not follow that that property constitutes the object of that person's belief. And from the fact that a certain property constitutes the *object* of a belief, it does not follow that that property constitutes the content of the belief.[10]

Although Chisholm is a declared Platonist, this quotation shows he would not go that far and uphold that to attribute the property *being F* to *x* would be the same as to attribute the relation *being exemplified by* to *being F* and *x*, I think. In the second case *being F* is an object of the thought as well as *x* is, and *being exemplified by* is the content of the thought, i.e., what is attributed to something. Moreover, this interpretation would lead to an infinite regress. You have to go further on and accept *being exemplified by* as object besides *being F* and *x*. Chisholm does not bring up the regress problem in this context, but there is a further motive for Chisholm to maintain the asymmetry between object and content of thinking. This motive is made up by the role which *conceiving a property* plays in acts of thinking.

Chisholm seems to indicate a further way, a third one, in which intentional reference to properties is possible. In *The First Person* he calls it the primary way: "The primary way, then, of referring to an eternal object is to *conceive* it."[11] After stating that the "concept of a property is inseparably connected with the concept of *conceiving*," he affirms the principle "Every property is possibly such that there is someone who conceives it." In quite a lot of his ontological works he uses the term "conceiving" (or the more informal "grasping") as an undefined primitive term. Although this notion is central to his ontological theory, which he himself understands as an "ontology intentionally considered,"[12] Chisholm makes no effort to provide a direct explanation of it, as Jaegwon Kim critically notes.[13] With regard to the subject matter of my paper, questions like the following arise to me quite instantaneously: What is the relation between *conceiving a property* and *having the property as content of thinking* on the one side, and between *conceiving a property* and *having the property as object of thinking* on the other side? Further, can *conceiving* be an independent act of thinking as *judging* is an act of its own, or can it only be a nonindependent intentional part of an act of thinking?

Concerning the last question, I think, Chisholm presupposes that just to conceive a property is not possible; it always has to be connected with an act of thinking like judging, desiring, etc.

In his reply to Steve E. Boër, Chisholm agrees that *conceiving* is a necessary condition of *attributing*: "one cannot attribute a property

unless one can conceive that property."[14] But what about *having properties as object of an attribution?*—In this case, Chisholm seems to allow the reference to properties without conceiving them.

In order to get a better understanding of these questions and some of their possible answers it seems necessary to me to present a short survey of Chisholm's theory of reference and intentionality, especially to make explicit his distinction between direct and indirect content of an attribution (and direct and indirect object respectively).

C. Direct Attribution: Properties as Content of Thinking

The following fact represents the starting point of Chisholm's considerations. In cases where the object of an attribution is the attributing person herself, let us call such cases self-attributions, two possibilities can be distinguished.

First, the self-attributing person means herself knowingly, and, second, she does not mean herself knowingly. In the first case, the person *directly* attributes to herself a certain property—as Chisholm puts it— whereas in the other case the person only *indirectly* attributes to herself the property in question. It makes a big difference whether the tallest man, for example, believes that he himself is wise in a kind of self-knowledge (belief *de se*), or whether he believes that the tallest man is wise and "hits" himself by this attribution (belief *de re*). In contrast to the second example, the first one leaves it open whether the self-attributing person believes that the tallest man is wise, and in contrast to the first example, the second one does not imply that the attributing person believes himself to be wise.

Chisholm not only sees a difference between the two cases but also claims that the *de se* instance cannot be understood as a special form of a *de re* instance. One contention of his approach is that the specific direct reference to oneself is not reducible to a neutral concept of (*de re*) reference. The main reason why Chisholm pleads for the independence of the *de se* from the *de re* is that he does not see good grounds to accept first-person propositions: "although there *are* first-person sentences, there are *no* such things as first-person propositions."[15]

Instead of adopting a propositional theory of believing he takes up a theory of property attribution connected with a very strong thesis of the primacy of *de se*. Attributions *de se* are not explicable as attributions *de re*; it is, furthermore, the other way around, because all *de re* attribution is *de se* attribution in the end. The primacy of *de se* Chisholm votes for is

even more far-reaching: even every *de dicto* belief[16] can be shown as a special form of a *de se* attribution. In sum, every belief is a form of *de se* attribution, and every *de se* attribution is a direct attribution of a property to the believer himself or herself—believing (attributing respectively) is always a relation between the attributing person and the property attributed to something. Chisholm spells out

The property of being *F* is such that *x* directly attributes it to *y*

as his basic doxastic locution.[17] The connection between believing and attributing seems to be established by the following definition:

x believes that he himself is *F* = Df. The property of being *F* is such that *x* directly attributes it to *x*.[18]

Two principles of direct attribution Chisholm finds worth mentioning here can be paraphrased by the following: (1) What can be directly attributed to something, i.e., the content of a direct attribution, is always a property. (2) The object of a direct attribution is always the believer himself or herself; in other words, you cannot directly attribute a property to something else than yourself. It is important to note that this principle excludes any direct attribution to properties. But another kind of direct intentional reference to properties can be found in direct attributions. The property which is attributed to something, the content of attribution, can only be apprehended immediately—it has to be conceived.

Starting from this basic locution makes it obvious that Chisholm does not take *attribution* in a neutral and general sense as a primitive notion in order to define the term "direct attribution" by adding some specifications to the concept of attribution. His procedure is led by the primacy of *de se*. Consequently, he begins by taking "direct attribution" as primitive, and then in terms of this notion he defines indirect attribution which includes attributions to oneself in the *de re* mode and to other things than oneself. In this way he gets the notion of attribution in general (in short: attribution = direct attribution + indirect attribution).

D. Indirect Attribution: Properties as Content and Object of Thinking

Chisholm concedes that you can attribute properties to other things than yourself, though only in an indirect way. A fortiori, you can attribute properties to properties, though also only in an indirect manner. As

Chisholm defines indirect attribution by the notion of direct attribution, every attribution comes down to a direct attribution in the end.

It is about time to illustrate Chisholm's theory of intentional reference in presenting characteristic examples of direct and indirect contents of thinking, and of direct and indirect objects respectively. A sketch of the simplest cases will be sufficient for the purpose to reassess Chisholm's main theses on intentional reference to properties.[19]

The simplest case is given by something like the following: the believing person directly attributes a property to herself. The believer takes herself as her intentional object in a direct way, and in so doing she directly refers to the property which, by conceiving it, she attributes to herself. When I judge that I am white, then I directly attribute the property *being white* to me. The reference to myself and to the property *being white* is carried out in an unmediated way, directly, i.e., without consulting an identifying property either of myself or of the property I am self-attributing. I do not have to grasp something like my own individual essence or haecceity, and I conceive the property *being white* without thinking of an individuating property of it (e.g., that it is the color property snow usually has). I am the direct object of my own attribution, and *being white* is its direct content.

Let us consider an example of indirect attribution.[20] Every nondirect attribution, especially every attribution to something else than oneself, is an indirect attribution.

When I judge *being white* to be exemplified by many different things, then, according to Chisholm, I am making an indirect attribution to the property *being white*.[21] Concerning this example, it can be said: (1) the property *being white* is the indirect object of my judgment; (2) the property *being exemplified by many different things* is its indirect content; (3) I myself am its direct object; and (4) a complex property which I shall explain is its direct content (the property I attribute to myself directly).

The explanation of the complex property is as follows. There has to be a certain relation I just bear to the indirect object (to the property *being white*). Let us assume I regard *being white* and only *being white* as the color property of snow. By means of this identifying relation I can single out *being white*, and it can become the indirect object of my judgment. The property that I directly attribute to myself would then be the property of regarding exactly one property to be the color property of snow and a property being exemplified by many different things.

Whenever a property is the object of someone's thought, it is an indirect object of this thought. The reference to the property as indirect

object is always given in the roundabout way mentioned in the last paragraph. The judging person cannot refer to the property in question just by conceiving it, but only by conceiving a further, identifying property (as part of the direct content) which allows the judging person to pick out the property as indirect object.

E. Criticism: Properties as "Direct" Object of Thinking

There is a strong intuition against Chisholm's view that properties, *insofar as they are objects of thoughts*, cannot just be conceived, because, *as objects of thoughts*, they have always to be indirect objects, singled out by that part of the direct content which individuates the properties in question.

I can share Chisholm's view that conceiving the property *being-F* is a necessary condition for attributing it to something. If *being-F* is the content of my attribution, I must directly refer to it by conceiving it. But, as Chisholm allows a kind of direct intentional reference to properties— in case they make up the content—why cannot this direct relationship to properties stay on in case they make up the object? Or in other words: As we intentionally refer to the property *being-F* in a direct manner, when we attribute it to something, why cannot such a direct apprehension occur when something is attributed to *being-F* itself? I do not say that we always conceive a property when it is the object of our thinking, because we can have it as object with the aid of an individuating description. But I prefer to maintain at least the *possibility* of a property being a nonindirect object of thinking.

To justify my preference I can appeal to my intuition, to a quotation from Jaegwon Kim, and to some counterexamples.

As Chisholm grants that there is a direct reference to properties by conceiving them, why cannot conceiving a property go together with having the property as object of thinking? Chisholm's decision seems to be too arbitrary against the possibility of a direct access to properties as objects of thinking. My intuition is that such a decision has to be justified, or at least more explained, and cannot be asserted just by stating a basic doxastic locution, definitions, and principles. But my intuition is more far-reaching: As we have direct access to properties by conceiving them, we can know the distinction between referring to the property in a direct or indirect way, when we can consider whether we refer to the property directly or indirectly (i.e., by conceiving further properties). I can know that I think of *being white* only and not of something I am contrasting with *being black*.[22] Such an obvious differ-

ence in the thoughts is not something which remains unnoticed when you pay heed to it.

The quotation is from Kim's Critical Notice to Chisholm's *The First Person* on page 496:

> Why cannot a person, for another example, conceive two properties, P and Q, and attribute Q to P "directly"? So the question is why conceiving something isn't enough to give it to us as an intentional object to which properties can then be directly attributed. Chisholm doesn't address this question; he seems merely to affirm that abstracta can only be objects of indirect attribution (pp. 37–38). But this isn't obvious; Chisholm himself says "The primary way, then, of referring to an eternal object is to conceive it" (p. 37). If grasping or conceiving something isn't enough to make it an intentional object to which properties can then be attributed directly, one would like to know why. . . . If it is sufficient, then self-attribution of properties would turn out not to be the only basic form of belief, contrary to one of the central claims of Chisholm's theory.

Let me add to this critical note that an answer to Kim's why-question could simply go like this: In Chisholm's account, there is no room at all for direct attribution to properties, because direct attribution is understood a priori in the sense that the direct object of an attribution must always be the attributing person herself. Insofar as a property is taken as the object of thinking only, it cannot be conceived. Therefore it cannot be taken into consideration that conceiving a property could be enough to make it a direct object of an attribution.

The following three counterexamples are supposed to make plausible that properties can be conceived insofar as they would be the object of thinking:

(1) Let me take again the example that I have the belief attitude that I am white. Therefore, I attribute *being white* directly to me, without referring to another property. I have conceived *being white*. Chisholm admits, moreover, he demands an immediate access to properties in case they are the content of thinking, but he forbids such a direct apprehension in cases where they would be the sole object of thinking. But, if I judge *being white* to be a color property, why do I have to individuate *being white* by going back to a further property? I can refer to *being white* just in conceiving it and not indirectly via thinking "as the property I'm now conceiving" or something similar to what Chisholm suggests.[23]

(2) Let me take the property *being exemplified*—a property many properties have—and use it as object as well as content of my thinking. The thought, for example, could be that *being exemplified* is itself exemplified. According to Chisholm such a thought has me myself as the direct object, and it has the property *being exemplified* as indirect content and as indirect object as well. As indirect content, *being*

exemplified is entailed[24] in the complex property, the direct content, that I attribute to myself. As indirect object, *being exemplified* is singled out by an individuating property of it. The complex property has to be conceived, otherwise I could not have the thought in question. But, as every property entailed in a conceived property is conceived too, I have to conceive *being exemplified*. Therefore, I would have a two-fold intentional relation to *being exemplified*, to wit, directly by conceiving it, and indirectly by thinking something which identifies it. But why should it be *necessary* to refer to the property indirectly, by means of an individuating description, when I am already conceiving the property?

(3) Finally an illustrative counterexample, which could be extracted from some of Chisholm's considerations on properties. Chisholm thinks that a negative property, like *being nonwhite*, "is possibly such that everything has it."[25] It may be exemplified in every category. As Chisholm also thinks that the positive property *being white* is conceived if the correspondent negative property *being nonwhite* is conceived,[26] the question arises again: Why cannot *being white* be both the object of my thinking and, in being that, conceived? When I am attributing (the property) *being nonwhite* to (the property) *being white* it seems counter-intuitive to me that I *have* to refer indirectly to *being white* as object of my thought, that I must go back to other individuating properties in order to single out *being white*.

Accepting this criticism would lead to far-reaching consequences in Chisholm's theory of intentionality and reference. There would be *de re* thoughts without being *de se* thoughts. Properties which are conceived would be the first candidates for such thoughts. But one could go further. Chisholm's method of using identifying properties of things can show how it is possible to refer to things other than oneself and the conceived properties. The reference to such things could be carried out also only indirectly. But instead of finding an individuating relation which connects the attributing person (direct object) to the indirect object, one could appeal to an individuating relation between properties (as *direct object*)[27] and the *indirect object*. In the following simple case the relation of exemplification is already sufficient:

Suppose there is one and only one inventor of instant soup, and Julius Maggi is the inventor. I can attribute to him being Swiss in thinking that *being the inventor of instant soup* is exemplified by someone who is Swiss, provided that the property *being the inventor of instant soup* has been conceived. In this example Julius Maggi is the *indirect object* of my judgment, the property *being Swiss* its *indirect content*, and the property *being the inventor of instant soup* its *direct*

object. The complex property that I *directly* attribute to the property *being the inventor of instant soup* would then be the property of being exemplified by one person and by a person *being Swiss.*

F. ATTRIBUTING IDENTITY OF PROPERTIES

Judgments about the identity of properties are able to show that a property—insofar as it is an object of thinking—can be conceived.

Let us compare the thoughts that

(I1) *being white* is the color property of snow
(I2) the color property of snow is the color property of chalk.

In (I1) as well as in (I2) properties are objects of thinking, and the relation of identity makes up the content. In case the thoughts are true, the *same* property always makes up the object. But I think that with the formulation of (I1) one is able to indicate that the property in question is conceived, whereas with the formulation of (I2) one is not able to do that.

One justification for my surmise can be taken from Chisholm's defense of his *intentional criterion of property identity.* In his paper "An Intentional Explication of Universals" he formulates this criterion.[28]

> (C1) attribute A is identical with property B =Df Attributes A and B are necessarily so related that whoever has the one as intentional content has the other as intentional content.

Chisholm presents the main objection against his criterion in the form of the following argument:

> (1) There is a person S who can truly say "Black is the color of my true love's hair"

> Therefore

> (2) The following properties are identical: (a) black and (b) the color of the true love's hair.
> (3) According to C1, the identity criterion for universals or properties, the two properties are distinct: one can attribute either of them without thereby attributing the other.

> Hence

> (4) The criterion of property identity is inadequate.[29]

In order to show that the third step does not follow, Chisholm draws the reader's attention to the ambiguity in the ordinary use of the verb "is"

and takes linguistic precautions to avoid it. The ambiguity of "is" Chisholm is interested in consists in the fact, that sometimes we use it as the "is" of predication and sometimes as the "is" of identity. In the predication case it is properly followed only by an adjectival expression, and in the identity case it properly falls between singular terms. Chisholm removes the ambiguity by refining upon our ordinary language:

> I propose that we reformulate the problem, replacing the "is" of identity by the identity sign ("="), an expression in which the verb "is" does not appear at all. When we do this, we will restrict "is" to its predicative use. And when we use adjectives as names, we will capitalize them, as one does in German.[30]

Because of this refinement the sentence in premise (1) of the objection, namely "Black is the color of my true love's hair," has two interpretations:

(A) My true love's hair is black,

and

(B) The color of my true love's hair = Black.

Premise (2) has to be reformulated by:

(C) The following properties are identical: (a) Black and (b) the color of my true love's hair.

In applying the definition (D1), i.e., "x's believing has being-F as its content =Df x believes that there is an F," Chisholm gets the statement:

(A1) For every x, x's believing has being-F as its content, if and only if, x believes that there is an F.

What Chisholm suggests next seems to be very important:

> If we replace "being-F" in the first clause by "Black" and replace "an F" in the final clause by "a thing that is black," then we have the following instantiation of A1:
>
> (A1') For every x, x's believing has Black as its content, if and only if, x believes that there is something that is black.

In the light of this argumentation Chisholm's criterion (C1) does not lead to the result that the properties Black and the color of my true love's hair are distinct; according to the assumptions made in his example the properties can be regarded as one and the same.

Chisholm's linguistic suggestion presupposes that the predicative use of "is" and an adjective, e.g., "is black," expresses the intentional act of attributing the property Black[31] (or according to the assumptions: the

color of my true love's hair). Consequently, this property is conceived as far as it is the content of thinking because conceiving a property is a necessary condition of having the property as content.[32] Sentence

(A) My true love's hair is black.

is an example of the predicative use. In spite of this, the nominative use of an adjective, e.g., "Black," indicates that one has the property as object of thinking. That is the case in sentence

(B) The color of my true love's hair = Black.

where the relation *being identical with* makes up the content.

The interesting point for my considerations consists in the fact that not all substantival expressions have an adjectival counterpart which functions in the same way as "is black" does with regard to the more or less automatically generated "Black." What would be the adequate predicative counterpart of "the color of my true love's hair"?

(1) Would it be: "is the color of my true love's hair"? But this clause indicates a property of a property at best (a raven is black and not the color of my true love's hair). Therefore the predicative clause "is the color of my true love's hair" does not work adequately; it is not an appropriate correlate to "is black."

(2) What about "has the color of my true love's hair"? In this case "has" means quite the same as "exemplifies." But "exemplifies the color of my true love's hair" is just as "exemplifies Black" on another level as "is black." The thought expressed by "The raven over there is black" has the property Black as content and not as object, whereas the thought expressed by "The raven over there exemplifies Black" has the property *exemplifying* as content and not Black—Black is part of the object. And similarly, in the sentence "The raven over there exemplifies the color of my true love's hair," the property Black, which is the color of my true love's hair according to the assumption, is the object and not the content of thinking.

In case "has (exemplifies) the color of my true love's hair" is admitted as a monadic predicate[33] one gets as nominal counterpart "having the color of my true love's hair." But this term designates another property than Chisholm's singular term "the color of my true love's hair." The predicative clause "has the color of my true love's hair" has another meaning than "is black" because another property than Black is attributed by using that clause. Only black things can truly be attributed by "is black," whereas not only black things can truly be attributed by "has the color of my true love's hair." On the one hand, this predicate is

interpreted to be monadic just as "black" is understood to be monadic. On the other hand, it expresses a relational property which the predicate "black" does not express. If my true love's hair were red, red things would not be black but they would be colored like my true love's hair.[34]

(3) There seems to be at least a third possibility. You can ask if the linguistic adjectival counterpart to "the color of my true love's hair" is something which corresponds to the adjective of the pair: "the color of gold" versus "gold-colored." The adjectival clause built on this model would be "my-true-love's-hair-colored." First of all, this case looks indistinct or, perhaps, ambiguous to me.

There seem to be reasons for accepting the interpretation that "gold-colored" (or better "golden") is used as a genuine color adjective like "black" or "white." In using "black," for example, you express simply the attributing and, with it, the conceiving of the color property Black; you have Black as content without conceiving other properties which are suitable to single out Black. The expression "black" as a real color adjective is (pre-)supposed to indicate the conceiving of the property Black and not conceiving of one of its individuating properties. In case we are willing to accept sentences like "Gold is not gold-colored anymore" as true, the use of "gold-colored" seems to be independent from conceiving the property *being gold.*[35] But then "the color of gold" would not be a definite description as "the color of my true love's hair" was supposed to be by Chisholm—it would be a proper name. Therefore "my-true-love's-hair-colored" cannot be understood analogously to this interpretation of "gold-colored."

In accordance with the other interpretation of "gold-colored" this term means rather something like "colored like gold." And correspondingly we can say that "my-true-love's-hair-colored" can be paraphrased by "colored like my true love's hair." But, again as in (2) this predicate has another meaning than "black"—another property than Black is attributed by "is colored like my true love's hair." Hence the nominal counterpart to the adjectival "my-true-love's-hair-colored" (= "colored like my true love's hair") would not be Chisholm's singular term "the color of my true love's hair," it would rather be something like "being colored like my true love's hair."

Therefore, I think there is no corresponding linguistic adjectival counterpart to Chisholm's expression "the color of my true love's hair" which functions in the equivalent way as Chisholm thinks "black" does the job to be the adjectival counterpart of the nominal "Black." I think the main reason why there is no appropriate adjective lies in the fact that the linguistic asymmetry also expresses a difference in thinking: Given

the conclusion Chisholm draws, to wit, the properties Black and the color of my true love's hair are one and the same, then the linguistic expressions indicate a difference of reference to this property. "Black" is more intimately connected with "black." The predicative clause "is black" can be understood as an expression of the attribution of the color property and therefore of the conceiving of the property; and the nominal "Black" can be understood as an expression of having the property as object *and* of conceiving it too. In contrast to this, the singular term "the color of my true love's hair" is an expression of having the property as object, but it does not express that the property is conceived.

When we apply this consideration to the initial sentences of this chapter we can see that the formulation

(I1′) *Being white* is the color property of snow

expresses that *being white* is not only object of thinking but conceived too, whereas with the formulation

(I2′) The color property of snow is the color property of chalk

one refers to *being white* as object without conceiving it.

As already mentioned, Chisholm claims in *The First Person* that to have a belief about a property is always an indirect attribution. In your belief about such a thing, you attribute a property to it, as the thing you are conceiving in a certain way, or as the thing you are contrasting with a certain property, for example.[36] Especially with Chisholm's view about the close connection between the predicative and the substantival use of an adjective in the background, I cannot see why "*Being white*" in (I1′) or "Black" in "Black is not a chromatic color" cannot express the conceiving of the properties and therefore an immediate reference to them, i.e., a reference without going back to further individuating properties. Why could this unmediated reference only be expressed by predicates? Or in other more intentionalistic words, why cannot properties be direct objects of thinking?

G. Three Versions of the Thesis of the Primacy of *De Se*: Historical and Systematic

In his review of Chisholm's *The First Person*, Kim distinguishes three possible readings of the thesis of the primacy of *de se*.[37] Applying his distinction to thoughts, i.e., attributions like belief, we can distinguish the following readings:

(1) No *de se* thought is reducible to any other form of thoughts.
(2) All thoughts essentially involves *de se* thoughts, i.e., it is impossible that someone has a thought without having a *de se* thought.
(3) All thought is reducible to a *de se* thought.

The versions of the thesis are formulated in order of increasing strength.

Against the weakest version, the first one, there are attempts which argue by starting with a general notion of *attributing something to something* and going on by defining special cases like self-attribution in a wider and stronger sense, and so on.[38]

That a belief *de se* cannot be sufficiently explained as a special case of a belief *de re* is the starting point of Chisholm's considerations upon intentionality.

Version two might be put—as Kim suggests—in a catchy way like this: "No consciousness without self-consciousness."[39] The thesis seems false to Kim if taken as a description of the phenomenology of consciousness, and he "doubt[s] this was Chisholm's intention."[40] But in Chisholm's work on Franz Brentano you can find passages making obvious that Chisholm had such an intention in mind.

Brentano's doctrine that every act of consciousness must have both a primary object and a secondary object, the act itself, seems to be an example of the second reading of the thesis of the primacy of *de se*. In experiencing, e.g., in hearing a sound, the experiencing person has the sound as primary object, and, incidentally, himself or herself hearing the sound as secondary object.

In a paper entitled "Brentano and Marty on Content: A Synthesis suggested by Brentano,"[41] Chisholm argues that the late Brentano held a stronger thesis of the primacy of *de se*, i.e., in the sense of the third reading. Chisholm concedes that Brentano explicitly held this strong doctrine only in the context of sensing. But Chisholm thinks that the doctrine can be extended to all types of thinking in order to make a good sense out of Brentano's remarks on inner experience, and therefore his first-person approach is supposed to make understandable Brentano's thesis that the subject is experienced in every presentation. The affinity between Chisholm and Brentano can be seen from the following passages from Brentano that Chisholm quotes to verify his claim. Just let "in recto" correspond to "directly," and "in obliquo" to "indirectly":

> For to the extent that we do thus sense ourselves as sensing being, we sense ourselves in recto, and we sense another thing *as* sensed by us and therefore in obliquo. One could look at the matter this way: as sensing being I am the only thing that is here sensed in recto; the other thing, the thing that I have as external object, is sensed only in obliquo. . . . In sensing I am myself the sole object that is presented in recto.[42]

In concluding his historical comments on Brentano's theory of intentionality, Chisholm notes:

> We can also see now that the words 'incidentally' and 'secondary' are somewhat misleading as descriptions of the *direct* object of sensation. The direct object may be considered as incidental or secondary so far as *interest* is concerned; but so far as the nature of *reference* is concerned, it is primary.[43]

Kim wonders if there is really a metaphysical basis in Chisholm's attempt to represent all belief as direct attribution of a property, and he asks "What is the philosophical gain?"[44] One answer, at least, is that Chisholm thinks that a thorough understanding of self-consciousness necessitates the acceptance of the third, the strongest level of the primacy of *de se*.

Chisholm emphasizes that the "essential things in intentionality are the direct object—namely, the thinking subject—and the content."[45] However, as conceiving a property is necessary to have the property as content of thinking, Chisholm admits a kind of direct intentional reference to properties. This thesis does not exclude yet the case that you can conceive a property when you have this property *only* as object. But this case is excluded by Chisholm's theory of (direct and indirect) content and object which holds the notion of *de se* attribution as primitive and as the basis for the concept of attribution in general. As Chisholm excludes properties as nonindirect objects without any further additional systematic explanation, I wonder whether the above-mentioned philosophical gain of Chisholm's approach can be sufficient to legitimate this exclusion. Slightly changing Chisholm's dictum on intentionality I would like to suggest: "The essential things in intentionality are the direct object—namely, the thinking subject or a conceived property—and the content."

This change would not alter Chisholm's main theses on intentionality and reference. Neither would it affect his thesis of the primacy of the intentional (psychological) upon the semantical nor his thesis of the primacy of properties upon states of affairs (propositions). My criticism maintains his important distinction between object and content of thinking and with it the claim that in intentional acts two things can be distinguished as epistemically intimate: There can be something like the Russellian acquaintance only to the judging person himself or herself (as object) and to a conceived property (as content and—this is where our opinions diverge—as object as well).[46] And in the end, one is not directly aware of oneself or a property in isolation: the direct reference happens

only in an act of thinking (attributing a property), i.e., one always thinks about there being something that is F.[47]

JOHANN CHRISTIAN MAREK

INSTITUT FÜR PHILOSOPHIE
KARL-FRANZENS-UNIVERSITÄT GRAZ
MARCH 1996

NOTES

1. Like Chisholm, I use these terms interchangeably, provided that there is no distinction indicated. Relations of more than one term are considered as properties too.

2. Roderick M. Chisholm, *The First Person: An Essay on Reference and Intentionality* (Minneapolis: University of Minnesota Press, 1981), p. 8.

3. He does this explicitly in ibid., p. 6.

4. See, for example, his "Self-Profile," in R. J. Bogdan, ed., *Profiles*, vol. 2, *Roderick M. Chisholm* (Dordrecht: Reidel, 1986), pp. 3–77; p. 24. Here, he distinguishes between attributes and properties: "[A]n *attribute* is whatever can be attributed: it is an entity which is possible such that there is someone who attributes it to something" and "a property is an attribute which could be exemplified."

 Could unexemplifiable properties not be admitted by a definition like this: *x* is a property = Df. (1) *x* is possibly such that there is something that exemplifies it, or (2) *x* is a negation of something which is possibly such that there is something that exemplifies it.—As far as I know, Chisholm would reply that the term "negation of" cannot be understood without presupposing linguistic or intentional characteristics. Cf. his *On Metaphysics* (Minneapolis: University of Minnesota Press, 1989), pp. 146–47.

5. Roderick M. Chisholm, "An Intentional Explication of Universals," *Conceptus* 25, no. 66 (1991): pp. 45–48; p. 46. He adds in clarification: "The "is" in the definiens ("x believes that there is an F") is the "is" of predication and not the "is" of identity. I have placed the indefinite article "an" before the predicate-letter "F" (thus saying "S believes that there is *an* F"), in order to insure that the "is" not be interpreted as the "is" of identity." In an unpublished manuscript, Chisholm generalizes the definition to all types of thinking—e.g. judging, trying or endeavoring, desiring, supposing—in substituting "believing" by "thinking": (1) x has being-F as the content of a thought = Df. x thinks of there being something that is an F. (2) x is a property = Df. x is possibly such that it is the content of someone's thinking.

6. Chisholm, "An Intentional Explication of Universals," p. 45. Examples of distinct properties which are exemplified by the same instances are legion: *being an animal with a kidney* vs. *being an animal with a heart*; *being an equiangular triangle* vs. *being an equilateral triangle; being a round square* vs. *being a married bachelor* vs. *being a dragon* vs. *being a unicorn* vs. *being non-self-identical.*

7. See Chisholm, *On Metaphysics*, p. 164. In his "Self-Profile," p. 26, Chisholm suggests quite another definition: "*x* is a contingent thing = Df There is something which is possibly such that *x* does not exist."

8. The idea can be extended to other types of thinking (see above note 5). The notion of attribution would then be modified insofar as "believing" is replaced by "thinking" in the definition (see also below note 18).

9. In the last example, both the properties, *being red* and *being colored*, are objects of your judgment, and the property you are attributing is *including*. *Including* should be understood in the sense Chisholm defines the term in his book *On Metaphysics*, p. 101: "*P* includes *Q* = Df. *P* is necessarily such that whatever has it has *Q*."

10. Chisholm, "Self-Profile," p. 20.

11. Chisholm, *The First Person*, p. 37.

12. Chisholm, "Self-Profile," p. 24.

13. Jaegwon Kim, "Critical Notice to *The First Person: An Essay on Reference and Intentionality*," *Philosophy and Phenomenological Review* 46 (1985/86): 483–507; p. 487.

14. In R. J. Bogdan, ed., *Profiles*, vol. 2, *Roderick M. Chisholm*, p. 198.

15. Chisholm, *The First Person*, p. 17.

16. I.e., acceptance of propositions like *There being something that is red*. See ibid., pp. 38–40.

17. Ibid., p. 27.

18. Ibid., p. 28. With regard to the general notion of thinking (see above notes 5 and 8), I think, the concept of attribution can be modified insofar as the definition is to be read then as follows: *x* thinks that he himself is *F* = Df. The property of being *F* is such that *x* directly attributes it to *x*.

19. For the sake of simplicity, there is no need to enter into the discussion of the distinction between *de re* beliefs in a wider, "latitudinarian" sense and in a stronger sense which implies a certain "degree of epistemic intimacy." See his *The First Person*, pp. 107–20, and later works where he refined his approach, e.g., "The Primacy of the Intentional," in Chisholm, *On Metaphysics*, pp. 129–38; "How We Refer to Things," *Philosophical Studies* 58 (1990): 155–64; "Referring to Things that No Longer Exist," in J. Tomberlin, ed., *Philosophical Perspectives*, vol. 4, *Action Theory and Philosophy of Mind* (Atascadero, Calif.: Ridgeview, 1990), pp. 545–56.

20. See *The First Person*, pp. 27–40, and Chisholm's "Self-Profile," p. 19.

21. See *The First Person*, pp. 37–38.

22. Such indirect attributions are suggested in his *The First Person*, p. 38.

23. Ibid.

24. In *The First Person*, on p. 7, Chisholm presents the following definition of entailment: "A property *P* may be said to *entail* a property *Q*, provided only that *P* is necessarily such, that if it is exemplified, then *Q* is exemplified, and whoever conceives it conceives *Q*."

25. Chisholm, *On Metaphysics*, p. 147.

26. Ibid., p. 143.

27. I am italicizing the words because in this roughly sketched outlook I am using them only in an analogous way to Chisholm's terms.

28. Chisholm, "An Intentional Explication of Universals," p. 46. In this paper, Chisholm mostly uses "attribute" instead of "property."

29. Ibid., p. 47.

30. Ibid., pp. 47–48.

31. In accordance with the diction of the present paper and also most works of Chisholm, one could use "being black" instead of "Black."

32. Let me leave aside the problem whether the predicative use of "black" expresses that one has really grasped the correspondent property and not an ersatz property. The idea is, that you express the act of attributing by using predicative clauses. But the use of a predicate does not already guarantee the conceiving and with it the attributing of the property.

33. One objection to constructing such predicates is that they contain demonstratives and, therefore, cannot indicate properties at all. If you admit a predicate of this sort, you already have to accept the existence of contingent things. But this violates the thesis that no property is dependent for its existence upon any contingent thing. (See Chisholm, "Self-Profile," p. 26, and *On Metaphysics*, p. 48). In the given example at least, the existence of the person referred to by the indexical "my" is presupposed. Let us assume the following two statements: (1) The use of the predicate "has the color of my true love's hair" expresses the attribution of the corresponding property (*having the color of my true love's hair*), and (2) the understanding of first-person indexicals cannot be reduced to an apprehending of an individual essence (haecceity) which is ontologically independent from any particular thing. From (1) and (2), we can conclude that the existence of the property in question would already presuppose that there is a contingent thing, to wit, I.

This objection is worth mentioning but does not actually affect the main point Chisholm has made. There are other compound predicates like "having the color of gold" and "colored like gold" which are not faced with this problem. The property which is expressed by the predicative clause "is colored like gold" exists even if there were no piece of gold. For the sake of argument, I admit the expressions "has the color of my true love's hair" or, later in point (3), "is colored like my true love's hair" as adequate predicative clauses.

34. In his paper "On an Objection to the Synonymy Principle of Property Identity," *Analysis* 41 (1981): 22–26; p. 24, Michael Tye argues something similar by means of a different metaphysical terminology. He thinks "that 'having the colour of ripe tomatoes' designates the same property in all worlds— a property which is common to all and only red objects in the actual world, to all and only green objects in the given possible world, and so on." In contrast to this the property *being red* is common to all and only red objects in the actual world as well as in the given possible world.

35. By the way, the German color adjectives "lila" and "violett" (in English "lilac" and "violet") are not—as regards content—connected anymore with the corresponding kinds of plants lilac (the German noun is: "Flieder") and violet (in German: "Veilchen") respectively, whereas in English, I think, there is such a connection of content.

36. Chisholm, *The First Person*, p. 38.

37. Jaegwon Kim, "Critical Notice," p. 503.

38. Heiner Rutte would be an example of such a position. See his "Über das Ich," in W. L. Gombocz, H. Rutte, W. Sauer, eds., *Traditionen und Perspektiven der analytischen Philosophie: Festschrift für Rudolf Haller* (Wien: Hölder-Pichler-Tempsky, 1989), pp. 322–42.

39. Kim, "Critical Notice," pp. 505–6.

40. Ibid., p. 506.

41. Roderick M. Chisholm, "Brentano and Marty on Content," in K. Mulligan, ed., *Mind, Meaning, and Metaphysics* (Dordrecht: Kluwer, 1990), pp. 1–9.

42. Ibid., p. 2. Chisholm refers to Franz Brentano, *Sensory and Noetic Consciousness* (London: Routledge and Kegan Paul, 1981), pp. 28–29.

43. Chisholm, "Brentano and Marty on Content," p. 3.

44. Kim, "Critical Notice," p. 506.

45. Chisholm, "Brentano and Marty on Content," p. 8.

46. I would like to note that when you have a property as content of thinking, i.e., when you attribute the property, you conceive the property but you do not have to attribute (or conceive) the property *conceiving* itself. And in the same way, when you have a property as object and conceive it, you do not have *conceiving* as object nor as content.

47. For helpful suggestions and comments I wish to thank Werner Sauer, Heiner Rutte, Maria E. Reicher—and Keith Lehrer who also helped me to get over some language difficulties.

REPLY TO JOHANN CHRISTIAN MAREK

Johann Christian Marek's essay is an extraordinarily subtle critique which differs from that of many of my other critics. He is primarily concerned with clarifying and straightening out my ideas. In doing this he is extraordinarily successful.

I have defended a realistic theory of properties in a book, *A Realistic Theory of Categories: An Essay on Ontology* (Cambridge University Press, 1996). The realism there defended is a version of what is sometimes called "extreme Platonism."

I am now considerably more skeptical about the nature of belief *de se* than I was when I wrote *The First Person*. Casteñeda was right in suggesting that such a theory requires us to take as undefined the locution: "x believes with respect to x itself that it is F."

The question, "How does the person go about doing that?" must go unanswered with respect to *some* activity at some point. After all one can ask, "How does a person go about thinking?"

<div align="right">R.M.C.</div>

24

Barry Smith

BOUNDARIES: AN ESSAY IN MEREOTOPOLOGY[1]

INTRODUCTION

Of Chisholm's many signal contributions to analytic metaphysics, perhaps the most important is his treatment of boundaries, a category of entity that has been neglected, to say the least, in the history of ontology. We can gain some preliminary idea of the sorts of problems which the Chisholmian ontology of boundaries is designed to solve, if we consider the following Zeno-inspired thought-experiment.

We are to imagine ourselves proceeding along a line through the middle of a disk that is divided into two precisely symmetrical segments, one of which is red, the other green, and that we move continuously from the red to the green segment. What happens as we pass the boundary between the two? Do we pass through a last point p_1 that is red and a first point p_2 that is green? Clearly not, given the density of every continuum; for then we should have to admit an indefinite number of further points between p_1 and p_2 which would somehow have no color. To acknowledge the existence of just one of p_1 and of p_2 but not of the other, however, as is dictated by the standard mathematical treatment of the continuum, would be to countenance a peculiar privileging of one of the two segments over the other; and such an unmotivated asymmetry can surely be rejected as a contravention of the principle of sufficient reason.

Perhaps, then, the line on which we move is colorless at the point where it crosses from one segment into the other. The two segments would then be analogous to open intervals in the set-theoretic sense. One might seek support for this idea by reflecting that points and lines are not in any case the sorts of things which can be colored, since color properly applies only to extended regions and not to the unextended boundaries thereof. Imagine, however, a perfectly homogeneous red surface. Is a point or a line within the interior of this surface not then also red? In the

end, however, it does not much matter how we answer this question. since an argument exactly analogous to the one here presented can be formulated also in relation to a range of other sorts of cases (indeed to qualities in general), including cases of qualities for which it is not attractive to suppose that extendedness in space is a precondition of existence.

Thus the argument can be applied to purely temporal phenomena, such as the beginnings and endings of mental processes. In the work of Zeno and of Bolzano it has been applied to the phenomena of motion and bodily contact. Imagine a body which is for a certain period at rest and then begins to move. Is there a last point in time p_1 when the body is at rest and a first point p_2 when it is in motion? Clearly not, given the density of every continuum; for then we should have to admit an indefinite number of further points between p_1 and p_2 at which the body would somehow be neither at rest nor in motion. To acknowledge one of p_1 and p_2 but not the other would again be to countenance a peculiar privileging of one of the two temporal segments over the other. Perhaps, then, the body is neither in motion nor at rest at the point in time where it crosses the segmentary divide, so that the two temporal intervals would be analogous, once again, to open regions. But is it even coherent to suppose that a body might be neither in motion nor at rest at a certain point in time?

Imagine, to pursue an example from Bolzano, two perfect spheres at rest and in contact with each other. What happens at the point where they touch? Is there a last point p_1 that belongs to the first sphere and a first point p_2 that belongs to the second? Again: clearly not, for then we should have to admit an indefinite number of further points between p_1 and p_2 and this would imply that the two spheres were not in contact after all. To acknowledge one of p_1 and p_2 but not the other would be to countenance an asymmetry of a quite peculiarly unmotivated sort. And our third alternative seems here to be ruled out also. For to admit that the point where the two spheres touch belongs to neither of the two spheres seems to amount to the thesis that the two spheres do not touch at all.

The Brentano-Chisholm Theory of the Continuum

What, then, is to be done? As Chisholm has insisted, there is in fact an alternative account of the actual reality, as far as color is concerned, at the point on the line where the red and green segments meet, an account which can be smoothly and uniformly extended to the other cases

mentioned. This affirms that there is but one (albeit complex) point of the line which lies precisely on the border between the two segments. This point is colored, but not in simple fashion, for it is in a certain sense *both red and green*. To put the matter in another way: it is at one and the same time a *ceasing to be red* and a *beginning to be green*. And in yet another way still: it is a point where a red point and a green point *coincide*. Similarly in the case of the particle that begins to move: here too there is a single point at which the body is *both at rest and moving* (or more precisely: it is at one and the same time *ceasing to be at rest* and *beginning to move*). The terminal boundary of the initial interval coincides with the initial boundary of the subsequent interval. And the same account can be given also of what occurs when two perfect spheres touch: a point on the boundary of the one sphere coincides with a point on the boundary of the adjacent sphere. All bodies and all temporal intervals are on this account analogous to closed regions—or perhaps we should more properly say that there is no analogue in the world of spatial and temporal continua of the standard opposition between open and closed.

It is the theory of coincidence, and the account of boundaries and the continuum which this dictates, which will occupy us in what follows. We shall concentrate especially on four papers in which Chisholm treats the theory of coincidence of boundaries in space (1983, 1989, 1992/93, and 1994). As will already be clear, analogous reasoning can be applied also to the coincidence of boundaries in time (to beginnings and endings, for example: see Chisholm 1982, 1992), though we shall here leave these temporal matters out of account.[2]

Chisholm's theory of coincidence is drawn from the work on space, time, and the continuum of Franz Brentano and above all from Brentano's idea that what is above all characteristic of a continuum is 'the possibility of a coincidence of boundaries' (Brentano 1988, pp. 4f.). Brentano's thesis runs: if something continuous is a mere boundary then it can never exist except in connection with other boundaries and except as belonging to a continuum of higher dimension. This must be said of all boundaries, including those which possess no dimension at all such as spatial points and moments of time and movement: a cutting free from everything that is continuous and extended is for them, too, absolutely impossible. Brentano's ideas are based in turn on the conception of boundaries and continua sketched by Aristotle in the *Physics*. As Brentano developed and elaborated Aristotle's sketchy remarks, so Chisholm sought to render Brentano's ideas in a formal manner, and to incorporate them into a general theory of kinds or categories of being. I shall attempt here to extend and to complete Chisholm's formalizations

and to show how much further work needs to be done. But I shall seek also to demonstrate that he has in a sense domesticated Brentano's ideas by dissociating them from a number of difficult and puzzling consequences which a more detailed analysis will show to be bound up inextricably with the notion of coincidence.

Set Theory

It is above all the predominance of set theory as an instrument of (or more precisely as a substitute for) ontological investigation that has dictated the neglect of the category of boundary on the part of those working in the field of analytic metaphysics.[3] Indeed already in the early years of this century Brentano had seen the need to criticize standard set-theoretic writings on the continuum where, as he points out, the idea of coincidence 'will be sought after entirely in vain' (Brentano 1988, p. 5).

From the point of view of set theory, boundaries are logical constructions, or in other words talk of boundaries is seen as a mere *façon de parler* about other things (effectively limits of sequences, or other like abstracta). Such treatments are of unquestioned value for mathematical purposes, and we must stress that we are not here attempting an alternative foundation of the mathematics of the continuum of the sort which Lesniewski projected. Rather, we are concerned with boundary-continuum structures as these make themselves manifest concretely, in bodies, or in what Chisholm calls 'spatial individuals'. The set-theoretic account of the continuum proves to be inadequate as an account of such concrete continua for at least the following reasons.

1. The latter are *qualitative* structures. This is so not merely in the sense that they are (standardly) filled by qualities (of color, temperature, hardness, etc.), but also in the sense that standard mathematical oppositions, for example between countable and uncountable magnitudes or between dense and continuous series, seem here to gain no purchase. Nothing like Cantor's continuum problem arises for the concrete continuum, and indeed the very existence of this problem testifies to a certain weakness in the set theoretic approach to the problems at issue.

2. The set-theoretical construction of the continuum is predicated on the highly questionable thesis that out of unextended building blocks an extended whole can somehow be constructed. Yet however many entities of zero-dimension are assembled together, it seems difficult to comprehend that a whole of higher dimension will somehow be formed.

3. The application of set theory to a subject-matter presupposes quite generally the isolation of some basic level of *Urelemente* in such a way as

to make possible a simulation of the structures appearing on higher levels by means of sets of successively higher types. In the world of concrete continua, in contrast, there need be no relevant *Urelemente* which could serve as such a starting point of ontological construction. It is however unproblematic that concrete continua are organized in such a way that parts, including boundary-parts, are capable of being discriminated within them.

4. Set theory sees the continuum as homogeneous, as made up of only one sort of ultimate part (according to preference: the empty set, points, atoms, or real numbers). Concrete continua are in contrast made up of different sorts of parts; above all, they are made up of boundaries of different numbers of dimensions, on the one hand, and of extended bodies or regions which these boundaries are the boundaries of, on the other.

MEREOLOGY

As an alternative to set theory, Chisholm adopts as his framework for dealing with the kinds or categories of individual beings the theory of part and whole or *mereology*:[4] boundaries are *parts* of the things they bound. Mereology has the advantage that we can use it to study the ontological structures in a given domain even in the absence of any ultimate knowledge as to the atoms, if any, out of which the domain is constructed. For the axioms of mereology apply whether the world is an infinitely divisible fluid or an edifice constructed out of atoms—or indeed some combination of the two of the sort that is exemplified, for example, by Descartes's bicategorial ontology of *res extensa* and *res cogitans*.

Boundaries of bodies are actual parts of the bodies which they bound. But they are not just any sort of part: rather they are parts which, as a matter of necessity, can exist only as proper parts of things of higher dimension which they are the boundaries of (where from the set-theoretic point of view, isolated extensionless points are presented as existing in complete independence of any larger wholes).

Boundaries cannot exist in isolation: there are, in reality, no isolated points, lines, or surfaces. As Brentano himself would express it, our healthy common sense, which is here evidence itself, would raise its head in violent protest at the postulation of such entities.[5] Boundaries are in this respect comparable to universal forms or structures (for example the structure of a molecule as this is realized in a given concrete instance), as also to shadows and holes.[6] Entities in all of these categories are such

that, while they require of necessity hosts which instantiate them, they can be instantiated by an indefinite variety of different hosts.[7]

Consider, for example, the surface of an apple. The whole apple can here serve as instantiating host, but so also can the apple minus core, which might have been eaten away to varying degrees from within.

In light of some of Chisholm's remarks on the nature of souls or minds,[8] we might point out that souls or minds, too, may have similar features. If there are souls, and if souls are hosted by bodies, then the same soul can be hosted by many bodies in the sense that a body may lose molecules, cells, and even limbs and yet preserve its relation to the same identical soul. The soul might even *be* a boundary. (This would be the case, for example—though it seems that an option along these lines is not what Chisholm has in mind—if the soul's [or mind's] activity were essentially a matter of what happens where nerve-endings are in multivariously patterned contact with each other inside the brain.)[9]

All the mentioned types of entities share further the fact that they license certain sorts of ontological inference (*if* there is a boundary/structure/hole/soul having these and those properties, *then* there is a host having these and those properties). We cannot infer to any specific host, however. Thus it cannot be said of any definite continuum that a boundary is dependent on *it*: that which a boundary is dependent on can be designated rather only via a general term: what is required by a boundary is, Brentano says, 'not this or that particular continuum, but any continuum of the appropriate kind'.[10] For while no boundary can exist without being connected with a continuum, 'there is no specifiable part, however small, of the continuum, and no point, however near it may be to the boundary, which is such that we may say that it is the existence of *that* part or of *that* point which conditions the boundary' (Brentano 1981, p. 56).

PLEROSIS

As will by now be clear, boundaries can be classified as *external*, for example a point on the surface of a sphere, and *internal*, for example a point or line or surface entirely within the interior of a sphere.[11] In contrast to standard set-theoretic treatments, the Brentano-Chisholm theory is now able to do justice to the fact that the boundaries given in experience are in many cases *asymmetrical* (so that we might in certain circumstances talk of 'oriented boundaries'). This applies, for example, to the external boundaries of bodies and to the beginnings and endings of processes extended in time. Intuitively it seems not to be the case that the

external boundary of a substance is in the same sense a boundary of the complement entity (i.e., of the entity which results when we imagine this substance as having been subtracted from the universe as a whole). (Even the thesis that there is such an entity is something which, from our present perspective, has to be taken with a pinch of salt.)

Boundaries, accordingly, may be boundaries only in certain directions and not in others. Imagine a line that is tangent to a circle, and meets the circle at a certain point. Strictly speaking we need here to recognize two points, a point on the line and a point on the circle, which *coincide*, the one with the other. The two points are not identical since they serve as boundaries in different directions. The point on the line is a boundary in two rectilinear directions, the point on the circle is a boundary in two directions of a certain determinate curvature.[12]

Every point, every line, every surface, must serve as a boundary in at least one direction. A point within the interior of a solid sphere is a boundary in all possible directions. The analogous point on the plane surface of a solid hemisphere is, in contrast, a boundary in exactly half this maximal number of directions. Brentano introduces at this point the notion of the *plerosis* or 'fullness' of a boundary. The mentioned interior boundary has full plerosis, the external hemispherical boundary has only half plerosis. Imagine that we have two cubes designed to fit exactly inside a container in such a way that the upper surface U of the lower cube coincides (in our technical sense) with the lower surface L of the upper cube. Consider two points p and q on opposite interior walls of the container and each located on the plane where the two cubes meet:

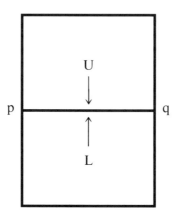

There are then *two* shortest lines connecting the given points: the line l_U in or on U and the coincident line l_L in or on L. This implies that 'the

geometer's proposition that only one straight line is conceivable between two points, is strictly speaking false' (Brentano 1988, p. 12).

The degree of plerosis of a boundary, together with the direction or directions in which it serves as boundary, yield further criteria in terms of which boundaries can be classified. As Brentano puts it in his *Theory of Categories*:

> [A] point differs spatially in its species [*spezifisch*] according to whether it serves as a boundary in all or only in some directions. Thus a point located inside a physical thing serves as a boundary in all directions, but a point on a surface or an edge or a vertex serves as a boundary only in some directions. And the point on a vertex will differ in its species in accordance with the shape and direction of the vertex. (Brentano 1981, p. 60)

In this geometrical sense, then, the boundary is determined in its nature by the continuum which it bounds.[13] Boundaries are determined by their hosts also qualitatively or materially:

> Imagine the mid-point of a blue circular surface. This appears as the boundary of numberless straight and crooked blue lines and of arbitrarily many blue sectors in which the circular area can be thought of as having been divided. If, however, the surface is made up of four quadrants, of which the first is white, the second blue, the third red, the fourth yellow, then we see the mid-point of the circle split apart in a certain way into a fourness of points. (Brentano 1988, p. 11)

Points, therefore, may have parts (called 'plerotic parts' in what follows). The parts of a point coincide with each other and with the point as a whole.

> Euclid's supposition that a point is that which has no parts was seen already by Galileo to be in error when he drew attention to the fact that the mid-point of a circle allows the distinction of just as many parts as there are points on the circumference since it differs in a certain sense as starting point of the different individual radii. (Brentano 1988, p. 41)

Each point within the interior of a two- or three-dimensional continuum is in fact an infinite (and as it were maximally compressed) collection of distinct but coincident points: punctiform boundaries of straight and crooked lines, of two-dimensional segments of surfaces and of interior regular and irregular cone-shaped portions within three-dimensional continua, etc. (Not for nothing were the Scholastic philosophers exercised by the question as to how many zero-dimensional beings might be fitted onto the head of a pin.) This ontological profligacy has its limits, however: the left punctiform boundary of a one-inch line is identical (and not merely coincident) with the left punctiform boundary of the corresponding initial half-inch segment. This is because it is only the

immediate neighborhood of a boundary that is relevant to determining the nature of the boundary itself.

Why are plerotic parts important? One reason might be this: that everything (including you and me) is one. This is the case insofar as everything exists only in the present moment of time, which is itself a boundary of the past and future. Everything exists, as Brentano puts it, only *einer Grenze nach*, or in other words only according to the manner of existing of a boundary.

THE FORMALIZATION OF THE BRENTANO-CHISHOLM THEORY

We shall orient ourselves in what follows around Chisholm's formalization of Brentano's ideas in his rich and compressed paper "Spatial Continuity and the Theory of Part and Whole." Chisholm takes as primitives the concepts of individual thing, coincidence, and *de re* possibility. These notions, which will be introduced in succession in what follows, are employed within a mereological framework constructed around the primitive *is a proper part of*, which we symbolize here by means of: $<$. We use \leq to represent the relation *part of*, which is defined in the usual way. Three further primitives will be introduced along the way: the notions of body, existence, and sameness of dimension.

If we define *overlaps* as

DO. $xOy := \exists z(z \leq x \wedge z \leq y)$ (overlaps)

then Chisholm's axioms for *part* can be formulated as follows (where initial universal quantifiers, here and in the sequel, are to be taken as understood):

A$<$1. $(x < y \wedge y < z) \rightarrow x < z$ (transitivity)
A$<$2. $x < y \rightarrow \neg y < x$ (asymmetry)
A$<$3. $x < y \rightarrow \exists z(z \leq y \wedge \neg zOx)$ (remainder)[14]

Here variables are to be conceived intuitively as ranging over individual spatial things, a primitive notion, which comprehends bodies and their boundaries, as well as continuous and noncontinuous collectives comprised of bodies and boundaries. We are not, in this preliminary formal foray through the territory of coincidence, too concerned with the question whether this set of axioms for mereology is the most adequate set, though we note that we shall have need of a mereological summation or fusion principle (or more precisely, a principle-schema), which we hereby add to the set of axioms supplied by Chisholm himself:

A<4. $\exists y(y = \sigma x \phi x)$ (sum)

for each unary predicate ϕ which is satisfied (i.e., yields the value true for at least one argument).[15]

$\sigma x \phi x$ is then defined contextually as follows:

Dσ. $\sigma x(\phi x) := \iota y \{\forall w [wOy \leftrightarrow \exists v(\phi v \wedge wOv)]\}$

(the sum of ϕ-ers is the entity y which is such that w overlaps with y if and only if w overlaps with something which ϕ's).

In these terms we can define the *mereological difference* of two objects by

D−. $x - y := \sigma z(z \leq x \wedge \neg zOy)$ (difference)

and similarly for the other standard mereological constants, above all *union* and *intersection*:

DU. $x \cup y := \sigma z(z \leq x \vee z \leq y)$ (union)
D∩. $x \cap y := \sigma z(z \leq x \wedge z \leq y)$ (intersection)

A strengthened version of the remainder principle A<3 might now be formulated as a step towards ensuring the density of wholes along the lines presupposed by Chisholm in his comment on A<3 (1992/93, p. 14), for example a principle of the form

T<1. $x < y \rightarrow \exists z(z = y - x)$ (exact remainder)

T<1 can be proved in the presence of A<4 by setting $\phi z := z < y - x$, a predicate we know is satisfied in virtue of A<3.

Note that T<1 is still rather weak. Thus it does not for example exclude a world containing only one single point that would be mereologically complex but only in the sense of containing Brentanian plerotic parts. (If a soul is zero-dimensional, and if solipsism is true, then the world would be precisely as thus described.)

COINCIDENCE

Coincidence, as we shall here understand the notion, is exclusively the sort of thing that pertains to boundaries.[16] Bodies do not coincide (not even with themselves); nor do they coincide with the spatial regions they occupy. Other sorts of coincidence may be contemplated, thus for example of *the road from Athens to Thebes* with *the road from Thebes to Athens*, of *Bill Clinton* with *the president of the United States*, of the *mind* and its *brain*, of *this clumsily carved statue* and *this lump of bronze*. Here,

however, potential generalizations of the theory of coincidence along these lines are left out of account.

Chisholm's axioms for *coincides* are (amended slightly):

A~1. $x \sim y \rightarrow y \sim x$ (symmetry)

A~2. $(x \sim y \wedge y \sim z) \rightarrow x \sim z$ (transitivity)

From which we can easily derive

T~1. $x \sim y \rightarrow x \sim x$ (all coincident entities are self-coincident)

and plerotic parts can be defined as those parts which self-coincide.

Chisholm adds a further axiom (1992/93, p. 15):

(*) $\Diamond_x \exists y(x \sim y) \rightarrow \Diamond_x \exists y(x \sim y \wedge x \neq y)$

(possibly coincident entities are possibly such that they coincide with something other than themselves).

Here '\Diamond_x' is an operator of *de re* possibility (read: 'x is possibly such that'). (Later we shall introduce the operator '\Box_x' for: 'x is necessarily such that'). Note that if, as it seems reasonable to suppose, all boundaries are self-coincident and all coincident entities are boundaries, then the first modal operator is redundant, since being possibly coincident is tantamount to being (self-)coincident.

We can now postulate as our equivalent of Chisholm's third axiom for coincidence an axiom asserting the possible non-self-coincidence of self-coincidents:

A~3. $x \sim x \rightarrow \Diamond_x \exists y(x \sim y \wedge x \neq y)$

(an entity which coincides with itself is of its nature an entity which can possibly coincide with something other than itself).

What Chisholm has in mind in inserting the second modal operator in (*) is the thesis that every external boundary is possibly such that, through *touching*, it can come to coincide with the external boundary of *some other thing*, and A~3, even in its revised form, is much too general as a rendering of this thesis. Indeed it seems on reflection that, in almost every type of case, the second modal operator is redundant also. This follows from the considerations on plerosis above. Suppose x is a point or line or internal surface, then in every case there is some larger continuum which it is a boundary in or of. x is then either complex, in which case it is actually (and not merely possibly) coincident with certain of its plerotic proper parts, or it is simple. In the latter case, however, it is difficult to conceive of examples which might fit the bill. Even setting x as identical with the point at the very tip of a cone, for

example, would mean that x has parts, according to our present conception, corresponding to the indefinite number of points coincident at this tip which serve, respectively, as the punctiform boundaries of the indefinite number of straight and crooked lines which there converge.

An improvement on A~3 might accordingly assert simply, and nonmodally:

A~3*. $x \sim x \rightarrow \exists y(x \sim y \wedge x \neq y)$.

In order to capture more closely what Chisholm has in mind in the case of touching bodies we might then countenance a further axiom to the effect that self-coincident entities are possibly such as to be coincident with entities with which they do not overlap:

A~3**. $x \sim x \rightarrow \Diamond_x \exists y(x \sim y \wedge \neg xOy)$.

We shall not seek to draw out the implications of these axioms here. We note only that it is primarily in the case of external surfaces where we would have need for Chisholm's second modal operator: for external surfaces, unlike boundaries of other sorts, can at any given time coincide at most with one other entity discrete from themselves, and they do not need to coincide with any other entity at all.

To do justice to the phenomena in hand we need to add to Chisholm's axioms a further summing principle to the effect that, if two entities coincide with two further entities, then the mereological sum of the first two coincides with the mereological sum of the second two:

A~4. $(x \sim y \wedge v \sim w) \rightarrow x \cup v \sim y \cup w$ (finite sum)

We will also need to add the following principle:

A~5. $[\exists y \phi y \wedge \forall y(\phi y \rightarrow x \sim y)] \rightarrow x \sim \sigma y \phi y$ (restricted sum)

(if something ϕ's and if everything which ϕ's coincides with x, then x coincides with the sum of ϕ-ers).

Thus in particular if x coincides with both y and z then it coincides also with the sum of y and z. From A~5 we can prove also that, for satisfied predicates ϕ and ψ:

$\forall xy[(\phi x \wedge \psi y) \rightarrow x \sim y] \rightarrow \sigma x \phi x \sim \sigma y \psi y$.

A~4 and A~5 are modeled on standard axioms of general topology.[17] They will help us to move towards a position where we are able to have non-set-theoretic analogs of such topological notions as 'connectedness' and 'dimension' which are central to Chisholm's ontological scheme but which cannot be defined on the basis of the axioms he supplies.

We shall also adopt an axiom to the effect that a boundary coincides with its plerotic parts (for example where the mereological sum of a coincident red and blue line coincides with the red line taken singly):

A~6. $x \sim x \rightarrow \forall y(y < x \rightarrow y \sim y)$

<div align="right">(parts of self-coincidents self-coincide)</div>

BODIES

Chisholm gives the following definition of 'spatial individual' on p. 15 of his 1992/93:[18]

> x is a *spatial individual*: = (1) x is an individual thing; (2) x has a constituent that coincides with something: and (3) x is not possibly such that it coincides with anything.

In this spirit, we might seek to define what it is for an individual thing to be a body (*Körper*) as follows:

$$Kx := \neg \exists y(x \sim y) \wedge \exists y(y < x \wedge y \sim y)$$

(a body is an individual thing which does not coincide with anything and which has as proper part something which is self-coincident).

This definition, taken in conjunction with our schema A<4, does not impose very strong constraints on 'body'. Thus it allows as bodies not only scattered bodily collectives,[19] but also, and more worrisomely, randomly assorted collective wholes containing boundaries and non-boundaries as mutually unconnected parts. It would allow as bodies wholes consisting of bodies with isolated boundarylike outgrowths, thus for example an apple from which there protrudes an infinitely thin line. No formal means can be found to exclude these and other eldritch creatures from the realm of body in terms of the primitive notions thus far introduced. We shall accordingly embrace the concept of body as a further primitive, and seek to exclude these different sorts of counter-example by imposing constraints by means of axioms.

Our notion of body is to be conceived widely enough to allow as bodies both (scattered and nonscattered) collectives of bodies and (scattered and nonscattered) bodily parts of bodies (for example a sphere of one-inch diameter that is abstractly discriminable within a concentric sphere of two-inch diameter). Later we shall define the narrower concept of *substance* which will exclude these sorts of cases.

First we impose on bodies a principle to the effect that every body contains a self-coincident entity as proper part:

AK1. $Kx \rightarrow \exists y \, (y < x \land y \sim y)$ (bodies have plerotic parts)

Second we impose on bodies a constraint of *density*:

AK2. $Kx \rightarrow \exists yz \, (Ky \land Kz \land y \cup z = x \land \neg yOz)$ (density)

(each body can be divided without remainder into two further bodies which are discrete).

AK2 rules out the idea that there is a simplest body and it implies that all bodies are in the relevant sense bulky (are possessed of a certain material thickness).

Thirdly we assert:

AK3. $(Kx \land Ky \land xOy) \rightarrow K(y \cap x)$ (bodily intersection)

from which we can infer:

TK1. $(Kx \land Ky \land x < y) \rightarrow K(y - x)$ (subtraction)

(the mereological difference between two bodies is in every case a body).

AK3 rules out that bodies may manifest what we might refer to in standard topological terms as total or partial openness. Thus the interior of a body (the body minus its exterior boundary) is not a body, by AK3 and TK1, since the boundary itself is not a body. AK3 guarantees, too, that a hole or slit in a body always has a certain finite thickness.

BOUNDARIES

We now have two (in the end equivalent) alternatives in regard to the definition of *boundary*: on the one hand we might exploit in Chisholmian fashion the use of *de re* modalities and define boundaries as entities that are necessarily such as to exist as parts of bodies; on the other hand we might exploit the notion of coincidence and define boundaries as coincident entities. Here we follow Chisholm in taking the former course. We shall then lay down the interrelation between boundaries and coincidence by means of an axiom.

Chisholm's D2 (1992/93, p. 16) would seem to amount, in our present context (where we are dealing exclusively with the spatial case) to the following definition of boundary:

$Bx := \Box_x \exists y(Ky \land x < y)$

(x is a boundary iff x is necessarily such that there is some body of which it is a proper part).

Boundaries are necessary proper parts of bodies. This will not do as it

stands, however, first of all because there are other sorts of things which are necessary parts of this sort. Thus the definition is satisfied also by the interior of a body (i.e., by the result of deleting from a body its external boundary). It may be satisfied, too, by minds or souls (though then the proponent of the Brentano-Chisholm view of boundaries might argue in turn that minds or souls are themselves a species of zero-dimensional boundary). It may be that there are boundaries which are not parts of that which they bound: holes, for example, have boundaries of this sort on the view defended by Casati and Varzi (1994).

We can easily construct further counterexamples to the definition of boundary that is here formulated: take x to be the mereological sum of a banana together with a point on the surface of an apple. Then the point on the apple is a necessary proper part (it cannot exist without relevant larger apple-parts), and thus so also is the sum in question (it cannot exist without analogous larger parts of a banana-including sum); yet x is not itself a boundary. A more adequate definition of boundary along Brentanian-Chisholmian lines would therefore be (in keeping with Chisholm's own approach at p. 85 of his 1989):

DB. $Bx := \square_x \forall z[z \leq x \rightarrow \exists y(Ky \wedge z < y)]$

(a boundary is an entity which is as a matter of necessity such that it *and all its parts* are necessary proper parts of bodies).

In this way, too, we rule out interiors of bodies (though we seem not to rule out minds or souls, and other like examples).

Recall our principle to the effect that that which is above all else characteristic of a continuum is the possibility of a coincidence of boundaries. Chisholm gives as axiom (1992/93, p. 17):

$Bx \leftrightarrow \lozenge_x \exists y(x \sim y \wedge \neg\, y < x).$

A simpler axiom is:

AB1. $Bx \leftrightarrow x \sim x$ (boundaries are self-coincident)

Boundaries fall into two classes: punctiform boundaries, which have no extension, and boundaries of other sorts which share with bodies some of the extension which the latter in every case enjoy. Defining point as follows:

DPT. $PTx := Bx \wedge \forall y(y \leq x \rightarrow y \sim x)$ (point)

we can then assert by analogy with AK2:

AB2. $Bx \rightarrow PTx \vee \exists yz(By \wedge Bz \wedge y \cup z = x \wedge \neg\, yOz)$
 (weak density)

(every nonpunctiform boundary can be divided into two discrete boundary parts).

IF THERE BE MONSTERS

Consider the following superficially attractive density principle:

(**) $\forall x \exists y (y \leq x \wedge y \sim y)$.

This asserts that boundaries are thick on the ground (that everything has or includes one: that boundaries and nonboundaries mutually penetrate). Unfortunately we can easily prove from this principle that the world is built up out of boundaries alone. Or in other words that the sum total of everything is equal to the sum total of self-coinciders: $\sigma x(x = x) = \sigma x(x \sim x)$.

Let us suppose, for the sake of argument, that we are able to protect our theory from a conclusion of this sort. (Recall that one of our reasons for rejecting the set-theoretical conception of the continuum above was our rejection of the view that what is extended can somehow be built up by combining together a sufficiently large number of extensionless parts.) We are then able to countenance a thought-experiment along the following lines.[20] We define the form of a body as the sum total of all the boundaries within it: a body's *matter* (its unformed *materia prima*) can then be defined as what results when this form is taken away (the latter is of course merely the abstract result of a purely abstract subtraction, for form and matter are each as a matter of necessity such that they cannot exist without the other):

DF. $\mathrm{form}(x) := \sigma y(y < x \wedge y \sim y)$
DM. $\mathrm{matter}(x) := x - \mathrm{form}(x)$.[21]

Note that both the form and the matter of a body are dense; but neither constitutes a continuum, since a continuum is essentially such as to contain both boundaries and the things they bound.

But now other such artefacts can be constructed (or defined within our theory). Given any point within the interior of a body, we can define its left- and right-directed point-counterparts, two different sorts of punctiform plerotic parts within the given point, as follows: take a spherical neighborhood around the given point as center, and imagine a vertical plane bisecting the neighborhood. Then the left-directed points (LDP's) are all those points coincident with the given point which serve as boundaries in directions properly included within the left hemisphere; the right-directed points (RDP's) are all those points coincident with the

given point which serve as boundaries in directions properly included within the right hemisphere. We can now define two new sorts of bodily parts: the left- and right-point-surrogates of a body, respectively:

DLPS. $LPS(x) := \sigma y(y < x \wedge LDPy)$
DLPR. $RPS(x) := \sigma y(y < x \wedge RDPy)$.

The principle that from extensionless points extended wholes can never be constructed implies that these peculiar bodily surrogates are strictly distinct from the body itself with which we begin. They are analogues, within our mereotopological frameworks of the space-filling curves, the Menger-Sierpinski sponges, and the deleted Tychonoff planks of standard set theory.[22] Such monsters force us to be on our guard when formulating axioms and definitions, since our definitions may be satisfied by the monsters in question even though the latter correspond in no wise to the intuitive understanding which these definitions were designed to express. If on the other hand we accept the density principle (**) above, and swallow the consequences which we have otherwise seen reason to reject, then we thereby exclude these eldritch creatures by having them collapse onto each other and onto their respective bodies. This in turn, however, will carry a further price to the effect that our initial mereological axioms will have to be adjusted. Specifically, the standard ('additive') mereological summing principle will need to be replaced by a principle which allows that the sum of two objects may contain as parts objects which do not overlap with either of the two objects with which we begin.[23]

VARIETIES OF CONNECTEDNESS

A pair of spatial entities are in contact with each other directly when their respective boundaries, in whole or in part, coincide. Chisholm defines *direct contact* as follows:

> x is in direct spatial contact with y := a constituent of x spatially coincides with a constituent of y. (1992/93, p. 16)

Unfortunately, however, this definition does not work in the general case. Thus for example it cannot capture the case in which a point-boundary x inside the interior of a body y is in direct contact with the punctured neighborhood $y-\sigma z(z \sim x)$. We can, however, define a relation of direct contact for bodies:

DDCOK. $xDCOKy := Kx \wedge Ky \wedge \exists vw(v < x \wedge w < y \wedge$
$v \sim w \wedge v \neq w)$ (bodily direct contact)

Note, however, that this definition imposes no constraint of connected-
ness on either x or y or their sum. Consider the case where x is the
mereological sum of a banana and a point on an apple, y the mereologi-
cal sum of some coincident point on the same apple together with a
second banana some miles distant from the first. We then have xDCOKy
even though the whole x ∪ y is not connected.

At this point Chisholm writes:

> A thing that turns back on itself (e.g. a tire, a hoop, or a doughnut) is in
> contact with itself. Lines and surfaces can turn back on themselves.
> (1992/93, p. 17)

A pliable rod, it seems clear, can be turned back upon itself in some
special sense (the two ends can be brought into contact with each other).
But surely the sense in which a doughnut is in contact with itself applies
to all connected bodies (consider v in DDCOK as the right boundary of
the left hemisphere of a sphere, w as the left boundary of the right
hemisphere of the same sphere). Indeed it follows from our considera-
tions on internal boundaries above that xDCOKx holds for every body x,
since every body is large or thick enough to contain at least two
coincident entities as parts.

TOUCHING

In fact, to do justice to what Chisholm has in mind, we must therefore
distinguish *touching* as a special case of direct contact which applies only
to coincident parts of external boundaries of mutually discrete bodies:
an entity x touches an entity y if each is such that it can exist without
detriment even should the other be destroyed. We might, accordingly,
introduce a new primitive 'exists' (symbolized by 'E!') and formulate a
definition along the lines of:

DTO. $xTOy := xDCOKy \land \neg xOy \land$
 $\forall z(z \leq y \to \Diamond_x E!z) \land \forall z(z \leq x \to \Diamond_y \neg E!z)$ (touching)

(x touches y iff x and y are discrete bodies in direct contact and, given
any part z of y, x is possibly such that z does not exist and, given any part
z of x, y is possibly such that z does not exist).

Thus imagine a pair of exactly similar hemispheres h_1 and h_2 which
touch each other in such a way that the flat portions of each coincide in a
horizontal plane. Imagine, on the other hand, a single sphere s, of
identical proportions. s has running through its central horizontal plane
a boundary in full plerosis that is in many respects similar to the sum of

coincident boundaries, each in half plerosis, existing where h_1 and h_2 touch. The former differs from the latter, now, in that we can separate this sum of coincident boundaries without detriment to either half of the pair. The two correspondingly coincident boundaries in the solid sphere cannot, correspondingly, be cut apart: they belong together intrinsically (as a matter of necessity).

CONTACT

Bodies are *in contact* in the broader sense when they and all their parts are connected to one another, possibly via others, in such a way as to establish a seamless chain of direct contact. Chisholm seeks to define *contact* in this wider sense as the successor-relation of direct contact as follows:

> x is in *spatial contact* with y := x belongs to every class C which contains y and anything that is in direct spatial contact with any member of C. (1992/93, p. 17)

Here we take a different tack, one surely more in keeping with the remainder of the present theory, and define first of all what it is for a body to be *connected*:

DCNK. $CNKx := Kx \land \forall yz[(Ky \land Kz \land x = y \cup z) \rightarrow yDCOKz]$
$$\text{(connectedness for bodies)}^{24}$$

(x is a connected body iff all partitions of x into a pair of bodies y and z are such that y is in direct contact with z).

We go on to set as a definition of *bodily contact*:

DCOK. $xCOKy := Kx \land Ky \land \exists z (CNKz \land x \cup y \le z)$
$$\text{(bodily contact)}$$

(bodies x and y are in bodily contact iff their sum is part of some connected body).

My left hand and my right hand are in contact with each other in this sense as long as they remain attached to my body; they are in direct contact only if they touch each other.

A further sort of contact, illustrated by the case of two coincident surfaces, s_1 and s_2, where every part of s_1 is in contact with some part of s_2 and vice versa, is called by Chisholm *total contact*:

$$xTCOy := \forall z[z \le y \rightarrow \exists w(w \le x \land z \sim w)] \land \forall z[z \le x \rightarrow \exists w(w \le y \land z \sim w)]$$

(x is in total contact with y iff x and y are in contact and all parts of x and y are in contact with corresponding parts of y and x).

Total contact is clearly impossible between entities that have any sort of thickness. (Such thickness would, as it were, shield certain interior parts from contact with the other entity.) Accordingly, Chisholm asserts as axiom:

xTCOy ↔ x ~ y.

Boundary Of

Rushing in where Chisholm fears to tread, we may now define a series of further mereotopological concepts on the basis of the notions defined thus far. Thus we may define the relational concept x *is a boundary of the body* y, where x is to be conceived as an exterior boundary—and thus as a boundary in the surface of y (which may mean: in the surface of an internal cavity of y):

DBK. $xBKy := Bx \wedge x < y \wedge Ky \wedge$
$\qquad \diamond_y \exists z[yTOz \wedge \exists w(w < z \wedge x \sim w)]$ (boundary of body)

(x is a boundary of a body y iff x is a boundary and a part of y and y is possibly such as to touch some z with part of which x is coincident).

We may then define the notion of a maximal (exterior) boundary (complete boundary or 'envelope') of a body as follows:

DCBK. $xCBKy := xBKy \wedge \forall z(zBKy \rightarrow z \leq x)$ (envelope)

Connectedness for Boundaries

We may define *connectedness for boundaries* as follows:

DCNB. $CNBx := Bx \wedge \forall yz(y \cup z = x \wedge \forall uv[(Ku \wedge Kv \wedge yBKu \wedge zBKv) \rightarrow uDCOKv])$ (connectedness for boundaries)[25]

(a boundary is connected iff any partition into y and z is such that if y is a boundary of body u and z is a boundary of body v then u and v are in direct contact.)

We may then define *connectedness* in *general* as follows:

DCN. $CNx := CNKx \vee CNBx$ (connectedness)

In addition, and at the risk of some redundancy, we can assert the following principles for boundaries:

AB3. $(xBy \land yBz) \rightarrow xBz$ (transitivity)
AB4. $(xBz \land yBz \land x \sim y) \rightarrow x = y$
 (coincident boundaries of identicals are identical)
AB5. $(xBz \land yBz) \rightarrow x \cup yBz$ (finite union)

We can prove:

TB1. $xBy \rightarrow \neg yBx$ (antisymmetry)

from which it follows trivially that it is never the case that xBx.

SUBSTANCE

Our gloss on the primitive concept of *body* told us that bodies can fall short of being substances in two different ways: (1) in being too big, they contain two or more bodies as nonconnected parts; (2) in being too small, they are parts of larger connected bodies (as one solid metal sphere may be discriminable inside a second, larger sphere).[26]

To exclude the first sort of counterexample we shall need to insist, following Chisholm,[27] that substances are connected bodies. To exclude counterexamples of the second sort we shall need to require in addition that substances are maximally connected bodies. This yields as candidate the definition

$$Sx := CNKx \land \forall y(x < y \rightarrow \neg CNKy).$$

We still, however, need to take account of the possibility that one substance might touch (be more or less momentarily in contact with) another. (The mereological sum of two such substances is connected by our definition of CNK above.) Accordingly we set:

DS. $Sx := CNKx \land \forall y[(x < y \land CNKy) \rightarrow \exists t(x \cup t = y \land xTOt)]$
 (substance)

(a substance is a connected body which is such that if it serves as part of a larger connected body then this only because it touches some second body).

Note that DS is consistent with the fact that substances may have holes of various shapes and sizes.

Dimensions

Boundaries can be classified according to the number of their dimensions. Thus we can distinguish one-, two-, and three-dimensional continua and we can even contemplate continua of higher numbers of dimensions. From Brentano's point of view, a continuum

> is to be designated as one-dimensional if it has no other boundaries than such as are not themselves continuous. . . . The spatial line, too, has no boundaries other than non-extended ones, namely the spatial points, and it is for this reason that Euclid defined the point as that which has no parts. The surface, in contrast, belongs with the two-dimensional continua since its boundaries comprehend not only points but also lines. And a body is to be designated as a three-dimensional continuum since not only is the whole body bounded by a surface but so also each one of its parts is separated from the remainder by a surface that is a two-dimensional boundary. (1988, p. 10)

Chisholm's approach to the problem of dimension is to begin by defining *surface* as follows:

$$SFx := Bx \wedge \Diamond_x \neg \exists y \, (x < y \wedge By)$$

(a surface is a boundary—an envelope—which is possibly such that it is not a proper part of a boundary).

One problem with this definition, conceived as a definition of what we normally think of as two-dimensional boundaries, turns on the fact that there might be what Brentano calls 'topoids' of four or more dimensions, whose boundaries would satisfy the definition yet would not be surfaces in the intended (two-dimensional) sense. This we might solve by means of an axiom ruling out such cases, for example by setting as axiom:

$$\forall x \exists y (Ky \wedge x \leq y).$$

This will serve our purposes, however, only if we know in advance that bodies have always exactly three dimensions. This in its turn cannot be stipulated as an axiom unless we already have a concept of dimension at our disposal. No simple way out of this impasse presents itself, though for the moment we can follow Chisholm and impose (in effect) the requirement that the range of variables of our theory be restricted to spatial objects of three or less than three dimensions.

Another problem with Chisholm's proposed definition of surface is that it does not do justice to what we might call open surfaces, surfaces which are arbitrarily delineated subregions of other, larger surfaces.

A better definition can be achieved if we use an earlier proposal

(advanced by Chisholm in his 1989, p. 88) and define surfaces by appealing to the fact that a surface, unlike other boundaries, can coincide at most with one other surface (where points and lines can coincide with an infinity of other points and lines). We then have (provisionally and tentatively):

DSF. $SFx := Bx \wedge \Box_x \forall yz[(x \sim y \wedge y \sim z) \rightarrow (z = x \vee z = y)]$.

Points, Lines, and Surfaces

We have already given the following definition of point:

DPT. $PTx := Bx \wedge \forall y(y \leq x \rightarrow y \sim x)$.

Chisholm defines point as follows (1992/93, p. 19):

$PTx := Bx \wedge \neg \Diamond_x \exists y(y < x)$.

The problem with a definition of this sort is that as we have seen, the mereological sum of coincident points (the red, green, and blue points at the center of a disk divided into three differently colored segments) is itself a point, and thus such as to have proper parts. Chisholm seeks to define *line* as follows (1992/93, p. 19):

$LNx := Bx \wedge \exists y (y < x) \wedge \neg SFx$.

A line would then be a boundary which has parts but is not a surface. To rule out complex points from counting as lines the middle conjunct needs to be adjusted to:

$\exists y(y < x \wedge \neg x \sim y)$.

Sums of separate boundaries (pairs of separate points, sums of points, and lines, etc.) would still provide counterexamples to the definition. To solve these difficult problems in the space available to us here we therefore introduce the notion of sameness of dimension ($=_{dim}$) as an additional primitive notion of our theory.[28]

We can now affirm a generalization of the subtraction theorem for bodies (TK1) above:

ADim1. $(x < y \wedge x =_{dim} y) \rightarrow x =_{dim} (x-y)$

We can also define, by analogy with the case for bodies, what it is for two boundaries to be in direct contact:

DDCOB. $xDCOBy := Bx \wedge By \wedge x =_{dim} y \wedge \exists vw(v < x \wedge w < y \wedge v \sim w \wedge v \neq w)$

And we can affirm an axiom of *density for non-punctiform boundaries*:

ADim2. Bx → PTx \lor \existsyz (By \land Bz \land y \cup z = x \land \neg yOz \land x $=_{dim}$
 y $=_{dim}$ z).

Can we now define a line as a suitably complex dense boundary that
is not a surface and that is connected? To see why not, consider
complexes of lines like these, which meet all of these conditions and yet
are not *lines*:

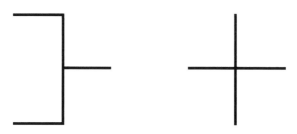

Let us therefore define first of all the notion of a *line-complex* via:

DLC. LCx := Bx \land CNBx \land \neg PTx \land $\neg\exists$y(SFy \land y ≤ x)
 (line-complex)

We can eliminate those and other troublesome line-complexes by defin-
ing a relation of *contact for line-complexes* and restricting lines to those
line complexes where at most two constituents are in contact at any given
point:

DLCC. xLCCy := LCx \land LCy \land CNBx\cupy \land \neg xOy
 (connectedness for line-complexes)

We then set:

DLN. LNx := LCx \land \forallyz[(y < x \land z < x \land yLCCz)
 → \forallw[(w < x \land wLCCy) → wOz)]] (line)

(lines are line-complexes which, for every point of their extension, can be
split into at most two mutually disjoint constituent line-complexes).

A similar operation will now have to be mounted in order to
distinguish genuine surfaces from surface-complexes which arise where
surfaces cross or split. (We shall then need to reexamine our definition of
line-complex, which employs our earlier, provisional definition of sur-
face.)

Even when this is done, much will have been left unsaid. Thus we
have not specified that points are parts of lines, that lines are parts of
surfaces. Thus a fortiori we have not said either that lines are not mere

sums of points and that surfaces are not mere sums of lines. Nor have we said that lines and surfaces *have* boundaries. We have not defined the single dimensions, nor ruled out fractional dimensions, nor have we said that points, lines, and surfaces are entities of zero, one, and two dimensions, respectively. All of these things need to be proved, or stipulated axiomatically on the basis of intuitively reasonable, sound, and satisfactory mereotopological considerations. Only then will we have more than the beginnings of a theory of boundaries and coincidence.

BARRY SMITH
DEPARTMENT OF PHILOSOPHY AND CENTER FOR COGNITIVE SCIENCE
SUNY AT BUFFALO
APRIL 1996

NOTES

1. Early drafts of this essay were prepared as part of the project "Formal Ontology and the Philosophical Foundations of Artificial Intelligence Research" of the Swiss National Foundation (SNF). These drafts were presented at workshops in Padua and Hamburg in 1993 and 1994. My thanks go especially to Carola Eschenbach and I am grateful also to Roberto Casati, Nicola Guarino, Christopher Habel, Wolfgang Heydrich, Barbara Morawska, Mark Textor, Achille Varzi, Graham White, and Wojciech Zelaniec for helpful comments, and also to the Alexander von Humboldt-Stiftung for generous support.

2. For further discussion of temporal analogues of the issues here discussed see Pianesi and Varzi 1996. See also, for a general formal treatment, Galton 1995.

3. The popularity of set theory among contemporary philosophers has been further sustained by remnants of older corpuscularistic ideas to the effect that atomistic physics (or some similar deep-level theory) enjoys a privileged status over other, competing assays of reality.

4. See Simons 1987.

5. Cf. Brentano 1988, p. 22.

6. On holes and their hosts see Casati and Varzi 1994.

7. Brentano even went so far as to identify boundaries as special sorts of universals:

Because a boundary, even when itself continuous, can never exist except as belonging to something continuous of more dimensions (indeed receives its fully determinate and exactly specific character only through the manner of this belongingness), it is, considered for itself, nothing other than a universal, to which as to other universals more than one thing can correspond. (Brentano 1988, p. 12)

8. See for example his 1989a, pp. 115, 157.

9. An alternative view along these lines is defended by Brentano in the following passage:

> What is continuous can be sub-divided . . . into what is continuously many and what is continuously manifold. . . . As an example of the continuously many we can give a body, of the continuously manifold someone who sees something spatial precisely in so far as he sees it. The body is a unity which can be decomposed into a plurality in such a way that if one of its parts is destroyed the remainder can continue to exist just as it was before. . . . Things are quite different in the case of someone who intuits something spatially extended. This someone is as such not something simple but something manifold, since he sees not merely one but many parts of a continuum and could go on to see one such part while he ceases to see the others. But in so far as he sees the one part he does not amount to something totally other than what he is in so far as he sees the other part. We have before us not a duality, as we would have in the case where it was one who sees this part and another who sees that. . . . I cannot speak of a plurality of unities here but only of the manifold character of something that is itself one. . . . This distinction between the continuously many and the continuously manifold was borne insufficiently in mind by Aristotle when he inferred a spatial extension of the sensing subject from the spatial extension of the objects of sense. The consideration of what is given when someone who momentarily presents to himself a temporal continuum could have kept him from this false conclusion. (Brentano 1988, pp. 32f.)

10. Brentano 1981, p. 56: translation corrected. The continuum is specifically dependent on its boundary, but the boundary is not in this same sense dependent on its continuum: it is only generically so. See § 10 of Smith 1992 for further discussion of this generic dependence of boundaries upon their hosts.

11. See Brentano 1988, pp. 10f. A line stretching from the surface of the sphere to its midpoint is partly internal, partly external. Note that a boundary on the surface of a cavity inside a sphere is an external boundary, in our present terminology.

12. Since boundaries in general exist always in consort with, and are determined in their nature by, the things they bound, we might think of boundaries as being 'unsaturated' in something like Frege's sense, which is to say: they need to be completed in certain predetermined ways and in certain predetermined directions.

13. Note that, if a boundary is determined essentially by the direction in which it bounds, then the following question presents itself: if a point is the interior boundary of a straight line and the line becomes bent into a semicircle, does the point retain its identity?

14. This is in fact a slightly weakened version of Chisholm's remainder principle:

$$y < x \rightarrow \exists z(z < x - y).$$

The latter would imply that atoms do not exist, an implication which, for the sake of neutrality and generality, we here wish to avoid.

15. Varzi 1994 provides an extended treatment of the problems here at issue.

16. To aid his intuitions, the reader might provisionally view coincidence as a relation which obtains between two boundaries whenever they occupy exactly the same spatial location.

17. See for example chapter 1 of Steen and Seebach 1978.

18. This definition is formulated by Chisholm in terms of the notions: individual thing, part, coincidence, and possibility. We note in passing that there is a question whether the concept of what is spatial can truly be defined exclusively by means of such purely formal, abstract notions.

19. See Chisholm 1989a, pp. 90–99; Cartwright, 1975.

20. Compare Zimmerman 1996.

21. These definitions may capture part of what is involved in the insight that bodies, in contrast to boundaries, are bulky: 'matter', on our present conception, is another term for bulk.

22. See, again, Steen and Seebach 1978.

23. For a discussion of such nonadditive summation principles see Smith 1991.

24. We might seek to define *connectedness for boundaries* analogously by means of:

$$\text{CNBx} := \text{Bx} \wedge \forall yz[(\text{By} \wedge \text{Bz} \wedge x = y \cup z) \rightarrow \exists vw(v \leq y \wedge w \leq z \wedge v \neq w \wedge v \sim w)]$$

This will not work, however, as can be seen if we take a connected line x, and define y as the result of subtracting from x the sum z of all points in x coincident with a given interior point. We must return to this issue later, when we have a notion of *sameness of dimension* (and when we are in a position to eliminate punctured entities and other similar monsters from the class of boundaries).

25. With the help of this concept of connectedness for boundaries, the definition of xBKy would enable us to formulate the equivalent of the "second Brentanian thesis" of Smith 1993, which affirms, for connected boundaries, the existence of connected bodies which they are the boundaries of:

$$(\text{Bx} \wedge \text{CNBx}) \rightarrow \exists y \, (\text{xBKy} \wedge \text{CNKy}).$$

26. Every substance contains *substantials* which are in this sense too small. Thus my arm is a substantial in relation to me as substance. See Smith 1997.

27. Chisholm gives the definition (1992/93, p. 17):

$$\text{Sx} := \text{Kx} \wedge \forall y[y < x \wedge \text{Ky} \sim \exists z(z < x \wedge z \neq y \wedge y\text{COz})]$$

(a substance is a body all of whose proper bodily parts are in contact with some other proper parts).

This is too weak, however. Even collectives made up of several separate bodies are such that all parts y are in contact either with their own respective proper parts or, in case y is a point which has no proper parts, with the surrounding portion of the relevant body.

28. This notion can, incidentally, enable us to formulate an alternative definition of connectedness for boundaries along the following lines:

DCNB*. $\text{CNBx} := \text{Bx} \wedge \forall yz[(\text{By} \wedge \text{Bz} \wedge x =_{\dim} y =_{\dim} z \wedge x = y \cup z) \rightarrow \exists vw(v \leq y \wedge w \leq z \wedge v \neq w \wedge v \sim w)].$

REFERENCES

Brentano, Franz. 1981. *The Theory of Categories.* Translated by Roderick M. Chisholm and Norbert Guterman. The Hague: Martinus Nijhoff.

———.1988. *Philosophical Investigations on Space, Time, and the Continuum.* Edited by Stephan Körner and Roderick M. Chisholm, translated by Barry Smith. London/New York/Sydney: Croom Helm.

Cartwright, Richard. 1975. "Scattered Objects." In K. Lehrer, ed., *Analysis and Metaphysics,* 153–71. Dordrecht: Reidel. Reprinted in Cartwright, *Philosophical Essays,* 171–86. Cambridge, Mass.: MIT Press, 1987.

Casati, Roberto and Achille Varzi. 1994. *Holes and Other Superficialities.* Cambridge, Mass.: MIT Press.

Chisholm, Roderick M. 1982. "Beginnings and Endings." In *Brentano and Meinong Studies,* 114–24. Amsterdam: Rodopi.

———. 1983. "Boundaries as Dependent Particulars." *Grazer Philosophische Studien* 20: 87–96.

———. 1989. "Boundaries." In Chisholm 1989a, 83–90.

———. 1989a. *On Metaphysics.* Minneapolis: University of Minnesota Press.

———. 1992. "The Basic Ontological Categories." In Mulligan, ed., 1–13.

———. 1992/93. "Spatial Continuity and the Theory of Part and Whole: A Brentano Study." *Brentano Studien* 4: 11–23.

———. 1994. "Ontologically Dependent Entities." *Philosophy and Phenomenological Research* 54: 499–507.

Galton, Antony. 1995. "Towards a Qualitative Theory of Movement." In Andrew U. Frank and Werner Kuhn, eds., *Spatial Information Theory: A Theoretical Basis for GIS,* 377–96. Berlin: Springer.

Mulligan, Kevin, ed. 1992. *Language, Truth, and Ontology.* Dordrecht/Boston/London: Kluwer.

Pianesi, F. and A. C. Varzi. 1993. "Events, Topology, and Temporal Relations." *Monist* 79: 89–116.

Simons, Peter. 1987. *Parts: A Study in Ontology.* Oxford: Clarendon Press.

Smith, Barry. 1987. "The Substance of Brentano's Ontology." *Topoi* 6: 39–49.

———. 1991. "Relevance, Relatedness, and Restricted Set Theory." In G. Schurz and G. J. W. Dorn, eds., *Advances in Scientific Philosophy: Essays in Honour of Paul Weingartner,* 45–46. Amsterdam/Atlanta: Rodopi.

———. 1992. "Characteristica Universalis," 50–81. In Mulligan, ed.

———. 1993. "Ontology and the Logistic Analysis of Reality." In N. Guarino and R. Poli, eds., *Proceedings of the International Workshop on Formal Ontology in Conceptual Analysis and Knowledge Representation,* 51–68. Institute for Systems Theory and Biomedical Engineering of the Italian National Research Council, Padua, Italy. Revised version as: "Mereotopology: A Theory of Parts and Boundaries." *Data and Knowledge Engineering* 20 (1996): 286-303.

———. 1997. "On Substances, Accidents, and Universals: In Defense of a Constituent Ontology." *Philosophical Papers* 27: 105-127.

Steen, Lynn Arthur and J. Arthur Seebach. 1978. *Counterexamples in Topology.* Berlin: Springer.

Varzi, Achille. 1994. "On the Boundary between Mereology and Topology." In Roberto Casati, Barry Smith, and Graham White, eds., *Philosophy and the Cognitive Sciences,* 423–42. Vienna: Hölder-Pichler-Tempsky.

Zimmerman, Dean W. 1996. "Could Extended Objects Be Made Out of Simple Parts? An Argument for 'Atomless Gunk'." *Philosophy and Phenomenological Research* 56: 1–30.

REPLY TO BARRY SMITH

Barry Smith's "On the Nature of Boundaries: A Mereotopological Study," is the best account of my views, as well as of those of Brentano, on the subject. And it is the most thoroughgoing treatment of these subjects that is to be found.

Smith suggests a useful way of extending my theory. His suggestion leads to still another possibility which I will develop here. This development will be my reply to his essay.

The project has three stages: (A) that of saying what a spatial boundary is; (B) that of assuring ourselves that such boundaries are continuous; and (C) that of saying what an external boundary is.

My general conception of the theory of boundaries requires five primitive concepts. They are those of an individual, a (proper) part, a state, coincidence, and that expressed by "is necessarily such that" with its variant "is possibly such that." The concept of a state is required by the theory of *temporal* boundaries and not by that of spatial boundaries. The concept of coincidence is here restricted to boundaries.

We begin with spatial boundaries.

D1 x is a spatial boundary of y =Df. x is necessarily such that it is a (proper) part of y.

Now we say what a spatial individual is; for there may be individuals that are not spatial.

D2 x is a spatial individual =Df. x is an individual such that every part of it either is a spatial boundary or has a spatial boundary as a part.

A spatial individual is what Smith refers to as "a body."

We are now in a position to define spatial continuity.

D3 x is a spatially continuous individual =Df. x is a spatial individual such that, for every spatial individual y that is a (proper) part of x, there is a spatial individual that is part of x and other than y.

Divide such an individual as you will and the leftovers will still be spatial individuals.

Finally I offer a definition of what an *external* boundary is.

D4 x is one of the external boundaries of y =Df. x is possibly such that a spatial individual having only boundaries in common with it has a boundary such that all its parts coincide with one of y's boundaries.

Concerning the number of boundaries that a thing may have, note that: a Parmenidian plenum has none; a ring has two; a solid can has three; and a slice of Swiss cheese may have as many more than one as you like.

We no longer need Brentano's concept of the fullness or plerosis of a boundary. A boundary is in complete plerosis if and only if it is not external.

I agree with Smith, then, on the essentials of "mereotopology."

R.M.C.

25

Martine Nida-Rümelin

CHISHOLM ON PERSONAL IDENTITY AND THE ATTRIBUTION OF EXPERIENCES

INTRODUCTION

Maria goes to the hospital on Monday evening. She has no chance to survive except by having her brain transplanted into another body. On Tuesday morning a woman wakes up after the transplantation with a brain that was Maria's brain on Monday. When Maria goes to the hospital she believes that she will wake up after the operation and she anticipates with horror the strange experience of having a new body.[1] Maria believes that she will be the person that wakes up after the operation. She believes that this specific future 'postoperational' person (I will call her the PO-person in the following) is *identical* with herself.

Maria's case is an example of the type of epistemic situation considered in the philosophical discussion about personal identity through time: We know of a certain person P that he or she existed at time t_1 and we can refer by some definite description to a future person P' that will exist at t_2. In this epistemic situation we consider the question whether P and P' are one and the same. Most people, nonphilosophers and philosophers as well, would not seriously doubt the identity between Maria and the person who wakes up after the transplantation. But what is it we thereby agree about? What is asserted by saying that Maria and this future person are one and the same? As is well-known, philosophers disagree quite radically about what the correct answers are to these questions.

Reductionists with respect to personal identity through time believe that there is some empirical transtemporal relation R (e.g., of psychological continuity, bodily continuity, or some combination thereof) such that the question whether Maria and the PO-person are identical amounts to the question whether they stand in the relation R. Most

reductionists, however, do *not* mean to say that the meaning of the sentence "Maria is identical with the PO-person" when uttered in the situation at issue can be analyzed by the sentence "Maria and the PO-person are R-related" (for an appropriately chosen relation R). They do admit that there is something more to the *meaning* of such identity statements than what is asserted by saying that the persons at issue are empirically related in a certain way. But the reductionist typically insists on the following claim: Insofar as, e.g., "Maria is identical with the PO-person" is a statement about the world (about something that may or may not be the case), it can be reformulated by some appropriate statement about the holding of a certain empirical relation R.

There is some prima facie plausibility to the reductionist view: Human beings are products of nature. The human organism in front of me now, in 1996, when I talk with my cousin Robin, has evolved in a typical manner out of the small human organism I remember having seen thirty years ago. I seem to be justified in accepting the identity of Robin, the person in front of me now, and Robin, the four-year-old child of 1966, on the basis of my knowledge that this adult human body has developed from the four-year-old human body of 1966. One might thus be led to the conclusion that to assert the identity of Robin, the adult person in 1996, and Robin the four-year old of 1966 is to assert something like the following: those empirical transtemporal relations that typically hold in a case of normal development of a human organism through time, hold in the case at issue.

But the intuitive plausibility of the reductionist view seems to disappear on further reflection. Empirical concepts typically allow for borderline cases. Therefore, if the reductionist is right, then cases may arise where the question whether a person A is identical with a later existing person B has no definite answer and can only be decided by convention. In such a case there is in principle no correct answer to A's question as to what he or she will experience at the later moment considered. The nonreductionist insists that this consequence contradicts our most basic natural intuitions.

Most contemporary philosophers in the analytical tradition presuppose that some version of reductionism with respect to personal identity must be correct. Philosophical work about the topic is in the great majority of cases devoted to a discussion of competing versions of reductionism. There are few among those who participate in the ongoing debate who defend a nonreductionist view. Chisholm is one of the most important contemporary proponents of nonreductionism with respect to personal identity.

In what follows I shall describe, comment on, and defend Chisholm's

view. In the first part, several central claims that may be taken to characterize Chisholm's position will be explicated and their systematic interrelation explored.[2] The second part goes beyond what Chisholm explicitly states in his writings. I will propose a reconstruction of Chisholm's view about personal identity on the basis of a thesis about the attribution of experiences to others. This thesis seems to me to be a natural addition to Chisholm's view of self-attribution. The reconstruction proposed will relate Chisholm's view about personal identity to his theory of what he calls direct attribution.

PART I: CHISHOLM'S VIEW OF PERSONAL IDENTITY: FIVE THESES

2.1. No Borderline Cases

In "Identity through Time"[3] Chisholm first discusses the problem of persistence for ordinary material objects without consciousness and, following Butler, he proposes the view that in these cases we may speak of identity through time only in a 'loose and popular sense of identity'.[4] Chisholm proposes an interpretation of transtemporal identity statements with respect to ordinary material objects without consciousness: "x is the same as y" when used to assert the persistence of, e.g., a ship, should be interpreted as "x constitutes the same ship as y." The notion of constitution is intuitively introduced by the example of railroad trains:

> Suppose we ask: Is this the same train we rode on last year? We are not concerned to know whether the set of objects that makes up today's train is identical with the set of objects that made up the train of a year ago.[5]

According to Chisholm what we *are* concerned to know in this case is whether the set of cars we ride on today 'constitute' the same train as the train that was constituted by the set of cars we rode on last year. Analogously, according to Chisholm, to say that this is the same ship I saw yesterday, is to say that the object y I now refer to now constitutes the same ship that was constituted by the object x that I saw yesterday. "x is the same as y" on this interpretation therefore does not imply identity between x and y. Chisholm then states his view that there are no borderline cases of personal identity through time in the following way:

> [W]e are using the expression 'x is the same person as y' in a strict and philosophical sense if we are using it in such a way that it implies 'x is identical with y'. I wish to suggest that 'x is the same person as y', where the expression in the place of 'x' is taken to designate a certain person as existing at one time and where the expression in the place of 'y' is taken to designate

a certain person existing at a different time, does have this strict and philosophical use. When we use 'the same person' in this strict way, then, although cases may well arise in which we have no way of *deciding* whether the person x is the same person as the person y, nevertheless the question "Is x the same person as y?" will *have* an answer and that answer will be either "Yes" or "No." If we know that x is a person and if we also know that y is a person, then it is not possible to imagine circumstances under which the question "Is x the same person as y?" is a borderline question—a question admitting only of a "Yes and no" answer.[6]

One may formulate the central point of the cited passage briefly as follows:

(T1) No-borderline-thesis

> In every conceivable case where a person A exists at an earlier moment t_1 and a person B exists at a later moment t_2, there is a definite answer to the question whether A and B are one and the same person.

What does it mean that there is or there is not a 'definite answer' to an identity question? To explain the intuition behind this locution it may be helpful to compare the following two examples:

Example 1:

> A ship, Michelangelo, is in part destroyed in an accident. The ship is rebuilt with several essential changes in its construction and more than 50% of its former parts are replaced. The resulting ship is given a new name, "Raffaele," and it travels following a different schedule.

Example 2:

> Anna is still more unlucky than Maria. The medical doctors not only believe it necessary to transplant her brain into another body, they also decide to replace essential parts of her brain by some other material. Unfortunately, the person who wakes up after the operation is very much unlike Anna with respect to character and memories. She even feels so much different from Anna that she does not wish to be called "Anna." She chooses the name "Petra" instead.

We may ask with respect to these examples the parallel questions:

(F1) Is Michelangelo the same ship as Raffaele?
(F2) Is Anna the same person as Petra?

Example 1 is a typical borderline case for the question of persistence. (F1) has no definite answer in the following sense: *We may decide to accept either of the two possible answers without taking any epistemic risk.* This is to say: If we decide to accept that Raffaele and Michelangelo are the same, we do not thereby take the risk that we got it the wrong way. Suppose someone said: "We agreed that Michelangelo and Raffaele are the same ship, but maybe we are wrong. Maybe, *in reality*, Michelangelo ceased to exist in the accident and Raffaele came into existence only afterwards." A person who talks this way is either confused or only pretends to consider seriously a certain hypothesis, since it is obviously unclear what it is he or she thereby considers.

Example 2 would be a typical example for a borderline case of personal identity if there were such borderline cases. But, according to Chisholm, and, as I would like to add, according to our most basic natural intuitions, there is a definite answer to question (F2). Again, one may paraphrase this claim in the following way: *If we decide to accept either of the two possible answers we do take an epistemic risk.* If we decide to accept that Anna survived and woke up with a new body, in which case Anna and Petra are one and the same, then it is possible that we got it the wrong way. We may argue that there is no reason to believe in the mysterious creation of a new person, Petra, in the case at issue. But we certainly should concede that it is quite clear what someone considers if he or she considers the possibility that Petra and Anna are not identical: If this possibility is realized then Anna's hope that she will wake up after the operation has not been fulfilled; she died and never woke up again.

I just gave an interpretation of what is meant by saying that a question has or does not have a definite answer. There is reason to believe that Chisholm would agree with this interpretation. Compare the following passage:

> [W]e cannot answer the question 'Is x the same person as y?' merely by deciding what would be practically convenient. To be sure, if we lack sufficient evidence for making a decision, it may yet be necessary for the courts to *rule* that x is the same person as y, or that he is not. . . . But if Bishop Butler, as I have interpreted him, is right, then one may always ask of any such ruling 'But is it *correct*, or *true*?'

The above passage implicitly contains another formulation of the no-borderline-thesis which may be put in the following way:

(T2) In every conceivable case where a person A exists at an earlier moment t_1 and a person B exists at a later moment t_2, the question

whether A and B are one and the same person is a factual question that cannot be decided by adopting a convention.

Given the above interpretation of what it is for a question to have a definite answer, (T1) and (T2) are only different formulations of the same claim. That a question cannot be decided by convention means that if we thus decide it, we can still meaningfully ask which answer is actually true. And this is to say that we cannot decide it without taking an epistemic risk.

Only a few contemporary philosophers agree with Chisholm with respect to the no-borderline-thesis.[7] According to mainstream opinion the no-borderline-thesis must be rejected. Some proponents of reductionism, however, do admit that according to our natural intuition there must be a definite answer to the question of personal identity in every conceivable case.[8] But they argue that this intuition should be given up like other intuitive prejudices have been when they turned out wrong after further reflection or research.

Chisholm, I think, would or could reply to this in the following way: Many of our intuitive convictions can be given up quite easily once we see that there are good theoretical reasons to believe them false. This is so, for example, with some of our unreflected moral convictions or with beliefs that are based on certain properties of perception (compare the belief that the earth is flat). But the conviction that there can be no borderline cases of personal identity is not of this kind. A borderline case of personal identity is conceptually impossible. Here the reductionist might reply: But why should it be impossible to modify our concept of a subject of experience in such a way that it allows for borderline cases of identity through time? I will come back to this point.

2.2. Chisholm on 'Fission Cases'

Closely related to the question whether there are borderline cases of transtemporal personal identity is the question how one should deal with so-called 'fission' cases. As an example consider the following possibility:

Example 3:

Andrea has been kidnapped by a group of criminal neurophysiologists who divide her brain and transplant the two halves in two living bodies. After the operation two women wake up who both believe themselves to be Andrea and share apparent memories of Andrea's life.

In "Identity through Time" Chisholm says about cases of this kind:

> Suppose you know that your body, like an amoeba, would one day undergo fission and that you would go off, so to speak, in two different directions. Suppose you also know, somehow, that the one who went off to the left would experience the most wretched of all lives and that the one who went off to the right would experience a life of great happiness and value. If I am right in saying that one's question "Will that person be I?" or "Will I be he?" always has a definite answer, then, I think, we may draw these conclusions. There is no possibility whatever that you would be *both*, the person on the right and the person on the left. Moreover, there *is* a possibility that you would be one or the other of these two persons. . . . And it seems to me absolutely certain that no fears that you might have, about being the half on the left, could reasonably be allayed by the adoption of a convention, or by the formulation of a criterion, even if our procedure were endorsed by the highest authorities.[9]

The philosophical claim about 'fission' cases to be found in this passage implies a thesis like this:

(T3) There are exactly three conceivable possibilities in a 'fission' case, where a person A has two successors B and C: Either (1) A is identical with B (and not with C), or (2) A is identical with C (and not with B), or (3) A is neither identical with B nor with C.

One might wonder how someone could possibly doubt this seemingly obvious claim. But (T3) is not commonly accepted in the debate. The content of (T3) depends, of course, on what kind of cases one wishes to summarize under the term 'fission case'. For an interpretation of Chisholm's claim one may partly characterize 'fission' cases by the following conditions:

(a) A certain person A exists at t_1.
(b) Certain persons B and C exist at t_2 and B and C are not identical.
(c) A is not identical with any person existing at t_2 other than B or C.
(d) There is no relevant difference in the transtemporal empirical relation between A and B on the one hand and A and C on the other.

Let us interpret (d) in the following way: If there is an empirical relation R holding between A and B that supports the claim that A and B are the same person, then this relation R also holds between A and C (and vice versa). It follows immediately that, if (d) holds, then no person nonidentical with A, B, or C who has all the relevant empirical knowledge could ever have reason to prefer epistemically the hypothesis that A is identical with one particular of his or her successors. Also, A, B, and C themselves are in no better epistemical position with respect to their own identity. B might seem to remember having done something

that A did and therefore believe himself or herself to be A. But, since being 'memory-related' in this way supports, we may assume, the identity hypothesis, it follows from (d) in the above given interpretation that C has the same memory-based reason to believe himself or herself to be A. But then, if B has all the relevant empirical knowledge and thus knows about C's apparent memories, B has to concede that C has equally good reason to believe himself or herself to be A, and that thus both B and C have *no* reason to believe themselves to be A on the basis of their apparent memories. So if (d) holds in a concrete case, then the identity question at issue is epistemically inaccessible in the following sense: No epistemic subject can ever have reason to prefer epistemically either of the two possible hypotheses. As is well known, many philosophers reject the idea of epistemically inaccessible facts. According to them, if there can be no reason to prefer epistemically one of the two 'possibilities' (1) and (2) cited in (T3), then there is no 'real' or 'factual' difference between the two. They thus would reject (T3) as counting too many 'possibilities' as different.

Assuming that 'fission cases' are conceivable, it follows directly from (T3) in the above given interpretation that identity facts may obtain although there is in principle no way to find out that they obtain. This thesis may be found in "Problems of Identity." After having introduced 'primary things' as individuals that have the same parts at every moment of their existence and after having proposed the view that persons are primary things, Chisholm says with respect to a foregoing example:

> We should also note that it is logically possible for a primary thing to persist from one time to another without there being any *criterion* by means of which anyone who had identified it at the earlier time could also identify it at the later time. Hence if Mr. Jones is a primary thing, it is possible that *he* will be the one who has bodily parts IJ even though neither he nor anyone else will ever know, or even have good reason to believe, that the man who now has bodily parts AB is also the man who will have bodily parts IJ.[10]

So Chisholm clearly subscribes to the following thesis:

(T4) Epistemically inaccessible identity facts

> There are conceivable cases where a person B existing at t_2 is identical with a person A who existed at t_1 and yet it is in principle impossible that anyone has reason to believe that this identity holds.

Let us now consider a subclass of fission cases which is characterized by the following assumption: The kind of psychological continuity that typically holds for one and the same person with respect to different

moments t_1 and t_2, holds between a person A existing at t_1 and two successors B and C who exist at t_2. Following Parfit many reductionists subscribe to the following view of such cases: (a) We may describe the case as one in which A does not exist at t_2 (there is no person existing at t_2 who is identical with A), but (b) it would not be appropriate in A's situation to fear 'fission' like death. The reductionist at issue holds that in a fission case of this kind what a person rationally values in his or her own survival is realized even twice and that 'fission', therefore, cannot be worse for the 'divided' person than surviving in the normal way.[11]

What is wrong with this view according to Chisholm is quite clear from the cited passage of "Identity through Time" and using example 3 it may be put as follows. There is no person at t_2, after the operation, who mysteriously has *both* bodies. (If someone doubts this assumption, we may simply take it as part of the example and as part of what characterizes 'fission cases' in general). It follows that the person who wakes up with the right hemisphere does not also experience what the person experiences who wakes up with the left hemisphere. Knowing this and considering her own future experiences Andrea therefore must exclude the possibility that she will experience both lives, the one of the successor with the left hemisphere and the one of the successor with the right hemisphere, simultaneously. She may hope, at best, that she will *either* experience what the one with the right hemisphere experiences, *or* experience what the one with the left hemisphere experiences. But Andrea will experience what a specific one of her two successors will experience iff she will *be* that specific successor. Therefore, if Andrea is not identical with either of the two, then she will have no experiences after the operation. But what Andrea fears when she fears death, we may assume, is that she will not experience anything anymore. So, contrary to the above view, one who assumes that Andrea is not identical with either of her two successors, also has to admit that it *is* rational for Andrea to fear her 'fission' like death.

2.3. Criteria of Identification

Suppose there is a controversy about whether Raffaele and Michelangelo are one and the same ship. Then, according to Chisholm, this controversy is about the *criteria* for applying the expression "x is the same ship as y." Contrary to this, if there is a controversy about whether Anna and Petra are one and the same person, then, according to Chisholm, the disagreement is not about the *criteria* for applying the expression "x is the same person as y." Considering an example similar to example 1 (the ship case), Chisholm says:

There is no dispute about any of the observational data. You are in agreement about crews, schedules, stuff, and traditions, and about what things are called what. Your dispute has to do with criteria for constituting the same ship, or, as we may now also put it, with criteria for applying the expression 'x constitutes the same ship as does y'. The members of each faction have correctly applied their own criteria. If you are inclined to say that your criterion is the right one and that the other one is the wrong one, reflect a little further and I'm sure we can find some nonphilosophical expert who can help you settle the question. Do you think, for example, that you are using 'the same ship' the way the majority of people do or the way the nautical people do? The linguists can check on that for you. Or do you think you are using it the way it's used in the courts? Then we can call in the lawyers. Or do you think that your way of using it is the most convenient one given your purposes or given the purposes of most people? State as clearly as you can what the purposes in question are and then we can find an expert who will help you out.[12]

Chisholm then considers an example where a certain Mr. Jones has two successors A and B such that there is psychological continuity between Jones and A and bodily continuity between Jones and B. Jones wishes to know whether he will be A or B. Chisholm then describes the view of someone who thinks that this question too is simply about the criteria for applying the expression "x is the same person as y" in the following way:

He will note that Mr. Jones is raising a question about criteria: Is 'the memory criterion' or 'the bodily criterion' the correct criterion of what it is for someone at one time to constitute the same person as does someone at another time'? He will point out to Mr. Jones that, in asking which is the correct criterion, he is in fact concerned with some more specific question. If he is asking how the majority of people, or how certain people, use the term 'same person', he should consult the linguists. If he is asking how the courts should deal with that question, he should look up the law books. And if he is asking, with respect to certain definite ends, what linguistic uses would best promote that ends, there will be authorities who can give him at least a probable answer.[13]

But, Chisholm points out, "after Mr. Jones has consulted the various empirical authorities, he will still wonder whether he has an answer to his question: 'Which one am I going to be'?"[14]

Here is a proposal about how to state Chisholm's view about the different role of 'criteria' in a disagreement about the identity of an object like a ship on the one hand and a person on the other:

(T5) The role of identity criteria

(1) If A and B both know that o_1 is an object without consciousness of kind F existing at t_1, and o_2 is an object without consciousness

existing at t_2, and if they agree about all relevant empirical relations that obtain between these objects but disagree about whether o_1 and o_2 are the same F, then their disagreement can be rationally reconstructed only as being about one of the following questions:

- Under what empirical conditions is it appropriate according to the standards of a certain language community (or subgroup of a language community) to say of objects of kind F that they are the same?
- Under what empirical conditions is it convenient relative to certain ends to say of objects of kind F (or of the concrete objects at issue) that they are the same?

(2) If A and B both know that p_1 is a person existing at t_1, and p_2 is a person existing at t_2, and if they agree about all relevant empirical relations that obtain between p_1 and p_2 but disagree about whether p_1 and p_2 are the same person, then their disagreement cannot be adequately interpreted as being about one of the following questions:

- Under what empirical conditions is it appropriate according to the standards of a certain language community (or subgroup of a language community) to say of a person p_1 and a person p_2 that they are the same?
- Under what empirical conditions is it convenient relative to certain ends to say of a person p_1 and a person p_2 (or of the concrete persons at issue) that they are the same?

The theses (T1)–(T5) describe the special conceptual status of claims of identity through time with respect to persons or other conscious beings which is distinct from the conceptual status of such claims with respect to objects without consciousness like ships, stones, etc. Why is the attribution of consciousness to individuals relevant to the conceptual status of identity statements with respect to these individuals in the way stated by (T1)–(T5)? Conscious beings are characterized by the fact that they are capable of experiencing something. One may therefore try to explain the special status at issue on the basis of some conceptual peculiarity of the attribution of experiences.

PART II: ATTRIBUTION OF EXPERIENCES AND PERSONAL IDENTITY: A REINTERPRETATION OF CHISHOLM'S VIEW

What follows may be seen as a comment to the following footnote 19 in "Identity through Time":

I would agree with Shoemaker's contention that "our ability to know first-person psychological statements to be true, or the fact that we make them

(for the most part) only when they are true, cannot possibly be explained by the supposition that we make them on the basis of criteria." Sidney Shoemaker, *Self-Knowledge and Self-Identity* (Ithaca, N.Y.: Cornell University Press, 1963), p. 214. One consequence of this fact, I suggest, is the following: it makes sense to suppose in connection with the above example [a 'fission case'] that you are in fact the half that goes off to the left and not the one that goes off to the right even though there is no criterion at all by means of which anyone could decide the matter.[15]

In this passage Chisholm tells us that the special conceptual status of statements of identity through time with respect to persons is based on the special status of first-person psychological statements. I will make a proposal about how one may try to spell out this theoretical interrelation.

3.1. Primacy of Transtemporal Experience Attribution

The following two sentences are logically equivalent:

(1) Maria will have a toothache on the first of April in 1997.
(2) There is a person P such that P has a toothache on the first of April in 1997 and P is identical with Maria.

Asserting (1) we attribute to Maria the property of being someone who will have a toothache next year. (1) is an example of what I will call a transtemporal experience attribution. Transtemporal experience attributions are either attributions of past or of future experiences. It might appear as if (2) in some way explicates (1) and that therefore we first need to understand what is asserted by a claim of personal identity through time, before we can understand what it means that Maria will have a toothache next year. Contrary to this I would like to propose the following view: Transtemporal experience attribution is conceptually prior to transtemporal identification. This is to say that we need to understand sentences like (1) in order to be able to understand sentences like

(3) Maria (the person I now refer to in 1996) is identical with the person P who exists in 1997,

while it is not necessary to first understand sentences like (3) in order to be able to grasp what is asserted by sentences like (1). An analogous primacy thesis is not true for objects without consciousness. In order to understand what is meant by the assertion that the ship Michelangelo will be painted in blue in 1998 we already need to have an idea of what it means for ships to persist through time. So, according to the view I wish

to propose, contrary to the case of persons and other individuals with consciousness, transtemporal identification is conceptually prior to transtemporal attribution of properties in general in the case of objects without consciousness. The point may be summarized by the following claims:

(1) (a) Transtemporal attribution of experiences does not conceptually presuppose a notion of identity through time for the kind of conscious being at issue.
 (b) Transtemporal attribution of experiences does not involve an implicit application of empirical criteria of identity through time for the kind of conscious being at issue.

(2) Claims of identity through time with respect to conscious individuals presuppose an understanding of transtemporal attribution of experiences.

(3) (a) Transtemporal attribution of properties in general to concrete things without consciousness presupposes a notion of identity through time for the kind of object at issue.
 (b) Transtemporal attribution of properties in general to concrete things without consciousness involves the implicit application of empirical criteria of identity through time for the kind of object at issue.

I will call the conjunction of these claims the 'primacy thesis' (conceptual primacy of transtemporal attribution of experiences in the first case, conceptual primacy of identification in the second).[16] To give a precise account of these claims it would be necessary to explicate several problematic locutions: For instance, what does it mean that 'a claim presupposes an understanding of another claim' or that 'an attribution involves the implicit application of certain empirical criteria'? I cannot begin clarifying these issues here but I will give examples that may help to clarify the intuitive content of these claims.

The five theses (T1)–(T5) I attributed to Chisholm can now be seen to be quite direct consequences of the view characterized by the primacy thesis.

3.2. Self-Attribution without Identification

When a traveler on a ship near Naples judges on the basis of his perception that it is raining on the island Ischia, then he may be wrong in two ways: He may be wrong in assuming that it is raining on the island he perceives. He then attributes to the island a property it actually does not

have. In this case the mistake lies in the property attribution. Or he may actually see that it rains on Procida and mistake Procida for Ischia. One may call the first kind of mistake a mispredication and the second a misidentification. In many simple examples of judgments where a property is attributed to an object, the judgment may be wrong in these two ways.

As has been pointed out by several philosophers, there is, however, only one way to be mistaken in normal cases of self-attribution of present experiences.[17] The traveler might correct himself saying: "It was indeed raining on the island out there, but I mistook this island for another one." But now compare a case where John says "I am feeling sadness but no jealousy." John might be a victim of self-deception, he might be wrong assuming that what he feels is no jealousy. So this might be a case of mispredication. But if John makes his judgment on the basis of what he feels, then it is quite clearly impossible to imagine circumstances where John could correct himself later by saying: "I was right that the person I had in mind felt sadness and no jealousy, but I was wrong about who the person was. I mistook her for myself." According to a widely accepted diagnosis the reason why normal cases of self-attribution of experiences cannot go wrong by misidentification is that there is no identification involved in the first place. When John judges that he is sad then he certainly does not first pick out a person whom he believes to be sad and then judge on the basis of the person's properties that the person is himself. In normal cases of self-attribution we do not apply any criteria of identification, rather we 'directly' refer to ourselves.[18] Chisholm introduces the technical term of direct attribution which is reserved for self-attribution: If x directly attributes the property P to y, then x is y.[19]

Now consider a case where Peter attributes to himself the property of being someone who will have a toothache tomorrow. Peter does not refer to a future person whom he believes to have a toothache and then judge on the basis of some empirical relation between this person and himself, that he will be that person. Rather he directly attributes to himself the future property at issue. In normal cases self-attribution of future and passed experiences does not involve the application of any criteria of identity.[20]

This claim may be less obvious than the analogous claim regarding self-attribution of present properties. Comparison of the following two examples may help to explicate and support this claim for the case of future experiences:

Example 4:
A) Poro has been raised in a foreign culture but he knows English

quite well. It happens sometimes, however, that Poro misunderstands certain things in a systematic manner and that he uses English sentences to assert something quite different from what is normally asserted using them. On a certain occasion Poro expresses his belief that a certain table will be painted in blue tomorrow. In the same night Poro observes the following happen: Strangers enter the house, they saw up the table and burn its parts in the fireplace. Then they carry a new table into the room that looks exactly like the old one and they paint this table in a blue color. The following day, to our surprise, Poro claims that he was right and that his prophecy has been fulfilled. He insists that the blue table over there in the middle of the room is no other table than the one he referred to the day before.

Let us suppose that Poro is honest and that he remembers very well what happened in the night. In this case there seems to be only one possible explanation for Poro's unwillingness to admit that he was wrong: He obviously has another conception of what it means for a table to persist through time. Maybe in his culture the identity of tables through time is constituted by their social function. It might be that, in his society, a table is considered the same as an earlier existing table if it is used for the same purposes by the same family.

Example 5:
Poro has to go to the dentist tomorrow and he believes he will have to suffer pains. We now ask Poro to imagine the following possibility: Medical doctors will take out his brain from his skull and destroy it and they will implant the brain of another person. The dentist will do his work after this operation. We ask Poro whether he would expect to suffer pains under the dentist's treatment in this case too. Poro knows what an educated person normally knows in our culture about the way our experiences depend on the processes in our brains. To our great surprise Poro claims to believe that in this case too he would be the one who would have to suffer the pains.

With respect to example 4 we could say that Poro obviously has another conception of what it means for a table to persist through time. When claiming that a table will have a certain property tomorrow, Poro expresses a different belief from the belief that is normally expressed in that way. In other words: From the fact that Poro accepts different criteria for the identity of tables through time it follows that Poro means something different when attributing a future property to a table. This supports the following claim: Criteria of identification enter the meaning

of sentences that are used for transtemporal attribution of properties in the case of tables and other objects without consciousness.

But should we conclude analogously with respect to example 5 that Poro wishes to assert something different from what is normally thus asserted when saying "I will have pains tomorrow"?—In a certain sense, of course, every speaker expresses a different belief when using these words on a certain occasion, since what is thus asserted depends on when and by whom the sentence is uttered. But this is not what is at stake here. In a certain sense it is always the same belief that is expressed by this sentence, namely the expectation of the speaker that he* or she* will suffer pains the next day. The following appears quite obvious: Poro's unexpected reaction does not give us reason to assume that by his first-person statement he expresses a different expectation than is normally expressed in that way. He simply has unusual opinions about the empirical conditions under which this first-person statement would turn out true.

Maybe in Poro's society people believe that the person goes where his or her heart goes which would explain his reaction. If this is so, then, where he comes from, people generally would not agree to have their heart replaced by an artificial one since they would not expect to survive such a procedure. In this society, one who knows that his heart will be transplanted into another body, expects to wake up with the other body. But obviously we do not have any difficulty understanding what these people mean by their self-attribution of future experiences. We do not need to reinterpret their self-attributions. So what criteria of personal identity through time these people accept is irrelevant for our understanding of their self-attributions of future experiences.

Examples 4 and 5 support the following claims: One who has no, or radically false, ideas about the criteria accepted in our language community for the identity through time of, e.g., a table, does not understand what is normally meant by a transtemporal attribution of a property to a table. On the other hand: From the fact that a person has radically false ideas about the criteria accepted in our language community for the identity of persons through time, it does not follow that he or she systematically misinterprets first-person statements. One who accepts radically different criteria for the identity through time for tables intends to assert something different from what is normally thus asserted when he or she attributes a future or past property to a table. But from the fact that someone accepts radically different criteria of personal identity through time it does not follow that he or she intends to assert something different from what is normally thus asserted when self-attributing a future or past experience. These observations can be explained by the

second part of the primacy thesis and by the analogue of the first part for self-attribution: Transtemporal attribution of properties to tables pre-supposes criteria of table identity through time. Contrary to this, self-attribution of future or past experiences does not conceptually presuppose criteria of transtemporal identification of persons.

To see how the nonreductionist view of personal identity may be based on these insights we have to make, I think, one essential further step: We have to realize how the special status of transtemporal self-attribution of experiences carries over to the attribution of future and past experiences to other conscious beings.

3.3. Transtemporal Attribution of Experiences to Others

Some philosophers seem to suspect an asymmetry with respect to the problem of personal identity between the first-person point of view and the third-person point of view that may be formulated in the following way: When a person like Andrea (example 3) knows that she will undergo 'fission', then from her point of view (from the first-person perspective), the question makes sense whether she will have the experiences of her successor A or those of her successor C. But, from a third-person perspective the corresponding question whether Andrea will have the experiences of, e.g., her successor B cannot be meaningfully asked without thereby presupposing some empirical criteria of identity through time. And since, ex hypothesi, there is no relevant empirical difference between B and C in their relations to Andrea, we cannot, from a third-person perspective, meaningfully consider the hypothesis that Andrea is, e.g., identical with B and not with C. If, however, the view I proposed is correct, then there is no such asymmetry between the first- and the third-person perspective with respect to personal identity through time. If we can grasp self-attributions without thereby presupposing empirical criteria of personal identity through time, then this is true not just for our own self-attributions but for those made by others as well: We can understand without implicit reference to criteria of identity through time what Andrea wishes to know when she asks herself whether she will have the experiences of her successor B.

Another story about Poro may help to clarify this point. Suppose Poro believes, as mentioned before, that 'the person goes where his or her heart goes'. He knows that the heart of his friend Peter will be transplanted into another body and he knows, for some reason, that the person who will wake up with this body will listen to the second movement of Schubert's second piano trio immediately after waking up. On the basis of his strange belief in the special role of the heart, Poro

believes that Peter will listen to this part of the trio. Poro believes that
Peter would be right if he self-attributed the future property of listening
to this piece of music, if he expected having this specific kind of acoustic
experience. Poro does not need to make reference to any criteria of
identity through time to understand what it would mean that Peter
correctly attributes this future experience to himself. But to attribute a
future experience to a person amounts to believing that the person would
be right if he or she self-attributed the experience at issue. Therefore, if it
is correct that we can consider the hypothesis that another person is
correctly self-attributing a future or past experience without thereby
presupposing any empirical criteria of transtemporal personal identity,
then we can attribute future and past experiences to others without such
reference to empirical criteria.

3.4. Chisholm's View of Personal Identity and the Primacy Thesis

Let us now turn to the relation between the primacy thesis and
Chisholm's view of personal identity. In normal cases where a property
is attributed to an object, there are, as has been explained before, two
ways to be mistaken, through mispredication and through misidentifica-
tion. Analogously, in normal cases, there are two sources for vagueness.
The question whether the ship Michelangelo is painted in blue next year
may have no definite answer for two different kinds of reasons: Michel-
angelo may be painted next year in a color somewhere between blue and
violet in which case the source for vagueness lies in the vagueness of the
attributed property; we thus have, as one might say, a case of vagueness
through predication. Or there is, next year, actually a ship that is painted
in a color that is a clear case of blue, but the question whether this ship is
Michelangelo can only be decided by convention. In this case we have, as
one might say, vagueness through identification. There is no conceptual
room, however, for vagueness through identification in those exceptional
cases where the attribution of a property does not conceptually involve
an identification of the object at issue. When I assert that I am in pain,
my self-attribution may be neither true nor false only if the way I feel is a
borderline case of being in pain. If the primacy thesis is correct, then the
same applies to attributions of experiences to others. This is why we may
apply the intuitive standard argument against the possibility of border-
line cases of personal identity: Suppose that the identity of a person A
existing at t_1 and a person B existing at t_2 is underdetermined (the
question whether the identity holds does not admit of a 'yes' or 'no'
answer). Now assume that there is some kind of experience E such that B

clearly has experience E at t_2 and such that every other person existing at t_2 clearly does not have this kind of experience at t_2. Then vagueness through predication is excluded for the attribution "A has the kind of experience E at t_2." Since A has the kind of experience E at t_2 iff A and B are identical, this is also true for the corresponding identity claim (compare [T1]). If this is so, then the question whether A and B are one and the same, cannot be ruled by convention (compare [T2]).

(T3) follows from the primacy thesis in an analogous manner. We only have to assume that there is some kind of experience E_1 and some kind of experience E_2 such that no one can ever have both kinds of experiences at once and such that the successor B has E (and no other person has that kind of experience at t_2) and the successor C has E_2 (and no other person has that kind of experience at t_2). With these assumptions we have excluded vagueness through predication for the claims "A has the experience E_1 at t_2," and "A has the experience E_2 at t_2." We can conclude that A definitely has either the experience E_1 at t_2, or E_2 at t_2, or neither the first nor the second kind of experience. According to the construction of the example, A has E_1 iff A is B, and A has E_2 iff A is C. So either A is definitely identical with B or with C or with neither of the two.

The theoretical relation between (T3) and the primacy thesis may also be seen in another way. The reductionist's reason for denying (T3) can be formulated like this: There is no relevant empirical difference between the two successors in a fission case. Therefore, the hypothesis that the original person A is, e.g., identical with B, but not with C, has no understandable content. On the basis of the primacy thesis we can reply in the following way: One who considers the hypothesis that the original person A is identical with B considers that A will have those experiences at t_2 that B has at t_2. This transtemporal attribution of experiences can be grasped without thereby implicitly applying or presupposing empirical criteria of identification.[21]

According to (T5), when there is agreement about the empirical relations obtaining between a ship A existing at t_1 and a ship B existing at t_2, then a possible disagreement about their identity can only be interpreted as a disagreement about the correct or convenient use of language, while, contrary to this, when there is agreement about the relevant empirical relations between a person A existing at t_1 and a person B existing at t_2, then a possible disagreement about whether A and B are identical is a disagreement about something that may or may not be the case. We can now explain this difference in the following way: In the second case, when discussing the identity of the person A with the person B, we also discuss what future experiences may correctly be

attributed to A, whether A will experience B's life. According to the primacy thesis, transtemporal experience attributions are conceptually independent of empirical criteria of personal identity through time. Therefore, even if we agree about the relevant observational data, we still have to get clear about the further conceptually independent question, whether A will experience B's life. When we discuss the identity of the ship Michelangelo with the ship Raffaele we thereby also discuss whether Michelangelo will have Raffaele's properties. But in this case, according to the primacy thesis, we have no independent understanding of what it would mean if these transtemporal property attributions were true. Therefore, there is no conceptual room for a further conceptually independent question once we agree about the observational data.

Some reductionists could agree that (T1)–(T5) describe our natural understanding of a subject of experience and its identity through time and still insist that after further reflection we should change our concepts in such a way that (T1)–(T5) cease to be conceptually true. Chisholm would claim that it is impossible for us to change our concepts in such a way. Having based (T1)–(T5) on a thesis about the conceptual status of transtemporal experience attribution which is based on the insight that self-attribution does not involve identification, we can now justify this claim if we agree that the special feature of self-attribution at issue is a necessary feature of self-attribution and that the capability of self-attributing is a necessary feature of any epistemic subject.

MARTINE NIDA-RÜMELIN
INSTITUT FÜR PHILOSOPHIE, LOGIK, UND WISSENHAFTSTHEORIE
UNIVERSITY OF MUNICH
APRIL 1996

NOTES

1. Following Castañeda I use "*" to indicate *de se* belief; see, e.g., H.-N. Castañeda, "On the Logic of Attribution of Self-Knowledge to Others," *Journal of Philosophy* 65 (1968): 439–56.

2. I will select only a few claims characteristic for Chisholm's position. Chisholm has a lot more to say about personal identity and the problem of identity through time in general than can be treated in this paper.

3. R. M. Chisholm, "Identity through Time," in Howard E. Kiefer and Milton K. Munitz, eds., *Language Belief and Metaphysics*, reprinted in R. M. Chisholm, *On Metaphysics* (Minneapolis: University of Minnesota Press, 1989). The paper will be referred to by "Chisholm 1970/1989"; citations are taken from the version published in *On Metaphysics*.

4. Chisholm talks of "the identity of such things as ships" through time and does not tell us explicitly what objects are relevantly similar to ships in this context. I trust Chisholm would agree with the following: we can talk of identity through time only in a loose and popular sense in the case of those concrete objects that are not capable of any kind of experience or intentionality. What Chisholm says about personal identity, he probably would also be ready to say about the identity of any other sentient creature. This at least is a result of my reconstruction proposed in part 2.

5. Chisholm 1970/1989, p. 28.

6. Chisholm 1970/1989, p. 35.

7. Richard Swinburne does; see his "Personal Identity: The Dualist Theory," in Shoemaker and Swinburne, ed., *Personal Identity* (Oxford: Basil Blackwell, 1984).

8. See, e.g., John Mackie, *Problems from Locke* (Oxford: Oxford University Press, 1976), p. 193 and Derek Parfit, *Reasons and Persons* (Oxford: Clarendon Press, 1984), p. 214.

9. Chisholm 1970/1989, p. 39.

10. Cited from "Problems of Identity," in Milton K. Munitz, ed., *Identity and Individuation* (New York University Press, 1971), pp. 3–30. In this passage it seems as if Chisholm thinks that the identity of persons may be epistemically inaccessible *because* they are primary things. I will propose, however, that this claim about personal identity holds because persons are capable of having experiences.

11. See, e.g., Derek Parfit, *Reasons and Persons*; John Perry, "The Importance of Being Identical," in Amelie Rorty, ed., *The Identity of Persons* (Berkeley), 67–90; and Sidney Shoemaker, "Personal Identity: The Materialist Theory," in Shoemaker and Swinburne, eds., *Personal Identity* (Oxford: Basil Blackwell, 1984), sec. 12.

12. Cited from "Problems of Identity," p. 7.

13. Ibid, p. 9.

14. Ibid, p. 10.

15. Cited from Chisholm 1970/1989, p. 41.

16. (1b) is only mentioned to be explicit, since (lb) follows from (la).

17. See, e.g., G. E. M. Anscombe, "The First Person," in S. Guttenplan, ed., *Mind and Language: Wolfson College Lectures 1974* (Oxford: Clarendon Press), 45–64. The insight is formulated very clearly in S. Shoemaker, "Self-Reference and Self-Awareness," *Journal of Philosophy* 65 (1968): 555–67; see also S. Shoemaker, "Persons and Their Past," *American Philosophical Quarterly* 7 (1970): 269–85.

18. There are exceptional cases where a person self-attributes a property on the basis of having identified someone as him- or herself, e.g., when a property is self-attributed on the basis of perceiving someone in a mirror (this example is commented on in Shoemaker 1970, p. 270).

19. See Chisholm, *The First Person* (Brighton, Sussex: Harvester Press, 1981), chapter 3, in particular p. 28.

20. Compare Shoemaker 1970.

21. (T4), as mentioned earlier, follows from (T3) under the assumption that fission cases are conceivable.

NOTE ON REPLIES TO CHAPTERS 25–30

Unfortunately, we have no responses to chapters 25–30. As he explained with reference to Professor Nida-Rümelin's paper, Professor Chisholm's vision has deteriorated to the point where he can no longer see well enough to read the remaining papers, and he does not feel that having someone read them to him would be very helpful since, like many of the rest of us, he tends to think in visual terms.

With specific reference to Professor Nida-Rümelin's paper he wrote that he could understand my eagerness to include it in the volume inasmuch as it would certainly extend the number of significant perspectives represented in it. Both he and I regret very much his inability to reply to her paper and the remaining five others he could not read, but each of them further extends the number of significant perspectives represented in the volume, and fortunately the discerning reader can see in the many replies he did write that portions of them are also relevant for the final six chapters of the volume.

L.E.H.

26

John A.I. Bewaji

THE CERTAIN, THE EVIDENT, AND THE PROBLEM OF CRITERION: PERSPECTIVES IN RODERICK CHISHOLM'S RESPONSE TO SKEPTICAL EPISTEMOLOGY

Contemporary Western epistemology sees "theory of knowledge" in terms of providing a refutation of various forms of skepticism.[1] This derives from numerous foundations; one is the academic heritage of the Greeks, the second is the Humean heritage, third is the way in which Descartes thought it necessary to proceed to arrive at his (pre)conceived proof of the certainty of knowledge of the self, as a thinking being, from which all other existences and cognitions must be derived. Thus "cogito" is the ground (the "ergo") for the reality of the "sum" and, of course, all other things;[2] for,

> everything that can fall under human knowledge forms a similar sequence; and that so long as we avoid accepting as true what is not so, and always preserve the right order of one thing from another, there can be nothing too remote to be reached in the end, or too well hidden to be discovered.[3]

Contemporary factors have been the dual heritage of positivism and linguistic analytic philosophy. Even those philosophers who do not accept the rationalist procedure have found themselves shackled by the "formalism, foundationalism, reductionism and deductivism" that Russell has lamented.[4]

Consequently, Chisholm's philosophy of knowledge, though occupied with the same skeptical problems as his contemporaries, provides a refreshingly different perspective worthy of exploration, especially as it attempts to provide an avenue for dealing with the problems of knowledge, without getting distracted by the alternative epistemological *cul-de-sac* which skeptical theory of knowledge enjoins, while at the same time

responding rationally to skeptical questions. This essay, therefore, attempts to explore this strand of Chisholm's epistemology, to see to what extent Chisholm has succeeded in his attempt to account for human knowledge, giving a thorough study of epistemological issues such as the place of truth, certainty, belief, memory, and the like in the total coefficient of knowledge, and making available a criterion by which skepticism might be kept in abeyance when it arises, as it must, for rational persons.[5]

In this regard, it is noteworthy that Chisholm made a monumental effort to wrestle "theory of knowledge" back into its primary place from the infestation of skepticism which had plagued its consideration as a philosophical discourse by such eminent contemporary philosophers as Ayer, Russell, Lehrer, Hamlyn, Unger, Rescher, Malcolm,[6] and others. For as Chisholm says,

> Reflection upon the nature of our knowledge gives rise to a number of perplexing philosophical problems. These constitute the subject matter of theory of knowledge, or epistemology. (p. 1)[7]

After listing these philosophical problems as "the distinction between knowledge and true opinion," the problem of "evidence," "foundationalism," "extent of our knowledge," "truths of reason," and the "problem of truth," he says

> The theory of knowledge could be said to have as its subject matter the *justification of belief*, or, more exactly, the justification of *believing*. (p. 5)

What I attempt to achieve in this essay is to reiterate Chisholm's primary belief that any philosophy that fails to be in accord with facts of human life and experience must be examined carefully to gain an understanding of what may be the cause of such an aberration. In this regard, I examine Chisholm's epistemological theory, developed carefully and with such painstaking precision, to show that human knowledge is a fact, a reality that is not discountable or deniable. This is not saying that Chisholm is not aware of all the possible pitfalls of the diverse forms and sources of human knowledge, yet Chisholm is careful at every turn to indicate the measure by which these pitfalls can be recognized and avoided. The three prongs on which this epistemism or cognitivist philosophy of knowledge stands are *the evident, the certain, and the resolution of the problem of criterion*. These tripodal foundations are intricately examined and developed to provide the necessary security that meets the most stringent of the requirements that any rational skeptic, as a participant in the cognitive experience, may legitimately

(that is, logically, rationally, historiographically, and intuitively) produce.

Roderick Chisholm describes his philosophy of knowledge in two ways: "commonsensism"[8] or "critical cognitivism" (p. 125). The first derives from the bold philosophical realism (not the orthodox realist position marking the divide between the rationalists and empiricists, but one that strives to square theory with reality and practice) that distinguished G. E. Moore, and the second derives, I believe, from the position that is most rational for scientific minds, being aware of the pitfalls of knowledge, a position which is not ashamed to affirm what is undeniable, but does so in a critical, circumspective, proactive, and positive (not positivist) manner.[9]

In order to make this discussion brief, I shall consider the preliminary conceptual clarifications that Chisholm undertook. After that, I will discuss the three basic tools used to construct valid epistemist philosophy, namely, the evident, the certain, and the problem of criterion. Finally, I shall briefly comment on the few gaps that I find needful of filling in order that the critical cognitivist or commonsensist epistemologist might survive the academic attacks of the skeptic, both serious and purely intellectual.

CONCEPTUAL ISSUES

The first conceptual matter addressed is how a doxastic datum might be "*beyond reasonable doubt*" for a subject. Chisholm defines this thus:

> h is beyond reasonable doubt for S = Df Accepting h is more reasonable for S than withholding h. (p. 7)

What is obvious in this definition is multifold. First, it takes care of the practical situations in which we claim doxastic items as beyond reasonable doubt. Second, it takes care of our legal practice of passing judgment of guilt, innocence, inconclusiveness, on account of evidence which is either beyond or not beyond reasonable doubt. Third, the definition presupposes that assent is given or withheld not on the ground of attainment or nonattainment of "totality" or "all relevant" evidence as it is clear that in no time is all evidence ever obtainable or obtained regarding any given matter. Fourth, it has the further implication of being person dependent, as it shows that what one person may consider beyond reasonable doubt because of various factors (e.g., one's epistemic equipage, historical epoch, memory configuration, scientific age, religio-

cultural disposition, and the like) may radically differ from what another person will consider beyond reasonable doubt. In this last regard, pointing to logical and mathematical truths may be of little avail. This is why Chisholm had to insist on the time specificity of the concept of "beyond reasonable doubt":

> In this definition and others like it that will follow, we will assume that there is also a reference to some specific time. What is beyond reasonable doubt for a given person at one time need not be beyond reasonable doubt for that person at other times. (pp. 7–8)

The second definition that Chisholm provides is even more revealing. This is of the idea of some epistemic datum *having presumption in its favor*:

> h has presumption in its favor for S = Df Accepting h is more reasonable for S than accepting not-h. (p. 8)

Chisholm contends that what is beyond reasonable doubt has prima facie presumption in its favor, but whatever has a presumption in its favor is not necessarily beyond reasonable doubt (p. 8). The negation is more problematic. Not accepting h is more reasonable than accepting h (that is, not accepting not-h)—"Not accepting 'snow is white' is more reasonable than accepting 'snow is not white'" for example. The point being made is that "not accepting h is not more reasonable than rejecting h."

Epistemically unacceptable propositions are such that they evoke our epistemic dispraise or condemnation, for it means that withholding them is more reasonable than accepting them. This leads to a third definition which clarifies what has been the main concept used in defining previous ideas—the concept of "acceptability":

> h is *acceptable* for S = Df Withholding h is not more reasonable for S than accepting h. (p. 9)

The implication is that all reasonable propositions have unacceptable negations, but we cannot say that all unacceptable propositions have reasonable negations. I should like to suggest tangentially that the concept of acceptability is, like previous ones ('reasonable' and 'presumption'), culture dependent: if in a culture the affirmation of "God is good" and its negation "God is bad" are reasonable, there arises a paradox. This implies that, what constitutes epistemic praise or dispraise in such a culture will have to be more sensitively examined if a universal theory of knowledge is to be devised!

CERTAINTY

While Descartes used the idea of 'clearness and distinctness' as the marks of certainty, built on proofs 'more geometrico', Chisholm employed the axiomatic methodology after a modern fashion. Through definitional precision the groundwork for the attainment (attainability) of knowledge is laid. Emerging from an astute definition of having "presumption in favor of" and being epistemically "acceptable," Chisholm regards *certainty* as a term of epistemic praise higher than being merely "beyond reasonable doubt" and he demarcates between *epistemic certainty, logical certainty,* and *psychological certainty.* He characterizes in the category of epistemic and logical certainty such propositions as "I *seem* to see a man standing before me," and characterizes propositions of logic and mathematics as absolutely certain. The main point being to show that these are propositions that are beyond reasonable doubt such that there are no other propositions that it is more reasonable to accept before them or that have greater command to acceptability over them.

In a real sense, the reason why Chisholm is concerned to separate epistemic certainty from psychological certainty is the logical difference between them. As Ludwig Wittgenstein said,

> One does not infer how things are from one's certainty. Certainty is, as it were, a tone of voice in which one declares how things are, but one does not infer from the tone of voice that one is justified.[10]

This is further confirmed by Bertrand Russell's affirmation that "subjective certainty is no guarantee of truth or even a high degree of credibility."[11]

What Chisholm attempts to capture is an epistemic feature of our cognitive predicament that is most difficult to put in words. In the case of psychological certainty it is not dependent on cognitive assurance or intellectual understanding grounded in evidence or factual presentation. It could be dependent on an instinctive, emotional realization or assurance which may often prove useful in the ordering of life and detection of truth based on prior cultivation. But it cannot substitute for hard logical proof or factual presentation. This type of certainty accounts for a genre of unwarranted dogmatism that does not entertain any alternative as plausible as they are foreclosed *ab initio.* This type of certainty encapsulates subjective assurance per se. But the unacceptability of such certainty as a measure of cognitive and epistemic warrant is derived from the fact that how I feel or that I feel certain is not enough

and cannot be used to support what is truth, unless its being the truth is the basis of my feeling. This makes it obvious that my feeling is irrelevant to the truth content of the subject at issue.

However, if I am considered knowledgeable in the matter being considered, my feeling might be understood to convey my judgment based on informed opinion. This gives the impression that, the issue at stake being my area of competence and assuming that I have no reason to perjure my deliverance, I can be relied upon to be in the right. This type of preference for informed opinion saves us from the headache of having to individually source our epistemic matters at every turn. For if we cannot rely on the trustworthiness of others in their cognitive affirmations it will mean that we cannot take advantage of the equipage of epistemic heritage of humankind and that we must jettison the advantages of *reliable evidence* (p. 63).

A second interpretation of certainty that Chisholm considered here is *logical certainty* via *logical necessity*. This account of certainty derives from an acceptance of what John Dewey calls the *spectator theory of knowledge*.[12] On this theory only what is completely fixed and immutable can be real or certain. It equates what is certain with what is logically necessary, taking logical necessity to mean, on the one hand, the internal relationship of propositions, the type whose denial involves a contradiction. On the other hand, logical necessity is understood in the sense in which statements of logic and mathematics are certain, because they are, within the system in which they are situated, logically necessary and analytic (p. 35). Thus, according to Chisholm,

> Reason, according to one traditional view, functions as a source of knowledge. This view, when it is clearly articulated, may be seen to involve a number of metaphysical presuppositions and it is, therefore, unacceptable to many contemporary philosophers. But the alternatives to this view, once *they* are clearly articulated, may be seen to be at least problematic and *to imply an extreme form of skepticism*. (p. 34; emphasis mine)

A further fact is brought to the surface but its implication is concealed until the discussion of intuitive induction. (I am of the suspicion that Chisholm did not realize the germaneness of this to the project of repudiating extreme skepticism.) In a real sense, Chisholm shows the paradox in the position of unfettered rationalism and its compatriot, extreme empiricism. These views are diachronically regarded as traditional epistemological views. Thus, he says,

> According to this traditional view, there are certain *truths of reason* and some of these truths of reason can be known *a priori*. These truths pertain to certain abstract or eternal objects—things such as properties, numbers, and

propositions or states of affairs, *things that would exist even if there weren't any contingent things such as persons and physical objects.* (p. 34; emphasis mine)

The fact that two not-necessarily coterminous paths have been thought by Plato and Aristotle to lead to *intuitive induction* (p. 39), a type of inferential knowledge that derives from experience but that does not owe its continued truth or validity to experience, shows that such knowledge can only accrue to beings mentally configured in a universe physically and psychologically cognizable as the one we inhabit. While this is not directly a Chisholmian way of presenting this implication, it is, however, one that is obvious from his exhibition of the weakness of the extreme skepticism that calls for abdication of all responsible cognitive affirmations on the speculative and metaphysical grounds that "*you cannot really know, with respect to any proposition that it is one that is axiomatic*" (or directly evident in the sense of being self presenting) (p. 48).

Chisholm recognizes the possibility of proffering a Nelsonian response to skepticism. But he prefers to explore another form of argumentation against skepticism. What he advocates, and which seems the best and most plausible way, is not to fall into the trap of the skeptic; we simply respond to the skeptic by saying *we do* know that we have such *certain* knowledge (p. 50). This type of response is not without its disadvantages. But these are disadvantages that all rational critical cognitivists and even skeptics have lived with and must continue to live with. The difference is that while the skeptic is discouraged by the fact that we do not have indefeasible, infallible, perfect, and incorrigible knowledge, what we have, according to Chisholm, has served us well and can be made to serve even better through an attitude of positive critical investigation.

The Evident

What now is the epistemic status of the *ordinary things* we know—the *proposition*, say, that the sun is now shining, or that it was shining yesterday, or that we are now in a room with other people? If we look just to the epistemic concepts that have been singled out so far, we must choose between saying either that these propositions are absolutely certain or else that they are not certain, but beyond reasonable doubt. To say that they are absolutely certain, however, would seem to be saying too much. And to say only that they are beyond reasonable doubt would seem to be saying not enough. (p. 11)

Chisholm is concerned with the way in which ordinary things that we justifiably claim knowledge of have been described hitherto by philosophers of knowledge. He is therefore very careful to annotate the realm of what is certain, stating why some epistemic claims are more certain than others. The categories of items listed are simple perceptual facts, simple reports of memory, simple claims concerning the knowledge of the external world, simple statements concerning the existence of other humans as ourselves, claims regarding the existence of the self, and simple arithmetic truths. He however was able to conclude that some of these claims are of different degrees of certainty. The above-listed perceptual statements are not "absolutely certain," but they are more than "beyond reasonable doubt," while the simple arithmetic truths and logical propositions are absolutely certain.

> When we say of a proposition that it is known to be true, then we are saying somewhat more than that it is true and beyond reasonable doubt, and we are saying somewhat less than that it is true and absolutely certain. What, then, is the epistemic status of the ordinary things we know? (p. 11)

The category to which Chisholm assigns this is that of the "evident." This category is, according to him, more impressive than being beyond reasonable doubt but less than absolutely certain. This is formulated thus:

> h is evident for S = Df (i) h is beyond reasonable doubt for S and (ii) for every i, if accepting i is more reasonable for S than accepting h, then i is certain for S. (p 12)

The analysis which Chisholm provided of epistemic preferability, rules of evidence, self-presenting, and phenomenalist presentation in terms of "seeming" and "appearing" and how they relate to the concept of the directly evident is very illuminating. This helps to recognize the fact that when we consider something to be self-evident or directly evident, it is not to suggest that it is beyond the Cartesian hyperbolic form of skepticism,[13] or the type that C. I. Lewis raised concerning the knowledge of "this piece of paper before me now,"[14] or the innumerable test possibilities which are never exhausted at any given epistemic point in time, or even the type formulated by Peter Unger in his ultimate form of philosophy of ignorance or agnoiology.[15] In fact, the whole point of engaging in theory of knowledge the way Chisholm did, it seems to me, is not to arrive at an account of knowledge that is totally immune to doubt of the type that Unger and others proffer. The point is to bolster our commitment to the scientific and other knowledge-acquiring mechanisms that have served humanity in good stead in the not-too-epistemically clement universe.

THE PROBLEM OF CRITERION

Coming to discuss the problem of criterion, Chisholm attempted a formulation of the two general problems of epistemology thus:

> *What* do we know?" and "How are we to decide, in any particular case, *whether* we know?" The first of these may also be put by asking, "What is the *extent* of our knowledge" and the second, by asking, "What are the *criteria* of knowing?" (p. 120)

He went on to say of these questions that

> If we know the answer to either one of these questions, then perhaps we may devise a procedure that will enable us to answer the other. If we can specify the criteria of knowledge, we may have a way of deciding how far our knowledge extends. Or if we know how far it does extend, and are able to say what the things are that we know, then we may be able to formulate criteria enabling us to mark off the things that we do know from those that we do not know.
>
> But if we do not have the answer to the first question, then, it would seem, we have no way of answering the second. And if we do not have the answer to the second, then, it would seem, we have no way of answering the first. (p. 120)

After considering the attempts by empiricists, commonsensists, and agnosticist-skeptics to answer the questions one way or the other, through empiricist and commonsensist answering of the second question first by touting experience, and the skeptic answering neither question, claiming that they cannot be positively answered, Chisholm was quick to point out the respective weaknesses in the empiricist and skeptic positions, which consist in the empiricist implication that "we know next to nothing about ourselves and about other physical objects around us" (p. 120), and the total abstinence of the skeptic in staking out any claim to knowledge or preference of any criterion of knowing (p. 121). From there Chisholm presented the position canvassed in the book, namely the position of "commonsensism," saying,

> Unlike the empiricist, we have not begun with general criteria of knowing. Rather we have attempted to derive criteria of knowing, accommodating their criteria to our prior assumptions about what it is that we do know. *And we have rejected skepticism, for we have assumed that our knowledge goes beyond what is directly evident or a priori.* (p. 121)

Considering the propositions of ethics Chisholm indicates that they are disputed by those who consider that we do have such knowledge and those who are convinced that we do not. The reasons may be that such persons believe that they meet the requirements of the four traditional sources of knowledge or that they do not. These are: external perception,

memory, self-awareness (reflection, or inner perception), and reason (p. 122). The fact that deductive or inductive arguments cannot be constructed to validate the claim that "Mercy as such is good" is used by such persons to show their inadmissibility to the hall of fame of knowledge (p. 123).

Roderick Chisholm's method of refuting skepticism is interesting in the manner in which it effectively shows the errors of intuitionism and skepticism with regard to ethical knowledge. I put together the two arguments of intuitionism and skepticism and the proposed view that Chisholm propounds.

Intuitionism:

(P) We have knowledge of certain ethical facts.
(Q) Experience and reason do not yield such knowledge.
(R) Therefore, there is no additional source of knowledge. (p. 123)

Skepticism:

(Not-R) There is no source of knowledge other than experience and reason.
(Q) Experience and reason do not yield any knowledge of ethical facts.
(Not-P) Therefore, we do not have knowledge of ethical facts. (p. 124)

Chisholm constructed an argument which the two arguments preferred above do not preclude. In effect, this exhibits the weakness of both positions. Here is the argument:

(Not-R) There is no source of knowledge other than experience and reason.
(P) We have knowledge of certain ethical facts.
(Not-Q) Therefore, experience and reason yield knowledge of ethical facts.

Chisholm then says,

> With this type of argument, one might be said to reject the *faculty* that is claimed by the intuitionist and yet accept the intuitionist's claim to *knowledge;* in so doing, one is led to reject the *assessment* of experience and reason common to the intuitionist and the skeptic. One says in effect: "It is true that, starting with those propositions that are traditionally attributed to self-awareness, external perception, memory, and reason, we cannot construct any good *inductive* or *deductive* arguments for such propositions as 'Mercy as such is good' and 'Ingratitude is bad'. But from this it does not follow that these traditional sources do not yield any knowledge of ethical and moral truths." This is the only plausible procedure for one who believes

that we do have knowledge of ethical facts and that we do not have a special faculty of moral intuition. (pp. 124–25)

On the whole, Chisholm has illuminated our epistemic practice, bringing out clearly the gaps, the weak links, and the insufficiency of the "evidence" that we are capable of providing, either as intuitionists, reductionists, dogmatists, phenomenalists, skeptics, and even cognitivists (the critical version of which position he endorses), for our knowledge claims. Chisholm is convinced, just like most of us, that we do have knowledge. (In fact, the writing of any material on a topic such as this is indicative of this conclusion.) The fact that we cannot prove everything that we know is not to be regarded as enough to disprove our thus having such knowledge.

SOME CLARIFICATIONS

There are some minor issues to be considered in relation to the critical cognitivism that Chisholm has enunciated. Chisholm's epistemology is punctuated by his acquiescence to the traditional epistemological practice of reducing all epistemic considerations to propositional considerations. This is formulated in the statement that "*What* one believes, then, is always a proposition" (p. 6). Thus, Chisholm says,

> An adequate theory of perception, for example might require us to say that: if I have that experience which might naturally be expressed by saying that I "seem to see" a certain state of affairs (e.g., "I seem to see a man standing there"), *then the state of affairs that I thus seem to perceive (the proposition that a man is standing there) is* one that is, for me, ipso facto, acceptable. (p. 10)

While it is true that the only way anyone else will know that you have any perceptual state or cognitive disposition is in the propositions that you utter, or the gestures you make, the utterance of a proposition and the making of the gesture are not in themselves the same as the perception. Chisholm attempted to clear this hurdle, in many respects one of the reasons why his epistemology is richer and more in consonance with our epistemic dispositions at both the prereflective and reflective levels.

How he does this will become evident presently. For now let it be stated that knowledge is not a proposition, and that its reduction to propositional form obfuscates the meaning of knowledge. In other words, neither "I see a man standing there" nor "I seem to see a man

standing there" is equivalent to the proposition "a man is standing there," even though the truth content of my perceptual state is equivalent to the truth value of the epistemic affirmation in the second proposition. How does this pan out in real life? Why is it not the same to say that "I see a man standing there" and "I seem to see a man standing there" equals "a man is standing there"? There are two reasons that immediately spring to mind. One with a strictly philosophical import, the other with a quasi-psychological and almost irrational justification. Let us consider the first. Descartes says in *Oeuvres Descartes*[16] and *Philosophical Writings*[17] that the phrase "we appear to see clearly" is not a mark of doubt:

> The reason I used the word appear is that perhaps anyone is capable of denying that we see the point in question. But in any case, what "appears" to us is enough to prove what I want. For since we need to rely on our own minds and what we are aware of in ourselves, what we 'see' must ultimately reduce to what 'appears' to us. And what appears to us in fact requires the existence of material objects as a source of the ideas in question.[18]

What Descartes is trying to show is manifold. In the first instance, there is the "perceptual appearance" or the mental phenomena. This is what is immediately present in cognition. It is often difficult to find adequate and unencumbered philosophical language, bereft of unwarranted phenomenological and phenomenalistic baggage, that will do duty for the proper representation of what is present here. These have been variously represented as 'percept', 'datum', 'data', 'given', etc. Secondly, there is the 'percipient being', the agent or the 'mind' or 'res cogitans'. Thirdly, there is the relationship between the percept and the percipient being. This is what, for Descartes, can be marked by "clearness and distinctness" and which depends on a training of the mind. For clear perception is a precursor of true conception. However, there is another component equally, if not more, important. That is the object of perception. Of this Descartes says,

> in perception the images are imprinted by external objects which are actually present[19]

and

> what appears to us in fact requires the existence of material objects as a source of the ideas in question.[20]

If we fail to recognize this fact we would, according to Descartes,

> draw the mind too far away from physical objects and observable things, and make it unfit to study them.[21]

The purely philosophical import here is the necessary distinction

between percept, object, perceptual relation, interpretation or conception. The last (interpretation or conception) is of very serious moment. It leads to the quasipsychological implication which Chisholm did not broach but which deserves mention as it has determined, by and large, which "man standing there" shall be seen as a "man standing there" or otherwise seen as a "Turk" or other.[22]

But why bring in this type of extraneous consideration? The reason is simple enough. What we see is as much a product of training to "see" as it is dependent on the presence of the "object." As such it is not such a simple matter to say that "a man standing there" is present in one's perception, as it accounts for the importance of chimera and physical objects in their relationship in conception and why both have played large roles in determining what is. Training by either the self or by the culture we are enmeshed in determines largely what we actually consider as seeing in this regard.

One other big implication is that one will be hard pressed to interpret all philosophical and epistemic phenomena and concepts in propositional terms. Simply because, in order to communicate our cognitive ideas to each other, we need language, which does not mean that without language we cannot apprehend reality. Of course, we are again confronted by the Wittgensteinian dictum that the limit of one's language is the limit of one's world, forgetting that the deaf and dumb have ideas which are not communicated in propositional language, and that those of us in the majority who have the facility of language, do not communicate and cannot communicate all our ideas in language to others (p. 6). Michael Polanyi formulated this point very clearly, thus:

> I shall consider human knowledge by starting from the fact that *we can know more than we can tell*. This fact seems obvious enough; but it is not easy to say exactly what it means. Take an example. We know a person's face, and we can recognize it among a thousand, indeed among a million. Yet we usually cannot tell how we recognize a face we know. So most of this knowledge cannot be put into words.[23]

Because Chisholm embraces the traditional understanding of the relationship between knowledge and propositions it is a bit difficult to clearly see the difference between his theory of knowledge, as the clear-cut epistemist, cognitivist position that it is, and those of Ayer, Lehrer, Rescher, and others of the same philosophical generation. Consider Chisholm's contention that

> All propositions that are beyond reasonable doubt will, of course, be acceptable, but there are many acceptable propositions that are not beyond reasonable doubt. An adequate theory of perception, for example, might require us to say that if I have that experience which might naturally be

expressed by saying that I "seem to see" a certain state of affairs (e.g., "I seem to see a man standing there"), *then the state of affairs that I thus seem to perceive (the proposition that a man is standing there)* is one that is for me, ipso facto, acceptable. (pp. 9–10; emphasis mine)

It is clear that what is perceived is not a proposition, but a state of affairs. Even when we read a text, it is not literally the text that is perceived or understood but the content of the text. And apart from the dating of the text and issues of authenticity of authorship, it is not the text that is said to be true, but what the text conveys. The propositional analysis of our perceptual terms has occasioned a serious infraction of our epistemic analysis, scuttling a proper understanding and perjuring accurate representation and the debate on knowledge. Another problem easily arises when we consider the looseness of the language in which our epistemic discourse is conducted. Consider the movement from "I see a man standing there" to the putative and uncertain equivalent that we are urged to accept: "It seems that I see a man standing there." The only way in which this type of equivalence makes any sense at all is when we fail to notice the fallacy of equivocation involved. This plays on the word "there." When I say that "I see a man standing there" it is an absolutist type of claim involving a definite space that has some very close proximity to myself, seen clearly in good light, either with or without my pair of glasses on (if I use them). It is something about which I do not seem to be tentative or dubious.

On the other hand, when I move over to saying that "I seem to see a man standing there" I have lost the type of perceptual proximity of the first assertion. I am now claiming that the distance is considerable and "there" no longer is invariable, that I am not wearing my glasses (if I use them), that the lighting situation does not assist in certain apprehension because it is dull, that there is some fog or other mediating circumstances that makes "there" indeterminate, seeing-wise (p. 10).

In a certain sense this might be regarded as an unavoidable obscurity in what Chisholm says regarding the epistemological expostulations of the characters he typifies as the skeptic and the dogmatist. This is probably a consequence of the vagueness of "knowledge" as a concept which Bertrand Russell pointed out.[24] He vacillates between the description of knowledge as propositions and as entities or objects. Propositions are only entities or objects in a linguistic sense. This is the sense in which utterances are facts, just as "the man standing outside the window" is a fact.

There appears to be another minor weak link in Chisholm's epistemology that must be strengthened. He supposes there may be a principle

of inductive reasoning that can be used to generate, from the directly evident, propositions that are indirectly evident, such as the unknown fact that "there is a cat on the next house." He tries the analogical argument form (an argument form that he has validly employed respecting the repudiation of psychologism and linguisticism), but this fails in this instance (pp. 51–54). The only type of successful argument that will meet the demands of rational skepticism about the existence of 'a cat on the next house' is the testimony of an eyewitness (such as myself or a reliable person privy to sighting of the cat) or other similarly cogent fact such as a report of some evidence that accrues as a result of some test of the assertion (pp. 65–67).

Why Chisholm supposes that this leads to the conclusion that there is a principle of justification or evidence different from induction or deduction is not very clear. In any case, this seems to be in consonance with the position that Chisholm had maintained, recognizing the fact that human beings have knowledge of various types. The usual Western account of the sources of such knowledge is as defective as it is inexhaustive. These are listed as (1) external perception (*sensory perception*), (2) memory (*recollections of past experiences and ideas*), (3) self-awareness (reflection, or inner consciousness) (*introspection and intuition*), and (4) reason (*deliverances of logical, mathematical, and formal thoughts generally*) (p. 122; italics mine). John Hospers, for example, lists six sources of knowledge, viz., experience, reason, memory, introspection, tradition, and revelation; but apart from experience and reason, others are either dependent for validation on experience or reason, or their validation cannot be determined conclusively. Speaking of revelation as a source of knowledge he writes,

> Sometimes one claims to know something by means of revelation; but what this claim comes to depends on how one came by the revelation. . . . If the claims made are such that sense-experience or reason could substantiate them, then it is because of this, and not because the book says so, that we believe that the claims are true. But if, as often happens, the claims made are of such a nature that we could never verify them, how can we ever be in a position to select one of them as "the true revelation?"[25]

However, Karl R. Popper, in his usually perceptive way, not only acknowledges the existence of various kinds and sources of knowledge, he also argued that there is no easily ascertainable, legitimate way by which non–a priori and nonempirical knowledge could be ruled out of court as popularly thought by philosophers. There are only two sources—reason and experience—and two kinds—a priori and a posteriori—of knowledge that he regards as mistaken. Hence, he says:

> The fundamental mistake made by the philosophical theory of the ultimate source of our knowledge is that it does not distinguish clearly enough between questions of origin and questions of validity.[26]

The awkwardness of the restriction of the possible sources of knowledge to two major types has engendered the recourse which Western epistemologists have to phenomenalistic language, which is an advisedly cautious way of evading the form of dogmatism that could be embarrassing when we are confronted with the false judgments to which it occasionally leads. But it seems that there is no a priori way of avoiding this predicament. It is just as natural to err as it is to attempt to avoid error. For if we are not aware of the possibility of erring, we may not take all measures to secure our knowledge, and claims to knowledge, on good grounds. What Carneades and other skeptics, who have been crudely ridiculed in epistemological treatises, have done is to use an *ad absurdum* type of reductionism to show that in too much confidence is too much misery. So, when Chisholm says,

> We can say for Carneades . . . that it may be directly evident to a man, on a particular occasion, that he is "having a perception of a cat," but it is never directly evident to a man that he is "perceiving a cat." Hence, if our epistemic principles are to be applied to what is "directly evident," we must refer to "having a perception of something being F" (p. 69),

he was applying the traditional epistemological heritage of construing all knowledge in propositional terms, hence, not fully utilizing the epistemological insight that critical cognitivism or epistemic commonsensism avails. His quotation of Cicero, to wit,

> the perceptions of what is true are of such a kind that a perception of what is false might also be of the same kind (p. 71),

and his remark that Cicero seems to think that this is the most powerful argument in favor of skepticism, are insightful, as what Cicero was suggesting is that psychologically, there are no special differences in *perceptions*. Perceptions are in themselves mental states that are indistinguishable one from the other. What distinguishes the veridical perception from the nonveridical perception does not belong in the state of mind of the percipient. Rather, as it is a matter that is very difficult to explicate totally in words there is much that can be said about it, but a lot must remain obscure.

In a serious sense we are compelled to relapse to self-defensive reaffirmation of what we simply know as knowing agents. This is a type of response that is very pervasive in the epistemology of Chisholm. This is not because Chisholm does not recognize a need to transcend the

affirmation of knowledge by assertion of knowledge, but because there is no further evidence in most circumstances of our knowledge that we can present to someone who decides not to grant any epistemic claims that we may issue forth, simply because it is conceivable that we may be wrong in such claims or because in the past we have found that others, and ourselves as well, have erred on such matters.

This is what has made the philosophy of knowledge an epitome of lively philosophical disagreements. That whatever one affirms can be denied by someone else for reasons that are real or apparent is not something to be lamented but part of the variety that spices up our epistemic being and landscape. For example, concerning "Perception and Self-Presentation," Chisholm says:

> In answer to the question: "What is my justification for thinking that I know such and such?" S may say: "My justification for thinking that I know such and such is the fact the I know so and so." Let us express this briefly by saying: S justifies his claim or belief that he knows such and such by appeal to the proposition that he knows so and so. (p. 73)

The fact is that "such and such" may or may not be identical with "so and so." If it is identical, then we stand the risk of maintaining our knowledge by mere assertion. If on the other hand it is different, as is often the case, then our knowledge is based on something else or someone else's knowledge. Either way we do not escape hyperbolic forms of skepticism, nor are we shackled unnecessarily by it.

The other minor point that needs to be reiterated is that it is not often the case that our knowledge that p is a propositional one, nor is it always based on another proposition whose truth or falsity is not in doubt. This is what Chisholm was alluding to when he spoke of the interpretational difficulties that ordinary language creates for us, especially the perception words that we are constrained to employ to describe our epistemic states.

The essential difficulty that surfaces in Chisholm's epistemology is his attempt to take care of all possible objections that the skeptic might formulate, real and imagined; he becomes almost overcautious. Thus when Chisholm says,

> If an evident proposition is not non-defectively evident, then, of course, it is defectively evident (p. 109),

it is very difficult to understand what is meant. For if the proposition h has property e in the manner of being evident, then to say that it is "not non-defectively" evident is superfluous. If it were evident in the first place in the manner that Chisholm had carefully annotated, then it

cannot be defectively evident, because being defective is ruled out by being prima facie evident. And Chisholm was very careful to restrict the evident to the essentials for the construction of his epistemology.

Another minor unnecessary complication noticeable in the "traditional definition of knowledge repaired" is the circuitous manner in which it makes the concept of the "evident" to be self-validating. If we say that some proposition h is evident for S, assuming that it is only propositions that are ever so evident, when we introduce the idea, concept, or requirement of "non-defectively evident," we would have made the "evidence" a judge in its own cause and by extension, we would have made the agent, the percipient, a judge in her own epistemic cause.

CONCLUSION

In this tribute to Chisholm's epistemology I have taken some liberty to give a novel interpretation of the perspectives that have constituted the legacy he has bequeathed to the philosophical community. I have taken the liberty to call his epistemology a realistic one which attempts not only to meet the rigorous standards of philosophical analysis of the West but also to represent faithfully the standards that informed epistemic judgment strives to attain. The developments in science, technology, and various other intellectual domains constitute a testament to the validity of Chisholm's epistemology.

In this regard, Chisholm's position is very close to that of Popper. Popper contends, and I think this is valid of Chisholm's theory of knowledge also, that

> What we should do, I suggest, is to give up the idea of ultimate sources of knowledge, and admit that all knowledge is human; that it is mixed with our errors, our prejudices, our dreams, and our hopes; that all we can do is to grope for truth even though it be beyond our reach. We may admit that our groping is often inspired, but we must be on our guard against the belief, however deeply felt, that our inspiration carries any authority, divine or otherwise.[27]

This is why, in the final analysis, we have to rely on

> an account of what the facts are, and . . . an account of the types of proposition upon which they may be said to confer evidence, reasonableness, or acceptability.[28]

Finally, it is obvious that Chisholm is not the only philosopher who takes seriously the skeptical engagement and who has seen fit to give the

only type of answer that the skeptic cannot but admit as valid. The words of Marie McGinn are very germane here and they clearly illustrate the position of Chisholm. She says,

> Moore's Proof should be seen as an argument from the inability of scepticism to bring conviction that our ordinary judgements and knowledge claims are false or unwarranted, to its complete intellectual bankruptcy. I suggested that the ambivalence we feel concerning the Proof arises because it makes us feel the tension between the unanswerability and unliveability of skepticism. On the one hand, we cannot but recognize that we share Moore's conviction concerning the judgment 'This is a hand'; on the other, we cannot but feel that, while the sceptical argument remains unanswered, he (the sceptic) has no right to affirm it.[29]

It is with this assurance that we can say with confidence with Chisholm that we do have knowledge, however transitory this may be, as knowledge is continually evolving with the definite strides that we make in our search for truth. It is also with this assurance that we can say that we are certain about certain knowledge claims and perceptual facts.

JOHN A.I. BEWAJI
DEPARTMENT OF LANGUAGES, LINGUISTICS, AND PHILOSOPHY
UNIVERSITY OF THE WEST INDIES
JUNE 1996

NOTES

1. Some representative Western epistemologists who have been compelled to see "theory of knowledge" in terms of a response to skepticism include D. W. Hamlyn, who says in *The Theory of Knowledge* (London: Macmillan Educational Ltd. 1970) that,

> In a certain sense, however, all the problems of the theory of knowledge, even the more general ones, arise against and by contrast with a quite different point of view. That is, that knowledge is impossible, or at least that we can never be sure that we have attained it. (p. 7)

Similarly A. J. Ayer, in *The Problem of Knowledge* (London: Macmillan Educational Ltd., 1956), contends that,

> these sceptical challenges . . . supply the main subject matter for what is called theory of knowledge; and different philosophical standpoints are characterized by the acceptance or denial of different stages of the sceptic's arguments. (p. 6)

Other leading contemporary epistemologists with not-too-dissimilar views are Keith Lehrer, in *Knowledge* (London: Oxford University Press, 1974), p. 1. and

L. P. Pojman, *What Can We Know?* (Belmont, Calif.: Wardsworth Publishers, 1995), p. 39.

2. René Descartes, *Discourse on Method* and *Meditations on First Philosophy* in *Descartes' Philosophical Writings*, translated by Anscombe and Geach (Edinburgh: Thomas Nelson and Sons Ltd., 1954).

3. René Descartes, *Discourse on Method*, p. 21.

4. Bertrand Russell, *A History of Western Philosophy* (New York: Simon and Schuster, 1945), p. 29.

5. The works of Roderick Chisholm cited are *Perception: A Philosophical Study* (Ithaca, N.Y.: Cornell University Press, 1957); *Theory of Knowledge* (Englewood Cliffs, N. J.: Prentice Hall, 1977), from which most of the citations are made; and "One Version of Foundationalism," in Goodman and Snyder, eds., *Contemporary Readings in Epistemology* (Englewood Cliffs, N. J.: Prentice Hall, 1993), pp. 53–69.

6. A. J. Ayer, *The Foundations of Empirical Knowledge* (London: Macmillan Press, 1940) and his *The Problem of Knowledge* (London: Macmillan Press, 1956); D. W. Hamlyn, *The Theory of Knowledge* (London: Macmillan Press, 1970); Keith Lehrer, *Knowledge* (London: Oxford University Press, 1974); Norman Malcolm, *Knowledge and Certainty* (Ithaca, N.Y.: Cornell University Press, 1963); Nicholas Rescher, *Scepticism* (Oxford: Basil Blackwell, 1980); and Bertrand Russell, *Human Knowledge—Its Scope and Limits* (London: Allen and Unwin, 1948).

7. References to passages in Chisholm's *Theory of Knowledge* are in parentheses in the text.

8. R. M. Chisholm, *Theory of Knowledge,* p. 120.

9. The rather lengthy introduction has been necessary because the task prosecuted here is to bring epistemologists back to the type of down-to-earth manner in which Chisholm approached his philosophical thinking, and also to prepare the ground for an open reception of the highlights of the deep insights which surface in Chisholm's legacy without unnecessarily suggesting that Chisholm's epistemology was flawless.

10. Ludwig Wittgenstein, *On Certainty* (Oxford: Basil Blackwell Press, 1969), p. 30.

11. Bertrand Russell, *Human Knowledge—Its Scope and Limits*, p. 444.

12. John Dewey, *The Quest for Certainty* (New York: Capricorn Books, 1960), p. 23.

13. The evil-genius hypothesis was formulated by Descartes to suggest that we may never actually attain knowledge of any of the items that we thought we knew. Hyperbolic though this type of skepticism is, it has given impetus to the formulation of more extreme forms of skepticism. See René Descartes's *Second Meditation*, p. 67.

14. C. I. Lewis, *An Analysis of Knowledge and Valuation* (La Salle, Ill.: Open Court, 1947), p. 180.

15. P. Unger, *Ignorance* (Oxford: Clarendon Press, 1975), p. 1.

16. René Descartes, *Oeuvres de Descartes* (Paris: Vrin, 1957), pp. viii and 22.

17. René Descartes, *Philosophical Writings*, pp. i and 238.

18. John Cottingham, trans. *Descartes' Conversation with Burman* (Oxford: Clarendon Press, 1976), p. 34.

19. Ibid., p. 27.

20. Ibid., p. 34.

21. Ibid., p. 30.

22. Ibid., p. 21.

23. Michael Polanyi, *The Tacit Dimension* (London: Routledge and Kegan Paul Ltd., 1967), p. 4.

24. Bertrand Russell, *Human Knowledge—Its Scope and Limits* (London: Allen and Unwin Ltd., 1948), p. 113.

25. John Hospers, *An Introduction to Philosophical Analysis* (London: Routledge and Kegan Paul Ltd., 1973), pp. 139–40.

26. Karl R. Popper, *Conjectures and Refutations* (London: Routledge and Kegan Paul Ltd., 1972), p. 24.

27. Karl R. Popper, *Conjectures and Refutations* (London: Routledge and Kegan Paul, 1963), p. 30.

28. R. M. Chisholm, *Theory of Knowledge*, p. 134.

29. Marie McGinn, *Sense and Certainty—A Dissolution of Scepticism* (Oxford: Basil Blackwell, 1989), pp. 161–62. Cf. David Papineau's concluding words in *Sense and Representation* (Oxford: Basil Blackwell, 1987):

> Since naturalized justification can depend on facts not available to consciousness, it is possible for even the most concerned believer to be mistaken about the extent to which a given belief is justified. Perhaps this seems odd. But we should learn to come to terms with it. Once we give up the idea that justification resides in self-transparent minds, and switch to the naturalized idea that justification is simply a matter of being well-adjusted to the world, then it is scarcely surprising that it is in principle possible to be mistaken about our own epistemological situation, just as it is in principle possible to be mistaken about anything else. (p. 233)

27

Noah M. Lemos

CHISHOLM, THE A PRIORI, AND EPISTEMIC PRINCIPLES

Few philosophers have done more in the past fifty years to advance our understanding of intrinsic value and epistemic principles than Roderick Chisholm. He has tried to explain the concept of intrinsic value and identify some states of affairs that have it. He has set forth epistemic principles telling us under what conditions a belief is epistemically justified. Chisholm's writings, however, display a certain ambivalence about our epistemic justification for accepting epistemic and axiological principles. He sometimes suggests that they are knowable a priori, yet at other times he argues against this view. In the first section, I present briefly two contrasting stands Chisholm takes on the epistemic status of such principles. In the second section, I explore two "Chisholmian" arguments against a priori knowledge of epistemic and axiological principles. The first argument presupposes Chisholm's requirements for a priori knowledge and claims that our belief in such principles cannot meet those requirements. The second argument assumes that certain kinds of disagreement about such principles is incompatible with one's having basic a priori justification for accepting them. In the third section, I maintain that these arguments are not compelling. I argue that we should reject Chisholm's view of a priori knowledge in favor of a more modest view that does not require that basic a priori justification be certain or indefeasible. In the final section, I briefly explore what might be our reasons for accepting a basic a priori proposition. I assume that (i) we do have basic a priori justification, and (ii) if one's justification is truly basic, one must have a reason for believing that does not consist in one's being justified in believing some other proposition. What could such a reason be? I suggest that Chisholm's own account of intrinsic preferability provides a clue.

I

Let us begin by considering some of Chisholm's recent views on epistemic principles and judgments of intrinsic value. In his 1990 essay, "The Status of Epistemic Principles," Chisholm presents the following epistemic principle:

(A) If (i) a person S thinks he perceives that there is an F, if (ii) it is epistemically in the clear for S that there is something that he perceives to be F, then it is beyond reasonable doubt for S that he is perceiving an F.[1]

For Chisholm, epistemic justification is an evaluative notion. To say that a belief is "beyond reasonable doubt" is to make a favorable evaluation of that belief. Chisholm compares (A) with the following ethical principle that, for the sake of argument, we may pretend is true:

(B) If an act is such that (i) performing it would result in more pleasure and in less pain than would any other act that a person S could perform, and (ii) if the act is one of those that S is able to perform, then S ought to perform that act.

Chisholm says that both (A) and (B) are *normative supervenience principles*. According to Chisholm, to say that (A) and (B) are normative supervenience principles is to imply that they are necessarily true.[2] In every possible world, whoever satisfies the antecedent is in the normative or evaluative state described in the consequent. Chisholm adds,

> A further feature of such principles of supervenience is sometimes put by saying that they are "synthetic *a priori*." The expression "synthetic" is suggested by the fact that the principles cannot be said to be "true in virtue of their form." And since the principles are necessary, it is concluded that if we can *know* them to be true, then such knowledge is *a priori*.[3]

Insofar as normative supervenience principles, such as (A) and (B), express something *necessarily* true, it seems that if they can be known, then such knowledge is a priori.

A year earlier, however, in the third edition of *Theory of Knowledge*, Chisholm again presents a variety of epistemic principles, including the following:

(C) If S *seems to remember* having been F, and if it is epistemically in the clear for him that he remembers having been F, then it is *beyond reasonable doubt* for S that he remembers having been F.[4]

(D) If S takes there to be an F and if it is beyond reasonable doubt for S

that he is perceiving something to be F, then it is evident for S that he is perceiving something to be F.[5]

But here Chisholm claims principles such as (C) and (D) are *not* known a priori: "It would not be plausible to say that they are *a priori* since many philosophers have understood them without thereby seeing that they are true."[6]

Though he rejects, in the third edition of *Theory of Knowledge*, the view that such principles are known a priori, he makes the following suggestion. He asks us to consider one of the general presuppositions the traditional epistemologist makes in asking the Socratic questions, "What am I justified in believing?" and "What am I justified in presupposing when I try to find out what I am justified in believing?" The presupposition in question is the following:

> (P) I am justified in believing that I can improve and correct my system of beliefs. Of those that are of interest and concern to me, I can eliminate the ones that are unjustified and add others that are justified; and I can replace less justified beliefs about those topics by beliefs that are more justified.[7]

Chisholm suggests that the conditional propositions that are formed by taking (P) as an antecedent and an epistemic principle such as (C) or (D) above as the consequent *are* knowable a priori. He writes, "I suggest that these conditional propositions *can* be known [*a*] *priori* to be true. This means that, for any subject, for whom any such conditional is evident, the consequent of that conditional is at least as justified as is the antecedent."[8] In other words, while we cannot say that epistemic principles such as (C) and (D) are justified a priori, the conditional proposition "If (P), then (C)" can be known a priori.

Chisholm's views on intrinsic value reveal a similar ambivalence. In his 1981 essay, "Defining Intrinsic Value," Chisholm makes the following suggestion:

(D1) p is intrinsically preferable to q =Df. p and q are necessarily such that, for any x, the contemplation of just p and q by x requires that x prefer p to q.[9]

The concept of intrinsic preferability is explicated, in part, in terms of the concept of necessity, and Chisholm makes it clear that the necessity involved is not mere causal or physical necessity. Perhaps it is not surprising, therefore, that he should write in the third edition of *Theory of Knowledge*,

> It has been held, not without plausibility, that certain ethical sentences express what is synthetic *a priori*. . . . consider the sentence, "All pleasures,

as such are intrinsically good, or good in themselves, whenever and wherever they may occur. If this sentence expresses something that is known to be true, then what it expresses must be synthetic *a priori*."[10]

Given these remarks one could take the axiological principle, "If X is an instance of pleasure, then X is intrinsically good" to be a normative supervenience principle akin to epistemic principles such as (C) and (D). We may say that it is necessarily true that whenever the antecedent obtains, so too does the normative or evaluative consequent.

Though the preceding remarks indicate sympathy for the view that some axiological claims are knowable a priori, Chisholm, again, seems to have mixed views. First, recall Chisholm's claim that it is *implausible* that epistemic principles such as (C) or (D) are knowable a priori because many philosophers have understood them without seeing that they are true. Surely the same consideration would apply to these axiological claims. Surely many philosophers have understood the claim, "all pleasures, as such, are intrinsically good whenever and wherever they may occur" without thereby seeing that it is true. Second, we may note the stand he takes in the second edition of *Theory of Knowledge*. There he suggests that our knowledge of intrinsic value is not based on reason, that it is not a matter of a priori insight. Instead, Chisholm follows the Austrian tradition that locates our knowledge of value in *das Wertgefühle*, in our feelings for value and various emotional experiences.

Whether it is reasonable to believe that epistemic and axiological principles are knowable a priori is surely an important question for ethics and epistemology, and surely our answers depend on our conception of a priori knowledge and justification. In the next section, I examine Chisholm's strong conception of a priori knowledge and its implications for our knowledge of epistemic and evaluative principles.

II

Let us consider briefly Chisholm's account of a priori knowledge in the third edition of *Theory of Knowledge*, one that is, I suggest, fairly traditional. Chisholm's view of a priori knowledge is explicated through a series of definitions. The fundamental concept is that of an axiom:

(D2) h is an axiom =Df. h is necessarily such that (i) it is true and (ii) for every S, if S accepts h, then h is certain for S.[11]

Given (D2), the following propositions may be said to be axioms: *all men are men; if some men are Greeks, then some Greeks are men*; and *all*

round things have a shape. Chisholm says that for those who really do consider these propositions, they may be said to be *axiomatic* in the following sense:

(D3) h is *axiomatic* for S =Df. (i) h is an axiom and (ii) S accepts h.[12]

According to Chisholm, our a priori knowledge is not limited to what is axiomatic for us, for we know some things a priori because we can see that they follow from what is axiomatic for us. In this way we can know the Pythagorean Theorem a priori, even though it is not axiomatic for us. Chisholm suggests that we can capture this broader notion of the a priori as follows:

(D4) h is known a priori by S =Df. There is an e such that (i) e is axiomatic for S, (ii) the proposition, e implies h, is axiomatic for S, and (iii) S accepts h.[13]

Given this understanding of a priori knowledge, everything we know a priori is either axiomatic for us or we know that it follows from something we know with certainty and something that is axiomatic for us. A priori knowledge has a foundational structure. The foundation consists of what is axiomatic for us and everything else we know a priori rests on what is axiomatic for us.

Chisholm's is a strong conception of a priori knowledge. It is strong in its account of the foundation and in its account of the links between the foundation and the rest of what is known a priori. Let us consider first the description of the foundation. Two features of the foundation make it very strong. First, foundational or basic a priori knowledge is certain. What is axiomatic for us is certain for us, and certainty is the very highest level of epistemic warrant or justification. Thus, if any proposition, p, is less than certain for us, then our knowledge that p is not foundational or basic a priori knowledge. Second, foundational a priori knowledge is indefeasible. It is indefeasible in the sense that as long as one believes what is axiomatic, there is nothing that one could come to know, believe, or experience that would undercut one's justification for believing it. Recall that if p is an axiom, then p is necessarily such that if S accepts p then p is certain for S. Thus, as long as S accepts p, S is maximally justified in believing p, and nothing S can know or experience will make S not justified in believing p. Of course, S might simply stop believing p. Suppose that there is some information that S might acquire that would cause S to stop believing p. Would this be enough to show that S's justification in believing p is defensible? No, for not just anything that causes a person to stop believing something he is otherwise justified in

believing defeats his justification. A sharp rap on the head can cause a person to quit believing something without being a reason to do so. People can also sometimes quit believing things they are otherwise justified in accepting for *bad* reasons that do not defeat their justification. Consequently, even if there are some things that might cause a person to quit believing an axiom, it does not follow that his justification for accepting that proposition is defeasible.[14]

Chisholm's account of a priori knowledge is also strong in its account of the supporting links between the foundation and the rest of our a priori knowledge. For S to have some nonfoundational a priori knowledge that p there must be some proposition, e, that is axiomatic for S, and it must be axiomatic for S that e implies p. Thus, the nonfoundational bits of a priori knowledge are connected by logical implication to the foundation, and this is a very tight connection. This view of the supporting links may be contrasted with certain foundational views of empirical knowledge that take various sensory states or ways of being appeared to as foundational. On these views, the fact that one is being appeared to in a certain way provides evidence (or is a reason) for one's beliefs about external material objects even though one's being appeared to in that way does not imply that one's beliefs are true. For example, one might hold that one's being appeared to in a whitish, roundish way provides some evidence for the belief that there is a white round object before one. That one is appeared to in this way provides support for the belief even though one's being appeared to in this way does not imply that the belief is true, that there is a white round object before one. Chisholm's account of the a priori forecloses the possibility of such purely nondeductive support for those bits of a priori knowledge outside the foundation.

Given this brief account of Chisholm's view of a priori knowledge and justification, we are now in a position to consider two arguments against our knowing a priori axiological principles or epistemic principles such as (C) and (D). For the sake of brevity, I shall focus on epistemic principles, but much of what is said applies also to axiological principles. Our first argument maintains that epistemic principles such as (C) and (D) cannot meet the requirements of Chisholm's strong conception of a priori knowledge.

Argument A:

(1) We know p a priori only if (i) p is axiomatic for us, or (ii) there is an e such that e is axiomatic for us and the proposition, e implies p, is axiomatic for us.

(2) Epistemic principles such as (C) and (D) are not axiomatic for us.

(3) There is no e such that e is axiomatic for us and the proposition, e implies (C) (or D), is axiomatic for us.

(4) Therefore, we do not know epistemic principles such as (C) and (D) a priori.

The first premise simply tells us what Chisholm's strong account requires for a priori knowledge. The second and third premises tell us that the sorts of epistemic principles Chisholm proposes cannot meet those requirements.

The second premise is true for the following reason. If epistemic principles such as (C) or (D) were axiomatic for us, then they would be certain for us. But since they are not certain for us, they are not axiomatic for us. It is doubtful that many proponents of such principles would claim that they are certain, and surely it is not as reasonable for us to accept those epistemic principles as it is for us to accept such things as all men are men or $2 = 2$. Furthermore, even if we accept such principles, we typically do not think our justification is indefeasible, for even while we accept them we remain open to the possibility of counterexamples or other forms of argument against them. In practice, we do not assume that they are indefeasible. We examine them and look for defeating considerations. If our justification for holding such principles is defeasible or less than certain, then it seems that such principles are not axiomatic for us and not candidates for basic a priori knowledge.

Are these epistemic principles nonfoundational items of a priori knowledge? This too is unlikely, for in order for them to be known in this way, it would have to be the case that there is some e that is axiomatic for us and such that it is axiomatic for us that e implies the epistemic principles in question. But since there appears to be no axiomatic implication between such principles and anything that is axiomatic for us, it appears that such principles are not instances of nonfoundational a priori knowledge. If this is so, then premise 3 is true. Given the strong account of a priori knowledge, the epistemic principles in question seem to be neither basic or foundational nor nonfoundational items of a priori knowledge.

Let us turn to a second argument. As we have seen, Chisholm rejects the view that epistemic principles such as (C) and (D) are known a priori because "many philosophers have understood them without thereby seeing that they are true." Other philosophers have taken a similar stance toward other principles. For example, William Rowe rejects the view that the Principle of Sufficient Reason is known "intuitively." Like

Chisholm, Rowe does not reject the view that we know some things intuitively. For example, Rowe suggests that we know intuitively the propositions expressed by the sentences "Every triangle has three sides" and "No physical object can be in two different places at the same time." He says that we can apprehend the truth of these propositions "just by understanding and reflecting on them."[15] Still, Rowe says, "The difficulty with the claim that PSR is intuitively true, however, is that a number of very able philosophers fail to apprehend its truth, and some even claim that the principle is false. It is doubtful, therefore, that many of us, if any, know intuitively that PSR is true."[16]

I take Chisholm and Rowe to hold that no proposition is an instance of basic a priori knowledge if many philosophers have understood it without seeing that it is true. This suggests the following argument.

Argument B:

(1) One has basic a priori knowledge that p only if it is false that there are many philosophers who understand p without thereby believing that it is true.
(2) Many philosophers have understood (C) and (D) without thereby believing that they are true.
(3) Therefore, it is false that one has basic a priori knowledge that (C) and (D) are true.

This argument would only show that there is no basic a priori knowledge of the principles in question. But, as argued above, it is also doubtful that we have nonbasic a priori knowledge of them.

Before considering responses to these arguments we should note that both arguments A and B cut against the suggestion in the third edition of *Theory of Knowledge* that we know a priori the conditional proposition that takes (P) as an antecedent and (C) or (D) as a consequent. First, that conditional proposition is not certain for us. It lacks the same level of justification as all men are men or $2 = 2$. Furthermore, it is not at all clear that there is some e that is axiomatic for us and such that the proposition, e implies *if P, then C*, is axiomatic for us. Thus, given Chisholm's account of a priori knowledge, the conditional proposition that Chisholm suggests is knowable a priori would seem to be neither basic nor nonbasic a priori knowledge. Second, in my own case, when I consider the conditional proposition, if (P), then (C), I believe that I understand it without thereby seeing that it is true. I suspect there are others who do so as well. It is not clear, therefore, that Chisholm can consistently hold that we know a priori that particular conditional

proposition and reject our knowing epistemic principles on the basis of arguments A and B.

III

Neither argument A nor argument B provide compelling reasons for rejecting the view that we have a priori knowledge or justification for accepting epistemic principles. The chief weakness with both arguments is that they require too much for a priori knowledge and justification.

We may note that the first premises in arguments A and B fail to satisfy the strong account's requirements for a priori knowledge. In neither argument does the first premise enjoy the certainty of all men are men or all squares have a shape, and thus neither premise seems axiomatic for us. But neither does it seem that either premise is a bit of nonfoundational a priori knowledge, something known by being seen to follow from what is axiomatic. Thus, one might ask the proponent of these arguments what justifies him in accepting the first premises.

The strong view of a priori knowledge and justification that underlies argument A assumes that basic a priori justification must be (1) certain or maximally justified and (2) indefeasible. Why assume such things? The view that basic a priori justification comes in degrees and need not be certain has distinguished historical precedents. The view that intuitive warrant comes in degrees was suggested by Bertrand Russell[17] and A. C. Ewing, who held that basic a priori judgments need be neither certain nor indefeasible.[18] More recently, Alvin Plantinga takes a similar view[19] and Laurence BonJour claims that basic a priori justification need not be certain.[20] Others have taken the same stand.[21] But among the clearest opponents of the view that basic a priori justification must be certain and indefeasible is Thomas Reid. Reid asks us to consider the case of a mathematician having completed a demonstration.

> He commits his demonstration to the examination of a mathematical friend, who he esteems a competent judge, and waits with impatience the issue of his judgment. Here I would ask again, Whether the verdict of his friend, according as it has been favorable or unfavorable, will not greatly increase or diminish confidence in his own judgment? Most certainly it will and it ought.[22]

For Reid, the level of justification the man's belief enjoys can be affected by the testimony of his friend. Even though he might have a priori grounds for accepting the conclusion, the warrant these grounds confer on his conclusion can be defeated or undercut by the testimony of others.

In the preceding example, Reid deals with the nonbasic a priori justification one has for accepting the conclusion of an argument. Yet similar considerations apply to the level of warrant of noninferential a priori beliefs. Concerning "first principles," Reid asks, "Is it not possible, that men who really love truth, and are open to conviction, may differ about first principles?"[23] For Reid, honest disagreement about first principles is possible. "A man of candour and humility will, in such a case, very naturally suspect his own judgment, so far as to be desirous to enter into a serious examination, even of what he has long held as a first principle."[24] Reid appears to hold that in the face of such disagreement it is natural and appropriate for us to be suspicious of our own judgment. I take him to hold that knowledge of such disagreement can lower the credence we ought to place in that judgment. For Reid, then, empirical or non-a priori considerations can lower or defeat the justification of those things that we have some a priori ground for accepting. Plantinga agrees: "I am a philosophical tyro and you a distinguished practitioner of the art; you tell me that those who think about these things are unanimous in endorsing Meinong and rejecting my view that there aren't things that don't exist: then too, I should think, my view would no longer have warrant (or *much* warrant) for me."[25]

But it isn't only empirical or non-a priori considerations that can lower or defeat a priori justification. Plantinga calls our attention to the various assumptions that lead to Russell's paradoxes, propositions such as that every property has a complement, that there is a property of self-exemplification. Each of these propositions has a certain degree of plausibility or level of warrant for us. Indeed it is precisely because the initial assumptions seem so plausible, that each has "a ring of truth" to it, that their paradoxical implication seems so startling. Yet once we see what they imply, it is reasonable for us to reject one or more of these assumptions. Our justification for believing some of these propositions is undercut or defeated by seeing what they imply. "No doubt Frege was rational in believing a priori that for every condition there is a set of just those things that satisfy that condition; but no doubt he was equally rational in rejecting that proposition later on, upon seeing where it led.[26] If the arguments advanced by Reid and Plantinga are sound, then we should reject the strong Chisholmian view of a priori justification that underlies argument A.

Let us turn to argument B. The first premise tells us that one has basic a priori knowledge that p only if it is false that there are many philosophers who understand p without thereby believing that it is true. Why should one think this premise true? I suggest that there are two different reasons. First, one might think that there is a basic a priori

reason for believing p only if p is "doxastically compelling." In other words one might accept

(E) One has a basic a priori reason to accept p only if anyone who grasps and considers p will believe p.

If (E) is true, someone's not finding p doxastically compelling would imply that there is no basic a priori reason for believing it. There are three points worth making about this view.

First, (E) does not fit well with the view defended above that basic a priori justification is defeasible, for on that view one could have *both* an a priori reason for believing p and a defeater for that a priori reason (such as the testimony of an expert or seeing that p implies something absurd). If (E) were true, then, since p is doxastically compelling, one would be unable to give up belief in p in the face of defeating reasons. One would be in the epistemically awkward position of being compelled to hold a belief one knew one was not justified in believing. Second, we should distinguish (E) from

(F) One has a basic a priori reason for believing p only if anyone who understands and considers p has a reason for believing it.

(F) seems a plausible thesis and unlike (E) does not raise problems about defeated a priori justification. Still, (F) does not imply (E), since one can have a reason for believing something and yet fail to believe it. Even if (F) is a plausible thesis about basic a priori reasons, it does not follow that (E) is. Finally, it seems that (E) is simply false. Why should someone's failure to believe p upon grasping and considering it imply that I have no basic a priori reason to believe it? Suppose Smith has some disorder that allows him to grasp and consider p, but prevents him from believing it. Or suppose that Smith has decided to embrace skepticism and refuses to believe anything other than his skeptical principle. It hardly seems to follow that others would have no basic a priori reason to believe p.

Let us consider a second ground for the view that one has basic a priori knowledge that p only if it is false that many philosophers understand p without accepting it. This second reason is suggested by the previous remarks of Reid and Plantinga, namely, that the empirical knowledge of certain kinds of disagreement might weaken or defeat whatever a priori ground one has for accepting a proposition. On this view, knowing that competent philosophers have considered epistemic principles such as (C) and (D) without believing them would weaken the level of justification those principles have for me or defeat whatever reason I have for believing them.

There are several points worth making about this way of supporting argument B. First, we should note that the mere fact of disagreement does not necessarily lower the level of justification one might have for believing a proposition. Suppose, for example, that someone denied that all men are men or that if some men are Greeks, then some Greeks are men. It does not seem that knowledge of such disagreement would make us any less justified in believing such propositions. Second, suppose we know that competent philosophers have understood p, but do not believe it. Even if we assume that this weakens our level of justification for believing p why should we assume that it weakens it below the level of justification required for knowing that p? As Reid says, such disagreement may be a reason to suspect our own judgment, but it does not follow that we are no longer sufficiently justified in believing p to know it. Third, suppose, for example, that one finds that the disagreement is based on a mistaken notion of what a priori knowledge requires or that those who reject the proposition do so because they mistakenly think that they have counterexamples to the principles in question. In this case, it is not clear that one could not be sufficiently justified in believing the proposition to know it. Even if such disagreement were a defeater for believing p, this defeater could itself be defeated.

Disagreement over principles need not be unreasonable or mere blind stubbornness to see what is obvious. If basic a priori justification is defeasible, then two philosophers could both understand the same epistemic principle and reasonably disagree about its truth. This could happen if one has (or merely thinks he has) reasons that defeat his justification in believing it. One philosopher might have (or merely think he has) counterexamples to or arguments against the principle in question. But the existence of disagreement does not show that the epistemic principles in question have no a priori status. It does not show that one cannot have a defeasible a priori reason for believing them or that one cannot be sufficiently justified in believing the principles to know them.

Given Chisholm's strong conception of a priori knowledge and justification, it is not plausible to believe that epistemic principles such as (C) and (D) are known a priori. But we should reject that notion of the a priori in favor of a more modest view that does not treat basic a priori justification as certain and indefeasible. If we think, as Chisholm sometimes does, that normative supervenience principles, such as epistemic principles and principles about intrinsic value, are knowable a priori, then we should favor this more modest view.

Finally, I would also urge that this more modest view is a better fit with the "commonsense" tradition in epistemology than Chisholm's

strong account. It is characteristic of the commonsense tradition in epistemology to accommodate one's epistemic principles to one's beliefs about what one ordinarily thinks one knows or is justified in believing. Part of seeking such accommodation involves rejecting epistemic principles that do not fit or cohere with one's beliefs about what one ordinarily thinks one knows or is justified in believing. In this tradition, it is reasonable to reject epistemic principles because they fail to fit or cohere with particular epistemic judgments such as "I am justified in believing that I had eggs for breakfast" or "I am justified in believing that there is a chair before me." Yet these particular epistemic propositions about what I am justified in believing are not themselves known a priori. Merely reflecting on them, merely grasping and considering them, is not sufficient for my having any reason for believing them. Nor am I justified in believing them because I have deduced them from what I do know a priori. Still, I *do* know such particular propositions about what I am justified in believing.

If we were to accept the strong Chisholmian view of a priori knowledge and justification, then it is not clear that one may consistently accept both the commonsense tradition and the view that some epistemic principles have an a priori status for us. This is so simply because the strong view of the a priori treats basic a priori beliefs as indefeasible. No epistemic principles could enjoy a priori status and be in principle defeated by failing to fit or cohere with particular propositions about what I am justified in believing. But clearly, on the more modest view of the a priori this problem does not arise, for it does not insist that our a priori justification for believing an epistemic principle is certain or indefeasible. On this more modest view, epistemic principles can be defeated by the relations they bear to particular epistemic propositions, propositions about what we know or take ourselves to be justified in believing.

IV

Suppose we accept the modest view that basic a priori beliefs need not be certain or indefeasible. We may still ask, "What kind of reason can one have for believing a basic a priori proposition?" I assume here that (i) we do have basic a priori justification for believing various propositions and (ii) if one's justification is truly basic, one must have a reason for believing that does not consist in one's being justified in believing some *other* proposition. But what might such a reason be? I suggest that Chisholm's remarks about the nature of intrinsic value provide a clue.

Let us introduce the following definitions of a "reason" and a "defeater" offered by John Pollock:

(D5) A state M of a person S is a reason for S to believe Q if and only if it is logically possible for S to become justified in believing Q on the basis of being in state M.[27]

It is plausible to think that perceptual and mnemonic experiences are reasons, that, for example, one's being appeared to redly is a reason to believe that there is something red before one and that one's seeming to remember that one had eggs for breakfast is a reason to believe that one did indeed have eggs for breakfast. With respect to defeaters, let us say:

(D6) If M is a reason for S to believe Q, a state M^* is a defeater for this reason if and only if it is logically possible for S to be in the combined state consisting of being in both state M and the state M^* at the same time, and this combined state is not a reason for S to believe Q.[28]

If something's looking red to me is a reason to believe that there is something red before me, this reason can be defeated by my coming to learn that there is a red light shining on that thing or learning that I have an eye disorder that makes white things look red.

What kind of reason might one have for believing a basic a priori proposition? Suppose we say that one has such a reason for believing p if one finds p "doxastically compelling." Thus, one has a reason for believing p if one grasps and considers p and one cannot help believing p. This proposal however suffers several defects. First, it is not clear that one would have a reason to believe something *simply* because one could not help believing it. If because of paranoia Smith cannot help believing that Jones is out to kill him, Smith still has no reason to believe that Jones is out to kill him. Second, as we noted in the last section, if we accept the modest view, then we think that our a priori reasons are in some cases defeasible. But if the fact that one cannot help believing a proposition were the reason for accepting it, then we could be in the unhappy position of having defeaters for that proposition, while being unable to stop believing it. If we accept the modest view, then it seems we should look elsewhere.

A second sort of proposal might be that when we grasp and consider some proposition, p, this produces in us a certain phenomenologically distinctive state, one directed toward p. Let us call this state "ϕ-ing that p." ϕ-ing that p will be analogous to other phenomenologically distinctive states that function as reasons and have propositional objects, such as seeming to see that there is a dog or seeming to feel that something is

smooth. On this proposal it is this phenomenologically distinctive state of ϕ-ing that p that is our reason for believing that p. Perhaps the chief difficulty with this view is that it is unclear that there is any such experience or that it is to be found in every instance in which we have basic a priori justification. Here, as in any case in which one appeals to such an experience, one must ultimately reflect on one's own situation, and I find that when I consider propositions such as those expressed by "2 = 2" or "If some men are Greeks, then some Greeks are men," I do not find the relevant state. I am certain that these things are true, but I do not find that I have the relevant experience or that I believe them on the basis of such an experience. Furthermore, suppose that I were to understand and consider the propositions expressed by "2 = 3" or "some men are not men" *and* have that distinctive experience toward them. Suppose that I were to ϕ that 2 = 3 or ϕ that some men are not men. It is far from clear that I would have any reason whatever for thinking that those propositions were true.

A third, and I think more promising, proposal is suggested by various accounts of what it is for something to be intrinsically good. C. D. Broad once wrote that "X is good" can "be defined as meaning that X is such that it would be a fitting object of desire to any mind which had an adequate idea of its non-ethical characteristics."[29] Let us recall Chisholm's definition of intrinsic preferability from the first section:

(D1) p is intrinsically preferable to q =Df. p and q are necessarily such that for any x, the contemplation of just p and q by x requires that x prefer p to q.[30]

On this view, to say that someone's being happy is intrinsically preferable to someone's being sad is to say that those states of affairs are necessarily such that, for any x, the contemplation of just those states of affairs requires that one prefer the former to the latter. According to Chisholm, one's *contemplating* certain states of affairs *ethically requires* that one have certain nondoxastic attitudes toward them. On this view, what requires the nondoxastic attitude is not a distinctive phenomenological state caused by one's contemplation. What requires the nondoxastic attitude is simply one's contemplating a specific state of affairs.

Suppose we follow this approach and say that the contemplating or the grasping and considering of certain propositions *epistemically requires* that one have certain doxastic attitudes toward them. We might say that some propositions, but not others, are necessarily such that, for any x, the contemplation or the comprehending consideration of those propositions *epistemically* requires that x accept or believe them. The analogy between the intrinsically valuable and certain propositions may

be said to consist in this: Just as the comprehending consideration of certain states of affairs, but not others, is an ethical reason to favor or prefer them, so the comprehending consideration of certain propositions, but not others, is an epistemic reason to believe or accept them. Just as some states of affairs are intrinsically good or desirable, we may say that some propositions are "intrinsically acceptable." Let us say,

(D7) p is an intrinsically acceptable proposition =Df. p is necessarily such that, for any S, S's comprehending considering of p is a reason for S to believe p.

We may say that the propositions expressed by the sentences "All men are men" and "If some men are Greeks, then some Greeks are men" are intrinsically acceptable. Of course, there are a great many propositions that aren't intrinsically acceptable. Those expressed by the sentences "The Pope is in Rome," "It is raining," and "Austin is in Texas" are not such that one's comprehending consideration of them gives one any reason to believe them. It is important to note that on this view one's reason for believing, say, that all men are men does not consist merely in one's comprehendingly considering something, but rather upon one's comprehendingly considering the specific proposition that all men are men. We may say that one's reason depends upon the specific nature or content of the proposition, as well as on the fact that one is comprehendingly considering it. In this respect, an intrinsically acceptable proposition is like those states of affairs that are intrinsically good, for it is not the mere fact that one considers something that requires that one have a pro attitude toward a state of affairs: it is that one considers a state of affairs having a specific content or nature.

If there are intrinsically acceptable propositions, then it seems that the following general principle is true:

(G) If (1) p is an intrinsically acceptable proposition, and (2) S believes p on the basis of one's grasping and considering p, and (3) this reason is not defeated by anything S is justified in believing, then S is justified in accepting p a priori.

Thus, if a proposition such as "No cube is a sphere" is intrinsically acceptable, then we may say that anyone who believes that proposition on the basis of grasping and considering it and has no defeating reason for that proposition is justified in accepting it a priori.

The present view tells us that some propositions, but not others, are such that one's comprehending consideration of them is a reason to believe them. Let me briefly consider three objections. First, one might object that grasping and considering an intrinsically acceptable proposi-

tion is not sufficient for one's being justified in believing it. "Suppose Jones grasps and considers the proposition, everything flat is extended, while he is preoccupied in figuring out what Smith just said. It seems possible that Jones does so without being justified in believing it." The response to this is that if Jones is really preoccupied with figuring out what Smith just said, then it isn't clear that he has really considered whether the proposition, everything flat is extended, is true. If he is attempting to figure out what Smith said, he is not considering the truth of the proposition in question, though he might be considering something else.

A second objection may be put this way: "This proposal does not really tell us what we want to know about basic a priori justification. It says that some propositions, but not others, are such that one's comprehending consideration of them is a reason to believe them. Yet it does not tell us why some propositions are like this and others aren't." It must be admitted that no explanation has been offered for the fact that some propositions have this character and others don't. Frankly, it is unclear why some do have it and others don't or that there must be some deeper explanation for this fact. In any case, it would be a mistake to claim that this account is empty. For if we ask, for example, what is our reason for believing that no cube is a sphere, we *do* have an answer: It is the fact that we comprehendingly consider the proposition that no cube is a sphere. For every intrinsically acceptable proposition, p, we can identify our reason for believing it, namely, the fact that we comprehendingly consider p. If there is a deeper explanation it would be nice to have it, but it is not obvious that there is any such explanation, and it is not necessary that we have it in order to answer the opening question of this section.

Another objection to this view is that it leaves us with a "scattered" plurality of warrant-making properties, a plurality having no common unifying feature.[31] But how damaging is this objection? Why should we presume that there is some deep underlying unity among warrant-making properties? It is not obvious that the sources of epistemic warrant must be any less diverse than the sources of intrinsic value or beauty. Why assume that the warrant-making properties of belief are any less diverse than good-making properties or beauty-making properties? If this view is correct, then a correct epistemic theory about what makes beliefs justified resembles the pluralism of certain theories of value rather than a normative theory that identifies one fundamental right-making property such as maximizing utility or acting in accord with the categorical imperative. A plurality of warrant-making properties is objectionable only if a more unified account is compatible with and

explains what we recognize or reasonably take to be instances of justified belief. Furthermore, it is worth noting that a similar problem confronts any theory that makes use of the concept of defeasible reasons. Take any theory that claims a belief is justified only if it is undefeated by the set of the subject's other beliefs and experiences. It is fair to ask whether it offers any systematic account or criterion by which we can pick out defeaters. No epistemic theory, to my knowledge, offers us a criterion by which we can pick out all and only perceptual and mnemonic defeaters. In this respect, then, any epistemic theory that makes use of the concept of defeat seems open to the "scatter" objection.

The account offered here is certainly no proof that epistemic or axiological principles enjoy basic a priori justification. It also offers nothing I should care to call a "method" for determining whether a belief is justified a priori. But if we accept the view defended in the previous section, that beliefs having such justification need not be certain or indefeasible, then we are in a stronger position to hold that our belief in such principles can have such justification. Moreover, if the account sketched in this section is correct, then we can say what our reasons are for accepting various epistemic and axiological principles. Our reasons would consist in our grasping and considering those very principles. Though Chisholm's formal account of the a priori poses problems for the view that such principles are justified a priori, what he says about the concept of intrinsic value suggests a more promising approach. It seems especially fitting that the key to our understanding our knowledge of epistemic and axiological principles might lie in our thinking of epistemic reasons in a manner analogous to the way Chisholm says we ought to think about intrinsic value itself.

Noah M. Lemos

Department of Philosophy
DePauw University
July 1996

NOTES

1. Roderick Chisholm, "The Status of Epistemic Principles," *Nous* 24, no. 2 (1990): 209.
2. Ibid., p. 210.
3. Ibid.
4. Roderick Chisholm, *Theory of Knowledge,* 3d ed. (Englewood Cliffs, N.J.: Prentice Hall, 1989), p. 68.

5. Ibid., p. 72.

6. Ibid.

7. Ibid., p. 73.

8. Ibid.

9. Roderick Chisholm, "Defining Intrinsic Value," *Analysis* 41 (March 1981): 100.

10. Chisholm, *Theory of Knowledge*, 3d ed., p. 36.

11. Ibid., p. 28.

12. Ibid.

13. Ibid., p. 29.

14. For an excellent discussion of reasons and defeaters see John Pollock, *Contemporary Theories of Knowledge* (Totowa, N.J.: Rowman and Littlefield, 1986), pp. 36–39 and 175–79.

15. William L. Rowe, "The Cosmological Argument," in *Philosophy of Religion* (Belmont, Calif.: Wadsworth Publishing Co., 1978), reprinted in *Reason and Responsibility* 8th ed., edited by Joel Feinberg (Belmont, Calif.: Wadsworth Publishing Co., 1993), p. 27.

16. Ibid.

17. For example, Russell writes, "It should be observed that, in all cases of general principles, particular instances, dealing with familiar things, are more evident than the general principle. For example, the law of contradiction states that nothing can both have a certain property and not have it. This is evident as soon as it is understood, but it is not so evident as that a particular rose which we see cannot be both red and not red." If the general principle is less evident than the particular instance, then the general principle is not maximally warranted. Bertrand Russell, *The Problems of Philosophy* (Oxford: Oxford University Press, 1912), pp. 112–13.

18. Ewing writes, "Many philosophers have preferred to limit the term 'intuition' to cases of certain knowledge, but there are many cases where something presents itself to one intuitively as deserving a certain degree of credence but falling short of certainty or where an intuition has some value but is confused and inextricably blended with erroneous assumptions and inferences." A. C. Ewing, *The Fundamental Questions of Philosophy* (London: Routledge and Kegan Paul, 1951), p. 49. He adds, pp. 50–51, "Arguments may well be available which without strictly proving either side to be wrong put a disputant into a position in which he can see better for himself whether he is right or wrong or at least cast doubt on the truth of his view."

19. Plantinga writes, "Intuitive warrant comes in degrees (and hence in less than maximal degrees); that makes it possible for the intuitive warrant for a given proposition to be defeated." Alvin Plantinga, *Warrant and Proper Function* (Oxford: Oxford University Press, 1993), p. 112.

20. Laurence BonJour, *The Structure of Empirical Knowledge* (Cambridge, Mass.: Harvard University Press, 1985), p. 208.

21. See for example Jerold Katz, "What Mathematical Knowledge Could Be," *Mind* 104 (July 1995): 511; Tyler Burge, "Content Preservation," *Philosophical Review* 102 (October 1993): 461; Donna Summerfield, "Modest A Priori Knowledge," *Philosophy and Phenomenological Research* 51 (March 1991): 49–50.

22. Thomas Reid, *Essays on the Intellectual Powers of Man* (Cambridge, Mass.: MIT Press, 1969), essay 6, chapter 4, p. 610.

23. Ibid., essay 6, chapter 4, p. 603.

24. Ibid., essay 6, chapter 4, pp. 603–4.

25. Plantinga, p. 112.

26. Ibid., p. 110. I use a similar example in *Intrinsic Value: Concept and Warrant* (Cambridge: Cambridge University Press, 1994), p. 148.

27. John Pollock, *Contemporary Theories of Knowledge* (Totowa, N.J.: Rowman and Littlefield, 1986), p. 175.

28. Ibid., p. 176.

29. C. D. Broad, *Five Types of Ethical Theory* (New York: Harcourt, Brace, and Co., 1930), p. 238.

30. Roderick Chisholm, "Defining Intrinsic Value," *Analysis 41* (March 1981): 100.

31. See Ernest Sosa's objection to foundationalist views about justification in "The Raft and The Pyramid: Coherence versus Foundations in the Theory of Knowledge," *Midwest Studies in Philosophy V*, edited by Peter French, Theodore Uehling, and Howard Wettstein (Minneapolis, Minnesota: University of Minnesota Press, 1980), esp. pp. 20–23.

28

Marian David

TWO CONCEPTIONS OF THE SYNTHETIC A PRIORI

R oderick Chisholm appears to agree with Kant on the question of the existence of synthetic a priori knowledge. But Chisholm's conception of the a priori is a traditional Aristotelian conception and differs markedly from Kant's. Closer scrutiny reveals that their agreement on the question of the synthetic a priori is merely verbal: what Kant meant to affirm, Chisholm denies. Curiously, it looks as if Chisholm agreed on all substantive issues with the empiricist rejection of Kant's synthetic a priori. In the end, it turns out that Chisholm disagrees with empiricism and Kantianism over a fundamental question: whether mere understanding of the contents of our thoughts must always remain within the circle of our own ideas or can provide us with genuine knowledge of matters of fact.

I. Kant's A Priori

Kant defined a priori knowledge as "any knowledge that is thus independent of experience and even of all impressions of the senses" (1787, B2). A posteriori, or empirical, knowledge he defined as knowledge that is not thus independent of experience. The notion of independence that occurs in these definitions is intended as a strictly epistemic notion. What is at issue here is whether the epistemic status of someone's belief, its constituting knowledge as opposed to mere opinion, does or does not depend on experience. The psychological question whether one needs (to have had) experience to be able to hold the belief, or to grasp the concepts constituting its content, is not at issue. Kant wanted to count a proposition as known a priori just in case it is known independently of experience other than whatever experience, if any, is required for understanding the proposition. Using the epistemic concept of

justification to focus on the epistemic status of a belief, we can rephrase Kant's definition in the following way:

AP_K S knows a priori that p = Df. S knows that p and S's justification for believing that p does not depend on experience.

Based on this definition of a priori knowledge, we can introduce talk of a priori propositions as derived from talk about a priori knowledge:

AP h is an a priori proposition = Df. It is possible that there is some S such that h is known a priori by S.

Kant defined a priori knowledge with reference to judgments rather than propositions. I have suppressed this feature of Kant's definitions. It will resurface eventually.

Besides this strictly epistemic notion of the a priori, Kant was also interested in a psychological notion which he characterized with reference to concepts. An a priori concept would be one that is not derived from experience, while an empirical concept would be one that is derived from experience (by some process of abstraction). If a proposition is known a priori in the epistemic sense defined above and if, in addition, all the concepts that enter into the proposition are a priori in the psychological sense, then he calls that proposition a piece of "pure" a priori knowledge. If, on the other hand, some concepts that are empirical in the psychological sense enter into a proposition that is known a priori in the epistemic sense, then Kant calls such a proposition a piece of "impure" a priori knowledge (cf. 1787, B3).

Kant's definition of a priori knowledge will probably not be completely satisfying. Since it is a negative definition, one might complain that it does not really tell us what a priori knowledge is but merely suggests a general direction in which to look for an account that *does* tell us what it is. To say, based on this definition, that a priori knowledge is a *kind* of knowledge seems a bit like saying that not-red is a kind of color. Moreover, since it does not specify what to count as experience, the Kantian account is vague at a crucial point. The type of experience involved in sense perception will count as experience of course. But what about memory and introspection? Most philosophers would agree that if one's knowledge of a proposition depends on memory or introspection, then one does not know it a priori. So memorial "seemings" will count as experiences for the purposes of the definition, even though it is not obvious that they really are experiences in any ordinary sense of the term. Introspective seemings are probably much more like sense experiences than memorial seemings; nevertheless, introspection is still a problematic case because we do not have a very secure grip on what falls

under it. Does my knowledge that I exist derive from introspection? And what about my knowledge that I believe something or other? It is hard to tell. Another source of vagueness in the Kantian account of the a priori is its failure to specify what kind of cognitive beings are to be subsumed under S. Only humans? Or should we also subsume (possible) beings with more ideal cognitive powers?

Kant maintained that every necessary proposition can be known a priori by someone. This thesis seems excessively strong unless we count (possible) omnipotent beings among the someones. Maybe he really meant to propose a weaker thesis, namely that every necessary truth that can be known (by beings like us) can be known a priori (by beings like us). Even this weaker thesis is contentious. Kripke and Putnam have argued that we know some necessary propositions, e.g., the proposition that water is H_2O, that can only be known a posteriori (at least by beings like us). Kant also seems to have held that every proposition that can be known a priori is a necessary truth. This thesis is also contentious. Kripke has argued that some contingent propositions can be known a priori, e.g., the proposition that the Urmeter in Paris is one meter long. And Plantinga has suggested that S can know a priori that she knows a priori that $2 + 2 = 4$, yet the proposition that she knows a priori that $2 + 2 = 4$ seems contingent.

The points just mentioned raise interesting but difficult issues for the Kantian conception of the a priori. Fortunately, it will not be necessary to make Kant's conception more precise for the purposes of the present paper, nor will it be necessary to take a stance on the relation between a priori knowledge and necessary truth.

2. CHISHOLM'S A PRIORI

Chisholm's conception of the a priori goes back to Descartes and Leibniz and beyond to the Aristotelian tradition. When introducing this conception, Chisholm tends to quote a remark from Leibniz's *New Essays*: "You will find a hundred passages in which scholastic philosophers have said that such propositions are evident *ex terminis*—from their terms— as soon as they are understood" (Leibniz 1981, p. 406). A definition of a priori knowledge that is based on this characterization will, just like Kant's definition, leave room for impure as well as pure a priori knowledge: whatever experience, if any, is required for understanding a proposition, if understanding it is sufficient for knowing it, then it can be known a priori. However, as Chisholm remarks (cf. 1989, p. 27), the account as stated so far would be too narrow. A satisfactory account

should allow for a priori propositions that we know on the basis of others but that are not themselves known as soon as they are understood. Chisholm offers definitions equivalent to the following (cf. 1989, p. 28f.):

h is axiomatic for S $=$Df. S accepts h, and h is necessarily such that (i) it is true, and (ii) for every S', if S' accepts h, then h is certain for S';

h is known a priori by S $=$Df. There is an e such that (i) e is axiomatic for S, (ii) the proposition, e implies h, is axiomatic for S, and (iii) S accepts h.

These definitions are designed to explain the a priori by way of a two-step approach. Roughly, a priori knowledge is either immediate or it is mediated by an inferential step that is itself immediately a priori and based on something that is immediately a priori. Notice that Kant's conception does not require such a two-step approach. In the Kantian definition, a priori knowledge that is mediated by (derived from) other a priori knowledge is already taken care of by defining the a priori in terms of what can be known independently of experience.

I wish to contrast the Chisholmian conception of the a priori with the Kantian conception. To make this easier, I will make some relatively minor changes in Chisholm's definition of the axiomatic. I will also repair what seems to be a flaw in his definition of a priori knowledge. Chisholm does not explicitly invoke the traditional idea that what makes a proposition axiomatic is that *understanding* it is sufficient for knowing it. Instead, he singles out *accepting* as the relevant attitude. However, he explains that his account presupposes the traditional idea. For, one cannot accept a proposition (in Chisholm's sense of accepting) without understanding it, and in the case of propositions that are axiomatic understanding is sufficient for knowing. He also remarks that in order to understand a proposition, in the sense presupposed by his definition, one must grasp what it is for that proposition to be true; the proposition must be one "that you have contemplated and reflected upon" (1989, p. 27). In the definition to be given below, I will revert back to the more traditional formulation that explicitly refers to the notion of understanding rather than implicitly presupposing it.

Chisholm defines what is axiomatic for S in terms of what is *certain* for S rather than what is *known* by S or what S is *justified* in believing. The reference to certainty is intended to indicate that the kind of justification required for a proposition to be axiomatic is more "exalted" than the kind of justification normally required for knowledge. I will suppress this feature of Chisholm's account. I will say that, according to

the Chisholmian conception, a proposition is axiomatic for S just in case it is known by S and is such that understanding it is sufficient for being justified in believing it. This will greatly facilitate the comparison with the Kantian conception. The notion of justification that occurs in both accounts can be taken to be silently restricted to the exalted kind of justification required for certainty.

Chisholm's definitions of the axiomatic and the a priori are not purely epistemic. They are partly metaphysical because Chisholm requires, by definition, that an axiomatic proposition (and hence an a priori proposition) be a necessary truth. Below, I will remove this feature from Chisholm's definitions. Instead, I will assume that Chisholm, much like Kant, supplements his definitions of the axiomatic and the a priori with the additional (contentious) thesis that every proposition that is axiomatic, and consequently every a priori proposition, is a necessary truth. It should be noted that, unlike Kant, Chisholm does not hold that every necessary truth (that can be known) can be known a priori. This difference between the two views will not be relevant to our discussion.

Finally, it seems that there is a flaw in Chisholm's definition of a priori knowledge that needs to be corrected. Chisholm maintains that our axiomatic knowledge is a subspecies of our a priori knowledge, i.e., he claims that whatever is axiomatic for S is known a priori by S (cf. 1989, p. 28). But his definition of a priori knowledge does not bear out this claim. It would bear out the claim only if the following assumption were true: Whenever some proposition h is axiomatic for S, then S knows h on the basis of another axiomatic proposition e together with the proposition that e implies h or S knows h on the basis of h itself together with the proposition that h implies h. This is a highly implausible assumption which, moreover, seems to go against the spirit of Chisholm's conception.[1] I will formulate the definition of a priori knowledge so as to avoid this consequence:

AX_c h is axiomatic for S =Df. S knows h, and h is necessarily such that for every S', if S' understands h, then S' is justified in believing h;
AP_c h is known a priori by S =Df. Either h is axiomatic for S, or there is an e such that e is axiomatic for S, the proposition, e implies h, is axiomatic for S, and S accepts h;
AP h is an a priori proposition =Df. It is possible that there is some S such that h is known a priori by S.

Notice that there is no verbal difference between Chisholm's and Kant's versions of the definition of what it is for a proposition to be an a priori proposition. Of course, underneath this verbal similarity lies a difference in content. The Kantian conception of the a priori employs the idea of

"knowledge independent of experience," whereas Chisholm's conception develops the "understanding is sufficient for knowing" idea. In what follows, I will often rely on these short characterizations to simplify the discussion.

3. Pure *ANSCHAUUNG*

If understanding a proposition is sufficient for knowing it, then mere understanding provides all the evidence that is needed for knowing the proposition, that is, the proposition is known independently of experience. In other words, whatever is known a priori in Chisholm's sense is known a priori in Kant's sense. But what about the converse? Does Kant's a priori imply Chisholm's a priori? Is it the case that whatever is known independently of experience is such that understanding it is sufficient for knowing it? I will suggest shortly that Kant should give a negative answer to this question while Chisholm would give a positive answer. The point, I think, is of some interest. Kant maintained that there is synthetic a priori knowledge, and Chisholm agrees with Kant on this question. If, however, they disagree on the question whether Kant's a priori implies Chisholm's a priori, their agreement about the existence of synthetic a priori knowledge may be largely verbal; it may mask an important disagreement on what synthetic a priori knowledge amounts to.

It is not hard to see on what grounds someone might maintain that Kant's a priori does not imply Chisholm's a priori. If one thinks that there is some knowledge that does not depend on experience but does depend on something else, X, such that X is not required for understanding the proposition in question, then one will hold that there is a priori knowledge that is Kantian but not Chisholmian. Kant, it seems, held just such a view. It seems that the propositions he regarded as synthetic a priori are just those that, according to Kant, can be known independently of experience while, at the same time, knowing them requires some X that is not required for understanding them. This factor X is of course nonempirical, or "pure," intuition (*reine Anschauung*).

This interpretation of Kant's position depends on a crucial point. For the interpretation to be correct, Kant must not have held that pure intuition is already required for understanding a synthetic a priori proposition. On the contrary, he must have held that it is in principle possible to understand such a proposition without knowing that it is true because one might lack the pure intuition required for knowing it. He must have held, in other words, that pure intuition is an epistemic factor,

one that is required for the justification of the synthetic a priori, rather than a psychological factor required for grasping the concepts entering into a synthetic a priori proposition. Unfortunately, Kant was a bit less explicit on this crucial point than I would wish. Let us look at some passages in which Kant talks about synthetic judgments in general and synthetic a priori judgments in particular. It will be helpful to remember that when Kant talked generally about judgments, he usually had in mind judgments of the form "All As are Bs" which he took to be of the subject-predicate form:

> Thus it is evident . . . that in synthetic judgments I must have besides the concept of the subject something else (X), upon which the understanding may rely, if it is to know that a predicate, not contained in this concept, nevertheless belongs to it. In the case of empirical judgments, judgments of experience, there is no difficulty whatsoever in meeting this demand. This X is the complete experience of the object which I think through the concept A. . . . Experience is thus the X which lies outside the concept A, and on which rests the possibility of the synthesis of the predicate . . . (B) with the concept (A). (Kant 1787, A7–8)

> But in *a priori* synthetic judgment this help is entirely lacking. . . . Upon what, then, am I to rely, when I seek to go beyond the concept A, and to know that another concept B is connected with it? Through what is the synthesis made possible? Let us take the proposition 'Everything which happens has a cause'. . . . The concept of a 'cause' lies entirely outside the other concept, and signifies something different from 'that which happens', and is not therefore in any way contained in this latter representation. How come I then to predicate of that which happens something quite different, and to apprehend that the concept of cause, though not contained in it, yet belongs, and indeed necessarily belongs, to it? What is here the unknown = X which gives support to the understanding when it believes that it can discover outside the concept A a predicate foreign to this concept, which it yet at the same time considers to be connected with it? (Kant 1787, B13–14)

> Granted, then, we must advance beyond a given concept in order to compare it synthetically with another, a third something is necessary, as that wherein alone the synthesis of two concepts can be achieved. (Kant 1787, B194)

At times, especially at the end of the second passage, Kant's language may suggest the following picture. Being already in possession of concept A, I cast about for another concept that goes beyond A. With the help of X (experience or pure intuition, as the case may be) I discover, or grasp, or form, a new concept B, one that goes beyond A and that I did not have before. X then enables me to synthesize concepts B and A into a belief that I could not have held before because I lacked one of the requisite concepts. If this is the picture Kant meant to convey, then X is required for understanding the proposition in question and Kant's conception of the a priori coincides with Chisholm's conception. But I think that, on

balance, the passages above support the alternative interpretation that pure intuition is not logically required for understanding a synthetic a priori proposition. Although Kant does not say so explicitly, his language tends to imply that the predicate concept, B, is already given: we are looking for *a third* something that will effect the synthesis of B with A. Moreover, at two points—at the beginning of the first passage and at the beginning of the second passage—Kant seems to emphasize that the factor X (experience, pure intuition) is required for *knowing* the proposition in question, thereby indicating that X is an epistemic factor required for justification rather than a psychological factor required for belief (or concept) formation. Assuming this interpretation of the role of pure intuition in synthetic a priori knowledge, it follows that the Kantian a priori does not imply Chisholm's a priori. According to Kant, nonempirical intuition is required for the justification of synthetic a priori propositions but not required for understanding them.

I have already mentioned that Chisholm agrees with Kant, at least verbally, on the question of the existence of a priori knowledge. But nowhere in Chisholm's work can one find anything like Kant's account of the synthetic a priori. Chisholm never invokes Kant's pure intuition or anything like it. In fact, he never invokes anything that would explain synthetic a priori knowledge by going beyond what is already required for understanding a synthetic a priori proposition. The reason for this is, I suggest, that, according to Chisholm's view, a proposition is a priori in Kant's sense only if it is a priori in Chisholm's sense: whatever can be known independently of experience can be known merely through understanding the propositions involved. The Kantian account of synthetic a priori knowledge based on nonempirical intuition is simply excluded by Chisholm's conception of the a priori. Since Chisholm nevertheless affirms the existence of synthetic a priori knowledge, he must either have an alternative account of the synthetic a priori or he must have a conception of *syntheticity* that differs from Kant's conception. We will see that there is a bit of both of these alternatives in Chisholm's view on the synthetic a priori.

4. LEWIS'S CONCEPTION OF THE SYNTHETIC A PRIORI

In *An Analysis of Knowledge and Valuation*, we find C. I. Lewis characterizing the analytic and the a priori in the following words:

> Traditionally a statement which can be certified by reference exclusively to defined or definable meanings is called *analytic*; what is nonanalytic being

called *synthetic*. And traditionally that knowledge whose correctness can be assured without reference to any particular experience of sense is called *a priori*; that which requires to be determined by sense experience being called *a posteriori*. (Lewis 1946, p. 35)

There can be no doubt that Lewis's definition of the a priori coincides precisely with Kant's definition and differs from Chisholm's. What about his definition of the analytic? Notice first that Lewis gives an *epistemic* definition of analyticity as what is *certifiable* solely by reference to meanings. This indicates that Lewis's notion of analyticity is not Kant's famous notion of analyticity as conceptual containment for, as we shall see in the next section, the latter is not defined in epistemic terms at all. In fact, it looks like Lewis's analytic is a linguistic version of Chisholm's a priori. According to Lewis, analytic statements are "determinable as true by reference exclusively to the meanings of expressions used" (1946, p. 35). If we translate this into the language of propositions, we get a characterization of analytic propositions as those that can be known solely on the basis of understanding them, and that is just Chisholm's account of the a priori.[2]

Lewis, of course, denied the existence of synthetic a priori knowledge while Chisholm affirms it. However, what Lewis denied can hardly be what Chisholm affirms because Lewis understands 'synthetic' in much the same way as Chisholm understands 'a posteriori'. So Lewis's denial of the synthetic a priori comes out as the claim that whatever is a priori in Kant's sense is a priori in Chisholm's sense. And we have seen above that Chisholm seems to share *that* view, although he certainly denies that it expresses the thesis that there is no synthetic a priori. To use obvious abbreviations, Chisholm and Lewis both hold that $AP_K \rightarrow AP_C$. And on this point they both disagree with Kant, or at least with Kant as interpreted in the previous section, since Kant maintained that there is knowledge that is a priori in his sense but not in the Chisholmian sense, i.e., he held that $\neg(AP_K \rightarrow AP_C)$. What we need to find out now is how this thesis relates to the claim that there is synthetic a priori knowledge. And in order to do so, we need to consider Kant's notions of the analytic and the synthetic.

5. ANALYTICITY

Kant gave at least three accounts of the analytic and the synthetic. According to the first account, an analytic proposition is one in which "the predicate B belongs to the subject A, as something which is

(covertly) contained in this subject A" (1787, B10). This definition of analyticity in terms of conceptual containment appears to be applicable only to those propositions that Aristotelian logic classifies as affirmative subject-predicate propositions ("All As are Bs"). Kant did not remark on how one could expand the definition to cover other propositions. Moreover, the definition accounts only for analytic *truth*, even though Kant apparently intended to recognize analytic falsehoods as well (cf. 1787, B 193). The following would be a definition of the analytic and the synthetic that repairs at least the second shortcoming of Kant's definition:

AN h is analytically true = Df. The predicate concept of h is (covertly) contained in its subject concept. h is analytically false = Df. The negation of the predicate concept of h is (covertly) contained in its subject concept. h is analytic = Df. h is either analytically true or analytically false.

SYN h is synthetic = Df. h is neither analytically true nor analytically false.

In these definitions, h must be restricted to range only over affirmative and negative Aristotelian subject-predicate propositions. Moreover, the definitions presuppose explanations of what counts as the subject concept of a proposition, what counts as the predicate concept of a proposition, and what counts as the negation of a concept. I will refer to the notions defined above as the *containment* notions of analyticity and syntheticity.

Kant apparently assumed that the crucial relation of conceptual containment could be spelled out in terms of an account of conceptual analysis (cf. 1787, B11). Such an account would have to comprise (i) a compositional theory of concepts that explains how logically complex concepts are composed of logically simpler concepts, e.g., how C & D is composed of C and D; and (ii) a theory of the individuation of concepts that explains under what conditions concept A is identical with concept C & D, and under what conditions concept D is identical with concept B. Based on the theories of composition and identity of concepts, the analyticity of a proposition of the form "All As are Bs" will be explained in terms of A = C & D and D = B. It seems fair to say that Kant did not provide such an account of conceptual analysis.

Kant's second account defines an analytically true proposition as one whose negation is reducible to an explicit contradiction (cf. 1783, p. 267). Kant assumed that this second definition coincides with his first definition.

According to Kant's third account, analytic judgments are "merely

explicative, adding nothing to the content of the cognition (= piece of knowledge [*Erkenntnis*])," while synthetic judgments are "ampliative, increasing the given cognition" (1783, p. 266). What is the relation between this third account and Kant's first account? Kant maintained that what is nonampliative must coincide with what is containment analytic and what is ampliative must coincide with what is containment synthetic. I disagree. One can, of course, read the non-ampliative/ampliative distinction in such a way that the equation "ampliative = no conceptual containment" comes out as true by definition. But I suggest that this is not the best way to understand the point of this distinction. Kant tended to think of the ampliative in terms of informativeness, that is, as "what will lead to a genuinely new addition to all previous knowledge" (1787, B14), and it is far from trivial to maintain that whatever is not containment analytic will lead to a genuinely new addition to knowledge. More importantly, it seems that it was really the idea of ampliative (in this sense) a priori knowledge that lay at the center of Kant's concerns. It was only because Kant thought that the somewhat obscure notion of the ampliative could be made more precise in terms of the absence of conceptual containment that he tended to describe himself as being concerned with a priori knowledge that is synthetic in the (non)containment sense of syntheticity.

This view commits me to the following hypothesis: If the containment notion of analyticity turns out to be too narrow to cover intuitively trivial truths, Kant should not have taken this as an occasion to announce the discovery of trivial cases of ampliative a priori knowledge. Rather, he should have taken this as an occasion to drop the equation "ampliative = no conceptual containment." An example may help make this clearer. Strictly speaking, a proposition of the form "$\neg p \not\psi p$" is not containment analytic. Should Kant have claimed that this is yet another case of ampliative a priori knowledge? I suggest not. He should rather have admitted, and with good reason, that his explanation of the ampliative in terms of noncontainment was inadequate.

It is well known that it is misleading to describe the debate between rationalism and empiricism as the debate about the existence of a priori knowledge. Described this way, the leading empiricists of Kant's time had already admitted defeat. Even Hume acknowledged the existence of a priori knowledge. But the description does injustice to Hume's empiricism. For Hume had maintained that a priori knowledge is somehow not "genuine" knowledge. It does not allow us to go outside of what is immediately given to our own minds because it is concerned merely with "relations of ideas." Genuine knowledge, according to Hume, concerns "matters of fact" in the external world and is always

empirical. This distinction between relations of ideas and matters of fact, although of crucial importance to empiricism, is not easy to make precise. Kant attempted to do so with his distinction between the containment analytic and the containment synthetic. The nonampliative/ampliative distinction, on the other hand, can be interpreted as Kant's way of marking Hume's distinction merely in terms of the role the distinction is supposed to play in the defense of empiricism. 'Nonampliative' would then be used to refer to whatever the empiricist can allow to be known a priori without relinquishing empiricism. 'Ampliative' would be used to refer to what the empiricist cannot allow to be known a priori without relinquishing empiricism—roughly, knowledge about the external world.

From this point of view, the nonampliative/ampliative distinction is more central than the noncontainment/containment distinction. The former distinction is supposed to refer, albeit not very informatively, to the line separating what is acceptable to empiricism from what is not. The latter distinction is merely intended as a specific proposal for identifying the "items" that occupy the areas separated by the former. As such the noncontainment/containment distinction may be "negotiable." If it turns out to lead to an overly narrow view of what counts as nonampliative—overly narrow in terms of the role the nonampliative has to play in the defense of empiricism—then it may be discarded and replaced by another proposal for identifying what is to count as nonampliative and what as ampliative.

6. A KANTIAN CONCEPTION OF THE SYNTHETIC A PRIORI

We have seen that Kant has at least two ways of stating his thesis that there is synthetic a priori knowledge: in terms of the ampliative a priori and in terms of the a priori that is synthetic in the containment sense. Let me use 'AN' and 'SYN' exclusively for the containment notions of analyticity and syntheticity. Kant's somewhat more obscure Humean distinction between genuinely and not genuinely new knowledge will be marked by 'AMPL' and '\negAMPL'. Using these abbreviations, the first version of Kant's thesis comes out as $\neg(AP_K \rightarrow \neg AMPL)$, while the second version comes out as $\neg(AP_K \rightarrow AN)$. In the previous section I have argued that these two versions of Kant's thesis should not be seen as mere notational variants and that the first version is the more central because it directly, though rather vaguely, expresses Kant's central concern for a priori knowledge that is "genuine" in the sense of Hume's distinction. The second version derives from the additional idea that this

vague notion of ampliative knowledge can be spelled out in terms of what is not containment analytic.

Lewis, as we have seen, wanted to express Kant's thesis as the claim that $\neg(AP_K \rightarrow AP_C)$. Even though this has earned him the accusation of confusing the analytic with the a priori,[3] it appears we can interpret Lewis's formulation more fruitfully, if we understand it as incorporating an alternative proposal for spelling out what could be meant by nonampliative knowledge. According to Lewis's proposal, the nonampliative/ampliative distinction should be spelled out in terms of Chisholm's a priori/a posteriori distinction. Admittedly, putting it this way is verbally awkward. But we should remember that on Chisholm's conception the a priori is what can be known through mere understanding of propositions (plus what can be known on the basis of what can be known through mere understanding of propositions). And this is a candidate for spelling out the nonampliative/ampliative distinction that will look promising to Kantians and empiricists alike.[4]

Empiricists and Kantians have a shared interest in drawing the line between a priori knowledge that is acceptable by empiricist standards and a priori knowledge that is not so acceptable; they have a shared interest in trying to make this line a bit more precise. Lewis's proposal should look promising from both points of view for two reasons. First, the notion of what can be known through mere understanding seems to capture Hume's knowledge of relations of ideas as opposed to matters of fact. Knowledge through mere understanding of propositions seems to concern only our thoughts, the contents of our own minds. As such it will not inform us about the external world and does not constitute "genuine" knowledge. Kant by and large agrees with Hume that the theory of understanding is, at bottom, a theory about the thoughts in us and not about the world outside us. So knowledge through mere understanding cannot be ampliative. Also, knowledge that is not "genuine" in the sense that Hume and Kant were aiming at, but still deserves its title as knowledge, must be concerned with what is already implicit in our understanding of our own thoughts. Nonampliative knowledge must be knowledge through mere understanding.

The second reason why Lewis's proposal may be welcome from a Kantian as well as an empiricist point of view is that it offers an account of the nonampliative that is less narrow than the account in terms of containment analyticity. As I remarked earlier, the containment notion of analyticity makes it very easy for a proposition to be synthetic, viz., "$\neg p \lor p$." Taken by itself this is not a problem. But the identification $\neg AMPL = AN$, and the consequent identification $SYN = AMPL$, seems to make it too easy for a proposition to be ampliative. Surely,

many propositions that come out as containment synthetic should fall on the side of Hume's distinction that is concerned with mere knowledge of our own thoughts. The identification \negAMPL $=$ AP$_C$ would seem to give a much better account of what Kant intended with the notion of nonampliative knowledge, that is, a better account in terms of the role this distinction has to play in the defense of empiricism.

So Kantians and empiricists may both welcome Lewis's proposal. Of course, the empiricist will go on to deny that there is any synthetic a priori knowledge in the sense of the proposal. She will argue for the claim that AP$_K$ \to AP$_C$ because she holds, much like Chisholm and Lewis, that "there are no other sources of knowledge than on the one hand data of sense and on the other hand our own intended meanings" (1946, p. 35). This is where empiricism and Kant part ways. After all, Kant thought that pure intuition is on the one hand a source of knowledge that is independent of experience but is on the other hand not already involved in our own intended meanings.

7. CHISHOLM'S CONCEPTION OF THE SYNTHETIC A PRIORI

I have in effect argued above that Kant's second way of stating the claim that there is synthetic a priori knowledge, namely in terms of the containment notion of syntheticity, results from a combination of two Kantian theses: the fundamental thesis that some a priori knowledge is ampliative, and the less important thesis that ampliativeness can be spelled out as containment syntheticity. I have also argued that Kant, or at least a Kantian, may well drop the latter thesis on the ground that it will misclassify as ampliative knowledge that is intuitively not genuine in the Humean sense. Instead, the Kantian may go along with Lewis's proposal and spell out the ampliative in terms of knowledge not attainable through mere understanding, that is, in terms of Chisholm's conception of the a posteriori. If our Kantian thus identifies the ampliative with Chisholm's a posteriori, he will of course deny the claim that what is a priori in Chisholm's sense is exhausted by what is containment analytic.

Chisholm affirms the existence of synthetic a priori knowledge. But we have already seen that Chisholm, just like an empiricist, denies that there is a priori knowledge in Kant's sense that is not a priori in Chisholm's sense. So in terms of the Kantian conception outlined in the previous section, Chisholm denies the existence of the synthetic a priori because, like the empiricist, he is not a friend of Kant's pure intuition.

What, then, does Chisholm affirm when he says "there is synthetic a priori knowledge"?

As we will see later on, Chisholm embraces an account of the analytic/synthetic distinction similar to the containment account given in section 5. That is, Chisholm adopts the containment notions of analyticity and syntheticity. Consequently, his claim that there is synthetic a priori knowledge comes out as the claim that not all knowledge that is a priori in Chisholm's sense is containment analytic. This creates a curious situation: it looks as if on the substantive issues Chisholm is in perfect agreement with empiricism and opposed to Kant. His only disagreement with empiricism seems to be over the verbal issue whether the thesis that the Chisholm a priori is not exhausted by the containment analytic should be taken to express Kant's famous claim. Chisholm seems to be saying that it should, whereas for the empiricist, as well as the Kantian described above, this thesis expresses merely the claim that the containment analytic offers too narrow an account of the nonampliative.

Is Chisholm then really an empiricist at heart? Is his disagreement with empiricism merely verbal? I think not. For Chisholm disagrees with the empiricist and our Kantian over the question whether the nonampliative should be identified with Chisholm's a priori, that is, they disagree over Lewis' proposal. I think a chart will be welcome to make the various positions more perspicuous. The chart assumes that the empiricist and our Kantian have adopted Lewis's proposal as described in the previous section. Hume will have to do duty (somewhat anachronistically) for our generic empiricist:

	$AP_K \rightarrow AP_C$	$AP_C \rightarrow AN$	$AP_C = \neg AMPL$
Kant	No	No	Yes
Hume	Yes	No	Yes
Chisholm	Yes	No	No

Looking only at the first two columns one might indeed conclude that Chisholm's disagreement with Hume is merely verbal. However, the crucial third column shows that Chisholm disagrees with Hume as well as with our Kantian over Lewis's proposal to identify the nonampliative with the a priori in Chisholm's sense. Remembering Chisholm's conception of the a priori, we see that their disagreement is over the question whether knowledge that derives from mere understanding must be nonampliative. And this is a substantive and even fundamental issue. Chisholm maintains, in opposition to Kant and Hume, that our grasp of our own concepts will furnish us with genuine knowledge about matters of fact.

8. KANT'S PRINCIPLE

Kant tended to argue for the need of pure intuition along the following lines: The proposition that every event has a cause is not containment analytic, that is, it is containment synthetic. Therefore, it is ampliative. What then is the basis of our knowledge of the law of causation? Since the law is necessary and known a priori, our knowledge cannot derive from experience in this case. But since our understanding of our own concepts can yield only non-ampliative knowledge, our knowledge of the law cannot be based on concepts either. Hence, there must be a third source of knowledge: pure intuition. (cf. 1787, B64–65)

 The first step in this reasoning relies on Kant's original identification of the containment synthetic with the ampliative. But the step is not really essential to the argument for pure intuition. Kant may well have adopted Lewis's proposal and put the first step of the argument like this: The causal law is a priori but our knowledge of it does not derive merely from understanding what it says. Therefore, it is ampliative. This reformulation would have been just as convincing to Kant, for what it does is point out what Kant really wanted to point out, namely that the law of causation does not concern Hume's relations of ideas but matters of fact. The crucial step in the argument comes rather with the claim that our understanding of our own concepts cannot yield ampliative knowledge:

> As regards the first and sole means of arriving at such knowledge [of theorems of geometry], namely, in *a priori* fashion through mere concepts or through intuitions, it is evident that from mere concepts only analytic knowledge, not synthetic knowledge, is to be obtained. (Kant 1787, B64–65)

Naturally, Kant does not specify which meaning of 'analytic' and 'synthetic' he has in mind. But as I have tried to show, the primary point Kant wanted to make in his argument for the need for pure intuition is that our knowledge of the law of causation and the theorems of geometry and arithmetic does not derive merely from our understanding of the propositions involved. So the crucial step in Kant's argument for pure intuition is

> *Kant's Principle*: From mere concepts only nonampliative knowledge, no ampliative knowledge, is to be obtained.[5]

The principle helps us to understand the table in the previous section. Hume and Kant both accept Kant's principle. For them it expresses the almost trivial point that our grasp of our own concepts cannot lead us

beyond relations of ideas to matters of fact. Twentieth-century logical empiricism put this point in terms of meanings and conventions: grasp of meanings cannot lead us beyond our own conventions to matters of fact about the external world. This signifies a shift of focus away from the content of thought to the content of language, but the basic adherence to Kant's principle remains. Of course, all empiricists reject Kant's addition to the sources of knowledge. They reject pure intuition and maintain that the propositions Kant took to be a priori and ampliative are really a priori and nonampliative. Chisholm, too, rejects pure intuition. But he also rejects Kant's principle. On his view, Kant's principle implies a deeply mistaken view that must quickly lead into some unacceptable form of psychologism or linguistic conventionalism about necessary truth. On Chisholm's view, the knowledge that can be obtained from "mere concepts" is as factual as any other knowledge about "matters of fact."[6]

9. CHISHOLM'S PRE-KANTIAN RATIONALISM

Earlier I mentioned that Chisholm embraces a conceptual containment account of the analytic/synthetic distinction similar to the one given in section 5. It has now turned out that allegiance to the containment notion of analyticity is essential to Chisholm's position. If, like our empiricist and our Kantian, he were prepared to remove containment analyticity from its prominent place on the grounds that \negAMPL is more fruitfully spelled out in terms of AP_C, Chisholm's position would collapse. So it is time to take a look at Chisholm's account of the analytic. This look will also reveal what Chisholm regards as the basis of all a priori knowledge, analytic as well as synthetic.

Chisholm gives a schematic definition of analyticity for Aristotelian subject-predicate propositions (1989, p. 34):

AN_C The proposition that all Fs are Gs is analytic =Df The property of being F is conceptually equivalent to a conjunction of properties, P and Q, such that: (i) P does not imply Q, (ii) Q does not imply P, and (iii) the property of being G is conceptually equivalent to Q.

This definition really defines analytic truth. Analytic falsehood can be defined by substituting "the property G is conceptually equivalent to the negation of Q" in clause (iii). The synthetic will be defined as what is not analytic (neither analytically true nor analytically false). The notion of property implication is explained in the following way: the property P

implies the property Q just in case P is necessarily such that if something exemplifies it then something exemplifies Q. The definition given above makes clear that Chisholm's containment analytic is just as narrow as Kant's. However, on Chisholm's view, this is of little consequence. There is no reason to worry that the containment analytic may give too narrow an account of the nonampliative and make it too easy for a proposition to be ampliative. Once Kant's principle is denied, the Kantian *cum* Humean understanding of the nonampliative/ampliative distinction in terms of "relations of ideas" versus "matters of fact" loses its foothold: all a priori knowledge, be it synthetic or analytic, is equally concerned with matters of fact. We will be able to see this more clearly, when we look into Chisholm's brand of rationalism.

The explication of the notion of conceptual equivalence that is crucial to Chisholm's definition of analyticity will lead us to one of Chisholm's most central notions:

P is conceptually equivalent to Q =Df. P entails Q, and Q entails P.

The property of being F entails the property of being G =Df. The property of being F is necessarily such that whoever believes something to be F believes something to be G.[7]

Property entailment is one of the central notions of Chisholm's "intentional approach to ontology" developed in a number of publications that appeared in the 1980s. In these publications, Chisholm uses the metaphysical notion of necessity and property exemplification together with two primitive intentional notions to define relations between properties and propositions or states of affairs. The primitive intentional notions are usually the relation of *conceiving* that obtains between a subject and a property, and the relation of *attributing* that obtains between a subject, a property, and an object (at times attributing is replaced by *believing something to be F*). Properties are defined as essentially attributable, although their existence does not depend on actually being attributed by anyone to anything: P is a property = Df. P is possibly such that there is someone who attributes it to something. The intentional approach to ontology offers (i) a theory of the logical structure of properties which defines negative properties, conjunctive properties, disjunctive properties, etc., and (ii) a theory of the identity conditions of properties (sometimes replaced by conditions for conceptual equivalence). In short, Chisholm's intentional approach attempts to provide what Kant failed to provide for his containment notion of analyticity: an account of conceptual analysis.[8]

One should not, however, be misled by the term 'conceptual' in 'conceptual analysis'. Chisholm's brand of conceptual analysis is a

theory of mind- and language-independent properties (and propositions or states of affairs) and the modal and intentional relations that obtain of necessity among them and between them and us. I mentioned earlier that Kant framed his definitions of the a priori and the analytic with reference to judgments rather than propositions. We can now see this as another symptom of the difference between his approach and Chisholm's. To Chisholm, Kant's reliance on the notion of a judgment will suggest that Kant's thought on necessity, the a priori, the analytic, and on conceptual analysis was infected by psychologism. Kant's 'judgment' refers either to a psychological act or it refers confusedly to a mixture between psychological act and objective content, a mixture that requires sorting out. Chisholm's approach attempts to do that. It analyzes talk of concepts and judgments into talk of intentional relations (grasping, attributing, believing) and objective properties and propositions (or states of affairs). Intentional relations are "externalist" in the sense that they relate cognitive subjects to (abstract) external objects existing independently of any cognitive subjects and their relations to them. Internal, or narrow, psychological states and acts have no role to play in this approach. The intentional approach to ontology attempts to keep clearly in view the lines separating the narrowly psychological from the intentional and the ontological.

At the core of the intentional approach to ontology lies a principle that ties the intentional relation of property entailment to the purely ontological relation of property implication:

CPR₁ If F entails G, then F is necessarily such that, if something exemplifies F then something exemplifies G. I.e.:
If F entails G, then F implies G.

Often Chisholm also introduces a concept of property entailment narrower than the one defined above, which gives rise to another principle tying an intentional relation to a purely ontological relation:

F n-entails G = Df. F is necessarily such that, for every x, whoever attributes F to x attributes G to x.

CPR₂ If F n-entails G, then F is necessarily such that, whatever exemplifies F exemplifies G. I.e.:
If F n-entails G, then F includes G.[9]

I have labeled these principles "CPR" for "Chisholm's Platonist Rationalism" because they express the Platonist idea that our intentional access to properties provides us with access to objective features of all possible worlds. However, for a full account of what I take Chisholm to

see as the source of our knowledge of analytic as well as synthetic a priori truths, we need a further principle, a principle that identifies our access to objective properties and their necessary relations as a privileged form of *epistemic* access:

CPR (a) F entails/n-entails G iff we can know a priori in Chisholm's sense that F entails/n-entails G;

(b) CPR_1 and CPR_2 can be known a priori in Chisholm's sense.

The principle tells us that we can know property entailments merely on the basis of our understanding, or grasp, of the properties involved. It also tells us that this a priori knowledge of intentional relations between properties yields a priori knowledge of nonintentional relations between properties. I do not know whether Chisholm has ever explicitly stated such principles. But it seems that CPR, or some principle like it, is required to make sense of Chisholm's position in the debate about the synthetic a priori. The three CPR principles locate the source of all our a priori knowledge in our intentional access to objective properties and their relations. The distinction between the synthetic a priori and the analytic a priori requires no additional epistemic basis. In some cases, the analytic ones, the entailment relation between two properties A and B reduces to underlying entailments between simpler properties because A = C & D and D = B and property identity (or conceptual equivalence) is itself a matter of entailments. In other cases, the synthetic ones, the entailment is irreducible. In both cases, our a priori knowledge of the entailments is based on our intentional access to the properties involved. Chisholm's Platonist rationalism is, then, closely related to Bolzano's view on the synthetic and the analytic a priori:

> What justifies the understanding to attribute to a subject A a predicate B which does not lie in the concept A? Nothing I say but that the understanding *has* and *knows* the two concepts A and B. I think that we must be in a position to judge about certain concepts merely because we have them. For, to say that somebody has certain concepts A, B, C, . . . surely means that he knows them and can distinguish them. . . . Since this holds generally, it also holds in the case when these concepts are simple. But in this case the judgments which we make about them are certainly synthetic. (Bolzano 1837, p. 347)

10. CONCLUSION

I have described two conceptions of the synthetic a priori: Chisholm's conception and a Kantian conception. Chisholm rejects the Kantian conception because, like the empiricists, he sees no need for pure intuition as a third source of knowledge: experience and understanding

are sufficient. But Chisholm rejects empiricism as well. For, according to Chisholm, our understanding of our concepts reaches beyond the circle of our own ideas and provides us with genuine knowledge of matters of fact. Kant and the logical empiricists all agreed with Hume that the theory of the contents of our thoughts is ultimately a theory about our own psychology or about our own intended conventional meanings. They all accepted the argument, sketched in section 6 and later compressed into Kant's principle, that knowledge through mere understanding cannot be genuine, or ampliative, because it can never reach beyond the relations of our own ideas to the external world. Chisholm rejects this argument and rejects Kant's principle: knowledge through mere understanding of our thoughts concerns matters as factual as anything.[10]

MARIAN DAVID

DEPARTMENT OF PHILOSOPHY
NOTRE DAME UNIVERSITY
OCTOBER 1996

NOTES

1. The context of Chisholm's definition of a priori knowledge suggests that he intends it to spell out the idea that some a priori propositions are known *on the basis of* axiomatic propositions (cf. 1989, p. 28f.). However, Patricia Blanchette has reminded me that the definition itself does not make use of this talk and is, consequently, not committed to the assumption I described in the text. Nevertheless, the definition is committed to the following implausible assumption: h is axiomatic for S, only if S accepts that h implies h or accepts that e implies h for some e other than h. Remember that Chisholm's acceptance requires that one has contemplated the proposition in question and reflected upon it.
2. This is a slight oversimplification. Speaking more precisely, Lewis's analytic can be regarded as a linguistic version of Chisholm's a priori, provided Lewis really had the following definition in mind: A statement is analytic just in case it is certifiable solely by reference to meanings or is derived from a statement certifiable solely by reference to meanings via an inference that is certifiable solely by reference to meanings.
3. From Pap (1958, pp. 97–103) who interprets Kant's conception of the a priori in terms of Chisholm's conception.
4. Lewis is not the only philosopher to make "Lewis's proposal." Mill seems to have anticipated it. He distinguishes between "real" and "verbal" propositions and says of the latter that they "convey no information to anyone who previously understood the whole meaning of the terms" (1872, p. 113). In a footnote he remarks that his real/verbal distinction is meant to correspond to

Kant's analytic/synthetic distinction, thereby indicating that he thinks of the latter primarily in terms of the nonampliative/ampliative distinction (cf. 1872, p. 116). To give a much more recent example, Paul Boghossian (forthcoming) argues that the only tenable notion of the analytic is one that is at bottom epistemic. He defines a statement to be analytic just in case mere grasp of its meaning suffices for being justified in believing it. This is of course exactly what I have called Lewis's proposal. Boghossian, just like Lewis, thinks that the containment notion of the analytic is untenable and should be replaced by (a linguistic version of) Chisholm's a priori. Boghossian's emphasis on the epistemic nature of his notion of analyticity indicates that he is primarily aiming to spell out the difficult distinction between the nonampliative and the ampliative.

5. The crucial role played by what I call "Kant's Principle" in Kant's argument for pure intuition is emphasized in Coffa (1991, pp. 17ff.).

6. Lewis, by the way, argues against linguistic conventionalism about necessary truth. Although he is usually regarded as one of the eminent empiricists of the era, his views on a priori knowledge have more in common with Chisholm's than with the views characteristic of logical empiricism (cf. Lewis 1946, chap. 6).

7. See Chisholm 1989, p. 33. The definition of conceptual equivalence given in the text does not correspond to the one given by Chisholm. But evidence from the context (pp. 33–35) shows, by my lights conclusively, that Chisholm's version is a misprint. I have given the definition that Chisholm must have intended to give.

8. See Chisholm 1981, 1982, 1986, 1989, and 1996.

9. For CPR_1, see Chisholm 1989, p. 51. For the definition of what I have called "n-entails" and for CPR_2, see Chisholm 1982, p. 144. Interestingly, Chisholm tends to not emphasize the CPR principles very much.

10. In recent years Chisholm has tended to state the most basic definition of his intentional approach to ontology by making use of schematic predicate letters; see 1996, chap. 2. This has the consequence that subsequent definitions that allow for quantification over properties cannot ultimately be interpreted as allowing for *objectual* quantification over properties. Their "property variables," it seems, must be understood along the lines of a *substitutional* interpretation of quantification. This incorporates a linguistic element into the core of Chisholm's intentional approach to ontology. Whether this signals a move away from strict Platonism and towards a more linguistic understanding of properties I do not know.

REFERENCES

Boghossian, P. Forthcoming. "Analyticity." In C. Wright and B. Hale, eds., *A Companion to the Philosophy of Language.* Oxford: Blackwell.

Bolzano, B. [1837] 1972. *Theory of Science.* Edited and translated by R. George. Berkeley and Los Angeles: University of California Press.

Chisholm, R. 1981. *The First Person: An Essay on Reference and Intentionality.* Brighton: Harvester Press.

———. 1989. "Properties and States of Affairs Intentionally Considered." In *On Metaphysics*, pp. 141–55. Minneapolis: University of Minnesota Press.

———. 1986. "Self-Profile." In R. J. Bogdan, ed., *Roderick M. Chisholm*, pp. 3–77. Dordrecht: Reidel.

————. 1989. *Theory of Knowledge*, 3d ed. Englewood Cliffs, N.J.: Prentice Hall.

————. 1996. *A Realistic Theory of Categories: An Essay on Ontology*. Cambridge: Cambridge University Press.

Coffa, J. A. 1991. *The Semantic Tradition from Kant to Carnap: To the Vienna Station*. Cambridge: Cambridge University Press.

Kant, I. [1783] 1977. *Prolegomena to Any Future Metaphysics*. Newly revised by J. W. Ellington from Carus. Indianapolis: Hackett.

————. [1787] 1929. *Critique of Pure Reason*. Translated by N. Kemp Smith. New York: St. Martin's Press.

Leibniz, G. W. 1981. *New Essays on Human Understanding*. Edited and translated by P. Remnant and J. Bennett. Cambridge: Cambridge University Press.

Lewis, C. I. 1946. *An Analysis of Knowledge and Valuation*. La Salle, Ill.: Open Court.

Mill, J. S. [1872] 1973. *A System of Logic: Rationative and Inductive*. Edited by J. M. Robson. Toronto and Buffalo: University of Toronto Press.

Pap, A. 1958. *Semantics and Necessary Truth: An Enquiry into the Foundations of Analytic Philosophy*. New Haven: Yale University Press.

29

Marie-Luise Schubert Kalsi

THE PROBLEM OF SELF-PRESENTING PROPERTIES IN CHISHOLM'S THEORY OF KNOWLEDGE AND THE SPECKLED HEN

Chisholm's theory of knowledge is influenced by his studies and discussions of Brentano's and Meinong's philosophies and, of course, among many others, the philosophy of Thomas Reid. One must not forget Bolzano and the theories which are now called 'Austrian Philosophy'.

The Prentice Hall edition of Chisholm's *Theory of Knowledge* of 1989 is an axiomatization of the theory which is generally called 'foundationalism' or 'internalism'.[1] Unfortunately, this important book is, in general, ignored by present-day literature, except for a few quotes or paraphrases from it which are of a general but not technical nature. This edition is by far much more difficult to read than the two previous ones. The reason may be that it is written in a very condensed style: propositions and definitions are stated without explanation where an explanation would have been most helpful. The same holds for undefined terms. One example is 'thinking' which seems to mean all kinds of mental or psychic states or activities. And 'seems to mean' must be underlined. Perhaps 'thinking' is used instead of 'mental' or 'psychic' in order to avoid a dualistic language, even though Chisholm tends toward a mentalistic vocabulary.

It seems to me that it is accepted as a fact by many that one must turn inward to find the truth about oneself and also about the world around us. For foundationalism or internalism inward turning as a methodological principle is the appropriate thing to do. So, one of the key concepts for developing a foundationist theory of knowledge is that of self-presentation. A property is self-presenting when it is the property of the

sensing subject and when the subject is immediately aware of it without the medium of reflection or (external) perception. The property presents itself to the subject. Just imagine a toothache: one cannot be mistaken about it and it cannot be overlooked; it is there and one knows it. Whether there is, in fact, a defective tooth is another question. Chisholm, in trying to build his theory of knowledge in an axiomatic form, gives a definition of the concept of self-presentation which is, I think, supposed to eliminate any property that could be mistakenly understood as self-presenting and which is supposed to cover all self-presenting properties. I do not think that the definition works, nor do I think that it is necessary. This will be discussed in the following.[2]

JUSTIFICATION AND EVIDENCE

Chisholm exhibits an optimistic attitude toward knowledge and justified belief. Instead of trying to avoid unjustified beliefs in the fashion of Phyrronism, he prefers to aim at justified beliefs.[3] In this he concurs with William James who considers the following statement as expressing two separate laws: "we must know truth and we must avoid error."[4] Justification is a concept which was developed by the Austrian school of philosophy, in particular by Meinong. However, it has its roots in Hume's theory of the evident. According to those philosophers, justification is a feeling which accompanies judgments. So it is internal to the judging person. According to tradition, judgments are the psychic presentations of propositions. They are internal events or mental events which carry with them or are accompanied by an emotion or feeling. The emotion is a conviction, a more or less of it (it has degrees), of the truth of the judgment. This conviction is the justification of the judgment. 'Justification' cannot be defined. But it is an indicator of a judgment's evidence and of the judgment's truth. So, evidence is a property of an internal event; it is internal to the judging person. It is difficult to assign to it a numerical value even though it is said to be of degrees. This is the basis for Chisholm's thought which he develops in an axiomatic form in his book. Although the concept of justification remains undefined, qualified justifications are defined, as for example, 'externally justified'. Justification is an epistemic appraisal of a belief which expresses the reasonableness of the belief.[5] What is reasonable must also be gleaned from the context in which it is discussed. The term 'reasonable' is not defined but 'more reasonable than . . .' is defined.

Chisholm does not speak of judging; he speaks, instead, of believing a proposition. Just as judging so believing is a psychic activity. One may

wonder about the difference between believing and judging. Both are intellectual psychic events, the acceptance of a proposition. They seem to be the same thing. For one would not believe what one would not think or judge to be the case. In believing, just as in judging, there are degrees of confidence. So, I think that the term 'judgment' as used traditionally, namely as naming an internal act of assertion, is an older way of expressing what Chisholm expresses with the term 'belief'.

Chisholm writes on page 5 of his book: "I have an idea of what it is for a belief to be justified; I have an idea of what it is to know something; and I have an idea of what it is for one thing to be *more justified* than another." 'Justification' or 'being justified in believing' is, as we know, the basic and undefined concept. On that basis which seems to be more emotional than intellectual, we can consider our various beliefs and try to order or rank them in respect to their justification. This presupposes that I can know something about my beliefs and present state of mind. We must understand, then, that justification is a ranking of one's own beliefs against each other. I do not think that Chisholm is talking about the acquisition of first beliefs but that he presupposes that we already have a body of beliefs and that any appraisal of any belief is done in comparison with that body of beliefs. Somewhere the transition from emotional states to intellectual appraisals has to be accomplished. Chisholm does make explicit that the appraisal also presupposes our ability to recall all or at least many of our beliefs in their original or updated strength. It also presupposes that any belief's justification can vary with time as new beliefs are acquired. Accordingly, the body of beliefs is like a living organism, constantly under revision and change.

What I just wrote about emotional appraisal seems to be contradicted by Chisholm's reference to D. J. Mercier:[6] The concept of epistemic justification is objective, internal, and *immediate*. 'Objective' means that epistemic justification itself can be an object of justification and knowledge. Epistemic justification is internal and immediate "in that one can find out directly, by reflection, what one is justified in believing at any time." In this he deviated from the Austrians (excepting Brentano) who believed that any judgment carried with it a feeling of justification which makes itself felt without reflection. But Chisholm thinks that we can know that we are justified in believing a certain thing by *reflecting* on our own state of mind and by reflecting on our other beliefs; this is crucial for his theory of knowledge. Perhaps reflection does not completely exclude the emotional side of justification. This state of mind is *internal justification* and its derivative, evidence. All evident beliefs are justified but not all justified beliefs are evident. So, internal justification is a basic notion or concept, and its meaning is indicated by what has been said.

SELF-PRESENTATION

Before the weighing of internal states can be discussed self-presentation must be introduced. Internal states, many of them at least, are immediately known to us. We know when we are thinking, dreaming, feeling sorrow, pleasure, etc., and even pain. According to the tradition of the Austrian school their degree of justification is extremely high because of our immediate awareness of them. However, according to that tradition, immediate awareness and justification collapse into one. There can be no higher certainty. Simply expressed, one cannot be mistaken about the occurrence of one's own mental states, such as sadness, elation, decision making, fantasizing, so-called perceptual experiences, etc. Consider the example: when I believe that there are dogs, I know immediately of my belief; I do not need any criterion for that knowledge. If there are in fact dogs is a different question. I am immediately aware of a pain and cannot be mistaken about it, whereas I am not at all certain about the source of the pain. All self-presenting properties are certain to the person who has them. What is important to remember is that only my own properties can present themselves to me, and of those properties only some can do that. Self-presentation is the basis of Chisholm's epistemology; it is the underpinning of justification and reasonableness.

He gives a very complicated definition of self-presentation in the course of making his theory of knowledge axiomatic. He denies that self-presenting mental events of which I am immediately aware when they are occurring have to be accompanied by a feeling of certainty or have to be accompanied by a feeling of justification.[7] In fact, he believes, we are certain beyond any doubt about the event's occurring. Justification has to do with the subject matter to which the mental event is directed. And of those only the ones which are beliefs require justification, and justification as a mental state presents itself, of course. But on the other hand, reflection seems to be required by Chisholm because comparison with other beliefs and their justification is involved.

Before Chisholm's definition of self-presentation is given, some attention must be paid to entailment and inclusion which are central to the definition. Chisholm gives an explanation of entailment and inclusion.[8] "One property may be said to *include* another if the first is necessarily such that anything that has it also has the second." For example, the property of being a rectangular triangle *includes* the property of being a triangle. The property of being red includes the property of being colored.

"The property of being F may be said to *entail* the property of being G provided that believing something to be F *includes* believing some-

thing to be G."[9] From Ralph Kennedy's paper on the problem of the speckled hen of which I shall speak in a moment, I came to be assured that the 'somethings' of the definition of entailment do not have to be the same somethings. However, it is nowhere stated that they cannot be the same.[10] The reason for this seems to provide a certain latitude for the definition. For example, anyone who believes that there are rectangular triangles has to believe that there are triangles. So, believing that there are rectangular triangles includes believing that there are triangles. However, someone believing something to be red does not have to believe something to be colored. All entailment is inclusion or logical implication but not vice versa. Chisholm gives this example: the property of being greater than 7 implies or includes the property of being greater than the square root of 49. But believing that something is greater than 7 does not imply or include believing that something is greater than the square root of 49. All mental states of which I am aware imply or include thinking.[11] This again supports my claim than 'thinking' stands for mental states.

Now, the focus can be on self-presentation. According to Chisholm, P is self-presenting =df. Every property that P entails includes the property of thinking. That is, P is self-presenting if and only if (P)(Q)(if P entails Q then Q includes thinking.) Or, (P)(Q)(If believing something to be P includes believing something to be Q, then Q includes thinking). Consider the following example: if believing that I am dreaming frightening dreams includes believing that I am having dreams, then I am having dreams includes thinking. I am dreaming frightening dreams, then, is a self-presenting property.

Why such a difficult definition? As I mentioned before, we are not told what thinking is. But it seems that all mental or psychic or emotional events and states are thinking, but not each instance of thinking is self-presenting.[12] That is, there are instances of thinking or mental states of which we are not aware. This is not a strange idea. Consider problem solving which involves many thoughts or series of thoughts of which we are not aware.

It may be asked why the middle member 'entails Q' or 'includes believing Q' is inserted. Or rather, why the whole entailment clause is put down as the antecedent. Chisholm speaks of *any* property entailing another property. The term 'any property' refers to all properties, also those which are not mental or are not beliefs. The entailment clause ensures awareness. And in self-presentation we have exclusive awareness of our own mental (or psychic) states. The main connective and consequent '. . . then Q includes thinking' insures that the property is a mental property. If the definition would go as follows: 'having a mental

state P includes thinking', then the definition is too wide. It would include mental events of which I am not aware. So, the stipulation must be made that the P which is self-presenting is a P which I believe I have. Thus, if believing to feel sad includes believing something being felt, then something being felt includes thinking. All this seems to safeguard the recognition of beliefs and their feeling of justification. What about the toothache? If believing to have a toothache includes believing to be hurting, then hurting includes thinking. If "thinking" is understood in the wide sense which was mentioned above, then hurting is, in fact, self-presenting—which, of course, it is. But is it physical or mental? According to the definition it must be mental, and I will just let this stand as it is.

So far, I have only attempted to explain Chisholm's definition, not to defend it. On the whole I think it is not necessary. Moreover, going through a number of examples it seems not to work in some cases. For it still appears to allow some properties to be self-presenting which are not so and it excludes some properties from self-presenting which are. It works for the following cases: I believe having a bicycle does not include thinking. So, having a bicycle is not self-presenting. I believe perceiving a dog includes believing that something is a dog; something being a dog does not include thinking. Thus, perceiving a dog is not self-presenting. For perceiving implies that there is something which is perceived. However, if "perceiving" is replaced by "sensing," then believing to sense a dog includes believing that something is a sensation (it does not include believing that something is a dog), and something is a sensation includes thinking. So sensing is self-presenting, perceiving is not. We know already that 'perceiving' and 'sensing' have different meanings; this is an important point which, unfortunately, is not stressed by Chisholm in this particular context nor by Ralph Kennedy who criticizes Chisholm's treatment of the speckled hen. (Indeed, Chisholm's definition does not solve the famous problem of the speckled hen to which I shall return in a moment.)[13] The definition also does not seem to work for the following example. I believe to be in pain includes my believing that something is hurting me. Something is hurting me does not include thinking. To be in pain would, then, not be self-presenting, that is, we would not be immediately aware of the pain. That is simply not true.

Now, back to the speckled hen.[14] Chisholm writes:

> Consider the *visual sensation* that is yielded by *a single glance* at a speckled hen.[15] The *sensation* may be said to contain many speckles. One may ask therefore, "How many speckles are there?" If we judge, say, that the sensation contains 48 speckles, we may very well be mistaken: perhaps there

are a few more speckles or less. Your own judgment is a judgment about the nature of the sense-datum or about the nature of the way we sense. The fact that such a judgment may be mistaken would seem to be in conflict with our view according to which the nature of what we sense is self-presenting and therefore a source of certainty.[16]

Note that in this example, perceiving, the glance at the speckled hen, and sensing are not clearly separated. For when the term 'perceiving' is used, it is presupposed that there is something which is perceived, whereas 'sensing' is only about one's own state. Chisholm's argument goes approximately as follows: my believing that my sense datum contains forty-eight speckles includes my believing that something is a speckle, and something is a speckle does not include thinking. This argument has been successfully refuted by Ralph Kennedy: the content of a sense datum does in no way guarantee that there exists something corresponding to the content of the sense datum. The argument's purpose is to show that sensing forty-eight speckles is not self-presenting, and that claim itself is correct.

The example of the speckled hen can be reformulated in various ways: One way is that my sense datum containing a definite number of speckles entails my sense datum containing speckles. My sense datum containing speckles is an instance of thinking. Or I am sensing a hen with a definite number of speckles entails sensing a hen; sensing a hen includes thinking. So, taking a hen to have a definite number of speckles is self-presenting, according to the definition, and our common sense tells us that it is not.

The statement about having forty-eight speckles is irrelevant in respect to self-presentation. This is true even with and without Chisholm's heavy apparatus. I agree with Chisholm, as anyone else would, that the image of a hen's having forty-eight speckles is not self-presenting, and quite unnecessarily Chisholm feels compelled to present an argument against taking forty-eight speckles as a self-presenting property. However, it was seen that his definition of self-presentation does not exclude 'I am sensing forty-eight speckles' or I am sensing a definite number of speckles, or even 'I am perceiving forty-eight speckles' from being self-presenting. And the forty-eight-speckled hen being a candidate for self-presentation is precisely what Chisholm does not want.

It seems to me that Chisholm and others before him maintain that if we see something speckled we ought to be able to say how many speckles there are. In fact, the important question is: why don't we have to know or why can we not know immediately the exact number of a plurality of things?

We have seen that each self-presenting property includes thinking. But not all cases of thinking include self-presentation. To have a self-presenting mental state means that one knows when one has it. That is, one is immediately aware of it. Allow me to return once more to the speckled hen. I am aware of my seeing or of my thinking to be seeing a speckled hen. At any rate I am immediately aware of my sensing a speckled hen regardless of whether there exists something which is speckled or not. How many speckles there are is not given in my awareness of the perception, even though it may perhaps contain a definite number. But to know the number presupposes counting. Counting is a mental activity which can present itself. Both are different from sensing something speckled. The result of counting, the thought of a number—even though wrong—may be self-presenting. If one absolutely insists that there has to be a definition of self-presentation then the following may work but I still hold it to be superfluous, and its examination will be left to the reader: a property P is self-presenting if and only if I feel certain to have it and it includes thinking. This definition insures awareness and being mental. but it still does not answer my question about the toothache which is a self-presenting but perhaps physical state. Self-presentation is a primitive property or perhaps relation which can at most be explained but cannot be defined. It is one of the basic concepts of internalism, just as are unqualified justification and reasonableness.

AWARENESS OF A MULTIPLICITY OR OF A MULTIPLEX

The relevant question to ask is: how can I be aware of a multiplicity of speckles at all? It is not to ask, can I be aware of a definite number of speckles? The awareness of a multiplicity or multiplex, to use Chisholm's term, is a real problem of epistemology. But being aware of a multiplex is warranted by an albeit hypothetical preintellectual activity which has been called 'psychic analysis' for almost a hundred years. That is, I am given a complex out of which speckles are analyzed. That is, in order to be aware of a multiplicity at all some mental process has to be postulated by which a complex datum or information piece is analyzed or recognized as a multiplicity and not as a simple unanalyzable piece of information. We are not aware of that process, it does not present itself, and that is the reason why it is called 'preintellectual'. But according to Chisholm, it is still thinking, and I agree with that. It is a hypothesized activity which serves to explain our ability to perceive a multiplicity. It does not present itself and cannot be the object of a definition because we

cannot trace it and be aware of it. It must be unearthed by some other means. The multiplicity of speckles in no way indicates the number of speckles. So we can never be immediately aware of having the perception of a hen with forty-eight speckles. On the other hand, counting includes the awareness of a multiplicity. We cannot know the number unless we take the hen and count the speckles. It does not seem possible to hang on to the memory image in order to count the speckles. In order to count the speckles a panoramic image of the multiplex or of something far more complicated—as, e.g., a heap of stones—has to be retained. We cannot do that. This is a psychological fact, at least for most of us. Even though the property of counting may be self-presenting and the result of counting, namely remembering 'I have counted forty-eight speckles', may be self-presenting (both include thinking), the awareness of a speckled object does not include the awareness of the number of the speckles nor need it include this. However, as was just said, the awareness of the number of the speckles includes the awareness of speckles. It is not necessary to suppose, and I do not see why one should feel compelled to suppose it, that my sense datum of a multiplex implies that the sense datum contains the number of the elements or all members which constitute the actual multiplex.[17] It just contains a multiplex. The object of the sense datum contains (so we suppose) a definite number of elements, but that number does not have to be given in the corresponding sense datum. Nowhere is it written that our perceptions or imagings have to correspond directly to the object perceived or imaged. Just think of snowflakes falling. However, my being aware of something being of a certain number implies my being aware of a multiplex. How could I be aware of ten people in a room without knowing that there was a plurality of people, even though I may not have consciously thought of plurality before counting its elements? It is difficult to find a philosophical reason for this, as is shown by Chisholm's own attempt. Perhaps it is one of those problems which fall outside the competence of philosophical technology.

Reasonableness and Evidence

Chisholm deviates from the traditional notion of evidence by introducing the concept of '*reasonableness*' of a belief. It is based on self-presentation and may apply to inner perception and also to perception of external objects. Like 'justified', 'reasonable' is a relative concept. There is a more or less of it. The concept is introduced by the definition of 'p is beyond reasonable doubt for S' (and the S which is a person is all-

important because beliefs are assessed by the one who has them). The definition of a p which is beyond reasonable doubt for S is as follows: "S is more justified in believing p than in withholding p." So, reasonableness is also an internal state, an attitude toward our own beliefs. It has to do with how beliefs feel in comparison with other beliefs. Those feelings present themselves as do the beliefs which they accompany. If we compare our various beliefs it ought to be the case, as I mentioned earlier, that we either must recall them all or at least keep a list of them with a corresponding justification indicator. This involves memory and its justification which, at this place, I will only call to the reader's attention. It is not the subject of discussion here, even though it is very important in this context. Chisholm does not address the question in his book.

The evident is explained in terms of justification and withholding, where withholding is also a degree of justification, that is, two justifications are compared with each other: "S is more justified in believing p than in withholding p" sounds quite weak, at first glance. But, in the context of S's experiences, p is held against other beliefs which are of a high degree of justification, and in respect to these beliefs p has a certain weight. There are propositions which are evident and also false. We know that from experience. It is accepted for the reason that most evident propositions are probably true and only some are false. At various places, truth, for Chisholm, comes across as germane to the truth of the correspondence theory, and in this context where he speaks of reasonableness and evidence, truth, in the epistemic sense, is not a matter of correspondence with reality but a matter of probability and reasonableness, and also of success in operating on the belief held. One takes the risk of error.[18]

Chisholm's notion of 'more reasonable than' seems to be in reality a utilitarian notion of the acceptance of an external world, a world which can be adequately enough perceived—mistakes notwithstanding. To what extent the perception is adequate cannot be established with certainty. The problem lies in our inability to establish what exactly a correct belief is. We cannot do that, not within the theory with which we are dealing.

EPISTEMIC JUSTIFICATION

We may hold a true belief without the accompanying feeling of justification. That is, we may believe something tentatively and it may happen that the belief is true. That is not knowledge, of course; 'being justified'

can be taken as a relation in the sense of 'p is more justified for S than q'. This relation is transitive and not reflexive, that is, if p is more justified for S than q, then q is not more justified for S than p. Take definition 3 on page 11:

> p is beyond reasonable doubt for S =df S is more justified in believing p than withholding p. ('Withholding p' means that one is as justified in believing 'p' as one is justified in believing 'not p'.)

It seems that if gradations are allowed, the justification for believing p has to be only slightly higher than the justification for believing not p in order to be beyond reasonable doubt. At first glance this seems to be a very weak definition. Upon contemplating it further it may be taken to say the following: one is already believing p. Now we reflect upon 'not p' and the reasonableness or justification of believing it. If 'not p' neither feels justified nor seems to be reasonable then p is reasonable.

The relationship between reasonable and evident is not quite clear. The evident ranks higher than 'beyond reasonable doubt' but is not certain. Chisholm begins by saying 'The evident is that which, when added to true belief, yields knowledge'. We do not know what true belief is. Assuming that there is true belief then it is very likely that we can hold a true belief without the feeling of justification. In fact, without reasonableness and evidence we have no idea what truth may be except perhaps in William James's sense that there is a reality, and we are working our way toward it. A difficulty of interpretation arises when Chisholm approaches the concept of the certain. Of course, Chisholm again is not talking about what is objectively certain. He is talking of what proposition is certain for S. Let us consider his definition D5 of 'epistemic certainty' which poses a great problem.[19]

> p is certain for S =df for every q, believing p is more justified for S (1) than withholding q is justified for S; (2) than believing q is justified for S.

Chisholm gives no explanation for this definition. It is not said that q means all propositions other than p. It seems obvious that q is not identical with p. It seems that withholding q is not reasonable. On a scale where all beliefs are weighed against each other p weighs heavier or at least as heavy as q. That is, there is greater feeling of justification for p than for q, psychologically speaking, or what is the same thing epistemically; as far as my justification situation is concerned p ranks higher or at least as high as some others, those others being a group of beliefs called q's which already have considerable weight. These feelings are self-presenting or accessible upon reflection.

THE EVIDENCE OF THE SENSES[20]

In respect to the reliability of sense perception Chisholm follows the authority of St. Augustine who suggested that, even though there may be ground to question the reliability of the senses, most of us are more justified most of the time in believing that we can rely upon them than believing that we cannot rely upon them. This means, in respect to beliefs, if one feels justified, then one is justified. One can reflect on one's internal states and know something about them. Chisholm claims that, on the other hand, one can also know something about the external world. And it is assumed that there is one. The problem is how to get to it adequately enough. We operate on the assumption that we can know something about the world, and there, the notion of justification comes in. It is neither practical nor reasonable to be pyrrhonistic, namely to hold the belief that we cannot know anything. But we are still confronted with the age-old problem of how to get from the appearance of an object to the object itself. In Chisholm's comparative and internalistic theory of truth he reaches the following tentative resolution: "*Occasionally at least, the senses provide us with evidence pertaining to the existence of such things as trees, ships and houses. The best answer to the question, 'what is the nature of this evidence?' seems to be this: the fact that we are appeared to in certain ways tends to make it evident for us that there is a tree that we perceive.*"[21] "Tending to be evident" is the next item on the agenda of questions which cannot be further pursued here. But we can see that on the basis of what has been said so far, a justification of judgments of external perception can be supplied although the definition of the basic concept of self-presentation fails the test. But the failure of its definition by no means indicates a failure of the basic concept itself.

MARIE-LUISE SCHUBERT KALSI

DEPARTMENT OF PHILOSOPHY
SOUTHWEST TEXAS STATE UNIVERSITY
DECEMBER 1996

NOTES

1. Chisholm receives a scathing criticism of his theory (but that of 1977) in William Alston's paper "Epistemic Desiderata," *Philosophy and Phenomenological Research* 53 (1993). Alston ignores the fact that problems can be accessed and studied from different points of view, each of which has as much right to be

considered as the other. Chisholm's own paper "The Status of Epistemic Principles," *Noûs* (1990): pp. 209–16, unfortunately does not shed much light on the problems in my discussion.

2. Chisholm refers to Russell (*Human Knowledge: Its Scope and Limits*, [New York: Simon and Schuster, 1948], p. 381). He compares Russell's 'degree of credibility' with his own 'level of justification' but concludes that it is too narrow; he quotes "when in relation to all the available evidence, a proposition has a certain mathematical probability, then this measures a degree of credibility." He also refers, among others, to Keith Lehrer, quoting from his *Self-Profile*: "the only security we have in the quest for truth is our trust in our intellectual powers to reach our objective and the sense not to fall into error."

3. Chisholm, *Theory of Knowledge*, 3d ed. (Englewood Cliffs, N.J.: Prentice Hall, 1989), p. 9.

4. William James, *The Will to Believe and Other Essays in Popular Philosophy* (1911).

5. Chisholm, p. 8.

6. Ibid., p. 7.

7. Ibid., p. 19.

8. Ibid.

9. Emphasis is mine.

10. See note 13.

11. Chisholm, p. 51.

12. Supported by Chisholm's remark, ibid., p. 19.

13. See Ralph Kennedy, "Professor Chisholm and the Problem of the Speckled Hen," *Journal of Philosophical Research* 18 (1993). The author focuses on other problems of the definition of self-presenting which I am not considering in this paper. He tries to solve the problem by Chisholm's old approach of being appeared to adverbially. He also focuses on properties which are properties of the sense datum and not of the person having the sense datum, and in self-presentation we are always having the person in mind.

14. See also Ayer, *The Foundation of Empirical Knowledge* (New York: Macmillan, 1940), pp. 124ff.; Chisholm, "The Problem of the Speckled Hen," *Mind* 41 (1943): 368–73.

15. Emphasis is mine.

16. Chisholm, p. 25.

17. This reminds me of an old German children's song which states that we see so many stars but do not and cannot know how many there are; only God keeps track of their number: "*Weißt Du wieviel Sternlein stehen. . . .*"

18. Chisholm, p. 12.

19. Ibid.

20. Ibid., pp. 39ff.

21. Ibid., p. 48. Emphasis is mine.

30

Pat A. Manfredi and Donna M. Summerfield

CHISHOLM ON INTENTIONALITY: WITTGENSTEIN'S QUESTIONS

> I can look for him when he is not there, but not hang him when he is not there. (Wittgenstein 1958, p. 133e)
>
> What makes my idea of him an idea of *him*? (Wittgenstein 1958, p. 177, Chisholm's translation)

Throughout Chisholm's philosophical writings, from his early, classic paper "Sentences about Believing" (Chisholm 1956) to his most recent book (Chisholm 1996), Chisholm returns, again and again, to puzzles about intentionality (aboutness), frequently citing Wittgenstein's famous wordings of these puzzles. In this paper, we trace aspects of Chisholm's answer, from *The First Person* (1981) to the present, to the questions of how it is possible to think about something, both when it is and when it is not, and both as it is and as it is not. We offer not so much a straight explication of Chisholm as a reconstruction, a reconstruction which attempts to take into account changes and refinements that have occurred over the years and which attempts to account for those changes by suggesting reasons for them, reasons that are not always explicitly stated by Chisholm himself. In the process, we hope both to capture the spirit of Chisholm's bold and resilient theory of intentionality and to raise critical challenges to that theory.

WHAT ARE THE QUESTIONS?

In an illuminating self-profile to a 1986 volume on Chisholm's philosophy (Bogdan 1986, p. 14), Chisholm lists several questions, all of which are aspects of what he calls "the problem of objective reference," or the problem of how *one* thing succeeds in directing its thoughts upon *another* thing:

(A) How does one direct one's thoughts on things other than oneself?
(B) How does one manage to think about things in the way in which they *are*?
(C) How does one manage to think about things in a way in which they *aren't*?
(D) How does one succeed in thinking about what does not exist?

Questions (A) and (D) ask, in effect: how is it possible to think about things, both when they are and when they are not? They are questions regarding the *objects* of our thought. Questions (B) and (C) ask, in effect: how is it possible for one's thoughts about things to be both true and false? They are questions regarding the *content* of our thought.

Traditionally, it has been tempting to suppose that any thought about an object requires that there be (or subsist) an object of some sort. This temptation has led some to posit objects that, although they do not really exist, have "intentional inexistence." Chisholm wants to resist this temptation, and he seeks to offer explanations of (A) through (D) which do not resort to any such posits.

As we shall see, there is a fifth question that Chisholm regards as crucial (although it does not appear on the list he gives in his self-profile), call it (E):

(E) How does one take oneself as the indirect object of one's thoughts?

What Does Chisholm Take as Basic?

Now that we have an initial list of the questions Chisholm seeks to answer, what function as the primitives in his explanation? What does Chisholm take as basic? The outline of Chisholm's answer is clear and has not changed substantially since *The First Person*,[1] although the details have been modified along the way. According to Chisholm, persons have two fundamental abilities, the ability to conceive properties (including relations and the property of being such that p, where p is a state of affairs or proposition)[2] and the ability to attribute such properties directly to themselves. Taking these abilities as basic, Chisholm's central insight is that all of my thoughts about objects are first and foremost thoughts about myself, in that they are a matter of directly attributing to myself certain properties, properties which I have a basic ability to conceive.

In *The First Person*, Chisholm presents what he takes to be the basic

doxastic locution, together with some principles that clarify its proper application (Chisholm 1981, pp. 27–28):

> The property of being F is such that x directly attributes it to y.
> P1 For every x, every y and every z, if x directly attributes z to y, then x is identical with y.
> P2 For every x, every y and every z, if x directly attributes z to y, then z is a property.

Given these principles, I can directly attribute properties only to myself, and properties are the only sorts of things that can be directly attributed. Since a direct attribution can be made only by some person x, these principles guarantee that any direct attribution will have a direct object (the person who makes it). In any thinking about objects, there is always a direct object of thought, and the direct object of thought is always the person who is doing the thinking. Accordingly, Chisholm defines what he calls 'he, himself' judgments as follows:

> D1′ x judges that he himself is F = Df. x directly attributes to x the property of being F.[3]

In one sense, all judgments, of any sort, turn out to be judgments of this basic form, since all involve the direct attribution of some property to a direct object which is the person who is making the judgment.

In summary: the account Chisholm offers regards as basic the ability to take oneself as one's direct intentional object,[4] which is a matter of grasping or conceiving properties and attributing them to oneself (Chisholm 1981, p. 28).

INDIRECT ATTRIBUTIONS

Given the ability to directly attribute properties to myself, how do I manage to attribute properties to other things and in other ways? Chisholm's initial answer is this: there are, in some cases, indirect objects as well as myself as the direct object, and when there is one (or more) indirect object, then I have a thought about that object (or those objects).[5] In *The First Person*, Chisholm defines indirect attribution as follows:

> D2: y is such that, as the thing that x bears R to, x indirectly attributes to it the property of being F = df x bears R to y and only to y; and x directly attributes to x a property which entails the property of bearing R to just one thing and to a thing that is F. (Chisholm 1981, p. 31)

Chisholm explicates the notion of the entailment of one property or relation by another: "one property or relation may be said to *entail* another property or relation provided the first is necessarily such that (a) if it is exemplified then the second is exemplified and (b) whoever conceives it conceives the second" (p. 31).

Chisholm gives the following example:

> Suppose, for example, that I am talking with you and only with you, and that I believe with respect to you that you are wearing a hat. Then the property of being *F*—the property I indirectly attribute to you—would be that of wearing a hat; the identifying relation *R* that I bear to you and only to you would be that of talking with; and the property that I directly attribute to myself would be the property of talking with exactly one person and with a person wearing a hat. In thus indirectly attributing a property to you, I directly attribute a certain two-fold property to me. The first part of my direct attribution (that I bear the relation *R* to one and only one thing) will be correct; for I can attribute a property to you only if the identifying relation by means of which I attempt to single you out is a relation I bear to you and only to you. But the second part of the direct attribution (that the thing to which I bear *R* is a thing that is *F*) may or may not be correct. In either case, we may say: you are such that, *as* the person I am talking with, I indirectly attribute to you the property of wearing a hat. (Chisholm 1981, p. 30)

In effect, D2 says that a thinker succeeds in thinking about an existing object (other than herself as the direct object of her thoughts) when and only when she actually bears a certain unique relation *R* to the object of her thoughts *and* she directly attributes to herself a certain special property. The property she attributes to herself in this case, unlike other properties she may attribute to herself, has a couple of special features: (i) she actually has this property only if she also bears a certain unique relation *R* to the object of her thoughts, and (ii) if she grasps or conceives this property (as she must to succeed in attributing it to herself), she must also grasp or conceive the twofold property of bearing *R* to just one thing and to a thing that is *F*.

To understand the explanation Chisholm offers of how it is possible to attribute properties to other things and in other ways, it is important to understand his distinction not only between *direct* and *indirect* attributions, but also his distinction between *object* and *content*. Chisholm's discussion of the content/object distinction in his self-profile is especially useful:

> Consider . . . the example of *x* judging *y* to be a philosopher. The person *x* is the *direct object* of his own attribution. The *direct content* will be the property that *x* directly attributes to himself—that of being a person such that the only violinist in the room with him is a philosopher. The *indirect*

object is the other person *y*, the violinist. And the *indirect content* will be the property that *x* indirectly attributes to *y*—namely, the property of being a philosopher. (Bogdan 1986, pp. 19–20; Chisholm 1990a, p. 5)

Taken together, these two distinctions (between direct and indirect attributions, and between content and object) give Chisholm several possible scenarios: an attribution of a property to oneself must always have a direct object and a direct content, but it may or may not have an indirect content (depending, as we will see, on whether or not it "purports to refer"), and, when it has an indirect content, it may or may not have an indirect object. These various possibilities give Chisholm (or so he thinks, at any rate) the flexibility he needs to show how it is possible to think about something, both when it is and when it is not, and both as it is and as it is not.

CHISHOLM'S ANSWERS

Let us, then, turn to Chisholm's answers to the first three of the five questions (A)–(E), beginning with (A):

(A) How does one direct one's thoughts on things other than oneself?

This is Wittgenstein's question, "What makes my idea of him an idea of *him*?" and in *The First Person*, Chisholm answers this question simply and directly.

> We can answer without appealing to words or to terms that refer to him. A partial answer would be this: 'There is a certain relation I bear just to him; and I directly attribute to myself the property of bearing that relation to just one thing'. It is difficult to think of any answer that is simpler than this.
> But to the question 'What makes his *direct* attribution of a property to himself an attribution of a property to *him*?' there can be no answer at all, beyond that of 'He just does—and that is the end of the matter!' (Chisholm 1981, p. 32)

In short, Chisholm says, I think about an object other than myself *by means of* thinking about myself. I directly attribute to myself a twofold property, a property that entails that I bear a certain relation *R* to just one thing and to a thing that is *F*. If I do in fact bear a certain relation *R* to just one thing, then, whether or not that thing is *F*, I succeed in directing my thoughts upon the object *O* to which *R* relates me.

This explanation is a perfectly general explanation of how a thought has an indirect object, but it is no explanation at all (nor does it pretend to be) of how a thought has a direct object. As Chisholm emphasizes, if I

explain indirect attribution in terms of direct attribution, then I have not explained direct attribution but rather taken it as a primitive. And that is what Chisholm does.

Given Chisholm's answer to (A), the answer to (B) is easy:

(B) How does one manage to think about things in the way in which they *are*?

The answer to part of question (B) has already been given in the answer to (A), that is, the answer to how one manages to think *about things*. But there is more to be said here. Since Chisholm distinguishes the indirect object of thought from the indirect content of thought, he can say that I manage to think about things in the way in which they are just in case my thought not only has an indirect object, but in addition the indirect object actually has the property that constitutes the indirect content of my thought. In other words, my indirect attribution of a property to you involves two components, my grasp of relation R, the relation that purports to relate me to you, and my grasp of property F, which is the indirect content of my thought about you. Once I have succeeded in thinking about you, if you actually have the property I indirectly attribute to you, then I succeed also in thinking about you in a way in which you are.

Given Chisholm's answer to (A), the answer to (C) is as easy as the answer to (B):

(C) How does one manage to think about things in a way in which they *aren't*?

If we assume that (C) asks about how we can think, of existing objects, what is false, then the answer to part of (C), like the answer to part of question (B), has already been given in the answer to (A), that is, the answer to how one manages to think *about things*. But, again, there is more to be said. Once I have succeeded in thinking about you, if you fail to have the property I indirectly attribute to you, then I think about you in a way in which you are not. Consider again Chisholm's definition of indirect attribution (D2). As Chisholm emphasizes, relation R may be exemplified, so that the first main clause is satisfied and one "part of my direct attribution (that I bear the relation R to one and only one thing) will be correct" without its being the case that the second part of my direct attribution is correct (that the thing to which I bear R is F). This makes it possible for me to believe, of you, what is in fact false (for example, you may not in fact be wearing a hat even though you are in fact the person with whom I am talking).

Two questions remain to be answered: (D) How does one succeed in

thinking about what does not exist? and (E) How does one take oneself as an indirect object of thought? Before answering these questions, however, we think it will help to explore the implications of Chisholm's distinctions between direct/indirect and object/content for a categorization of judgments. It is these distinctions between what is direct and what is indirect, and between object and content, rather than any traditional notions of *de re* judgments versus *de dicto* judgments versus *de se* judgments, that motivate and underlie Chisholm's discussions. Whereas it is traditional to divide judgments according to the nature of their objects (of the *thing*, of the *proposition*, of the *self*), Chisholm does not do so: things, propositions, and selves may all be indirect objects of judgments. Although Chisholm himself (especially in *The First Person*) diligently tries to show how his account sheds light on traditional *de re* and *de dicto* judgments, we think that beginning with these categories is liable to lead to misunderstanding, since Chisholm's distinctions don't coincide neatly with those traditional divisions. Thus, we propose to divide things along what we take to be Chisholm's preferred lines.

DIVISION OF JUDGMENTS

As we have already mentioned, every judgment involves the direct attribution of some property to oneself. The direct object of every judgment is oneself. Given this common characteristic of judgments and given Chisholm's clear and continuing emphasis on indirect attribution, the most fundamental distinction initially seems to be a distinction between judgments that involve only direct attribution and those that involve both direct and indirect attribution. But, despite the fact that Chisholm always defines indirect attribution, and never (so far as we know) defines indirect content, we do not think that this is the most charitable way to interpret Chisholm's theory.

To see this, consider what indirect attribution requires. When Chisholm introduces it in *The First Person*, as we saw previously, he defines it as follows:

> D2: y is such that, as the thing that x bears R to, x indirectly attributes to it the property of being F = df x bears R to y and only to y; and x directly attributes to x a property which entails the property of bearing R to just one thing and to a thing that is F. (Chisholm 1981, p. 31)

From this definition it follows that any judgment involving indirect attribution has, not only both direct and indirect content, but also both an object of direct attribution *and at least one object of indirect attribution.*[6]

Consider again the example (from Chisholm's self-profile, cited above) of x judging y to be a philosopher. In making this judgment, I am the object of direct attribution. The direct content of my judgment is the property of being a person such that the only violinist in the room with me is a philosopher. The only violinist in the room with me is the object of indirect attribution, and the indirect content of my judgment is the property of being a philosopher. In this example, my judgment has everything: direct object and content, and indirect object and content. Given these sorts of examples, it seems natural to make a fundamental distinction between direct attributions, which involve only direct objects and contents, and indirect attributions, which involve also indirect objects and contents, and to divide judgments accordingly.

Shall we, then, divide judgments according to whether they involve indirect as well as direct attributions? Matters are not quite as simple as Chisholm's definition of indirect attribution and this example suggest. In his self-profile, Chisholm notes that some judgments have indirect contents even though they lack indirect objects.

> An attribution may . . . purport to have an indirect object and yet fail to have such an object. This would happen if there were no violinist in the room or if there were more than one, and I attributed to myself the property of being such that the only violinist in the room with me is a philosopher. In such a case, the attribution has a direct object, a direct and an indirect content, and *no* indirect object. (Bogdan 1986, p. 20; Chisholm 1990a, pp. 5–6)

This immediately raises a puzzle. How can a judgment involve an indirect content if there is no indirect object? A judgment with indirect content and no indirect object is not an indirect attribution, according to Chisholm's definition. However, neither is it merely a direct attribution: in such cases we cannot say that I exemplify the property that constitutes the indirect content, for in judging that the only violinist in the room with me is a philosopher, I do not judge that I am a philosopher (even if I am). Rather, as Chisholm recognizes, judgments with indirect content but no indirect object *purport* to have indirect objects when they do not; they *purport* to be indirect attributions of properties to indirect objects even when they are not.[7] In light of this, we suggest that it is most charitable to interpret Chisholm's view so that the most fundamental distinction between judgments is not a distinction between judgments that involve only direct attribution and those that involve both direct and indirect attribution, but a distinction between judgments that have only direct content and judgments that have indirect as well as direct content. Judgments of the latter type *purport* to have indirect objects, and, when they do have such objects, they will involve the indirect

attribution of some property to those objects. As we will see, making the distinction between direct and indirect content fundamental, rather than the distinction between direct and indirect attribution, is critical if Chisholm wants to offer a plausible solution to question (D) about how judgments can be about objects that do not exist.

Our preferred way of dividing judgments, a way that we think is true to the spirit if not to every letter of Chisholm's view, yields further divisions among judgments. Judgments that do not purport to have indirect objects (i.e., those with only direct content) divide into two general groups: (traditional) he, himself judgments and what we will call 'being such that p judgments'.[8] In *The First Person*, Chisholm characterizes the latter as one variety of *de dicto* beliefs.[9] It is perhaps worth noting that Chisholm's preferred classification groups some (but not all)[10] traditional *de se* judgments with some (but not all)[11] traditional *de dicto* judgments. For Chisholm, the traditional classification obscures two striking similarities between a certain group of *de se* judgments and a certain group of *de dicto* judgments (i.e., *being such that p* judgments): judgments of both groups involve directly attributing to oneself a property *and* do not involve purporting to have an indirect object. To see the strong similarity between he, himself judgments and *being such that p* judgments, compare the definitions Chisholm offers of D1′ and D4(a).

D1′ *x* judges that he himself is *F* = Df. *x* directly attributes to *x* the property of being *F*

D4(a) The state of affairs that *p* is accepted *(de dicto)* by *x* = Df. There is one and only one state of affairs which is the state of affairs that *p*, and . . . (a) *x* directly attributes to *x* the property of being such that *p*. . . .

Chisholm says that the letter 'F' in D1 "is schematic and may be replaced by any predicative expression having a property as its sense" (Chisholm 1981, p. 28). If we take him at his word, this means that *being such that p* judgments are, in effect, a subset of he, himself judgments, since the predicative expression 'being such that *p*' has a property as its sense. Thus, the only difference between he, himself judgments and *being such that p* judgments is the type of property directly attributed to oneself.[12] Moreover, *being such that p* judgments are like what we would ordinarily call he, himself judgments and unlike other judgments in this respect: they do not even purport to have indirect objects. Given these two striking similarities between he, himself judgments and *being such that p* judgments, they can be characterized as belonging to a fundamental type of judgment: those judgments that have only direct content.[13]

Turning from judgments that do not purport to have indirect objects

to those that do, we are left with a crucial question: what is it to purport to have an indirect object? Although there is no answer in Chisholm's system to the question of what gives a judgment its *direct* content, there had better be an answer to the question of what gives a judgment its *indirect* content, since the notion of indirect content is not taken to be basic. As Chisholm sees it, the problem "is to exhibit the nature of the judging in such a way that we can see both (1) how it is that, your neighbor having the properties he does have, your judging can be said to be *directed upon* him, and also (2) how *this same judging* could be made even if it were not directed upon anything" (Chisholm 1987, p. 497; second emphasis ours). In short, how could *this same judging* be made both when it has and when it lacks an indirect object?

To answer this question is, in effect, to uncover an answer to Chisholm's question (D): How does one succeed in thinking about what does not exist? For if Chisholm can give an answer to what it is to have indirect content that is acceptable whether or not there is an indirect object, then he can say that, when we think about objects that do not exist, our judgments have the same content they would have if the object existed. Chisholm's attempt to say what it is to have indirect content, and thereby to answer (D), we believe, leads to a tension at the heart of his view. Before we explore Chisholm's various attempts to answer (D), and the tension to which they lead, let us turn to the fifth and final question with which we began.

TAKING ONESELF AS INDIRECT OBJECT

Given the discussion above about how Chisholm divides judgments, into those that have merely direct content and those that also have indirect content, in that they purport to refer to objects, we can now answer (E):

(E) How does one take oneself as the indirect object of one's thoughts?

Very briefly, the answer is this: the same way that one takes anything, or purports to take anything, as an indirect object of one's thoughts.

In a way, to ask this as a separate, fifth question obscures the connection between Chisholm's answer to this question and his answer to question (A). In fact, it perhaps would be more accurate to ask a more general question which incorporates both (A) and (E), call it (AE):

(AE) How does one direct one's thoughts on things, including oneself, when one's directing one's thoughts on things is not merely a matter of taking oneself as a direct object of thought?

Contrast his answer to this question with his answer to the question of how one directs one's thoughts on oneself as a direct object. To the latter question, as we saw earlier, he provides no answer, apart from one "just does—and that is the end of the matter," whereas to the former question, (AE), he replies that "there is a certain relation I bear just to" any indirect object of my thoughts, including myself; "and I directly attribute to myself the property of bearing that relation to just one thing" (Chisholm 1981, p. 32). Because a judgment may pick out one thing, its direct object, in a way that allows for no failure and yet at the same time pick out something, its indirect object (which may be the same as or different from the first), in a very different way, in a way that does allow for failure, I can succeed in thinking about myself in two very different ways within the same judgment.

The fact that there are two separate answers to these two questions, according to Chisholm, enables him to solve a stubborn philosophical perplexity, "the problem of the 'he, himself' locution." Moreover, in Chisholm's view, the fact that his account solves the he, himself problem provides the clearest rationale for his choice of primitives; the answer to (AE), together with an understanding of how it solves the he, himself problem, gives us a reason for taking the ability to directly attribute properties to oneself as basic to an account of intentionality.

Just what is "the problem of the 'he, himself' locution"? Chisholm cites an example from Ernst Mach that illustrates the difficulty:

> The 'he, himself' locution may be illustrated by an example that Ernst Mach cites in the second edition of the *Analysis of Sensations.* He writes: 'Not long ago, after a trying railway journey by night, and much fatigued, I got into an omnibus, just as another gentleman appeared at the other end. "What a shabby pedagogue is that, that has just entered?" thought I. It was myself; opposite me hung a large mirror. The physiognomy of my class, accordingly, was better known to me than my own'. As Mach entered the bus, then, he believed with respect to Mach—and therefore with respect to himself—that he was a shabby pedagogue, but he did not believe *himself* to be a shabby pedagogue. The experience might have made him say: *'That* man is a shabby pedagogue'. But—prior to his discovery of the mirror—it would not have led him to say: *'I* am a shabby pedagogue'. (Chisholm 1981, p. 18)

The problem is this: intuitively, Mach can judge, of the gentleman he sees at the other end of the omnibus, that he is a shabby pedagogue, without judging, of himself, that he is a shabby pedagogue. But how can this be? Since Mach is identical with the gentleman he sees at the other end of the omnibus, it would seem that any judgment directed on one is at the same time a judgment directed on the other.

Recall that Chisholm defines the 'he, himself' locution, "x judges that he himself is F," as follows: x directly attributes to x the property of

being *F*. One may wonder, as does Jaegwon Kim in this volume, how Chisholm's definition fares with Mach's example:

> For Chisholm's definition to come out right, it must be the case that Mach does not directly attribute the property of being a shabby pedagogue to Mach. But Mach = the man Mach sees as entering the bus from the opposite side. From this it follows then that Mach does not directly attribute the property of being a shabby pedagogue to the man he sees as entering from the opposite side. Is this an intended consequence of D1? Is it true? (p. 369)

In our view, that Mach does not directly attribute the property of being a shabby pedagogue to the man he sees as entering from the opposite side is indeed an intended consequence of D1. Mach does not *directly* attribute that property to *anyone*. In *The First Person*, Chisholm states what he takes to be a general thesis about intentionality that is key to resolving our philosophical perplexity about the 'he, himself' locution: "In application to believing, it is the thesis that one may attribute a property to oneself without *directly* attributing that property to oneself" (Chisholm 1981, p. 34). As applied to Mach's example, Chisholm will claim that Mach *indirectly* attributes to himself, as the person he is conceiving in a certain way (i.e., as the only man who appears to be at the other end of the omnibus), the property of being a shabby pedagogue. Of course, since every indirect attribution is also a direct attribution, he does directly attribute a property to himself. However, the property directly attributed is *not* the property of being a shabby pedagogue, but rather something like the property of being such that the one and only man who appears to be at the other end of the omnibus is a shabby pedagogue. He may grasp this property (as he must do to attribute it to himself) without in any way recognizing that he *is* the man who appears to be at the other end of the omnibus.

How, then, is the problem solved? The problem was to understand how it can be the case that Mach can judge, of the gentleman who appears to be at the other end of the omnibus, that he is a shabby pedagogue, without judging, of him, himself, that he is a shabby pedagogue, when in fact he *is* the man who appears to be at the other end of the omnibus. Chisholm's answer is that he can do so because there are two fundamentally different ways of attributing properties to objects, direct and indirect. Mach can make a judgment of which he is both the direct and the indirect object, and he can indirectly attribute a property to himself without at the same time directly attributing that same property to himself. So he can believe, of himself as identified in a certain way, that he is a shabby pedagogue, without at the same time believing that he, himself is a shabby pedagogue.

Understanding Chisholm's solution to the problem of the 'he, him-

self' locution can help us to answer other criticisms of Chisholm that have been made in the literature, for example a criticism made by Steven E. Boër. Boër raises some purported counterexamples to Chisholm's view, cases "in which there is at least a *prima facie* presumption that attempts at reflexive thought might fail to secure an object" (Bogdan 1986, p. 97). He recognizes that Chisholm regards self-reference as basic, and so concludes that Chisholm is "committed to two very strong claims: first, that the ability to think directly of oneself is in no way conditioned by the various perceptual and nonperceptual ways one has of gaining information about oneself . . . ; and second, that the ability in question is independent of the ability to locate oneself in the objective world" (Bogdan 1986, p. 98). This is correct as far as it goes. But the purported counterexamples fail, because not *all* self-reference is basic, and thus, not all self-reference is unconditioned or independent in the way Boër supposes. In some cases misidentification of ourselves is possible; in those cases we are taking ourselves as indirect rather than direct objects of thought. The ability to think *indirectly* of oneself is in every way "conditioned by the various perceptual and nonperceptual ways one has of gaining information" about any contingent object, and it is not "independent of the ability to locate oneself in the objective world." In short, you can pick yourself out as an object in one of two ways: either directly, and in that case you can't misidentify yourself (because there is no need to identify yourself), and indirectly, in the same ways in which other objects are picked out, and in that case you may very well misidentify yourself.[14]

THINKING ABOUT WHAT DOES NOT EXIST

Finally, we turn to an exploration of Chisholm's answer to (D): How does one succeed in thinking about what does not exist? In "Presence in Absence," Chisholm explicitly answers this question.

> If you judge your neighbor to be a philosopher and if you have just one neighbor, then you make a judgment which implies him to be a philosopher. The judgment may be said, therefore, to be *directed upon* him. But you *could* make the judgment even if he didn't exist and even if you had no neighbor. For it is possible for it to be the case both (1) that one makes a judgment which implies that whatever has *P* is *F* and also (2) that nothing has *P*. (Chisholm 1987, p. 498; Chisholm 1989a, p. 108)

Again, in "How We Refer to Things," he writes:

> if you judge that the only thing that is so-and-so is such-and-such, and if it is not the case that there is just one thing that is so-and-so, then you are

making a judgment about something that does not exist; your judgment is not directed upon anything. (Chisholm 1990b, p. 159)

short, Chisholm's general answer to the question of how it is possible think about what does not exist appears to be this: a judgment about a inexistent thing is not "directed upon" anything, since what it purports be directed upon does not exist; nevertheless, such a judgment has the sme (direct and indirect) content it would have had if it had been dected upon something that does exist, a content that is markedly derent from that of judgments that do not purport to have indirect objcts. Thus, judgments that purport, but fail, to have indirect objects cat be said to "be about" objects that do not exist. Although I cannot relly think *of him* when he is not there, what I can do is make a judgment that has the same (direct and indirect) content as the one I wold have been able to make if he were there.[15]

What is it to purport to refer to an object? Chisholm's definition of indrect attribution in *The First Person* tells us what "purporting" to have an indirect object amounts to. The "purporting" is covered by the second clause of (D2). To *succeed* in thinking about an actually existing object, the first as well as part of the second condition must be fulfilled: there must actually be a unique relation *R* which links the thinker to the object *O*. In this case, the object *O* is the indirect object of the attribution. To purport to refer, only the second condition need be fulfilled: the thinker attributes to herself a property (even though she may fail to exemplify it) which involves (in part) conceiving "the property of bearing *R* to just one thing." Thus, as we read certain texts of Chisholm's that we regard as central, to purport to refer to an object is simply

(A) for *x* to directly attribute to *x* (and thus to conceive) the property of bearing *R* to just one thing.[16]

If we are correct that this is Chisholm's solution to question (D), then we have additional support for our suggestion that the distinction between judgments that have only direct content and those that have both direct and indirect content is more fundamental to Chisholm's schema than that between judgments that have indirect objects and those that lack them. Chisholm's solution to question (D), as we have interpreted it, comes from distinguishing indirect objects from direct and indirect content. Because two judgments may share the same direct and indirect content, a content that makes them "purport" to have an indirect object, even if one of them has and the other lacks such an object, we can think about what does not exist. Chisholm's solution to

question (A), by contrast, stems from distinguishing direct from indirect objects. Because one judgment may have one direct object (myself), but a different indirect object, I can succeed in thinking about things other than myself. Neither Chisholm's answer to (A) nor his answer to (D) rests on the distinction between judgments that have indirect objects and those that lack them. In fact, none of Chisholm's answers to (A) through (E) rest on that distinction. Therefore, we conclude that the latter distinction is not fundamental to Chisholm's theory of intentionality.

CHALLENGES TO THE VIEW

Chisholm's view faces several challenges that threaten to force Chisholm toward the externalist thesis that, in at least some cases, the way the world is (partially) determines the content of our thoughts. That Chisholm does not share externalist intuitions and that he wants to avoid externalism can be seen from his response to Putnam's classic twin-earth case. According to Chisholm, when an ordinary person makes the judgment that there is water in the glass she is holding, she is attributing to herself a certain property, "some such property as this: being a person such that the glass that [s]he is holding contains that colorless, tasteless liquid which is to be found in lakes and rivers and which [s]he uses for washing and for quenching [her] thirst." But this property is precisely the same property that is attributed by the person's *Doppelganger* on twin-earth. In short, Chisholm simply denies externalist intuitions about this case, insisting that there is no difference in the content of the judgments made; "neither H_2O nor XYZ is involved in the content" of those judgments (Bogdan 1986, p. 199).

However, consider a young child's thought, of her mother, that she is holding a cookie. In this case it seems counterintuitive to require that the child be able to attribute to herself (and thus to conceive) properties as complex as that of *bearing the relation of standing in the same room next to one and only one person and to a person who is holding a cookie.* At the same time, it seems intuitive to suppose that the child is nevertheless able to think, of her mother, that she is holding a cookie. And yet, Chisholm's account, as articulated above, seems to imply either that the child has very sophisticated abilities or that she lacks the ability to take her mother as an indirect object of thought. In short, Chisholm apparently faces a dilemma: either (i) intuitively unsophisticated believers such as young children and animals have some fairly remarkable abilities or (ii) they cannot have beliefs that purport to be about objects at all.

one way out of Chisholm's dilemma is to accept externalism by granting that the world is such that the child can think of her mother regardless of her relatively simple conceptual resources. The fact that the child has a properly functioning perceptual system which is capable of detecting and discriminating objects the size of adult human beings which are standing only a few feet away, and the fact that the current observation conditions are such that the child's system delivers reliable information in those conditions should, the externalist urges, be sufficient to allow the child's judgment to succeed in being about her mother. It is in part the world (including the child's perceptual system), not the conceptual abilities of the child alone, that determines the content of the child's judgment.

At one point, Chisholm responds to an objection, made by Steven Boër, that his account "seems to sever certain intuitive connections between believing and the possession of various concepts" (Bogdan 1986, pp. 94 and 197). Initially, in his response to Boër (and elsewhere), Chisholm seems to concede to the externalist that to judge, of one's mother, that she is holding a cookie, one need not conceive of the relation that connects one to the indirect object of a judgment. He does this by modifying his definition of indirect attribution.

According to this modification, to purport to refer to an object is:

(B) for x to directly attribute to x "a property P which is necessarily such that (i) whatever has P bears R to something that is F, (ii) whoever conceives P conceives being-F, and (iii) it is possible to attribute P directly to oneself without attributing being-F directly to oneself."[17]

Given this modification, a child does not need to conceive the sophisticated property of *bearing the relation of standing in the same room next to one and only one person and to a person who is holding a cookie*. All the child needs to conceive is some other property P which necessarily is exemplified only if *there is* some such relation R. The child must be able to conceive the property of *holding a cookie*, and the child must be able to conceive property P, but the child need not conceive the property of being related in such-and-such a way to one and only one person.

However, we do not think that Chisholm's apparent concession to the externalist on this point is his final, all-things-considered position on the matter. In fact, we think (1) that this modification threatens to introduce additional problems into Chisholm's account; (2) that it does not really succeed in avoiding the problem anyway; (3) that Chisholm is evidently ambivalent at best about the modification, since it appears unequivocally only in 1986 at the time when he is directly under attack by Boër on

this point; and (4) that ultimately Chisholm should (to be consistent with other views he holds) bite the internalist bullet and claim that the child cannot really direct a judgment upon her mother, even though it may seem that she can—and then attempt to explain away the intuition that she can.

We will elaborate briefly on each of these four points. First, the modification threatens to introduce additional problems into Chisholm's account. When Chisholm introduces the modification, he points out that clause (ii), that is, "whoever conceives P conceives being-F," is needed to avoid the conclusion that "if I judge you to be a philosopher, then I also judge you to be such that $7 + 5 = 12$" (Bogdan 1986, p. 19). But it is not clear to us what will prevent an analogous problem from arising with respect to relation R, precisely because Chisholm does not require that whoever conceives P conceives R. Since the modification only requires the thing which has P to be necessarily such that it bears a relation R to some unique thing, there will always be an additional relation R^* which is such that any individual who exemplifies P and R also exemplifies R^*, and which is such that R and R^* point to two different individuals as the indirect object of the judgment. For example, let P be the property of talking to just one person and to a person who is wearing a hat. In this case, whoever has P is necessarily such that she has R, the property of talking to some unique individual. But it is also the case that whoever has P is necessarily such that she has R^*, the property of being self-identical. Consequently, in *directly* attributing P to myself, it appears that I am *indirectly* attributing the property of wearing a hat both to the intended indirect object (in this case, the person to whom I am talking) and to myself.

Someone might object that clause (i) of Chisholm's definition (i.e., the property P is necessarily such that "whatever has P bears R to something that is F,") requires that the thing to which I bear R must also be such that it is F. Consequently, if I am not wearing a hat, the relation that I bear to myself is excluded as a candidate for relation R. But if this were the intended reading, then it would be impossible for any judgments with indirect objects to be false: for example, if the person with whom I am speaking is not wearing a hat, the relation I bear to that person would also be excluded as a candidate for relation R.

Second, we are not convinced that the modification really succeeds in avoiding the problem. So far as we can tell, Chisholm never gives an example of a property P which bears the intended relationship to R (as specified in the modified definition) and which can itself be conceived by the thinker, and yet which does not require that the thinker conceive R

itself. What would such a property be? Moreover, what reason is there to think that property P, whatever it is, requires less sophistication of the believer than R?

Third, Chisholm is evidently ambivalent at best about the modification, since, so far as we can tell, the version of Chisholm's definition of indirect attribution that appears in his 1986 self-profile (Bogdan 1986) is the only one that unequivocally denies that a thinker must conceive relation R. In Chisholm's reply to Steven Boër in the same volume, he interprets *The First Person* account as denying that a thinker must conceive relation R (Bogdan 1986, p. 198). Given Chisholm's definition of property entailment in *The First Person,* however, we do not understand how he can do so.[18] Later versions which appear to deny that a thinker must conceive relation R do not do so unequivocally.[19] The upshot is this: Chisholm clearly and unequivocally backs off from his strong internalist requirement that relation R be conceived only in 1986, when he is directly under attack by Boër. In nearly every other publication, he appears to require that relation R itself (rather than some other property P that somehow "includes" it) be conceived.

Fourth, and finally, we think that Chisholm should (to be consistent with other views he holds) bite the internalist bullet and claim that the child cannot really direct a judgment upon her mother at all, even though it may seem that she can. However, he need not stop there—he has the resources to account for the intuition that a child can direct a judgment upon her mother. Briefly, he can say that, although a child without the sophistication to grasp relation R cannot really have a belief (or make a judgment) that is directed on her mother, she may say or do something which we, as the hearers or observers, *interpret* as being directed on the child's mother. In short, Chisholm can distinguish between speaker's meaning and hearer's meaning, as he does elsewhere (Chisholm 1981, pp. 69–70; Chisholm 1984a, pp. 102ff.), and insist that, although the child cannot really think *of* her mother (and thus cannot speak *of* her either), a sophisticated hearer can be caused by the child's words and actions to think *of* the child's mother.

Thus far, we have discussed two alternative accounts of what it is for a judgment to purport to have an indirect object, one of which requires that the thinker conceive relation R, and the other of which does not require this. The former has the disadvantage of requiring a good deal of sophistication of thinkers. The latter at least appears at first glance to have the advantage of requiring less of thinkers, but, because it expands the relevant relations R beyond the bounds of what a thinker conceives in directly attributing P, it faces counterexamples that do not arise for

the first alternative and it conflicts with Chisholm's firmly held internalist intuitions. All things considered, we believe that the former (the definition which requires conceiving R) is the one that Chisholm should and does prefer.

Note that both of these alternatives have a counterintuitive consequence: all judgments that purport to have indirect objects but fail will be false. On both versions, if a judgment fails to have an indirect object, relation R will fail to be exemplified by the thinker. If relation R fails to be exemplified, then the property directly attributed to the thinker (P, or R itself) will fail to be exemplified by the thinker. But this is just what it is for a judgment to be false, on Chisholm's account. Thus, Chisholm's account appears to have the consequence that no judgments that fail (for whatever reason) to have indirect objects can be true.

This counterintuitive consequence leads directly to further challenges, only one of which we will discuss here. There are at least three sorts of cases in which this consequence may seem to be clearly unacceptable:[20]

(1) Judgments about Socrates (and other previously existent but presently nonexistent contingent things)
(2) Donnellan cases
(3) Judgments about the Devil (and other nonexisting things which nevertheless may be thought to exist)

Consider judgments about Socrates. On the answer to (D) we have attributed to Chisholm, no judgments that fail to have indirect objects can be true. Since Socrates (at present) is neither an actually existing individual nor an eternal object, Socrates himself cannot be the indirect object of the judgment, say, that Socrates is a famous philosopher. Unless this judgment has some other indirect object, therefore, it looks as though it will be false. But we all (think we) know that this judgment is *true*. How can this be?

Moreover, intuitively, it seems that we ought to be able to think about Socrates in a way that is different from the way in which we are able to think about Santa Claus. After all, Socrates once actually existed, whereas Santa Claus did not. To acknowledge the force of this distinction faces Chisholm with a dilemma. A judgment about Socrates and a judgment about Santa Claus are judgments about objects that do not exist. On the one hand, if Chisholm's theory treats both judgments in exactly the same way, then the intuitive difference between them is lost. On the other hand, if Chisholm's theory treats these judgments differently, then he has apparently made a concession to externalism. Recall

that, for Chisholm, (nonepistemic) differences in judgments are, ultimately, differences in their direct content, i.e., differences in the properties one directly attributes to oneself. Intuitive differences between judgments about Socrates and judgments about Santa Claus should be reflected in the direct content. But the fact that Socrates existed and Santa Claus did not is a contingent fact about the world. An obvious way to preserve the intuitive difference between these judgments would be for Chisholm to admit that such facts can, in part, determine the contents of our judgments. But to admit this would be to make a concession to those who favor externalist accounts of content.

In "Referring to Things that No Longer Exist" (Chisholm 1990c), Chisholm tackles judgments about Socrates (and other previously existent but presently nonexistent contingent things). Moreover, he seems, at least initially, to share the externalist intuition just noted, since he offers an account of thoughts about Socrates which differs substantially from the account he has offered of thoughts about other things (existing and nonexisting). According to Chisholm, the key to understanding thoughts about Socrates is found in recognizing that there are some things now existing, e.g., eternal objects such as properties, that have tensed properties. "If there once was a philosopher who drank the hemlock and who no longer exists, then there always will be something—for example, the property blue—which once *was* such that there *is* a philosopher who is drinking the hemlock" (Chisholm 1990c, p. 554).

One might suppose that Chisholm is suggesting that, when I make the judgment that Socrates drank the hemlock, I do not take Socrates himself as my indirect object, but instead my judgment has another indirect object, namely, the property blue. However, there are problems with this supposition: (1) No particular abstract object (e.g., the property blue, the property of being such that $2 + 2 = 4$, etc.) has any unique claim to be the indirect object of such a judgment, so the uniqueness clause of the definition of indirect attribution will never be fulfilled; (2) although this supposition would make it possible for my judgment that Socrates drank the hemlock to be *true*, it would not support the intuition that my judgment is *about* Socrates, that it has a man, not a color, as its object. The judgment would have the thinker as direct object and a color as indirect object. It would be true, but it would appear to be about *those objects*, not about Socrates.

There is another option, and it is an option that fits better with Chisholm's text: Chisholm is suggesting that, when I make the judgment that Socrates drank the hemlock, I do not take Socrates himself as my indirect object; in fact, my judgment *has no indirect object at all.*

Nevertheless, my judgment can be *true*, not because it has some other indirect object, but precisely because it does not even *purport* to have an indirect object. Rather, it is what we have called a *being such that p* judgment. When I make the judgment that the *G* is *F*, where the *G* no longer exists, I directly attribute to myself the property of its being such that there exists something which was such that there is something which is the *G* and an *F*. When I make the judgment that the *G* is *F*, I am saying merely that something exists (it may be the property red, it may be the property of being such that $5 - 2 = 3$, it may be all eternal properties) which has a certain further property. My judgment has no indirect object at all, but, if it is true, then something or other has the property of having been such that there is something which is the *G* and an *F*.[21]

This purported solution to the problem of judgments about previously existing contingent things has a couple of advantages over the other proposal we considered: (1) Since *being such that p* judgments have no uniqueness clause, there is no need to specify a unique relation *R* between the thinker and some one property (or other object of thought); (2) The judgment can be true without having as an indirect object an object that is intuitively the *wrong* object.

However, in our view, this purported solution to the problem of judgments about Socrates also has several striking disadvantages: (1) In effect, Chisholm simply abandons his general answer to (D) with respect to judgments about Socrates (and thus with respect to *all judgments about contingent things that either have existed or will exist*)![22] The general answer to (D) was supposed to be that judgments about things that do not exist may nevertheless have the same content as do judgments about things that do exist. But, with respect to Socrates, Chisholm now says that such judgments do not share anything like the same content. They do not have indirect objects, and they do not even purport to have indirect objects. On our proposed division of judgments, they belong on the side of traditional he, himself and *being such that p* judgments. (2) By abandoning his general answer to (D) with respect to judgments about Socrates, Chisholm in effect admits that his fundamental distinction between what is direct and what is indirect does not help in any way to answer the question of how we can think about Socrates. (3) By admitting that the direct/indirect distinction does not help with respect to thoughts about Socrates, Chisholm admits that he has no solution to the problem of objective reference with respect to Socrates. Thoughts about Socrates collapse into the direct attribution of properties to myself of a sort that involves no indirect content (let alone indirect objects). Whereas Chisholm's account of intentionality was

supposed to show us how to solve the problem of objective reference and thus how to get outside of the circle of our own ideas *by taking objects other than ourselves as indirect objects of our thought*,[23] with respect to thoughts about Socrates, Chisholm says simply that this is not what we do.

As if all of this is not bad enough, there is a fourth consequence of Chisholm's purported solution that we think Chisholm should find intolerable. (4) Tacking this solution to the problem of Socrates onto Chisholm's general solution to the problem of how we refer to things other than ourselves apparently has a rather bizarre form of externalism as a consequence. Consider the following example. As we write this, we have a friend who is seriously ill, so ill that she could die at any moment. Consider the judgment, with respect to Diane, that she made a great difference in the Carbondale community. Suppose that we (each of us individually) make this judgment at two times, T1 and T3. Suppose that, unbeknownst to us, Diane dies at T2. For all we know, we are making precisely the same judgment, with the same content, at T1 and at T3. However, Chisholm's account would seem to have the consequence that there has been a significant change, not only in the object, but also in the *content*, of our thoughts. At T1, we could (and did) think *of Diane*: our thoughts purported to have an indirect object, and thus involved attributing to ourselves a certain relation *R*, and our thoughts had Diane as their indirect object. At T3, however, no matter how hard we try, we cannot think *of Diane* in the same way; our thoughts, insofar as they are true, do not even purport to have indirect objects, and they do not involve attributing to ourselves any relations that, if exemplified, link us to one and only one individual. Our thoughts at T3 differ from our thoughts at T1, not only with respect to their objects, but with respect to their *content*.

Perhaps Chisholm would reply that, at T3, given that we do not know that our friend has died, we can indeed make the same judgment that we made at T1, although it would no longer be *true*. Since we do not know that our friend has died, we attribute to ourselves a relation *R* that we exemplify only if there is an individual who fits our description. In effect, Chisholm would be saying that false thoughts about contingently nonexisting things may have the same content as true thoughts about contingently existing things, although true thoughts about contingently nonexisting things must have a different content.

We are not satisfied with this response, both because our intuition strongly suggests that we can make *true* judgments with the same content at both T1 and T3[24] and because it implies that, if we think an object exists when it does not, all of our judgments about it will be false. As we

understand things, the prime motivation for offering a different account of judgments about Socrates was to allow that many of our judgments about Socrates are *true*. We think the solution offered comes with a price that is too high for Chisholm to pay, since it undermines his general solution to (D) while at the same time failing to show how many of our judgments about previously existing but nonexistent things can be true. Intuitively, although I may not know whether or not the *G* still exists, I can nevertheless think true thoughts of the *G*.

A second reply Chisholm might make is the following. Why not simply extend the account given of judgments about Socrates to all objects, both existing and nonexisting?[25] This would unify the account by insisting that thoughts about my spouse get the same treatment as thoughts about Socrates, and it would avoid the conclusion that if we think an object exists when it no longer does, all of our judgments about it must be false.

However, to take this route is, in effect, to give up the attempt to offer an explanation of how we refer to things other than ourselves in terms of our basic ability to directly attribute properties to ourselves. A great virtue of Chisholm's original account, in our view, is that, although it takes as basic one intentional ability (direct attribution), it promises to explain other intentional abilities (e.g., indirect attribution) in terms of the basic abilities. On the proposed unification, however, this explanation evaporates. It appears that either (a) we cannot get outside of the circle of our own ideas, or, (b) if we can, we have no explanation at all of how we manage to do it other than we just do—and that is the end of the matter.

Since, as indicated above, we do not think the gerrymandered solution offered to problems about Socrates is adequate, we suggest that Chisholm has two live options:[26] (1) Bite the internalist bullet, accept the counterintuitive result that all judgments about nonexistent objects, of whatever sort, are false, and hold on to the general solution to (D), maintaining that a judgment that lacks an indirect object may nevertheless purport to refer in precisely the same sense as do judgments that have indirect objects; (2) Give up the general solution to (D), and with it, the general solution to (A), and admit that he really has no solution at all to offer to the problem of objective reference.

PAT A. MANFREDI
DONNA M. SUMMERFIELD

SOUTHERN ILLINOIS UNIVERSITY AT CARBONDALE
DEPARTMENT OF PHILOSOPHY
APRIL 1997

NOTES

1. A possible exception is Chisholm's most recent work (Chisholm 1996).

2. For Chisholm, states of affairs are abstract rather than concrete objects, and propositions are a subset of states of affairs (Chisholm 1989a, pp. 165–66). The differences between states of affairs and propositions won't matter for our purposes, so we will use 'states of affairs' and 'propositions' interchangeably.

3. As stated in *The First Person,* the definition is: "D1 x believes that he himself is F = Df. The property of being F is such that x directly attributes it to x." However, by the time Chisholm published a self-profile (1986), he had substituted *judging* for *believing* in D1, on the grounds that "'judging,' unlike 'believing,' suggests a mental *act*—an occurrent phenomenon. 'Believing,' unlike 'judging,' is compatible with the mere presence of a disposition. (Five minutes ago, I believed myself to be in Rhode Island, but I did not then *judge* that I was in Rhode Island.)" Chisholm thinks that what he says about judging "can be applied, *mutatis mutandis,* to the other intentional attitudes" (Bogdan 1986, p. 15).

 In light of this shift, we have substituted "judges" for "believes" in D1, and we have used the phrasing that Chisholm uses in the self-profile.

4. Note that the most basic relation in Chisholm's account of how it is possible to think about something (the direct attribution of a property to oneself) itself has only one of the three features highlighted in Chisholm's linguistic version of Brentano's thesis (Chisholm 1958). Although the early Chisholm states these features in linguistic terms, they translate into talk about thought rather than language, roughly, as (1) we can think about things that do not exist; (2) we can misrepresent things; (3) we frequently think of things in such a way that the same thing can be presented to us in two different ways without our recognizing that it is the same thing, e.g., "I may see that Albert is here and Albert may be the man who will win the prize; but I do not now see that the man who will win the prize is here" (Chisholm 1958, p. 511). Of these features, only (2) applies to the direct attribution of a property to oneself: one cannot fail to take oneself as a direct object (as in 1), and taking oneself as a direct object is not a matter of identifying oneself by one "mode of presentation" rather than another (as in 3), but one may directly attribute to oneself properties that one does not possess (as in 2). Thus, direct reference to oneself lacks two of the three characteristics commonly associated with intentionality. And yet, it is an intentional relation, both because it is, intuitively, an "aboutness" relation and because one may directly attribute to oneself properties that one does not possess, even though one may not be mistaken regarding who one directly attributes those properties to or regarding what properties one directly attributes.

5. As we shall see, this preliminary answer will not quite do as the final answer, since it will not enable Chisholm to answer question (D). This is the first hint of a tension in Chisholm's view which we will explore later in this paper.

6. Although there are many refinements and modifications over the years in Chisholm's definition of indirect attribution, this feature never changes.

7. Chisholm intends to follow Quine in his use of 'purport' (Bogdan 1986, p. 20; Chisholm 1990a, p. 5).

8. Judgments of this type are judgments in which the properties directly

attributed to oneself are propositions. In Chisholm's most recent book (Chisholm 1996, p. 24), he introduces propositions as attributes of the form "being such that *p*."

9. The entire definition reads as follows: "D4 The state of affairs that *p* is accepted (*de dicto*) by *x* = Df. There is one and only one state of affairs which is the state of affairs that *p;* and either (a) *x* directly attributes to *x* the property of being such that *p,* or (b) *x* attributes to the state of affairs that *p,* as the thing he is conceiving in a certain way, the property of being true" (Chisholm 1981, p. 38). We think there is a typographical error in (b), which should read "*x* indirectly attributes . . ." The next page corroborates this assumption: "the second condition is that wherein one indirectly attributes to the state of affairs the property of obtaining (or being true)."

10. As we shall see when we discuss the "problem of the 'he, himself' locution," some judgments about oneself involve taking oneself as the indirect object of one's judgment, and so belong on the other side of the division of judgments, with judgments that purport to have indirect objects.

11. Some *de dicto* judgments, those covered by clause (b) in definition D4 above, are judgments that indirectly attribute the property of *being true* (or *obtaining*) to propositions. These judgments, like traditional *de re* judgments, have indirect objects, and so belong on the other side of the division of judgments we attribute to Chisholm. For Chisholm, a proposition can be involved in a judgment in at least two different ways: as its direct content and as its indirect object.

12. In fact, this is generally the case, for all sorts of judgments. Ultimately, apart from epistemic differences, the only difference between various types of judgments lies in the properties *x* directly attributes to *x*. Thus, in one sense, all judgments are 'he, himself' judgments, as defined by D1, since they all involve the direct attribution of a property to oneself.

13. Although we think it is instructive to ask how Chisholm divides the other basic class of judgments, namely, those with indirect as well as direct contents (those that purport to have indirect objects), we will not do so here.

14. In cases in which you succeed in taking yourself as an indirect object of thought, there will be cases (such as the Mach case) in which you fail to recognize that you are the indirect object, and other cases (such as the Mach case after recognition dawns) in which you recognize that you are the indirect object.

15. Chisholm, so far as we know, does not explicitly say that a judgment about a nonexistent thing has the same direct and indirect content as a judgment about an existing thing that fits the same description would have, but it is difficult to see what the solution is supposed to be if this is not his intention.

16. See Chisholm 1982, 1984a, 1984b. Compare Chisholm 1981, p. 31. So far as we know, Chisholm never directly defines *purporting to refer* for attributions, although he does at one point define it for thinking of: "D3.3 *x* has a thought that purports to be about something that is *F* = Df. There is a relation *R* such that *x* directly considers *x* as bearing *R* to just one thing and to a thing that is *F*" (Chisholm 1984a, p. 100).

17. Bogdan 1986, p. 19. The complete definition is as follows:

x indirectly attributes to *y* the property of being-*F* = df There is a relation *R* such that (a) *x* bears *R* to *y* and only to *y* and (b) *x* directly attributes to [*x*] a

property *P* which is necessarily such that (i) whatever has *P* bears *R* to something that is *F*, (ii) whoever conceives *P* conceives being-*F*, and (iii) it is possible to attribute *P* directly to oneself without attributing being-*F* directly to oneself.

There is a misprint in clause (b): it reads "*x* directly attributes to *y* a property *P* . . . ," but should read "*x* directly attributes to *x* a property *P* . . ."

18. In *The First Person*, Chisholm says that when *x* indirectly attributes the property of being *F* to *y*, "*x* directly attributes to *x* a property which entails the property of bearing *R* to just one thing and to a thing that is *F*" (Chisholm 1981, p. 31). For our present purposes, the important point is that the definition of indirect attribution given in *The First Person* requires that *x* directly attribute to *x* a property which entails the property of bearing *R* to just one thing and that this, in turn, requires that *x* conceive the property of bearing *R* to just one thing.

19. Compare the two definitions on p. 111 of Chisholm 1989b, which is a reprint of Chisholm 1987. See also clause (3) of definition 7 (a definition of "*x* indirectly attributes to *y* the property of being *F*") in Chisholm 1990c, which reads "*x*'s directly attributing includes directly attributing the property of bearing *R* to just one thing and to a thing that is *F*." Chisholm defines "includes" in a way that explicitly excludes the notion of conceiving: "*P* includes *Q* = Df *P* is necessarily such that whatever exemplifies it exemplifies *Q*" (Chisholm 1989a, p. 143). So one might think that Chisholm is here defining indirect attribution in a way that excludes the need to conceive relation *R*. But since "includes" is defined for properties, not for direct attributions, this is not the case. Chisholm is clearly committed to the view that any direct attributing of a property *P* requires conceiving that property *P*. He affirms that central principle even in Bogdan 1986, p. 198, where he explicitly denies that relation *R* must be conceived. But this implies that relation *R* can avoid needing to be conceived, so to speak, only if it is not what is directly attributed. In the definition under consideration, however, "*x*'s directly attributing includes *directly attributing* the property of bearing *R* to just one thing and to a thing that is *F*." Thus, the property of bearing *R* to just one thing must be conceived. There is one article after 1986 that clearly implies that relation *R* need not be conceived (Chisholm 1990a); however, since the relevant portion of the article is simply a verbatim reprint of the 1986 version, we are not convinced that it represents Chisholm's post-1986 thinking on the issue.

20. Two cases that we ignore here are judgments about impossible objects and states of affairs such as the round square and the round square's being round, and judgments about fictional characters such as Sherlock Holmes, where such characters are explicitly recognized not to exist. For remarks on impossible states of affairs, see Chisholm's reply to Boër in Bogdan 1986. For remarks on Sherlock Holmes, see Chisholm's most recent book (Chisholm 1996).

21. Chisholm's final definition is as follows (Chisholm 1990c, p. 556).

D9 *x* judges with respect to the thing that was G that it is *F* = Df
(1) There exists something which was such that the *G* exists;
(2) *x* judges with respect to *x* that it is such that there exists something which was such that there is something which is the *G* and an *F*; and
(3) *x* is more justified in judging with respect to *x* that it is such that there exists something which was such that the *G* exists than in not so judging.

22. Although we have not explicitly discussed this aspect of his purported solution, he extends his definitions to include judgments about things that will exist but do not now exist.

23. The problem of objective reference, according to Chisholm, is one side of the traditional problem of how the mind gets "outside the circle of its own ideas," the other side of which is the problem of how we have knowledge, or justified true belief, about other things (Bogdan 1986, p. 14).

24. Notice that our intuition is not incompatible with common forms of externalism. We are willing to grant that judgments that are, for all we can tell, identical to those we make at T1 and T3 *might* well be different on twin-earth, if, for example, on twin-earth the being we call 'Diane' is a robot. But our intuition suggests that the event of our friend's dying can make no more difference to the content or truth of our judgment, of Diane, that she made a great difference in the Carbondale community, than a scientist's discovering some new property of H_2O is supposed, on standard externalist stories, to make to the content or truth of my judgment, of H_2O, that it is wet.

25. There is some indication in Chisholm's most recent work that he is tempted by a unified account of this sort, since that work makes no mention of the direct versus indirect distinction (Chisholm 1996).

26. We do not mean to suggest that there are only two logically possible choices here. For example, one might accept the reality of possible worlds (as does David Lewis) and say that judgments that purport to be about Socrates should be understood as judgments that are true of some actually existing counterpart individual. However, Chisholm's resistance to an ontology that countenances real possible worlds is strong, and we do not think this option is one that would be a "live" option for him.

WORKS CITED

Bogdan, R. J., ed., 1986. *Roderick M. Chisholm*. Dordrecht, Holland: D. Reidel.

Chisholm, R. M. 1956. "Sentences about Believing." *Proceedings of the Aristotelian Society* 56: 125–48.

———. 1958. "Sentences about Believing." In H. Feigl, M. Scriven, and G. Maxwell, eds., *Concepts, Theories, and the Mind-Body Problem*, pp. 510–20. Minneapolis: University of Minnesota Press.

———. 1981. *The First Person: An Essay on Reference and Intentionality*. Brighton, Sussex: Harvester Press.

———. 1982. "Converse Intentional Properties." *Journal of Philosophy* 79, no. 10: 537–45.

———. 1984a. "The Primacy of the Intentional." *Synthese* 61, no. 1: 89–109.

———. 1984b. "What Is the Problem of Objective Reference?" *Dialectica 38*, nos. 2–3: 131–42.

———. 1987. "Presence in Absence." *Monist* 69: 497–504.

———. 1989a. *On Metaphysics*. Minneapolis: University of Minnesota Press.

———. 1989b. "Presence in Absence." In *On Metaphysics*, pp. 107–13. Minneapolis: University of Minnesota Press.

———. 1990a. "Brentano and Marty on Content: A Synthesis Suggested by

Brentano." In K. Mulligan, ed., *Mind, Meaning, and Metaphysics: The Philosophy and Theory of Language of Anton Marty*, pp. 1–9. Dordrecht: Kluwer Academic Publishers.

———. 1990b. "How We Refer to Things." *Philosophical Studies* 58, nos. 1–2: 155–64.

———. 1990c. "Referring to Things that No Longer Exist." In J. E. Tomberlin, ed., *Action Theory and Philosophy of Mind*, pp. 545–56. Atascadero, Calif.: Ridgeview Publishing Company.

———. 1996. *A Realistic Theory of Categories: An Essay on Ontology*. Cambridge: Cambridge University Press.

Wittgenstein, L. 1958. *Philosophical Investigations*. Trans. G. E. M. Anscombe. New York: Macmillan Publishing Company.

PART THREE

BIBLIOGRAPHY OF THE WRITINGS OF RODERICK M. CHISHOLM

Compiled by

RODERICK M. CHISHOLM

PREFACE TO THE BIBLIOGRAPHY OF THE WRITINGS OF RODERICK M. CHISHOLM

I am grateful to Dr. George Chatalian for helpful background material on Professor Chisholm and had hoped before his health took a turn for the worse that he would be able to contribute an essay to our volume. The sampling of works on Chisholm, a selection of Academic and Professional Honors, and the Partial List of Academic Appointments I owe to him. The Bibliography of Chisholm's writings was prepared by Professor Chisholm.

A. PARTIAL LIST OF WORKS ON THE PHILOSOPHY OF R. M. CHISHOLM

1. Lehrer, Keith, ed. 1975. *Analysis and Metaphysics: Essays in Honor of R. M. Chisholm.* Dordrecht: D. Reidel.
2. 1978. *Philosophia: Philosophical Quarterly of Israel* 7, nos. 3–4; this issue has the subtitle "The Philosophy of Roderick M. Chisholm."
3. 1979. *Grazer Philosophische Studien* 7/8; this issue has the subtitle "Essays on the Philosophy of Roderick M. Chisholm." It is published separately as *Essays in the Philosophy of Roderick M. Chisholm,* edited by Ernest Sosa (Amsterdam: Editions Rodopi N.V., 1979).
4. Schuwey, Bruno. 1983. *Chisholm über Intentionalität: Kritik und Verteidigung von Chisholms Explikationen der sogenannten psychologischen Theses Brentanos.* Bern, Frankfurt am Main, New York: Peter Lang.
5. Bogdan, Radu J., ed. 1986. *Profiles: Roderick M. Chisholm.* Dordrecht: D. Reidel. In *Profiles: An International Series on Contemporary Philosophers and Logicians.* Contains "Self-Profile" by Chisholm.
6. 1986. *Grazer Philosophische Studien* 28; this volume is entitled *Philosophische Aufsätze zu Ehren von Roderick M. Chisholm.* It is published separately under the latter title, edited by Marian David and Leopold Stubenberg.

7. Scotti, Nicoletta. 1986. *La Problematica Gnoseological nel Pensiero di Roderick M. Chisholm.* Milan: Gooperativa Universitaria Studio e Lavero.

B. ACADEMIC AND PROFESSIONAL HONORS

Fellow of the American Academy of Arts and Sciences, since 1958. President of the Eastern Division of the American Philosophical Association, 1968; Vice President, 1962; Member of Executive Committee, 1953–1956. Chairman, American Philosophical Association Subcommittee on Lectureship, 1969–1979. President of the Metaphysical Society of America, 1972–1973; Councilor, 1963–1966. Chairman of the Council for Philosophical Studies, 1972–1979. (The Council had an important role in supporting philosophical activities, especially in the period before the National Endowment for the Humanities was created. L.E.H.) Member of Organizing Committee for 16th World Congress of Philosophy, 1975–1978. Executive Director, Franz Brentano Foundation, since 1970. President of the Fifth Interamerican Congress of Philosophy, Washington, D.C., 1957. Secretary, the Sociedad Interamericana de Filosofia, 1946–1957. Member of Institut International de Philosophie, since 1971; Honorary Vice-President. Seminar for Austro-German Philosophy, The University, Manchester, England.

Associate Editor: *Philosophy and Phenomenological Research.* Consulting Editor: *Metaphilosophy; The Southwestern Journal of Philosophy; Grazer Philosophische Studien; Manuscrito* (São Paulo); *The Pacific Philosophical Quarterly; Ratio* (Oxford and Hamburg); *Midwest Studies in Philosophy* (Morris, Minn.). Formerly consulting editor of *The American Philosophical Quarterly.*

Carus Lecturer, American Philosophical Association, 1967. Nellie Wallace Lecturer, Oxford University, Hilary Term, 1967. Aquinas Lecturer, Marquette University, 1973. The first "Benefactors' Lecturer" before the Royal Institute of Philosophy, University of London, 1979. Kant Lectures, Stanford University, April 1983.

Honorary Degrees: (1) Doctor of Philosophy, University of Graz, 15 June 1972; (2) Doctor of Humane Letters, Brown University, 30 May 1988; (3) Doctor of Philosophy, Internationale Akademie für Philosophie in Fürstentum Lichtenstein, 1996.

Appointed as Permanent Guest Professor ("als ständigen Gast-Professor"), University of Würzburg, 15 July 1980.

21–23 November 1986, Brown University, a Conference entitled "Justification in Epistemology: A Conference at Brown University in Honor of R. M. Chisholm on his Seventieth Birthday."

25 May 1986, received "das Ehrenzeichen der Landeshauptstadt Graz in Gold" in recognition of "special services to the city of Graz." These services constitute a continuation of the work for which the Honorary Degree was awarded in 1972.

C. PARTIAL LIST OF ACADEMIC APPOINTMENTS

Barnes Foundation Professor of Philosophy at the University of Pennsylvania and the Barnes Foundation, Semester I, 1946–1947.

Assistant Professor of Philosophy, University of Pennsylvania, Semester II, 1946–1947.

Member of the Department of Philosophy, Brown University, since September 1947; Chairman, 1951–1964; Andrew W. Mellon Professor of the Humanities, 1972–1987.

Visiting Lecturer, Harvard University, 1950. Visiting Professor, University of Southern California, 1955. Fulbright Professor, Karl-Franzens-Universität, Graz, Austria, 1959–1960. Visiting Professor, Harvard University, 1960; Princeton University, 1961–1962; University of California at Santa Barbara, 1964; University of Alberta in Calgary, 1965; University of Illinois at Urbana, 1966; University of Chicago, 1967; Harvard University, 1969; University of Massachusetts at Amherst, 1970–1975; University of Salzburg, 1972; University of Graz, 1974–1987; University of Illinois at Chicago Circle, 1977; University of Heidelberg, Summer Semester 1977 and Summer Semester 1980.

LEWIS EDWIN HAHN
EDITOR

DEPARTMENT OF PHILOSOPHY
SOUTHERN ILLINOIS UNIVERSITY AT CARBONDALE
JUNE 1997

BIBLIOGRAPHY OF THE WRITINGS OF RODERICK M. CHISHOLM

1. 1941. "Sextus Empiricus and Modern Empiricism." *Philosophy of Science* 8: 371–84.

2. 1942. "The Problem of the Speckled Hen." *Mind* 51: 368–73.

3. 1943. Review of *Art Criticism and Semantic Discipline* by Lewis W. Beck. *Philosophy and Phenomenological Research* 4: 578–80.

4. 1943. Review of *Lewin's Topological and Vector Psychology* by Robert W. Leeper. *Philosophy and Phenomenological Research* 4: 110–13.

5. 1944. "The Relation of Mental Disorders to Race and Nationality" (with R. W. Hyde). *New England Journal of Medicine* 231: 612–18.

6. 1944. Review of *The Philosophy of Marsilio Ficino* by Paul Kristeller. *Philosophy and Phenomenological Research* 4: 578–80.

7. 1944. "Russell on the Foundations of Empirical Knowledge." In *The Philosophy of Bertrand Russell* (The Library of Living Philosophers, vol. 5), ed. P. A. Schilpp, 421–44. Evanston, Ill.: Northwestern University Press.

8. 1945. Review of *New Bearings in Esthetics and Art Criticism* by Bernard Heyl. *Philosophy and Phenomenological Research* 5: 426–28.

9. 1946. "The Basic Propositions of Empirical Knowledge." In *Summaries of Theses: 1942*, 334–37. Cambridge: Harvard University Press.

10. 1946. "The Contrary to Fact Conditional." *Mind* 55: 289–307.

 Reprinted with revisions in Herbert Feigl and W. S. Sellars, eds., *Readings in Philosophical Analysis*, 482–97. New York: Appleton Century Crofts, 1949.

 Reprinted with omissions in Peter T. Manicas, ed., *Logic as Philosophy: An Introductory Anthology*, 118–28. New York: Van Nostrand Reinhold Company, 1971.

 The foregoing version is translated into Italian as "Il Condizionale Controfattuale," in *Leggi di Natura, Modalita, Ipotesi: La Logica del Ragionamento Controfattuale*, ed. Claudio Pizzi, 95–111. Milan: Feltrinelli, 1978.

11. 1946. Review of *The A Priori in Physical Theory* by Arthur Pap. *Philosophical Review* 55: 594–97.

12. 1946. Review of *O Sentido da Nova Lógica* by W. V. Quine. *Philosophy and Phenomenological Research* 6: 645–48.

13. 1947. Review of "Os Estados Unidos e o Ressurgimento da Lógica" by W. V. Quine. *Philosophy and Phenomenological Research* 7: 483–84.

14. 1947. Review of *Power and Events* by Andrew Paul Ushenko. *Philosophical Review* 56: 431–33.

15. 1948. "The Problem of Empiricism." *Journal of Philosophy* 45: 512–17.

Reprinted in Robert J. Swartz, ed., *Perceiving, Sensing, and Knowing,* 347–55. Garden City, N.Y.: Doubleday and Co., 1965.

Reprinted in Ernest Nagel and Richard Brandt, eds., *Meaning and Knowledge,* 576–80. New York: Harcourt, Brace, and World, 1965.

Reprinted separately as Number 46 in the Reprint Series in Philosophy. Indianapolis: Bobbs-Merrill Company, 1969.

16. 1948. Review of *Freedom and Experience,* ed. Sidney Hook and M. R. Konvitz. *Philosophical Review* 57: 613–19.

17. 1949. Review of "Der Begriff des Guten" by Uuno Saarnio. *Journal of Symbolic Logic* 14: 250.

18. 1950. "Bertrand Russell." In *Collier's Encyclopedia,* vol. 17, 199–201. New York. Reprinted with revisions in subsequent editions.

19. 1950. Review of "Dialectique et logique" by Ph. Devaux (and of comment by E. W. Beth, F. Gonseth, et al.). *Journal of Symbolic Logic* 15: 145–47.

20. 1950. Review of "Hypotheticals" by David Pears. *Journal of Symbolic Logic* 15: 215–16.

21. 1950. Review of *Introduction to Realistic Philosophy* by John Wild. *Philosophical Review* 59: 391–94.

22. 1950. Review of *Symbolische Logik und Grundlegung der exacten Wissenschafte:* by E. W. Beth, and *Der logische Positivismus* by Karl Dürr. *Journal of Symbolic Logic* 15: 72.

23. 1950. "The Theory of Appearing." In Max Black, ed., *Philosophical Analysis: A Collection of Essays,* 102–18. Ithaca, N.Y.: Cornell University Press.

Reprinted in Robert J. Swartz, ed., *Perceiving, Sensing, and Knowing,* 168–86. Garden City, N.Y.: Doubleday and Co., 1965.

Reprinted as "To-sig-teorin" in K. Marc-Wogau, ed., *Filosofia Genom Tidona* [*Philosophy through the Ages*]. Stockholm: Albert Bonner, 1980. Filosofia 1980.

24. 1951. "Philosophers and Ordinary Language." *Philosophical Review* 60: 317–28.

Reprinted in Richard Rorty, ed., *The Linguistic Turn,* 175–82. Chicago: University of Chicago Press, 1967.

25. 1951. "Psychophysics and Structural Similarity." *Revista Brasileira de Filosofia* 1: 31–35.

26. 1951. "Reichenbach on Observing and Perceiving." *Philosophical Studies* 2: 31–35.

27. 1951. Review of "Are All Necessary Propositions Analytic?" by Arthur Pap. *Journal of Symbolic Logic* 17: 140.

28. 1951. Review of "Der Begriff der Funktion in der symbolischen Logik" by Karl Dürr, "Interpretationen von Kalkülen" by W. Britzelmayer, and "The Pragmatic Foundations of Semantics" by A. Grezegorczyk. *Journal of Symbolic Logic* 16: 292.

29. 1951. Review of "Categoricals and Hypotheticals in George Boole and his Successors" by A. N. Prior. *Journal of Symbolic Logic* 17: 224.

30. 1951. Review of "The Many-Level-Structure of Language" by F. Waismann, "Logical and Psychological Aspects in the Consideration of Language" by E. W. Beth, and "Logische und psychologische Aspekte in der Sprachbetrachtung" by F. Waismann. *Journal of Symbolic Logic* 16: 75–76.

31. 1951. Review of "Natural Laws and Contrary-to-Fact Conditionals" by William Kneale. *Journal of Symbolic Logic* 16: 64.

32. 1951. Review of "Non-accidental and Counterfactual Sentences" by E. L. Beardsley. *Journal of Symbolic Logic* 16: 63–64.

33. 1951. Review of *Structure, Method, and Meaning,* ed. Paul Henle et al. *United States Quarterly Book Review* 7: 250.

34. 1951. "Verification and Perception." *Revue Internationale de Philosophie,* cinquième anneé, 251–56.

Reprinted separately as Number 57 in the Reprint Series in Philosophy. Indianapolis: Bobbs-Merrill Company, 1969.

35. 1952. "Comments on the 'Proposal Theory' of Philosophy." *Journal of Philosophy* 49: 301–6.

Reprinted in Richard Rorty, ed., *The Linguistic Turn,* 156–59. Chicago: University of Chicago Press, 1967.

36. 1952. "Ducasse's Theory of Properties and Qualities." *Philosophy and Phenomenological Research* 13: 42–56.

37. 1952. "Fallibilism and Belief." In *Studies in the Philosophy of Charles Sanders Peirce,* ed. Philip Wiener and Frederic H. Young, 92–110, 338–40. Cambridge: Harvard University Press.

38. 1952. "Intentionality and the Theory of Signs." *Philosophical Studies* 3: 56–63.

Reprinted in Ernest Nagel and Richard Brandt, eds., *Meaning and Knowledge,* 101–5. New York: Harcourt, Brace, and World, 1965.

Reprinted separately as Number 54 in the Reprint Series in Philosophy. Indianapolis: Bobbs-Merrill Company, 1969.

Reprinted in Herbert Feigl, Wilfrid Sellars, and Keith Lehrer, eds., *New Readings in Philosophical Analysis,* 424–29. New York: Appleton-Century-Crofts, 1972.

Reprinted in D. S. Clarke, Jr., ed., *Sources of Semiotic,* 106–10. Carbondale: Southern Illinois University Press, 1990.

39. 1952. "Reichenbach on Perceiving." *Philosophical Studies* 3: 82–83.

40. 1952. Review of *Anais de Primeiro Congresso Brasileire de Filosofia. Philosophy and Phenomenological Research* 13: 457–59.

41. 1952. Review of "Anwendung der Logistik und analytischen Sozialpsychologie in der Grundlagenforschung der Sozialwissenschaften" by E. J. Walter. *Journal of Symbolic Logic* 17: 61.

42. 1952. Review of "Boole's Philosophy of Logic" by Mary B. Hesse. *Journal of Symbolic Logic* 17: 285.

43. 1952. Review of "On the Meaningfulness of Vague Language" by G. Watts Cunningham. *Journal of Symbolic Logic* 17: 219–20.

44. 1952. Review of "On the Modal and Causal Functions in Symbolic Logic" by Stanislaw Jaskowski. *Journal of Symbolic Logic* 17: 142.

45. 1952. Review of *Structure, Method, and Meaning,* ed. Paul Henle et al. *Philosophical Review* 61: 246–48.

46. 1952. "Some Theses on Empirical Certainty." *Review of Metaphysics* 5: 625–26.

47. 1953. Review of "Die Anwendung der logistischen Analyse auf philosophische Probleme" by Bela von Juhos. *Journal of Symbolic Logic* 18: 337–38.

48. 1953. Review of *Mind, Perception, and Science* by W. Russell Brain. *Journal of Philosophy* 50: 502–5.

49. 1953. Review of *Die Philosophie* by Max Bense. *Journal of Symbolic Logic* 18: 82.

50. 1953. Review of *Semantics and the Philosophy of Language,* ed. Leonard Linsky, and *Meaning, Communication, and Value* by Paul Kecskemeti. *Philosophy and Phenomenological Research* 14: 115–21.

51. 1953. Review of "Die vier 'ungültigen' Modi" by G. Lebzeltern. *Journal of Symbolic Logic* 18: 273.

52. 1953. Review of "Zur Lehre von den Kontrapositionsschlüssen" by Ulrich Klug, and "Über das System der Modi des Syllogismus" by Bruno von Freytag-Loringhoff. *Journal of Symbolic Logic* 18: 273.

53. 1954. "Knowledge and Certainty." *Review of Metaphysics* 7: 685–87.

54. 1954. "On the Uses of Intentional Words." *Journal of Philosophy* 51: 436–41.

55. 1954. Review of "Die Implikation als echte Wenn-So-Beziehung" by Paul F. Linke. *Journal of Symbolic Logic* 19: 67.

56. 1954. Review of *Meinong-Gedenkschrift,* ed. K. Radakovic, A. Silva Tarouca, and F. Weinhandl. *Philosophical Review* 61: 620–23.

57. 1954. Review of *The Sensory Order* by F. A. Hayek. *Philosophical Review* 63: 135–36.

58. 1954. Review of "Was ist Logik?" by Paul F. Linke. *Journal of Symbolic Logic* 19: 65.

59. 1954. "Sellars' Critical Realism." *Philosophy and Phenomenological Research* 15: 33–47.

60. 1955. "A Priori." In *Twentieth Century Encyclopedia of Religious Knowledge (An Extension of the New Schaff-Herzog Encyclopedia of Religious Knowledge),* vol. 1, 57. Grand Rapids, Mich.: Baker Book House.

61. 1955. "Dynamism." Ibid., vol. 1, 355.

62. 1955. "Law Statements and Counterfactual Inference." *Analysis* 15: 97–105.

Reprinted in Edward Madden, ed., *The Structure of Scientific Thought.* Boston: Houghton Mifflin Company, 1960.

Reprinted separately as Number 55 in the Reprint Series in Philosophy. Indianapolis: Bobbs-Merrill Company, 1969.

Reprinted in Herbert Feigl, Wilfrid Sellars, and Keith Lehrer, eds., *New Readings in Philosophical Analysis,* 524–29. New York: Appleton-Century-Crofts, 1972.

Reprinted in Ernest Sosa, ed., *Causation and Conditionals,* 147–55. London: Oxford University Press, 1975.

Reprinted in Andrew B. Schoedinger, ed., *Metaphysics: The Fundamental Questions,* 163–71. Buffalo: Prometheus Books, 1991.

63. 1955. "A Note on Carnap's Meaning Analysis." *Philosophical Studies* 6: 87–89.

Reprinted, together with two papers by Rudolf Carnap, as Number 46 in the Reprint Series in Philosophy. Indianapolis: Bobbs-Merrill Company, 1969.

64. 1955. Review of *Philosophical Essays* by A. J. Ayer. *Journal of Philosophy* 52: 571–72.

65. 1955. Review of *Problems of Analysis* by Max Black. *Philosophical Review* 64: 652–56.

66. 1955. Review of *Some Main Problems of Philosophy* by G. E. Moore. *Philosophy and Phenomenological Research* 15: 571–72.

67. 1955. Editor and cotranslator of *The Vocation of Man* by Johann Gottlieb Fichte. New York: Liberal Arts Press. Editor's introduction, vii–xvii.

68. 1955–1956. "Sentences about Believing." *Proceedings of the Aristotelian Society* 56: 125–48.

Reprinted with revisions in the *Minnesota Studies in the Philosophy of Science* 2: 511–20.

Reprinted as "Irreducible Intentionality as the Mark of the Psychological," in Leonard I. Krimerman, ed., *The Nature and Scope of Social Science,* 398–408. New York: Appleton-Century-Crofts, 1969.

Reprinted in Ausonio Marras, ed., *Intentionality, Mind, and Language,* 31–51. Urbana: University of Illinois Press, 1972.

Translated into Spanish as "Oraciones De Creencia," in *Semántica: filosófica problemas y discusiones,* ed. Thomas Moro Simpson, 417–37. Buenos Aires: Siglo 21 Argentina Editores S.A., 1973.

Reprinted in Myles Brand, ed., *The Nature of Causation,* 113–21. Urbana: University of Illinois Press, 1976.

Reprinted as "Sätze über Glauben," in Peter Bieri, ed., *Analytische Philosophie des Geistes,* 145–61. Königstein/Taunus: Hain Verlag, 1981. Volume 6 of the series *Analyse und Grundlegung.*

69. 1956. "'Appear,' 'Take,' and 'Evident.'" *Journal of Philosophy* 53: 722–31.

Reprinted in Robert J. Swartz, ed., *Perceiving, Sensing, and Knowing.* Garden City, N.Y.: Doubleday and Co., 1965.

Reprinted in part (as "The Empirical Criterion") in John W. Yolton, ed., *Theory of Knowledge.* New York: Macmillan Company, 1965.

70. 1956. "Epistemic Statements and the Ethics of Belief." *Philosophy and Phenomenological Research* 16: 447–60.

71. Review of *Religion und Philosophie* by Franz Brentano. *Philosophy and Phenomenological Research* 16: 439–40.

72. 1956. Review of *Theories of Perception and the Concept of Structure* by Floyd H. Allport. *Personalist* 37: 332–33.

73. 1956–1957. "Report on the Fifth Interamerican Congress of Philosophy." *Proceedings of the American Philosophical Association* 30: 83–90.

74. 1957. "Chisholm-Sellars Correspondence on Intentionality." *Minnesota Studies in the Philosophy of Science* 2: 521–39.

 Reprinted in Ausonio Marras, ed., *Intentionality, Mind, and Language,* 214–48. Urbana: University of Illinois Press, 1972.

 Reprinted in French as "La Correspondance sur l'intentionalité de Wilfrid Sellars-Roderick Chisholm," in Fabien Cayla, *Routes et deroutes de l'intentionalité,* 7–38. Combas, France: Editions de l'Eclat, 1991.

75. 1957. "Inference by Complementary Elimination" (with Bernard K. Symonds). *Journal of Symbolic Logic* 22: 233–36.

76. 1957. *Perceiving: A Philosophical Study.* Ithaca, N.Y.: Cornell University Press.

 Appendix reprinted as "Problems of Phenomenalism" in John V. Canfield and Franklin H. Donnell, eds., *Readings in the Theory of Knowledge,* 469–74. New York: Appleton-Century-Crofts, 1964.

 Parts of chapter 1 and all of chapter 7 reprinted as "The Nature and Justification of Epistemic Statements" in Ernest Nagel and Richard Brandt, eds., *Meaning and Knowledge,* 652–68. New York: Harcourt, Brace, and World, 1965.

 Appendix reprinted as "Difficulties for Phenomenalism" in William P. Alston and Richard B. Brandt, eds., *The Problems of Philosophy: Introductory Readings,* 678–83. Boston: Allyn and Bacon, Inc., 1967.

 Appendix reprinted with additions as "Phenomenalism" in Gale W. Engle and Gabriele Taylor, eds., *Berkeley's Principles of Human Knowledge,* 83–88. Belmont, Calif.: Wadsworth Publishing Company, Inc., 1968.

 Chapter 11 reprinted in Joseph Margolis, ed., *An Introduction to Philosophical Inquiry,* 758–67. New York: Alfred A. Knopf, 1968.

 Chapter 1 reprinted in Julius Weinberg and Keith Yandel, eds., *Theory of Knowledge: Problems in Philosophical Inquiry, Part I,* 145–72. New York: Holt, Rinehart, and Winston, Inc., 1971.

 Chapters 1 and 6 reprinted in Herbert Feigl, Wilfrid Sellars, and Keith Lehrer, eds., *New Readings in Philosophical Analysis,* 259–67 and 268–81. New York: Appleton-Century-Crofts, 1972.

 Chapter 11 reprinted in Linda McAlister, ed., *The Philosophy of Franz Brentano,* 140–50. London: Duckworth, 1976.

 Chapter 11 reprinted in David M. Rosenthal, ed., *The Nature of Mind,* 280–84. New York and Oxford: Oxford University Press, 1991.

 Pp. 15–21 translated as "Epistemische Ausdrücke," in Peter Bieri, ed., *Analytische Philosophie der Erkenntnis,* 85–90. Frankfurt am Main: Athenäm, 1987.

 Translated into Japanese by T. Nakasai, T. Takakani, and K. Iida, and published in the series "Classics of Anglo-Saxon Philosophy." Tokyo: Keiso-Shobo, 1994.

77. 1957. Review of "Eigentliche und uneigentliche Logik" by Paul F. Linke. *Journal of Symbolic Logic* 22: 383–84.

78. 1957–1958. "Quinto Congreso Interamericano de Filosofia." *Revista de Filosofia de la Universidad de Costa Rica* 1: 166–68.

79. 1957–1958. "La Teoria del Objeto de Meinong." *Revista de Filosofía de la Universidad de Costa Rica* 1: 337–42.

80. 1958. "Responsibility and Avoidability." In *Determinism and Freedom in the Age of Modern Physics*, ed. Sidney Hook, 145–46. New York: New York University Press.

Reprinted in Joel Feinberg, ed., *Reason and Responsibility*, 332–33. Belmont, Calif.: Dickinson Publishing Company, 1965; 2d ed., 1971.

Reprinted in Fred A. Westphal, *The Art of Philosophy*, 135–37. Prentice Hall, Inc., 1972.

81. 1958. Review of *Die Lehre vom richtigen Urteil* by Franz Brentano. *Philosophy and Phenomenological Research* 19: 273.

82. 1958–1959. "Graduate Education in Philosophy." *Proceedings of the American Philosophical Association* 32: 145–56; report of a committee composed of H. G. Alexander, P. C. Hayner, C. W. Hendel, and R. M. Chisholm, Chairman.

83. 1959. Review of *An Analysis of Knowing* by John Hartland-Swann. *Philosophy and Phenomenological Research* 20: 276–77.

84. 1959. Review of *Intention* by G. E. M. Anscombe. *Philosophical Review* 68: 110–15.

85. 1960. "Making Things To Have Happened" (with Richard Taylor). *Analysis* 20: 73–78.

86. 1960. Editor and cotranslator, *Realism and the Background of Phenomenology.* Glencoe, Ill.: Free Press. Editor's preface and introduction, v, 8–36.

Reprinted in 1981 by Ridgeview Publishing Company (Atascadero, California.)

87. 1961. "Evidence as Justification." *Journal of Philosophy* 58: 739–48.

88. 1961. "Jenseits von Sein und Nichtsein." In Karl S. Guthke, ed., *Dichtung und Deutung*, 23–31. Bern: Francke Verlag.

89. 1961. "Die Lehre Peirces vom Pragmatismus und 'Commonsensismus.' " *Unser Weg: Pädagogische Zeitschrift* (Graz-Vienna) 16: 129–39.

90. 1961. "Perspective '61: Philosophy." Supplement of the Brown Daily Herald 4, no. 1: 7, 11.

91. 1961. "What Is It To Act Upon a Proposition?" *Analysis* 22: 1–6.

92. 1962. Review of "Dimensions of Knowledge" by P. Oppenheim, and of comments thereon by C. Morris, F. R. Kling, and S. Bromberger. *Journal of Symbolic Logic* 27: 126.

93. 1962. Review of "A Physicist's Thoughts on the Formal Structure and Psychological Motivation of Theory and Observation" by Jerome Rothstein. *Journal of Symbolic Logic* 27: 126.

94. 1963. "Brentano, Franz Clemens." In *Encyclopedia International*, vol. 3, 257. New York: Grolier, Inc.

95. 1963. "Contrary-to-Duty Imperatives and Deontic Logic." *Analysis* 24: 33–36.

96. 1963. "Epistemology, or Theory of Knowledge." In *Collier's Encyclopedia*, vol. 9, 271–72. New York: Crown-Collier.

97. 1963. "The Logic of Knowing." *Journal of Philosophy* 60: 773–95.

Reprinted in Michael D. Roth and Leon Galis, eds., *Knowing: Essays in the Analysis of Knowledge,* 189–219. New York: Random House, 1970.

98. 1963. "Notes on the Logic of Believing." *Philosophy and Phenomenological Research* 24: 195–201.

Reprinted in Ausonio Marras, ed., *Intentionality, Mind, and Language,* 75–84. Urbana: University of Illinois Press, 1972.

99. 1963. "Supererogation and Offence: A Conceptual Scheme for Ethics." *Ratio* 5: 1–14.

Published also in the German edition of *Ratio* 5: 1–12, as "Übergebührlichkeit und Anstössigkeit: ein Begriffsschema fur die Ethik."

Reprinted in Judith J. Thomson and Gerald Dworkin, eds., *Ethics,* 412–29. New York: Harper and Row, 1968.

100. 1964. "Believing and Intentionality: A Reply to Mr. Luce and Mr. Sleigh." *Philosophy and Phenomenological Research* 25: 266–69.

Reprinted in Ausonio Marras, ed., *Intentionality, Mind, and Language,* 91–96. Urbana: University of Illinois Press, 1972.

101. 1964. "The Descriptive Element in the Concept of Action." *Journal of Philosophy* 61: 613–25.

102. 1964. "The Ethics of Requirement." *American Philosophical Quarterly* 1: 147–53.

103. 1964. *Human Freedom and the Self.* Lindley Lecture. Lawrence, Kans.: University of Kansas Press.

Reprinted with revisions in Joel Feinberg, ed., *Reason and Responsibility,* 359–66. Belmont, Calif.: Wadsworth Publishing Company, 1971.

Reprinted with omissions and revisions in W. K. Frankena, J. T. Granrose, eds., *Introductory Readings in Ethics,* 289–94. Englewood Cliffs, N. J.: Prentice Hall, Inc., 1974.

Reprinted in John Bricke, ed., *Freedom and Morality,* 23–55. Lawrence, Kans.: University of Kansas Press, 1976.

Translated into German as "Die menschliche Freiheit und das Selbst," in *Seminar: Freies Handeln und Determinismus,* ed. Ulrich Pothast, 71–87. Frankfurt: Suhrkamp Verlag, 1978.

Reprinted in Gary Watson, ed., *Free Will,* 24–35. Oxford: Oxford University Press, 1982.

Reprinted in Donald C. Hoy and Nathan Oaklander, eds., *Metaphysics: Classic and Contemporary Readings,* 360–67. Belmont, Calif.: Wadsworth Publishing Co., 1990.

104. 1964. "J. L. Austin's Philosophical Papers." *Mind* 73: 1–26.

Reprinted in part in Bernard Berofsky, ed., *Free Will and Determinism,* 339–45. New York: Harper and Row, 1966.

Reprinted in K. T. Fann, ed., *Symposium on J. L. Austin,* 101–26. London: Routledge and Kegan Paul, 1969.

Reprinted in part in Myles Brand, ed., *The Nature of Human Action,* 187–91. Glenview, Ill.: Scott, Foresman and Company, 1970.

105. 1964. Monograph: "Theory of Knowledge." In Roderick M. Chisholm, Herbert Feigl, William K. Frankena, John Passmore, and Manley Thomson, eds., *Philosophy: The Princeton Studies: Humanistic Scholarship in America*, 233–344. Garden City, N. J.: Prentice Hall, Inc.

Chapter 2, "The Myth of the Given," in Paul K. Moser, ed., *Empirical Knowledge: Readings in Contemporary Epistemology*, 55–75. Totowa, N. J.: Bowman and Littlefield, 1986.

106. 1964. "A Note on Saying." *Analysis* 24: 182–84.

107. 1965. "Contemporary Developments in American Epistemology." In *Aspects of Contemporary American Philosophy*, ed. Franklin H. Donnell, Jr., 9–17. Würzburg and Vienna: Physica Verlag.

108. 1965. "The Foundation of Empirical Statements." In K. Ajdukiewicz, ed., *The Foundation of Statements and Decisions*, 111–20. Warsaw: Polish Scientific Publishers.

Reprinted with revisions in Michael D. Roth and Leon Galis, *Knowing: Essays in the Analysis of Knowledge*, 39–53. New York: Random House, 1971.

109. 1965. "Leibniz's Law in Belief Contexts." In A. Tymieniecka, ed., *Contributions to Logic and Methodology in Honor of J. M. Bochenski*, 243–50. Amsterdam: North Holland Publishing Company.

110. 1965. "Notes on the Awareness of the Self." *Monist* 49: 28–35.

111. 1965. "Query on Substitutivity." In R. S. Cohen and M. W. Wartofsky, eds., *Boston Studies in the Philosophy of Science*, 275–78. New York: Humanities Press.

112. 1965. Review of *Die sprachlichen Grundlagen der Philosophie* by George Janoska. *Philosophy and Phenomenological Research* 25: 447–48.

113. 1965. "Self-Founding Statements and Beliefs." In K. Ajdukiewicz, ed., *The Foundation of Statements and Decisions*, 45–46. Warsaw: Polish Scientific Publishers.

114. 1966. "Brentano's Theory of Correct and Incorrect Emotion." *Revue Internationale de Philosophie*, vingtième année, no. 78: 395–414.

Revision reprinted in Linda McAlister, ed., *The Philosophy of Franz Brentano*, 160–75. London: Duckworth, 1976.

115. 1966. "Freedom and Action." In Keith Lehrer, ed., *Freedom and Determinism*, 11–44. New York: Random House.

Reprinted in part in Myles Brand, ed., *The Nature of Human Action*, 283–92. Glenview, Ill.: Scott, Foresman and Company, 1970.

Translated into German as "Freiheit und Handeln," in *Analytische Handlungstheorie*, vol. 1, ed. Georg Meggle, 354–87. Frankfurt: Suhrkamp Verlag, 1977.

Reprinted as "Libertarianism," in Raziel Abelson and Marie-Louise Frequegnon, eds., *Ethics for Modern Life*, 5th ed., 139–52. New York: St. Martin's, 1995.

116. 1966. "Intrinsic Preferability and the Problem of Supererogation" (with Ernest Sosa). *Synthese* 16: 321–31.

117. 1966. "On the Logic of 'Intrinsically Better'" (with Ernest Sosa). *American Philosophical Quarterly* 3: 244–49.

118. 1966. "The Principles of Epistemic Appraisal." In Frederick C. Dommeyer, ed., *Current Philosophical Issues: Essays in Honor of Curt John Ducasse,* 87–104. Springfield, Ill.: Charles C. Thomas.

119. 1966. Review of *Metaphysics: A Systematic Survey* by John A. Peters. *Personalist* 47: 125.

120. 1966. *Theory of Knowledge,* 1st ed. Englewood Cliffs, N. J.: Prentice Hall, Inc.

Translated into Chinese as *Chih shih lun.* Taipei: San Min Shu Chu, 1967.

Translated into Italian as *Teoria della conoscenza.* Bologna: Societa editri il Mulino, 1968. Translated into Dutch as *Kennistheorie.* Utrecht and Antwerp: Het Spectrum, 1968.

Translated into Japanese as *Chishiki No Riron.* Tokyo: Faifu Kan, 1970.

Chapter 1 ("Knowledge and True Opinion") reprinted in Robert Paul Wolff, ed., *Philosophy: A Modern Encounter,* 240–56. Englewood Cliffs, N.J.: Prentice Hall, Inc., 1971.

Chapter 2 ("The Status of Appearances") reprinted in Margaret D. Wilson, Dan W. Brock, and Richard F. Kuhns, eds., *Philosophy: An Introduction,* 220–29. New York: Meredith Corporation, 1972.

Chapter 2 ("The Directly Evident") reprinted, in part, in Robert C. Solomon, *Phenomenology and Existentialism,* 168–77. Washington: University Press of America, 1979.

Chapter 6 reprinted in David M. Rosenthal, ed., *The Nature of Mind,* 280–84. New York and Oxford: Oxford University Press, 1991.

See item 188 for second edition with reprintings and translations; item 290 for third edition and translation.

121. 1966. Editor and cotranslator, *The True and the Evident* by Franz Brentano. London: Routledge and Kegan Paul. (A translation of *Wahrheit und Evidenz* by Franz Brentano [Leipzig: Felix Meiner, 1930].) Editor's introduction, vii–viii.

122. 1967. "Brentano on Descriptive Psychology and the Intentional." In *Phenomenology and Existentialism,* ed. Edward N. Lee and Maurice Mandelbaum, 1–23. Baltimore: Johns Hopkins Press.

Reprinted in Harold Morick, ed., *Introduction to the Philosophy of Mind,* 130–49. Glenview, Ill.: Scott, Foresman and Company, 1970.

123. 1967. "Comments on D. Davidson's 'The Logical Form of Action Sentences.'" In *The Logic of Decision and Action,* ed. Nicholas Rescher, 113–14. Pittsburgh: University of Pittsburgh Press.

124. 1967. "Comments on von Wright's 'The Logic of Action.'" In *The Logic of Decision and Action,* ed. Nicholas Rescher, 137–39. Pittsburgh: University of Pittsburgh Press.

125. 1967. "Franz Brentano." In *The Encyclopedia of Philosophy,* ed. Paul Edwards, vol. 1, 365–68. New York: Macmillan Company.

126. 1967. "'He Could Have Done Otherwise.'" *Journal of Philosophy* 64: 409–18.

Reprinted with revisions in Jerry H. Gill, ed., *Philosophy Today,* no. 1, 236–49. New York: Macmillan Company, 1968.

Reprinted with revisions in Myles Brand, ed., *The Nature of Human Action,* 293–301. Glenview, Ill.: Scott, Foresman and Company, 1970.

Revised version translated into German as "Er hätte etwas anderes tun Können," in *Conceptus: Zeitschrift fur Philosophie* 5, nos. 1 and 2 (1971): 13–19.

German translation reprinted in Hans Lenk, ed., *Handlungstheorien interdisziplinar* 2, 391–98. Munich: Wilhelm Fink Verlag, 1978.

127. 1967. "Identity through Possible Worlds: Some Questions." *Nous* 1: 1–8.

Reprinted in M. J. Loux, ed., *The Possible and the Actual: Readings in the Metaphysics of Modality*, 80–87. Ithaca, N.Y.: Cornell University Press, 1979.

128. 1967. "Intentionality." In *The Encyclopedia of Philosophy*, ed. Paul Edwards, vol. 4, 201–4. New York: Macmillan Company.

129. 1967. "Marty, Anton." In *The Encyclopedia of Philosophy*, ed. Paul Edwards, vol. 5, 170–71. New York: Macmillan Company.

130. 1967. "Meinong, Alexius." In *The Encyclopedia of Philosophy*, ed. Paul Edwards, vol. 5, 261–63. New York: Macmillan Company.

131. 1967. "On Some Psychological Concepts and the 'Logic' of Intentionality." In Hector-Neri Castañeda, ed., *Intentionality, Minds, and Perception*, 11–35. Detroit: Wayne State University Press.

132. 1967. "Rejoinder." In Hector-Neri Castañeda, ed., *Intentionality, Minds, and Perception*, 46–57. Detroit: Wayne State University Press.

133. 1967. Review of *Meinong's Theory of Objects and Values* by J. N. Findlay. *Philosophy and Phenomenological Research* 28: 448–49.

134. 1967. Review of *The Structure of Mind* by Reinhardt Grossman. *Philosophy* 42: 160.

135. 1968. "Brentano's Descriptive Psychology." *Proceedings of the XIVth International Congress of Philosophy: Vienna, September 2–9, 1968*, vol. 2, 164–74. Vienna: University of Vienna Press.

Revision reprinted in Linda McAlister, ed., *The Philosophy of Franz Brentano*, 91–100. London: Duckworth, 1976.

136. 1968. "Lewis' Ethics of Belief." In *The Philosophy of C. I. Lewis* (The Library of Living Philosophers, vol. 13), ed. P. A. Schilpp, 223–42. La Salle, Ill.: Open Court.

137. 1968. Review of *Philosophenbriefe aus der wissenschaftlichen Korrespondenz von Alexius Meinong*, ed. Rudolf Kindinger. *Philosophical Review* 77: 372–75.

138. 1968–1969. "The Defeat of Good and Evil." Presidential Address before the Eastern Division of the American Philosophical Association. *Proceedings and Addresses of the American Philosophical Association* 42: 21–38.

Reprinted in J. E. Smith, ed., *Contemporary American Philosophy: Second Series*, 152–69. London: George Allen and Unwin, 1970.

Reprinted with revisions in Marilyn M. Adams and Robert M. Adams, *The Problem of Evil*, 53–68. Oxford: Oxford University Press, 1990.

139. 1969. "Language, Logic, and States of Affairs." In Sidney Hook, ed., *Language and Philosophy*, 241–48. New York: New York University Press.

140. 1969. "The Loose and Popular and the Strict and Philosophical Senses of Identity." In Norman S. Care and Robert H. Grimm, eds., *Perception and Personal Identity*, 82–106. Cleveland, Ohio: Case Western Reserve University Press.

141. 1969. "On a Principle of Epistemic Preferability." *Philosophy and Phenomenological Research* 30: 294–301.

142. 1969. "On the Observability of the Self." *Philosophy and Phenomenological Research* 30: 7–21.

 Reprinted in Paul Kurtz, ed., *Language and Human Nature: A French-American Philosophers' Dialogue,* 140–54. St. Louis: Warren H. Greene, Inc., 1971.

 Reprinted in John Donnelly, ed., *Logical Analysis and Contemporary Theism,* 276–93. New York: Fordham University Press, 1972.

 Reprinted in John Donnelly, ed., *Language, Metaphysics, and Death,* 137–49. Bronx: Fordham University Press, 1978.

 Reprinted in Quassim Cassam, ed., *Self-Knowledge,* 94–108. Oxford: Oxford University Press, 1994.

143. 1969. Editor and cotranslator, *The Origin of Our Knowledge of Right and Wrong* by Franz Brentano. London: Routledge and Kegan Paul. (A translation of *Vom Ursprung sittlicher Erkenntnis* by Franz Brentano, 3d ed. Leipzig: Felix Meiner, 1934.) Editor's introduction, vii–viii.

144. 1969. "Reply." In Norman S. Care and Robert H. Grimm, eds., *Perception and Personal Identity,* 128–39. Cleveland, Ohio: Case Western Reserve University Press.

145. 1969. "Some Puzzles about Agency." In Karel Lambert, ed., *The Logical Way of Doing Things,* 199–217. New Haven: Yale University Press.

146. 1970. "C. J. Ducasse (1881–1969)." *Philosophy and Phenomenological Research* 30: 631–33.

147. 1970. "Comments on Mr. Strawson's Paper." In H. E. Kiefer and M. K. Munitz, eds., *Language, Belief, and Metaphysics,* 87–92. Albany: State University of New York Press.

148. 1970. "Events and Propositions." *Nous* 4: 15–24.

149. 1970. "Identity Through Time." In H. E. Kiefer and M. K. Munitz, eds., *Language, Belief, and Metaphysics,* 163–82. Albany: State University of New York Press.

150. 1970. "On the Nature of Empirical Evidence." In L. Foster and J. W. Swanson, eds., *Experience and Theory,* 103–34. Amherst: University of Massachusetts Press.

 Reprinted with revisions in Roderick M. Chisholm and Robert J. Swartz, eds., *Empirical Knowledge: Readings from Contemporary Sources,* 224–49. Englewood Cliffs, N.J.: Prentice Hall, Inc., 1973.

 Reprinted with additional revisions (and thus in a third version) in *Essays on Knowledge and Justification,* ed. George S. Pappas and Marshall Swain, 253–78. Ithaca, N.Y.: Cornell University Press, 1978.

151. 1970. "Reply to Strawson's Comments." In H. E. Kiefer and M. K. Munitz, eds., *Language, Belief, and Metaphysics,* 187–89. Albany: State University of New York Press.

152. 1970. "The Structure of Intention." *Journal of Philosophy* 67: 633–47.

153. 1971. "On the Logic of Intentional Action." In *Agent, Action, and Reason,* ed. R. Binkley, R. Bronaugh, A. Marras, 38–69. Toronto: University of Toronto Press.

154. 1971. "Problems of Identity." In *Identity and Individuation,* ed. Milton K. Munitz, 3–30. New York: New York University Press.

Reprinted in Donald C. Hoy and Nathan Oaklander, eds., *Metaphysics: Classic and Contemporary Readings,* 138–47. Belmont, Calif.: Wadsworth Publishing Co.

155. 1971. "Reflections on Human Agency." *Idealistic Studies* 1: 33–46.

156. 1971. "Rejoinder to Perelman." In Paul Kurtz, ed., *Language and Human Nature: A French-American Philosophers' Dialogue,* 167–68. St. Louis: Warren H. Green, Inc. (A reply to criticisms in 145.)

157. 1971. "Reply." In *Agent, Action, and Reason,* ed. R. Binkley, R. Bronaugh, A. Marras, 76–80. Toronto: University of Toronto Press.

158. 1971. "States of Affairs Again." *Nous* 5: 179–89.

159. 1972. Editor, *Alexius Meinong Gesamtausgabe (Über Möglichkeit und Wahrscheinlichkeit),* vol. 6. Graz: Akademische Druck- und Verlagsanstalt. Editor's introduction, ix–xii.

160. 1972. "Beyond Being and Nonbeing." In *Jenseits von Sein und Nichtsein,* ed. Rudolf Haller, 25–36. Graz: Akademische Druck- und Verlagsanstalt.

Reprinted in Herbert Feigl, Wilfrid Sellars, and Keith Lehrer, eds., *New Readings in Philosophical Analysis,* 15–22. New York: Appleton-Century-Crofts, 1972.

Reprinted in *Philosophical Studies* 24 (1973): 245–55.

161. 1972. "Objectives and Intrinsic Value." In *Jenseits von Sein und Nichtsein,* ed. Rudolf Haller, 261–70. Graz: Akademische Druck- und. Verlagsanstalt.

162. 1972. "A System of Epistemic Logic" (with Robert G. Keim). *Ratio* 14: 99–115.

Published also in the German edition of *Ratio* 14 (1972) as "Ein System der epistemischen Logik," 95–110.

163. 1973. Editor, *Alexius Meinong Gesamtausgabe.* Vol. 5. Graz: Akademische Druck-u. Verlagsanstalt. Editor's introduction, vii–xi.

164. 1973. *Empirical Knowledge: Readings from Contemporary Sources* (with Robert J. Swartz). Englewood Cliffs, N.J.: Prentice Hall, Inc. Editors' introduction, vii–x.

165. 1973. "Homeless Objects." *Revue Internationale de Philosophie,* vingt-septième année, 207–23.

166. 1973. "Parts as Essential to Their Wholes." *Review of Metaphysics* 25: 581–603.

167. 1973. *The Problem of the Criterion.* Aquinas Lecture. Milwaukee: Marquette University Press.

168. 1973. Review of Leonard Nelson, *Critique of Practical Reason. Journal of Philosophy* 70: 722–23.

169. 1974. "On the Nature of Acquaintance: A Discussion of Russell's Theory of Knowledge." In George Nakhnikian, ed., *Bertrand Russell's Philosophy,* 47–56. London: George Duckworth and Co., Ltd.

170. 1974. "Practical Reason and the Logic of Requirement." In Stephan Körner, ed., *Practical Reason,* 1–17. Oxford: Basil Blackwell.

Reprinted with omissions in Joseph Raz, ed., *Practical Reasoning,* 118–27. Oxford: Oxford University Press, 1978.

171. 1974. "Reply." In Stephan Körner, ed., *Practical Reason,* 40–53. Oxford: Basil Blackwell.

172. 1975. "Individuation: Some Thomistic Questions and Answers." *Grazer Philosophische Studien* 1: 25–41.

173. 1975. "The Intrinsic Value in Disjunctive States of Affairs." *Nous* 9: 295–308.

174. 1975. "Mereological Essentialism: Some Further Considerations." *Review of Metaphysics* 28: 477–84.

175. 1975. Editor, with Reinhard Fabian, "Was an Reid zu Loben ist: Über die philosophie von Thomas Reid" by Franz Brentano. *Grazer Philosophische Studien* 1: 1–18.

176. 1976. "The Agent as Cause." In M. Brand and D. Walton, eds., *Action Theory,* 199–211. Dordrecht: D. Reidel.

Translated into German as "Der Handelnde als Ursache," in Hans Lenk, ed., *Handlungstheorien Interdisziplinar 2,* 399–416. Munich: Wilhelm Fink Verlag, 1978.

Translated into French as "L'Agent en tant que cause," in Marc Neuberg, ed., *Theorie de l'action: Textes majeurs de la philosophie analytique de l'action,* 225–39. Liège: Pierre Mardaga, 1991.

177. 1976. "Bibliography of the Published Writings of Franz Brentano." In Linda McAlister, ed., *The Philosophy of Franz Brentano,* 240–47. London: Duckworth.

178. 1976. "Brentano's Nonpropositional Theory of Judgment." *Midwest Studies in Philosophy* 1: 91–95.

179. 1976. "Knowledge and Belief: 'De Dicto' and 'De Re'." *Philosophical Studies* 29: 1–20.

180. 1976. "On the Identification of Bodies" (abstract of comments). *Nous* 10: 33–34.

181. 1976. *Person and Object: A Metaphysical Study.* La Salle, Ill.: Open Court Publishing Company; and Muirhead Library of Philosophy, London: Allen and Unwin, Ltd.

A revised version of Chapter 1 appears as "Data for the Theory of Persons," in *Science and Psychotherapy,* ed. R. Stern, L. Horovitz, and Jack Lynes, 125–132. New York: Haven Publishing Company, 1977.

Translated into Japanese by Seiji Nakahori and published by Misuzu Shobo, Tokyo, 1991.

182. 1976. Editor, with Stephan Körner, *Philosophische Untersuchungen zu Raum, Zeit und Kontinuum* by Franz Brentano. Hamburg: Felix Meiner Verlag. Editors' *Vorwort,* vii; editors' *Einleitung,* viii–xxxiv.

English translation, *Philosophical Investigations on Space, Time, and the Continuum.* London: Croom Helm, 1988. Editors' introduction, vi–xxiii.

183. 1976. "Ein zurückhaltender Realismus." *Freiburger Zeitschrift für Philosophie und Theologie* 23: 190–97.

184. 1977. "Coming into Being and Passing Away: Can the Metaphysician Help?" In S. F. Spicker and H. T. Englehardt, eds., *Philosophical Medical Ethics: Its Nature and Significance,* 169–82. Dordrecht: D. Reidel.

Reprinted in John Donnelly, ed., *Language, Metaphysics, and Death*, 13–24. Bronx: Fordham University Press, 1978.

185. 1977. "Individuation *per se.*" In Gilbert Ryle, ed., *Contemporary Aspects of Philosophy*, 122–31. London: Oriel Press.

186. 1977. "The Intent to Deceive" (with Thomas D. Feehan). *Journal of Philosophy* 74: 143–59.

187. 1977. Review of *Hauptströmungen der Gegenwarts-Philosophie* by Wolfgang Stegmüller. *Ratio* 19: 181–82.

A German translation appears in the German edition of *Ratio* 19: 169–70.

188. 1977. *Theory of Knowledge*, 2d ed. Englewood Cliffs, N.J.: Prentice Hall, Inc.

Translated by Rudolf Haller into German as *Erkenntnistheorie.* Munich: Deutscher Taschenbuch Verlag, 1979. Translator's introduction, 7–11.

Translated by Vicente Peris Mingueza into Spanish as *Teoría del Conocimiento*, 417–27. Madrid: Editorial Tecnos, S.A. 1982.

Chapter 3 ("The Truths of Reason"), in Paul K. Moser, ed., *A Priori Knowledge*, 112–44. Oxford: Oxford University Press, 1987.

Abridged versions of chapter 2, "The Directly Evident," and chapter 3, "The Indirectly Evident," in Michael F. Goodman and Robert A. Snyder, eds., *Contemporary Readings in Epistemology*, 53–69. Englewood Cliffs, N.J.: 1993.

189. 1977. "Thought and its Reference." *American Philosophical Quarterly* 14: 167–72.

190. 1978. "Apriorische Erkenntnis und ihr Verhältnis zu Skeptizismus und Gewissheit." *Perspektiven der Philosophie* 3: 19–29.

191. 1978. Cotranslator, with Rolf George, and author of the introduction to *Aristotle and His World-View* by Franz Brentano. Los Angeles: University of California Press. The introduction is on vii–ix.

A German translation of the introduction appears in Franz Brentano, *Aristoteles und seine Weltanschauung*, v–viii. Hamburg: Felix Meiner, 1977.

192. 1978. "Brentano als analytischer Metaphysiker." In *Österreichische Philosophen und ihr Einfluss auf die analytische Philosophie der Gegenwart*. Vol. 1, 77–82. This volume is a special issue of *Conceptus* (Innsbruck).

193. 1978. "Brentano's Conception of Substance and Accident." *Grazer Philosophische Studien* 5: 199–210.

Also printed in *Die Philosophie Franz Brentanos: Beiträge zur Brentano-Konferenz, Graz 1977.* Amsterdam: Editions Rodopi N.V., 1978.

194. 1978. "Comments and Replies." *Philosophia: Philosophical Quarterly of Israel* 7: 597–636. This issue of *Philosophia* is devoted to "The Philosophy of Roderick M. Chisholm."

195. 1978. Comments on Marc-Wogau on Perceptual Space. In *L'Espace*, ed. Maja Svila and A. Mercier, 202–3. Bern: Peter Lang.

196. 1978. "Intrinsic Value." In A. I. Goldman and J. Kim, eds., *Values and Morals*, 121–30. Dordrecht: D. Reidel Publishing Company.

197. 1978. "Is There a Mind-Body Problem?" *Philosophical Exchange* 2: 25–34.

198. 1978. Editor, with Rudolf Haller, *Die Philosophie Franz Brentanos: Beiträge zur Brentano-Konferenz, Graz 1977.* Amsterdam: Editions Rodopi N.V., 1978.

199. 1978. "The Self and the World." In *Wittgenstein and His Impact on Contemporary Thought: Proceedings of the Second International Wittgenstein Symposium,* 407–10. Vienna: Hölder Pichler Tempsky.

Reprinted in John Canfield, ed., *Wittgenstein and His Impact on Contemporary Philosophy,* 269–73. New York: Garland Publishing, Inc., 1986.

200. 1978. "What Is a Transcendental Argument?" *Neue Hefte für Philosophie* 14: 19–22.

201. 1979. "The Directly Evident." In G. Pappas, ed., *Justification and Knowledge: New Studies in Epistemology,* 115–27. Dordrecht: D. Reidel.

202. 1979. "Events, Propositions, and States of Affairs." In P. Weingartner and E. Morscher, eds., *Ontologie und Logik,* 27–47. Berlin: Duncker und Humblot.

203. 1979. "The Indirect Reflexive." In Cora Diamond and Jenny Teichman, eds., *Intention and Intentionality: Essays in Honour of G. E. M. Anscombe,* 39–53. Brighton: Harvester Press.

204. 1979. "Objects and Persons: Revision and Replies." *Grazer Philosophische Studien* 7/8: 317–88.

Published also in *Essays on the Philosophy of Roderick M. Chisholm,* ed. Ernest Sosa, 317–88. Amsterdam: Editions Rodopi N. V.

205. 1979. "On the Logic of Purpose." *Midwest Studies in Philosophy* 4: 223–37.

206. 1979. "Possibility and States of Affairs." In P. Weingartner and E. Morscher, eds., *Ontologie und Logik,* 53–57. Berlin: Duncker und Humblot.

207. 1979. Review of *Thinking and Doing* by Hector Neri Castañeda. *Nous* 8: 385–96.

208. 1979. "Socratic Method and the Theory of Knowledge" and "Diskussion." In Peter Schröder, ed., *Vernunft Erkenntnis Sittlichkeit,* 37–53. Hamburg: Felix Meiner Verlag.

Reprinted in *Ratio* 21: 97–108.

209. 1979. "Toward a Theory of Attributes." In Ernest Sosa, ed., *The Philosophy of Nicholas Rescher,* 97–105. Dordrecht: D. Reidel.

210. 1979. Editor, with Reinhard Fabian, *Untersuchungen zur Sinnespsychologie* by Franz Brentano. 2d ed. Hamburg: Felix Meiner Verlag. "Einleitung" by R. M. Chisholm, vii–xxvi.

211. 1979. "Verstehen: The Epistemological Question." *Dialectica* 33: 233–46.

Reprinted in Polish as "Verstehen jako sagadnienie epistemologiczne," in *Educacja Filozoficzna* 13 (1992): 9–20.

212. 1980. "Beginnings and Endings." In Peter van Inwagen, ed., *Time and Cause,* 17–25. Dordrecht: D. Reidel.

213. 1980. "Epistemic Reasoning and the Logic of Epistemic Concepts." In G. H. von Wright, ed., *Logic and Philosophy,* 71–78. The Hague: Martinus Nijhoff.

214. 1980. "Evidenz." In J. Speck, ed., *Handbuch wissenschafts-theoretischer Begriffe,* vol. 1, 196–97. Göttingen: Vandenhoeck und Ruprecht.

215. 1980. "The Logic of Believing." *Pacific Philosophical Quarterly* 61: 31–49.

216. 1980. "On the Meaning of Proper Names." In *Language, Logic, and Philosophy: Proceedings of the Fourth International Wittgenstein Symposium,* 51–61. Vienna: Hölder Pichler Tempsky.

217. 1980. "Sachverhalt." In J. Speck, ed., *Handbuch wissenschafts-theoretischer Begriffe,* vol. 3, 565–66. Göttingen: Vandenhoeck und Ruprecht.

218. 1980. "Tatsache." In J. Speck, ed., *Handbuch wissenschafts-theoretischer Begriffe,* vol. 3, 622–23. Göttingen: Vandenhoeck und Ruprecht.

219. 1980. "A Version of Foundationalism." *Midwest Studies in Philosophy* 5: 543–64.

 Published in Hebrew as "Ha-Hipus ahar Ikronot HaKara" ("The Quest for Epistemic Principles"), in Asa Kasher and Shalom Lappin, eds., *Z'ramim Hadisim b'Philosophia* ("Modern Trends in Philosophy"), 57–75. Tel-Aviv: "Yachdav" United Publishers Co. Ltd., 1982.

220. 1981. "Brentano's Analysis of the Consciousness of Time." *Midwest Studies in Philosophy* 6: 3–16.

221. 1981. "Defining Intrinsic Value." *Analysis* 41: 99–100.

222. 1981. "Editorial Note." *Philosophy and Phenomenological Research* 12: 266.

223. 1981. "Endeavor and Its Objects." *Manuscrito* 4: 7–16.

224. 1981. "Epistemic Principles." *Dialectica* 35: 341–45.

225. 1981. "Feldman on *De Dicto* Endeavor." *Manuscrito* 4: 23–25.

226. 1981. *The First Person: An Essay on Reference and Intentionality.* The Benefactors' Lectures of the Royal Institute of Philosophy, 1979. Brighton, Sussex: Harvester Press Ltd., 1981. This book is published in the United States by the University of Minnesota Press in Minneapolis.

 Chapter 4 reprinted in David M. Rosenthal, ed., *The Nature of Mind,* 280–84. New York and Oxford: Oxford University Press, 1991.

 Translated into German by Dieter Münch as *Die erste Person: Theorie der Referenz und Intentionalität.* Frankfurt am Main: Suhrkamp, 1992.

 Chapter 3 of German translation ("Das Problem der Sätze der Erste Person") reprinted in *Protosoziologie* 4 ("Sprechakttheorie" 2) (1993): 3–14.

 Chapters 3, 4, and 7 of German translation reprinted in Manfred Frank, ed., *Analytische Theorien des Selbstbewusstseins,* 265–334. Frankfurt am Main: Suhrkamp, 1994.

227. 1981. "Laws of Nature and Causation." In E. Morscher, O. Neumaier, and G. Zecha, eds., *Philosophie als Wissenschaft/Essays in Scientific Philosophy,* 57–64. Bad Reichenhall: Comes Verlag.

228. 1981. "The Paradox of Analysis: A Solution" (with Richard Potter). *Metaphilosophy* 12: 1–7.

229. 1981. Review of *The Acting Person* by Cardinal Karol Wojtyla. In *Religious Studies* 17: 408–9.

230. 1981. Editor and cotranslator, *The Theory of Categories* by Franz Brentano. The Hague: Martinus Nijhoff.

231. 1981. "Time and Temporal Demonstratives." In K. Weinke, ed., *Logik, Ethik, und Sprache,* 31–36. Vienna and Munich: R. Oldenburg Verlag.

232. 1982. *Brentano and Meinong Studies.* Vol. 3 of *Studien zur Österreichischen Philosophie,* ed. R. Haller. Amsterdam: Editions Rodopi N.V.

233. 1982. "The Brentano-Vailati Correspondence" (with Michael Corrado). *Topoi* 1: 3–30.

234. 1982. "Converse Intentional Properties." *Journal of Philosophy* 79: 537–45.

235. 1982. Coeditor and coauthor, with Wilhelm Baumgartner, of the introduction and notes to *Deskriptive Psychologie* by Franz Brentano. Hamburg: Felix Meiner Verlag.

236. 1982. "Epistemic Reasoning." *Dialectica* 36: 169–77.

237. 1982. *The Foundations of Knowing.* Brighton and Minneapolis: Harvesters Ltd. and the University of Minnesota Press.

Revised version of chapter 3 ("Knowledge as Justified True Belief") in Paul K. Moser, ed., *Readings in Contemporary Philosophy,* 55–75. Totowa, N.J.: Rowman and Littlefield, 1986.

Also reprinted in Paul K. Moser and Arnold Vander Nat, eds., *Human Knowledge: Classical and Contemporary Approaches,* 266–69. Oxford: Oxford University Press.

238. 1982. "Marvin Farber." *Proceedings and Addresses of the American Philosophical Association* 55: 578–79.

239. 1982. "On the Nature of the Psychological." *Philosophical Studies* 43: 155–64.

240. 1982. "Properties Intentionally Considered." *Proceedings of the Sixth International Wittgenstein Symposium,* 117–21. Vienna: Hölder Pichler Tempsky.

241. 1982. "Schlick on the Foundations of Knowing." *Grazer Philosophische Studien* 16/17: 149–57.

242. 1983. "Believing as an Intentional Concept." In Herman Parret, ed., *On Believing: Epistemological and Semiotic Approaches,* 48–56. Berlin: Walter de Gruyter.

243. 1983. "Boundaries as Dependent Particulars." *Grazer Philosophische Studien* 21: 87–95.

244. 1983. "Confirmation as an Epistemic Category." In James E. Tomberlin, ed., *Agent, Language, and the Structure of the World,* 287–92. Indianapolis: Hackett Publishing Company.

245. 1983. "Herbert Heidelberger." *Proceedings and Addresses of the American Philosophical Association* 56: 405–6.

246. 1983. "The 'Koperkanische Wendung' in Brentano's Philosophy." In Dieter Henrich, ed., *Kant oder Hegel?: Stuttgarter Hegel Kongress, 1981,* 287–98. Stuttgart: Ernst Klett—J. G. Cotta'sche Buchhandlung.

247. 1983. "The Philosophy Department and Its Viennese Connection." *The George Street Journal* 9, no. 6 (November 15): 8.

248. 1983. Review of *Thomas Reid's Inquiry: The Geometry of Visibles and the Case for Realism* by Norman Daniels. *Philosophia: Philosophical Quarterly of Israel* 13: 81–84.

249. 1983. "Two Dimensions of Rational Action." *Social Theory and Practice* 9: 223–30.

250. 1983. Untitled article on Franz Brentano and the Philosophische Bibliothek. In Manfred Meiner, ed., *Ceterum censeo . . . : Bemerkungen zu Aufgabe und Tätigkeit eines philosophischen Verlegers.* Festschrift in honor of Richard Meiner, published privately in Hamburg.

251. 1984. "Foreword." In *The Search for an Alternative: Philosophical Perspectives of Subjectivism and Marxism* by Marvin Farber, vi–xi. Philadelphia: University of Pennsylvania Press.

252. 1984. "The Intentional Approach to Ontology." In Kah Kyung Cho, ed., *Philosophy and Science in Phenomenological Perspective,* 1–8. Dordrecht: Martinus Nijhof.

253. 1984. "The Primacy of the Intentional." *Synthese* 61: 89–109.

Reprinted in Serbo-Croation as "Primarnost intencionalnega," in *Anthropos* (Liubliana), UDK 3 (1986): 345–60.

Reprinted with revisions in David I. Cole, James H. Fetzger, and Terry L. Rankin, eds., *Philosophy, Mind, and Cognitive Inquiry: Resources for Understanding Mental Process,* 255–66. Dordrecht: Kluwer Academic Publishers, 1990.

Reprinted as "Primat Intencionalnosci," in *Edukacia Filozoficna* (Warsaw) 16 (1993): 5–20.

254. 1984. "Self-Presentation and the Psychological." *Grazer Philosophische Studien* 22: 5–11.

255. 1984. "What is the Problem of Objective Reference?" *Dialectica* 38: 131–42.

256. 1985. "Adverbs and Subdeterminates." In E. L. Lepore and B. McLaughlin, eds., *Actions and Events,* 124–28. Oxford: Basil Blackwell.

257. 1985. "A Logical Characterization of the Psychological." In *Proceedings of the Ninth International Wittgenstein Symposium,* 156–61. Vienna: Hölder-Pichler-Tempsky.

258. 1985. "Opening Address" (in German and English). In *Proceedings of the Ninth International Wittgenstein Symposium,* 22–27. Vienna: Hölder-Pichler-Tempsky.

259. "Preface" (in German and English). In *Proceedings of the Ninth International Wittgenstein Symposium,* 12–200. Vienna: Hölder-Pichler-Tempsky.

260. 1985. Coeditor with Adolf Hübner, John Blackmore, and J. C. Marek, *Proceedings of the Ninth International Wittgenstein Symposium.* Vienna: Hölder-Pichler-Tempsky.

261. 1985. "The Structure of States of Affairs." In B. Vermazen and M. Hintikka, eds., *Essays on Davidson: Actions and Events,* 107–14. Oxford: Clarendon Press.

262. 1985–1986. "George Katkov as Philosopher." *Grazer Philosophische Studien* 25/26: 601–2.

263. 1985–1986. "On the Positive and Negative States of Things." *Grazer Philosophische Studien* 25/26: 97–106.

264. 1986. *Brentano and Intrinsic Value.* Cambridge: Cambridge University Press.

265. 1986. "Brentano on Preference, Desire, and Intrinsic Value." In W. Grassl and B. Smith, eds., *Austrian Philosophy: Historical and Philosophical Background,* 183–95. London: Croom Helm.

266. 1986. "The Place of Epistemic Justification." *Philosophical Topics* 14: 85–92.

267. 1986. "Possibility without Haecceity." *Midwest Studies in Philosophy* 11: 157–63.

268. 1986. "Presence in Absence." *Monist* 69: 497–504.

269. 1986. "Reflections on Ehrenfels and the Unity of Consciousness." In Reinhard Fabian, ed., *Christian von Ehrenfels: Leben und Werk,* 136–49. Amsterdam: Editions Rodopi.

270. 1986. "The Self in Austrian Philosophy." In J. C. Nuiíri, ed., *From Bolzano to Wittgenstein: The Tradition of Austrian Philosophy,* in *Schriften der Wittgenstein-Gesellschaft,* vol. 12/2, pp. 71–74. Vienna: Verlag-Hölder-Pichler-Tempsky.

271. 1987. "Brentano and One-Sided Detachability." *Conceptus* 21: 153–59.

272. 1987. "Brentano's Theory of Pleasure and Pain." *Topoi* 6: 59–64.

273. 1987. Review of *Intentionality, Sense, and the Mind* by Maurita J. Harney. *Philosophical Review* 96: 283–86.

274. 1987. "Scattered Objects." In Judith Jarvis Thomson, ed., *On Being and Saying: Essays for Richard Cartwright,* 167–73. Cambridge: M.I.T. Press.

275. 1987. Coeditor, with Rudolf Haller, *Topoi: The Descriptive Psychology of Brentano and his School,* an issue of *Topoi: An International Journal of Philosophy,* vol. 6. Editors' introduction, p. 1.

276. 1987. "A Version of Cartesian Method." In J.T.J. Srzednicki, ed., *Stephan Körner: Philosophical Analysis and Reconstruction,* 1–8. Dordrecht: Martinus Nijhoff.

277. 1988. "An Analysis of Thirteen Epistemic Categories." In D. J. Austin, ed., *Philosophical Analysis,* 47–54. Dordrecht: D. Reidel.

278. 1988. "The Evidence of the Senses." *Philosophical Perspectives* 2: 71–90.

279. 1988. "The Indispensability of Internal Justification." *Synthese* 74: 285–396.

280. 1988. "Introduction." *Brentano Studien* 1: 15–17.

281. 1988. "Reply to Amico on the Problem of the Criterion." *Philosophical Papers* 17: 231–34.

282. 1988. Review of *Back to Things in Themselves: A Phenomenological Foundation for Classical Realism* by Josef Seifert. *Philosophy and Phenomenological Research* 48: 569–70.

283. 1988. "Theory and Practice: The Point of Contact." In Barry Smith and J. C. Nyíri, eds., *Practical Knowledge: Outlines of a Theory of Traditions and Skills,* 53–60. London: Croom Helm.

284. 1988. Coeditor, with Johann C. Marek, *Über Ernst Machs "Erkenntnis und Irrtum"* by Franz Brentano. Amsterdam: Rodopi.

285. 1988. "What are Wittgenstein's Remarks on Color About?" *Proceedings of the Annual Wittgenstein Symposium* 12: 290–95.

Translated as "Sur quoi portent les *Remarques sur les couleurs* de Wittgenstein?" In J.-P. Leyvras and Kevin Mulligan, eds., *Wittgenstein Analysé,* 281–97. Nîmes: Editions Jacqueline Chambon, 1993.

286. 1989. "Bolzano on the Simplicity of the Soul." In W. Gombocz, H. Rutte, and W. Sauer, eds., *Traditionen und Perspektiven der analytischen Philosophie,* 79–88. Vienna: Hölder-Pichler-Tempsky.

287. 1989. "The Objects of Sensation: A Brentano Study." *Topoi* 8: 3–8.

288. 1989. *On Metaphysics.* Minneapolis: University of Minnesota Press.

289. 1989. "Probability in the Theory of Knowledge." In Marjorie Clay and Keith Lehrer, eds., *Knowledge and Skepticism,* 119–30. Boulder: Westview Press.

290. 1989. *Theory of Knowledge.* 3d ed. Englewood Cliffs, N.J.: Prentice Hall, Inc.

 Translated into Polish by Renata Ziemińska as *Teoria Poznania.* Lublin: Daimonion, 1994.

291. 1989. "Why Singular Propositions?" In J. Almog, J. Perry, and H. Wettstein, eds., *Themes from Kaplan,* 145–50. New York and Oxford: Oxford University Press.

292. 1990. "Brentano and Marty on Content." In Kevin Mulligan, ed., *Mind, Meaning, and Metaphysics.* Dordrecht: Kluwer Academic Publishers.

293. 1990. "Einleitung." In Reinhard Fabian, ed., *Metaphysic.* Vol. 4 of *Christian von Ehrenfels: Philosophische Schriften,* 1–9. Munich: Philosophia Verlag.

294. 1990. "Events without Times: An Essay on Ontology." *Nous* 24: 413–28.

295. 1990. "How We Refer to Things." *Philosophical Studies* 58: 155–64.

296. 1990. "Keith Lehrer and Thomas Reid." *Philosophical Studies* 60: 33–38.

297. 1990. "The Nature of Epistemic Principles." *Nous* 24: 209–16.

298. 1990. "On the Simplicity of the Soul: Some Logical Considerations." *Hamline Review* (Hamline University, St. Paul, Minnesota) 14 (spring): 1–8.

299. 1990. "Referring to Things that No Longer Exist." *Philosophical Perspectives* 4: 545–56.

300. 1991. "Act, Content, and the Duck-Rabbit." In *Proceedings of the Fourteenth International Wittgenstein-Symposium,* 63–73. Vienna: Hölder-Pichler-Tempsky.

 Reprinted in John V. Canfield and Stuart G. Shankers, eds., *Wittgenstein's Intentions,* 87–103. New York: Garland Publishing Company.

301. 1991. "The Bearers of Psychological Properties." *Revista de Filosofia* (Murcia, Spain), no. 3: 7–14.

302. 1991. "Bernard Bolzano's Philosophy of Mind." *Philosophical Topics* 19: 207–16.

303. 1991. "Firth and the Ethics of Belief." *Philosophy and Phenomenological Research* 51: 119–28.

304. 1991. "Foreword." In George Chatalian, *Epistemology and Skepticism: An Inquiry into the Nature of Epistemology,* xi–xii. Carbondale and Edwardsville: Southern Illinois University Press.

305. 1991. "The Formal Structure of the Intentional." *Brentano Studien* 3: 11–17.

306. 1991. "An Intentional Explication of Universals." *Conceptus* 25: 45–48.

307. 1991. "Mind." In Hans Burkhardt and Barry Smith, eds., *Handbook of Metaphysics and Ontology,* vol. 2, 553–57. Munich: Philosophia Verlag.

308. 1991. "On the Simplicity of the Soul." *Philosophical Perspectives* 5: 157–81.

309. 1992. "The Basic Ontological Categories." In Kevin Mulligan, ed., *Language, Truth, and Ontology*, 1–13. Dordrecht: Kluwer Academic Publishers.

Reprinted in Polish in *Educasja Filosoficzna* (Warsaw) 18 (1994): 31–49.

310. 1992. "Brentano, Franz Clemens." In Lawrence C. Becker, ed., *Encyclopedia of Ethics*, 97–98. New York and London: Garland Publishing, Inc.

311. 1992. "Identity Criteria for Properties." *Harvard Review of Philosophy* 2, issue 1 (spring): 14–16.

312. 1992. "William James's Theory of Truth." *Monist* 75: 568–79.

313. 1993. "Brentano on 'Unconscious Consciousness.'" In Roberto Poli, ed., *Consciousness, Knowledge, and Truth*, 153–59. Dordrecht: Kluwer Academic Publishers.

314. 1993. "Masaryck and Brentano on the Nature of the Mental." In Josef Zumr and Thomas Binder, eds., *T. G. Masaryck und die Brentano Schule*, 22–28. Prague and Graz: Čzeskoslovenské Akademie and Forschungstelle und Dokumentationszentrum für Österreichischen Philosophie.

315. 1993. "The Theory of Knowledge." In Michael Boylan, ed., *Perspectives in Philosophy*, 171–75. Fort Worth: Harcourt Brace Jovanovich.

316. 1994. "Ontologically Dependent Entities." *Philosophy and Phenomenological Research* 54: 499–506.

317. 1995. "Ducasse, C. J." In Robert Audi, ed., *The Cambridge Dictionary of Philosophy*, 210–11. New York: Cambridge University Press.

318. 1996. *A Realistic Theory of Categories: An Essay on Ontology.* Cambridge: Cambridge University Press.

319. 1997. "Gadamer and Realism: Reaching an Understanding." In Lewis E. Hahn, ed., Library of Living Philosophers, vol. 24, *The Philosophy of Hans-Georg Gadamer*, 99–108. Chicago and La Salle, Ill: Open Court.

320. 1997. *The Philosophy of Roderick M. Chisholm,* ed. Lewis E. Hahn. Library of Living Philosophers, vol. 25. Chicago and La Salle, Ill: Open Court.

INDEX